Florine Stettheimer

a BIOGRAPHY

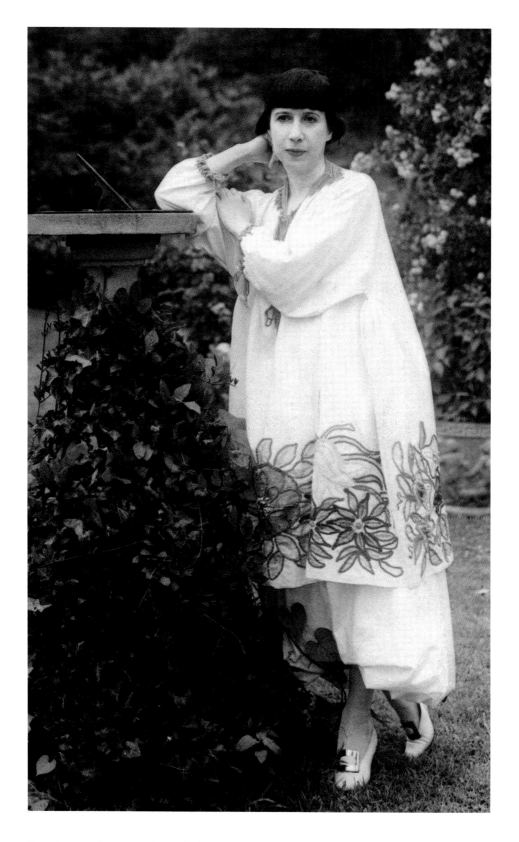

Fig. 1 Peter A. Juley & Sons, *Photograph of Florine Stettheimer*, c. 1917–20, Florine Stettheimer Papers, Rare Book and Manuscript Library, Columbia University in the City of New York, Gift of the Estate of Ettie Stettheimer.

Florine Stettheimer

a BIOGRAPHY

~~~~~~

### BARBARA BLOEMINK

HIRMER

# CONTENTS

# ACKNOWLEDGMENTS

This book reflects decades of learning from so many prior colleagues' research and assistance that they cannot all be mentioned by name. However, I am deeply grateful. I want to particularly single out my mentor at Yale University, Jules Prown, who supported my Ph.D. thesis on Florine Stettheimer. Dr. Prown also was critical in overcoming obstacles in my co-curating the 1995 retrospective Stettheimer exhibition at the Whitney Museum of American Art. My sincerest thanks also to the J. Paul Mellon Foundation for the two-year Mellon fellowship that allowed me to write my dissertation, the basis for my 1995 Yale University Press biography, *The Life and Art of Florine Stettheimer*.

The brilliant feminist art historian Linda Nochlin forever changed the field of art history. She was the first reader and an enthusiastic supporter of this new biography shortly before her passing. I will miss her for the rest of my life. My Toronto colleagues Irene Gammel and Suzanne Zelazo reprinted Stettheimer's poetry, *Crystal Flowers*, in 2010 and kindly invited me to give the keynote talk at their Stettheimer Symposium in 2015. Zelazo also served as the second reader for this work and provided excellent suggestions, for which I thank her. Art writer, critic, and Stettheimer lover Andrew Russeth, with whom I have shared fascinating discussions about the artist, read the manuscript and proved an indispensable editor with a keen eye for detail. Thank you so very much!

Special appreciation is extended to my late friends, Stettheimer trustee Joseph Solomon and the collector Kelly Simpson, for the myriad stories and crucial information about Stettheimer's life and work that they shared with me. For further information, particularly genealogical, thanks go to family members, including Barbara Katzander, Jean Steinhardt, Mrs. John D. Gordon, Marjorie Gordan Borden, Sherry Wanger, and Cynthia and Jan Nadelman. A great deal of information in this book also comes from interviews in the mid- to late 1990s with Virgil Thomson and John Houseman, who provided their special insights and memories, and to Steven Watson, who shared his fine scholarship on the creation, evolution, and performances of the *Four Saints in Three Acts* opera and his interviews with Virgil Thomson.

For their recent assistance, my gratitude to Alan Solomon, Diane Kempner, and especially, for her generous time and effort, to Jennifer E. Lee, Curator, Performing Arts Collections, Rare Book & Manuscript Library, Butler Library, Columbia University. My thanks also to Roberto C. Ferrari, Curator of Art Properties, and Meredith Self at Columbia University's Butler Library; James M. Sousa, Registrar, Addison Gallery of American Art, Phillips Academy; Deborah Diemente and Kelly Holbert of the Smith College Museum of Art; the Frick Art Reference Librarians, Annalise Welte of the Getty Research Institute; Amy Kilkenny, Head of Library and Archives of the Wadsworth Atheneum Museum of Art for their particular help; and all the museum registrars who assisted in providing images and information. My acknowledgments also to Valerie Amend, my publications assistant.

Thanks to Charlotte Sheedy, agent extraordinaire, and the talented Alex Kalman, who beautifully brought exactly the right contemporary/feminine sensibility to the design that Stettheimer would have loved. I am grateful to Elisabeth Rochau-Shalem, Rainer Arnold, and everyone at HIRMER publishers for making this book possible. There are not enough ways to thank Marina Auerbach, Ellen Ehrenkranz, Marjolijn Vencken, Ariane Zurcher, Jan Abrams, Lynn Goldsmith, Louise Sloane, Annette Fox, and my family, Van and Clint Franklin, Marybeth Foley, Rachael Briner, Li Yao and Jenny D. Lee, Cely Riva, Jared Dangremond and Christopher Lane — you make everything worthwhile.

Finally, all my love to Michael Franklin, for proving true love really exists and making me laugh and dance every day.

Now that this is done, I hope it will lead to decades of further scholarship and close viewing of Stettheimer's innovative and significant work.

# INTRODUCTION

During her lifetime, Stettheimer was invited to, and exhibited in, over forty of the most important international art exhibitions of the time, often to critical and curatorial acclaim.[1] She created a unique, theatrically based, experiential style that was one of the first to consciously depict broad subject matter through a female, rather than the traditional male, lens and was one of the first artists to document many of the central characters, events, and social issues that characterized the first four decades of twentieth-century New York City. In doing so, Stettheimer accurately depicted and celebrated the architectural and cultural development and events making Manhattan the new international center of finance, entertainment, wealth, and the art world.

For her time, Stettheimer painted several works with remarkably explicit sexual imagery. This included the first nude, feminist self-portrait by a woman in Western art history, and another with a shocking detail of a woman's genitals.[2] Relative to the racist and sexually restrictive "black and white" world in which she lived, Stettheimer was among the rare individuals who saw in "shades of brown." She typically avoided the ugly, negative aspects of life, instead conveying her opinions and pointed sexual and political commentary through humorous imagery, subjects' contexts and titles of her paintings and poetry. In addition, many years before her American contemporaries, Stettheimer painted several works dealing with issues such as African American segregation, anti-Jewish and Catholic bigotry, women's rights and independence, and fluid sexual preference, all topics that were highly controversial at the time. Stettheimer's paintings are also unusual for her time in being among the few overtly humorous, monumental, early twentieth-century paintings.[3]

Moreover, Stettheimer was one of the first American multidisciplinary artists: writing witty, sardonic, often savagely humorous poetry, designing elaborate furniture and matching frames as integral "installations" for her paintings, and creating the librettos and costumes for two ballets. Further, Florine Stettheimer received international acclaim for her costumes and stage designs for Gertrude Stein and Virgil Thomson's *Four Saints in Three Acts*, the first American avant-garde opera.

In 1939, the Museum of Modern Art celebrated its tenth anniversary and opened in its new building with *Art of Our Time*, an exhibition featuring the work of what its curators considered the 180 most important international contemporary artists. Stettheimer was one of only three women in the exhibition, which included the work of Picasso, Cézanne, Kandinsky, Duchamp, Homer,

Monet, O'Keeffe, and Cassatt. Stettheimer was also the first woman artist to be given a full retrospective exhibition of her life's work at the Museum of Modern Art.[4] It was curated, at his request, by her friend and colleague, Marcel Duchamp, and is the only retrospective of another artist he is known to have organized.

Yet as Duchamp would later observe:

> The danger is always in pleasing the immediate public, the one which surrounds you, receives you, finally consecrates you and confers success and…the rest. Contrary to that, perhaps one might have to wait fifty or a hundred years to reach his real public, but it is that which interests me.[5]

In fact, despite several short revivals, for seventy-five years since her death, Florine Stettheimer and her work have continued to be misrepresented by inaccurate information and such superficial reading of her work that most of the specific innovative achievements mentioned above, and therefore her significance in art history, remain largely unrecognized and unacknowledged even one hundred and fifty years after her birth.

Instead, since her death, Florine Stettheimer has most often been characterized as a "naturally timid and hypersensitive…cloistral"[6] spinster and "eccentric maiden aunt"[7] who was too fearful of rejection to publicly exhibit her work except to close friends and who wanted her work destroyed when she died.[8] Similarly, Stettheimer's work has been falsely marginalized and described as too saccharine like "puff-pastry,"[9] or primitive, "naif," "overly feminine," and resembling "outsider" or children's art.[10] In addition, her works are often classified as "decorative fantasies,"[11] without attention to her significant and occasionally controversial subject matter, factual, specific content, and originality.

In this biography, through closer, more sustained, careful viewing of her work and by placing it within its larger context, the above statements are proven to be inaccurate, and Florine Stettheimer is finally established stylistically, in terms of subject matter, context, and style, as one of the most innovative and significant artists of the twentieth century. Furthermore, with the current emphasis on gender and controversial identity issues, it is apparent why Stettheimer's work continues to remain highly relevant in the first decades of the twenty-first century.

Until now, there has been no available biography of Florine Stettheimer, nor an in-depth, accurate reading of all of her paintings.[12] It is time, therefore, to finally lay the inaccurate "myths" about Florine Stettheimer and her work to rest and acknowledge her importance in art history. Before doing so, however, it is instructive to understand from where so much long-promoted misinformation came, and some of the reasons it has taken so long for her significance to be fully recognized.

## COUNTERING THE MYTHS

The most influential source of inaccurate information about Stettheimer and her work is the subjective biography written by the film critic Parker Tyler, who was commissioned by the family lawyer, Joseph Solomon, over fifteen years after her death. The only recorded meeting between Tyler and Stettheimer occurred when she was quite elderly, and he openly admitted in his book that he made up and exaggerated a great deal of what he wrote. As he noted to Stettheimer's lawyer, Joseph Solomon, "my expository zeal made me overstress certain parts of my descriptions of Florine and her sisters, and use my overactive imagination to fabricate readings of Stettheimer's personality, work and intentions."[13] In his prelude to the Tyler biography, the novelist Carl Van Vechten, one of Stettheimer's closest friends, corroborates that Tyler "used his imagination so successfully that […] Florine herself appears even a trifle bigger than life size. […] [H]e has even employed metaphysical means in the process of completing his true picture."[14]

Unfortunately, Tyler's characterizations of Stettheimer as a "timid," "hypersensitive," disappointed, reclusive, and amateur artist who was so devastated her paintings did not sell in their earliest 1916 exhibition that "she never (or rarely) exhibited publicly again except to friends at a public salon"[15] have proven irresistible to all but a few art writers/critics/museum curators writing about Stettheimer since the 1970s. This more than anything has resulted in her inaccurately being seen as an "eccentric,"[16] rather than the confident, progressive woman she was. As H. Alexander Rich ironically noted, "when described again and again as 'eccentric'…Stettheimer herself comes across in many articles as a bit batty and more a sketchily drawn caricature than a living, breathing person."[17]

In fact, Stettheimer was an ambitious feminist who fully understood the significance and value of her paintings and was determined to be taken seriously as a professional artist. In a letter about her sister written in 1946, Ettie wrote that Stettheimer "rated herself relatively very high in the scale of contemporary painters"[18] and later she observed of her sister that "she did not thirst or starve into fecundity, her indomitable spirit was well nourished on her own confidence and enthusiasm."[19] As her close friend, the noted art critic Henry McBride, recognized, Florine Stettheimer was "willful" and "unconcerned with precedent…. Miss Stettheimer knew what she was doing."[20] Although an introvert who preferred one-one-one conversations to large groups, Stettheimer was not shy; nor, given how often she publicly exhibited her work, was she afraid of the public's opinion of it. Stating that Stettheimer had "plenty…[of] public spirit," McBride further remarked, "In spite of Miss Stettheimer's efforts to protect herself from the clamor of modern activity, she was by no means a recluse in the Emily Dickinsonian sense although like the poet she astonished people

occasionally by shrewd comments upon phases of existence from which it had been presumed she had been shielded."[21]

Nor was Stettheimer either a "cloistered spinster" (other than the fact that she never married), in its connotation of being virginal and cut off from the realities of life; nor, as will be discussed in the following chapters, sexually or politically "conservative." In at least two instances, her paintings demonstrate she was decidedly "suggestive" sexually, at least in private, for her time. Like her sister Ettie, Stettheimer was a progressive feminist, attending numerous women-oriented performances, and throughout her life chose to specifically read books by and biographies about strong and interesting, innovative women. In her diaries she recorded her enjoyment at attending many premieres of the most sexually provocative, controversial, theatrical and ballet performances in Europe.[22]

Although thin and petite in stature, Stettheimer was not "delicate," but she was a remarkably hardworking, businesslike artist for her time. As Georgia O'Keeffe noted, "Florine Stettheimer made very large paintings for the time,"[23] many measuring sixty by fifty inches, with elaborate, fragile frames making them very hard to manage.

It is surprising to consider that unlike O'Keeffe, whose husband, Alfred Stieglitz's, prominent art gallery undoubtedly handled all the framing and arrangements for insuring and transporting her paintings to and from exhibitions, Stettheimer had to take care of all this business by herself. This was particularly true as her sisters and mother never supported her art practice. Instead they considered it merely a pastime and distained any woman of their class seeking professional publicity, believing it to be unladylike and unbecoming.

Like O'Keeffe, Stettheimer was a highly ambitious, single-minded artist. To that end, she also manifested a remarkable control over every aspect of how she was perceived in public and for posterity. Both women used their clothing and their public image as a form of "signature."[24] From an early age, Stettheimer controlled how she was "seen" by visually "branding" herself as a professional artist: usually painting her self-portraits wearing a painting smock, an artist's beret, and holding a paintbrush and easel. Further managing her image, Stettheimer refused to allow herself to be photographed after her forties, despite her friendships with all of the major photographers of the time. Defying time and gravity, although she continued to include self-portraits in her works until her death in her seventies, Stettheimer always painted herself as ageless—in her thirties to early forties—often in some form of pantaloons, capri pants, or a velvet pantsuit she had made, and always wearing bright red or black high stiletto heels.

Additionally, she completely staged the unique idiosyncratic environment of her life and paintings, designing matching furniture and frames as well as her entire studio with huge cellophane

curtains, cellophane flowers within reflective vases, and cellophane chandeliers. Upstairs her bedroom, into which she invited special guests, was completely draped in Nottingham lace, with her paintings and matching frames hung on the walls. Everything was carefully controlled by Stettheimer's signature "brand."

The most often repeated fallacy in Parker Tyler's writing about Stettheimer is the myth that the lack of sales of her early Matisse-derivative paintings at a 1916 solo Knoedler Gallery exhibition caused a "wound" that so "demolished" Stettheimer's "illusion[s]" of the commercial art market that she never publicly exhibited again.[25] Henry McBride, who, unlike Tyler, was a close and longtime friend of Stettheimer's, observed more accurately that the 1916 Knoedler exhibition "was early in her career, before her style had crystallized."[26] Further, the idea that Stettheimer was unwilling or too upset to publicly exhibit after 1916 is quickly disproved by her continuing to publicly exhibit her work six months later and almost annually for the remainder of her life, as discussed in the ensuing text. Although Stettheimer often gave parties for friends to view her paintings in her studio, these were "unveiling birthday parties" for her newest works, prior to her then sending virtually all of the paintings to public exhibitions.

Any quick research on her exhibition history will reveal that, far from shying away from publicly showing her work, Stettheimer was invited to and exhibited in most of the most important contemporary exhibitions of the time, including the first Whitney Biennial, the earliest exhibitions at the Museum of Modern Art, the Carnegie International, and the *Salon D'Automne* in Paris. The artist attended her exhibition openings whenever possible and was delighted with the critical attention she earned at them and the international public recognition she gained for her sets and costume designs for *Four Saints in Three Acts*. She subscribed to *Romeicke's Clipping Service* to ensure she never missed any reviews or articles that mentioned her or her work.

Other of Tyler's inaccuracies that furthered the idea that Stettheimer was "eccentric" was his bizarre insistence that her last wishes were "the inherent, anachronistic impulse toward the burial of her works with herself"[27] and that her youngest sister, Ettie, "ignoring her wishes, saved them."[28] These have been repeated endlessly over the years, despite the fact that the artist's last will and testament expressly stated her sisters be given all her art, as they knew that her wish was that all her artworks be donated to a museum upon her death. Her continual invitations by curators to exhibit in major contemporary museum exhibitions affirmed her conviction that her work would eventually end up in museums after her death. Rather than "saving" her sister's works, Ettie largely left the donation process in the hands of her lawyer, Joseph Solomon, and her sister's friends Carl Van Vechten and gallerist Kirk Askew who, as per Stettheimer's wishes, donated her paintings to museums across the country.

In addition, most writers' and curators' too superficial viewing of her paintings over the decades has led to an inaccurate identification of subject matter and titles of various work and deceptive characterizations of her painting style. As Henry McBride accurately noted:

> Although she took all the license of a *primitive* she was by no means one herself. Her "line" was a draughtsman's line (she had been a pupil of Kenyon Cox at the Art Students' League), calligraphic, like so much of the best modern "line," and never to be accused of fumbling.[29]

As her early academic work demonstrates, unlike self-taught or so-called primitive artists, Stettheimer was well trained academically in a highly realistic manner. (*Fig. 2*) By 1915, she was confident enough of her artistic mastery to then repudiate traditional European realism, in order to develop an entirely new style. The paintings themselves have often been deemed "too feminine" (although it would be hard to imagine work such as that by her contemporary Marsden Hartley described as "too masculine") when, for many decades, "femininity" in art was considered a derogatory term.

Stettheimer's paintings are complicated; they don't fit neatly within any traditionally defined art movements associated with modernism between 1910 and 1945. Hers are not the flat, surface-based imagery of the Alfred Stieglitz circle, the masculine, baroque regionalism of Reginald Marsh, Thomas Hart Benton, and Grant Wood, nor the abstraction of the European expatriates in New York during the first decades of the twentieth century. Instead, in deciding to capture the specific figures, sites, and sensory experiences that characterized modernist twentieth-century New York City, Stettheimer created a figurative, narrative style that she based on her experiences of the Ballets Russes and the maquettes and figures she had designed for her early ballet, *Orphée des Quat'z-Arts*. The figures themselves are painted as though suddenly frozen while in motion. Gradually miniaturizing these elements, she consciously developed a highly detailed, Rococo, uniquely *feminine* style that was radical for the time, characterized by curling figures in the "s" curves.

Stettheimer's narratives are continuous, unfolding, intimate, visual *documentaries* of an era and class. They directly challenge the arrested moment as captured by the camera lens. Instead they are like the experiential flux of moving through time and the montage of moving pictures, with the sensory elements of textures, sounds, and colors of live theater and ballet performances. The rich, pure colors are reminiscent of the costume designs of the Ballets Russes, and Stettheimer's addition of sensory elements — jazz musicians and marching bands, pianists, hot, burning sun or cool moonlight, opera singers, airplanes, parades, Salvation Army singers — all add to the unusually performative elements of the paintings.

Stettheimer often used pure, unmixed colors, adding to the overall brightness of her paintings, as well as additive media that are, on occasion, almost three-dimensional on the canvases' surfaces.

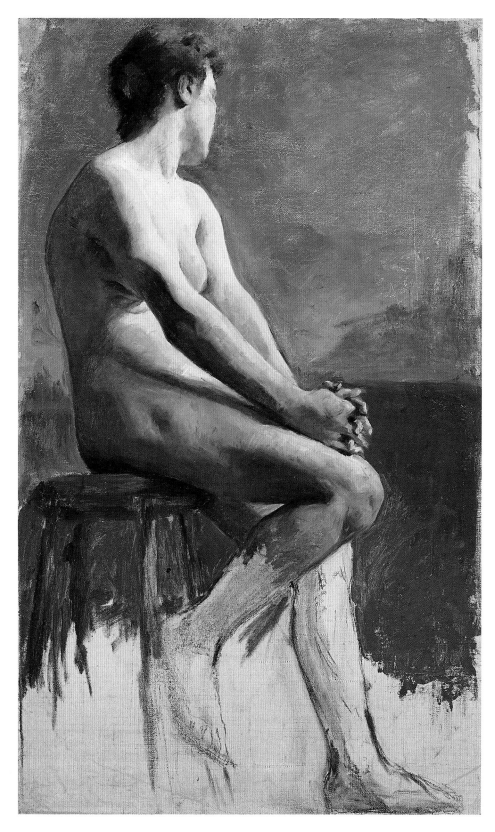

**Fig. 2** Florine Stettheimer, *Nude Study, Seated with Head Turned*, 1890s, oil on canvas mounted on board, 30 × 18 in., Art Properties, Avery Architectural & Fine Arts Library, Columbia University in the City of New York, Gift of the Estate of Ettie Stettheimer.

Although meaning and deep pleasure can be found in Stettheimer's paintings without having to identify the specific figures and/or the contexts in which the scenes take place, the numerous ironic, humorous, and witty details, as well as several fascinating progressive ideas, come alive when the figures' identities, the myriad details and the works' contexts are understood. A central element of Stettheimer's paintings is the extensive research she spent *factually documenting* every specific detail. Nothing was left to "fantasy" except for the floral elements. As many of the paintings depict several activities taking place concurrently, they cannot be fully appreciated or understood at a glance. Instead, Stettheimer's paintings reward extended and repeated viewing.

For Stettheimer, as a woman artist, there was no script to follow, no recognizable career stages, as there would be for men whose "lives include risk and the desire for individual achievements in the public world…"[30] Until her mid-sixties, when she could finally move away from her sisters and into her own studio, Stettheimer maintained a running battle to control time and place to work on her art. Her mature painting style was accomplished when Stettheimer was between forty-five and seventy years old. The notion of a middle-aged, wealthy, quiet, introverted, white woman with a biting sense of humor, who created independent, prescient, innovative artwork, remains disconcerting even today, contributing to her elusive reputation. Instead, as Deborah Solomon noted, many have a vague sense of Stettheimer as some:

> Odd-duck lady who lived in the 1920s and painted eccentrically naïve pictures of people socializing at parties…less like a legend of modern art than a creature from some "Little Women" drama of her own devising.[31]

As is true of all humans, Stettheimer was a mass of contradictions, and cannot be fully "known," even were she alive today to give extensive interviews. Unfortunately, after her death, Stettheimer's extraordinary furniture and many of her matching frames were destroyed, and her diary (and presumably her letters) were ruthlessly edited of everything personal, that is, all "family matters,"[32] by her sister Ettie. This has made it all the more important that her extant paintings, poetry, letters,

diaries, historical facts, and only direct *primary* sources from her friends and acquaintances, who knew and interacted with the artist, serve as the main resources for information about Florine Stettheimer and her work. In addition, it is important that accuracy of information in identifying the details in her paintings and close viewing be essential when discussing her life and work.

There is no evidence that Stettheimer ever intended her poetry to be read by anyone. In fact, throughout her life, she refused to allow it to be published. However, the acerbic, witty, and frank poems reveal many aspects of her private opinions and emotions, giving us another source of insight into the artist. They correspond to periods of her life, reacting to romantic interludes, describing specific friends and various moods, as well as giving her opinions about women and creativity, marriage, the art market, art museums, and the spectacle of modern New York City. Just as her paintings, Stettheimer's poetry is sensory, evoking emotions, tastes, colors, sounds, and lights. Dr. Lesley Higgins observes that they are the "essence of subjectivity….vivid experience poems, that share with noted poets Gertrude Stein, H.D., and Langston Hughes, a 'strategic simplicity,' and, like those of Emily Dickinson, cut to the quick."[33]

As Stettheimer's friend and fellow artist Marguerite Zorach noted, she was a "genuine person" and "an original artist."[34] What mattered most to Stettheimer was making her work. As Ettie observed after her sister's death:

> "To this life that she loved, Florine withdrew…. from social gatherings…. Whatever enjoyment she derived from these often visually attractive occasions was largely in connection with the use she might make of them in her work. It was her work, first and last, that she enjoyed, planning her next painting, experimenting technically, doing research for it, and finally painting it."[35]

Although in a sense self-created, neither Florine Stettheimer's personality, nor her painting style, appeared suddenly. Both evolved due to a series of influences, events, and her conscious choices. Her familial background, relations, upbringing, education, friends, relations, interests, and the social/political/cultural issues of the times in which she lived all had decisive and powerful significance for the development of her mature style and subject matter. It is therefore only by understanding from where she came, and the world in which she lived, that we can judge her, and her work, with any degree of understanding.

*chapter one*

ORIGINS

1870 – 1890s

On a sunny fall day in 1948, a New York lawyer, Joseph Solomon, found himself seated in a rental boat in the middle of the Hudson River.[1] On his lap, he held a shoebox containing the ashes of the renowned artist Florine Stettheimer. A few weeks earlier, Solomon had received a call from one of his elderly clients, Stettheimer's sister Ettie, requesting that he hire a private motorboat for the afternoon to travel up the Hudson. Ettie also asked Solomon to call the Universal Funeral Chapel and arrange to have her sister's ashes taken from the urn in which they had been confined for the past four years and placed in a cardboard box for retrieval.

That Saturday Solomon collected the ashes and picked up Ettie and her paid companion at Manhattan's Dorset Hotel. The three then continued by car to Nyack, where their launch awaited. The weather was ideal for sailing. The lawyer assumed that the ladies were headed for West Point, where, thirty years earlier, Florine had begun painting one of the first paintings in her mature, idiosyncratic style. Instead, as they passed Hook Mountain, Ettie asked that the boat turn around and head back. She then surprised Solomon by offering him the cardboard box with her sister's remains. "Now, Joe," she said, "open the box and scatter the ashes."

Shocked, Solomon protested that Florine was, after all, not *his* sister, and handed the container back. So Ettie poured most of the ashes into the silver and green water, then urged the lawyer to scatter the last bit. As Solomon threw the shoebox and its remaining contents into the river, Ettie tossed in a bunch of brightly colored zinnias, recalling her sister's many annual floral birthday paintings. Then, to his astonishment, she opened a large picnic hamper and handed the lawyer a chicken sandwich. After eating, Ettie insisted that they stop for tea at the Bear Mountain Inn before returning to Manhattan. Solomon was taken aback by Ettie's lack of sentimentality toward her sister as, by contrast, when their older sister Carrie had died, she'd had her immediately interred in the family plot and was inconsolable for months.

Ettie also went through all of Florine's diaries and correspondence, ripping out large chunks of pages containing everything she stated was of a "personal" nature. Ettie and Florine had never been particularly close, despite living together for the first fifty-plus years of their lives. Ettie was a dramatic extrovert compared to Florine's more introverted personality. In addition, the lifetime lack of affection between the two sisters was probably due to jealousy on Ettie's part. Ettie had

earned significant academic degrees and published several books, but Florine, the most talented, provocative, and risk-taking of the youngest three Stettheimer sisters, received far more public and critical acclaim for her work than either of her two siblings. This and her self-confidence and ambitions as a professional artist were also antithetical to their views of proper decorum.

Nonetheless, for much of their lives, the Stettheimer sisters appeared to outsiders to form a threesome, living and traveling with their mother, Rosetta. The four women shared an apartment until well into Florine's mid-sixties, when Rosetta passed away. Yet her diaries and correspondence attest that Florine constantly found herself caught between two worlds: the social mores and requirements of her upper-class family, and her need to find time alone to make and exhibit her art. At the same time, the strong, educated, wealthy, matrilineal nature of her family, as well as the rapidly changing times in which she lived, enabled Stettheimer to create her innovative, uniquely prescient feminist paintings.

Florine Stettheimer was born within the hermetic, financially comfortable world of New York's prominent German-Jewish members of the "One Hundred Families" of the other society. Stettheimer's matrilineal Walters family was directly related to and socialized with many of the other wealthiest members of this group, including the Seligmans, Goodharts, Bernheimers, Neustadters, and Guggenheims. Stettheimer's early life was therefore the site of "quietly ticking clocks . . . private elevators . . . slippered servants' feet . . . fires laid behind paper fans."[2] Through intricate intermarriages,

> It was a world of heavily encrusted calling cards and invitations to teas, coming-out parties, weddings — but all within the group . . . It was a world of contradictions. It held its share of decidedly middle-class notions . . . yet it was also a world of imposing wealth. . . . It was a world that moved seasonally — to the vast "camps" in the Adirondacks (not the Catskills), to the Jersey Shore (not Newport) . . . Chefs, stewards, butlers, valets, and maids traveled with their masters and mistresses . . . Every two years there was a ritual steamer-crossing to Europe.[3]

Stettheimer's paternal ancestors came from Niederstetten, Stuttgart, in Württemberg, Germany, which at the time was a southwestern state whose major industries included textiles. The Stettheimer family was enormous, and its many parts spread though Germany during the eighteenth century and then the northeastern region of the United Stated during the nineteenth and early twentieth centuries. Many worked as clothing merchants in the United States but never gained the family wealth or social prestige of the maternal side of Florine's family.[4] Stettheimer's great-grandfather, Moses Stettheimer, who lived from 1780 to 1855, married Jette Hasselberger. Their son, Sigmund Sussmann Stettheimer, one of ten children, was born on June 13, 1813.[5] Sigmund married Henrietta Jacob Hesselberger, and the first of their children, Florine's father, Joseph S. Stettheimer, was born in 1840 in Württemberg.[6]

In the mid-1840s, Sigmund, along with his wife and son, emigrated from Germany to the United States. Like an increasing number of Jewish immigrants, they settled in the new city of Rochester, New York, which was becoming a center of the clothing industry. In 1848, Sigmund opened up a dry goods store at 57 Main Street.[7] Over the next decade, Rochester would become the fourth-largest producer of menswear in the country.[8] By 1853 Sigmund and Henrietta had six children and he had earned enough money to purchase a large house on St. Paul Street for $6,500 in cash.

The 1860 Rochester census indicates Sigmund's business did very well, as it lists his "personal estate value" as $50,000 (or more than $1,600,000.00 today.)[9] That year, Joseph, 21, was still living with his parents, siblings, and three servants, and working for his father as a "clothing merchant." Within the next two to three years, he met Rosetta Walter, Florine's mother, and apparently moved to New York City to be near Rosetta as he no longer appears in the Rochester census. On May 5, 1863 they married and moved into the enormous apartment of Rosetta's mother, Henrietta Walter, at 132 West Forty-Second Street in Manhattan. There, the newlyweds lived for the next eight years, with Joseph's mother-in-law, Rosetta's four youngest sisters, and three live-in servants.[10] In 1865 and 1867, the couple had the eldest of Florine's four siblings, Stella, Walter, and Carrie. Also already living with them was Florine's beloved Irish nurse, Maggie.

In Rochester, the continuing high demand for clothing during the years immediately following the Civil War aided Sigmund in establishing one of the largest ready-made dry goods stores in the city. With the Tone Brothers he also established a bank, Stettheimer, Tone & Company, where he and a number of his sons worked beginning in the late 1860s. In 1871, Joseph S. Stettheimer returned to Rochester with Henrietta and his three young children to again work at Stettheimer & Company wholesale clothing store. Florine was born on August 29, 1871 and Ettie soon after. In 1873 Joseph built a brick house for his family at 19 Clinton Street South, down the street from his father,[11] and lived relatively prosperously with his family for the next four years.

Soon, however, the economic depression that swept across the country began to seriously affect the Stettheimer fortunes. In 1875, Sigmund was forced to take on a partner for the wholesale clothing business, now calling it Stettheimer, Burrell & Company. A year later the store failed and closed, and, although Joseph continued to live at Clinton Street with Rosetta and their children, he remained unemployed for another year.[12] By 1878, Joseph disappeared, abandoning Rosetta and their children, and supposedly emigrating to Australia.[13] Stettheimer's mother never heard from her husband again. Within a year she and her children returned to New York City to again be near her family.[14] Half a century later, Joseph Solomon noted that the Stettheimer sisters never mentioned their father: "It was a closed book . . . they always talked about their mother, their mother, their mother, you see, but never about their father; and that left, I think, quite a mark on

Florine Stettheimer."[15] This desertion by their father left the youngest three daughters within the strongly matriarchal, extremely wealthy, mother's side of the family and made them more open to the era's new feminist movement.

Florine's maternal relations formed a large, extended clan. The Walters were a combination of Dutch Protestant ancestry and Jewish immigrant money. Given to independent thinking and possessed of wealth and forceful personalities, members intermarried, provided each other with training and employment, and closely monitored each other's activities. Her maternal great-great-grandparents, the Pikes, are the artist's earliest known relatives on her mother Rosetta's side. Mr. Pike was a German Jew and his wife a Dutch Protestant.[16] After Napoleon's conquest of the Netherlands in 1806, the couple left Amsterdam with their baby son, Samuel, arriving in New York City around 1809, where they soon had a daughter. Samuel Pike went on to be the great-grandfather of the acclaimed poet Natalie Barney. His sister Angelina married Simon Content, the son of an auspicious colonial family.[17]

In 1833, Simon and Angelina Content, Stettheimer's great-grandparents, were living in lower Manhattan and were financially comfortable enough to commission the Staten Island artist I. Bradley to paint their portrait.[18] In the paired paintings, the Contents are portrayed as self-assured and successful. Angelina, wearing dangling gold earrings and other jewelry, sits holding a copy of the Protestant *Book of Common Prayer*, the official prayer book of the Church of England. This indicates that at least Angelina was brought up in her mother's religion as a Protestant, although her brother Samuel identified as a Jew. In his portrait, her husband Simon holds up a manuscript inscribed in Hebrew. The continuing generational mix of religions probably contributed to Florine's lack of any strong religious faith. Other than Florine's grandfather, Israel Walter, most members of her immediate family did not actively practice any religion.[19]

The Contents' daughter, Florine's grandmother, Henrietta, married Israel Walter, who was born in Germany on May 27, 1818. Israel immigrated to America and enlisted in the US Army's Seventh Cavalry Regiment during the Mexican War. He then established what became a highly successful and profitable wholesale dry goods business at 40 Beaver Street in Manhattan. It is not by accident that all of Stettheimer's later paintings of figures from her childhood portray women, as Henrietta Walter bore one son and nine girls. (*Fig. 4*) Rosetta was the second-oldest child, born on July 22, 1843 in New York City. Little is known about her early life.[20] Once her husband deserted his family, Rosetta and her children returned to New York City, where several of her sisters had married into the wealthiest Jewish families in Manhattan, including the Bernheimers and particularly the Seligmans, the latter of whom had made enormous fortunes in the banking industry. Rosetta and her daughters' relationships with these family members (including the Guggenheims) remained close throughout the rest of the Stettheimer sisters' lives.

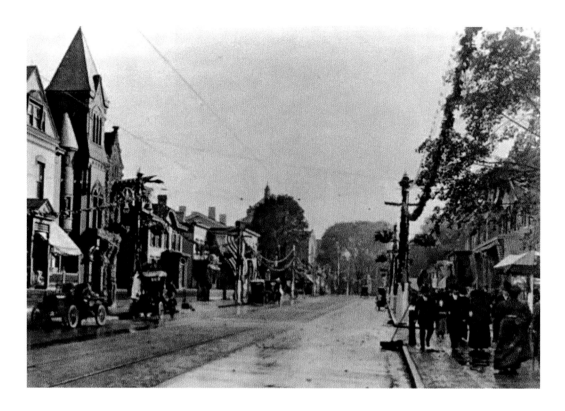

**Fig. 3** 19 Clinton Street, Rochester, New York. Collection of the Rochester Public Library Local History & Genealogy Division.

Two of Florine's aunts — Caroline, the eldest, and Josephine, the youngest — were among the most important figures in her childhood. Caroline Walter, nicknamed LaLa, twice married into the wealthy Neustadter family: first to Louis Neustadter and, after Louis's death, to his brother Henry. Both men grew extremely wealthy by establishing the earliest men's clothing manufacturer in San Francisco, a company that was later the direct rival to Levi Strauss & Co. Caroline traveled widely, is said to have crossed the Atlantic more than forty times, and kept apartments in New York, Stuttgart, and Paris. To the Stettheimer sisters, Caroline Neustadter embodied formidable and majestic female authority.

In 1928, after Caroline's death, Florine painted a memorial *Portrait of My Aunt, Caroline Walter Neustadter*. (*Fig. 5*) It depicts Caroline, notably standing alone, wearing a black lace dress and train. In the foreground, she is surrounded by an elaborately carved torchère on the right and a then popular "blackamoor" statue[21] on the left holding a visiting card with the artist's name. The portrait emphasizes Caroline's characteristic erect and corseted carriage. An obituary noted that at her death at age seventy-one, Neustadter was "still a beautiful woman, with manners that lent grace to her years . . . her carriage was always stately."[22] At the back of the painting, Stettheimer included a small vignette with a second portrait of Caroline presiding over a formal dinner party.

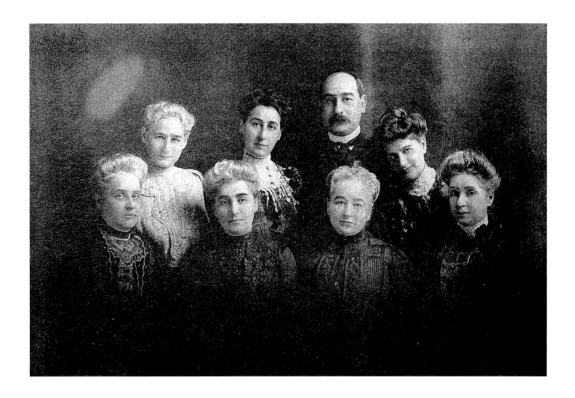

**Fig. 4** Unknown photographer: Rosetta Walter Stettheimer (far right) with her sisters and brother. (left to right) Front row: Millie W. Weil, Sophie W. Baer, Caroline W. Neustadter. Back row: Dr. Josephine Walter, Nina W. Sternberger, William Israel Walter, Adele W. Seligman. Date unknown, photographed by the author. Collection of John Gordon family.

This inclusion of multiple incidents indicating separate periods of time taking place within a single canvas is a device the artist would often repeat in her mature work.

The other aunt who had the most influence on Florine was Josephine, the seventh Walter sibling.[23] She was an exceptional woman in terms of her education and accomplishments, who proved so intelligent that the family physician encouraged her to study medicine. She matriculated at the College of the New York Infirmary for Women, receiving special permission to attend the lectures of Ogden N. Rood, professor of physics at Columbia College. In so doing, Josephine became the first woman to attend what later became the medical school at Columbia University.[24] Following her graduation, she won a position on the house staff of Mount Sinai Hospital in New York. In 1886, the hospital granted Josephine its diploma, and she went on to become the first woman intern in America.

After three years in hospital service, Dr. Walter continued her studies in Europe with various highly respected teachers of medicine. She studied gynecology in Vienna; worked in Berlin with Professor Rudolf Virchow, considered to have first discovered cancer's origin in cells; and studied in Paris under Jean-Martin Charcot, the father of neurology, who was also Sigmund Freud's teacher.

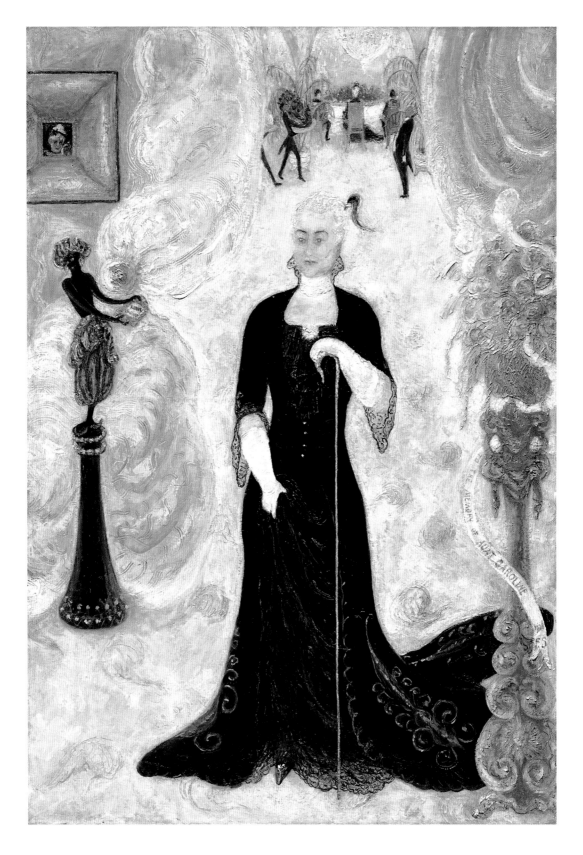

**Fig. 5** Florine Stettheimer, *Portrait of My Aunt, Caroline Neustadter*. 1928, oil on canvas, 38 × 26 ¼ in., The Nelson-Atkins Museum of Art, Kansas City, MO, Gift of Miss Ettie Stettheimer.

She returned to New York in 1888 and entered active practice, specializing in the diseases and ailments of women. Josephine Walter never married. Her highly unconventional life, with its specialized education traditionally offered only to men and her concentration on the new medical science of women's issues, offered a unique role model for her young nieces Florine and Ettie.

The influence of the remaining Walter children on their Stettheimer nieces was mainly social. Only Caroline and Josephine Walter, the best educated and most independent of her relatives, are mentioned with regularity in Florine's diaries. To the others, she was always polite but kept her true self guarded, as is shown by one of her ironic, revealing poems:

~~~~~~~~~~~

Tame little kisses
one must give
to Uncles Nephews
and Nieces
And to friends
who say you are charming
one does likewise
nothing alarming[25]

~~~~~~~~~~~

Apparently Rosetta married Joseph Stettheimer in 1864 when living in New York, where their eldest three children, Stella, Walter, and Caroline (Carrie), were born. They then moved to Rochester, where Rosetta had Florine and Henrietta (Ettie). Little is known about Stella and Walter's early interactions with their mother or youngest three sisters. The latter three women actively contributed to a certain vagueness surrounding their births by refusing to acknowledge their age.[26] Family records, however,indicate that Carrie was born in 1869, Florine on August 29, 1871, and Ettie on July 31, 1875.

Carrie was blue-eyed with a round face and a square jaw. She was the sister most firmly entrenched in nineteenth-century behavior, without the active ambition of her two younger sisters. Instead, she engaged in numerous charitable, social, and domestic activities, serving as the family hostess and coordinating the menus for special occasions.[27] Unlike Ettie and Florine, Carrie did not leave behind diaries or any correspondence of substance. Ettie, the self-described family intellectual, had features that were distinguished by prominent eyebrows that almost met over her nose. She was known for her piercing dark gaze, sharp tongue, intelligence, and inability to suffer fools. She was the most flirtatious, dramatic, and outspoken of the sisters. The few existing photographs of Florine show her with attractive, large brown eyes, a longish nose, wide mouth, and pointed chin. Two years

after her death, friends recalled her as being "small, dark, exceedingly slender, exceedingly modest, fanciful, and . . . of singular charm."[28] Continually caught between gracious, duty-bound Carrie and temperamental, outspoken Ettie, Florine acted like many middle children, keeping her own counsel and observing rather than interacting at social occasions.

Stettheimer's early childhood encompassed a medley of people, places, and visual imagery, and she used the materials of her existence to fuel her creative energies. The timing of the artist's life, caught on the cusp between two centuries and cultures, gave it a complexity and richness of contrasts drawn together into a visual crazy quilt of memories. The quilt's underlying structure — the culture and manners of nineteenth-century upper-class life — was balanced by the social changes brought about by the new century.

Another significant figure in Florine's childhood was the family's Irish Catholic nurse, Margaret Burgess, whom they called Maggie. Years later, when Stettheimer painted a portrait of her mother, she included a background scene showing the beloved nurse, probably around age 32–33,[29] taking care of the Stettheimer children in the garden of their Rochester home. In the vignette, Maggie, holding baby Ettie, stands in an elegant garden with potted oleander trees and a white picket fence. Meanwhile, the four other Stettheimer children gather around a makeshift stage. Walter reads from a book on the stage next to blonde Carrie; Stella, the tall, slim, eldest stands holding a tambourine; and toddler Florine raises her hands as though begging Maggie to lift her up. The scene appears to be a reenactment of an early childhood memory:

My ring fell from the nursery window
into a flower bed below
A fairy hopped out of a waterlily
in a Xmas Pantomime Show.
Maggie carried me into a circus
to give the little rider a kiss
In our oleandertreed yard on a stage
I sang 'little Maggie May' with bliss
I dressed up in paper muslin
with fringes and gold stars
in that golden era when to
adventures there were no bars[30]

In 1929 Stettheimer painted a solo portrait of their former nurse with her five little Stettheimer "angels" floating above her head. (*Fig. 6*) The painting is a memorial depicting Maggie floating on an "Irish-green" cloud in Heaven, her little charges affirming her good works on Earth.[31] Maggie stands in an authoritative pose: one hand resting on her prie-dieu holds a stylus, the other a spelling book. The black prie-dieu, with its bright red tufted pillow, bears a sign proclaiming her "Maggie, Nurse, Teacher, Guide" and is covered with lace on which Stettheimer signed her name. Further signs of Maggie's Catholicism are the rosary she wears and the gold-framed icon of the Madonna and child topped by a flaming heart, next to which lies a small Bible. Of the young Stettheimer children's faces hovering in a semicircle above Maggie's head, young Florine, her reddish-brown hair worn in a long braid, occupies the nearest space.

In a poem she titled "First Plastic Art — Herr Gott," the artist ironically recalled that Maggie's religious faith resulted in one of her introductions to sculpture:

Sh-Sh-shushed Maggie
Sprinkling holy water in my face
On entering the little chapel
From the sunny village street

In the light of the tall window
An enormous statue stood
A man in a purple gown
With a high golden crown

He had very pink cheeks
And a long white beard
And his hand was raised in blessing

Maggie knelt and pulled me down
Crossing herself she loudly whispered
"That is the Lord God
With the golden crown[32]

When the retired nurse died in 1913, Florine noted in her diary, "Our Maggie is dead . . . I hope she found the heaven she always strove to attain."

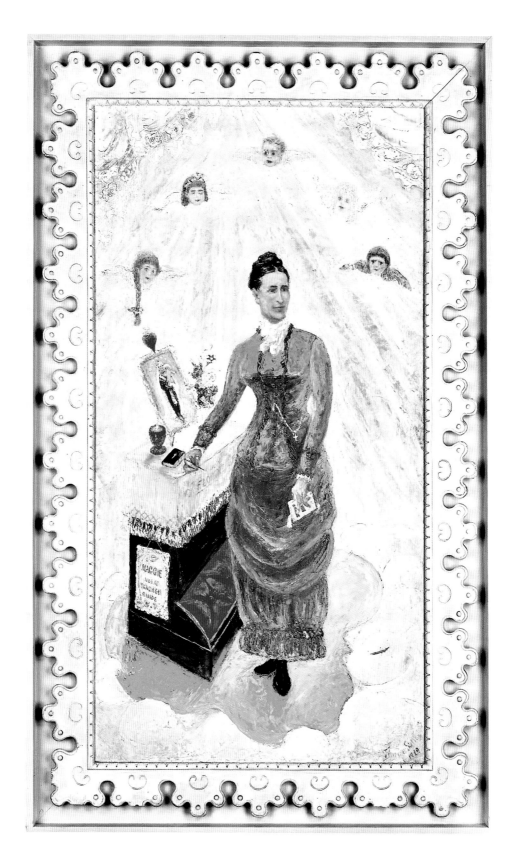

**Fig. 6** Florine Stettheimer, *Portrait of Our Nurse, Margaret Burgess*, 1929, oil on canvas, 38 × 26 in., The Minneapolis Institute of Art, Gift of Ettie Stettheimer.

When her father deserted the family around 1878, Florine Stettheimer was seven years old, and Rosetta had begun spending most of every year living with her young children in Europe. This decision enabled her to avoid any social embarrassment at her husband's desertion, and her very wealthy sister Caroline Neustadter, who had a major apartment in Germany, provided a base of operations. Financially the women remained well-off, and as her diary entries indicate, Stettheimer and her mother and siblings lived and traveled in relative luxury in Europe during the first forty years of her life.[33] Although her diaries do not extend back to her early childhood and school years, they can be traced through her poems:

~~~~~~~~~~~~~~~~~~~~~~~~~~~~~~~~~~~~~

> Schooldays in a pretty town
> Where lived a King and Queen
> And Papageno and Oberon
> Goetz and Lohengrin
> There was a military band
> To which we "Little Ones" paraded
> With Maggie[34] every day at noon
> And a cakestore which we raided
> Every day at four
> And life was full of parties
> In wood where wildflowers grew
> In parks where Greek Gods postured
> In our parlor of tufted Nattier blue[35]

~~~~~~~~~~~~~~~~~~~~~~~~~~~~~~~~~~~~~

Germany provided the main context for her early life. From the late 1870s to 1886, Rosetta and her children lived in Stuttgart. Stettheimer's childhood memories, described in later poems and images, are of a happy time filled with creative activities. When interviewed decades later, Stettheimer remarked, "I began painting as a little child," noting that she had had a great deal of regular art training, "Oh, lots and lots of it," but it didn't exactly "take," and she was "rather glad it didn't."[36] Among the few items that remain from when she was very young are a set of twenty-five awkwardly drawn fortune-telling cards painted by "Flossie" in pen and ink with watercolors and a childhood scrapbook with a series of small watercolors of figures correlated with animals and birds. A nurse with a furrowed brow, for example, is compared to an owl, a bespectacled tutor to a grasshopper, a professorial man to a sly fox, and an elderly knitting nanny to both a crab and a

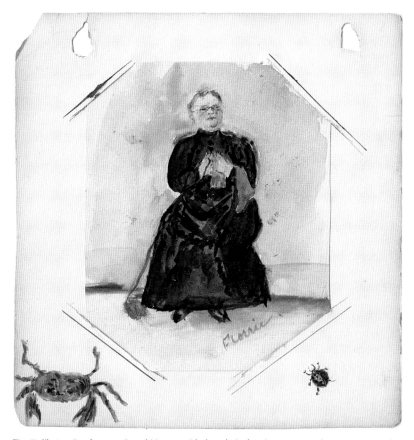

**Fig. 7** Florine Stettheimer, *Seated Nanny in Black with Crab*, c. late 1870s–early 1880s, watercolor and graphite on card stock, 8.46 × 7.87 in., Florine Stettheimer Papers, Rare Book and Manuscript Library, Columbia University in the City of New York, Gift of the Estate of Ettie Stettheimer.

ladybug. (*Fig. 7*) The childish style and handling of the sketches suggest they were executed well before Stettheimer was an adolescent.

In Stuttgart, Florine attended the Priesersches Institut, a private school for upper-class girls, where she took art lessons from its director, Sophie von Prieser.[37] Almost half a century later, in 1929, Stettheimer painted a portrait of von Prieser standing in an elaborate room with a terrace overlooking Stuttgart's baroque palace, home of the former Württemberg kings. (*Fig. 8*) Von Prieser, severely dressed in black, holds a pair of reading spectacles raised in the air as though directing her student. A book titled *Sights of Stuttgart* in German lies on the adjacent table. Hanging on the left wall, a mirror reflects Florine as a young schoolgirl, hands clasped and mouth open, obediently reciting her lessons for her teacher. On a shelf behind the teacher is a large classical bust of Juno, the Greek goddess whom von Prieser believed she resembled. Florine readily reinforced this belief in her painting by replicating the pursed lips of both her teacher and the statue.

From 1887 to 1889, with Florine now in her mid-teens, the four Stettheimers spent at least part of the year in Berlin. In contrast to the more historic and traditional Stuttgart, Berlin was fast-paced

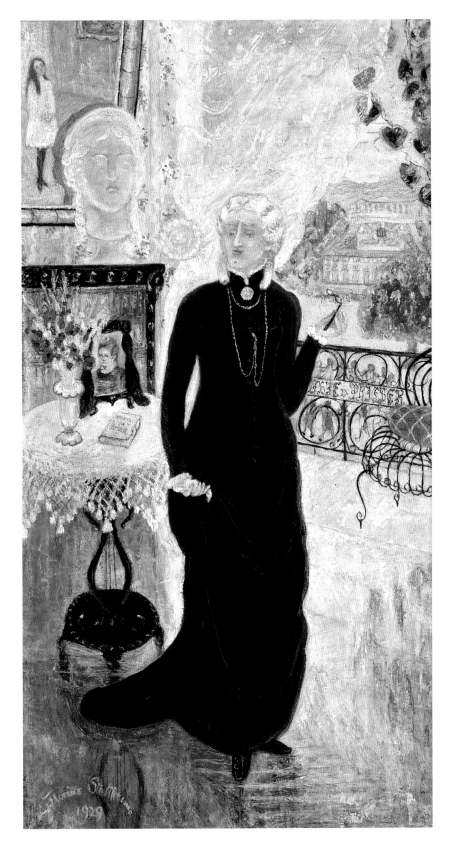

**Fig. 8** Florine Stettheimer, *Portrait of My Teacher, Fräulein Sophie von Prieser*, oil on canvas, 30 × 20 in., Portland Museum of Art, Portland, OR, Gift of the Ettie Stettheimer Estate.

and modern. Its central geographic location attracted both Germans and foreigners, giving it an air of transience.[38] Another sketchbook, labeled "F's schoolgirl productions," contains images reflecting the romantic yearnings of a young girl. On one page, Stettheimer drew, then partially erased, a heart next to a sketch of a handsome lieutenant; there are numerous other drawings of young men, including one titled "Fred," who gazes with admiration at a young girl with blond hair (perhaps Florine's sister Stella). There is also a beautiful pencil sketch of Florine's brother Walter sleeping. Most drawings show Germans on holiday, women with parasols, boys with boats, men with cigarettes, and families with young girls visiting the baths at Warnemünde. Unfortunately, Ettie also edited this scrapbook after the artist's death, eliminating its final pages.[39]

While in Berlin, Florine continued both her art training and her aesthetic appreciation of young men, particularly those in uniform:

In Berlin
I went to school
I painted
I skated
I adored gay uniforms
I thought they contained super forms
Though they did not quite conform
To my beauty norm
The Apollo Belvedere[40]

During these years, Florine made several drawings copied from reproductions of well-known artworks. The eclectic subject matter and disparate approaches of the works indicate different art teachers and a precocious interest in working through various drawing techniques. The Berlin works are all academic in style, providing further evidence that her artistic production by age fifteen was the result of tutelage as to what was correct drawing technique. At a young age, Stettheimer was already a very capable artist. During these years, her subjects ranged from fairy queens with thick peasant legs to finely modeled classical heads. A beautiful graphite drawing of a woman's head, inscribed "F. 16 years old," demonstrates her advanced skill at creating a sense of three-dimensionality through line and shading. A trompe l'oeil drawing of a handkerchief hanging on a nail similarly attests to her early mastery of draftsmanship. (*Fig. 9*)

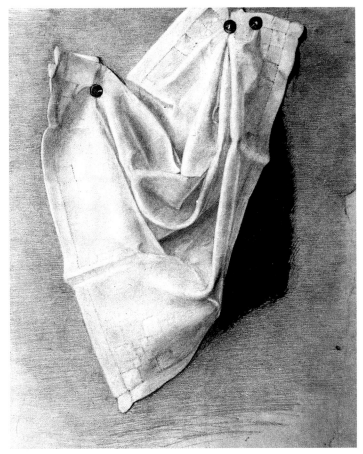

**Fig. 9** Florine Stettheimer, *Drawing of a Handkerchief*, 1887, pencil on paper, 12 ¾ × 9 in., Art Properties, Avery Architectural & Fine Arts Library, Columbia University in the City of New York, Gift of the Estate of Ettie Stettheimer.

In the early 1890s, Rosetta and her children returned temporarily to New York. The eldest sister, Stella, married a Mr. Feuchtwanger and left with him to settle in northern California.[41] As soon as he finished high school, Walter also moved to California, where he married, and raised Scottish terriers. According to his daughter, Jean, he grew distant from his "Eastern, non-marrying" youngest sisters as he was apparently shocked by their avant-garde lifestyle, including their friendships with artists and homosexual men.[42]

Although Rosetta lacked the intellectual and professional training of several of her siblings, she compensated by instilling an unusually strong sense of individuality and independence in her two youngest daughters. She encouraged Florine and Ettie to acquire the same education and professional training as their male contemporaries, something highly unusual for women at the time. In 1895, Ettie, following in the footsteps of her aunt Jo, enrolled in Barnard College of Columbia, becoming one of the first women to attain a bachelor's degree from the university.[43] She then earned

a master's degree there in psychology in 1898. After graduation, Ettie went on to take courses in economics and medieval history and earned a Ph.D. in philosophy at the renowned Albert-Ludwig University in Freiburg im Breisgau, Germany. Her dissertation examined the metaphysics of William James and even impressed James himself, who wrote to her, praising it.[44]

In 1892, Florine enrolled in a four-year drawing and painting program at the Art Students League in New York. The artist later recorded her memories of these years in a poem that indicates that during her twenties she lived the life of a typical young upper-class woman, attending various social functions and having conversations with men whom she found attractive:

Art Student days in New York
Streets of stoop houses all alike
People dressed sedately
Bright colors considered loud
Jewels shoddy
I affected empire gowns
Had an afternoon at home
Attended balls and parties
At Sherry's and Delmonico's
Sat through operas and the
Philharmonic
I had a friend who looked Byronic
With whom I discussed books
Emerson and Ruskin
Mills and Henry James
When we felt mild
When we felt ironic
It was Whistler and Wilde[45]

Stettheimer's choice of the Art Students League was likely based in part on its liberal policies toward women. The League's structure and teaching methods were considered radical for the time. One-third of the institution's founders and a large percentage of the students who dominated the Board of Control were women. When announcing the founding of its new art school, the Art Students League declared that it would offer the first life drawing class for women in New York. (It was only the

second such class given in the United States.)[46] Among the few extant records is a listing showing that in 1895 Stettheimer was elected "Corresponding Secretary" of the Governing Board of the League.[47]

Although women in Europe and America regularly attended art classes, they were unable to attend the major European art academies such as Paris's École des Beaux-Arts until late in the nineteenth century, when it was no longer a highly prized achievement.[48] In addition, although it was considered essential for true artistic training, women wishing to do male figure studies generally had to work from plaster replicas of antique statuary. At the Art Students League, by contrast, women were allowed to work directly from nude male models. Stettheimer took advantage of this at the League, as evident from an observation she made in her 1909 diary after seeing the premiere of Gabriele D'Annunzio's highly controversial production of *Fedra* in Rome on May 25. In her diary she noted that the "first night was very interesting . . . Gabriele d'Annunzio's Ippolito, reason of his lack of clothing . . . He reminded me of my Life Class days—not that he was quite without clothing, but his build is such that students love to draw."

In October 1892, the year when twenty-one-year-old Stettheimer enrolled, the Art Students League had just moved to its present location at 215 West Fifty-Seventh Street. The school prided itself on teaching all contemporary trends. Courses were treated as a combination of idealized nineteenth-century Parisian ateliers and medieval apprenticeships, where students learned from professionals through demonstration or criticism. From the outset, the League hired artists who had studied in Munich as well as Paris to teach contrasting academic styles. To balance her youthful training in German art techniques and philosophies, Stettheimer chose teachers well versed in the French tradition, with its emphasis on synthesis and clarity.[49] (*Fig. 10*)

Stettheimer began her tenure at the League with Carroll Beckwith, who had worked in the Paris atelier of Charles Carolus-Duran and developed a reputation for portraiture. Based on the subject's age and the artist's style and manner of painting, Stettheimer's realistic, full-length portrait of her older sister Carrie in a flowing white dress, painted in muted colors with bravura brushstrokes, may well date from her years with Beckwith. (*Fig. 11*) In 1893, Stettheimer took a life drawing and painting class with H. Siddons Mowbray, who had studied in Paris in the atelier of Léon Bonnat. His interest in exotic subjects included a love of Japanese *ukiyo-e*, or "floating world" woodblock prints, which Stettheimer shared and began to collect. While visiting an exhibition of Japanese prints in Europe in 1909, she was excited to discover a print by the artist Rumisada Magawa (also called Toyo Rumi II, 1789–1865) that she also owned.[50] Later, she incorporated many of the formal design and compositional motifs of Japanese art into her paintings and furniture designs.

Stettheimer also attended a life class with Kenyon Cox. While not denying individuality and originality, Cox believed that modern art should steep itself in historicism and tradition: "It wishes

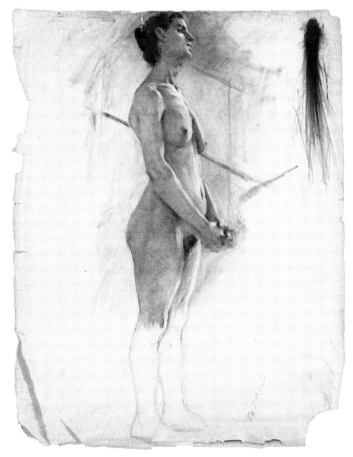

**Fig. 10** Florine Stettheimer, *Nude Life Study Drawing with Hands Clasped*, ca. mid-1890s, charcoal on paper, varied size, Art Properties, Avery Architectural & Fine Arts Library, Columbia University in the City of New York, Gift of Joseph Solomon, 1972.

to add link by link to the chain of tradition, but it does not wish to break the chain."[51] In his teaching, Cox placed great emphasis on technique. Maintaining that modern art had lost a feeling for workmanship, he made his students examine artists as diverse as Velázquez, Titian, Tintoretto, Rembrandt, Rubens, Frans Hals, and Millet. Cox also admired Italian Renaissance murals for their rich color and complex, site-specific compositions. He thought that mural painting would further the renaissance of American art. Two extant early mural studies by Stettheimer — a ceiling with an octagonal central panel and a lunette — were probably painted while she was working with Cox.

Although nude drawings of male models by Stettheimer exist, the only paintings of nudes we know of from the 1890s are of young women. They reveal her proficient handling of paint, form, and composition and her mastery of perspective and foreshortening. (*Fig. 12*) Stettheimer did not idealize the nudes, but rather noted every dimpled thigh and reddened hand. In one painting, she captured the broad, individualized features of a standing model but depicted her with eyes shut, as

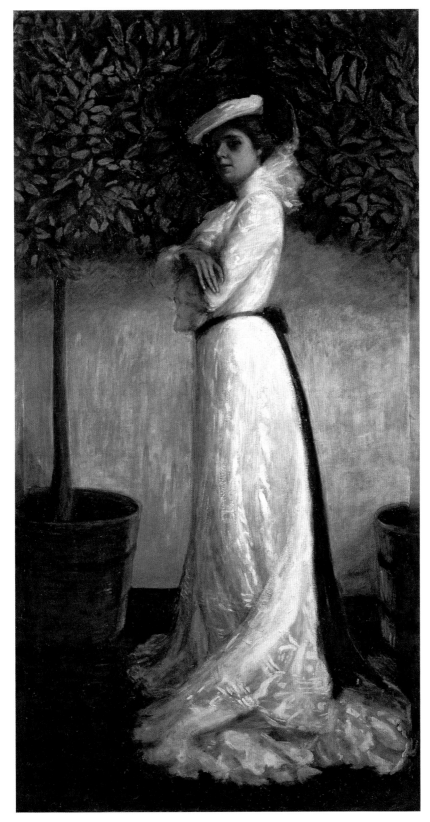

**Fig. 11** Florine Stettheimer, *Portrait of My Sister Carrie W. Stettheimer in a White Dress,* mid- to late 1890s, oil on canvas, 90 ¾ × 47 ⅓ in., Art Properties, Avery Architectural & Fine Arts Library, Columbia University in the City of New York, Gift of the Estate of Ettie Stettheimer.

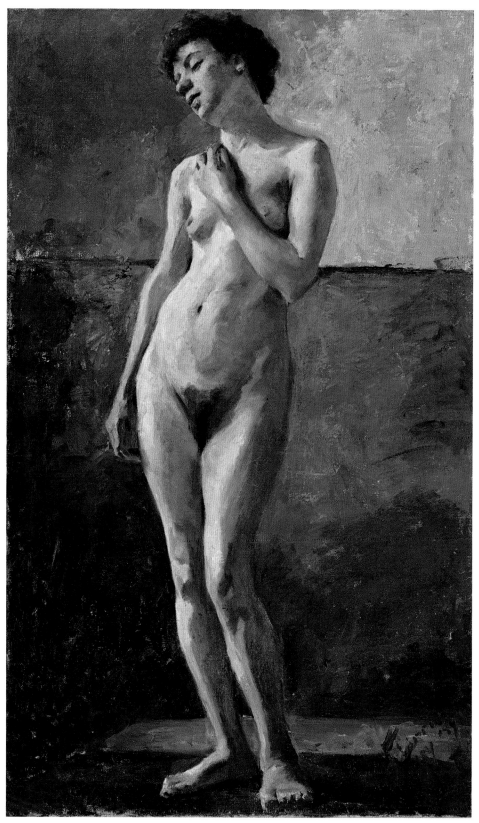

**Fig. 12** Florine Stettheimer, *Nude Study Standing with Hand to Shoulder*, 1895, oil on canvas mounted on board, Art Properties, Avery Architectural & Fine Arts Library, Columbia University in the City of New York, Gift of the Estate of Ettie Stettheimer.

if bored and removed in thought from her present circumstance. After completing her studies at the Art Students League, Stettheimer continued to take specialized classes in Europe on occasion. As Ettie noted, "After [Florine] left school, she attended art classes continually for many years, both here and abroad, where she also traveled as extensively as possible to see European art."[52]

Ettie and Florine both engaged in numerous flirtations and romantic relationships with men during their twenties. Since Stettheimer's death, the fact that she never married has been interpreted variously as a result of Stettheimer's not attracting suitors, her "eccentricity," lesbian inclinations, or physical appearance, rather than by her choice. However, many entries in the artist's diaries and poetry describe dalliances in which she broke men's hearts and had her heart broken in turn, while others demonstrate her clear admiration of male bodies. Although she and her sisters befriended and regularly associated socially with gay men, bisexuals, and lesbians, there is also no indication in any of Florine Stettheimer's correspondence, poems, or paintings of a sexual preference for women. Yet Stettheimer's imagined preference for the idea of *romantic* love over the realities of sexual relations can be seen in a notation in her diary of January 1914. On hearing that a *vicomte* and a married woman ("*Madame*") were planning to live together at 7, Villa Said in Paris, Stettheimer noted in her diary, "I do not find French ways of doing things disgusts me — it's too prosaic for a romantic love!"

That the youngest Stettheimer sisters chose not to marry was undoubtedly a response to their matriarchal upbringing and to the changing role of women during the last decades of the nineteenth century. The 1890s marked the first decade of significant transformation in the legal and professional possibilities for middle-class Western women. In large numbers these women grew increasingly sensitized to the debates on "the Woman Question" and began fighting for better educational and professional opportunities. In 1894 new laws in France gave women the right to initiate divorce proceedings, and growing demands for liberation generated a powerful new symbol: the "Femme Nouvelle." The image of this "New Woman" pervaded mass media on both sides of the Atlantic between 1889 and 1898. The French art critic Marius Ary-Leblond, commenting on the arrival of this new phenomenon, observed:

> We find her in the salons, this *New Woman* . . . She lives a full life, a complete and powerful one, equal in intensity and output to that of a man. . . . She has an individuality that contemporary painting . . . is beginning to translate into the frank and self-confident gestures, a quick suppleness, and firm, electric expressions. . . . These modern Amazons are fiercely independent . . . The New Woman is the woman of a century of inventions, independent, nomadic.[53]

The symbol of the New Woman offered an alternative to late nineteenth-century notions of unmarried women as easily pitied or patronized celibate spinsters.[54] Ary-Leblond's description of the *Femme Nouvelle* in fact provides a very fitting physical description of Stettheimer herself:

> The New Woman is not beautiful. She looks rather like a boy and illustrates more than anything the expression of a firm character, a serene soul . . . with her elegant but weary body, her simple but courageous gestures completely devoid of the useless illusions that can be found in the falseness of high luxury.[55]

In a diary notation from the 1890s following a meeting with an old friend, Marie Glanz, now Frau Professor Drier, Stettheimer observed: "Her husband is very unattractive, but most husbands are!" The artist's reaction to the marriage of another friend, Alice Bamberger, who married a Frenchman, was no less cynical: "It seems strange that she lost her nationality on account of a proceeding that took five minutes."

Remaining single, if one could afford it, became not only a highly viable but occasionally even preferable option for women. The American feminist Mary Livermore advised parents to train their daughters to support themselves because opportunities for good marriages were diminishing — men who were not killed by drink, vice, or overwork were not necessarily going to be good or competent husbands, as they could be unambitious or deserters or dissolutes — types with which the Stettheimer women were already all too familiar.[56] The decision not to marry reflected women's rising expectations of "enlightened" men and, consequently, diminishing opportunities to find them. Women who, like the Stettheimer sisters, had the highest social status, standard of living, and level of education were left with the smallest pool of marriageable men.

Among Florine's poems is one with overtly ironic overtones regarding contractual affiliations with men:

Sweet little Miss Mouse
Wanted her own house
So she married Mr. Mole
And only got a hole[57]

Ettie Stettheimer was an outspoken feminist, and pamphlets in their scrapbooks indicate that she and Florine were aware of, and possibly attended, the proceedings of the First International Feminist Congress, held in Paris in 1896. They both probably also attended meetings of both the Interurban Woman Suffrage Council and the National Woman Suffrage Association in New York.[58] Florine's early diaries and poems reveal her allegiance to women's causes and her developing female aesthetic. After attending a 1909 performance of *Lysistrata* in Munich, Florine complained that it was a horrible evening: "The play was written by a man who was completely anti-feminist. . . . I have concluded that they should have all the roles taken by men and the performance only for men — the way it was written, no woman could enjoy it as it was."

Stettheimer's pro-women attitude and awareness of the stereotypes too often pinned on women worked their way into her opinion of other artists. She found the women in paintings by Ferdinand Hodler "pathetically patient-looking," and visited the Alte Pinakothek in Munich, where "the thing that impressed me most was a delicate, nervous-looking little female copying Rubens's *Rape of the Two Nude Females*, I believe the *Sabines*, copying it life size and with tremendous dash and strength." As her life and work progressed, Stettheimer's ambition to be a professional artist and her strong feminist inclinations became all the more apparent.

*chapter two*

# EUROPE INFLUENCES

## 1890 – 1915

By 1898, Rosetta and the three Stettheimer sisters were peripatetic travelers. They left New York every April and, with their base in Germany, wandered through Italy, Switzerland, Spain, and especially France. Florine was resentful at having to travel with her family since it kept her away from the New York studio she maintained overlooking Bryant Park. This particularly bothered her when she could not find a tenant to sublease the studio, and therefore lost forty-five dollars a month on rent. Florine kept diaries on many of their trips. Although Ettie later excised large quantities of personal material, the diaries still provide unique impressions of the artist during this period of her life.

Written during her twenties and thirties, the pages are full of references to Stettheimer's likes and dislikes among men (potential and old suitors, good-looking cadets, actors, and dancers), European food and accommodations, and artworks, both contemporary and Old Masters. They reveal that the artist was a complex personality who held a number of ambivalent, even contradictory, attitudes. Besides being progressive and feminist, Stettheimer was also a snob, and she expected others to treat her with proper nineteenth-century decorum. Particularly critical when she was not painting, in 1906 on route to Italy on board the *Princess Irene*, she noted her family's "usual bad luck — we are at table with the most underbred people aboard. I don't know the others but I cannot imagine them as bad." As a result, she tended to keep to herself:

> The world is full of strangers
> They are very strange
> I am never going to know them
> Which I find easy to arrange[1]

When they landed in Naples the captain of the ocean liner helped the Stettheimer ladies settle in their hotel and mentioned that an earthquake had just decimated San Francisco. The women remained terrified about the fate of Stella and her family until learning they had escaped unharmed. Concurrently a volcanic eruption of nearby Vesuvius caused sand to rain down on them during their stay.

On several voyages across the Atlantic there were diversions, such as the artist's mild flirtation in 1907 with a naval doctor named Ricci whom Florine met by dropping her book and speaking to him in Italian.[2] Demonstrating that she was not above personal vanity, Stettheimer also noted in her diary her concern that drinking too much Pilsner beer would make her fat. In 1912 they were crossing to Europe when they learned of the sinking of the *Titanic* along with the parents of three of the women on board their ship.

During the first decades of the twentieth century, a temporary revival of the eighteenth-century decorative Rococo style had a major influence on Stettheimer and her later painting style. Originating during the reign of Louis XV, the Rococo was considered "feminine" as it was characterized by delicacy, curved lines, organic forms, and artifice; and it was the era when French taste was believed to represent the apogee of Western culture. The Rococo revival came about primarily because toward the end of the nineteenth century the French government determined that it was slipping economically due to its declining birth rate relative to neighboring Germany. They attributed their diminishing of pregnancies to the growing popularity of the *Femme Nouvelle*, or liberated woman, a phenomenon that they feared was turning women's interests away from domestic matters. To counterbalance this, the French government began to officially promote the Rococo, believing that it emphasized the organic side of the female gender, and by subliminally emphasizing the cycles and fecundity of nature, would promote childbearing.[3] In 1890, France founded a new Decorative Art Salon, in which for the first time decorative arts such as furniture and objects were granted equal status with painting and sculpture. To many, this action represented a significant "renaissance of national taste"[4] and was a forerunner of the Art Nouveau in France.

At the same time, in a contradictory argument, the French media and influential tastemakers like the Goncourt brothers positioned Rococo objects and furnishings as representing the ultimate female-defined contemporary style, thereby infusing it with new meaning. Through their efforts, decorative arts were no longer considered merely a technically skilled "craft," but represented the individual creativity of their designers in the expression of their exceptional vision and genius. They based this on French psychology of the 1890s, particularly that espoused by noted French neurologist Jean-Martin Charcot. Charcot fashioned his Parisian home as a space for the "exteriorization of dreams" and, like Stettheimer, designed the furniture for his home. Charcot believed in subjective transformation, stamping the objects in his collection with personal memory and his own personality.

The influential journal *La Grande Dame revue de l'élégance et des arts* reinforced the idea of Rococo as the ultimate female-defined style. It did this by including articles and illustrations suggesting to the modern woman that using the Rococo style to imprint her distinctive aesthetic

on the objects around her would make an interior space reflect her unique personality in a highly contemporary manner:

> The woman of today is wholly different from the woman of thirty years ago. She has become more intelligent, more personal. Today's woman is also more artistic, more refined . . . She is intuitive and refined . . . one who enjoys the quest for originality, new forms, rare harmonies. She . . . seeks to enchant even the smallest element of the interior with the mark of her personality.[5]

Throughout his writing, Marcel Proust, Stettheimer's favorite author, defined interior space as the index of personal memories: "That composite, heterogenous room has kept in my memory a cohesion . . . alive and stamped with the imprint of a living personality. . . .The things in my room. . .were . . . an enlargement of myself."[6] This concept of creating unique, contemporary "personalities" for interior spaces, as well as the femininity of the Rococo aesthetic, appealed to Stettheimer's own sensibility.

In 1892, at the *First French Exhibition of the Arts of Women*, Georges Berger, president of the French Central Union, declared that women were "the directors and protectors of the decorative arts" and assigned women the responsibility of saving the French economy.[7] It is not known whether Stettheimer attended the Salon, but her Rococo drawings and subsequent furniture designs indicate she was fully aware of this and the subsequent exhibition and the style revival. As she traveled through Europe during the early years of the century, the artist filled sketchbooks with drawings of probably both French and German Rococo interiors and furniture designs.[8] In 1895, the cover for the catalogue of the *Second French Exhibition of the Arts of Women* reinforced the feminine qualities of the decorative arts by depicting two women, one sewing, the other holding an open book and pointing at the word *femme*.[9] At the upper right corner, an attenuated butterfly hovers near a flower blossom. The butterfly motif was also used as a signature by James McNeill Whistler, an artist Stettheimer mentioned in an early poem. The butterfly motif reoccurred throughout her own later work.

In the same year as the second French exhibition, Stettheimer made a similar Rococo-style drawing of a long, sinuous woman for the cover of the catalogue of the Art Collection of the Fair in Aid of the Educational Alliance and Hebrew Technical Institute in New York, an organization Carrie supported through volunteer work.[10] Stettheimer later abandoned specific references to Rococo ornamentation. However, she retained the underlying "S"-curve of the style and its philosophy that all objects, from paintings to furniture, should be stylistically integrated—something that would later set her apart from her modernist contemporaries.

Fig. 13 Florine Stettheimer, detail of *Le Jeu (The Game, Chinese Acrobats) Three-Panel Screen,* c. 1910, oil paint and gilded plaster on wood, each panel: 64 ¾ × 23 ¾ in., The Museum of Modern Art, New York, Barbara S. Adler Bequest.

At the turn of the century, Stettheimer was already designing furniture and decorative objects, an activity that she continued throughout her life. She designed several gilded Rococo Revival–style screens that demonstrate her early interest in experimenting with and borrowing traditional and diverse art-making techniques.[11] On one of these screens, she decided to make the decoration stand in relief against the wood-paneled backgrounds. While in Rome in 1909, she visited the Borgia apartments to study how this might be accomplished: "[I wanted] to see how high & how much relief was in the architectural part," she noted. "I have begun trying some gold decoration but unsuccessfully so far — I may improve Le Jeu when I return to New York."

In making her screen, *Le Jeu* (or *The Game*) (*Fig. 13*), Stettheimer initially drew the outlines of the decoration in watercolor or gouache over unprimed wood. She covered the wood surfaces with a light celadon green paint to resemble patinated metal. Using a mixture of plaster and gesso, she built up a three-dimensional relief for the figures and ancillary vegetation. She then covered the plaster with a thick gilding of gold paint, which she tooled to give it a varied surface texture. For the surface decoration, Stettheimer combined Asian and Rococo motifs in the manner of eighteenth-century

Fig. 14  Florine Stettheimer, Four Panel [Sibling] Screen, c. 1912–14, oil paint and gilded plaster on wood, each panel: 87 ⅝ × 35 ⅞ in., The Museum of Modern Art, New York, Barbara S. Adler Bequest.

French chinoiserie. The composition of *Le Jeu*, a symmetrical and beautiful example of Rococo-Revival decoration, portrays three Chinese men dressed in stylized robes, demonstrating gymnastic skills on the branches of an ornately curved vine.

Stettheimer designed her second five-panel screen as a family portrait of her siblings during a stay in New York between periods of traveling in Europe.[12] (*Fig. 14*) It includes portraits of the artist, Ettie, and Carrie, and one of the only portraits she made of her brother Walter. Her oldest sister, Stella, is not included, probably because at the time the screen was made, she had already left the family for San Francisco. Each panel of the screen shows one sibling with characteristic attributes surrounding him or her. Walter, wearing jodhpurs, is shown playing with two of his beloved terriers[13] while Carrie wears a couture gown, with her ubiquitous dog-collar necklace. Ettie's dramatic temperament is indicated by the tragedy/comedy theatrical masks that hang above her. With her dark cloche hat pulled down around her dark eyebrows, she holds a large quill pen, identifying her as an author. As was her preferred self-representation, Florine portrayed herself as an artist, wearing an artist's beret, with functional, pantaloon pants, associated with women's suffrage. (*Fig. 15*) She holds a paintbrush in one hand, in the other a palette, and her stance and wide-eyed facial expression are those of an artist stepping back to view a painting from a distance.[14] The umbrella shading her indicates she is working outside. The flowers in Stettheimer's self-portrait on this screen are the most unrestrained and upward-facing of all of the panels.

**Fig. 15** Florine Stettheimer, Self-Portrait, detail of Four Panel [Sibling] Screen, c. 1912–14, oil paint and gilded plaster on wood, The Museum of Modern Art, New York, Barbara S. Adler Bequest.

In May 1900, the Art Students League organized a twenty-fifth anniversary exhibition of its alumni at New York's Fine Arts Society Building. The exhibition ran from May 10 to 19 and because Stettheimer was still in Europe, she arranged to have a painting sent.[15] While traveling throughout western Europe from 1907 to 1910 Florine and Ettie made a point of attending progressive, controversial performances that featured spirited heroines and examined themes exploring women's independence, as well as works with overt sexual overtones. These included *Electra*, starring British actress Mrs. Patrick Campbell in 1908, Henrik Ibsen's *Hedda Gabler* and *A Doll's House*, and works with major actresses in leading roles.[16] They also enjoyed performances of more popular culture, including the Ziegfeld Follies and *Wildfire*, a play that was also made into a silent film in which the figure of Henrietta "saves the day." The lead part in both the play and film was played by the infamous and beautiful actress Lillian Russell who, like her mother, was active in the women's suffrage movement.

The Stettheimers also saw Richard Strauss's scandalous interpretation of *Salome* at the Berlin Opera House and, in 1909, saw Oscar Wilde's rendition of *Salome* in Paris with the debut of Russian performer Ida Rubenstein in the title role, which was considered so provocative it was shut down.

This has been called one of the first "feminist" productions of Wilde's play.[17] Stettheimer also attended Diaghilev's production of *Cleopatra* with Rubenstein in which she revealed her naked body in the "Dance of the Seven Veils." Jean Cocteau described the process of the dance, with the gradual removal of the veils until the last, "most difficult of all, came away in one piece like the bark of a eucalyptus tree."[18] Stettheimer's reaction in her diary was typically ironic: "she [Rubenstein] looked wonderful. . . bust absurd . . . beautifully staged, blue predominated."[19] The production was banned soon after opening.

While in Munich during the 1900s Florine visited numerous art museums and galleries, including the Secession and Glaspalast, and various modern art galleries such as Thannhauser's Moderne Galerie.[20] In her diary of 1909 she commented on the "beastly weather"[21] and in July was particularly taken with the Bavarian Gothic Revival-style villa of the artist Franz von Lenbach. In her diary she commented on the villa's integration of paintings and furniture by stating, "it was wonderful—so many beautiful things, and he displayed exquisite taste in having the rooms fitted out—the ceilings and some of the doorways are beautiful."[22] In the villa's rooms, the paintings were set against decorative, jewel-colored wallpaper and installed with select pieces of furniture. This idea of complete installations of rooms with the paintings and furniture complementing each other coincided with Stettheimer's own thinking even at this early stage of her life. She also viewed the work of artists including Nabi-influenced Fritz Erler, Symbolist Ferdinand Hodler, and the German Secessionist Franz van Stuck. However, she pointedly did not like the work of the latter and rebuked one of his followers for painting "trivial rococo scenes."[23] Stettheimer was very taken, however, with the highly ornamental Viennese Secessionist paintings of Gustav Klimt.[24]

In 1910, the four Stettheimer women rented an apartment at Galeriestrasse 35 in Munich,[25] and rented a nearby studio in order to paint. By 1913 the women had moved to another apartment at Hohenstaufenstrasse 10, still in the city. Despite her ancestry and years spent living in the country, Stettheimer developed a deep loathing of the German people and their culture.[26] She wrote that she admired a "pretty" artillery Lieutenant Forseter, but otherwise her aversion to anything German is evident throughout her diaries. Her caustic remarks about friends, family, and the German people are often scathing.

In one instance, she observed of a room clerk and hotel manager in Munich that they "don't know their place, horribly German, we looked for rooms elsewhere." Commenting on the audience attending a performance at the Künstler theater, she complained that they "smelt as usual, the way only a German unwashed audience can smell," and in another entry, she stated, "A bath is still a luxury in Germany—in fact an acquired taste—oysters they are trying to master—but a bath is still a thing of the future." She never mentioned similar views about the French, Italian, Spanish, or English.

Stettheimer had particular contempt for the German word *Pflicht*, or duty, demonstrating a very twentieth-century, feminist attitude toward any kind of enforced male authority. In the late nineteenth century, *Pflicht* represented the ideal moral patriarchal code of the German middle class. It dictated that any individual effort be guided toward the public good, with personal restraint as the hallmark of respectability. In the wealthy German-Jewish families of New York and Europe, children were expected to have an attitude of *Pflicht und Arbeit* (duty and work) toward their parents, despite the irony that many of their immigrant parents had themselves been rebels and risk-takers. Florine later wrote with characteristic rebelliousness:

Oh horrors
I hate Beethoven
And I was brought up
To revere him
Adore him
Oh horrors
I hate Beethoven

I am hearing the Fifth
    Symphony
Led by Stokowski
It's being done heroically
Cheerfully pompous
Insistently Infallible
It says assertively
Ja — Ja — Ja
Jawohl — Jawohl
Pflicht — Pflicht
Jawohl

Herrliche Pflicht
Deutsches Pflicht
Ja — Ja — Ja — Ja
and heads nod
In the German way
Devoutly Affirmative
Oh horrors
And now
Pianissimo
And firmly tender
So — So — So — So
Jaso — Jaso
Gut — Gut
And heads nod
In the German way

Piously ecstatic
Oh horrors
I hate Beethoven[27]

Throughout her life, Stettheimer wrote these short poems on various scraps of loose paper. The author's loathing of pretentiousness or high cultural affect of any kind is apparent in her use of vernacular language, popular imagery, and firsthand experience in these poems. The simplistic structure of these poems reflects the spare, subjective, ironic, modernist manner of the Imagist poets

at the beginning of the twentieth century such as the American poets H.D., William Carlos Williams (whose work Stettheimer may have known through her friendship with Charlies Demuth),[28] and e.e. cummings, who attended the Stettheimer salons. The Imagists were known for rejecting Victorian sentimentalism in favor of free verse using common speech patterns, often including humor/irony and clear, concrete images.

Although she did not know Emily Dickinson's poetry, Stettheimer's short poems share with the New England poet the use of experimental, inexact rhyming and lack of punctuation. In some cases, they both used dashes, possibly to indicate that their poems were meant to be read aloud. This appears to be the case, particularly in the above poem, in which Stettheimer stresses the sounds Ja — Ja — Ja — Ja," which, when the poem is read aloud, imitate the rhythm of Beethoven's *Fifth Symphony*. Like so many of her paintings, her poems are sensory, rhythmic, and performative.

Stettheimer was often in a bad mood when, while traveling during the first decade of the 1900s, family responsibilities didn't give her any private time to paint. As a result, whenever her family was in one place for any period, she rented a studio and took art lessons from local instructors. In Munich in 1910, Stettheimer worked with several instructors, including an art teacher she called "Herr Apotheker F." Under his guidance, and that of Ernst Friedlein's book, *Tempera und Tempera-Technik*, she explored working with casein, a method of painting by which a derivative of milk is used as a paint binder to create a chalky surface like that used in fresco painting. This conversion of the natural into the artificial delighted her:

<div align="center">

~~~~~~~~~~~~

| | |
|---|---|
| Casein was once milk | Casein looks like fresco |
| And then it was cheese | And Herr Apotheker F. said |
| And now it is pictures | "red vill last foreffer" |
| How wonderful | How vonterfool |
| At noon came my 'Meister' | I shall paint the walls |
| In white tie and tails | For tout New York |
| To look at my work | On my return |
| How wonderful | Most wonderful[29] |

~~~~~~~~~~~~

</div>

Stettheimer eventually became dissatisfied with casein and desired a more brilliant medium to create depth in her paintings of laurel trees. Another of her instructors, Rafaello, invited her to visit him in his studio and view some of his *Proben* (studies), in which he was also trying to achieve warm depths. That evening she wrote in her diary, "I learned some important things from

Schuster-Woldan's experiments.[30] He said that I was lucky to just step in and learn the results of ten years of hard work. So, I went to Bruggers and got some Copal varnish and hope to get at those laurels tomorrow."

As evidence of continuing feminist views during the early years of the twentieth century, marriage was an often criticized topic among women of Stettheimer's avant-garde point of view. The ideal of maternal instinct was openly derided, as was the notion that childcare was the highest duty to which they should aspire. In the media, the "New Woman" justified her decision not to marry by pointing out that marriage, as conventionally defined, was little better than slavery. For example, in 1916 *Vanity Fair* noted: "Marriage will have to yield to feminism in the end."[31] In Munich, Stettheimer had tea with a former admirer, Herr Hess, and his wife. Reiterating her distaste for marriage, she observed that his "eyes glisten as of yore when they gaze upon me . . . he again told me the days of his youth and love for me were the happiest of his life — he is still a *Schwein* (pig) . . . his wife is housebound and tells pointless tasteless stories about her babies." In another instance in her 1909 diary, while in Germany, she noted, "Kilian announced his engagement — He is a wiggly thing to become engaged to . . ."

Nonetheless attractive men figure conspicuously in Stettheimer's diary during her final years in Europe. In Italy, while riding in a carriage in the amphitheater of the Borghese gardens, she was presented with red roses by two different men, but commented, "If they had been more picturesque looking, it would be a very interesting souvenir!" A number of her extant poems reveal that Stettheimer had a number of relatively strong romantic and in some cases heartbreaking interactions with men during her twenties and early thirties. Her attitude, although couched in food metaphors, was both ironic and erotic:

You beat me
I foamed
Your sweetest sweet you almost drowned me in
You parceled out my whole self
You thrust me into darkness
You made me hot — hot — hot
I crisped into 'kisses'[32]

And:

~~~~~~~~~~~~~~

You stirred me

You made me giddy

Then you poured oil on my stirred self

I'm mayonnaise[33]

~~~~~~~~~~~~~~

Others are evidently the result of relationships that ended badly:

~~~~~~~~~~~~~~

To a Gentleman Friend:

You fooled me you little floating

worm

For I looked for the wings

With which you seemed to fly

And made you different from other worms

And then I discovered the slender

thread

That fastened you safely to a solid tree

I touched the thread

With my finger tip

And you wiggled

I snapped the thread and you fell to

earth

And you squirmed

And wormed

And only wiggled[34]

~~~~~~~~~~~~~~

While in Europe in her early thirties, Stettheimer did have an extended romantic interlude with James Loeb, son of Solomon Loeb, founder of a major New York banking house. The flirtation between the artist and the handsome scholar and aesthete, who was an avid collector of Greek antiques and rare books, lasted several years. (*Fig. 16*) Stettheimer never let the romance interfere with her sense of herself and her interest in contemporary art. As she remarked in one of her diaries,

**Fig. 16** Unknown photographer: Photograph of James Loeb, c. 1900–10, Harvard University archives.

James Loeb spent a few hours with us in the afternoon. He looks so capable. He told me he had a statue cast in bronze — and he is going to build a house here — but he does not encourage modern art — I should like to see what he has contributed to it.

Early in their flirtation, Stettheimer lunched with Loeb at the Continental in Munich and revealed her independent, feminist spirit, and the importance she associated with being taken seriously as a professional artist: "I objected to being classed with the woman who is a mystery — I tried to make clear to him that she has become obsolete. He does not treat me *en artiste* [*sic*]. I am afraid he knows more faddists than artists. And still I was amused. . ." She recorded several meetings with Loeb, from sharing a beer to a visit to his house, which she decided "suits him, a good expression of his taste, his museum is very attractive."

In November 1913, when the Stettheimers boarded the *Amerika* for their journey back to New York, Florine was surprised to find a "distraction" on board in the form of Loeb. "He claims to have forgotten that I was to be aboard although I invited him to come on our steamer & thought he looked very pleased when I did!" Unfortunately, Ettie cut the following five pages out of the diary. When Florine again mentions Loeb in her diary, some years later, it is without emotion. One of Stettheimer's poems describes a flirtation aboard ship and may provide clues to the remainder of the journey:

~~~~~~~~~~

We flirted
In New York
On the Jersey Coast
In Paris
On the Riviera
In Munich
In the Engladine
For years and years
"I am sailing
for home
on the Rotterdam."
"I am booked
on the Majestic."
"Quel malheur!"
We flirted
On the Rotterdam

We passed the Narrows
Flirting
We passed French liberty
Flirting
"Let's celebrate
this faithful
long flirtation
give a fête

invite many
They shall give us
Crystal things
Diamonds
Venetian glass
Perhaps
we could accept
Sapphires
Perhaps
we could build
a treasure house
all of glass."
His glasses
strangely
dulled
His eyes
They became
An opaque barrier
on which
Our flirtation
Shattered
In a thousand
Splinters.[35]

~~~~~~~~~~

After this incident, most traces of romantic relations disappear from Stettheimer's diaries — at least from those pages that escaped Ettie's scissors. Florine's attitude became, if anything, increasingly cynical over the years. Later in life she wrote a poem titled "J.L." (or "J.S." — the handwriting is unclear), which clearly manifests her changed, cynical attitude toward men:

He came to my studio
He had begged
"It's years since I've been
I'm crazy to see your paintings
I love to chat with you
I adore having tea with you."
He bores me
I let him come

I gave him tea
I did not chat
He did some chatting
Then suddenly I heard
"You have a superiority complex"
And I never knew it —
So, it was funny after all.[36]

Romantic interludes during these years were not the only subject Ettie deleted from her sister's diaries. The location of the excisions indicates that whenever Florine became cranky or moody, Ettie removed the evidence. The artist was often out of sorts and occasionally ill-tempered toward her family, particularly when they insisted on leaving a city and its art collections before she was ready to do so. Stettheimer also often chafed against family routines. In one instance, instead of continuing a leisurely drive, she and Carrie were forced to return to dinner with the family, leading her to note: "Meals are ridiculous institutions — we are such slaves to them. We were not hungry and 20 minutes more on the Appian way would have given us enjoyment but we had to go to dinner."

Continuing on to France, Stettheimer could not help herself from offering opinions, at least in her diary, on everything she saw. More often than not, her entries reveal her knowledge of art history and connoisseurship, but also her biting, caustic sense of humor. In 1909, on a side trip she made with her sisters to the cathedral in Orléans, she disparaged the cathedral's decoration: "they shirked work on it; instead of lace it merely looked like old-fashioned underwear embroidery." On her birthday that same year, Stettheimer and her sisters visited Aix-en-Provence in "Aunt Lala's" car. That evening they watched baccarat played at the Villa des Fleurs (Aunt Millie's birthday gift was a baccarat ticket), an activity which Stettheimer observed "would make a socialist of any human being with a mind." When she developed tonsillitis in Italy, she became irritated:

I am out of sorts, my counterpane is so dirty . . . and if I have the maid in to change it she will hang about and talk — and if I tell her I don't understand she will explain until I have to and Urbino is so near and I shall not see it — and in this place, nothing ever happens or if it did, I can't imagine how it did. And I am reading a childish book by the 2 Marguerites.

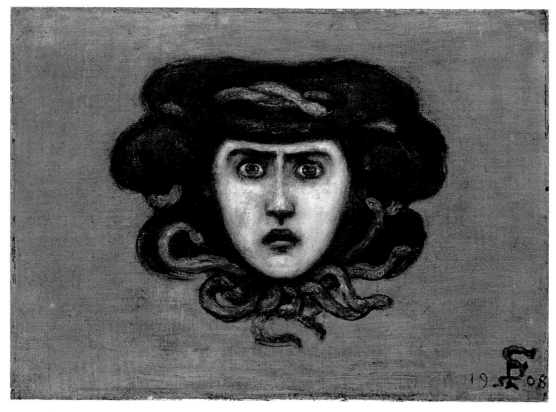

**Fig. 17** Florine Stettheimer, *Head of Medusa (Head of Ettie Stettheimer as Medusa)*, 1908, oil on canvas, 16 ¼ × 23 ⅛ in., Art Properties, Avery Architectural & Fine Arts Library, Columbia University in the City of New York, Gift of the Estate of Ettie Stettheimer.

I don't know why it took two men to write it — unless they are grown together and have one brain between them.

The rest was deleted by Ettie.

Relations between Ettie and Florine were often far from amicable. In Munich in 1909, Florine painted a portrait of Ettie in which she characterized her younger sister as Medusa, the mythological Gorgon whose face and hair, made of writhing snakes, were so horrifying that men turned to stone at the sight of her.[37] (*Fig. 17*) Stettheimer based her composition on Franz von Stuck's 1892 Symbolist version of the demonic monster but she characteristically removed all of the mystical elements of von Stuck's rendition. Instead, Ettie is immediately recognizable by her level, unrelentingly gaze, close brows, and critical expression — the manner in which Stettheimer would always portray her sister. Stettheimer signed her Medusa with her initials intertwined in the form of a snake. In a diary entry, Stettheimer described being in a museum in Italy when a custodian pointed out that she was gazing at a Medusa, whereupon she told him in no uncertain terms that she was "well acquainted" with the subject. After Florine's death, Ettie voiced surprise that there were not more critical comments from her sister that needed to be deleted: "In fact my critical sister criticized so

little & exercised such discretion that I wonder whether she suspected that these entries might be read by others,"[38] thereby reinforcing that the sisters often did not get along.

European hotel accommodations and food were another source of continual irritation and discontent among the Stettheimer women. Like so many Americans of their class who valued their creature comforts, they regularly changed hotels before finding one they deemed satisfactory. Florine was often bored: "All we seem to do is have breakfast — then sit about for an hour or so because it is so cold and looks like rain again — if it isn't raining then go out and have lunch and come home after lunch and then it rains so we have to stay home."[39]

Rome, however, held a special, romantic place in the artist's heart:

~~~~~~~~~

Rome with streets of palaces Music on the Pincio
Villas and Roman baths Magnolias and fireflies
Diplomats and savanti Dreaming in the Villa d'Este
Archaeologists and galanti Having pearls put in my hair
Litterati and padri By a painter who proclaimed me
Camellias and olive trees Not unlike Pinturricchio damosels
Battaglie de Fiori fair[40]

~~~~~~~~~

On her arrival in the Eternal City, Stettheimer changed into a white linen suit to look less like a tourist, and ventured out, making note of the dignity and stateliness of the Roman people. Besides being the home of the Sistine Chapel, which she considered "the most marvelous thing ever created by an artist," the city also boasted fine accommodations. The Stettheimers rented an apartment with three bedrooms, bath, and parlor provided by a Mr. Haase, "the only person I know who has lived up to his ideals: he told me before he built this hotel that he was going to make it fit for civilized women to live in."

Despite her lack of religious faith, Stettheimer was continually drawn to theatrical aspects of the traditional Roman Catholic mass. While in Europe, particularly in Italy, the Stettheimers regularly attended masses and saw paintings in the churches in Lanterno, San Clemente, and Santa Maria Maggiore, and even attended a beatification at St. Peter's in Rome by Pope Pius X. They also attended masses in Franscati, Narni, Terni, Rieti, Spoleto, Perugia, and Poligno. Stettheimer made numerous watercolor sketches recording the deep purple robes and prescribed actions of the priests during the ceremonies. The four women visited the small German town of Oberammergau to watch the Catholic Passion Play, which had first been performed there in 1634 by inhabitants

in the hopes of being spared from the bubonic plague. Stettheimer's humorous view of the event is evident in her diary: "Jesus Christ from Oberammegau was at the hamlet in a dress suit—he looked like a hair tonic ad." In 1909, the artist attended a mass in Santa Maria della Minerva, with a Bishop Ireland officiating, and with her characteristically cynical eye, she noted that the mass did not go off without a hitch: an Italian "prompter" (or "master of ceremony") had to stand at the bishop's sleeve and remind him of his different moves. The artist would later insert similar interpreters into her costumes and scenery for the opera *Four Saints in Three Acts* and into her final painting, *The Cathedrals of Art*.

Between 1906 and 1910, Rome and its surroundings served as the subject for several of Stettheimer's sketches and paintings. The Italian countryside provided a varied topography, and Stettheimer conceived of "stacks of new landscapes." Among her favorite sites were the Villa d'Este, with its beautiful cypress trees, and the Villa Borghese, where she spent many weeks painting and sketching in the gardens. On one occasion, she mentioned in her diary that she was joined by a French abbot, who feigned being lost in prayer as he wandered behind the artist to get a glimpse of her sketches.

Italy's monumental landscape prompted Stettheimer to want to paint panoramic compositions, but when traveling, she rarely had access to sufficiently large canvases. To overcome the small size of her sketchbooks, the artist covered facing pages of her notebooks with a single watercolor wash, over which she painted images ranging from huge gnarled trees to towns set in the Italian hills. (*Fig. 18*) During an Italian sojourn in 1909, Stettheimer used a medium-sized canvas to paint a quietly evocative work titled *The Poplars*, in which a small faun sits, gazing up toward the sky. The tiny figure, which appears in several of Stettheimer's paintings, hugs its knees, and props its back against the trunk of a tree. The painting's composition presciently resembles a theatrical stage set: its layering of cypress trees and deep vista appear as though seen by a viewer seated in a high central box seat looking down upon a stage.

Other paintings from these years, including brightly fauve-colored landscapes such as *The Fountain*, share many of the theatrical effects of *The Poplars*. They, too, were painted from high vistas and feature layered movement back in relatively shallow space. This device is facilitated by the dropped foreground, which allows easy entry into the compositions. This theatrical device presages the significant influence the theater would have on the compositional structure of her mature painting style.

From 1900 to 1914, Stettheimer tried her hand at a variety of media, from colored crayons on paper to oil applied thickly with a palette knife on rough, unprimed canvas. Although she would later go through at least one "purge," destroying large quantities of these early works, Stettheimer's remaining sketchbooks and paintings attest that she worked in a myriad of styles. Her early works

**Fig. 18** Florine Stettheimer, Sketch of Leaning Trees, graphite watercolor and colored pencil on paper, each page 40 × 25 ½ in., Art Properties, Avery Architectural & Fine Arts Library, Columbia University in the City of New York, Gift of the Estate of Ettie Stettheimer.

from this period also demonstrate her diverse color palettes, from grisaille to hot, Fauvist tones. Stettheimer's diaries indicate that she saw a wide variety of burgeoning European modernist styles and tried them out herself. While in Europe between 1909 and 1912, for example, Stettheimer executed a brightly colored series of Pointillist-style paintings using small dots of juxtaposed color rather than outlines to create imagery. Post-Impressionism offered Stettheimer the opportunity to use spontaneity, pure color, simplified form, and spatial ambiguity. Its emphasis was on the work's surface, with rhythmic, often flat, applications of brushstrokes and forms often resembling ornamental patterns. These methods of painting the experience of optical effects of light rather than the false illusion of outlines of objects complemented the theories of popular philosopher Henri Bergson.

While living in Paris, on April 27, 1912, Stettheimer and Ettie went to the Collège de France to hear Bergson deliver a lecture.[41] He was the most authoritative spokesman for the "new vitalism" and was for a time one of the most influential thinkers in the world. He espoused the idea that

reality was found in the phenomena of movement and change, and that life was a "continuity of flowing."[42] To Bergson, time was an experience rather than a succession of isolated moments. Life consisted of essential sensations of being and change, a stream of consciousness he termed *la durée*.[43] Bergson's theories represented to Stettheimer an alternative to traditional academic illusionism's frozen moment and prompted her to express through art the intangible experience of being alive. Although it would be four years before the thought of capturing the passage of time or the sensations of experiences in painting would be seen in Stettheimer's work, Bergson's philosophy was highly influential in the development of her ultimate idiosyncratic mature style.

One of Stettheimer's most Post-Impressionist, Pointillist works, *Landscape No. 2*, closely resembles Henri Matisse's well-known painting *Luxe, calme et volupté*, painted a few years earlier. (*Fig. 19*) In both artists' compositions, a group of enigmatic nude women gather by a wooded bank near a body of water in the late afternoon, forming a *paysage décoratif*. Stettheimer appropriated aspects of the Pointillist technique to capture the effects of changing sunlight on the surfaces of trees, water, and skin. In Matisse's painting, the sun has passed below the horizon, and it reflects back on the scene the jeweled colors of dusk. Stettheimer chose a much softer palette: the sun has moved well below the horizon, and it casts long purple-gray shadows against the grass and the figures' bodies. Unlike true Pointillism, neither artist was willing to completely dispense with solid outlines.

Stettheimer had many opportunities in Europe to become familiar with works by Matisse.[44] In 1904, Matisse's first one-person show opened at Ambroise Vollard's gallery in Paris, showing forty-five paintings and one drawing, and the artist sent fourteen paintings and two sculptures to the *Salon d'Automne*.[45] In 1908, Stettheimer was living in Paris when Matisse entered his painting *Harmony in Red* in that year's *Salon*. That same year in New York, two exhibitions of Matisse's work were presented at Alfred Stieglitz's 291 Gallery on Fifth Avenue. On August 14, 1910 Stettheimer wrote in her diary that all sorts of new directions in art had appeared, and that "some followers of Matisse are exhibiting canvases in frames with their name on them. They are idiotic." This aside demonstrates not only Stettheimer's knowledge of Matisse's work but also her awareness of his already substantial influence on other artists.

Not all of her experiments to emulate different painting techniques were successful. This may have been due in part to the disjointedness of the Stettheimers' lifestyle, with their traveling from city to city to sightsee across Europe. Throughout her diaries from these years, she notes the effects of constant moving on her ability to paint: "I am as unfit for hotel life as ever . . . I have sketched very little — rain and cold . . .I think I could paint something if I lived up in more beautiful bare mountains for a while . . ." The few large paintings Stettheimer executed during these years were painted in her Munich studio, with its "beautifully white" rooms and a long staircase that she

**Fig. 19** Florine Stettheimer, *Landscape No. 2*, 1911, oil on canvas, 30 × 26 in., Art Properties, Avery Architectural & Fine Arts Library, Columbia University in the City of New York, Gift of the Estate of Ettie Stettheimer.

speculated would keep her body "in form" to climb the steps of Notre Dame Cathedral the next time she was in Paris:

Munich with its carnival
Rosenkavalier Parzival
Künstler Feste Bals Parés
Satisfying my costume craze—
The gay youths had chic ways

And fortunately, fantastic arrays
And I tried many a new painting
   medium
Which prevented any tedium.[46]

As she was working her way through different painting techniques and styles, Stettheimer continued to devour art and books about art. Several years after Florine's death, Ettie recalled:

When finally, she felt that she had got all she could from being trained and taught and "shown," she had her own studio here in New York where she spent practically all the hours of all her days working. Her evenings at our family home she spent reading. I think she must have read everything concerning art published in English, French, German up to that time.[47]

The common denominator in all the artist's extant diaries is her continuous and single-minded interest in looking at art. Stettheimer was a highly opinionated, critical connoisseur, and she maintained a proprietary attitude toward the works she saw in her travels. Over the years, her opinions continued to be knowledgeable, if occasionally irreverent. She assiduously recorded the revelations, from the Pieter Brueghels in Vienna's Kunsthistorisches Museum, which she found "awfully effective," to paintings the renowned art scholar Bernard Berenson attributed to Lorenzo Lotto, some of which she declared fakes. Although she believed that Michelangelo "designed" his rondel painting of the Holy Family, she found the colors "too horrible — I hate to think he executed it — I can more readily believe he designed it." She reserved some of her most damning remarks for works by German artists such as a Lovis Corinth painting that, she declared, "should have been caged."

Stettheimer tended to classify everything she saw in art-historical terms. In Naples, she termed gazelles from Herculaneum "quite German Secessionistic" and found the frescoes "quite like Dietz." In the same manner as so many generations of privileged male artists before her, Stettheimer taught herself new techniques and art history by constantly looking at and reexamining the best examples of art in Europe's museum collections, exhibitions, and art galleries.

Stettheimer regularly revisited her favorite galleries and artists' studios and collected reproductions of an eclectic group of paintings and statues, the latter often of ancient nude men.[48] In her diaries, she was not above offering her opinions on how past works of art could be improved. In the Vatican in April 1906, she saw a figure of Apollo and decided he "looked handsome," continuing, "I wish his hands could be taken off and new ones substituted and I should like to change his drapery." In Florence she found it a "joy" to again see Michelangelo's *David* and Sandro Botticelli's *Primavera*, but she could not refrain from writing in her diaries what she believed were their failings: "David's proportions looked a little worse than ever to me today — I could not even imagine him placed high enough to get him right . . . If he were only heavier and longer from his waist to his knees!" In France, she found the anatomy of Tintoretto's *Danaë* "disagreeably shoved into a

difficult position and otherwise would be exquisitely beautiful." In Rome, she favorably compared an unfinished Michelangelo to a Rodin sculpture.

Stettheimer silently reproached the Uffizi for hanging Botticelli's golden-haired *Venus* against light-chocolate walls and mused that she would like to donate a beautiful gold frame for the painting, with the proviso that the walls be painted white. Despite her deep admiration for the artist, she reserved a particularly scathing comment for the figure of Flora from Botticelli's *Primavera*, declaring that she is "too fat to move and has not any curves to her busts — she would have been greatly improved by a well-developed under-arm curvature. That muscle is most attractive; why did he not see it — she certainly had it!"

In early December 1912, Stettheimer was firmly established at her Ainmillerstrasse 24 studio in Munich, which she described as having a "beautifully white" light. As she would throughout her life, Stettheimer took pains to control its interior decoration, ordering white and gilded chairs upholstered in chintz. There she began work on a full-length portrait of Ettie "in her black Japanese coat."[49] She also tried her hand at improving the figure of Botticelli's *Primavera* that she had criticized several years earlier in Florence. Stettheimer had begun her painting, *Spring*, in 1907 as it is signed with her monogram and dated that year. However, she only mentioned working on the *Flora* painting in 1912 in her Munich studio. As *primavera* is the Italian word for "spring," and the figure's stance and actions so closely mimic those in Botticelli's painting, it seems probable that *Flora* and *Spring* are the same work. Also as Stettheimer visited the museums in Florence many times during her years in Europe, she undoubtedly began her version of the Botticelli painting in 1907 and continued to work on it in Munich five years later. In any event, Stettheimer's version of Primavera ended up as a nineteenth-century parody of Botticelli's painting.[50] (*Fig. 20*)

Despite her usual love of bright pigments, Stettheimer chose to eliminate the seductively rich color of the Botticelli original and instead limited her painting to sepia, gray, and white tones. The pose of Stettheimer's figure emulates that of the Italian master in the twist of her body and the forward thrust and shape of her right leg. In both works, the figure stands amid a landscape populated by small animals and varied flora; however, Stettheimer's landscape more closely resembles an elaborate carpet or medieval tapestry than an actual meadow. Stettheimer's *Flora* is slimmer than its fifteenth-century counterpart, but her pronounced waist and bosom lack the original's symbolic aura of fecundity. Her Flora wears a modern, diaphanous dress and fashionable high heels, therefore robbing the painting of the original's mythological, timeless impact. A month and a half later, she recognized this, and in her diary stated, "My Flora is kitsch."

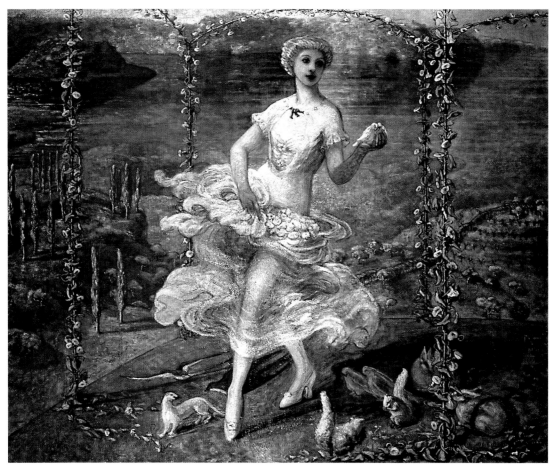

**Fig. 20** Florine Stettheimer, *Spring*, 1907, oil on canvas, 69 × 83 ⅞ in., Art Properties, Avery Architectural & Fine Arts Library, Columbia University in the City of New York, Gift of the Estate of Ettie Stettheimer.

Botticelli's influence on Stettheimer's work extended beyond a specific painting. The apartment the Stettheimers rented at Hohenstaufenstrasse 10 in Munich was light and spacious, and they filled the living room with Persian rugs, eclectic furniture with floral slipcovers, and numerous fresh flower bouquets. (*Fig. 21*) A small, framed reproduction of Botticelli's *Venus* was prominently displayed on top of the wainscoting covering a stylized column. English Pre-Raphaelite painters had revived Botticelli's work around 1867–71, believing that the Italian artist represented a more feminine sensibility than his contemporaries. They disseminated images of his work throughout Europe and the United States. The English artist John Ruskin was among the first to note that Botticelli's vision was centered in the strong, dark outlines he used to accentuate details and construct bodies and facial features, declaring him to be "one of the greatest poets of line whom history records."[51] This use of thick contour lines had a long-lasting influence on Stettheimer's subsequent work.

The *Self-Portrait with Chinese Screen*, painted sometime between 1913 and 1915, demonstrates Stettheimer's experimentation with the Italian fifteenth-century master's style.[52] (*Fig. 22*) In it, she

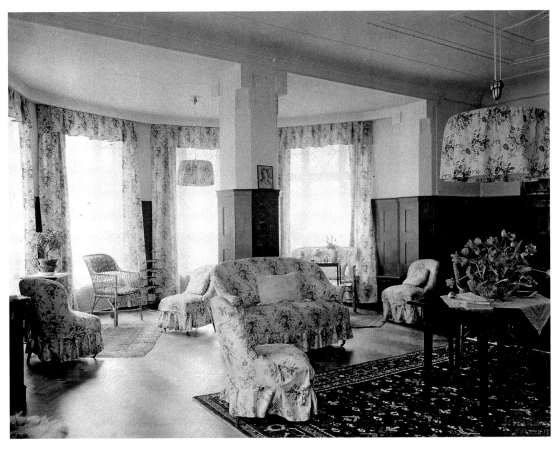

**Fig. 21** H. Wiedenmann, Munich: Apartment on Hohenstaufenstrasse 10/1, Munich, Germany, c. 1913, Yale Collection of American Literature, Beinecke Rare Book and Manuscript Library, New Haven, CT.

portrayed herself with the attributes of the professional artist, thereby granting herself the same form of self-assertion as past artists from Vigée-Lebrun to Courbet. The artist depicted herself against a beautiful screen embellished with exotic plumed birds. She wears a white smock and turban, which covers all but her bangs. In her hands she holds three paintbrushes and a palette, and she looks up as though we were interrupting her work. The three-quarter turn of her face is characteristic of Botticelli; he used it repeatedly in his religious and mythological paintings and in his secular portraits. Following the example of the Italian painter, Stettheimer painted her face by applying surface shadow over a flattish white background to denote her cheekbones and chin. Individual features such as the eyes, mouth, and nose are modeled in profile, using a dark line to outline each and set it off against the contrasting light skin. Botticelli's *Portrait of a Young Man with a Medal* shares both its mood and manner of execution with Stettheimer's painting. Like the Italian artist's unknown sitter, her expression in her self-portrait is somewhat guarded, and her eyes and mouth are large and rounded. In both portraits, the face is turned slightly to the right while the sitter's eyes gaze directly out at the viewer.

**Fig. 22** Florine Stettheimer, *Self-Portrait with Chinese Screen*, c. 1914–16, oil on canvas, 39 ½ × 31 ¾ in., Art Properties, Avery Architectural & Fine Arts Library, Columbia University in the City of New York, Gift of the Estate of Ettie Stettheimer.

A highly unusual feature of Botticelli's portrait is the insertion of a raised, gilded gesso medal between the sitter's hands. This is thought to be the only known Renaissance painting that features this device. Stettheimer not only also used gesso to build up bas-relief forms that she then gilded on her two screens; she later used the same method to create gilded gesso forms on several of her large, mature, paintings.[53] These were also likely due to the influence of Botticelli's painting.

According to her diaries, during 1912 Stettheimer spent most her free time honing her critical opinions of Western art, both historical and contemporary.[54] The four Stettheimer women left New York on April 11 and sailed for Paris. Florine spent as much time as she could visiting museums, art exhibitions, galleries, and artists' studios, all the while making judgments and comparisons between paintings and daily life: at the Moderne Galerie Heinrich Thannhauser in Munich she found it "rich in Hodlers," but in her feminist manner noted that "his females…remind me of the triste expression of a lonely little boy" as well as an exhibition of German Expressionist artists. In Paris she observed: "I have seen many things — Manets — very fine ones — his bar maid . . . Berthe Morisot who is tame… Cézannes galore…that were interesting and…the kind that are swamping the market. Renoirs that are all woolly like the Cézannes that are too many. A marvelous Eve — Rodin's."[55] Stettheimer found Monet's new Venice paintings "the most attractive things he has done so far." She also saw portraits by Van Gogh, and in Hamburg she saw one of his flower paintings and declared it "very attractive."

After one of her many visits to the Louvre, Stettheimer reacted ironically to the news that the *Mona Lisa* had been stolen: "I suppose if the general public realized the beauty of [Rembrandt's] *Hendrickje Stoffels* she would disappear also. The light is very disagreeable in the Louvre . . . I am not surprised someone wanted to see the *Gioconda* [*Mona Lisa*] in a becoming light." On another outing she visited the Gustave Moreau Museum, where she was astonished at the amount of work the artist had executed. She wondered "why he should have attempted large paintings he could not control . . . Although they mostly have charm of either color or technique, not one in particular has remained with me as particularly beautiful excepting for the copy of Carpaccio's *San Giorgio*."

One of the most crucial events that Florine Stettheimer attended while in Europe was the Paris 1912 "Salon d'Automne." In October, she went to the Salon twice and noted in her diary that she "enjoyed it." The 10th in the series of autumn salons at the Grand Palais, the 1912 version included more than 1,770 works, ranging in style from academic to Impressionist and highly controversial Cubist works. This *Salon d'Automne* was considered a highly political, exceptional exhibition as it also included a gallery with Cubist works by artists of several nationalities and a gallery that included a special room containing *La Maison Cubiste*. The latter was a house façade designed by Raymond Duchamp-Villon, Marcel Duchamp's brother, in front of a replica of a domestic hall, living room, and bedroom. In the living room, Cubist paintings by Marcel Duchamp, Albert Gleizes, Fernand

Léger, Roger de La Fresnaye, and Jean Metzinger hung on the walls. It was an example of *l'art décoratif*, where visitors walked through a full-scale plaster home where Cubist art was displayed amid the comfort and style of modern bourgeois life.

As a result, Stettheimer was aware of the early Cubist works of the artists, including Duchamp and Gleizes (who were to become some of her closest friends in New York), years before she knew the artists themselves. She was also among the earliest American artists to see these works at least a year before the Cubist architectural installation was exhibited at the 1913 "Armory Show" in New York. This example of exhibiting innovative modern art within a domestic installation was another significant influence on Stettheimer's idea that her paintings and furniture should be a single, integrated installation.

Among the many events that had taken place over the last decade, few were more influential in advancing Americans' awareness of European Post-Impressionist and modernist art than the *International Exhibition of Modern Art*, or "Armory Show." The exhibition opened in New York City on February 5, 1913, at the Sixty-Ninth Regiment Armory Building. The American public, used to viewing Ash Can School paintings as modern, was suddenly faced with examples of every variety of contemporary European art — Fauvism, Expressionism, Cubism — as well as works by artists exploring increasingly abstract styles. In March 1913, a month after the "Armory Show" opened in New York, Stettheimer's diary records her living in Germany, and there is no evidence that she attended it. All the same, she was certainly aware of the exhibition through art periodicals if she herself did not visit it. In one of her poems, she made a sly reference to Cubism:

Young Artist Rat
In a garret sat
Caught in a trap
"I'm a modern chap
For the funnel
I took for a tunnel
And the dead fish
It thought smelt delish
I shall paint in cubes
And call it Prudes
And add a rotten banana
In my very best manner."[56]

After traveling to Biarritz in 1912, the Stettheimers ventured into Spain for the first time. The artist noted a Cistercian monastery complete with "poplars and daisies and little blue pinafored bodies with their priests and angora sheep and black-gowned Spanish women — it was all so pretty," and she painted an oil sketch to commemorate the image. When touring the cathedral, the sisters took turns speaking Spanish to their guides to determine whether the money they had spent on twenty Spanish lessons was worthwhile: "Ettie can even speak some, Carrie speaks Italian and I make expressive gestures."

Arriving at the Hotel Ritz in Madrid, Stettheimer immediately sought out the Prado Museum, where she could see, firsthand, works she had heretofore only seen in reproduction. "I have seen wonders," she wrote, "such Titians and Velázquez and a Guercino the kind I never knew he painted . . . I can't remember when I saw so much that appealed to my sense of beauty. The Tintoretto portraits — and everything, yes everything, except the miserable painting called a 'Leonardo Mona Lisa.' They should throw her out or sell her to an American. We met the Blumenthals in the Velázquez room — she has just been painted by Boldini and looks as nervous as his pictures." In subsequent visits she noted, "There is no joie de vivre in Spanish art — no warm flesh adorned with gems, their earthly purgatory is really tragically felt and realistically depicted. — [However,] . . . the Titian *Venus* and *The Danaë* are intoxicatingly beautiful."

Velázquez was one of Stettheimer's favorite artists and she raved, "To my surprise [*Las Meninas*] had the quality of realism attributed to it by those who write about it — no reproduction does it justice, it is more real than the spectators before it — and it has the silvery quality of atmosphere that it is supposed to have." However, upon viewing paintings by El Greco in Toledo, Stettheimer admitted, "I am not wildly excited over him — I can't see that he is a marvelous colorist — I do see intensity of sentiment and [that he] sacrificed almost everything to expression." She also visited Madrid's Archaeological Museum, where she admired a collection of Greek vases, demonstrating her eclectic interests. On the other hand, she found contemporary Spanish paintings "miserable." Stettheimer became very frustrated that she was not able to spend more time visiting Spanish museums, as the rest of the ladies wanted to return to their regular surroundings. On the train back to Madrid, Florine complained, "I am disgusted — we are going out of Spain tomorrow — Carrie coughs and mother is nervous — and none of the family came here with great enthusiasm — and in consequence no risks will be taken."

The artist's sharp tongue and ambivalent, often contradictory attitude toward religion can be seen in a diary entry she made on May 26, 1912, en route to the Catholic shrine. She sat in a train compartment with a French lady, "with one of those mourning draperies suspended from her apex which the French seem to think de rigueur if anybody on a visiting list dies." The woman apparently:

made it her business to find out about my religious faith. I took pleasure in telling her I was not a Christian — in fact a Jewess — and she could not believe it — I was not "le type" — and was my mother a Jewess also — and were there other Jews in America. I told her all her Saints and her Sauveur and her Vierge were Jews — she did not believe it — and said the only one she knew was Judas le Traitre Escariot! none of the other disciples. She chucked me under the chin! and said she would pray for a change of heart for me in Lourdes — I asked her how she would like me to pray for a change of heart for her in my church! I did not tell her I have never attended a service in that same church.

The Frenchwoman's remarks continued to bother Stettheimer, and sometime later, when visiting Versailles, she described the incident to a priest who "seemed to live there . . . I wanted to know about the pious lady who only knew about Judas the traitor as the only Jew in the Bible — whether that was the usual religious teaching — I suggested it might be politics — he spoke well and was very fluent and assured me such ignorance was deplorable — I think he must be a Jesuit!" She later found out that the priest was in fact the Bishop of Tours.

When she finally arrived in Lourdes, Stettheimer found it disappointing. She attended vespers at the Church of the Rosary, hoping to see a "miracle." Instead, she found the famous grotto "disgustingly unsanitary." The high point of the trip came when the train first pulled up to the station and Stettheimer, looking out the window, saw a hill near the grotto covered with abandoned crutches and corsets. Her reaction reveals her rapier wit and "liberated" self-image: "Someone left a corset behind — I should think lots of women would do that. I shed mine long ago — but never thought of donating it to anything."

Back in Paris, Stettheimer's attitude toward the art world was no less cynical. She attended an exhibition at Georges Petit's, noting with irony that "*c'est délicieux* was applied to everything . . . Boucher's very indecent young female exposing her charms was certainly called *délicieuse*, chairs were *délicieuse*, and Chardin's oyster still life was *délicieuse* which was quite appropriately expressed."

With an increasingly prosperous middle class seeking new status symbols, the art market burgeoned. By the first decades of the twentieth century, the development of a substantial network of independent art dealers and collectors in Paris had rendered academic training and the official sanction of the Salon largely irrelevant. Culturally and economically, the main influences on contemporary art were the galleries and the auction market. Stettheimer divided gallery-goers between "all sorts of people who looked as if there were no art in their lives — and others who were interested commercially," and she tended to view the influence of art dealers and the commercial market, whether in Europe or America, with a great deal of skepticism:

〜〜〜〜〜〜〜〜

| | |
|---|---|
| In New York | Even flowers |
| Cows | Pompous |
| Sheep | Bearded |
| Even chickens | Painters |
| Hang | Painted them |
| In heavily gilt ornate frames | Pompous |
| On your | Picture dealers |
| Old rose | Sold them to you |
| Old gold | In red plush sanctums |
| Satin brocade walls | Cows |
| You live | Sheep |
| Sedately | Even pigs |
| Dignifiedly | Watch you |
| With your treasured costly | Sit |
|    cattle | Satisfiedly |
| portraits | On gilt velvet-tufted chairs.[57] |
| They replace ancestors | |

〜〜〜〜〜〜〜〜

In 1912, a painting of Salomé by the French academic artist Henri Regnault received extensive newspaper coverage and attention when it sold to Roland Knoedler, an American gallerist, for $100,000 (or $2.7 million today). While in Paris, Stettheimer visited a gallery where Regnault's painting was on view. She was taken aback, calling the painting "an abomination — I can't see how even the worst most ignorant collector could be taken in by it. I remember it as a piece of poor-quality crude yellow satin (cotton backed) in a black frame — they must be mad." Given her appreciation of many Renaissance and contemporary nudes, Stettheimer's criticism of the painting was not based on its licentious subject matter as much as on its retardataire, academic painting style. She noted its enormous sale price at auction in her diary, and it added to her cynical view of the commercial dealings of the art world.[58]

The Stettheimer ladies maintained very close relationships, staying with and visiting all of their extended family members in Europe and New York. Therefore, during her extended periods spent in Paris during the 1890s and early 1900s, it is likely that Stettheimer knew, and had at least some form of social interactions with, her cousin, the poet Natalie Barney. There were many similarities

between the two women: their families were directly related through their Pike ancestors, Barney and Florine were approximately the same age, and both had studied French academic art: Barney with Charles Carolus-Duran, and Stettheimer with his pupil, Carroll Beckwith. Florine and Ettie Stettheimer also shared with Barney an interest in contemporary European art and literature, particularly that written by women. There is no written record of the Stettheimers having attended Barney's Friday afternoon salons at her home at 20, rue Jacob in Paris. There, many of the most interesting and avant-garde American, European and French writers, artists, and performers, particularly lesbians, congregated until late in the evenings. However, several decades later, Barney and her lover Romaine Brooks were among the guests at Stettheimer's salon in New York.

Unlike in England and the United States, sexual relations between same-sex couples were not illegal in Paris. As Barney was openly lesbian, her salon was, just as the Stettheimers' would be in New York City, an unusually comfortable and secure site for individuals with fluid sexual orientation. Stettheimer's time in Paris undoubtedly contributed to the open attitude toward non-normative sexual relationships that distinguished her many friendships and the openness of her portrayal of her gay friends. Paris, with its more open lifestyle and innovative contemporary arts, was where Stettheimer felt most at home in Europe. It is also where she found the greatest influences for her later, mature aesthetic. Later, remembering this period of her life, Stettheimer wrote:

Paris — living in the Latin Quarter
And flanéing in the Bois
Going to staid dinner parties
In Callot gowns chez moibored[59] by
my painting master
Rather charmed by a blonde Vicomte
Approving of French tools
Also of French art
Thrilled by the Russian Ballet
And cakes made by Rebattet
Liking Marquis chocolate
and petit pois à la Française[60]

By far the greatest influence on Stettheimer's mature painting style was the theatrical productions of the Ballets Russes which she often attended in Paris. It is difficult today to comprehend the

transformation that Sergei Diaghilev's Ballets Russes brought to performance and the decorative arts in Europe and America. By the end of the nineteenth century, ballet in most of Europe had degenerated into a display of pleasantly controlled steps and attractive costumes. Stage design was not considered an art form, but a craft left to artisans. By contrast, Diaghilev's goal for his Ballets Russes was to challenge this by producing an innovative synthesis of all the art forms, or a "*Gesamtkunstwerk*." He believed that opera fell short of being this sort of "total art form" because of its excessive concentration on words and its use of stationary positioning without any drama. Instead, he suggested that only a new form of contemporary ballet, incorporating the best of contemporary artists, dancers, music, and design, had the potential to act as the true *Gesamtkunstwerk*.

To accomplish this synthesis, he gathered many of the most innovative artists of the time into his company. With its radically new incorporation of innovative artistic design, brilliant color, bold costumes, energetic choreography, and modern music, the Ballets Russes captured the imagination of an entire generation. The young poet Rupert Brooke, after seeing the Ballets Russes in 1912, declared that "they, if anything, can redeem our civilization. I'd give everything to be a ballet dancer."[61]

Over the next decades, the Ballets Russes influenced most of the arts. In Diaghilev's hands, art was not intended to imitate or teach; its purpose was to excite, provoke, inspire, and unlock *experience*. Under the influence of the Ballets Russes, the muted and mixed colors of fin-de-siècle taste were overwhelmed by a flood of pure, bright color that almost immediately found itself the height of fashion. Diaghilev's ballets were designed with sets and costumes by premier Russian artists such as Léon Bakst, Alexandre Benois, and Nicholas Roerich, who used bright, provocative colors and lavish Georgian silk to create sets that were an integral part of the spectacle.[62] The Stettheimer sisters' favorite couturier, Paul Poiret, even introduced the colors and patterns of the Ballets Russes into the clothes he designed.

The theatrical aspects of the Ballets Russes had an immediate and formidable impact on all of Stettheimer's subsequent work. It is because she so fully absorbed the concept of integrating many art forms rather than working within exclusive definitions of painting that Stettheimer's mature work does not resemble that of contemporary painters. The Ballets Russes, in the interest of bridging the gap between popular and high culture, the refined and the bawdy, also fostered in her an appreciation of popular culture.

Diaghilev opened the first season of his company in Paris with the ballet *Le Spectre de la Rose*, with the brilliant young Russians Vaslav Nijinsky and Tamara Karsavina dancing. It was a huge success, and four new ballets were planned for 1912, including *L'Après-midi d'un faune*, which Nijinsky both choreographed and danced. The style of dancing in *L'Après-midi* was completely new,

**Fig. 23** Baron Adolph de Meyer, *Vaslav Nijinsky, in "L'Après-midi d'un faune,"* 1912.

and the subject matter was sexually explicit in a way no Western ballet's subject matter had ever been before. The program notes, "A faun dozes, Nymphs tease him, a forgotten scarf satisfies his dream, the curtain descends so that the poem can begin in everyone's memory," gave no indication of the provocative and incendiary nature of the ballet. (*Fig. 23*)

Nijinsky interpreted Claude Debussy's score by breaking all of classical ballet's rules. As the faun, he executed his gestures flat-footed and in profile, through a series of angular, abstract, lateral movements. The effect was as if stylized images from the sides of ancient Greek vases had come to life. Nijinsky wore only skin-colored leotards with brown painted patches, with a garland of leaves around his hips. This made him appear naked with spotted skin, producing the effect of merging human and animal into a mythical creature complete with horns and a short tail.[63] Toward the end of the ballet, Nijinsky caused an uproar by undulating his hips, as though simulating an orgasm, over the abandoned scarf of the wood nymph. Gaston Calmette, editor of *Le Figaro*, refused to publish a review of the ballet. Instead, he wrote a front-page article calling the faun "lecherous" and his movements "filthy and bestial in their eroticism . . . whose gestures are as crude as they are indecent." He termed the production an "offense against good taste."[64] Many others agreed.

Not everyone inveighed against the ballet. The sculptor Auguste Rodin stood up and cheered at the end of the performance, and the author Marcel Proust described how the "charming invasion" of the Ballets Russes "infected Paris with a fever of curiosity."[65] Stettheimer was similarly caught up in the excitement when she saw the performance at the Théâtre du Châtelet in Paris on June 7, 1912, only ten days after its premiere.[66] Her reaction was ecstatic:

> I saw something beautiful last evening. The Russian Ballet — *L'après midi d'un faune.* Nijinsky the Faun was marvelous — he seemed to be true half beast if not two-thirds. He was not a Greek faun — for he had not the insouciant smile of a follower of Diogenese [*sic*], he knew not civilization — he was archaic so were the nymphs — he danced the *Dieu Bleu* and *The Rose* — in which he was as graceful as a woman — and *Scheherazade.* He is the most wonderful male dancer I have seen — and I imagine the rest of the world has never seen better. . . [Léon] Bakst the designer of costumes and painter is lucky to be so artistic and able to see his things executed.[67]

The experience so affected Stettheimer that during the years immediately after seeing the performance she created a ballet — writing the libretto and designing its sets and costumes, that she hoped to present to the Ballets Russes for a future production. This was to prove of significant importance to her later work, as in designing the drawings and two- and three-dimensional figures for her ballet, she developed the exact style, flattened manner, and active gestural forms and implied movement that later formed the basis of her unique mature painting style.[68]

Originally titled *The Revelers of the 4 Arts Ball*, then changed to *Orphée des Quat'z-Arts* (*Fig. 24*), Stettheimer created her ballet by directly drawing on Diaghilev's concept of modernism as a culture of sensations, energy, and fleeting moments. Stressing its contemporary nature, Stettheimer based her libretto on an actual carnival parade put on annually by Parisian art students of the École Nationale Supérieure des Beaux-Arts. She spent months planning and executing the sets, costumes, and libretto, and decided to emphasize the theatricality of the city's daily routines, as the street life shifted from hour to hour. Her drawings depict contemporary Paris at dusk with electric lamps along the Champs-Élysées extending its nightlife well into the morning. As the sun goes down, fiacres (horse-drawn carriages) crowd the streets. Outdoor street cafés fill with people watching others promenade along the Champs-Élysées, while in the Latin Quarter, young artists and art students gather for theoretical disputes about color and form.[69]

Stettheimer began writing the libretto for *Orphée* in French, changing it to English in subsequent drafts.[70] The concept of time passing, an essential element of her ballet, was to remain crucial to Stettheimer's aesthetic development throughout her career as the artist's mature painted

**Fig. 24** Florine Stettheimer, *Procession: Led by Georgette and Euridice*, Costume design from *Orphée des Quat'z-Arts*, c. 1912, gouache, metallic paint, watercolor and pencil on paper, 9 ⅛ × 15 ⅛ in., The Museum of Modern Art, Gift of Miss Ettie Stettheimer.

compositions grew directly out of the *Orphée* ballet's notion of performance as a progression in time with no apparent goal, a narrative not oriented toward any final resolution. Like Diaghilev, Stettheimer conceived of her work as a *Gesamtkunstwerk* or "choreographed drama with music." All of the elements of the ballet — the characters, costumes, setting, libretto, and actions — work together.

The libretto for *Orphée des Quat'z-Arts* in English reads:

> It is a starlit mid-spring night . . . Behind the great trees on the right of the stage are seen the lights of the restaurant "Les ambassadeurs"[71] . . . From the left an Apache and his girl come on fooling and playing. A short dispute, whether to stay or go on follows, which ends in their sitting on a bench on the roadside under a tree immobile in close embrace. The last couple now rise from their table and depart . . . The night becomes quiet and dark . . . suddenly the quiet is dispelled by music and a wild rush of revelers, artists and models coming straight from the quartz-arts ball . . . Orpheus with his charmed lyre leads the procession . . . nymphs, fauns, satyrs, bacchantes . . . take up the dance and it becomes a wild bacchanalia . . . the cortege is composed of animals . . . artists and models impersonating gods and animals charmed . . . by Orpheus' music.
>
> Eurydice does a snake dance and the Apache fascinated draws near and dances with her. A fiacre drives up from the left in which M. Dupetit and his daughter are seated, homeward

bound from a ball . . . They are waylaid by the revelers . . . Orpheus hands Georgette out of the fiacre, her father follows . . . gradually the music forces her to rhythmic dancing which becomes bacchanalian — while dancing . . . her gown is removed, and the artists drape her in some of their glittering things and bedeck her with flowers. Orpheus and Georgette dance, M. Dupetit dances a grotesque dance in which the models join him. Just as the sun begins to rise Mars appears on a white and gold charger . . . Georgette is helped with her wrap and lifted into the fiacre followed by M. Dupetit . . . they depart off right . . . Orpheus and his revelers . . . dance off toward the arc de triomphe . . . a girl, with a pushcart full of spring flower blossoms comes along, stops and looks after the revelers shading her eyes with her hand. — La fin.

Stettheimer, as she would in many of her later paintings, appropriated the theme for her ballet from an actual event, not from mythology or a fantasy. For centuries, the various guilds in Paris had celebrated an annual carnival. Only the arts guilds had no organized festivities. To correct this, in 1890 the students at the École Nationale Supérieure des Beaux-Arts met with members of the four artists' guilds (painting, sculpture, architecture, and literature) and decided to hold an annual ball arranged by a committee of representatives from the École, artists from the Latin Quarter, and "guests." The first Bal des Quat'z-Arts (Ball of the Four Arts), held at the Moulin Rouge in Montmartre, aroused enormous excitement. In the early hours of the morning, crowds of masked participants surged out into the streets and made their way past Parisians hurrying to work.

The Bal des Quat'z-Arts continued for several years; the main attractions were the huge floats, on which costumed artists and models mimed various themes. In 1893, for the first time, women artists were allowed to participate in the Bal des Quat'z-Arts parade. It was also the year the parade resulted in riots and a student being killed. As an artist who had lived and actively visited artists' studios in Paris, Stettheimer was undoubtedly aware of this incident and the history of the Bal des Quat'z-Arts when she chose it as the theme for her ballet. As one participant recalled, the theme of the 1893 parade was Cleopatra's court:

On a platform borne by Egyptian slaves Cleopatra lay surrounded by a group of girls forming a beautiful *tableau vivant*. They were all models whose bodies we knew by heart so that their clothing, or lack of it, was of very little importance. But a certain senator, M. Beranger, Père-la-Pudeur as we called him, took it in his head that the public had been scandalized by these naked bodies from the Bal des Quat'z-Arts and put the whole ball committee into the dock.[72]

A French court produced witnesses to testify that the Bal was a menace to public morals. A key witness, La Goulue, a star of the Moulin Rouge, surprisingly decried the moral depravity of the youthful artists. The court pronounced a severe fine of one hundred francs on the students and their models, none of whom could afford to pay it. In response, on July 2, 1893, the students organized a protest. The students held further demonstrations on July 3 and 4, and the government ordered out detachments of police. Skirmishes developed into week-long riots, and soon the entire Latin Quarter was up in arms. Students overturned buses, set them on fire, and looted shops. A heavy metal object thrown from the sidelines killed a twenty-year-old student named Antoine Nuger, who rapidly became a martyr for the cause.

Ultimately, Stettheimer's ballet was also autobiographical. The figure of Georgette, her ballet's protagonist, serves as a metaphor for Stettheimer's own desire to mediate between the disparate worlds of her upper-class family and that of the artists with whom she felt a creative affinity. Both women had to find special moments for art between the obligations of daily life. Stettheimer's personal and emotional allegiance to the artists shows throughout the ballet's story line, as Georgette moves with ease between high society and bohemia.

When introduced, Georgette wears an elaborately designed and fitted coat and sits in a carriage with her father as befits an upper-class lady. (*Fig. 25*) Later, when she joins the wild revelries of the artists, they undress her publicly, transforming her clothing into a diaphanous, virtually transparent, layered sheath, and for a while she, too, becomes a bohemian artist. Georgette's shoes alter from purple, matching the flowers in her elegant coat, to higher bright red stilettos — similar to those in which Stettheimer would depict herself in self-portraits throughout her life, furthering the implied tie between the two. The change in clothing symbolizes a liminal cultural space in which Georgette can temporarily transgress the social boundaries that normally restrict her conservative behavior. Eventually, as Stettheimer's surrogate, Georgette leaves the artists, re-covers her body in appropriate dress, and returns to the safety of her father's carriage. This distinction between the two worlds, between the social self she shows others and her true, more erotic self, expressed only when she is alone and painting, is a highly modern concept that Stettheimer knew all too well.[73]

To complete her final sketches and three-dimensional models for the ballet, Stettheimer spent hours in libraries in New York and Paris, researching customs and cultures, especially those of ancient Greece.[74] Eventually she painted more than fifty-four drawings and watercolors in which she designed the costumes and "animal floats" for each of the ballet's characters. Several begin as drawings, then progress to processions or parades of identifiable characters that she further designed as bas-reliefs complete with varied materials. (*Fig. 26*) In one maquette, for example, that she developed from a watercolor, she mixed mythical and historic figures, including Zizim of Persia,

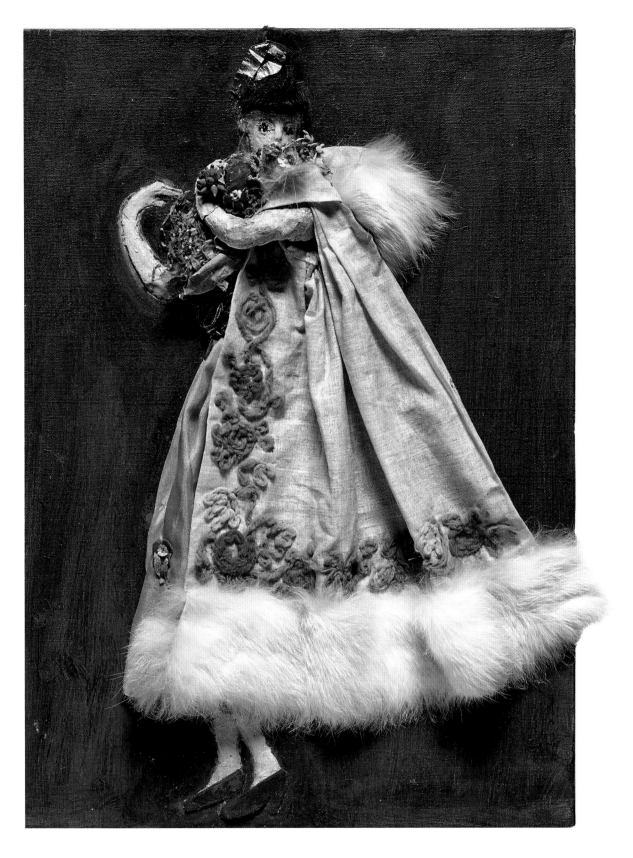

**Fig. 25** Florine Stettheimer, *Georgette in Fur-Lined Coat,* Costume design from *Orphée des Quat'z-Arts,* c. 1912, oil, cloth, fur, yarn, and hair on canvas, 17 ¼ x 15 ⅛ in., The Museum of Modern Art, Gift of Miss Ettie Stettheimer.

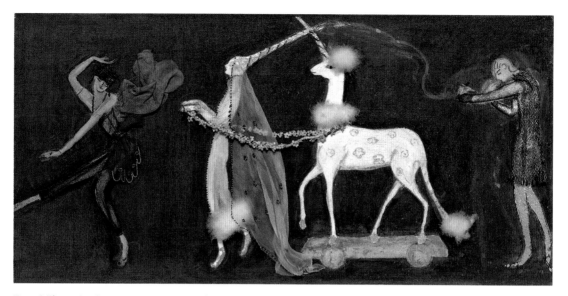

Agnes of Bourganeuf leading a white unicorn float, and Pierre d'Aubusson. The costumes include materials including netting, beading, silver mesh, feathery fluff, tiny cloth flowers and transparent, tiny beading, gilding, various forms of lace, and a newly invented material that would later gain her international fame.

In *Orphée*, as in her later mature paintings, Stettheimer's figures dance across space, reinforcing the fact that she was designing a ballet. At this early stage in her career, the artist already demonstrated one element that would uniquely characterize her later, mature work: differentiated figures, each designed with an individualized costume enabling viewers to identify them. For example, whether in her drawings, watercolors, or in gouaches with actual materials, thin, gold, beaded straps hold a pearl-studded halter over Eurydice's breasts. (*Fig. 27*) Her matching harem pants are striped with lines of gold beads that gather at her ankles over her gold heels. As she gracefully dances, her movements are echoed by the long, green, bead-trimmed snake on one arm and the bronzed, transparent scarf on her other.

Several of her ballet's characters' costumes, including *Ariadne*, *Wave*, and *Aphrodite*, are largely left naked, reflecting Stettheimer's comfort with nudity on the stage. Hinting at an ancient Roman costume, with her hairstyle and anklets rounded by gold beads, Aphrodite sits on a dolphin gilded with silver paint. Her only covering is transparent gold netting that folds over her pubic area. (*Fig. 28*) Her float is drawn by a similarly naked male, green-skinned dancing figure, which Stettheimer identifies in the accompanying gouache as *Wave*. His genitals, too, are barely covered, but this time with a thin skein of cellophane.

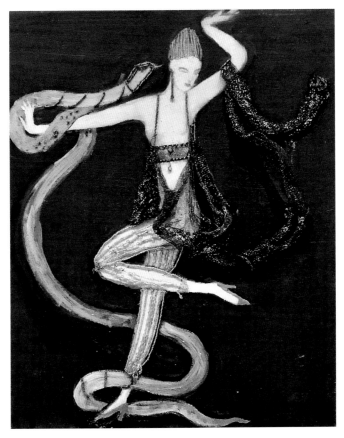

**Fig. 27** Florine Stettheimer, *Euridice and the Snake*, Costume design from ballet *Orphée des Quat'z-Arts*, 1912, oil, beads, and metal lace on canvas, 18 ⅝ × 15 ⅛ in., The Museum of Modern Art, Gift of Miss Ettie Stettheimer.

This very early use of cellophane in the 1912 *Orphée* ballet figures of *Wave* and *Ariadne* helps date Stettheimer's creation of the ballet design to sometime between 1912 and 1914. The material was invented in the early years of the century by a Swiss chemist who wanted to create a cloth that could repel liquids rather than absorb them. After trying to use a spray-on material, he began working with viscose, creating a transparent but stiff material that over time has become highly brittle and has a yellowish cast, indicating that her ballet was created very early in cellophane's development.[75] This early, highly innovative use of cellophane in stage costume and design also presages the use Stettheimer made of the transparent material twenty-two years later in her designs for *Four Saints in Three Acts*. The near nudity of several of the male and female figures, several covered only by the cellophane veils or a windswept swath of transparent material, would undoubtedly have been shocking to audiences at the time, something that doesn't seem to have fazed Stettheimer.

In addition to designing her ballet characters in pencil drawings, colored drawings, and maquettes with actual materials, Stettheimer made three-dimensional wire and plaster figures for *Orphée*, particularly for Nijinsky as Orpheus and Adolph Bolm as Mars. Orpheus (whom

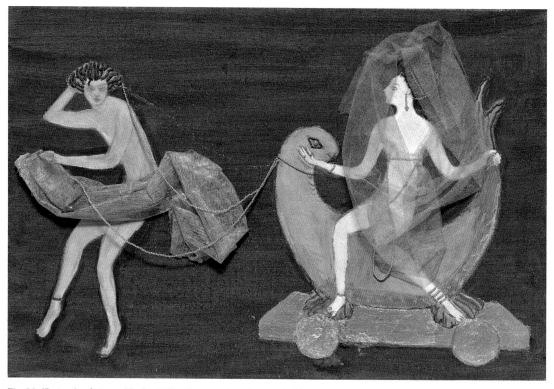

**Fig. 28** Florine Stettheimer, *(Orpheus) Wave Drawing Aphrodite on a Dolphin*, Costume design from ballet *Orphée des Quat'z-Arts*, 1912, oil, lace, beads, and silver foil sewed and pinned to canvas, 17 × 24 ⅞ in., The Museum of Modern Art, Gift of Miss Ettie Stettheimer.

Stettheimer originally identified as Wave), like most of the drawn and maquette figures, is caught mid-dance, about to rise *en pointe*. His greenish skin and naked torso, gold-beaded turquoise shorts, and transparent, beaded cape flow according to the graceful movement of his arms. (*Fig. 29*) For Mars, Stettheimer designed a figure covered with bright red paint wearing tooled metal armor, including aluminum shin guards and a breastplate bearing a detailed head of Medusa. She added the white horse on which he rides to welcome the dawn. A third three-dimensional bright yellow figure appears to be a satyr.

The ballet represents Stettheimer's first overt steps toward abandoning her academic training and Post-Impressionist experiments and formulating her own unique style. It was four years before anyone outside of the family saw her designs for the *Orphée* ballet. Nonetheless, the artist's conception and ballet designs are a highly significant turning point in her work. As a result, related issues of performance and audience became deeply ingrained in Stettheimer's aesthetic sensibilities and can be seen in her work from 1917 onward. The theatrical device enabled her to explore a variety of materials and modes of art-making foreign to her past fine-art training. If Stettheimer had had a chance to present the designs for this ballet as well as to continue working in this mode, she might have achieved notice as a modernist designer far sooner than as a painter.

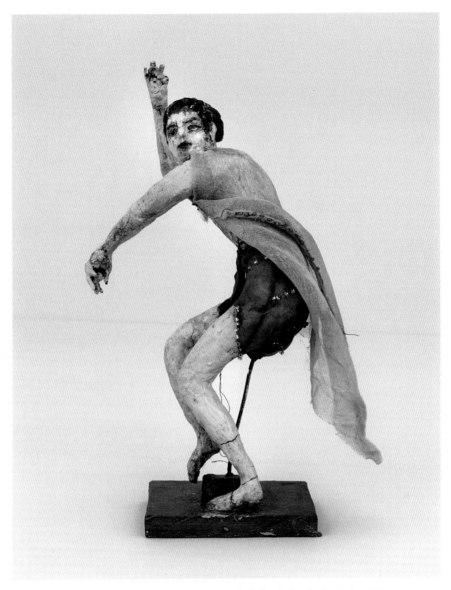

**Fig. 29** Florine Stettheimer, *Nijinsky* (*Wave*) Maquette for ballet *Orphée des Quat'z-Arts*, 1912, modeling putty and pigmented shellac-based paint on wire armature with fabric, beads, and wood, 10 ¹⁄₁₆ × 5 ¹⁄₁₆ × 5 in., The Museum of Modern Art, Gift of Miss Ettie Stettheimer.

At this point, though, she was still differentiating between the style she used in her furniture and theatrical designs and that of her paintings. It would be several years before she would allow herself to incorporate the idiosyncratic style of her fine, fluid, quirky contours, miniaturization of figures, theatrical movements, woman's point of view, idiosyncratic manner and characterizations evident in her ballet designs into her unique, mature painting style. Instead, for the next few years in her paintings she continued to experiment with modernist Post-Impressionism and European modernism.

During the remainder of 1912–13, the Stettheimer women continued to travel and live abroad. In September the family looked for an apartment in Munich, and Florine's caustic humor found various outlets. Upon viewing the work of a German artist named Hess, she wrote, "He approaches all his subjects with apparently the same feeling — be it a jug, an orange, a plucked chicken or his wife's portrait. I think I detected a trifle more sentiment in the case of the plucked chicken." She described the house that the family rented in the hills of Florence as "a Swiss chalet — a horror — not only in idea is it monstrous — but in reality, also — and the family is going to rent it — I suggest goats & cows with Swiss bells attached grazing in the garden." She complained in her diary that Carrie, meanwhile, was taking music lessons "at inconvenient hours."

Now finding herself "much more worldly wise," Stettheimer was nonetheless increasingly restless. While the Giottos in Santa Croce were "a delight forever," even the Ghirlandaios failed to provide their usual pleasure; and her first viewing of an airplane proved disappointing because, as she grumbled, she had already seen one on the cinema screen. She spent most of her travel time visiting museums in Italy, France, and Germany. She collected reproductions of works that pleased her, such as Daumier's *In the Theater* and a Goya still life, which she loosely inserted in her diary of 1913, along with several reproductions of works by Van Gogh. Stettheimer also visited an exhibition of flower paintings by Van Gogh and found the works "a very great surprise and very attractive." She saw an exhibition of self-portraits by contemporary artists at the Uffizi, which was rather depressing, as it reminded her that she was neglecting her own painting. Instead, she filled her days by buying Venetian paintings with gold and white frames, taking photographs, and collecting *vues d'optiques* of exotic sites in Egypt, China, and the Dardanelles, all the while complaining that she was not painting and had no place to paint. When the family returned to their "Swiss chalet," she purchased supplies and proceeded to execute several paintings of the monumental cypress trees that dotted the Italian landscape.

In March 1913, before Lent, the Stettheimer women attended the Fasching festivals in Germany. Florine enigmatically noted in her diary, "This carnival has been the means of revealing much," indicating again her interest in the theatrical aspects of popular culture. At concerts, the Stettheimer sisters took a theater box with another relative, Irene Guggenheim, but Florine was not particularly moved by the lieder songs, and noted, "Our German bringing up is wearing off." By winter the Stettheimers were living in Paris, where Florine had an operation on her eyelid, dieted, attended the "Salon d'Automne," took tango teas at the Olympia Hotel, and read voraciously.[76] In spring of the next year, Florine and Rosetta went to Mardi Gras in Paris, where the artist declared, "The French throw confetti more lavishly than the Germans." At the same time, Ettie and Carrie visited Carnival in Munich. The women wrote to each other almost daily.

**Fig. 30** Unknown photographer: Florine, Carrie, and Ettie Stettheimer (left to right), c. 1914, postcard photo collage; whereabouts unknown. From Parker Tyler, *Florine Stettheimer: A Life in Art*, p. 18. Photographs of three women set against a background of a view of Bern, Switzerland.

When World War I broke out in midsummer, the Stettheimer women were marooned in Bern, Switzerland. As she later noted in her diary, "My composing the [*Orphée*] ballet was a means of getting away from the war — like the Greeks invented their gay mythology to make life possible for their melancholy dispositions." In September 1914, Florine fell ill, and she wrote to Benjamin Tuska, her lawyer in New York, on the 22nd, asking him to amend a will that she had made two years earlier, as she felt it was "too fantastic." However, there is no information revealing what she meant by this statement.

In her new will she left everything to her mother and sisters, stating they could sell works if they wished, "but I request them not to give any of them away."[77] (*Fig. 30*) Seeing firsthand the plight of an increasing number of refugees fleeing from Germany, Stettheimer, her mother and two sisters feared being trapped in Europe. Instead they boarded a ship for New York, never to return. Stettheimer left a number of her works and clothes in storage at the Hotel Wagram in Paris that she was only able to recover and have sent to her in New York seven years later.

*chapter three*

# RETURN TO NEW YORK

## 1914 – 1915

There comes a point when the accumulation of an increasing skill in the mere representation begins to destroy the expressiveness of the design, and . . . the artist becomes uneasy. [S]he begins to try to unload, to simplify the drawing or painting by which natural objects are evoked, in order to recover the lost expressiveness and life. [S]he aims at synthesis in design . . . [s]he is prepared to subordinate consciously h[er] power of representing the part of h[er] picture as plausibly as possible, to the expressiveness of the whole design.[1]

In August 1914, with Germany having declared war on France, Stettheimer, her two sisters and mother sailed into New York's harbor. Even from the water it was obvious that the nineteenth-century city of Stettheimer's childhood was altered almost beyond recognition. New York was rapidly reinventing itself as the new global center of modern commerce, finance, and culture. A reporter, Matthew Lorden, later observed that the war in Europe had taken a huge toll on Stettheimer and had had a major impact on her future work. He described how Stettheimer

was stricken by the tragedies and horrified by the plight of refugees who had fled the horrors. The unimaginable terror that had shattered the old conventions aroused emotions that shook her out of her placid acceptances. . . . She discovered that between her and the past, a wall of memory had been reared. Another personality asserted itself. A personality to which the past and its ways was abhorrent. It sought the immediate, the untouched; it expressed itself in these strange, gay, fluent forms. They are not realistic — they release the emotions aroused in the artist's mind by things she sees about her. They express what she feels, and in painting them, she has the happiness of one delivered from bondage.[2]

The permanent return home also offered a fresh beginning for the artist. In Europe, where she had spent most of the previous forty years, life was steeped in history and tradition. Stettheimer returned home as a mature woman who had developed a taste for the most innovative and controversial elements of the avant-garde arts, including nudity and performances by and about strong, liberated women.

On her final return to the United States, Stettheimer therefore had the sense of "throw[ing] off old shackles" and "becom[ing] free."[3] From this moment on, Stettheimer also emotionally and

aesthetically committed herself to being a liberal, democratic American. By spending so much of her life abroad, Stettheimer benefited from a point of view which art critic Paul Rosenfeld astutely noted was "an expression of aspects of America tinged with the irony and merriment of a very perceptive and very detached observer." This, combined with her sardonic sense of humor, made the artist a unique social documentarian as well as a fascinating and innovative artist of her time. One of her poems captures the intermingling of the sights, sounds, and visual spectacles that greeted her on arriving back in New York:

〜〜〜〜〜〜〜〜〜

New York
At last grown young
with noise
and color
and light
and jazz
dance marathons and poultry shows
soulsavings and rodeos
gabfests and beauty contests
sky towers and bridal bowers
speakeasy bars and motor cars
columnists and movie stars[4]

〜〜〜〜〜〜〜〜〜

On returning to America, Stettheimer was older than what was considered the "marriageable age."[5] However, as she was wealthy, she was very aware that she would never have to be dependent on a man and so was free from society's traditional expectations. As a feminist/New Woman, she already adamantly opposed marriage, believing that it deeply constricted women's freedom. Years later, Carl Van Vechten told Parker Tyler that the Stettheimers were "virgins by desire."[6]

As a sign of her new self-liberation, one of the works Stettheimer painted during her first years back in New York is the startlingly subversive *Nude Self-Portrait*. (*Fig. 31*) The painting is the second known nude self-portrait ever painted by a woman artist[7] and the first nude self-portrait decidedly painted from a woman's gaze. Despite the early, transitional style, it reveals the overt nature of Stettheimer's feminist and progressive point of view. Stettheimer never publicly exhibited the work, although Carl Van Vechten described a "reclining nude maiden" painting over the mantelpiece in the family's Seventy-Sixth Street apartment.

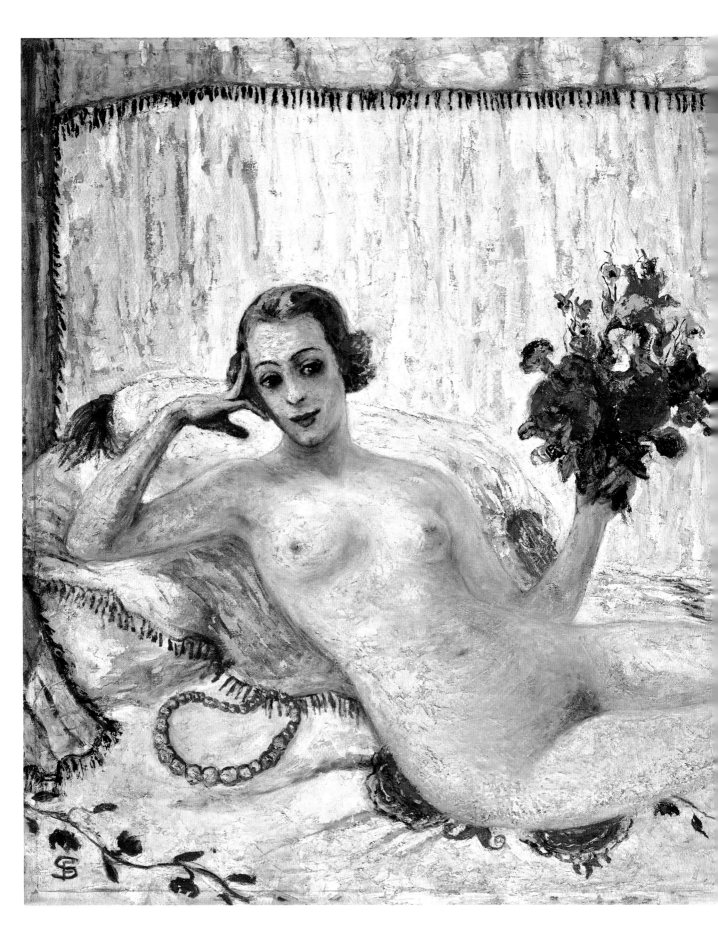

**Fig. 31** Florine Stettheimer, *Nude Self-Portrait*, oil on canvas, 48 ¼ × 68 ¼ in., The Museum of Modern Art, Gift of Miss Ettie Stettheimer.

At the time she executed the work, around 1915–16, the idea that a woman — particularly a wealthy, upper-class, unmarried, older woman — would paint herself naked was absolutely unthinkable and scandalous. So much so, in fact, that the painting was not identified as a self-portrait until the mid-1990s. Instead, despite its unmistakable likeness to the artist, the painting was referred to by her sister, her friends, Parker Tyler, and even Columbia University (where it was donated after Stettheimer's death) as simply *A Model*.[8] As a result, it was never the given the standing it deserves in the history of art.

It is significant to note that when Stettheimer completed *Nude Self-Portrait* she was around forty-five years old, which was the average life span for women who were born in the early 1870s. She was therefore not only "past her prime," she was an "older woman" when she painted herself naked, holding a bouquet of flowers above her waist. To give an idea of how outrageous this painting was, during the same years that it was painted, c. 1915–16, women's dresses were only beginning to rise above the ankle. In addition, female bathing suits consisted of wool chemises that were required to fall below the knees (officials at the beach measured their length to ensure they were long enough) and were worn with black wool tights that covered the legs, creating an uncomfortable, heavy mass when wet.

At the time, other than Old Master paintings, pictures of naked, identifiable women were unheard of, except of prostitutes. In painting her self-portrait as a nude, Stettheimer consciously reversed centuries of traditional Western painting by redefining the painted nude's cultural meaning and recreating the female body as a specifically *female* experience. In a consciously humorous note that also demonstrates her thorough knowledge of art history, Stettheimer's *Nude Self-Portrait* is immediately recognizable as based on three of the most famous and controversial nudes in Western art history: Titian's *Venus of Urbino*, Francisco Goya's *Nude Maja*, and Edouard Manet's *Olympia*.[9] It is therefore tempting to speculate that Stettheimer intended her *Nude Self-Portrait* as the coda, or swan song, to her decades of traditional academic European-style training.

For centuries, the term "nude," unless qualified, historically defined a painting of a nude *female*, who is placed in a provocative pose that accentuates and passively displays her physical attributes for the delectation of male viewers. In most examples, the nude, whether painted or sculpted, was created by male artists. Florine was clearly aware of this implication when she wrote:

〜〜〜〜〜〜

Must one have models

must one have models forever

nude ones

draped ones costumed ones

"The Blue Hat"

"The Yellow Shawl"

"The Patent Leather Slippers"

Possibly men painters really

need them — they created them[10]

〜〜〜〜〜〜

The polarization of gender roles in Western thought was first codified by Aristotle, who stated,

Man is active, full of movement, creative in politics, business, and culture. The male shapes and molds society and the world. Woman, on the other hand, is passive. She stays at home as is her nature. She is matter waiting to be formed and molded by the active male principle. [T]he relation of male to female is by nature a relation of superior to inferior and ruler to ruled.[11]

This idea has been universally accepted through the centuries by artists such as Titian, a reproduction of whose painting *Venus and Cupid* was among Stettheimer's private papers. As John Berger observed, the male spectator in most European nudes is never painted, yet everything in the painting is addressed to his voyeuristic power and visual control over the image.[12] To emphasize the passive receptivity and availability of the female nudes, male artists often depicted the women with their eyes averted or closed as though sleeping, and oblivious to the male gaze or unwilling to take any responsibility for it.

In composing her nude self-portrait, Stettheimer slyly based it on elements from Titian's *Venus of Urbino*, which she had often studied when visiting Florence's Uffizi Gallery. Based on his teacher Giorgione's *Sleeping Venus* from fifty years earlier, Titian set his nude in a contemporary domestic setting and stripped away any mythological attributes, thereby making her sensuality unapologetically erotic. His nude was also highly unusual in that she stares straight at the viewer, seemingly unconcerned with her nudity. Titian heightened the eroticism of his painting by having his Venus's left hand cross over her belly with her fingers curling inward, stroking her hairless pubis, clearly acting as a surrogate stimulant to the viewer. This traditional "presentation" pose was used to ensure the sexual areas of the female body were shown to their best, most visible advantage. In her other hand, Titian's Venus holds a small bouquet of flowers, drawing attention to her breasts. In 1880, Mark Twain playfully described Titian's painting as "the foulest, the vilest, the obscenest picture the world possesses."[13] In an identical manner, Stettheimer positioned her naked body in her portrait from left to right, with a three-quarter frontal turn of her raised hips. Her legs are similarly crossed at the knees, both breasts are visible, and her head is turned slightly to the right.

Stettheimer also based her self-portrait on two later nudes whose similar confrontational gazes caused them to be publicly criticized by contemporary audiences and critics. Stettheimer saw Goya's *Nude Maja* at the Prado Museum in 1912 and declared it to be "very piquant looking."[14] The painting is one of a pair depicting the same unknown woman, one clothed and the other nude, commissioned for a secret chamber of nude paintings owned by the Spanish prime minister, Manuel de Godoy. In 1808, the Spanish Inquisition confiscated the works and Goya was summoned on a

charge of "moral depravity." Goya, like Titian, painted his nude gazing directly out at the viewer; his painting is also considered the earliest Western painting to depict a woman's pubic hair.

Mirroring the direction of Goya's *Maja*, Stettheimer positioned herself to ensure that the most erotic and usually invisible representation of her sexuality — the bright red hair covering her genitals — was also optimally presented to the viewer. Her decision to show a thatch of pubic hair was completely shocking and audacious, especially for a middle-aged to elderly woman in the first decades of the twentieth century. As John Berger observed, pubic hair is rarely shown on nudes:

> The convention of not painting female body hair contributes to the representation of female submission by eliminating the hint of animal passion and physical desire suggested by hairy growth. . . . Her nakedness is valuable not for its individuality . . . but . . . a formalized language intended to feed male fantasies while it erases any potentially threatening signs of woman's desiring subjectivity.[15]

In her self-portrait, Stettheimer not only chose to fully expose her pubic hair, she directed the viewer's eye to it. In her left hand, she holds up a predominantly red cluster of flowers so that it fills the exact center of the composition, directly above her pubic hair. The vessel shape of the bouquet, and the vertical arm holding it, draws the viewer's eye straight down to the mirroring, nasturtium-red "V" shape below. With her head slightly cocked to the left, Stettheimer's facial expression suggests that viewers choose between the two vibrant options.

When Manet's *Olympia* was first publicly exhibited in 1863, the subject's arrogant gaze, normally a prerogative of the male viewer, scandalized French audiences and critics, who called the painting "impure" and "bestial." In fact, Manet's painting, like those by Goya and Stettheimer, is one of the rare depictions of the female nude as a fully integrated, rather than idealized, being.

Certain features indicate that the artist intended Olympia to be recognized as a prostitute whose physical attributes are literally for sale: Her body is rounded and plump but her skin is coldly, almost deadly white. Olympia's left hand pointedly conceals her genital area from view, not from shyness, but because it will be shared only once her client has paid. Her bold eyes are not those of an unsuspecting virgin being spied on by the male viewer, as in so many traditional nudes; rather, they reflect an unemotional challenge to the male spectator to step forward and sample her half-hidden wares. The green curtain and standing screen hint at future sexual actions that will be hidden from view, while various accoutrements surrounding the figure suggest a form of slavery by implying that the woman in the painting is figuratively "owned" by the viewer. The flower in Olympia's hair, the black ribbon tied around her neck, the easily slipped-off shoe, and the Black maidservant displaying an admirer's bouquet establish Manet's sitter as available for hire.

It is fascinating — and undoubtedly another sign of her ironic, pointed sense of humor — that Stettheimer based her own image on that of a prostitute. At the same time, the *Nude Self-Portrait* represents Stettheimer's "awakening" upon returning to New York and is her feminist, twentieth-century response to *Olympia*. In both works, a nude rests her right elbow on a wide pillow, reclines in a presentation pose with legs crossed at the ankles, and stares directly out at the viewer. Although her sketches for the painting show that Stettheimer originally considered putting her arms behind her head as in Goya's *Nude Maja*, she chose instead to emulate the arm position of the sitter in Manet's 1873 painting *Lady with Fans*, which she saw in Paris in 1912. She noted in her diary, "I have seen many things — Manets — very fine ones . . . a woman on a lounge resting her face on her hand — a face the way it looks when a hand it rests on draws it one-sided." The compositional planes of both *Olympia* and *Nude Self-Portrait* are quite shallow because of the gathered drapery that hangs directly behind and the curtains at the side of the beds.

Stettheimer, for her part, made subtle changes that radically altered the sitter's identity from prostitute to independent, fully conscious, self-confident modern woman. The *Nude Self-Portrait* references many details in Manet's painting, but with telling changes. Rather than resting temporarily on a shawl that can be thrown over her naked body between paying customers, Stettheimer lies comfortably naked on top of the embroidered comforter on her own bed, with no plan to move or change her pose. Unlike Olympia, who wears a gold bracelet, black velvet ribbon, and slippers, all presumed gifts from clients that subtly imply they could be quickly slipped off during sex, Florine is completely unadorned. The gold beaded necklace that lays next to her pillow appears more like a possession than a gift, and its placement, given the sitter's sardonic expression, gives the impression that Stettheimer is offering an irreverent choice: golden jewels, floral display or self-aware naked woman? Rather than needing a maid, receiving a bouquet from an implied admirer, or wearing jewelry to add to her beauty, Stettheimer pleases herself by holding her own flowers.

Stettheimer's *Nude Self-Portrait* also distinguishes itself from its predecessors in how it emphasizes the female body. In all three earlier nudes, the subjects' breasts, bellies, and thighs are brightly lit and thus draw the viewer's immediate attention. By contrast, Stettheimer's relatively small breasts and slim body are naturalistically but subtlety portrayed. Instead the viewer's eye is drawn to her highly individualized face, shock of pubic hair, bouquet of flowers, and, absurdly, her highly detailed feet. The image's resulting idiosyncrasy and refusal to compromise with the usual notions of mature age and ideal form make it a unique and innovative site at which to contemplate the existence of an attractive middle-aged woman.

Finally, Stettheimer's nude wears an expression that is altogether different from those of her counterparts. She does not invite male viewers' voyeuristic enjoyment of her sexuality, nor is she

being confrontational in the manner of *Olympia*. Instead, her expression is knowing, even mocking. In her frank outward gaze, she acknowledges that the subject matter of the portrait is a mature woman's experience of her own body, an exaltation of femaleness. Here she is not the object of the painting, but its subject. Stettheimer's nude body possesses the gaze rather than being the object of it—this is the first known example of a nude self-portrait of a "female" rather than the "male" gaze. The artist thereby creates a tension between the traditional male expectations of what it is to be a woman and the reality of female experience.

Stettheimer was proud of her fashionably slim body, small breasts, and shapely legs. She compared herself to the Australian champion swimmer and outspoken feminist Annette Kellerman, who established the precedent of linking feminine beauty with athletic ability. Several years after Stettheimer's portrait, Kellerman modeled skin-tight dark underwear for American women's magazines and designed a one-piece bathing suit intended to allow greater freedom in swimming. Her attire caused her to be arrested for indecent exposure on a Massachusetts beach. Kellerman also wrote a popular beauty manual in which she spoke of women's enslavement as man's "toy" and emphasized the need for women to pay attention to their physical appearance so that they would not "grow fat at forty" or "shrivel up at fifty" and lose their husbands to younger women.

Stettheimer believed that being slim and fit enabled her to stay strong for the physical exertion of working on her large paintings. As her sister noted, in order to dedicate herself to her work, Stettheimer "took care of her delicately made body and strengthened it into an effective tool."[16] Arranging bouquets daily and hauling her easels and canvases around her studio, Stettheimer never indicated that she felt too "precious" or "ill-suited for anything requiring muscular exertion," nor was she interested in projecting an image of "shyness . . . frailty, fear and incompetence."[17] Responding to a remark that Stettheimer was "fragile," Virgil Thomson specifically warned "against the legend of Florine's fragility as remember, she worked alone in her studio and handled her biggest canvases [a number of which measured 60 by 50 inches] without complaining or calling in for help."[18]

Stettheimer was highly aware of the lessening in men's eyes of a woman's value as she aged, as is apparent in a poem she titled *Civilizers of the World*:

They like a woman
to have a mind
They are of greater interest
they find

They are not very young
women of that
kind[19]

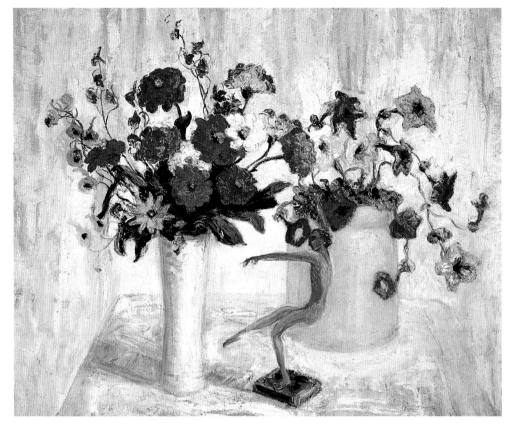

Fig. 32 Florine Stettheimer, *Flowers #6 (Dancing Figure with Two Vases)*, c. 1915, oil on canvas, 30 × 36 in., The Dayton Art Institute, Gift of the Estate of Ettie Stettheimer.

The artist's own physical identification with Kellerman diminished when she and an artist friend went to the cinema and saw the swimmer in a starring role. Stettheimer's reaction was typically caustic: "I shall no longer say I think I am shaped somewhat like Annette Kellerman. Having nothing on, it was easy to judge her looks."

In late 1914, Stettheimer made several profound, life-changing decisions: she resolved to concentrate entirely on being a serious, professional artist and to develop an original, American, feminine style of painting to reflect her modern city and century. Without a fully realized concept or vision of her own, Stettheimer initially drew on her knowledge of Matisse's sensibilities, colors, and techniques, and she began a series of floral still lifes directly emulating the French artist. Her subject matter included bouquets and disparate objects arranged on tabletops placed against solid-colored backgrounds.[20]

In these paintings, borrowing from Cubism and Matisse, Stettheimer's tabletops tilt downward from high vantage points, occasionally extending beyond the lower edge of the canvas, thereby offering viewers seamless entry into the paintings. (*Fig. 32*) Stettheimer would use this high horizon and tilted foreground in nearly all of her future work. She began to cover the ground of her paintings

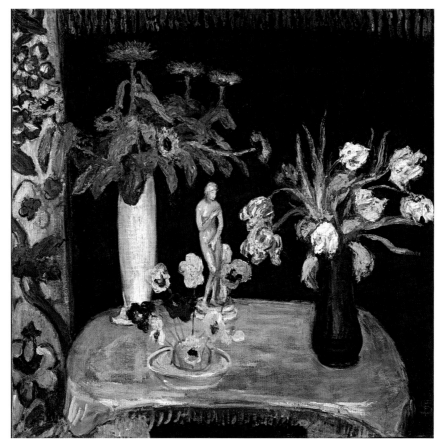

**Fig. 33** Florine Stettheimer, *Flowers with Aphrodite*, c. 1915, oil on canvas, 32 ⅛ × 32 ¼ in.,
Art Properties, Avery Architectural & Fine Arts Library, Columbia University in the City of New York,
Gift of the Estate of Ettie Stettheimer.

with a thick china-white paint over which she laid pure color directly from the tube. Although finding these paintings "somewhat lacking in form," one critic later noted that Stettheimer "believed that, with such colors as red, blue and yellow at her disposal, there is no reason why she should treat life as if it were all neutral brown or neutral gray. White is white, black is black and red is red."[21] Stettheimer's friend Henry McBride was more poetic: "Her colors instantly forgot they came from the paint-box and took on the tints of the flowers."[22]

Stettheimer would paint floral still lifes throughout her life. In them, she focused less on the individual blossoms than on the overall arrangement: explosions of color spilled out of a variety of vases with adjacent long-plumed parrots, bronze figurines, Japanese prints, and horses.[23] She often painted female figures in bronze and marble among bouquets, a device Matisse had used several times in works from between 1906 and 1908. Many of the objects, such as a statue of Aphrodite in one of her early post-Impressionist style flower paintings, were among those Stettheimer kept on her shelves throughout her life. She humorously altered the goddess of beauty, tucked amid three varying vases filled with bright blossoms, so that she appears to be embarrassed at being seen naked

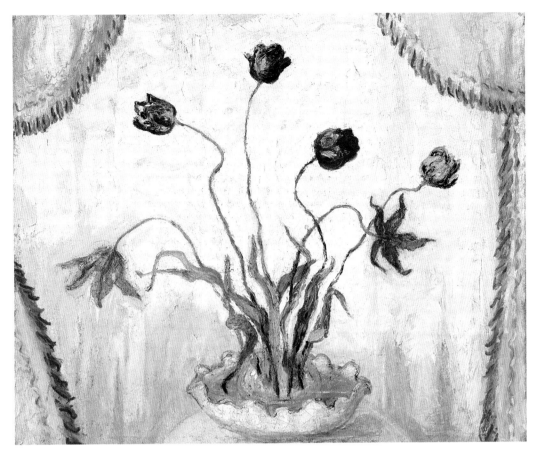

**Fig. 34** Florine Stettheimer, *Bowl of Tulips*, 1933, 30 ⅛ × 36 ⅛ in., Yale University of Art Gallery, Collection of Mary C. and James W. Fosburgh, B.A. 1933, M.A. 1935.

and bends slightly forward, covering her genitals and breasts with her hands. (*Fig. 33*) In these paintings, objects and surrounding space penetrate each other. By creating this indeterminate dance where pieces and surfaces blend, Stettheimer, like Matisse, gave equal importance to the tactile and the visible, investing both with expressive meaning. Florine never painted her flowers realistically, claiming that they were intended for contemplation. She called her bouquets "eyegays," a word she invented to emphasize that her flowers were not for the nose but for the eye. Over the decades, Stettheimer's flowers grew less detailed, more like broad splotches of color, and elements such as leaves are greatly reduced from her later floral arrangements. (*Fig. 34*)

McBride later wrote, "When she painted flowers she was never literal in her descriptions of them. . . . They are, I believe, sufficiently botanical, but they are also unearthly." Comparing Stettheimer's paintings to those of Odilon Redon, he noted that flowers were "merely points of departure." Of the two, McBride felt Florine granted flowers more actual freedom, describing the blossoms in her vases as wiggling upward "with a whimsicality in the stems that is not to be outmatched for waywardness in the 'automatic' paintings of Miró."[24] (*Fig. 35*) As would become

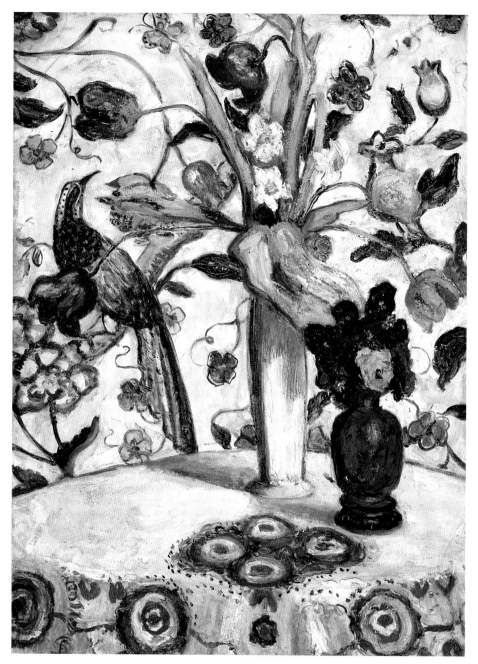

Fig. 35 Florine Stettheimer, *Flowers Against Wallpaper*, oil on canvas, Art Properties, Avery Architectural & Fine Arts Library, Columbia University in the City of New York, Gift of the Estate of Ettie Stettheimer.

clearer later, however, Stettheimer had no patience for or interest in the occult or any form of symbolism or mysticism. Unlike many of her contemporaries who painted flowers for their symbolic associations, Florine did not intend her painted arrangements to be metaphors; they stood only for what they were. In a later poem titled "The Revolt of the Violet," she noted:

This is a vulgar age

Sighed the violet

Why must humans drag us

Into their silly lives

They treat us

As attributes

As symbols

And make us

Fade

Stink[25]

Soon after arriving in New York, Stettheimer moved with her two sisters and mother into the brownstone on West Seventy-Sixth Street, which her aunt Caroline Neustadter had left Rosetta in her will along with income for life from a substantial trust fund.[26] Due to German-Jewish migration to the Upper West Side of Manhattan (particularly between Seventieth and Eightieth Streets, Central Park West, and Columbus Avenue), that part of the city was nicknamed the "Jewish Fifth Avenue." Ettie didn't feel it lived up to the elegance of their apartments in Europe, referring to it in a letter to her friend, Henri Gans, as a "*salle d'attente deuxième classe*" or second-class waiting room.[27] Soon, however, its interior reflected the ladies', particularly Florine's, aesthetic. Describing the design, friends later remembered the dining room being painted a warm, pale gray with gold molding on the panels, Venetian red taffeta draperies, red brocade upholstery, and Aubusson rugs, "like a room in a royal palace."[28] (*Fig. 36*) The focal point of the vast rooms were Stettheimer's paintings.[29]

Stettheimer painted numerous still lifes throughout her life and on every birthday she gathered a fresh bouquet or "eyegay" to celebrate the day. When the family entertained, the artist created magnificent floral arrangements compositions deemed by a friend to be "comparable to paintings by Van Huysum or by Florine herself."[30] When the family was in Manhattan, Stettheimer purchased flowers daily at florists. Once the family began renting summer estates, she rose at seven in the morning and devoted hours to raising her favorite varieties of flowers in the gardens. Van Vechten noted, "Whenever I remember Florine, I think about portulaca and zinnias, both of which appear in assorted colors; these were the flowers that she grew at various summer dwellings that she occupied with her family."[31] Always preferring the romantic, humorous, and ironic sides of life to its less pleasant realities, Stettheimer would immediately strip her floral bouquets of their extraneous

**Fig. 36** Unknown photographer: Stettheimer Living Room Interior at West Seventy-Sixth Street, New York, New York, c. 1914. Florine Stettheimer Papers, Rare Book and Manuscript Library, Columbia University in the City of New York. Gift of the Estate of Ettie Stettheimer.

leaves — to the consternation of a "former interior decantor," and quickly capture the brilliant colors and myriad floral shapes on canvas before their inevitable wilting:

All morning
for hours
I have been putting flowers
together
in vases
I strip them of their green
They look more brilliant —
become more effective
More "garish" our former
    timid interior
decantor
Mr. B.
would have said
The bouquet I like best
I put on the dining room
    table
On the filet-lace round
On the light-gray painted
    board
It helps — it satisfies
But tomorrow
my flowers
will show the ravages of time
They will wilt
They will smell
I will have a disgust for them
I shall dislike changing the
    water
And I shall feel sympathy
with Marcel
for preferring
artificial flowers[32]

By late 1915, Stettheimer progressively shifted from flower painting to figural narratives. One of her first such works, painted in her still strongly Matisse-influenced style, is a work that is highly unusual for its time, due to her choice and manner of painting an African American woman. Titled *Jenny and Genevieve (Fig. 37)*, it depicts a listless blonde woman sitting with her elbows propped on a table as an African American woman in the uniform of a domestic maid enters at the left. The motif of a female servant carrying fruit into a brightly patterned room is stylistically reminiscent of Matisse's 1908 painting *Harmony in Red*, which Stettheimer probably saw at the Salon in Paris. In both works, the maidservants hold dishes filled with oranges, apples, and grapes. In Matisse's painting the entire background is painted a solid red color, destroying any illusionary foreground or background depth. The only place where he alleviated the composition's allover flatness is through a window with a landscape view at the left. Initially in Stettheimer's painting, the high toned floral curtain also extended across the back of the canvas, flattening the space, and the work is painted in bright primary colors.

In *Jenny and Genevieve*, a blonde woman, Genevieve, sits at the right side of the composition. Her entire posture appears weary, with her head resting heavily in her hands.[33] The neglected cigarette resting in the ashtray near her left elbow reinforces her aura of dissipation. Genevieve's skin is painted with heavy, flat white paint identical in color to the curtain behind her. As a result, her skin and its two round circles of rouge on her cheeks melt into the fabric patterns as though they are decorative flowers. By placing a tall, brightly blooming floral arrangement on the tiny, cramped tabletop in front of Genevieve's right side, Stettheimer makes the woman virtually disappear into the painting's flower-patterned background, so that at first glance, she is almost invisible.

In contrast, Jenny, the African American maid, stands full height and takes up the full left side of the composition. Jenny's facial features are realistically lit to reveal her clearly defined bone structure. Through close viewing of the painting's details it is evident that Jenny is the main subject of the painting and the focus of Stettheimer's interest. At the time this work was painted, such specific individualization of Jenny, a Black woman, by a white artist would have been rare, even though as a maid she is depicted in a clearly subservient position. Since the 1890s, Jim Crow laws with the doctrine of "separate but equal" were in place, sanctioning segregation and discrimination across the United States. Stettheimer painted *Jenny and Genevieve* around 1915, a period when thousands of freed African Americas were migrating to urban areas such as New York, seeking employment and, for many women, a respite from the sexual violence they regularly experienced in the South during and after Reconstruction. Although they initially found themselves in competition with recent immigrants, by the second decade of the twentieth century,

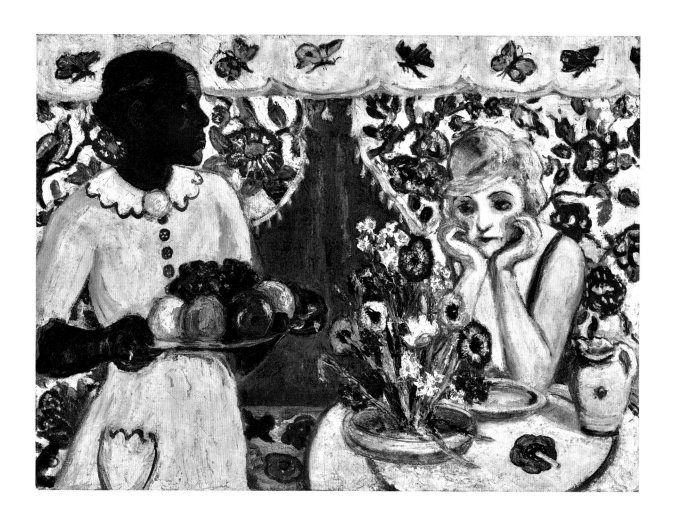

**Fig. 37** Florine Stettheimer. *Jenny and Genevieve*, c. 1915–16, oil on canvas, 32 × 43 ⅛ in., Art Properties, Avery Architectrural & Fine Arts Library, Columbia University in the City of New York, Gift of the Estate of Ettie Stettheimer.

African American women made up ninety percent of the domestic workers in New York. The most skilled, attractive, and well-spoken African Americans became live-in domestics who often worked for the same white family for years.

From her various diary entries and letters, it is apparent that Stettheimer employed African American maids until the last days of her life. Two years before she died, for example, Stettheimer lived alone with her "faithful as ever" Black maid, the description indicating that the relationship between the artist and her African American housekeeper was long-term. Nonetheless, within the context of the time, the association between the Black working women and their employers was never one of equals. Although Black maids often became intimately involved in the lives of the families for whom they worked, it was rarely reciprocal, with their white employers usually knowing nothing about the former's personal lives or living conditions.

An early photograph of the painting demonstrates that at some point Stettheimer significantly reworked parts of the composition in order to give greater emphasis to Jenny and added attractive visual elements to further draw viewers' attention to her. Although it is impossible to tell the exact color from the photograph, Jenny's uniform was originally a dark color. Stettheimer altered this by changing it to a bright white, and she added a decorative, red scalloped trim at the collar, sleeves, and the edge of a new large petal-style pocket. She also added matching large red buttons down the front. As a result, Jenny's figure is accentuated within the composition — particularly in contrast to the sulking, almost invisible Genevieve. Stettheimer added additional elements to enhance Jenny's appearance by placing gold rings on both of her hands and situating an enormous gold pin in the center of her collar. It is interesting that she added details and jewelry to Jenny's figure, but left Genevieve with only straps hinting at clothing and no other adornments. Stettheimer also later added Genevieve's ashtray and abandoned cigarette, further giving the latter a further sense of seeming apathy and disengagement.

The most significant alteration Stettheimer made to the original composition was by cutting through the curtain that originally tied the women together and instead creating a vast blue space between the two figures. The center is now empty except for part of Jenny's hand which bears the gold ring with prominent turquoise. The void creates a psychological distance and a subtle tension as though Stettheimer was visually acknowledging the insurmountable political, economic, and cultural gulf between the two women: Jenny is the maid; however, her expression is not subservient. Instead she gazes steadily at Genevieve and keeps her thoughts to herself. In this she embodies an emerging "agency," a capacity to act independently and control one's behavior, which was beginning to distinguish Black consciousness in the 1920s and '30s.[34] Using *Jenny and Genevieve* as an example, Stettheimer later stated that she had shown a personal interest in supporting African Americans

"long before Van Vechten had a colored salon,"[35] thereby revealing the deliberate decisions she made when painting this unusually progressive work for its time.

During these early years, as Stettheimer was learning to handle thick areas of paint and pure, unmodulated color, she also began painting family members. In late 1915, she painted *Family Portrait I*. (*Fig. 38*) Within a shallow painted white ground, the artist situated the four Stettheimer women like a decorative frieze around a cloth-covered table bearing a bowl of Cézannesque fruit. She repeated some of the same tropes from her earlier Matisse-like paintings: leafy branches hang down and divide the background like curtains; the table contains a bowl of fruit; and the large flower arrangement tilts toward the viewer.[36] Rosetta Stettheimer, dressed in a characteristically black gown with a prominent diamond ring, sits at the far right of the composition, reading a copy of her daughter Ettie's recently completed book, *Philosophy: An Autobiographical Fragment*. Ettie and Carrie, dressed in elegant afternoon dresses banded with decorative edges, engage in discussion at the left. Florine, wearing a broad-brimmed sun hat and looking directly outward at the viewer, stands above and separate from all the other women, adjusting a magnificent flower arrangement.[37]

Unlike the rest of her family members, who are wearing clothing appropriate to greeting afternoon guests, Florine is in a loosely fitting, gauzy white shirt that is open at the neck, identifying it as a painting smock. As was the case in many of her self-portraits, in *Family Portrait I*, Stettheimer's gaze holds our attention as though obliging us to notice the difference between herself and the others at the table. They sit passively while she stands. They are inactive as she arranges the floral bouquet, as if she has just come from painting in her studio. From this point on, Stettheimer often portrayed herself in her works with artist's accoutrements, and physically, as well as psychologically, set herself apart from her siblings in many of her paintings.

Throughout their lives, the three Stettheimer sisters were known for their individual, idiosyncratic styles.[38] Though not a widow, Rosetta always wore black. Her daughters wore the latest fashions by Parisian designers such as Maison Giraud, Callot, and especially Paul Poiret. While in New York, the Stettheimer ladies patronized certain stores, including Bendel's; and Florine's diary records that she shopped on occasion at the less expensive Lord & Taylor and Kargère. Their friends later remarked that regardless of the original price or designer, the three Stettheimers always had their clothing tailored. One entry in Stettheimer's diary indicates they had their own seamstress, as she describes putting on a dress that was "oyster-white with over-life-size shrimpfish roses….with Agnes' help." She also noted buying a cotton suit at Altman's department store, but even when she wore a red sweater, Stettheimer combined it with a lace dress, creating an original effect.

Carrie's old-fashioned and courtly manner of dress reflected her personality. She chose evening gowns of taffeta, satin, and velvet, which she preserved and wore for years. For jewelry, she would

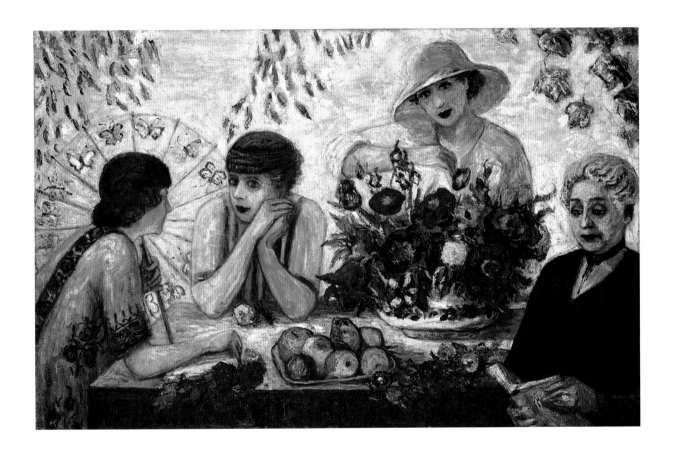

**Fig. 38** Florine Stettheimer, *Family Portrait I,* 1915, oil on canvas, 40 × 62 ¼ in., Art Properties, Avery Architectural & Fine Arts Library, Columbia University in the City of New York, Gift of the Estate of Ettie Stettheimer.

on occasion wear a tiara as a head ornament. Ettie usually wore the color red and loved velvet but was somewhat parsimonious in her spending. For special parties, she wore a red wig. She favored tailored clothing with unusual textures and luxurious materials. Florine was the most risk-taking and innovative of the three sisters in terms of fashion and taste. As her early self-portraits of about 1914–15 show, she regularly wore bright red lipstick and eye makeup and had her hair bobbed long before young flappers took up the fashion in the 1920s.[39]

During the first two decades of the twentieth century, it was still considered scandalous for middle- and upper-class women to wear men's styles. For a short period in the mid-1800s, a few English women's rights activists, including Elizabeth Smith Miller and Amelia Bloomer, had popularized bloomers, defined as wide, usually white trousers gathered at the ankles under knee-length skirts. By promoting this garment, they felt they were both associating themselves with male power and privilege and posing a challenge to the dominance of male discourse by using its own symbols against it. The *New York Tribune* publicized this trend, but it was so publicly ridiculed that the women eventually felt it became a distraction from the suffrage movement. They eventually stopped wearing the garments and the interest in them faded.

Later in the nineteenth century, a few exceptional French women, including the artist Rosa Bonheur, began wearing some form of pants. In the 1880s, Bonheur received a dispensation and a special license from the French government to wear pants "while painting."[40] Tellingly, Stettheimer later reproduced and labelled a small Rosa Bonheur canvas in her *Cathedrals of Broadway* painting. In Paris, where same-sex relationships were not illegal as they were in the rest of France, England, and the United States, prominent lesbians also wore versions of men's clothing during the first decades of the twentieth century.

For his 1910–11 Paris Collection, couturier Paul Poiret introduced Turkish harem pants for women. His direct influence was Léon Bakst's costumes for the Ballets Russes performance of *Scheherazade*, which were inspired by Persian miniatures. Poiret's "Style Sultane," as he called it, consisted of a high waist billowing out to full legs that were then tied at the ankle. The style's exoticism caused an immediate scandal as the design was widely regarded as immoral and inappropriately sexualized. As a result, they were worn only by the most avant-garde Parisian women, usually those associated with the stage, like Ida Rubenstein. In 1912, Stettheimer was in Paris, where she saw the Ballet Russes production with both Rubenstein and Nijinsky wearing Bakst's versions of harem pants. As a favored customer, she also undoubtedly knew Poiret's Sultane design.

The harem pants appealed enough to Stettheimer for her to include them in the costumes for several male and female characters in her *Orphée* ballet. On returning to the United States in 1914, she had white pantaloons made for herself, and they quickly became her signature artist uniform

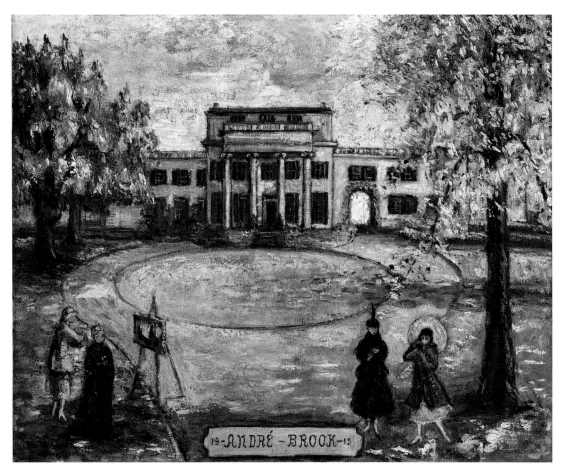

**Fig. 39** Florine Stettheimer, *Portrait of André Brook, Front Façade*, 1915, oil on canvas, 28 ¼ × 34 ¼ in., Art Properties, Avery Architectural & Fine Arts Library, Columbia University in the City of New York, Gift of the Estate of Ettie Stettheimer.

in many of her subsequent paintings. For Stettheimer, this sort of masculine attribute was not only practical, but it also undermined the dominant gender categorization that marginalized serious professional women. In turn, by so openly mocking the conventions of her social class, in a highly subversive manner she drew attention to the artificiality of the social order in which she lived. Her harem pants, baggy white pantaloons, also granted her far greater freedom of movement when painting or carrying large canvases around her studio than the slim, long skirts and dresses that were fashionable. Her preference echoed similar sentiments to those of the English mystery writer Dorothy Sayers, who stated, "If the trousers do not attract you, so much the worse; for the moment, I do not want to attract you. I want to enjoy myself as a human being."[41]

Beginning in 1915, to escape the hot New York City summers, the Stettheimer ladies began renting a summer estate, André Brook, near Tarrytown, about two hours north of the city.[42] The paintings *André Brook (Front View)* (*Fig. 39*) and *André Brook (Back View)* emulate an American folk tradition of "portraits" of seventeenth- and eighteenth-century estates. The latter painting depicts

**Fig. 40** Florine Stettheimer, *Self-Portrait with Palette (Painter and Faun)*, c. 1916, oil on canvas, 60 × 71 ⅞ in., Art Properties, Avery Architectural & Fine Arts Library, Columbia University in the City of New York, Gift of the Estate of Ettie Stettheimer.

the estate's multilayered formal gardens, with abundant flower beds, ivy-covered trellises, two elongated trees, and a fountain with a small stream running through the center. In her painting of the front, with its vast circular drive, Stettheimer included small figures of Ettie and Carrie under a tree at right; she placed her mother at left. Next to Rosetta, standing in front of an easel, wearing her uniform of smock, pantaloons, and sun hat, Stettheimer steps back to view her canvas. This device offers viewers a secondary, "meta" level of voyeurism—we are witnessing the act of painting the painting that we are viewing.

The motif of the artist painting herself in the act of painting is one that Stettheimer returned to twice more during her transitional period of 1915–17. In one of the last compositions where she used just a few large-scale figures, *Self-Portrait with Palette (Painter and Faun)*, Stettheimer pauses, her brush held in the air, as she works on a painting that is only partially visible at left. (*Fig. 40*) Stettheimer wears her white pantaloons and artist's smock and red high heels, a sign of vanity that persisted in her self-portraits into her seventies. The artist sits on a white bench against a bright red

tree that matches both her heels and her nasturtium-red hair.[43] A faun rests against the other side of the tree, draping its arms around his knees and gazing up to the sky. The faun's toes touch the ground in the ballet dancer's *en pointe* position. Her use of a faun in this painting, in the *Orphée* ballet, and in a later painting of a Sunday party undoubtedly recalls Nijinsky's performance in *L'Après-midi d'un faune*. As such, it adds to these paintings a sense of nostalgia, sexuality, and Stettheimer's feeling of separateness.

By the time she painted *Self-Portrait with Palette (Painter and Faun)*, probably in late 1915 to early 1916, Stettheimer had changed her manner of painting. She no longer applied paint with the rough, derivative, clumsiness of the earlier floral paintings or works such as *Jenny and Genevieve* and *Family Portrait I*. In *Self-Portrait with Palette (Painter and Faun)*, she first covered the surface with flat white paint, often applying it with a palette knife, and then smoothed the surface evenly with a cloth, building up the surface to a certain thickness. In areas of this painting—the green and yellow grass, the palette, her red hair—she applied layers of colored paint thickly with a palette knife, and then carved into the wet pigment with the back of her brush to create a surface texture and reveals the colors of underlying layers.[44] For the fine details evident in the face of the figures and hands, she used tiny paintbrushes. However, she now eliminated all black outlines, using a thin red line instead; and the colors are highly keyed, with large expanses of pure yellow, white, and red. The only dark paint Stettheimer used in the composition was a very thin dark grayish line to rim her eyes, a feature Stettheimer would accentuate in all her self-portraits. This image of herself, with even features and reddish-brown hair, wearing clothing identifying her as an artist and red high heels, was how the artist painted herself until the end of her life. This painting also marked the end of her transitional style. Stettheimer would soon discover her own uniquely innovative voice.

*chapter four*

# 1916

## THE PIVOTAL YEAR

~~~~~~~

In 1915, many members of Europe's cultural avant-garde, particularly artists and writers, came to New York City to escape the war in Europe. Among the first group who arrived were the artists Albert Gleizes and his wife, Juliette; Francis Picabia and his wife, Gabrielle Buffet; Elie Nadelman; and Marcel Duchamp. On arriving in Manhattan, all were amazed by its burgeoning skyscrapers and industrial modernity. Gleizes observed to a journalist, "The genius who built the Brooklyn Bridge is to be classed along the genius who built Notre Dame."[1]

On June 15, Duchamp, whose infamous painting *Nude Descending a Staircase* had scandalized the 1913 Armory Show, arrived in New York aboard the SS *Rochambeau*. World War I was ravaging his native France, and when an American collector suggested that he should visit the United States, the artist immediately booked his passage. Duchamp was quickly adopted and financially supported by wealthy members of New York's cultural circles, particularly Walter and Louise Arensberg. Several evenings a week, a varied mixture of the urban avant-garde would show up at the Arensberg's apartment on Sixty-Seventh Street, home to one of the city's liveliest salons. Their large studio room was filled with African art as well as the latest works by Picasso, Braque, Duchamp, Picabia, Brancusi, and many others. There the guests included European modernists, as well as American Ashcan artists, members of Alfred Stieglitz's circle of painters and photographers, and poets, writers, musicians, and dancers such as Isadora Duncan. Conversations would range from the works of art on the walls and the latest theatre productions to a particularly exciting chess match.

During the Gleizes' second night in New York, Duchamp introduced them to the Stettheimers at a dinner he hosted at the Brevoort Hotel including the Arensbergs and Stieglitz.[2] The Stettheimer sisters frequented the Arensbergs' salons, where they had probably met Duchamp, and in turn began hosting their own, inviting and befriending many of the same guests. Over time, the Stettheimer salon integrated these European artists with their many American friends, including writers, journalists, art critics, gallerists, actors, photographers, and artists.

Despite the fifteen-year age difference, the Stettheimer sisters were taken with twenty-eight-year-old Duchamp's looks, manners, and witty, provocative personality. Although Florine spoke and wrote French fluently, to help support him she paid Duchamp two dollars an hour to give her French lessons. The sessions quickly became eagerly anticipated social occasions. Before one, Florine

noted in a letter of August 1916, "It's a Duchamp day — but its early still . . ." Within a short time, Duchamp became a regular member of the Stettheimer circle.

Although socially active, the Stettheimers remained aware of the war in Europe. In 1916, Henri Gans, now a soldier in France, wrote to Ettie asking her views on the war. She replied that she and her sisters attended gatherings for supporters of the Allies at the home of her relative George Beer. She noted that although America was almost at war, "there is little sign in daily life except for the newspapers, recruiting stations, high price of living and good intentions to prepare practically." Carrie and Florine went regularly to Red Cross centers to roll bandages. The realities of war soon became far more personal as their sister Stella's son, Walter, passed the physical examination for the army and prepared to join the troops in Europe. Florine noted hopefully in her diary, "They don't think it will be France."[3]

That summer, the Stettheimer women set out on their "first auto trip in [our] own auto in our own country." The artist remarked on the unusualness of a journey where luncheon was a mere incident and not the entire reason for their outing. On June 22, driven by their chauffeur Richard, the women began their New York State tour. They stopped at various sites before arriving in Saratoga, which, Stettheimer wrote, had "heaps of character." From Lake George, they continued north toward Lower Saranac. During the drive, Stettheimer dreamed of living in a cobalt-blue room, complete with small cream oyster-white silk curtains with gold fringes. She made small sketches of what the room would look like in her diary. Arriving at Camp Massapequa, Stettheimer found it "a very perfect camp according to the accepted idea of a camp," for it had piled logs, a menagerie of stuffed birds and beasts, bear skins, moose heads, and fish, a stone fireplace, a Victrola, various "weapons," Native American rugs, electric lights, brass utensils, cows, and a "frisky calf."

Restless at not being able to paint, Stettheimer grew increasingly annoyed with the camp: "Atmosphere is not to be found — I have waited for it for two days . . . we made the round of the lake in our fastest launch yesterday — we have eaten homemade bread — and still this camp does not produce it. I want to get to work — there is nothing in this vacation, so far it all bores me — and I see boredom ahead. As soon as I got here I chose the most un-camplike room for mine. It is painted white, has white furniture and a bright pink rug. I hung some Japanese prints on the walls I brought from my room at 102 [West Seventh-Sixth Street]." Eventually, with Richard's help, she transformed one room into a working studio with furniture and a woodburning stove. In addition to the prints, the artist put out flowers, strung unbleached muslin curtains from wall to wall, and hung designs she had made earlier for her ballet *Orphée des Quat'z-Arts*. She found the resulting studio quite comfortable and was no longer bored with the lake visit, "at least not since I got to work."

The alterations exemplified Stettheimer's personal aesthetic. The basic elements — white walls, gold trim, and diaphanous materials — were to appear again and again in her later interior decorations and all displays of her works of art and ballet designs. The early date of 1916 and the nature of her idiosyncratic alterations to this lake cabin are crucial to understanding Stettheimer's multidisciplinary installation aesthetic and subsequent work. She chose this palette of solid white and gold trim for the furniture she would design, and both pure, flat white and gold paint came to characterize major elements of her mature painting style and many of her uniquely designed frames. Furthering her belief in a *Gesamtkunstwerk*, even the walls of her studio and only solo exhibition reflected this aesthetic color palette.

Florine was not alone among the Stettheimer sisters to use interior space for her aesthetic experiments. During the Stettheimers' stay at Lower Saranac, an epidemic of infantile paralysis broke out. Women in the adjoining camps organized a bazaar to raise funds to combat the disease. Carrie, inspired by the idea of creating a work that was valuable, gathered a number of wooden boxes from the local grocer and created a dollhouse with "an enchanting set of rooms . . . out of whatever she did get." This was raffled off, initially "won" by her mother who re-raffled it, raising significant funds for the disease. As a result of this experience, Carrie began a second, more extensive dollhouse. Adding to it occupied her free time for the next few decades.[4]

In September 1916, after spending a forty-fifth birthday "full of flowers" by the lakeside, Florine returned to New York by herself, noting, "I am going off by myself for the first time in my life." Initially enjoying her solitude, Florine slept in her studio overlooking Bryant Park, comparing the view from her long balcony window to that of the Tuileries in Paris. The primary reason for her return to Manhattan was her first solo art exhibition at Knoedler & Company, a major New York art gallery.

During the 1900s, Knoedler had twice held exhibitions of the work of Albert Sterner, who was one of the Stettheimer's artist friends. Around 1915 the gallery made the unusual choice of hiring a woman, his wife Marie Walther Sterner, to curate a series of contemporary exhibitions in order to give the gallery a reputation of being "up-to-date" and to "offer a site wherein those artists working in less explored fields may show the results of their labors to a partially won if somewhat skeptical audience."[5] Marie Sterner was Florine's close personal friend. Seven years later, in 1923, she would open her own gallery, becoming one of the first women gallerists in the United States.[6] Ever the feminist, Stettheimer wrote a poem highlighting Marie's increasingly complicated roles as wife and well-known gallerist:

There's Marie Sterner
she intended to be a musician
but Albert married her
she learned to adore his work
she enthusiastically
made conversation about it
Albert doted on her
Albert swore by her
Albert cherished her greatly
Marie had much charm
which she could not hide
 forever
behind Albert's pictures
Other artists
wanted
themselves
and
their
work
adored by Marie[7]

When she was asked to organize her own shows, Sterner decided that Florine would be one of the first artists to be given a solo exhibition. On returning to New York, Stettheimer immediately called Sterner to confirm that her exhibition remained on schedule for October: "I asked Marie whether Roland Knoedler the owner of the concern knew he was exhibiting me — that thought came to me when we were framing the invite in his name. 'Dear me no' was [Marie's] answer, 'they will all have fits when they see the paintings,' I asked if he would not perhaps close the ex. if he felt that way — she said 'no.'" It is interesting that both women believed that Stettheimer's work, although still largely derivative of Matisse and the Post-Impressionists, was so contemporary and untraditional that it would upset the gallery's owner if he saw it before the exhibition opening.

Sterner then introduced Stettheimer to Roland Knoedler, who responded cursorily about the forthcoming exhibition. Stettheimer was delighted at the prospect of mounting the show but was perturbed by the gallery owner's lack of interest in her work, implying it was because they were women, as reflected by her diary entry: "He permitted it!! and took no interest as if we were two children and might as well amuse ourselves . . . possibly he thinks nobody will see the show . . . It's certainly of no importance to them . . ."

Despite Stettheimer's exhibition in a major New York gallery, her mother and sisters still treated her art-making as a pastime rather than a serious profession — a prejudice that persisted throughout her life. Ettie, always the pragmatist, wrote in her diary that she was delighted that Florine was having the exhibition, but felt that "even if the critique is adverse in part, it's bound to do her good indirectly and some people will surely like her work." Showing her complete lack of understanding

of the modernist aspects of Florine's work, Ettie suggested that in order to ensure her exhibition had enough visitors, Marie Sterner should bring to the show visitors to the concurrent Knoedler exhibition of the academic society portraitist Howard Gardiner Cushing.

As she described in her diaries, at the same time as Stettheimer was preparing for her solo exhibition at Knoedler's, an equally exciting possibility arose to have her *Orpheé* ballet performed by the Ballets Russes. In September, the artist received a letter by special delivery from Adolph Bolm, who was in a Ballets Russes performance at the Booth Theater the following Monday. She immediately contacted her lawyer, Benjamin Tulka, and arranged for him to bring Bolm to her studio so that she might show the dancer her sketches and ideas for *Orphée des Quat'z-Arts*.

In preparation, the artist unpacked the ballet designs and figures and painted the interior of their packing case cobalt blue, adding a white and gold-fringed curtain, a green floor, and an electric lighting arrangement to create a miniature stage. When the dancer and lawyer arrived, Stettheimer informed Bolm that the ballet was based on an actual incident that had taken place in 1893 around the Bal des Quat'z-Arts in Paris. Bolm gleefully informed her that he had been one of the evening's revelers, and that he had plunged into the fountain at the Place de la Concorde on the night of one of the artists' balls.

Stettheimer noted in her diary that Bolm "sounded enthusiastic after he saw my designs — he said it was the real stuff — grand theatre." The dancer said he was impressed with "the grotesqueness" of Stettheimer's designs for the ballet, and while discussing the production of *Orphée*, he periodically got up and "did some grotesque dancing in illustration of things he was telling me . . . doesn't it seem wonderful." Bolm was apparently disappointed that the role of the Italian prince that she intended for him was "too effeminate," a sign that it had been written for his fellow dancer, Nijinsky. Stettheimer quickly created another, more appropriate, role of Mars for him. (*Fig. 41*) At the end of the evening, Bolm agreed to produce the ballet if they could find the right composer. He mentioned the French composer René Duclos, but as it would take too long to contact him, he suggested instead Leo Ornstein. Stettheimer was jubilant: "He is going to look him [the composer] over, it seems quite too good to be true."

After the meeting, Stettheimer impatiently called Tulka and asked whether he thought the presentation had been a success. The lawyer reassured her that Bolm had liked the ballet, "understood" Florine, and felt they could work well together. He then suggested to Stettheimer that she popularize her ballet by bringing in the war at the climax of the frivolity. Stettheimer's reaction was caustic: "I see his point, it would possibly popularize it, and positively make it inartistic. My composing the ballet was a means of getting away from the War like the way the Greeks invented their gay mythology to make life possible for their melancholy dispositions according to Nietzsche."

Meanwhile, from the Adirondack camp, Ettie, who was by now in her late forties, was wistfully fantasizing about which role in the ballet she might fill: "maybe Europa or the Apache!"

Despite her excitement about the potential performance of her ballet and supervision of the stretching of her paintings in preparation for the Knoedler exhibition, Stettheimer became depressed one afternoon. She was also in the midst of organizing her furniture and belongings for a move to a larger studio: "I am so tired — I am all alone again . . . I am living a quiet life — nobody seems anxious to play any role in it." She continued sleeping at her Bryant Park studio and talking to Sterner about her show, but she found the latter to also be on edge as she was also consumed with moving into a new house. Then, as Stettheimer's things were being moved by "three upholsterers, two porters, four electricians, her housekeeper Miss Sheridan, and her maid Rose," her friend the

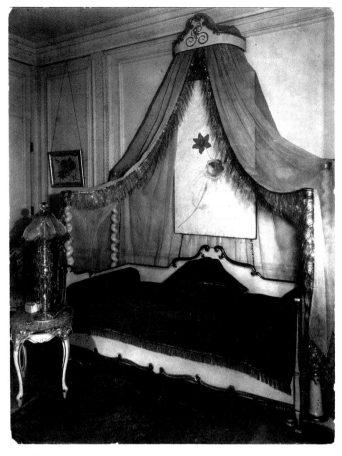

Fig. 42 Unknown photographer: Stettheimer-designed bed with turned wood columns and tinsel-lined canopy from her bedroom at West Seventy-Sixth Street, New York, Florine Stettheimer Papers, Rare Book and Manuscript Library, Columbia University in the City of New York, Gift of the Estate of Ettie Stettheimer.

playwright Avery Hopwood called. Abandoning the move, Stettheimer decided to escape with him for a noon drive. The two boarded the 5:12 train to Long Branch to see a production of one of his plays. Afterward, they continued to her relative Irene Guggenheim's beach house, where they had dinner. She remained there for the weekend, soaking in the ocean and summer breezes before returning to the city.

As the date for the Knoedler exhibition approached, Stettheimer decided to decorate the galleries to replicate her rooms where the paintings usually hung and create more of a *Gesamtkunstwerk* installation. She wanted the gallery to appear more intimate and theatrical than the usual spare white walls, which she felt was the wrong atmosphere to display her work. Just as she had in her Camp Saranac room, Stettheimer had the gallery walls covered with white muslin. On one wall, she added a bed with a translucent fringed canopy, which she designed and borrowed from her bedroom in the family apartment. (*Fig. 42*) In her diary, she described her delight with the effects: "My decorations

at Knoedler's promise to be successful — rehearsal of them today — 4 men working there for me. An amazing light pours [in the] middle of rooms: looks like sunlight . . . shines through a transparent fringe edged white canopy — walls unbleached muslin full . . . from Paganini!" Stettheimer carefully placed and "rehearsed" the gallery lighting to ensure that it complemented the installation of the paintings. It was as though she wanted her painting exhibition to be *experienced* by the viewers as a sensory theatrical production.

From October 10 to 16, the days leading up to the Knoedler opening, Stettheimer continued checking on her installation's progress, having the works photographed by professional photographer Peter Juley, Jr., attended the opera, and watched Bolm perform in a rehearsal for *Sadko*. She gave a party at her Beaux-Arts studio for friends including Isadora Duncan, who danced with the society sculptor Prince Alexis Troubetzkoy, and the photographer Arnold Genthe. Two days before the official opening, she visited the gallery and had the uneasy premonition that the paintings on view were not up to a solo exhibition: "My pictures are hanging at Knoedler's — I am very unhappy — and I don't think I deserve to be. I thought I might feel happier after dinner — but I have had dinner." On October 12, however, she felt better, writing in her diary, "Went to Knoedler's this aft. The room is finished — looks quite right."

On October 16, the morning of the opening of the *Exhibition of Paintings by Miss Florine Stettheimer*, the artist stopped in early to "see if the floor was swept & the drapery folds not too untidy." She ran into Roland Knoedler, who pointed out that the paintings were not numbered and had no prices listed, so Stettheimer and her nephew Harry Wanger hurried to print tags with information for each work. Knoedler also surprised the artist by saying that he liked her work and that his gallery "need[ed] modern paintings." The exhibition's first public visitor was her uncle Eugene Seligman. Stettheimer later noted sarcastically in her diary that as soon as Roland Knoedler realized that she was related to the extremely wealthy and well-connected Seligmans, he treated her with much more respect. Though throughout her life she had warned Florine against courting any publicity, on October 17, 1916, Ettie uncharacteristically noted in her diary that these were "exciting days for the Stettheimer family."

The Knoedler exhibition consisted of various European Post-Impressionist and Matisse-style paintings that Stettheimer executed in the two years since her return to New York.[8] They were largely derivative and reflected her early, still clumsy, explorations in handling thickly applied paint. Reviewers appropriately noted both the modern aspects and weaknesses of her paintings. A critic from *American Art News* described them as "flowers, young and elderly women and a country mansion figure. A somewhat effective allegorical canvas is called *Spring*."[9] In addition to the grisaille *Spring*, which surprisingly received the most favorable critical attention, the exhibition included

both versions of *André Brook* as well as *Family Portrait I, Jenny and Genevieve, Morning/White Curtain* (*Fig. 43*), and *Still Life with Aphrodite*. She also showed five floral still lifes with a high-keyed palette and decorative ambiance. A *New York Evening Post* reviewer unkindly compared Stettheimer's work to the way "an orchestra sounds when all the instruments are playing independently," but continued, "Miss Stettheimer's work is not nearly as crude as this comparison would imply. Her work, while lacking form, is courageous and straightforward, and if her independent beliefs develop into an abiding faith, her next exhibition will show a proportionate advance."[10] The critic for the *Evening Mail* noted that the "paintings are properly secluded in one of the upper rooms in Knoedler's where the glare of publicity is not too strong for their modest art constitutions."[11]

A number of critics were far more favorable. One referred to her as an exponent of modernity who "does not care who knows it,"[12] and *American Art News* stated that the artist "wields a vigorous brush, has good color sense and a supreme disregard for local truth . . . The figures . . . are agreeably handled, but curiously colored." The *New York Times* critic Dwight C. Sturges, whose review was titled "Clever Paintings," described the work as being "very modern as to color, not without weakness in construction and design, and filled with a pleasant sense of humor and fantasy." The article went on to state the gallery was "beautifully hung to make the most of the brilliant color schemes against a warm, white background with ample spacing," and Stettheimer's *Family Portrait I* was "a cheerful mingling of portraiture and generalization, a pleasant picture to have about in an unsentimental home."[13]

A review in the *Evening Post* ambiguously observed that Stettheimer's paintings were "independent without being entirely personal." The most positive review was by Frederick Eddy for the *World*: "An exhibition in the Knoedler's galleries . . . reveals Miss Florine Stettheimer as a versatile and pleasing painter. Most of the work is done with a bold, confident brush, in which color contrasts are emphasized in floral pieces, bits of landscape and figure groups. The chief attraction of the display is a panel painting of *Spring* . . . The panel might have had fitting place as a fresco on the walls of a Louis XVI chateau. Its setting within a frame shows to rare advantage the artist's inventive skill."[14]

Stettheimer wrote remarkably little in her diary about the exhibition. She stopped in at the gallery every day and noted that, according to the elevator man, quite a few people had been in to see it. Stettheimer speculated that the visitors must have been friends of the family because "only one party asked to see the price list." Her main source of satisfaction was in seeing her name on the gallery marquee, visible from Fifth Avenue. On October 24, she went there to meet Marcel Duchamp ("he looks thin, poor boy"), who "saw a real talent" in her work,[15] and found Elizabeth Duncan (sister of the dancer Isadora), Arnold Genthe, Marquis de Buenavista, and her two sisters speaking "amusingly admiringly of my work." Another day, she ran into Leo Stein in the gallery. As

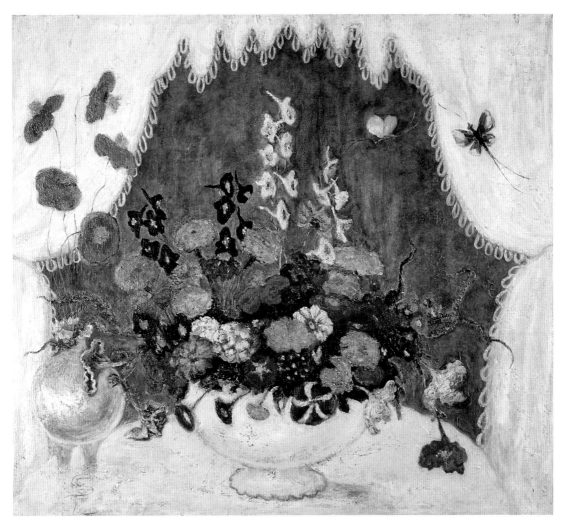

Fig. 43 Florine Stettheimer, *Morning (White Curtain*, repainted), n.p., oil on canvas, 32 × 36 in., Boston Athenaeum, Gift of Ettie Stettheimer.

the date for the close of the exhibition grew nearer, her comments were terse: "I met my successor Raukin and his work! . . . Mr. Fatman dropped in — and out." Her surprise at the exhibition's lack of success is evident: "I am not selling much to my amazement." It is worth noting that at this very early point in her career, she was still willing to sell her paintings, a sign that she had not formed a strong feeling of attachment to these early works as she would to her more mature paintings.

Within two days of each other, the Knoedler exhibition and the New York performances of the Ballets Russes ended. During the last weeks of October, Bolm convinced Stettheimer to hear *Carnival in Paris* by Johan Svendsen, a potential composer for the *Orphée* ballet. They attended with Ettie and Duchamp. Stettheimer tried to enjoy the concert but found that it sounded like "a new kind of civic recruiting" and decided she did not want him for the ballet. She noted, "I want a composer all to myself to tell him what to do."[16] Bolm and she visited the Central Park Zoo and

discussed using live animals for the production, and they searched through music stores for possible scores. But the subject of Stettheimer's ballet quietly died and was not brought up again.

On October 28, the last day of the Knoedler exhibition, Stettheimer spent part of the afternoon in the gallery where a Dr. Leipziger was the last visitor. She recorded in her diary, "Sold nothing." That night, she went to a performance of the Russian ballet and, having apparently advised him on doing his body and facial paint, noted: "Bolm in 3 things — He made up in Sadko the way I told him to — he looked much handsomer — Funny!" On the thirtieth of the month her diary records only: "X over . . . Russian Ballet over — Bolm rang me up to say good-bye."

Over the years, the legend of Stettheimer's "disappointment" with the Knoedler exhibition has reached almost mythic proportions. Parker Tyler, continuing to augment his fiction of Stettheimer as "naturally timid and hypersensitive," stated that the lack of sales at the 1916 Knoedler exhibition caused a "wound" in the artist.[17] Despite the fact that the reviews of the exhibition were generally fair, most who have consequently written about Stettheimer have referenced Tyler, stating that the "personal rejection" Stettheimer experienced at not selling any work had a "devastating effect" on her subsequent life. As a result, they claim she "retreated from the white light of publicity,"[18] and thereafter "never" or "exhibited her paintings only rarely during her lifetime."[19] This is untrue. Stettheimer continued to exhibit widely and subscribed to Romeicke's Clipping Service in order to receive any newspaper or magazine articles that mentioned her name or reviewed her work, and she kept all of the reviews in her scrapbooks.

Henry McBride far more accurately observed that the Knoedler exhibition "was early in her career, before her style had crystallized" and that she was only "vaguely dissatisfied" by the lack of sales.[20] McBride had a reasonable explanation of Stettheimer's failure to sell or receive significant attention from the show. She had only been living in America for a year and a half when the exhibition opened and had just begun exploring a new style and manner of painting. Given Stettheimer's ability to create perfectly realistically rendered imagery, it is clear that the heavy-handed treatment in these paintings reflects a conscious effort to overcome this natural skill and develop a new visual vocabulary. Nevertheless, Ettie was disappointed in the results of the exhibition and blamed Sterner's promotion: "Florine's exhibition was very interesting; she got good notices on the whole but sold nothing. I don't think Marie did all she could in the matter. It's too bad she didn't make more noise and sell. A number of people admired her work very much."[21]

One clear sign that Stettheimer was not particularly affected by the 1916 Knoedler's experience is that she again sent a painting to be exhibited at Knoedler's two years later! (As Knoedler was still a commercial art gallery, presumably the painting she sent was also for sale.) Her reputation remained intact so that in 1917, Carl Sprinchorn offered her a solo exhibition at his new gallery, and

she noted in her diary that another American modernist artist, Abraham Walkowitz, "wants me to have a book made of my paintings." In addition, a mere six months after the Knoedler exhibition, Stettheimer participated the *First Annual Exhibition of the Society of Independent Artists*, held at the Grand Central Palace, at which all works of art were also for sale. Although Stettheimer had already included *Jenny and Genevieve* in the Knoedler exhibition, she submitted it again, along with a second work. The exhibition was unusual as it was organized largely by artists and marketed as a wholly democratic, un-juried exhibition. Duchamp was one of the society's founders, along with Walter Pach and Walter Arensberg. Duchamp was also chairman of the exhibition's hanging committee. In opposition to usual practice in exhibitions, the Frenchman proposed installing the works in alphabetical order rather than according to size, medium, or style, and entrance was guaranteed to any artist who paid the entrance fee.[22]

The exhibition ran from April 10 to May 6 and included 2,500 works stretching over almost two miles of wall space. Despite the decision to install the works in as unbiased a fashion as possible, several of the exhibition organizers were shocked by the submission of a porcelain urinal titled *Fountain* and signed R. Mutt. Unable to understand how this could be a serious submission, they refused to include it. The work, long considered one of Duchamp's infamous "readymades," garnered significant media attention, especially when Walter Arensberg (who was aware in advance that it was submitted by Duchamp as a provocative challenge to the stated idea of an entrance "guaranteed" for any work) found *Fountain* hidden behind a curtain and proceeded to purchase it. Considered shocking at the time, the work was to prove seminal in changing forever the definition of what constitutes art.

The second painting that Stettheimer submitted was her 1915 *Portrait of Avery Hopwood*, one of the most anomalous, transitional works in Stettheimer's early career. (*Fig. 44*) Continuing the evolution toward her own unique style, the painting's palette is based on the pure nasturtium red, bright orange, and yellow coloring of her other transitional work of the same year, *Self-Portrait with Palette (Painter and Faun)*. The work's surface, except for the sitter's face, is similarly painted in flat white strokes, with large empty expanses.

The painting is also Stettheimer's first mature portrait of a man. Avery Hopwood, a decade younger than Stettheimer, came to New York from Michigan in 1905 with ambitions to produce commercial theater and make a great deal of money.[23] Hopwood soon became a celebrated playwright and wrote at least thirty-three light comedies. He was an early member of the Stettheimers' salon and introduced the artist to the writer Carl Van Vechten and his wife, the actress Fania Marianoff. Van Vechten, a writer and photographer, became one of her closest friends. Nicknamed the "playboy playwright," Hopwood specialized in provocative yet popular plays such as *Getting Gertie's Garter*

Fig. 44 Florine Stettheimer, *Portrait of Avery Hopwood*, 1915, oil on canvas, 42 × 30 ½ in., The Hopwood Awards Program of the University of Michigan, Gift of Ettie Stettheimer.

and *The Demi-Virgin*. The latter included a risqué game of cards called "Stripping Cupid," in which a bevy of showgirls teased the audience in their lingerie. This act led to Hopwood's being arrested and taken to court. The case was eventually dismissed, and by 1920 he was so successful that he had four plays on Broadway at the same time. Hopwood's greatest success was a bedroom farce called *Fair and Warmer* that opened to rave reviews at the Eltinge Theater on November 6, 1916.[24]

To commemorate the event, Stettheimer painted Hopwood standing in front of large block lettering of the play's title. Hopwood's features are realistically and delicately portrayed in subtle tones, as though Stettheimer had copied the composition from a publicity photograph. Just enough of the letters are cut off by the canvas's borders that their meaning is apparent only to viewers

already familiar with Hopwood's first name and the play's title. Stettheimer's combining images and words curiously foreshadows her friend Charles Demuth's poster portraits painted a decade later. When the painting was completed, Carl Van Vechten asked to see it. To accommodate him, on December 17, 1916, Stettheimer held her first of her many "private unveilings," inviting friends, including Duchamp, the Van Vechtens, Marie Sterner, and the Marquis de Buenavista, the Peruvian ambassador to the United States, to see the new painting and have tea in her studio.

In February 1917, Ettie again wrote to Henri Gans, fighting in Europe, congratulating him on receiving a medal. She mentioned that although it seemed clear that the United States would soon enter the war, "there is immense disgust at being forced into it." Her own view was that America was obliged to enter "to prevent a decisive victory for Germany." She noted that she was a godmother to a French soldier and that Carrie was a godmother to seven soldiers.[25] On May 12, the three sisters and Marcel Duchamp attended a pro-Allies event at City Hall to honor Marshal Joffre, France's "hero of the Marne." The parading troops of schoolgirls with flags, schoolboys in khakis, and uniformed soldiers drew so many onlookers that the women decided to view the spectacle from inside an adjacent store with second-story windows. Ettie convinced the manager to let them in, and he agreed as they were "ladies." She told him that they had a Frenchman with them, and the storeowner replied, "All right. Hats off to a Frenchman," and permitted Duchamp to join them inside. "This was funny," Ettie remarked, "because one of Duchamp's most positive ideas is that he won't fight."

Florine Stettheimer woke at six in the morning on June 5 and lay in bed listening to whistles and "something that sounds like a saluting gun, if it's not some other kind of gun." Conscription for the war had begun, and the sisters were very upset to learn that Stella's son Walter had volunteered and been accepted into the air corps.

chapter five

A UNIQUELY FEMININE, SUBVERSIVE STYLE

The most significant result of Stettheimer's lack of sales at the Knoedler exhibition was that she chose to further abandon traditional European influences in order to develop a unique modern style of painting. As she had originally vowed on returning to America, she wanted to create a new, contemporary style that captured all that was exciting about twentieth-century New York as she saw it and, more importantly, experienced it with her senses:

Then back to New York
And skytowers had begun to grow
And front stoop houses started to go
And life became quite different
And it was as tho' someone had planted seeds
And people sprouted like common weeds
And seemed unaware of accepted things
And did all sorts of unheard of things
And out of it grew an amusing thing
Which I think is America having its fling
And what I should like is to paint this thing.[1]

However, painting "this thing" meant that she needed to create a style that was in direct contrast to traditional modernism, in which artists were "denying subject matter and narrative altogether . . . painting was supposed to be only about itself, its materials, and 'flatness.'"[2] Instead, her new subject matter consisted of recognizable portraits of contemporary friends, acquaintances, and famous figures; carefully researched architecture; and specific events and locations in and around New York City. Every Stettheimer painting has familial, political, personal, or event-related subject matter.

To accomplish this, Stettheimer was not drawn to either the modernist abstract tendencies of many of her European expatriate and Stieglitz Gallery contemporaries, or to the masculine, baroque work of the social realists. This conscious rejection of her avant-garde peers' prevailing modernism

was a statement of unusual artistic self-confidence, particularly for a woman. Remarkably, rather than looking to the visual arts, Stettheimer turned back to the strong performative and theatrical aspects of Ballets Russes productions as the fundamental influence on her experiential new style of painting. To this she added the ideas of Bergson's theories of *durée* or the experiential "continuity of flowing and being alive." These early influences, plus the specific style of figuration, movement, and design she had developed in her *Orphée de Quat'z-Arts* ballet five years earlier, formed the basis of her unique mature painting style.

From this point forward, Stettheimer composed her paintings (except for her portraits) as though they were captured moments of theatrical productions. Figures animate the space, caught in the midst of moving and gesturing. Varied media, applied thickly, create visibly tactile textures on her canvases. Pure colors, often directly out of the tube, reflect emotional moods and ambient temperatures, while the images of instruments and musicians imply sounds. To Stettheimer, as it was to another recent arrival, the artist Francis Picabia, life in New York was a place where one would find:

> every language in the world spoken, the staccato of the New Yorker, the soft cadences of the Latin people, the heavy rumble of the Teuton, and the ensemble remains in my soul as the ensemble of some great opera.[3]

To capture this experience, Florine experimented in innovative ways on her canvases, using expensive oil paints, graphite, raised and gilded gesso, and ink to create her paintings, as described by Henry McBride:

> She had laws of her own and knew them positively even though she never defined them to herself. She followed her inner impulses with strict integrity and spared nor time nor labor to realize them. Very early she began to lean heavily upon the use of white pigment. Miss Ettie Stettheimer once remarked to me that she thought a special quality of her sister's work was its power of giving off light. This, I, in turn, thought to be due to the artist's lavish, preparatory build-up of Chinese white on the canvas, whites which often were piled up in relief before the actual painting began. Once this got under way I imagine the artist stopped at nothing. She sometimes applied thin tints only partly covering the heavy white base; she sometimes, I suspect, smudged areas of thick paint into smoothness with a cloth, giving it the appearance of a liquid that has been poured on rather than brushed. The actual brushstroke of the usual artist is so seldom employed in her later works that it suggests a palpable avoidance of "quotations" so confirmed had she become in the habit of

doing things in exactly her own way; — but with all the irregularities she was always able to get precision where and she wanted it.[4]

Stettheimer built up her paintings using a complex layering structuring technique she learned from studying Renaissance painting as well as *sgraffito* (the carving into paint to reveal under-layers of color) and other Old Master painting techniques.[5] To create her early individual imagery, Stettheimer returned to the flattened face, white skin and black outline of Botticelli's *Birth of Venus* she so admired, combined with the explicitly feminine "s" curves of the Rococo.

Stettheimer must have been aware that, as with her *Nude Self-Portrait*, creating a "feminine"-based style would court controversy. The latter term, when used to describe an artist's work, was a pejorative one. Although the influential art critic Charles Henry Caffin urged his readers to be open-minded about the European modernism of artists such as Henri Matisse, Paul Cézanne, and Georges Braque, he dismissed the "pinhead humor" of Marcel Duchamp, and warned against the dangers of the "feminine in painting."[6] Georgia O'Keeffe, a friend of Stettheimer's who often exhibited in the same exhibitions, controlled her self-image, choosing severe, androgynous clothing throughout her life. She actively denied any feminine or sexual attributions in her flower paintings. Even in the catalogue for Stettheimer's retrospective exhibition, McBride cryptically commented, "There was already enough freedom and femininity in the work to bar it from the then open exhibitions: femininity when too openly avowed being almost as reprehensible in those days as freedom of expression."[7]

Parker Tyler himself took umbrage with a review in which artist Marsden Hartley described Stettheimer's art as "chamber music meant to be heard by special sympathetic ears," and saw the "ultra-lyrical expression of an ultra-feminine spirit."[8] As Tyler noted, this was troublesome because, as a result, "any comparison with male artists seems forbidden." Hartley held unusually patriarchal views about gender differences. Considering the female the lesser gender, Hartley noted in a separate essay that the best "painting has become definitely masculine at last." Therefore, even in his own mind, his review of Stettheimer's work as "ultra-feminine" was not complimentary.

Stettheimer, however, had no problem with anyone applying the term to her work. She consciously chose it to characterize her new, mature, contemporary style of painting as a means to clearly distinguish it from that of other modernist artists. Stettheimer wrote Hartley a response to his review, thanking him, albeit somewhat ironically:

Your writings about me & my paintings are a delight — while reading them I felt myself curtseying to your low bows and then, walking on air I tumbled down the library stairs - and that accounts for this belated letter.....otherwise your eyes have now translated

my paintings and me into blue glassy sentences that must lead us into a crystal ball of fame — to which, when I move I shall bring tinsel fringed curtains — may I —?.... My thanks to you for thinking so well of me & so beautifully. This may be delayed some more[9]

Although it had no relation to their mechanical, abstract, or conceptual work, in courting femininity, Stettheimer's new style was closer to some of the European modernists than to most of her American counterparts. Other than her friend Charles Demuth's sexually explicit homosexual watercolors, the work of Stettheimer's American contemporaries was far more conservative. By contrast, the artists who left Europe for New York to escape World War I, including Duchamp, Gleizes, and Picabia, brought with them a more relaxed attitude toward sexuality and gender, and their work was often sexualized, with feminine undercurrents. Picabia's first after his arrival in America was his sexual-mechanical spark plug, which he titled *Portrait of a Young American Girl in a State of Nudity*. Similarly, Duchamp's *The Bride Stripped Bare by Her Bachelors, Even (The Large Glass)*, a piece he began in New York in 1915 and worked on for eight years, depicts the erotic encounter between the abstractly rendered "bride," in the upper panel, and her nine similarly abstract "bachelors" gathered below in the lower panel. These artists would increasingly show up as portraits in Stettheimer's now maturing style paintings.

Throughout late June and into July 1917, the Stettheimers held weekend parties at André Brook and invited members of their growing New York circle to come for a day in the country. On June 21, Duchamp came out to give Florine French lessons and spend the weekend. They were joined in the afternoon by the young gay Swiss dancer and society portrait painter Paul Thévenaz. Florine described him in her diary as "a very young faun [who] turned somersaults on the green, danced, smiled and seemed unconsciously happy — he suited the garden. I hope he will play about in it again." The following day the Stettheimers held a garden party with a number of guests, including Duchamp, Thévenaz, Parisian fashion photographer Baron de Meyer and his wife, Carl Van Vechten and his wife, the actress Fania Marinoff, the noted architect Paul Chalfin, and the Marquis de Buenavista and his wife. When one studies the details it is clear that Stettheimer combined incidents from several of these parties into the painting she titled *Sunday Afternoon in the Country*, although Van Vechten later stated that the subject was a "pure romantic fancy of the artist."[10] (*Fig. 45*)

One of the most immediately apparent differences in this work from her earlier paintings is the scale of the figures and action within the composition. Stettheimer basically miniaturized the style and manner of her early *Orphée* ballet figures, now placing them on a canvas "stage," interacting in contemporary clothes and in a specific context. Another possible influence was Persian miniatures, particularly those of the fourteenth and fifteenth centuries, in this new progressive compositional

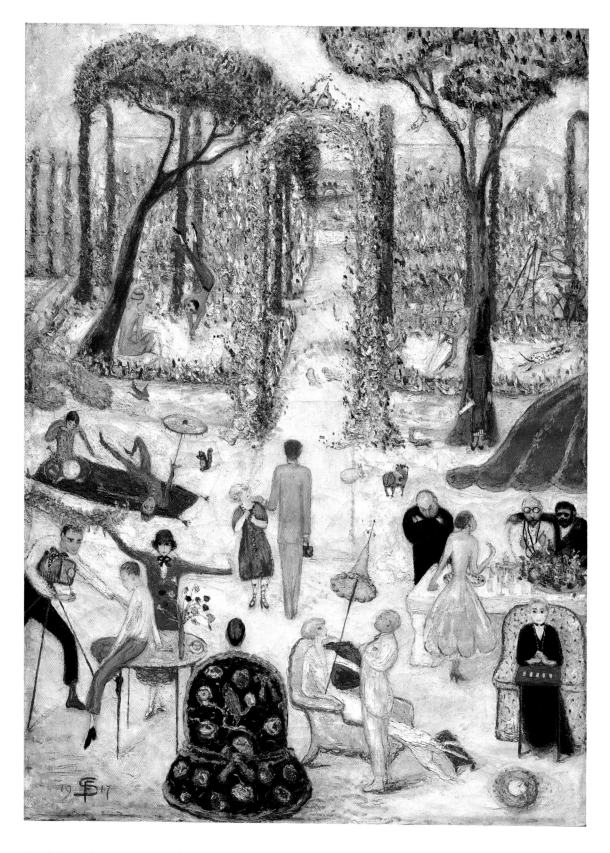

Fig. 45 Florine Stettheimer, *Sunday Afternoon in the Country*, 1917, oil on canvas, 50 ⅜ × 36 ⅜ in., The Cleveland Museum of Art, Cleveland, OH, Gift of Ettie Stettheimer.

"miniaturization." Stettheimer had included an Islamic prince in her *Orphée* ballet, and she had made sketches of figures from Persian miniatures in her scrapbooks from the exhibitions she'd visited and admired in Paris.[11] The other common motif she borrowed from Persian art was the extension of the composition's ground to terminate in a very high horizon line, made up of either a natural landscape element, an architectural element, or the meeting of floor and wall.

The action of *Sunday Afternoon in the Country* takes place in the back gardens of the André Brook estate, where the Hudson River is visible through a vine-covered trellis. In this early work in her new style, Stettheimer varied her approach in different areas of the canvas. In the background, she adapted a loose Pointillist technique for the natural elements of the landscape. For the many smaller figures in the middle ground and foreground, she used pure areas of largely unmodulated color within clearly delineated outlines. Finely painted details define and identify the figures' facial features and gestures. To viewers, the characters portrayed were either obvious or mysterious, depending on their familiarity, and, to quote Robert Goldwater, they therefore "become microcosmic comments on a larger world."[12]

Stettheimer arranged the painting's composition like a stage proscenium with a densely designed curtain backdrop. The whole is tilted vertically at such an acute angle that the horizon line lies at the top of the canvas and the bottom spills toward the viewer, implying our inclusion in the scene. The middle ground is empty of all but one almost-hidden figure plus a central strip containing twelve small birds and animals, including yellow squirrels hanging by their tails. It is an Edenic scene populated by humans and animals, like a medieval tapestry reminiscent of her early grisaille painting *Spring*. The rest of the composition is filled with twenty figures, eighteen of whom are arranged in two loose bands in the lower half of the canvas. There is no single unified action that brings all of the figures into mutual play. Instead, each area of the composition acts as a separate tableau, as in theatrical revues popular in Paris and New York at the turn of the century, in which unrelated events were enacted with total disregard for any continuous narrative. As a critic noted in 1912, "The cortege of a *revue* is composed of multiple characters, disparate, ceaselessly renewed, always inevitably foreign to an initial postulate. . . . It is precisely the revue's lack of cohesion which gives it its charm."[13]

At the upper left of *Sunday Afternoon*, for example, Paul Thévenaz executes a handstand in the grass while only Marie Sterner looks on.[14] Stettheimer later wrote a poem describing her impressions of this gymnastic demonstration. As she would do several times in her paintings and poetry, she reversed the male gaze, exploiting men's usual language in describing women's physical beauty by having it spoken by a woman admiring the physical attributes of a young man, and using irony at the poem's end to mock men's usual sense of superiority:

Narcissus

You play in my garden

You are very young

You are beautiful

You see in the red rambler arches

Frames for your posturing

In the full-blown peony borders

Boundaries for your dance

In the smooth lawn

A carpet for your somersaults

In the clear pool

Yourself reflected

To my eyes

Your selfworshipped self idolized[15]

In the middle left of the composition, Adolph Bolm, dressed in a ballet costume with green body paint, lies upside down, wiggling like a dog, with his legs in the air. Alice Coomaraswamy, an Englishwoman whose stage name during her 1917 American East Indian dance tour was Ratan Devi, accompanies him on a tambour.[16] In the left foreground, the photographer Edward Steichen adjusts his box camera in order to photograph the handsome young Marcel Duchamp, who poses against a yellow table behind which Ettie stands guard. In her usual officious manner, Ettie shields the artist's face from the sun by holding out a pine branch in one hand and stopping anyone from coming near with the other. Duchamp's pose and profile in this vignette are an exact replica of the famous photographic portrait of the artist taken by Edward Steichen that same year.[17] As Stettheimer's paintings are all made up of realistic details, it is probable Steichen actually took his photograph of Duchamp in the André Brook garden at one of the Stettheimer family's summer parties. Meanwhile, Rosetta sits in the lower right of the composition, in a bright yellow spotted chair playing her favorite card game of patience, while Carrie stands with her back to viewers, playing hostess at a table by entertaining guests.

Barely discernible in the upper right corner of the painting, as usual isolated from her family and guests, Florine sits at an easel, as though painting the scene from the other side. Once again, she is simultaneously documenter and one of the observed, giving the work a psychological tension. Stettheimer wears her artist's white pantaloons and a yellow straw hat to protect her face from the

Fig. 46 Marcel Duchamp, *Inscribed Place Cards for Birthday Party*, 1917, Image care of Francis M. Naumann.

sun. Preoccupied with painting, she ignores the rose offered by a red-skinned faun kneeling at her side. The faun self-consciously curls its body inward, its eyes glancing shyly toward the artist.

A simple palette unites the composition. Stettheimer used four colors as accents: red, green, yellow, and black, weaving elements of the composition together against a predominantly white ground. Red accentuates the four corners of the canvas. Clear lemon yellow is used to highlight inanimate objects such as chairs, tables, parasols, and flowers. Black is reserved for accenting the figures in a manner that causes the viewer's eye to circle around the lower third of the canvas. Duchamp once described Stettheimer's colors as "juicy."[18]

The Stettheimers held weekend parties at André Brook throughout the summer of 1917. On July 28, they threw Duchamp a thirtieth birthday celebration. Duchamp designed the place cards himself, writing the guests' names in parts, half on each side of a folded piece of paper. (*Fig. 46*) The full names could only be read if the paper was held up to a light, making the paper translucent—

an example of Duchamp's continuing interest in optics.[19] On the morning of the event, the sisters were concerned about the weather, as Ettie noted in her diary: "Friday was a scorcher and we feared for our party but Saturday was perfect: cool and sunny and at night windless and moony and Marcel Duchamp's birthday party was a great success. A series of pretty pictures—first, tea on the lawn under the maples and some of us '*sur l'herbe*,' and afterwards 3 tables on the terrace and Japanese lanterns blue and green and yellow." Florine declared the party "seemed very real, French," and noted that in her memory it was already "a classic," so she determined to paint it. She titled the work *La Fête à Duchamp*, and facetiously declared that her painting would become yet another advertisement for Duchamp to add "to the already long list."

In the painting, as on the day, the birthday party unfolded in several stages. (*Fig. 47*) The most striking and innovative aspect of Stettheimer's painting is the manner in which she included various sequences of time within one canvas, something Duchamp in 1919 termed her "*multiplication virtuelle*." On May 3, the French artist wrote Florine:

> "Group" is an excellent designation for the type of paintings that you have made. Group has nothing to do with the irksome [word] "composition" and is mobile, that is to say, instead of considering only the different situations colored or formulated on the canvas, one has to join what the different points would give if they changed places, and a virtual multiplication through color adds to the mobility of these points. The whole is not left to the imagination but is regulated by optical necessities, common to nearly every individual.[20]

The notion of reality as a "composite of multiple sensations and perceptions" corresponds to the writings of Stettheimer's favorite author, Marcel Proust, and Bergson's idea of *durée*. In designing the composition, as Proust would have described it, for Duchamp's party, Stettheimer created a "journey" through her memory of the event. Although the canvas is horizontal, the artist's placement of figures and colors makes the composition work both sideways and vertically. The viewer traces the day's occurrences in the manner of Asian "journey" scrolls and medieval and early Renaissance predellas.[21] As would be the case in several other Stettheimer paintings, the composition of *La Fête à Duchamp* is "zoned for time" by the repetition of characters and the inclusion of sequential events within a single canvas. Since time cannot be seen, it can only be experienced by the act of reading images across the surface of a painting. By repeating a figure within a composition, it becomes apparent to viewers that they are looking at distinct moments in time.

Chronologically, the painted events in *La Fête à Duchamp* begin on the far left side of the canvas, as Duchamp arrives in a red convertible sports car driven by Francis Picabia.[22] Waving at the guests scattered throughout the lower gardens, Duchamp and Picabia (whom Ettie called a

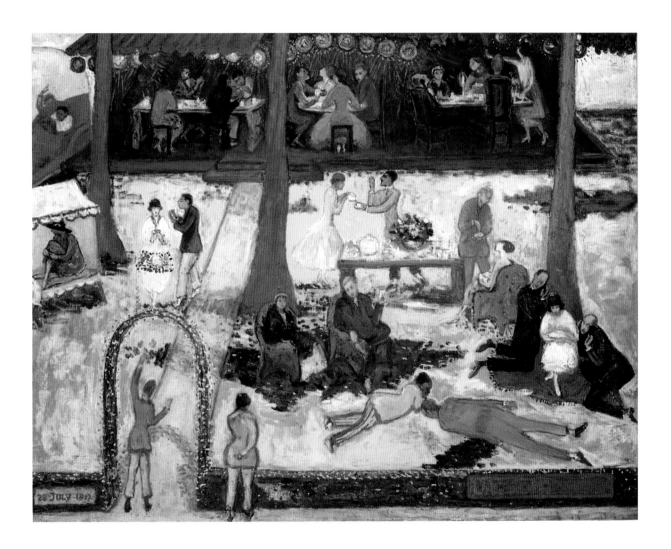

Fig. 47 Florine Stettheimer, *La Fête à Duchamp*, 1917, oil on canvas, 35 × 45 ½ in., Private collection.

"fat, womanish, enfant terrible, self-centered Bohemian with a high-power automobile in which he and Duche came out later than anyone else") enter the garden through a flower-covered trellis at the bottom of the painting. Stettheimer disengages herself from the artist Albert Gleizes (whom Ettie described as "a serious, very talkative, amiable, long-winded one") and steps forward to greet them. She is dressed in her white overblouse trimmed with a band of flowered embroidery over pantaloons. After they enter the painted gate, Duchamp and Picabia separate. Duchamp goes to sit in a covered swing at the left with the actress Fania Marinoff. Picabia moves to the right front lawn, where he lies on his stomach talking with the French writer Henri-Pierre Roché.

Roché humorously lies face-down and spread-eagled on the grass near where Ettie is sitting and reading aloud. As Ettie described it, "Quite an atmosphere. I read *Emotion* to Leo Stein and Roché *sur l'herbe* and it was atmospheric and amused me and they seemed to like it." In a rather cruel caricature exploiting his hardness of hearing, Stettheimer shows two images of Leo Stein, kneeling on both sides of Ettie. He is holding his hearing aid tightly to his left ear, straining to hear her read.[23] Ettie later recalled this detail in the painting, remarking, "I remember that Florine in *Fête de [sic] Duchamp* painted Leo Stein simultaneously on both sides of me, ear trumpet and all. I think this was the only bit of 'expressionism' she ever committed."[24] Further to the right, the green-suited Van Vechten lounges in a green wicker chair, talking with Elizabeth Duncan. Behind a table laden with an abundant bouquet, tea, and pastries, Carrie serves tea to the darkly elegant Marquis de Buenavista. At their right, Avery Hopwood, stirring his tea, stops to talk with Juliette Gleizes, whom Ettie described as "a refined Emanuelle, interesting, European and feminine."

Written vertically in red to the left bottom of her white pantaloons, and painted so lightly as to be almost invisible, Stettheimer added a small in-joke. Looking at first as though it is one of the red dotted flowers covering the bower is the Latin inscription "*pinxit*." This term is understood only by individuals familiar with the history of art and Old Master paintings. Thought to be first used in 1308 by the artist Duccio on his painting of the Maestà altarpiece in Siena, it is typically used following an artist's signature on a painting. It translates to "[the artist's name] painted it" and was generally added by artists only to works they felt they had done well and were significant. This is the only time Stettheimer included this inscription on one of her paintings; its inclusion indicates that Stettheimer felt confident enough of her painting to sign in the manner of an Old Master. There is also a hint of competitiveness: as the event and painting recording it for posterity was honoring Duchamp's artistry, she undoubtedly wanted to ensure her name was prominently signified as well.

The final sequence of Duchamp's painted birthday takes place in the back third of Stettheimer's composition, where, under the lantern-lit veranda, the guests sit at three dining tables. At the far right, Ettie stands and raises her glass in a toast to Duchamp, who rises at the far end of the other

table to accept it, his head lit with a halo by the Chinese lantern behind it. Ettie is flanked by the writers Roché, Hopwood, and Stein who is fast asleep (his hearing aid still by his ear), and Elizabeth Duncan. At the middle table, Carrie sits with her back still to the viewers, with Van Vechten at her right, Buenavista at her left, and Juliette Gleizes opposite. Along with Fania Marinoff, the guests at the leftmost table are artists, including Florine, who has the prize seat next to Duchamp, and Gleizes and Picabia, who are deep in conversation.

In *Fête*, Stettheimer again focused on pure, primary colors for the front three-quarters of the composition. This area of the painting is bathed in yellow ground, indicating the hot July sun on the grass. The artist used red to stabilize compositional elements: the sports car, two long tree trunks, thick outlines of the figures of Duchamp and Picabia, and a sign declaring the title of the work at the lower right. White is used as an accent to identify the three Stettheimer sisters among the participants. Besides mixing separate events and time sequences, Stettheimer juxtaposed two kinds of light. The few shadows against the bright flat yellow of the afternoon sun are in splotches of green. The lighting is reversed in the upper or back quarter of the composition, which is the terrace in evening on the same day. The ground, floor, and walls are indistinguishable, the figures identifiable only by the light of the lanterns.

Stettheimer included *La Fête à Duchamp* in the next year's *Exhibition of Independent Artists*, which opened in mid-April 1918 with a special reception. Henry McBride, the art critic for the *New York Sun*, who had not yet met the Stettheimers, reviewed the opening:

> I agree with Mr. Walkowitz that one of the most joyous of the paintings is the "Birthday Party" by Mrs. [*sic*] Florine Stettheimer . . . All the people at the party, Mr. Walkowitz says, are extremely well known in the most advanced Greenwich Village circles . . . Not to know the fair artists of the picture is to argue oneself unknown, I dare say, yet I cannot recall having heard of Mrs. Stettheimer before. I say "fair" advisedly, for the lady has some rather good things to say for herself. One of the gentlemen at the fete is lying face downward on the turf, and yet his toes point skyward. I believe it is Mr. Duchamp. At any rate he is very clever and could do it. One of the trees is painted scarlet and one a bright blue. The shadows are such colors as pleased the artist, and that is the reason, I think, they now please others . . . Mrs. Stettheimer appears to be a good provider. The more I think of it the more miffed I am that I wasn't asked to that party.[25]

McBride's review must have had an effect, because soon after he was a regular at the Stettheimer salons and became a lifelong friend of the artist and admirer of her work.

In her diary of 1917, Stettheimer noted another memorable evening event at André Brook, when Bolm, his wife, and the musician Ratan Devi came to dinner. The guests missed their return train to the city and stayed overnight, camping out on the lawn under one of the tall elm trees. Bolm borrowed one of Rosetta's frilly white batiste nightgowns and performed an impromptu dance by moonlight for his delighted hostesses. Ettie noted in her diary that her friend Elizabeth Duncan, a feminist who ran a school for young dancers, "without being married or anything," had bought herself a big house in Tarrytown that used to belong to the department-store mogul Louis Stern, saying, "It is clever, however she managed it."[26]

During 1917–18, Stettheimer painted another work, *Fête on the Lake*, in which she experimented with the effects of artificial light, this time against a night sky on the water. (*Fig. 48*) The three sisters ride in separate canoes near a bonfire on the water. On the upper right, an elegant Fania Marianoff rows Duchamp, who sits petting a small dog. Ettie sits in a red canoe with their cousin Eustace Seligman who waves at the upper left, while Carrie, with erect posture, is rowed by an unidentified woman in the midground. At the bottom, Florine sits in her canoe with her back to the viewer rowed by a young girl, possibly a niece. Another fashionably dressed, unidentified lady is also rowed by a young woman at the right. At the low left corner a man in a lone canoe appears to be turning on a gramophone. Although the painting remains unfinished, the composition reflects an early example of Stettheimer's reversal of traditional gender roles: of the five canoes being rowed, four are being rowed by women.

The Great War increasingly asserted its presence in the Stettheimers' lives. Carrie and Florine continued working for the Red Cross when not attending to Rosetta, whose health continued to decline over the next two decades. Ettie wrote to her friend Gans that she had "offered myself to my country for any purpose not resembling Red-Cross work, for which I am unfitted, to addressing and licking envelopes, for which I am fitted but of which I am not enamored." She eventually sat on the draft exemption board and translated German papers as "one of the legal advisers. It was interesting work and absorbing and wearing on the sympathies . . . We are too gay and yet it requires a strong dose of the harmless narcotic of distraction to distract one from the war."

During the end of August and early September, the four Stettheimer ladies took several trips in their chauffeured car through Connecticut and Boston, much to Florine's annoyance, for she was "in a working mood, and when not painting, in a very unhappy mood." Through a drugstore window in Waterbury, Connecticut, Florine noticed a youth in a sailor suit having corns removed "by a man who spoke through a megaphone to a crowd of spectators advertising the remedy. Otherwise I saw nothing to distinguish this place from others." In Boston, where they stayed at the Copley Plaza Hotel, Florine immediately went across the street to the public library to see the John Singer

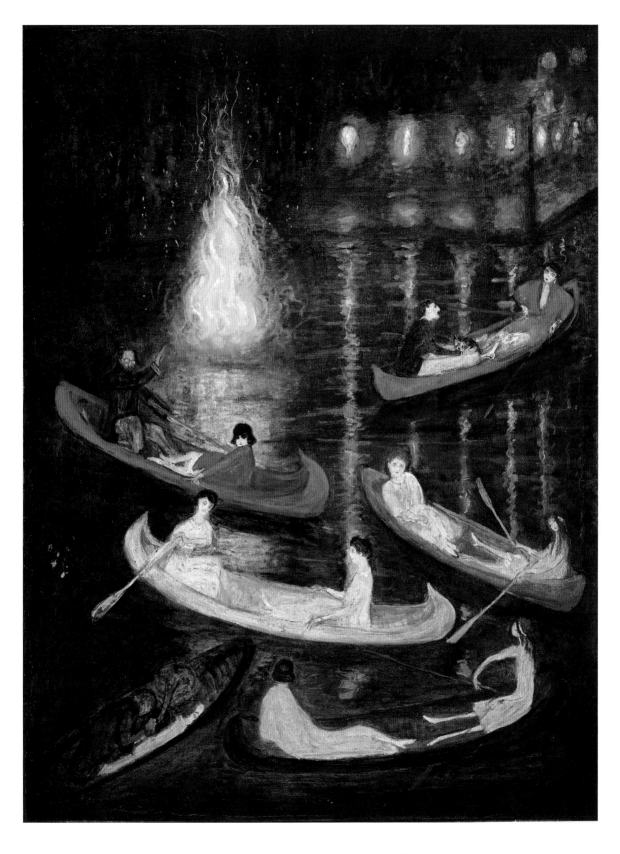

Fig. 48 Florine Stettheimer, *Fête on the Lake,* 1917–18, oil on cardboard mounted on board, 40 ⅜ × 30 ¼ in., Art Properties, Avery Architectural & Fine Arts Library, Columbia University in the City of New York, Gift of the Estate of Ettie Stettheimer.

Sargent murals. On their return trip, driving out of Springfield, Massachusetts, they passed two soldier "boys" sitting on a fence who looked as though they wanted a lift. At the same time, Florine recorded in her diary, a tire blew out, "with a sharp retort, I thought it was a shot." The soldiers helped replace the tire, so the Stettheimers offered them a lift. One soldier had a small red lizard that he was taking to show his family. Stettheimer noted that they were: "nice boys—going to the front shortly—it's horrible."

On August 29, the four Stettheimer women drove to Garrison, New York, and took a ferry to West Point to watch a cadet review. Florine, displaying her enthusiasm for spectacles and performances, found it "more like a hippodrome performance than anything militaristic I have ever seen—the perfect day—the beautiful setting like a stage background, the immaculate cadets, light and graceful marching to light music."

Stettheimer chose to paint two works having to do with World War I, yet she never addressed the violence. Despite living through the Depression and two wars and helping out at the Red Cross, Stettheimer never directly addressed these unpleasant topics in her work. Although horrified at seeing the plight of the European refugees fleeing the impending war in 1914, Stettheimer instead chose to paint and emphasize patriotic themes such as a visit to West Point, where American officers were being trained.

As with her *Fête à Duchamp*, the artist composed *A Day at West Point* as a sequential narrative played out on a vertical canvas. (*Fig. 49*) At the lowest level, at left, the Stettheimers stand by the railing at the front of the arriving ferry. Florine distinguished the four women by color: Rosetta is shown in black, wearing a veil, while the three sisters wear red, yellow, and blue coats.[27] After boarding an open, chauffeured car, the women pass under the Academy's stone-gray entrance arch and drive by a small Army band playing before khaki and red tents. The women then move up to the level of the parade grounds at upper right. There they watch the cadets march in formation around a bronze copy of the 1853 Union Square equestrian statue of George Washington by Henry Kirke Brown.[28] The women stop at the academy hotel, with its wide veranda, before reentering their car and touring the rest of the grounds. Stettheimer bounded the painting's central imagery with water at its bottom and a view of the Hudson River at the upper right. This reinforces the composition's vertical lift and its winding, progressive, narrative nature.

Penelope Redd, one of Stettheimer's most perceptive reviewers throughout her career, noted:

> Miss Stettheimer carries the art of painting to its completest power of expressing a number of incidents occurring simultaneously. A book requires pages to relate concurrent events; a drama requires words to do the same, but a painting by its very nature may express events simultaneously in a way so satisfactory that the smug would label it "efficient."[29]

WEST POINT
War 1917 August 1917 Day

PRICE 50 CENTS
60 CENTS IN CANADA

MAY 1945

Fig. 49 *A Day at West Point*, 1918, reproduced on the cover of *Town & Country* magazine, May 1945. Whereabouts of original painting unknown. Florine Stettheimer Papers, Rare Book and Manuscript Library, Columbia University in the City of New York, Gift of the Estate of Ettie Stettheimer.

Another critic, who saw the painting at the *Exhibition of the Independents* at the Waldorf Astoria, related the organization of Stettheimer's painting to a children's game: "She gets everything in and your eye travels up the canvas through the various depicted events much as in the childhood game one arrives at the 'Mansion of Happiness' after successive stages of joy and despair."[30] Stettheimer included *West Point* in the exhibition *American Paintings and Sculpture Pertaining to the War*, which Marie Sterner organized in 1917 at Knoedler & Company, a year after Stettheimer's solo exhibition. It included works by Cecilia Beaux, George Bellows, Guy Pène du Bois, William Glackens, Childe Hassam, Robert Henri, George Luks, John Sloan, and Gertrude Whitney, among others. All proceeds from the entrance fees were invested in Liberty Bonds.[31]

In her diary, Ettie matter-of-factly reported that their nephew, Walter Wanger, had joined the air corps and was "full of excitement and anticipation; [he] doesn't take his job lightly." Stettheimer began an unfinished portrait of him, and her reaction to his leaving for the fighting was unusually emotional, indicating a deep, apparently one-sided attachment to her nephew. In late August 1917, Walter visited her, and they had a long talk. As the artist noted, it was:

perhaps our last—I was awfully upset . . . we are very good friends—I love him dearly
. . . I felt happier because he had said he missed me often, that he often felt like writing to

me (but he doesn't), that he even thought of keeping a diary when he leaves — for me. He ended up promising it and letters and I am to write . . . something has happened — and he may be gone already.

Walter's orders came through a few days later, and Stettheimer worried less about the potential dangers of battle than about his lack of consideration for her feelings:

[I] went to town in the evening to try and see Walter & say good-bye. He had received his marching orders for the next morning. I waited at Stella's . . . Stella, Harry, he, some new friends were to dine — he did not ask me — although I was alone and came in for him — I am now glad of it — I have no heartache left . . . I mourned the death of my affection for him that night.

The subsequent pages were cut out of the diary by Ettie. Stella was older than Florine and married when the artist was nineteen years old. As a result, the artist must have been at least twenty years older than her nephew. Nonetheless, Stettheimer's impassioned response to Walter's not inviting her to his final dinner is far more emotional in tone than any other entry Ettie didn't excise, so it prevents us from ever knowing whether this strong reaction to her nephew's lack of consideration was an anomaly, or if this was another instance of a man Stettheimer cared deeply for who ultimately didn't return her feelings.

By 1918, Stettheimer had fully mastered her new style, as details of her paintings became more finely drawn and her compositions simplified. The André Brook estate was not available for the summer, so the Stettheimers rented the Rupert Hughes estate in Bedford Hills, New York. Ettie lamented in her diary, "We have a tennis court we don't use and a lake too dirty to bathe in, but not dirty enough not to want badly to bathe in, pigs, cows, horses, chickens etc. geese, whom Florrie calls the Germans. 'Here come the Germans,' she says when they approach the lake. I suppose we shall feel obliged to eat them when the weather gets cooler."[32] Friends continued to come out for weekend parties and new friends and acquaintances were added. As Stettheimer exclaimed,

Our Parties Seen in color and design
Our Picnics It amuses me
Our Banquets To recreate them
Our Friends To paint them.[33]
Have at least a raison d'être

In recreating one of their picnics, Florine used the Hughes farm as a backdrop, painting a loose variation on Manet's *Déjeuner sur l'herbe* which she titled *Picnic at Bedford Hills*. (*Fig. 50*) As she had with her *Nude Self-Portrait*, Stettheimer often referred to and played off earlier subjects and images from the history of art. She had seen Manet's painting in Paris on June 5, 1910, and declared it "looked hard in a bright, cold, light today." Hamilton Easter Field, head of the Society of Independent Artists, declared that Stettheimer's *Picnic* was, like *Déjeuner*, "a charming canvas, in which Miss S. has gently caricatured the doings of city folks amid the life of the country."[34]

In *Picnic*, Stettheimer juxtaposed images of rural workers who depend on the land for their livelihood with images of idle urbanites who venture into the country for leisure and relaxation. To accentuate these differences, she divided the painting by style, color, and subject matter into two unequal zones. The upper quarter of the canvas, framed by two large shade trees, is painted in a loose Impressionist technique of dashes of pure purples, blues, and yellows. The artist intended this area of the composition to illustrate the repetitive work patterns of the harvest. On the far left, mounds of drying hay await loading into a horse-drawn wagon that is barely discernible behind the central pink tree trunk. A farmer at right rakes the hay while another drags a heavy sack in the manner of Millet's 1858 *The Gleaners* — prototypical images of rural working life. At far right, haystacks stand in irregular rows awaiting retrieval.

In contrast, Stettheimer painted the lower three-quarters of the composition in bright, pure primary colors. The broad yellow ground is broken by the sprinkling of five figures and assorted cushions and blankets. Oblivious to the work taking place behind them, the figures in the foreground are relaxed and amorous, as though the natural landscape were a catalyst for flirtation. In this, the painting follows such prototypes as Jean-Antoine Watteau's Rococo *fête galante* paintings, works by the sixteenth-century Venetian artist Giorgione, and the allegories of Peter Paul Rubens.[35]

Stettheimer used the painting to give visual shape to the distinct and disparate personalities of herself and her two sisters: Carrie, the hostess, Ettie, the would-be siren, and Florine, the self-selected outsider. Marcel Duchamp, dressed in a lilac suit, raises the lid on a pot near Carrie, while Elie Nadelman, in a gold bodysuit, lies on his stomach facing Ettie. His feet terminate in points, reminiscent of the attenuated feet in his sculpture.[36] Both pairs of figures mirror each other in complementary poses: Duchamp and Carrie half-kneel with arms outstretched, while Nadelman and Ettie lie with elbows bent and legs crossed at the knee. Meanwhile, at the left, as usual, Florine sits alone, looking away from the others. Clearly separating herself from their activities, she watches the rapturous wiggling of an adjacent white dog. In several of these later family paintings, Stettheimer's separateness from the others involves interaction with a small animal.

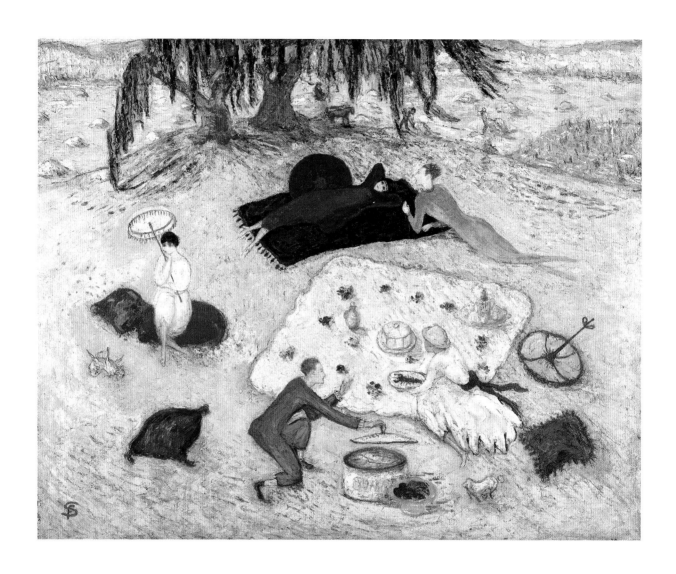

Fig. 50 Florine Stettheimer, *Picnic at Bedford Hills*, 1918, oil on canvas, 40 ⁵/₁₆ × 50 ¼ in., Pennsylvania Academy of Fine Arts, Gift of Ettie Stettheimer.

In *Picnic*, as in her early "siblings screen" and many of her subsequent portraits, the artist used props—in this case umbrellas with their names on each—to illustrate their personalities. The individual sisters are isolated in enjoyment of distinct activities. At the far left of the composition Florine sits on a rounded pillow. Of the three sisters, only she grasps her fringed parasol, using it to shield her skin from the sun and the prying eyes of any strangers looking on. In the lower center, Carrie bends over a flowered plate, preparing an elaborate meal of lobster, soup, and dessert. She is so intent on the meal that she does not notice her abandoned yellow parasol lying upside down at right. Ettie, in the background, engaged in her favorite pastime, flirting, lies on her back. She glances up, her head resting against her hands as Nadelman lies near her, talking. Ettie's purple and red umbrella is propped up on its side, accentuating the rounded lines of her hips and accentuating her flirtatiousness.[37]

On July 22, 1918, the Stettheimer sisters held an intimate party to celebrate Rosetta's birthday. Florine commented in her diary at the end of the summer, "The only things that amuse me nowadays are my own paintings in the making." A year later, Florine commemorated her mother's birthday by a painting she titled *Heat*, which was set in the backyard of their rented Bedford Hills summer home.[38] (*Fig. 51*) Carl Van Vechten described the painting as one "in which the corseted parent in heavy black sits bold upright, while her daughters [including the fourth daughter, Stella], exhausted by the humidity, recline, wilt, and expire in informal positions."[39]

Stettheimer artfully used the title, colors, and elements of the composition to add to the painting's sensory attributes. *Heat* is composed as a vertical flag, with three wide bands of red, yellow, and green. The languid poses of the women echo the sagging branches of the willow trees at top and the cherry blossom branches in a jar at bottom. Stettheimer borrowed these elements from Japanese woodblock prints that she collected and used for aesthetic effect rather than veracity—cherry blossoms are out of season during hot, humid Westchester summers.

Within these bright, hot color fields, the figures are disposed clockwise, with Rosetta at top, and her birthday cake, lit with candles, at bottom. *Heat* exemplifies what Charles Demuth wrote of Stettheimer's paintings: "There is to be found here a quality which is found in the 18th Century French, a quality of the slightly ennuied, not exhausted, just a trifle of fatigue, and not expecting but constantly demanding great surprises and thrills from a period too completely understood to furnish them. She is more in the know of the Trianon than Marie Laurencin who is generally acclaimed its modern interpreter."[40]

The three most traditional women all are accompanied by baskets containing knitting. At right, Carrie pauses from her knitting to smoke; the elegantly dressed Stella is shown in profile. Her knitting lies abandoned while she animatedly gestures to her mother, who sits like an enthroned

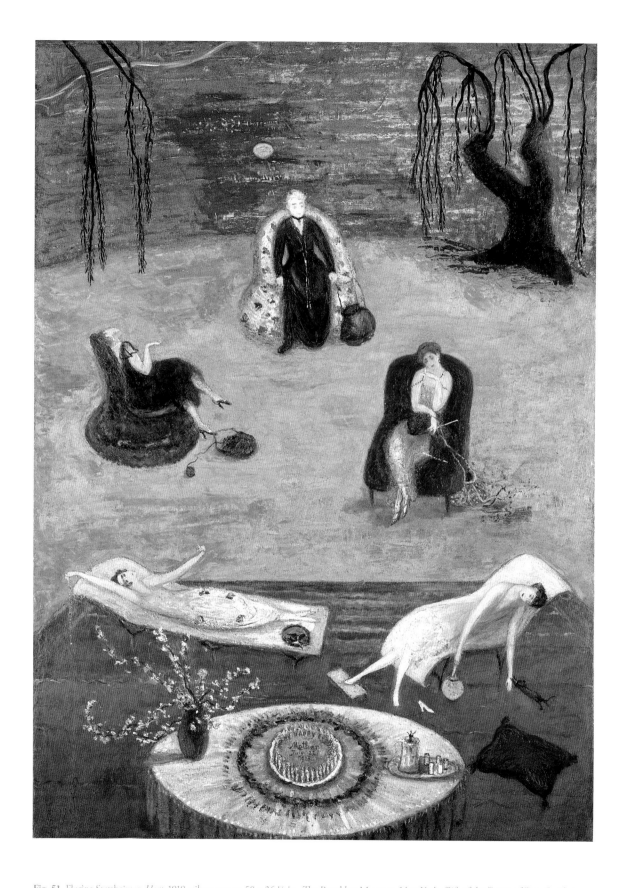

Fig. 51 Florine Stettheimer, *Heat*, 1919, oil on canvas, 50 × 36 ½ in., The Brooklyn Museum, New York, Gift of the Estate of Ettie Stettheimer.

Buddha at the apex of the triangular group, her basket lying at her feet. Ettie, with her prominent brows and rose-embroidered dress, lies at left, her arms stretched out, a pearl neckline in one hand, a cigarette in the other, a curled cat sleeping at her feet. Florine turns completely away, once more psychologically separating herself from the others. Instead, fan in one hand, she leans out to the right and plays with a small, exuberant cat.

In 1929, a jury of prominent art critics, museum directors, collectors, and art dealers was asked by the New York City Arts Council to submit the names of so-called "important contemporary artists" for an exhibition, *100 Important Paintings by Living Artists*. Stettheimer was one of the artists chosen, and she sent *Heat* to the exhibition, which included works by Charles Demuth, Joseph Stella, Henry O. Tanner, Thomas Dewing, and Preston Dickinson.[41] In his review in the *New York Times*, Edward Alden Jewell specifically praised *Heat*, calling the work "an amazingly successful affair."[42]

Toward the end of the July, Duchamp arrived at the Bedford Hills house with a miniature version of his painting *Nude Descending a Staircase*, painted especially for the gallery in Carrie's dollhouse. Because of America's involvement in the war, in which he refused to participate, Duchamp was uncomfortable in the United States, and he made plans to leave for Buenos Aires. According to Ettie, he made three requests to her to accompany him on the trip, leaving her baffled as to why he asked her. She also wrote that he intended to buy her a tortoiseshell ring and instead gave her a "guard ring and scratched something on it."[43] Although some have speculated that Ettie had a romantic relationship with Duchamp, Joseph Solomon later firmly disagreed, saying it was more an enjoyment of wordplay and that both loved to flirt.[44] He added, "Duchamp was for Florine." However, he described the latter two artists' relationship as "collegial rather than romantic" as they "shared conversations about art and respected each other's innovative work."[45] Duchamp was sixteen years younger than Florine and fourteen years younger than Ettie and was outspoken in his dislike of conventions such as romantic attachments. It was also well known among his friends that, during the period he lived in New York, Duchamp was involved sexually with several women. Given Florine's belief that romance interfered with a woman's creativity and independence, and given Ettie's inherent conservative prudishness, it is highly unlikely that the relationship with either Stettheimer resulted in anything more than a flirtation.

On August 12, Duchamp sent Florine a small drawing mapping his trip from New York to Argentina. Titled *Adieu à Florine*, the work consists of a map of the Americas with an over-scale drawing of their André Brook summer estate with the word "cool" written near it in its approximate location on the upper East Coast, and the word "hot" along the coast of Argentina, where he was then located, at the lower end of the drawing. On the other side, he noted "two years and twenty-seven days" from 1915 to 1918, which was the amount of time he had spent in the United States. It would be several years before Duchamp returned to New York.

The four Stettheimer women continued to entertain many members of New York's social, cultural, and literary avant-garde over the next two decades. Carrie was responsible for the elaborate, several-course meals served in the Manhattan apartment and weekend country houses. Duchamp humorously referred to her as "House keeperin,"[46] as she oversaw the food shopping and trained a series of German cooks. Afternoon parties consisted of rich Viennese or German Sacher torte served on fine porcelain with tea or Madeira. Even during Prohibition, evening activities at the Stettheimer household began with rum cocktails, daiquiris, or champagne served in the drawing room, although the Stettheimers refused to deal with bootleggers. Florine even wrote three versions of a poem titled "Prohibition," indicating they knew they were breaking the law. Version 1 reads:

〜〜〜〜〜〜〜

Prohibition
A blimpity blimp
Was a little way up
A voice called from earth
"Hey there stop!

I know you have wine
Send down a line
I'll come up
I'm a revenue cop"

"Come along up
But if you look
There's a parachute"[47]

〜〜〜〜〜〜〜

Dinners were held in the large family dining room and were prepared by the live-in chef. Carrie would carefully type out what was served for every special meal and who attended. The meals were notable for the house specialties, such as smelt stuffed with mushrooms, lobster in aspic mayonnaise, chicken chaud-froid, feather soup, oyster salad (immortalized by Avery Hopwood when he introduced it to the Broadway stage in his play *The Gold Diggers*), and many other specially prepared dishes. Dinners were served with heavy silverware and Worcester, Rockingham, or Crown Derby porcelain.[48]

In a 1945 review of Florine Stettheimer's Museum of Modern Art exhibition, the critic Paul Rosenberg, who attended the Stettheimer salons, noted:

inevitably like her paintings . . . figure in all accounts of the art movement in New York. It was a genuine gathering-place of its sort; not one of those which, in the wit's words, "set out to be salons and succeeded only in becoming restaurants." The celebrities in the world of art and literature periodically appeared there. God knows, on many occasions they formed notable collections of freaks. But one also met Henry Mencken,[49] Sherwood Anderson, Georgia O'Keeffe. Artists indeed voluntarily went there and not at all merely because of the individualities of the trio of women and their tasteful hospitality. They went for the reason that they felt themselves entirely at home . . . in their company. Art was an indispensable component of the modern, open intellectual life of the place. The sisters felt it as a living issue. Sincerely they lived it.[50]

Although noting that the salons were not occasions of wild, raucous activity, most friends agreed they were crucial sites of avant-garde intellectual and cultural thinking. They included a remarkable mix of guests, including museum curators and significant gallerists; innovative European and American artists, dancers, musicians, poets, and writers; noted historians and politicians, serious philosophers, and social dandies; gays, bisexuals, and heterosexuals; and Gentiles, Catholics, avowed atheists, and Jews.

In a catalogue of the 1945 exhibition, McBride remarked that Stettheimers' gatherings:

for almost a generation . . . [were] one of the most acknowledged intellection salons of the town[51] . . . [and] had considerable to do with the shaping of the intellectual and artistic impulses of the past just past . . . [and were where] hardy ideas were put into words which echoed sooner or later in other parts of the city. They were quite unlike other contemporary New York salons, where "something unexpected was apt to happen . . . there was nothing unexpected in the proprieties that prevailed there and which were fairly Bostonese in character. Occasionally a gifted refugee from Greenwich Village drifted in, but if there were too much of Eighth Street in his manner, he was unlikely to reappear.[52]

However, McBride vehemently asserted that conversations at the salons were intelligent and ranged in variety: "The Stettheimer salon was more *convenable* than most! . . . the conversation was far from routine," he wrote, ranging from the British intellectual Alfred R. Orage discussing the spiritual teachings of G. I. Gurdjieff, to Ettie mentioning actress Mae West's recent arrest due to her play *Sex* (which the Stettheimers had recently seen). The arrest, all agreed, was "to the great enhancement of [West's] reputation."[53]

Van Vechten, one of the Stettheimers' frequent guests, noted that the Stettheimers made no effort to "'capture lions'; nonetheless many 'lions' were attracted to and attended the ladies' Salons." Because of her doctoral degree, Ettie was considered the most intellectual of the three sisters.

She tended to lead the conversations at the family salons, encouraging serious conversations among the guests; as she noted in a letter, "I have become quite an amuser." Florine assumed the role of silent observer. As Van Vechten recalled, she was not particularly social, and "she seldom attended any except those given by members of her own family, and even at these she was frequently inconspicuous." Yet McBride also recalled that at the family salons,

> Stettheimer seemed often a furtive guest rather than one *genii loci* which she undoubtedly was, for her demure presence invariably counted. The artists who came to these parties came because of her, most of them in the avant-garde, such as Gaston Lachaise, Charles Demuth, Pavel Tchelitchew, et al., but all the others in attendance, the writers, singers, dancers, and sometimes even scientists, were definitely interested and amused by Florine's paintings.[54]

An anecdote told by Carl Sprinchorn, who captured a Stettheimer salon evening in a watercolor, reveals another, more characteristic, aspect of Florine's personality as both intelligent introvert and observer: he noted that she watched, listened, and didn't talk unless she had something to say. When she did, it was usually a strongly held opinion, often ironic, caustic, and best said one-on-one rather than to a group. One night at a particularly lively salon, Sprinchorn was about to leave but realized he had not spoken a single word to Florine. However, as he walked to the door, she suddenly materialized, and they spoke for half an hour before he left.[55] In a gouache, Sprinchorn captured this moment as the artist stands wearing a stylish crimson dress, a matching cape and her characteristic beret in the foyer of the Alwyn Court apartment. (*Fig. 52*)

Stettheimer recorded her view of the Stettheimer salons in a painting which she executed around 1919.[56] The work depicts her presenting one of her new paintings to her guests. The art critic Paul Rosenfeld later described viewing Stettheimer's work at these events, noting, "It hung on the walls, stood on the easels . . . And sitting before these pictures, probably more than one musing art-lover reached the conclusion that the painter was one of the most talented and individual artists of her sex that have appeared in English-speaking lands."[57] Rosenfeld's praise notwithstanding, the painting, titled *Soirée* (*Fig. 53*), is one of Stettheimer's most ironic and sophisticated works, a visual joke painted for her own amusement. At the same time, it is an exploration of the act of looking, or, to borrow a phrase from art historian Norman Bryson, "overlooking," and satirizes the posturing and blindness so often mistaken for art appreciation.[58]

At painting's top left, Ettie, Isabella Lachaise, and Maurice Sterne gather below a partial image of Florine's *Family Portrait I.* On the lower left, Gaston Lachaise and Albert Gleizes stand facing a canvas that can be seen only from its back. Avery Hopwood and Leo Stein sit in the central area; behind them is the Hindu poet Uday Sankar,[59] sitting directly before Stettheimer's nude self-portrait

Fig. 52 Carl Sprinchorn, *Florine Stettheimer in the Foyer of Alwyn Court*, 1936, 16 ½ × 12 in., Private collection.

on a large easel. At right, Juliette Roche-Gleizes, Florine, and a partial figure wearing a harlequin costume rest on a red and white couch.

Stettheimer again included in *Soirée* several allusions to well-known Old Master paintings — in this case, two proto-modern artists, Velázquez and Watteau, whose work is marked by ironic ambiguity about the nature of representation in art. Watteau is credited with inventing the genre of the *fête galante*, which depicted leisure amusements and frivolity among the eighteenth-century French upper class. At the same time, he was skilled at capturing psychological aspects of human nature. In his most ambitious paintings, he linked a series of significant moments into a psychological ensemble representing a "miniature Mozart operetta."[60]

Soirée represents a modern equivalent of Watteau's *fête galante*, with New York's cultural avant-garde enjoying their pleasures indoors. The most obvious reference to Watteau is a partial figure of Harlequin (Watteau also painted Harlequins) with folded hands at right. Considering Duchamp's personality, with his love of humor, irony, and tricks, Stettheimer likely intended this harlequin in *Soirée* to be a direct reference to Duchamp. However, she depicted him metaphorically, and only partially visible, as he had already left the country.[61]

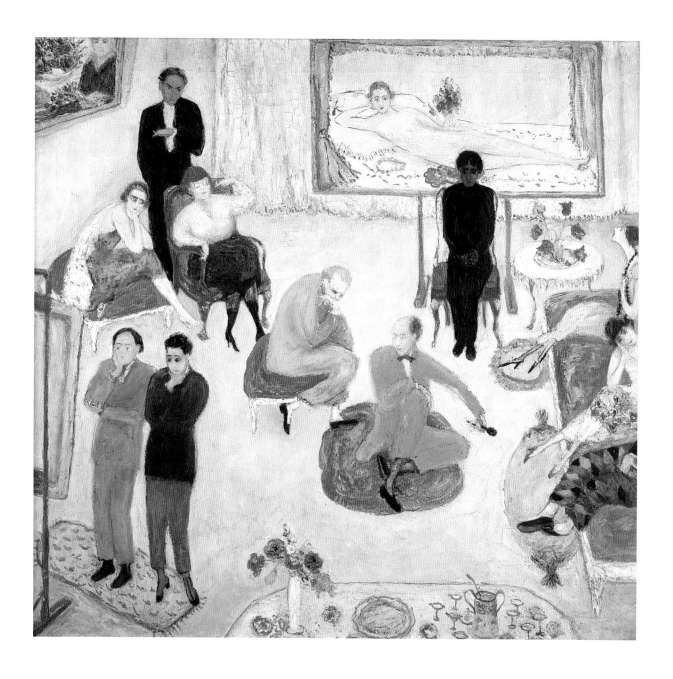

Fig. 53 Florine Stettheimer, *Soirée*, 1917–18, oil on canvas, 28 ¼ × 30 in., Yale Collection of American Literature, Beinecke Rare Book and Manuscript Library, Yale University, New Haven, CT.

In *Soirée*, the painting on the easel seen from the back refers to a similar device used by Velázquez in *Las Meninas*, the painting that Stettheimer greatly admired in the Prado in 1912. As in the Spanish painter's work, the conspicuous placement of the two-dimensional rectangle, whose subject we cannot see, reinforces the reading of Stettheimer's work as an exploration of the theme of looking at art. The figures gathered within Stettheimer's composition, like those in Velázquez's work, embody a form of royalty, a circle of literary and artist friends who made up the Stettheimers' avant-garde "family." And just as Velázquez included his own portrait at the back of his painting, Stettheimer similarly included an image of herself looking out at the viewer hanging on the back wall.

Furthering this idea are the telling gestures of the four frontmost male characters. Each man is covering or blocking one of his sensory organs: ears, mouth, or eyes turned away in response to the new work of art by Stettheimer that is the main event of the evening. They gesture like the monkeys who "hear no evil, speak no evil, and see no evil."[62] At farthest left in front of the painting, Lachaise holds his elbow with one hand while the other covers his right ear. Next to him, Gleizes cups his chin and seals his lips. Both men gaze at the unseen painting without expression. This is repeated in the center of the painting, where Hopwood sits eyes downcast, turned away from the painting with the back of his palm covering his mouth. In another humorous play with Leo Stein's earpiece, Stettheimer depicts the semi-deaf Stein holding his hearing aid as far away from his body as possible so he cannot hear anything—a nasty, humorous touch, as Hopwood was thought to be rather boring.[63]

In fact, of all the figures in the painting, only Gleizes and Lachaise actually look at Stettheimer's new work. Ettie, Isabella Lachaise, and Maurice Sterne on the left stare blankly forward. Only Juliette Gleizes, seated on the farthest edge of the sofa on the right, appears to notice the facial resemblance between the large nude painting hanging at the back of the room and her hostess, the artist, seated next to her. As she gazes up at the *Nude Self-Portrait*, Gleizes raises her hand to her chest in a gesture of astonishment.

Amusingly, the head of the Indian poet, his hands folded neatly over his crotch, conveniently blocks our view of the nude's genitals. In the painting within the painting, the nude self-portrait rests her head on her right palm and looks out at us even more impudently than in the original 1915 work. (*Fig. 54*) As if to reinforce the likeness between them, the figure of Stettheimer seated on the couch in *Soirée* holds her head in exactly the same pose as her painted avatar. (*Fig. 55*) She leans forward and stares out of the canvas, acknowledging our presence and inviting us to share her amusement at the blindness of the others in the scene. They are either too caught up in their own thoughts or too blind to recognize her *Nude Self-Portrait*, and thereby to recognize Stettheimer as a serious artist.

Fig. 54 Florine Stettheimer, detail of *Nude Self-Portrait* head from *Soirée*.

Fig. 55 Florine Stettheimer, detail from *Soirée*.

Whenever she could, Stettheimer escaped from her family to her studio, where she could be in a room of her own and seriously pursue her painting, without distractions. She had less and less in common with her sisters, who remained more inclined toward nineteenth-century manners and morals, and to an aversion to publicity. Nonetheless, in her diary of 1919, Ettie enviously noted, "If the family were only in good health, I would take a studio as F[lorine] does and absent myself during the day and work" [presumably on her fiction].

Sometime during that year, Stettheimer was asked to participate in an exhibition that was to be hung in Dr. Stickney Grant's Episcopal church, a site known for its "People's Forum" and the socialist leanings of its pastor. Stettheimer refused, stating that she disliked what she perceived as religious hypocrisy and that she did not respect churches that baptized so-called "fashionable Jews," who kept their designation as Jews but wanted to attend Christian services. She also declined organizer Hamilton Easter Field's request that she participate in a rival *salon des non-invités* to an affair known as the Luxembourg show, insisting that her refusal was not due to sulking at the fact that she had not been invited to participate in that exhibition.[64]

On November 3, 1918, the Allies signed an armistice with Austria-Hungary. During the next few days, as peace with Germany seemed certain, the people of New York celebrated. Ettie heard the city go "crazy with delight . . . following the premature report that Germany had signed the Foch armistice—stores closed, shop girls kissed all soldiers, deafening noise." On November 12, the Stettheimer sisters were awakened by bells and whistles announcing the armistice between Germany and the Allies, which had been the day before. Florine recorded the date and her activities in her journal, including her dining separately from the others in her large studio, and indicated her efforts on behalf of the war:

The first day of the new warless age — is it? — I hope but doubt it. I am tired, yesterday I was alive for so many hours at five the whistles told of the armistice — at seven I got up before ten — Fifth Avenue was a joyful mass of humanity — I left my studio and went to the Red Cross — celebrated that way — I sewed goods and watched the windows opposite the library, Mother and Carrie called for me at lunch . . . We marketed and I cooked the chops in my studio, then we all returned to the Red Cross — The Gleizes dined with us — we spoke — Gleizes did — politics.

Again, rather than explicitly dealing with the war, Stettheimer celebrated the peace process in a painting titled *New York/Liberty*, demonstrating her patriotism and love of New York. (*Fig. 56*) The painting is a highly realistic reenactment of President Woodrow Wilson on December 4, 1918, as he sailed from New York Harbor aboard the USS *George Washington* for the Paris Peace Conference. As usual, Stettheimer accurately depicted the many details of the scene through detailed research.

As it departed for the Conference, the USS *George Washington* was escorted through the harbor by the USS *Oklahoma* and other military ships and a Navy blimp flying overhead. These can be seen in the mid-ground and upper right of Stettheimer's painting. The perspective and scale of the composition give the impression that the viewer is on board the destroyer. The president stands in the battleship's forecastle, beneath the looming lookout tower with its early radio antenna. He is identifiable by his characteristic high forehead and round spectacles. Two sailors in dress uniform stand below in "manning the rail" ceremonial formation, used when entering and exiting a port. Between them is a huge rendition of the United States' Great Seal with the bald eagle and thirteen stars.

The high-relief, gold-plated rendition of the Statue of Liberty stands prominently on the left, more open side of the painting. The statue served as a monumental marker of boundaries between cultures and eras, marking "the spot where America begins and the authority of the Old World holds no sway."[65] Although the copper statue was dedicated on its site in 1886, the Statue of Liberty gained a widely recognized new meaning, visibility, and stature during World War I. In 1916, a fundraising initiative was begun by the newspaper *The World* to redesign Liberty's torch, replacing its copper with glass to enable it to light up. Over $30,000 was raised by the paper's readers, and, on December 2, 1916, President Wilson pressed the key that turned on the Statue of Liberty's torch light. Five months later, when the United States entered the war, the Statue of Liberty became a key symbol of why Americans were fighting overseas: to secure liberty in Europe as well as in the United States. Images of the statue were widely used by the U.S. government on recruitment posters and in materials promoting "Liberty Bond" drives that raised money to support the war.

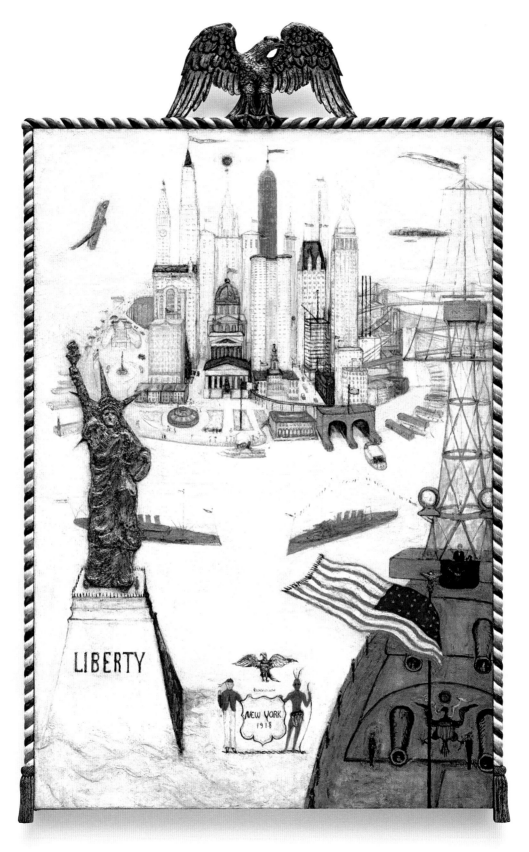

Fig. 56 Florine Stettheimer, *New York/Liberty*, 1918–19, oil on canvas, 23 ⅝ × 16 ¹⁷/₃₂ in., The Whitney Museum of American Art.

New York/Liberty offers an interesting homage to New York's past, present, and future. Stettheimer subtly divided Manhattan so that the right side, with its predominantly gray/silver paint, represents the growth of skyscrapers, bridges, new growth and construction, while the left side is the site of open, less constructed green space. At the bottom of the painting, the city's seal, bearing its name and the date of the painting, is surmounted by an eagle. Traditional renditions of a Dutch sailor and a Native American with feathered headdress stand on either side of the plaque, symbolizing Stettheimer's acknowledgment of the mixed ethnic origins of the city.[66]

The artist captured the Manhattan skyline circa 1918–20 as a mélange of traditional and modern architecture. In the foreground of Manhattan, Stettheimer included four diminutive Dutch brownstones at left; at right, the still-existing Greek Revival-style, red-roofed City Hall; and in the center, a stacking of government buildings, including the water-facing US Sub-Treasury Building, with its large George Washington statue in front. Directly behind it, one can see the columns and carved tympanum of the 1913 County Courthouse at 60 Center Street and the looming domed copper roof of the City Hall Post Office.

As though demonstrating the era's intense competition for the world's tallest building, the painting's skyline is crowded with the city's most recently completed skyscrapers. At left, there is the Metropolitan Life Insurance Building, with its large clock, located on Madison Avenue and Twenty-Third Street, which at 700 feet was the tallest building in the world from 1909 to 1912. Directly to its right and towering over all the others is the Neo-Gothic Woolworth Building. Completed in 1912 at 233 Broadway, it retained its claim as the world's tallest skyscraper until 1930. Adjacent to it stands the massive Manhattan Municipal Building, completed in 1914, with the large red, round-topped Singer Tower on its right side. The latter was completed in 1908 with a very ornate architectural design.[67] To help identify several of the skyscrapers, Stettheimer added a flag with the words "5 & 10 cents" atop the Woolworth building and wrote "Singer" on a banner flying from the top of that building's cupola. Tucked between the rising steel construction of a new building and the Municipal Ferry Terminal, one can see the very dark brownstone of Wall Street's Trinity Church, one of the oldest buildings in the United States.

Although the specific elements of her painting are rendered so as to be immediately recognizable, Stettheimer disregarded accurate distancing and placement in favor of depicting what she found made the most interesting composition. The locations of the State Park, the Ferry Terminal, and the string of bridges connecting Manhattan to the other boroughs on the right side of the painting are straightforward, but little is visible of the East Side beyond the buildings in the front. However, Stettheimer distorted the West Side of Manhattan by bringing Columbus Circle, which is located at Fifty-Ninth Street, all the way down to the bottom of the island, where it takes up a

quarter of the space. It would never have been visible from the harbor, nor would have been the painting's long view up the West Side Highway (already full of cars) to Washington Heights. There Ulysses S. Grant's large marble tomb, located at West One Hundred Twenty-Second Street, sits atop Riverside Park, in which Stettheimer accurately situated the Museum of Medieval Art, a private collection belonging to the sculptor George Grey Barnard that opened to the public in 1914. A decade later, with John D. Rockefeller's assistance, it would become the Metropolitan Museum of Art's collection of medieval art, housed yet farther uptown, at the Cloisters.

In the *New York* painting, apart from the gilded statues of Liberty and George Washington and the Courthouse dome, Stettheimer limited her palette to red, gray, and blue against a white background to reinforce its subject, America. The flat, neutral gray shape of the destroyer at right is partially covered by a large, billowing American flag. The extraordinary frame, surmounted by the large, three-dimensional gilded wooden eagle, is made of turned wood and is also painted red, white, and blue. There are many tiny American flags flying throughout the painting, all facing toward the right, indicating a strong eastern wind — except the two flags on the USS *George Washington* which point in the other direction. A prominent French flag stands at the front of Manhattan Island, indicating the president's ultimate destination.

A mixture of old and new technologies representing the past and the present is also apparent in the various forms of transportation Stettheimer chose to include in the painting. For example, several contemporary, flag-bedecked battleships skirt the tip of the island, bringing in the president's ship. The older Staten Island Ferry either enters or leaves its terminal at the right, and a small traditional paddleboat crosses in front of figures promenading along the boardwalk. In the sky, a small hot-air balloon flies directly over the Municipal Building while the huge, rigid, inflated Navy zeppelin escorting the presidential ship glides through the air at right. At left, a single-seat, open-cockpit World War I biplane fighter aircraft flies directly upward toward the three-dimensional gilded wood eagle astride the frame. Stettheimer had visited an air show in 1912 while living in Munich. In her diary, she noted seeing some "beautiful flying — it is the first time I have ever seen an aeroplane started — but — I was not as thrilled as I should have been if I had not seen it in cinema shows."

In 1921, a selection committee including regionalist artist Thomas Hart Benton, colorist Arthur B. Carles, modernist Joseph Stella, and Alfred Stieglitz included Stettheimer in the *Exhibition of Oil Paintings and Drawings Showing the Later Tendencies in Art*, at the Pennsylvania Academy of the Fine Arts. She sent two paintings to the show, *West Point* and *Asbury Park South*. For her birthday, Ettie gave Florine the British art critic Roger Fry's book *Vision and Design*. Its general thesis was that the purpose of art should not be the mere imitation of reality, but that its inspiration should

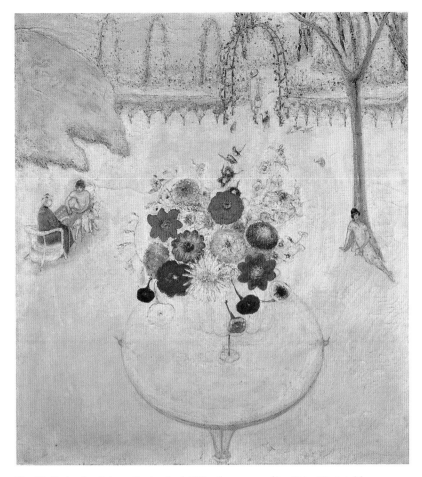

Fig. 57 Florine Stettheimer, *Russian Bank*, 1921, oil on canvas, 40 × 36 in., Virginia Museum of Fine Arts, Richmond, Gift of Miss Ettie Stettheimer.

spring from the artist's imagination. Stettheimer wrote a letter thanking Ettie but described Fry sarcastically as "a simple soul — and I think not from choice." She continued, "There is a reproduction of Gertrude Stein's portrait by Picasso in the book — it is interesting but she doesn't look fat, comfortable, nor humorous — and no Homeric laugh could ever come from the lips he painted," negatively comparing it to a poem she'd written about Stein.

That year, the Stettheimers again spent the summer at André Brook, where Florine painted a series of still lifes. with increasingly stylized flowers serving as the central compositional motif. She used the device of a large central flower bouquet to create a series of works, beginning with *Russian Bank*. (*Fig. 57*) The painting again is set in the André Brook garden. The title is based on the name of the card game that Rosetta and Carrie, seated in bright yellow chairs, play at left.[68] The artist depicted herself again with her back to the members of her family, wearing her white pantaloons and red high heels and accompanied by a small dog she walks back toward to bowers of the garden with a watering can. McBride later recalled that Rosetta often sat in the garden, playing Russian

Bank while "her giddy daughters enacted the roles of Julie de L'Espinasse, Mme du Défend and Mme de Staël in modern dress,"[69] although nothing in the actions or gestures of the three middle-aged sisters in the composition indicates their mood as particularly "giddy." The composition of *Russian Bank* remained the same through the 1930s, when Stettheimer had her large Beaux-Arts studio and apartment photographed. However, perhaps as a sign of the increasing enmity between them, Stettheimer at one point eliminated Ettie's image from the painting.[70]

During the early 1920s, Marie Sterner asked to take several of Stettheimer's paintings to Paris and London. Just as she had declined McBride's invitation of an exhibition of her work at the Galerie Charpentier in Paris, due to her worries of damage during ocean transit, she said no. In March 1921, Stettheimer again exhibited at the Society of Independent Artists, sending *Spring Sale at Bendel's*.[71] In April, she exhibited her painting *Russian Bank* in the first *Modern Artists of America* exhibition held at the Joseph Brummer Gallery, at 43 East Fifty-Seventh Street in New York. Brummer had relocated his gallery from Paris the year before and sold classical and Renaissance as well as modern European and American art. Once a year this included exhibiting for possible sale works by the members of Modern Artists of America. In the introduction to its first catalogue, this newly formed, membership-only, "experimental, anti-academic" art society claimed to be the "new hope for the future of American art," and stated that through its exhibitions, the "spirit of life, of fearlessness, of joy, of restlessness which animates so much of the work of the younger men will be able to make itself felt."[72]

As the membership in the Modern Artists of America was supposedly for men only, it is surprising that at the time of the founding, Stettheimer and her friend Marguerite Zorach were also listed as members. The male members—who included a mix of Stettheimer's friends such as Bouché, Lachaise, and Nadelman, as well as other noted artists including Stuart Davis, Yasuo Kuniyoshi, Joseph Stella, and Thomas Hart Benton—believed Stettheimer's art to be "fearless, joyful," and full of the "spirit of life," and made her a member. As Stettheimer was not interested in selling her work, she put a ridiculously high price on the paintings to ensure they would not be purchased.

Through invitations to the salons, many important guests became familiar with Stettheimer's unique furniture. Steichen was particularly taken with her aesthetic; and for a photo shoot of their upcoming film, *Monsieur Beaucaire* with film star Rudolf Valentino and his wife Natacha Rambova, he asked Stettheimer whether he could use her studio. She agreed and the November 23 issue of *Vanity Fair* magazine featured a photograph of the darkly handsome actor and his wife standing in front of a fire screen designed by Stettheimer in her studio. The screen's wood frame is covered with canvas with a small gessoed and plaster-raised, painted self-portrait of Stettheimer and her sisters. As was often the case, the artist portrayed herself wearing a fringed cloak and her white pantaloons. (*Fig. 58*)

Mr. and Mrs. Rodolph Valentino

Fig. 58 Edward Steichen: *Mr. and Mrs. Rudolph Valentino*, page from *Vanity Fair*, November 1923; Florine Stettheimer Papers, Rare Book and Manuscript Library, Columbia University in the City of New York.

Between 1921 and 1924, Stettheimer included paintings in at least twenty exhibitions at major museums, commercial art galleries, art clubs, and important invitational exhibitions of contemporary art. The Stettheimers spent the summer of 1923 in Sea Bright, New Jersey, where the artist brought her paints. Florine enjoyed being near the water and watching the bathers at the shore, noting in her diary, "The beaches are wonderful—America's youth have discarded all they can—and look well—unfortunately and funnily America's middle-aged fat and old fat are doing the same." Carl Spinghorn, the director of New York's New Gallery, offered Stettheimer a solo exhibition, but she declined.

The artist welcomed in the year 1924 by reading Marcel Proust's *Swann's Way*. It provided her winter entertainment, and according to friends, she talked "endlessly" about the author, whose *Remembrance of Things Past* she read volume after volume. When she finished the last book in the series, she "reread all the volumes consecutively."[73] In January, Stettheimer was sent an invitation to participate in the prestigious *Twenty-Third Annual International Exhibition of Paintings*, which opened in April at the Carnegie Institute in Pittsburgh. She sent *Russian Bank*. In mid-May, Carrie and Ettie took a trip through Massachusetts while Florine remained in New York and complained in a letter that Rosetta bossed and nagged her. She socialized with friends including Charles Demuth and painted. After years of absence, Adolfo Best-Maugard showed up at her studio, and the next day he brought the Mexican caricaturist Miguel Covarrubias to see her paintings.

When the *Twenty-Third Annual International Exhibition of Paintings*, or *Carnegie International*, opened its doors, Stettheimer relished the praise that *Russian Bank* received from critics. Organized by the noted artist Homer Saint-Gaudens, the exhibition had as its theme the different phases of contemporary art as practiced by academic, moderate, and "revolutionary" groups. Stettheimer's work was included in the American section, along with work by Cecilia Beaux, John Singer Sargent, and Joseph Stella, among others. Within a few days of the opening, Penelope Redd, writing in the *Pittsburgh Sunday Post*, singled out Stettheimer's painting and wrote perceptively of the innovative nature of Stettheimer's work:

> Florine Stettheimer invents a new mode of expressing symbolism as original as the Chinese in this painting (a garden scene entitled "Russian Bank"). She makes her garden not by the facts already described but in the superbly painted bouquet of flowers placed on a table, which makes a dazzling focus for the observer's eye. Miss Stettheimer is the only woman painter in America, and indeed there would seem to be few elsewhere who project an individual point of view on canvas. She carries the art of painting to its completest power in expressing a number of incidents occurring simultaneously . . . Miss Stettheimer, more than any other painter whom we know, has developed a symbolic and decorative type of painting that also engages us by its human interest.[74]

In June, Stettheimer joined her sisters in Williamstown, Massachusetts, stopping first in Cape Cod and Boston. Although Florine visited the Museum of Fine Arts and commented on some "charming" Indian and Persian miniature paintings, she generally found the museum's paintings "dreadful things — —they haven't even any color." The sisters continued their chauffeur-driven Packard trip to Providence, Rhode Island, where Stettheimer's taste and sense of racial tolerance clashed with that of a shopkeeper. When the elderly proprietress spoke "sneeringly" about a fan that the artist admired, saying: "Would anyone but the Chinese paint a red flower and decorate with a yellow tassel? . . . The Chinese are so crude." Stettheimer replied, pointedly misinterpreting her meaning, "Yes, [they have] *wonderful* color sense."

As usual, the artist quickly tired of travel and keenly missed being able to paint. In Providence, she complained in her diary, "I feel as if we were killing time—all summer I have felt that way—it's dreadful—and I am so conscious of the scarcity of time—I feel like an unwilling, helpless accomplice—I have done nothing—felt nothing—a fruitless summer." Although she returned to her New York studio, the scorching heat soon forced her to join the rest of her family in Atlantic City. On July Fourth weekend, she was accompanied at her family's house by Sherwood Anderson, the author of the acclaimed collection of short stories *Winesburg, Ohio: A Group of Tales of Ohio Small*

Town Life. Amused at watching him on the beach, she noted: "Sherwood Anderson / paternally / dutifully / naïvely / nude."[75]

In the fall, the women returned to New York, and Stettheimer read, at Van Vechten's suggestion, Léon Pierre-Quint's recent biography *Marcel Proust: His Life and Work*. She wrote to Van Vechten, "I liked the life of Marcel Proust, especially Pierre-Quint's appreciation of the Proustian Art. But I like your appreciation of my art even more."[76] In December, Stettheimer entered a group of painted flower panels in the *Twenty-Third Annual Exhibition of Modern Decorative Art*, at the Art Institute of Chicago. There they were exhibited with ceramics, tapestries, furniture, and decorative arts designed by some of the foremost artists and designers of the era. The assistant curator of the Art Institute wrote to her, asking whether she was willing to lower the price on her *Flower Panel with Pink Curtains* because a Mrs. Walter Brewster, "a very influential and delightful person with more taste than usual," had expressed interest in purchasing it. The curator wrote, "I think that her owning one of your pictures might possibly lead to others coming to Chicago." Stettheimer remained unwilling to sell and refused the offer.

The Stettheimer women spent summer 1925 along the Jersey Shore, this time in the wealthy section of West End, returning to New York for the occasional party. Florine attended a "colored party"[77] at the Van Vechtens' home and returned to her studio to paint. She also began two paintings of her neighbors and relatives the Guggenheims, labeling them in her diary as "the G's," resting near the water.[78] On one occasion, Irene Guggenheim came by to tell Florine that she had "a great admirer who is crazy to meet you." The artist retorted that she "did not want to be bothered," as she was working.

In 1926, the four Stettheimer women moved to a large fourteen-room apartment at Alwyn Court, on the corner of Fifty-Eighth Street and Seventh Avenue in Manhattan.[79] The building's François I exterior decoration, perfectly suited to Stettheimer's aesthetic, was "so alive with crawling salamanders and plump putti" that friends such as Van Vechten referred to it as the "Château Stettheimer." She decorated the drawing room and dining room of the apartment in the same white and gilded color scheme as she had their residence on Seventy-Sixth Street. However, when she offered to decorate the entire single-floor apartment, Ettie and Carrie "harbored exclusive tastes and protested volubly against this attempt to usurp their rights."[80] In keeping with their disparate personalities, Carrie's bedroom was quietly and elegantly decorated in shades of green, while Ettie's room was painted in violent tones of blue and red and furnished with theatrical Chinese-style furniture.

Florine's bedroom was the most whimsical of the three, and its abundant cellophane, crystal flowers, and gold decoration represented a rehearsal for the later decoration of her studio and public stage designs. Stettheimer had already designed an entire suite of furniture for herself by

Fig. 59 Florine Stettheimer's bedroom at Alwyn Court, Fifty-Eighth Street and Seventh Avenue, New York, New York, c. 1920s.

1916, as the canopied bed that she'd included in the Knoedler exhibition of that year was also her bed at Alwyn Court. Translucent material edged with tinsel fringe draped from the floor up to the top of four twisted free-standing columns on each side of the rectangular bed. The draperies then continued upward to the ceiling, gathering under a matching white and gilded crown inscribed with the artist's initials. A matching divan was positioned across the room, with four more curled columns on each corner. (*Fig. 59*) Instead of drapery, these columns were topped with fat, fully plumed palm leaves, also made of shiny tinsel. Completing the furniture were small rounded-front cupboards with skirts designed by Stettheimer to match her adjacent painting frames, tiny white and gilded side tables, and a white and gold-fringed painted dressing table.

The divan and bed were both covered with fringed, deep red upholstery, and a matching heavy red and gold-fringed fabric draped across and down all the bedroom windows. Next to this was shelving holding a collection of female statues representing various religions, displaying her catholic and feminist inclinations. These included Italian porcelains of bare-breasted women peeking out of vegetation, a small Madonna on a plinth, a pair of late fourth-century BC Greek Tanagra figurines and a Chinese blanc de chine bodhisattva. Whenever she moved, Stettheimer displayed her "favorite male" statue of the nude Apollo Belvedere in her bedroom. Now it was placed on the mantle of the fireplace, in front of her painting of zinnias flanked by curtains.[81]

In the late spring, McBride and Carrie left for Europe. In her sister's absence, Ettie "ran things" while Florine worked in her studio, and the two sisters went to movies at night. Rosetta continued

to need a great deal of care from her daughters, which prevented them from taking part in many outside activities. Carrie returned at the end of July, bringing her sisters elaborate Maison Giraud tea-gowns, but she too was soon worn out by the strain of caring for Rosetta. Florine and Ettie were alternately depressed and sick with asthma. Stettheimer found she had trouble painting due to "inner difficulties," possibly an early sign of her cancer. In mid-August, Stettheimer began several works, including two versions of *The Fourth of July*.[82] That Christmas Eve, the four ladies hosted a party with an eclectic guest list, including many of the major players in the city's cultural scene.

At the same time that the Stettheimer ladies moved into Alwyn Court, Florine exchanged her small studio for a very large duplex at the Beaux-Arts building that she referred to as her "estate." Her new studio, which looked out over Bryant Park, had a two-story living room with floor-to-ceiling windows, an upstairs bedroom, and a separate dining room. The enormous size of the main room enabled the artist to display large-scale works, and the long daylight through the tall windows proved ideal for working. Increasingly, when she did not need to assist with Rosetta, Stettheimer began sleeping at her studio, using the excuse of working late at her painting to avoid returning to her family apartment. Finally having the space to create the large works that interested her, she also began to search out new subject matter on the streets outside her studio.

| | |
|---|---|
| For a long time I gave myself | Color |
| To the arrested moment | Outside me |
| To the unfulfilled moment | Around me |
| To the moment of quiet expectation | Knocking me |
| I painted the trance moment | Jarring me |
| The promise moment | Hurting me |
| The moment in the balance | Rousing me |
| In mellow golden tones . . . | Smiling |
| Then I saw | Singing |
| Time | Forcing me in joy to paint |
| Noise | them . . .[83] |

During the next decade, from 1920 to 1930, not only would Stettheimer find entirely new subject matter for her work, but she would paint many of the most significant and accomplished works of her career.

chapter six

COURTING
CONTROVERSY

1919 – 1927

Stettheimer was more prolific during the 1920s than in any other decade. In addition to many flower paintings, she painted two significant groups of works, each very different in terms of subject matter and compositional structure. The first was a group of individual portraits that will be discussed in the next chapter. The second group comprised large works measuring up to four feet wide and six feet high. Each painting's subject addressed a highly controversial issue for the time and dealt with some form of identity politics. As examples of Stettheimer's fully mature style, these works require close, extended viewing as well as context to be fully understood. Perhaps this is the reason that the paintings' provocative subject matter and the innovative nature of Stettheimer's treatment were not recognized, either during her lifetime or in the near century since they were painted. But once we look closely at them, Stettheimer's radical points of view are evident.[1]

From an early age, Florine reveled in whatever was new. As Ettie noted, "Florine was one of the fortunate beings who live in the present because they love the present . . . and she loved the present because she was always occupied with painting and she loved to paint."[2] Beginning in 1919, Stettheimer painted several highly unprecedented, politically charged works exploring religion, race, gender, sexuality, and sexual orientation. She also depicted women without deference to male companions and, on occasion, reversed sexual roles with male bodies as the objects of desire. These were the only politically controversial works that Stettheimer would ever paint. Until now, they have not been fully considered in terms of what they reveal about the artist and her attitudes. Instead, they have always been superficially grouped together under classifications such as "amusements" and "entertainment pictures."[3]

To assess Stettheimer's progressiveness, it is important to take history on its own terms and not conflate the past with the present. During Stettheimer's lifetime, overt prejudice over race, sex, and religion was protected and even encouraged by federal and state laws. Jim Crow segregation, for example, was upheld by federal law until 1964. Homosexuality was illegal until 2003 and punished with jail time in many parts of the United States. During the 1920s through the 1940s, anti-Semitism and bigotry against Catholics by Protestants was rampant throughout most of the country; and American women did not receive the right to vote until 1920 (and as of this writing, the Equal Rights Amendment for women still has not passed.)

Stettheimer painted New York city and the world as she personally observed and experienced it. She addressed segregation, repression and bigotry around her by deftly undermining them, often using subtle humor. The paintings in this group are among the only works the artist titled according to specific, rather than generic, locations, thereby revealing their controversial nature due to the context of the sites. Stettheimer's social interactions as a wealthy older white woman were largely limited to those typical of her milieu: white members of the upper class and the avant-garde artists, writers, and intellectuals of varied sexual preferences who attended the various salons which she and her sisters hosted and frequented. Although an ardent liberal Democrat and feminist, Stettheimer was also an introvert and not an activist. Nonetheless, her views were unusually progressive for her time, and her family's salons were a uniquely safe and comfortable haven for friends of fluid sexuality and progressive ideas. But it is principally in her private diaries, poetry, and paintings that one finds the artist's subversive and controversial opinions.

In July 1919, only one month after the Armistice effectively ended World War I, the Stettheimers spent the summer at Camp Calumet, a vacation residence on Lake Placid owned by their cousin, Edwin A. Seligman. While there, Stettheimer painted a large work she titled *Lake Placid*, in which she captured an afternoon her family and friends spent swimming and boating on the lake. Due to her family's history with the area, Stettheimer was aware that Lake Placid, a fashionable retreat for wealthy Protestants, was also widely known to be a haven for anti-Semitism. In the mid- to late nineteenth century, her uncle, Joseph Seligman, had been the most prominent Jewish banker in the country and had served as a financial adviser to Presidents Abraham Lincoln, Ulysses S. Grant, and Rutherford B. Hayes. He was also the center of what many historians consider the first publicized anti-Semitic event in the United States: the Hilton-Seligman affair. In 1877, Seligman was denied admittance to the Grand Union Hotel in Saratoga Springs, New York, by its owner, Judge Henry Hilton. Declaring that the recent drop in his hotel's business was due to his Gentile patrons not wanting to fraternize with Jews, Hilton was generally hailed for using good business sense as a justification for the religious-based discrimination.[4]

This action immediately set a precedent for other hotel owners throughout the mountains and lakes of the Adirondacks taking the same action. The term "restricted" (which also became associated with the few Catholics in the area) was soon part of the area's lexicon. Within a few years, hotels were boldly advertising, "Jewish persons need not apply" and "Hebrews knock vainly for admission." In retaliation, Seligman and the Jewish community immediately called for a boycott of all Hilton-owned businesses, drawing national publicity and front-page headlines in the *New York Times*.

The Hilton-Seligman affair highlighted the budding sophistication of anti-Semitic practices throughout the United States as discrimination pivoted toward the alleged "lack of social refinement"

of Jews as a race. Hilton himself coined the term "Seligman Jew" to describe those possessing "vulgar ostentation, a puffed-up vanity . . . a lack of these considered civilities so much appreciated by good American society, and a general obtrusiveness that is frequently disgusting and always repulsive to the well-bred."[5]

In 1905, before the real estate surrounding the lake was fully developed, a few wealthy Jews, including Joseph's son Edwin, and cousin David Guggenheim, ignored the resort's discriminatory practices and bought land around the lake. They built their own large homes, or "camps," along the shore, forming a very small but wealthy Jewish enclave. Edwin was a highly respected Columbia University economics professor. But as a Jew, he was not allowed membership in what became the highly prestigious and renowned Lake Placid Club, established by New York's state librarian, Melvil Dewey, who dedicated himself to building "a community wealthy Jews would covet but could not join." The most popular social spot in the area, it was also known as "the flagship resort for bigotry . . . an efficient WASP's nest."[6] Under the heading of "Objectionable Guests," the club's 1901 handbook stated, "No person is admitted as a member or guest whom there is a reasonable, moral, social, race, or physical objection . . . the rule will be enforced whatever cost or annoyance." This rule was explicitly intended to exclude Jews and Catholics. Nor could Seligman, his family, or his friends go to most of the other local resorts or restaurants, including the popular Morley's Hotel, due to patrons' aversion to "association with Hebrews."[7]

In composing her painting *Lake Placid (Fig. 60),* Stettheimer tipped the foreground forward so that we become part of the composition and ran the mountainous horizon line along the upper edge of the painting. The figures, who are enjoying every form of leisure activity, are all identifiable, and with a few exceptions, ironically represent a mix of Jews and Catholics.

Lake Placid features Stettheimer's temporal unfolding (*multiplication virtuelle*), with her sister Carrie swimming toward the raft's left corner, and again seen sitting under a yellow parasol on the raft at right. Ettie is also depicted twice: in middle right, racing freestyle against the handsome, popular, and liberal Rabbi Stephen Wise, founder of the Free Synagogue in Manhattan; then again, in her red suit and cap, on the left side of the raft, where she crosses her legs and looks out at the viewer. Ettie later remarked in a letter about the painting, "I am performing the feat of being in two places, apparently at the same time."[8] This provides the composition with a sense of passing time and active motion.

The entire scene is carefully observed by Rosetta Stettheimer, standing on the deck, wearing her usual long black dress. On this occasion, rather than depicting herself as the observer, Florine, who was apparently sick and supposed to be staying in bed, gingerly tiptoes down the stairs in a pink fringed robe to join the activities, looking back to make sure her mother does not see her.

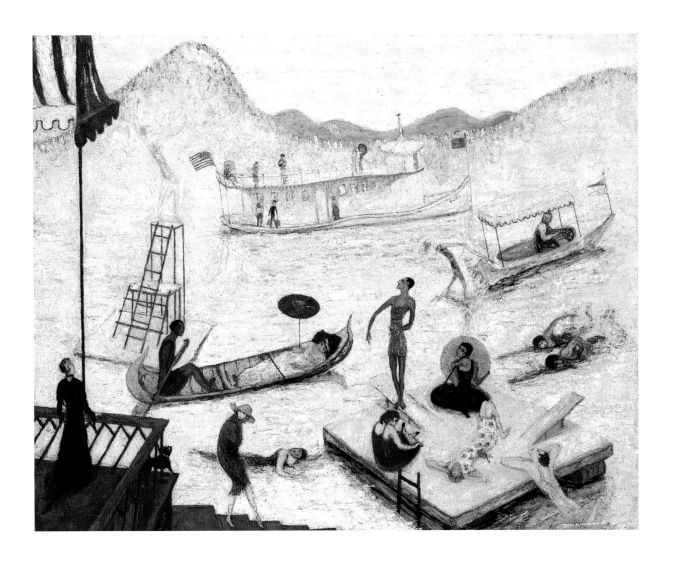

Fig. 60 Florine Stettheimer, *Lake Placid,* 1919, 40 ⅛ × 50 ⅛ in., Museum of Fine Arts, Boston, Gift of Miss Ettie Stettheimer.

Carrie on the raft looks up admiringly at the Catholic Marquis de Buenavista, who stands preening on the diving board. Once again, by depicting a man posing and showing off his slim body, well-shaped legs, and elegant profile, Stettheimer reverses the usual gender roles. Marie Sterner, in a flowered bathing suit, sunbathes with her arms behind her head, while Eli Nadelman, with his distinctive profile and curly red hair, hangs off the right side of the raft. At far right is the camp's owner, Edwin Seligman, at the helm of a canopied motorboat, with his daughter Hazel water skiing on a small platform, her blonde hair flying behind her.

If one looks closely at the figures, except for Rabbi Wise at the right, it is the *women* who are the most physically active figures in the composition. As historian David Tatham observed, "No painter before [Stettheimer] had portrayed the region as a place for . . . purely hedonistic play . . . included among its figures more women than men; or had made the women, whether active or indolent, equal in importance to their male companions."[9]

Stettheimer included *Lake Placid* in the 1919 *Exhibition of Independent Artists*. It caused a problem at the exhibition, though it was not the painting's subject matter, but its strong colors. As the artist gleefully noted in her diary, when *Lake Placid* was hung before the exhibition opening, its bright palette of celadon green, predominant reds, and yellow accents "apparently upset the other pictures on the wall" so that "it needed a whole wall to itself." The painting was therefore moved to a wall where it could hang alone. More than anything, the critics found the painting humorous. Although the critic for the *Boston Evening Transcript* called *Lake Placid* "silly, unbeauteous, and insane," other critics found it "rib-tickling, midriff-stirring" and "delightful, a vastly amusing, whimsical view of the ludicrousness of people when bathing."[10] S. Jay Kaufman, the critic for the *Globe*, cited the work for its exuberance and charm and suggested that the artist title it "*Symphony in Reds*" or "*Aquatic Sports*" or "anything joyous. We recommend it to the editor of *Playboy*, whose magazine, he claims, is for youth and jocundity. *Lake Placid* is both, and it would make a pleasant spot on anybody's wall. It's a tonic."[11] Henry McBride concurred:

> There is no doubt but that to her *Lake Placid* represents "heaven." The young lady swimmers all wear costumes from the smartest shops on Fifth Avenue, and the motorboats, gondolas, house boats etc., are of the latest models. There are one or two young men at the swimming party, so Miss Stett's Aunt Kate [Rosetta misidentified], clad in severe black, chaperones everybody from the balcony. The water is pure white in this picture, and the outlines have been touched in with crimson and living green.[12]

The artist consciously chose to tie the known anti-Semitism of the site with the mixed religions of the identifiable characters she included. In contrast to *Lake Placid*, the titles of the artist's other

group paintings up to this time, such as *Sunday Afternoon in the Country, Sun, Picnic, Heat, Birthday Bouquet, Russian Bank, Love Flight, Fête on the Lake*, and *La Fête à Duchamp*, do not identify the specific setting. Just as with her inclusion of *Nude Self-Portrait* in *Soirée*, perhaps she understood that most viewers would be seduced by the bright colors and feminine style of *Lake Placid* and therefore blind to any larger meaning. As so often in her paintings, the artist included private jokes and innuendo in the composition. However, by naming the bathing scene after a place known for its bigotry, Stettheimer explicitly provided an overtly progressive point of view to the prevailing prejudice of her time.

Stettheimer's painting *Asbury Park South* is also noteworthy because of its title of a specific site and that's site's importance in African American history.[13] For Black Americans, the breakdown of Reconstruction brought with it the loss of perceived freedoms and upward mobility promised by the Thirteenth and Fourteenth Amendments. The latter abolished slavery, offered African Americans' citizenship and supposedly "equal protection of the laws." However, in 1896, the Supreme Court upheld the infamous *Plessy v. Ferguson* "separate but equal" laws. As a result, African Americans were segregated into separate, usually greatly substandard, public facilities like public bathrooms, schools, areas of movie theaters, and beaches. Violence engendered by the years of slavery against Black Americans continued. By the mid-1920s there were estimated to be between three and eight million members of the Ku Klux Klan operating openly in at least twenty-seven states across the United States.[14]

Many Black Americans who migrated to New York City from the South began to congregate in Harlem, where they built a strong community of their own. Although many were forced to work menial jobs for low wages in segregated circumstances outside of Harlem, within this burgeoning community African Americans built strong, influential institutions, including newspapers, church organizations, schools, small businesses, women's clubs, and barbershops and hairdressers. In his historic book *The Souls of Black Folk*, African American scholar W. E. B. Du Bois coined the metaphor of the "veil" to describe the one-sided social wall that allowed African Americans a form of second sight, allowing them to see outward into the white world while limiting the ability of whites to authentically see into Black society.[15]

The 1920s in Harlem have become known as the Harlem Renaissance because they produced an astonishing number of brilliant Black philosophers, poets, producers, composers, musicians, and visual artists. Harlem became the cultural, intellectual, and social capital of Black America. The noted Harlem Renaissance artist Aaron Douglas's words appeared as a call to action to African Americans:

Our problem is to conceive, develop, establish an art era. Not white art painting, black . . .
let's bare our arms and plunge them deep through laughter, through pain, through sorrow,

through hope, through disappointment, into the very depths of the souls of our people and drag forth material crude, rough, neglected. Then let's sing it, dance it, write it, paint it. Let's do the impossible. Let's create something transcendentally material, mystically objective. Earthy. Spiritually earthy. Dynamic.[16]

Harlem became an epicenter of the newest form of African American music: jazz. This form broke the rules of conventional music, favoring improvisation and featuring performers over composers. Jazz was initially seen as immoral by many racially prejudiced whites, who worried that its Black roots would turn young people's interest away from what they considered proper: traditional (white) European classical music.

However, by the early 1920s, a taste for what they still prejudicially perceived as the exotic nature of African American culture, particularly its music, developed among certain members of the younger white population in New York and Paris. As jazz's popularity spread in New York, many members of the city's avant-garde also began to fill Black cabarets that opened throughout Harlem, featuring jazz music and dances of African American origin such as the Black Bottom, the Shimmy, and the Charleston. These speakeasies, promoting alcoholic beverages even during Prohibition, quickly became synonymous with jazz. Ironically, despite being located in Harlem, a number of these catered only to white customers, with African Americans admitted only as performers or musicians or in service roles. In these whites-only clubs, even famous Black musicians and singers were forced to use separate facilities, bathrooms, and entrances.

The white writer and photographer Carl Van Vechten grew up in the Midwest, where he fell in love with Black gospel music and jazz at a very early age. He wrote about them often as a reporter in Chicago and later at the *New York Times*. Ignoring Native American arts, Van Vechten became convinced that African American culture was the essence of America. Although the fiction he wrote can be seen as racist today, for his time he was an outspoken promoter of integration and a collector of African American art, literature, and memorabilia. Van Vechten helped develop general interest and publicize the important literature, theater and music of the Harlem Renaissance to white audiences, including the work of Langston Hughes, Ethel Waters, Richard Wright, Wallace Thurman, and Zora Neale Hurston. Hurston called him a "Negrotarian," and claimed, "If Carl Van Vechten were a people instead of a person, I would say, These are my people." Van Vechten also formed a lifelong friendship with Walter Francis White, the founder of the NAACP.

Among other things, Van Vechten often publicly argued for the need for a serious Black theater company because African American playwrights could not get produced on Broadway. As a result, a popular song of 1924, "Go Harlem," urged listeners to "go inspectin' like Van Vechten."[17] In

a later article about her work, Van Vechten paid Stettheimer what he believed was the ultimate compliment, describing her as having a unique ability to capture the spirit of the contemporary age:

> It is perhaps, however, in her riotous picnics and parties, flooded with sunlight and splashes of violent colour, that Miss Stettheimer is most original. This Lady has got into her painting a very modern quality, the quality that ambitious Americans will have to get into their compositions before anyone will listen to them. At the risk of being misunderstood, I must call this quality jazz. Jazz music, indubitably, is an art in itself, but before a contemporary American can triumph in the serious concert halls, he must reproduce not the thing itself but its spirit in a more lasting form. This, Miss Stettheimer has abundantly succeeded in doing. I hope some upstate Richard Strauss will be able to follow her!"[18]

Van Vechten introduced Stettheimer to the literature and art of the Harlem Renaissance and to many of Harlem's cultural figures. She attended parties at his Fifty-Fifth Street apartment that were famous for their racial mix of celebrities, with guests that included Langston Hughes, Paul Robeson, Bessie Smith, and the Mexican artist Miguel Covarrubias.[19] The latter often accompanied Van Vechten to Harlem nightclubs and literary salons during the 1920s. Covarrubias, however, gained a reputation among white readers of popular magazines for his African American "types" — the dancing waiter, the hoochie-coochie dancer, the willing servant —which exaggerated stereotypically racial characteristics of Blacks that were widely distributed and enjoyed by Caucasian audiences. Among these was a cartoon he made of Van Vechten with caricatured African American features.[20]

Although Black music forms such as jazz, the blues, and ragtime were increasingly appreciated and enjoyed by whites in large urban areas, virtually all visual imagery of African Americans, at least that seen by white audiences, was in the form of demeaning, stereotyped caricatures. As depicted by white American artists and illustrators during the 1920s and early 1930s, Black people were stereotyped as grinning simpletons with overly wide "googly eyes," pure black skin, oversized lips, and gleaming white teeth. Whether serving as dancing entertainers or in the service industry, they were often portrayed as foolish, lazy, sneaky, and without intelligence, ethics, or strength of character. These racist caricatures reinforced a white supremacist impulse across the country.

By 1883, Asbury Park, New Jersey, founded as a Methodist camp by James Bradley, had exploded, with hotels attracting almost 600,000 summer guests from New York, New Jersey, and Pennsylvania.[21] In addition to the beautiful beach, the town's amenities included a large boardwalk, indoor amusement arcade, carousel, music hall, and casino. (*Fig. 61*) The western end of town became home to a community of mostly African Americans and some Italian Americans who worked at the resort hotels and amusements as hotel staff, maids, laundresses, waiters, and janitors. They

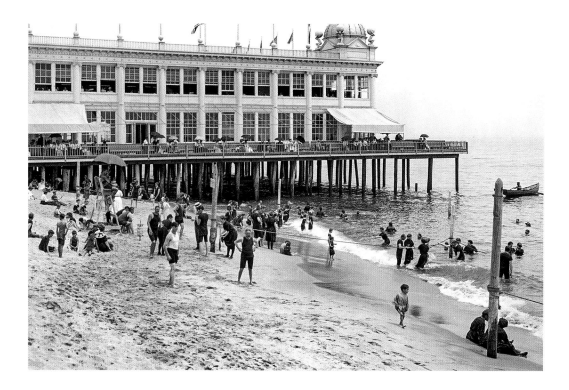

Fig. 61 Unknown photographer: Asbury Park Beach, c. 1900.

established their own schools, stores, institutions, and churches in the area, and over time, many of the residents earned enough to be comfortably middle class.

Music became a major part of African American life in Asbury Park, and jazz clubs and cabarets lined the West Side's Atlantic Avenue. The fame of these clubs spread, bringing in both white and Black audiences from all along the East Coast. They soon drew music greats such as William "Count" Basie early in his career. Josephine Baker came to Atlantic Avenue's Smile-A-While Club and hired bandleader Claude Hopkins and his stage dancers for her upcoming Revue Nègre at the Folies Bergère in Paris. One former African American resident, Madonna Carter Jackson, recalled, "Black people in Asbury Park worked hard, played hard, and always looked good." She described women in silk and satin dresses and "stiletto heels with French silk stockings." By the end of the week, she noted, "singing, dancing, entertaining, or being entertained, was a pleasure after a long week of working at the shore restaurants and hotels."[22]

Initially, African American residents and tourists openly mingled with whites and shared the beach and boardwalk amenities. However, although the white tourists accepted the presence of Black workers, they increasingly objected to lounging next to them along the beach or buying drinks and food at concessions next to them on the boardwalk. On July 20, 1885, a *New York Times* article titled "The Colored Controversy" lamented how Blacks in Asbury Park enjoyed "greater mobility

than at Long Branch or any other place along the coast," and stated that African Americans were "overstepping all bounds, intruding themselves in places where common sense should tell them not to go." Newspapers in the South picked up on this story about Asbury Park, citing that it revealed the "hypocrisy of the Northerner's 'liberal racial attitude,' as evidenced by the Northeasterner's discomfort with the 'social equality of blacks on beaches' where white people bathed."[23]

James Bradley began posting signs barring African Americans from boardwalks and bathhouses until after 10:30 p.m., claiming in *The Daily Journal*, the local newspaper he published, that it was in the Black workers' self-interest economically to segregate the beach. "In order that those people may earn their living, it is necessary that only the Caucasian race shall find Asbury Park attractive," Goldberg quoted Bradley as saying in a speech in 1893. "The question of color or rights should not enter into consideration."[24]

Unlike many other sites of enforced segregation, whenever the Asbury Park town leaders tried to restrict African Americans from using the beach during the day, the Black population resisted, both vocally and physically. Ministers of the local African American churches held meetings calling on their congregations to attack "all class legislation and race distinction."[25] In 1887, the Reverend J. Francis Robinson of the A. M. E. Church of West Asbury Park was quoted in a *New York Times* article, "Colored People at Asbury Park Speak Out in Meeting," stating:

> We colored people fought for our liberty some years ago, and we do not propose to be denied it at this late date. . . . We will not be dictated to in this manner by Mr. Bradley or any other man. The colored man contributes largely to the wealth of this country, including the town of Asbury Park, and we are here to stay. We fought to save the Union as the white man did. This country is for the whites and blacks alike, including even the beach of Asbury Park.[26]

As national newspapers like the *New York Times* sent reporters to cover the debate, Asbury Park quickly became a national symbol of segregation issues. Depending on which side you were on, newspapers carried articles titled "Too Many Colored People" and "Colored Invasion" as well as "Defending Their Race" and "Color Line at Asbury Park: Negroes Indignant at Threatened Exclusion from the Beach." When signs were posted throughout the town and officers were stationed near the beach, restricting all African Americans from entrance, Black citizens organized rallies, demonstrations, and public meetings, and many ignored their exclusion and simply went to the beach after hours.

As Asbury Park gained a national reputation for its open dispute regarding African Americans' usage of the white beaches, white tourism began to drop. Bradley, who still owned the land including

the Asbury Park beaches, used the argument that continuing integration would cause a major downturn in the economy. Eventually, he completely and finally segregated the southern portion of Asbury Park beach, on the opposite side of the main pavilions and Casino (where an open sewer pipe emptied sewage into the ocean), to African Americans. This area became known as "Asbury Park South." Asbury Park beaches were therefore among the very first along the Eastern shoreline to be officially segregated. By 1900, with the strict enforcement of Jim Crow laws, all beaches and public pools along the Northeast coastline became restricted, with only Caucasians allowed in the areas with better amenities.

On November 15, 1910 Asbury Park again gained national media notoriety with the arrest of a handyman, African American Thomas "Black Diamond" Williams, for the sexual assault and murder of ten-year-old Marie Smith. The white girl was found abandoned on Asbury Avenue, and Williams was arrested without evidence and virtually convicted of the "negro crime" by the press. A crowd of hundreds gathered outside the jail, calling for his lynching, until the actual murderer, a German immigrant, confessed.[27] Given these examples of nationally known African American incidents, Stettheimer's choice in 1920 of Asbury Park's Black segregated beach as the subject of her monumental painting is a fascinating choice.

As in the Adirondacks during the early decades of the twentieth century, the public beaches along the New Jersey coast were also segregated against Jews, and therefore wealthy Jews built their summer homes in separate areas along the shore. Long Branch, Monmouth, and Sea Bright became a German-Jewish colony known as "the Jewish Newport" where several of the Stettheimers' relations, including the Seligmans and Guggenheims, had residences along the beach. During the summer of 1920, the Stettheimers rented a cottage in Monmouth Beach, where friends including Duchamp, Thévenaz, the Marquis de Buenavista, and Van Vechten often came to visit. On one such occasion, Van Vechten suggested that a group of them visit Asbury Park South.

Soon after their visit, the artist documented it in her monumental painting, *Asbury Park South*. (*Fig. 62*) Stettheimer accurately recorded the physical environment of the site, including the broad boardwalk with a flag-laden reviewing stand connected to one of the main buildings, yet her painting characteristically captures the *experience* of being at Asbury Park South. It is as though a curtain has just been pulled back, momentarily capturing the beachgoers mid-activity. The day is hot: one can almost feel the yellow of the sun heating the boardwalk and sandy beach behind. There is little wind to cool the air, while across the wide boardwalk and seemingly endless sand, various figures preen, stretch, saunter, bend, and curve their arms and legs into momentary poses. The poster at the left advertising a Fourth of July recital by opera tenor Enrico Caruso underlines the composition's implied auditory sense.

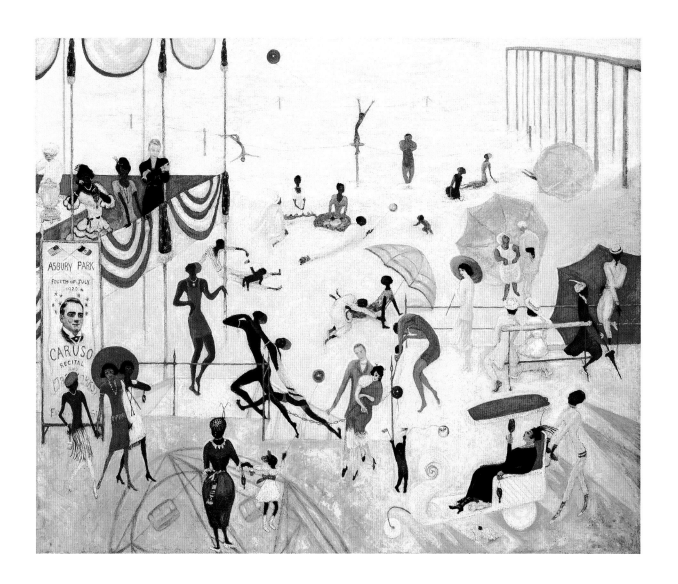

Fig. 62 Florine Stettheimer, *Asbury Park South*, 1920, oil on canvas, 50 × 60 ⅛ in., Collection of halley k harrisburg and Michael Rosenfeld, New York.

The main focus of *Asbury Park South* is on the African American beachgoers, all of whom are well dressed and delighting in their day at the shore. An unsigned note among the Stettheimer papers at Columbia University says that "Miss Florine herself thought this scene and these people very beautiful and the picture becomes a statement of her affection," and the work is unusual in providing highly individualized images of all African American figures of all ages, sizes and wearing various forms of attire. In this work, as in so many of her paintings, Stettheimer emphasized women over men. Although a few men in bathing gear or white linen suits are visible in the middle distance and background, Stettheimer's attention and detailing are on the dignified dowager with the egret-feathered hat who is paraded in her carriage by a liveried servant on the right; three beautiful young flappers entering the scene to the left; and a young girl in a white party dress who impatiently tugs at her beautifully dressed mother's hand, urging her toward the beach in the center. In the background, various families relax on the sand at low tide, playing with children or watching a group of acrobats balancing on a thin wire.

A striking aspect of *Asbury Park South* is that Stettheimer painted the Black persons in exactly the same manner as she painted the white figures: that is to say, without caricature. Recalling her early portrait of Jenny, every character is a fully realized, distinct personality, expressed through their pose, facial expression, clothing, and gesture. Stettheimer's close, progressively accurate observation is further evidenced by the multiplicity of African Americans' skin tones, which range from light tan to the deepest brown. They are also distinctive in their natural stylishness, poise, self-confidence, and vivacity. In contrast, the postures and gestures of the Caucasian figures indicate that they are not at the beach to enjoy the water but are there merely as visitors on the African Americans' territory. As such, Stettheimer depicts herself and her friends as largely stationary observers, there only through the permission of the African Americans, not the other way around. Van Vechten, as their "guide," observes everything from above, on a decorated reviewing stand next to two beautiful, well-dressed Black women.[28]

In *Asbury Park South*, Stettheimer was not painting a depiction of how Black and white people interacted equally. Instead she and her white friends are observing and listening to the African American residents whose seaside enjoyments, deportments, and family interactions are no different from those of their white contemporaries on the other side of the Boardwalk. One or two of the Black figures in the painting gaze at or, in one case, speak with the white visitors, but for the most part they continue doing what they are there to do: enjoying themselves at the beach and paying little attention to or interest in Stettheimer and her friends.

In the center of the boardwalk, Van Vechten's wife, Fania Marianoff, escorted by Marcel Duchamp, reaches toward a tiny boy exuberantly waving two small American flags. Directly behind

him, dancer Paul Thévenaz, tanned and in a red bathing suit, bends over a box camera, capturing a photograph of a handsome male character wearing a matching red suit and a gold medallion. Given Thévenaz's homosexuality, Stettheimer possibly meant this as a humorous aside, as the object of his photographs poses so obviously, and gazes up at bisexual Van Vechten, who looks directly back down at him. Thévenaz's is both the erotic male gaze and that of the more racially charged "tourist" viewing "the other."

Always the observer as well as the observed, Stettheimer stands in a tailored white dress, watching these proceedings from the right as she shields her face from the bright sun's reflection off the sand. The only one of the Caucasian friends who is actively engaged with the African Americans, Avery Hopwood, stands on the sandy beach in a white suit with a notebook tucked under his arm. He appears to be listening as a short, stout Black woman in a yellow dress and cap speaks with him, apparently quite vocally.

The jubilant and celebratory atmosphere befits the Fourth of July. Couples flirt, parents play with their children, men on the beach show off their muscles or practice acrobatics, and children wave little American flags. The shadow of a carnival ride can be seen in the foreground, and children and parents hold balloons while one rises in the distance, having escaped its hold. The painting hums with activity, a subtle but significant variation on Stettheimer's *multiplication virtuelle*: There is implied temporality, as though everyone were suddenly captured in motion. The African American figures scatter across the picture plane, moving clockwise in a huge, shifting circle, like small individual planets revolving around a central, yellow sun. Owing to the painting's use of color and movement, the viewer can almost hear the scene's laughter and gaiety. A year later, in June 1921, Stettheimer composed the following poem, reflecting her sensory impressions of the beach:

Asbury Park
It swings
It rings
It's full of noisy things

It's stretched
along the water
on a boardwalk.

Hurray
We are gay
is what the crowds say
lying stretched on land
along the water's sand[29]

When Stettheimer exhibited *Asbury Park South* the next year at the 1921 *Exhibition of Independent Artists*, the bright yellow-orange color of the sand caused one reviewer to describe the painting as "a revel of unabashed color . . . a glorious joke to be appreciated by all except the concession owners of that famous resort,"[30] a remark of implied racism. Another far more appreciative reviewer noted: "Florine Stettheimer has snap . . . She delights in it . . . *Asbury Park* is a beach scene . . . sunlight which makes you close your eyes. She figured you mightn't see the picture so she added gilded flounces to her frame (to the consternation of those who were so unfortunate as to have their work hung near *Asbury Park*). The art of Florine Stettheimer is entertaining."[31] Henry McBride, writing for the *New York Herald*, also commented that the bursts of sunlight in Stettheimer's "careful and realistic study" were so bright that they caused John Sloan's adjacent painting, *Picnic on the Ridge*, to appear dark: "there never was such sunlight as it appears in this picture. It is so powerful that many persons with normal sight assure me that they can see great golden sun rays protruding beyond the frame."[32]

No one commented on the predominance of African American figures in the composition, their non-caricatured treatment — particularly relative to the Caucasian figures — or the painting's setting on a segregated beach. There are several probable reasons. Stettheimer's characters were all so stylized, it simply went unnoticed. In addition, many of her other mature works did not contain specific political or social statements, and thus such aspects were not looked for in the works. Finally, it is doubtful that anyone, including her family and friends, expected Stettheimer to paint such controversial topics — they simply did not "see" them. Instead, they were blinded by Stettheimer's bright colors, humorous and factually researched details, animated, clever compositions, and unique style.

Stettheimer believed *Asbury Park South* to be one of her best paintings and submitted it to more exhibitions than any other work during her lifetime. On March 23, 1921, artist Gaston Lachaise wrote to Stettheimer that he was sorry to learn that she had hurt her arm. He was impatient for her to recommence painting, he said, for the purely egotistical reason that he had returned several times to see the "radiant" *Asbury Park South* at the *Independents* exhibition.[33] Albert Gleizes thought so highly of the painting that in 1922 he proposed *Asbury Park South* for inclusion in Paris's *Salon d'Automne*, where it was accepted. This rare occurrence for a contemporary American artist demonstrated the high regard in which many of her European contemporaries held Stettheimer's work. Duchamp is thought to have arranged the transportation of the painting to Paris and, apparently with Gleizes's help, also tried to secure a solo exhibition for Stettheimer at a Parisian gallery. However, the site turned out not to be suitable: "Florine I've seen the gallery in question: no good — no light, under the arcades of the rue des Pyramides . . . [*Asbury Park South*] must be on its way back to N.Y. . . .

It received a lot of attention at the Salon and Juliette [Gleizes] was very disappointed that you were insisting on such a large sum to give it up."[34]

Throughout the 1920s, Stettheimer continued her interest in and interactions with African Americans through her association with Van Vechten. After attending a party at Van Vechten's apartment, Florine happily informed her sisters that she had learned from two of the Black women guests that "rubber bands were infinitely more comfortable than garters . . . for holding up stockings." Van Vechten again took friends on visits to Asbury Park, as he wrote in his diary on July 1926: "I motor to Asbury Park. Frances, Hugo, Jack and I lunch at the Stettheimers. In the afternoon, we motor to Long Beach, Asbury Park, inspecting the negro and white beach."

The 1926 publication of Carl Van Vechten's fifth novel, *Nigger Heaven*, was intended, according to the author, to fool white audiences into purchasing the book because of its highly sensational title, only to have them wind up reading about life among intelligent, ambitious, middle-class African Americans. To that end, it was successful, but it was also highly controversial in Black circles in Harlem. W. E. B. Du Bois, for example, negatively reviewed the novel, declaring that it inflicted "violence to black people" and was a "blow in the face."[35] Van Vechten based the title on the double meaning of the phrase, which at the time was used on occasion by African Americans to refer to Harlem; it was also a derogatory term used for the top tier of theater seats that was restricted to people of color. The novel is a love story in which two young African Americans, a quiet, serious young librarian and a volatile, aspiring actor, fall in love, their dreams eventually torn apart by racism.

Van Vechten claimed that in the book, "I wrote about [African Americans] exactly as if they were white."[36] James Weldon Johnson praised it as well, agreeing that "the author pays colored people the rare tribute of writing about them as people rather than as puppets . . . the book and not the title is the thing . . . If the book has a thesis, it is: Negroes are people, they have the same passions, the same shortcomings, the same aspirations, the same gradations of social strata as other people."[37] However, Van Vechten's point of view ignored the brutal realities of life ruled by Jim Crow laws. It was also directly in contrast with promoters of the "New Negro" movement, who were seeking to create a distinctly Black identity.

Van Vechten dedicated the original edition of the novel to "the Stettheimer sisters." It is not known why he did not dedicate the book just to Florine, acknowledging Florine's mutual interest in exploring Black culture. There is no evidence that either Ettie or Carrie was particularly interested in African Americans. In fact, both were far more narrow-minded and conservative. At one point Van Vechten took Ettie to Greenwich Village, but as he observed to his wife, the youngest Stettheimer sister acted "silly and prudish . . . I wish people like that would stick to their own environment."

In her diary, Stettheimer noted, "*Nigger Heaven* by C. V. V. was received and read—I wrote him." Then she added her opinion of the work as "honest and courageous." However, she lamented, "but I fear it will do [African Americans] no good."[38] After Stettheimer's death, Van Vechten persuaded her executor, Joseph Solomon, to donate *Asbury Park South* to Fisk University, a Black university in Tennessee, where Stieglitz also donated works by artists from his galleries, including Georgia O'Keeffe. Van Vechten also gave his collection of art history books to Fisk University in Florine Stettheimer's name.[39]

The fight for women's suffrage was very visible during the years prior to its ratification into law, something Stettheimer, as a feminist, no doubt followed. On October 23, 1915, the same year that Stettheimer had painted her *Nude Self-Portrait* in New York, 25,000 people marched in a parade for women's suffrage in the city. The next year, Margaret Sanger opened and funded the first American birth-control clinic, in Brooklyn. This culminated in August 18, 1920 with the passage of the Nineteenth Amendment, granting American women the right to vote, although there were significant racist exceptions.[40]

As the decade began, Manhattan was experiencing a period of economic prosperity, cultural and technological innovation, increased consumer demand, and above all, a craving for the new, with young women in particular flaunting a disregard for traditional social norms and mores.[41] Among the areas that experienced radical change were women's fashions and the beauty industry. The rigid silhouettes of high-necked, corseted, and ankle-length dresses gave way to low-cut, high-hemmed, unstructured sheaths that followed the body's natural contours. Dieting became chic, and even the suggestion of a curve was derided as demonstrating lack of self-control and nutritional incontinence. Both younger and older women openly applied cosmetics, abandoned corsets, and bobbed or shingled their hair.[42]

As Florine's early self-portraits demonstrate, by 1915 she had already assumed a modern style of attire, wore bright red lipstick, and styled her hair in a modern bob. In 1920, friends remembered Carrie still wearing nineteenth-century-style Callot Soeurs gowns with trailing satin or taffeta, while Ettie favored flowered brocade or black lace. However, the boyish flapper styles suited Florine's slim figure, and when she wasn't wearing her painting pantaloons or some form of pants, she wore the latest knee-length, unstructured, sheath-style dresses. On one social occasion, her friend Max Ewing spied the artist wearing "white satin trousers underneath a flowery overdress of spangled net."[43] Reflecting the chic, contemporary, fashionable nature of Stettheimer and her work, in the early 1920s, *Vogue* magazine sent a photographer to shoot three models wearing the latest designer clothing in front of two of Stettheimer's paintings and her fire screen at the Alwyn Court apartment. (*Fig. 63*)

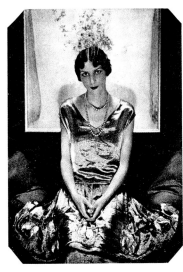

Fig. 63 Florine Stettheimer, *Vogue* models posed in Stettheimer apartment in front of Florine Stettheimer screen and paintings, Florine Stettheimer Papers, Rare Book and Manuscript Library, Columbia University in the City of New York.

As Stettheimer's subject matter increasingly transitioned from family and friends to larger issues and a wider perspective — including New York City streets and its environs — they continued to be painted decidedly from a woman's point of view. Around the beginning of the decade, while summering at André Brook, Stettheimer painted two unfinished works, a watercolor study and an oil painting, titled *The Bathers*. Both the study and the painting depict the Stettheimer sisters showering and sunbathing, outdoors, at their summer residence.[44] In the study, the outdoor shower is a functional affair, and all three sisters are visible. The figures, two of whom are nude, crowd the small vertical space. Each is in a different pose, unselfconscious and unaware of the viewer's gaze.

Although it has the same title and subject matter as the sketch, in the painting Stettheimer altered the composition dramatically to heighten the opulence of its surroundings, sense of open space, and overt sexuality. (*Fig. 64*) In the *Bathers* oil, dense rose-covered trellises are visible at upper left and clusters of red roses spill from a standing form at right. The terraced area is wide and only two of the Stettheimer sisters are present.

At right, Carrie, a tall, attenuated, blond figure, naked except for red heels, stands under an elaborate, Rococo-style gilded shower. She looks over her side, gazing directly out at the viewer. Ettie, identified by her darkly defined eyebrows, lies on a bright red towel at left and looks out toward the viewer. She lies on a scalloped towel, her body stretched out, one knee bent and slightly canted to the left in a provocative, sexual pose with red straps crossing her calves. The painting is audacious through its overt depiction of female genitalia: between Ettie's legs the two labial lips of her vulva are spread open to the sun. (*Fig. 65*) Although they are just two small, painted red lines, the image is shocking, particularly when depicted by a woman artist in such a casual yet visible manner as early as around 1920.

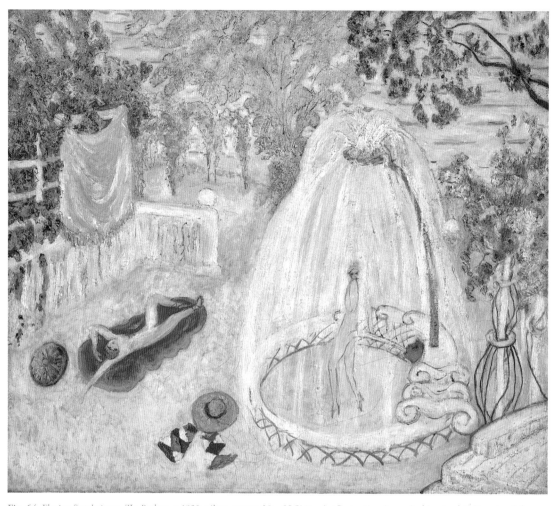

The image's existence clearly refutes any notion that Florine was timid or conservative in her attitude toward sexuality. The only well-known examples of Western art until decades later that so unflinchingly detail a women's genitals are works by men such as the 1909–14 watercolors by Egon Schiele and Gustave Courbet's 1866 *The Origin of the World*. Or the consciously pornographic photographs or works painted expressly for the private, voyeuristic enjoyment of the men who commissioned them.[45]

Stettheimer never finished the work. After the artist's death, Ettie firmly asserted that Florine never showed her paintings to anyone including her sisters until they were completely finished. As it could never be shown publicly given its explicit nature, Stettheimer kept it for herself, and when her unfinished works and sketchbooks were donated as a large group after her death, it is doubtful no one then, or since, looked closely enough at the painting to notice this remarkably progressively detail.

In keeping with her long-held female-centric outlook and undoubtedly inspired by the recent milestones in women's rights, during the 1920s Stettheimer also painted several monumental

paintings depicting women pursuing uniquely female activities. In 1921, Stettheimer made one of her most openly humorous paintings of women shown in a particularly unusual female environment: *Spring Sale at Bendel's*. In the painting she turns the act of shopping into a fantastic balletic comedy of commerce and consumption, vivid color, and frenzied action. (*Fig. 66*) Bendel's was an exclusive clothing store offering versions of couture designs to wealthy women; the idea of a sale was itself a sign of the new century's demands for goods and bargains. Capturing a generally unseen aspect of upper-class women's lives, the painting destroyed these women's ideals of themselves as models of controlled, decorous behavior. As one reviewer noted, "It must be true since all Miss Stettheimer's works are autobiographical."[46] The painting is all the more ironic because the artist was a member of the same social circle that she was ridiculing.

In *Spring Sale*, a voluminous gold-fringed red curtain, pulled aside on either side of the composition, reinforces that viewers are gaining access to a special performance. The composition is arranged like a stage set, with layers of overlapping activity drawing the viewer's eye around and through a variety of paneled and mirrored screens. Slim saleswomen in plain black dresses patiently wait while their customers prance, whirl, twist, and contort their bodies to glimpse their newly clothed figures.

The viewer's eye moves in a wide clockwise circle to capture all the details of the choreography. Each woman is isolated in self-absorbed reverie, seeking the very latest fashions. The shoppers act out a frenzied dance across the floor: one leaps up to catch sight of the elaborate fringes on a skirt, while another holds up a diaphanous, form-fitting lace overdress. Stettheimer inserted humorous details into every part of the painting: at lower right, a saleswoman holds a bright red dress in one arm and asks her gray-suited manager about a red fabric. Her wealthy, tiara-wearing client, dressed only in a slip, wraps her body in the curtain while waiting to hear the answer. Nearby, a heavy-set

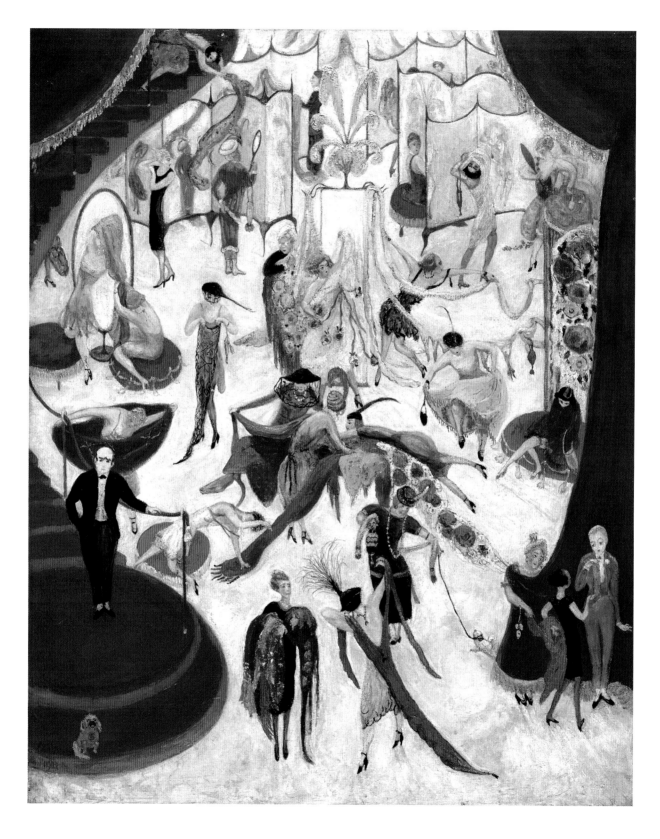

Fig. 66 Florine Stettheimer, *Spring Sale at Bendel's*, 1921, 50 × 40 in., Philadelphia Museum of Art, Gift of Miss Ettie Stettheimer.

woman in green adjusts a matching scarf across her broad posterior, while at far left a woman seated on a red cushion struggles to help her friend untangle herself from a dress.

In the middle foreground, a woman in the ardor of acquisition practically throws herself across a table of scarves, attempting to grab one at the other end before it disappears. Another woman reaches down from the top of the staircase and grabs a shawl from an unsuspecting shopper below. At lower right, a tuxedoed Henri Bendel, the store's owner, stands on the stair platform looking out at the viewer with a perplexed frown. On the bottom step a ridiculous small Pekingese sits wearing a sweater embroidered with the artist's monogram. The painting contains many signs of wealth: the sweeping, carpeted staircase (indicating perhaps more expensive clothing that is not on sale on the floor above), a central feather-plumed gilded mirror, and masses of luxurious fabrics. Nonetheless, the composition resembles a mad brawl.[47]

Most reviewers delighted in the painting. In a typical comment, David Lloyd said that Stettheimer had sent in "one of the genuine joys of the exhibition."[48] Paul Rosenfeld, writing in *The Nation*, commented that Stettheimer's work was "an expression of aspects of America, tinged with irony and merriment of a very perceptive and very detached observer."[49]

Throughout the early 1920s, Stettheimer submitted paintings to various exhibitions in New York and Philadelphia, where they were well received by artists and critics alike. In May 1921, Florine and Ettie went to Philadelphia to view the artist's paintings *A Day at West Point* and *Asbury Park South* hanging at the Pennsylvania Academy of Art's *Exhibition of New American-Style Painting*. In his review, Henry McBride declared, "The war has done a great deal to emancipate us and there are signs everywhere that we will shortly originate our own fashions . . . there are signs of it in this exhibition . . . [Demuth, Weber, Stella] and the amusing episodes from current history by Miss Stettheimer."[50]

By the end of August 1924, Stettheimer was back working in her New York studio. But the scorching heat soon forced her to join the rest of her family in Atlantic City. While there, she sent postcards to Carl Van Vechten describing the performers, acrobats, racing greyhounds, and artists on the Million Dollar Pier: "All go in bathing with us; the only abstainers are the Eden Museum waxworks." Throughout the 1920s Atlantic City all classes of white Americans came to vacation. Well-to-do patrons like the Stettheimers stayed in hotels along the boardwalk, while the less affluent occupied rooming houses a few blocks back from the beach. In 1921, in order to extend the summer season and increase tourism past Labor Day, a local Atlantic City businessman established a "Fall Frolic." Seizing on this idea in hopes of gaining national publicity, organizers created another event, the Inter-City Beauty Contest, held annually on September 7. It was judged on 50 percent audience applause and 50 percent judges' decision, based on a day of both groups' mingling with the contestants and the ladies' final appearance on stage. The contest initially involved only hopefuls from nearby beach towns.

Like so many activities along the seashore, the beauty contest occupied an ambiguous place in American society: it was exciting, but also proposed that young women expose themselves in bathing suits before a jury largely composed of men. To head off protests, managers of the contest promoted its "youthful and wholesome" nature and publicly stressed that none of the contestants wore makeup or bobbed their hair. Eventually renamed the "Miss America Beauty Contest," it became a national event, enshrining the bathing beauty as a central symbol of American womanhood. One commentator describing the event in 1922 wrote that the pageant's opening parade drew on "the splendors of the Orient, of jazz parlors, of bathing beaches, and even the circus. There were piquant jazz babies, who shook the meanest kind of shoulders; pink-skin beauties of all types; tanned athletic girls; bejeweled favorites of the harem."[51]

Stettheimer was drawn to the popular visual and aural cacophony of the contest, though not to the idea of judging women based on their physical appearance. During a 1924 stay in Atlantic City, she demonstrated her feminist perspective on the event in a painting. As she noted in her diary: "Beauty contests are a B.L.O.T. on American something — I believe life — or civilization." Titled satirically *Beauty Contest: To the Memory of P. T. Barnum*, Stettheimer's homage to the event is bordered by a carved white and gilded frame that Stettheimer designed to resemble a theater curtain that has been pulled back at the beginning of a performance. (*Fig. 67*)

The composition is again a sensory extravaganza of activity, color, sunlight, and sound. At the top, under an oval opening surmounted by American flags, the words "Beauty Contest" are written out of glass balls on jeweled and beaded curtains. In the upper center of the painting, Miss Asbury Park, the apparent winner, stands with her arms held over her head, offering her flapper, non-curved, swim-suited body for the scrutiny of the judges. By the 1920s, the Jantzen company had revolutionized swimwear material by substituting traditional, bulky wool with a stretchy, close-fitting ribbed jersey that came in many colors. Beach-going now involved recreational swimming, so this form of swimwear suited women's new interest in exercise and maintaining slim bodies. Stylistically, as worn by Miss Asbury Park, the suit consisted of a rounded neck and long thigh-length top, worn with a pair of matching jersey shorts that extended down the legs about eight inches.

At right, Miss Monmouth Beach, hoping to catch the judges' attention, steps down the ramp and bends seductively to adjust the strap on her shoe. Meanwhile, the exotic Miss Deal Beach[52] (Ettie later identified this figure as a portrait of the opera singer Marguerite d'Alvarez), draped in ermine, stands awaiting the verdict. The blue-eyed blonde Miss Atlantic City wears a bathing suit of red, white, and blue and stares blankly out at the viewer. At far left, watching the proceedings, the artist reclines in a translucent outfit, her red high heels jauntily strapped around her ankle. Her hair is mostly covered by an artist's beret, and she holds an umbrella to shield her face from

the sun. Adjacent to her, the writer Edna Kenton, clearly not interested in the contest, looks out of the picture frame, cupping a cigarette in her hands. Edward Steichen waves at the contestants to look his way so he can photograph them with his large box camera.

Stettheimer's main subject was ostensibly a beauty contest, and the contestants (except for d'Alvarez) represented a variety of bland, classic Caucasian American beauty types from the popular beach communities along the New Jersey shore. But the contestants themselves are given short shrift by the artist, vanishing into a background filled with American flags, blue and red glass drops, a red and gold fringed curtain, and palm fronds in scalloped containers. The most visible contestant in the painting is the darkly tanned, sleekly sophisticated Miss Spring Lake, who stands out among the white-skinned, virtually invisible contestants. Stettheimer cleverly invited viewers' eyes to follow her leg down to the tip of the African American jazz dancer's finger on the lower left.

Stettheimer focused most of the painting's action and bright colors along the bottom third of the compositional stage, from the grouping of Black musicians and dancers who perform at lower left, and across the front to the flag-draped judging box at right. (The latter would reappear in Stettheimer's stage sets for *Four Saints in Three Acts*.) Beginning at the left, each musician wears white pants, a red uniform jacket, and a red porter's hat. A tall, slim Black man in a matching uniform dances to their rhythm atop a yellow table. He is portrayed as though illustrating text in the June 1927 issue of *Vanity Fair*: "Sam, the dancing waiter, who, with the grace of a panther, serves his customers in perfect time to the complicated jazz-rhythms of the orchestra."[53] Stettheimer gave the four jazz musicians prominence by making them among the largest figures in the painting and having them dominate the lower left corner of the composition. But they are the most stereotypical of any of Stettheimer's representations of African Americans.

In the work's middle foreground, a plumed horse prances to the jazz music. The tasseled red blanket under its decorative red saddle is embroidered in bold with the letters "B & B" standing for "Barnum & Bailey," an allusion to the circus of painting's title. Its reins are held by the handsome Marquis de Buenavista, who dances *en pointe* in the painting's center. Dressed as a toreador, in gold with the purple shawl of kings, his slim, elegant figure is the painting's true focus. This is reinforced by the small page in green at whom he gazes, who holds the marquis' crown mounted with tiny genuine rhinestones. Behind, two other, feather-headdressed children struggle holding his heavy ermine-trimmed wrap. By providing so much of the paintings' geography, brightest color and details to these figures, Stettheimer further marginalizes the female contestants being judged by their physical attributes. Instead she implies that the handsome marquis' crowning, and soon-to-be riding atop the plumed horse, i.e. the adoration of male pulchritude and circus atmosphere, is of far greater interest than the beauty contest.

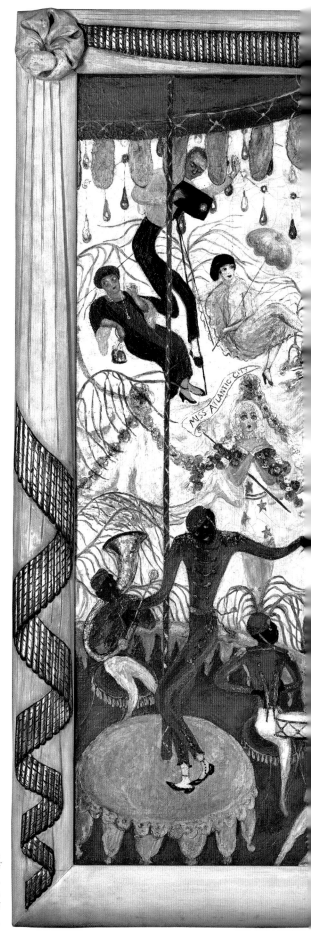

Fig. 67 Florine Stettheimer, *Beauty Contest: To the Memory of P. T. Barnum*, 1924, 50 × 60 ½ in., Wadsworth Atheneum Museum of Art, Hartford, CT, Gift of Ettie Stettheimer.

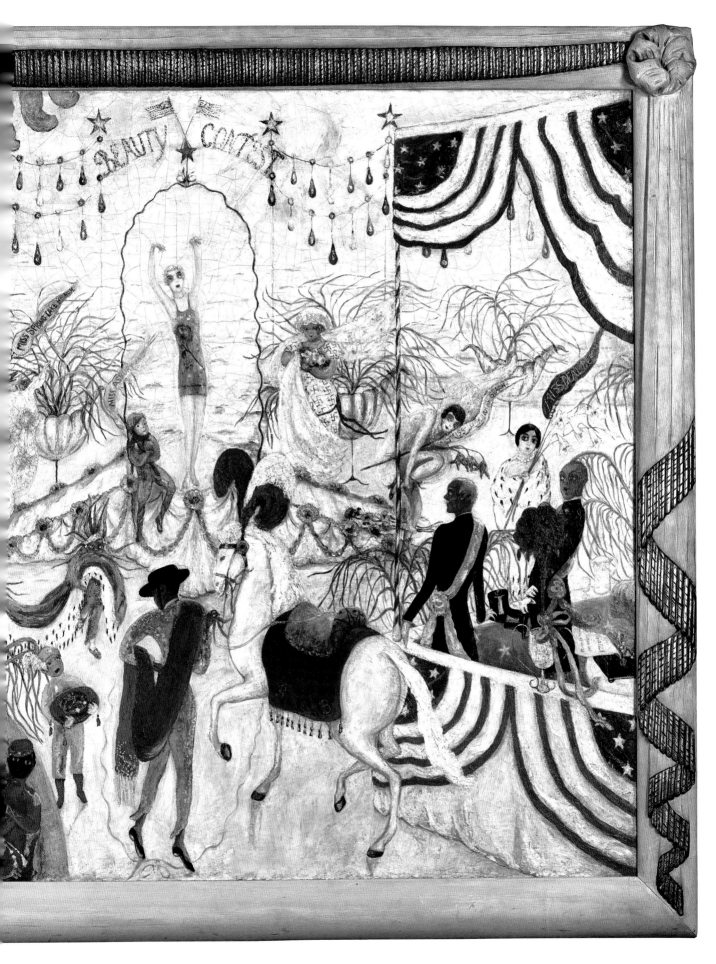

This is reinforced in the judges' reviewing stand, where two elegant contest judges are dressed in dark formal suits with ribbon sashes. The first, with a patrician profile, stands facing forward at the edge of the booth. The second, red-haired judge, possibly Elie Nadelman, holds a large bouquet of red roses.[54] However, rather than looking at the women he is supposed to be judging, Nadelman gazes in amazement at the white horse and marquis. Furthermore, when one looks closely at the two beauty contestants at the far right, they are similarly staring admiringly at the about-to-be-crowned man, rather than the contest proceedings.

Behind the judges, in the lower right corner, Stettheimer inserted a tiny but accurate portrait of the poet and sometime reporter Carl Sandburg, hunched over a manual typewriter.[55] With his long, straight hair hanging over his forehead, Sandburg looks out at the proceedings, while on his page he has typed "Florine Stettheimer, The Author, 1924." In effect, although a beauty contest is supposed to be wholly based on the male gaze, in Stettheimer's hands, the beauties literally disappear and what remains worth gazing at is the kitschy pomp and popular pageantry of a "Big Top" spectacle.

A close viewing at the details in *Beauty Contest* reveals a darker element: the dress on a central figure reveals a graphic element Stettheimer included to make a subtle yet highly pointed political statement. On the stage, to the right of Miss Asbury Park, is a short, plump, blond woman in a white hat. (*Fig. 68*) She is holding what appears to be a bridal veil and a bouquet of roses for the winner, implying a future of wedded bliss—something Stettheimer despised as depleting women's creativity. The woman's dress design, moreover, is made up of oversized, bright red, right-facing swastikas.

For centuries, the swastika represented good fortune in Eastern religions. By 1912, however, a red, right-facing swastika was adopted by the German far-right movement *Germanenorden* as

their Aryan, anti-Semitic symbol. By 1920, four years *before* Stettheimer painted *Beauty Contest*, Hitler and the Nazis had openly adopted the swastika and linked it to German national pride, anti-Semitism, and their goal for a racially pure state. There is no doubt that Stettheimer was fully aware of the symbol and its anti-Semitic meaning and use by the Nazis and the German far-right movements. She closely followed news in Europe and still had family relations in Germany.

By clothing the most visible (and Aryan) contestant's attendant in a dress of swastikas, in *Beauty Contest* Stettheimer further asserts her condemnation of these contests. It is interesting to speculate whether the artist was also making any reference to the absence of Jewish contestants among the bathing beauties. Although the first Jewish contestant entered the "Miss America" contest in 1924, it would be two decades before the first (and only since) would win the pageant.[56] In 1920s America, with its various segregated Jewish communities, it would have been unthinkable for a Jewish woman, no matter how beautiful, to win a beauty contest.

On July 26, 1926, Stettheimer began another large painting, this one showing women engaged in a sybaritic activity totally for their own pleasure. Stettheimer initially titled the work *Beauty Pool*. She began it in her studio in New York and continued working on it through the summer at the beach. When guests displaced her from one bedroom, she moved with her palette and paints into another. The finished work, which she titled *Natatorium Undine*, is another feminist work explicitly concerned with the world seen from a woman's viewpoint. (*Fig. 69*) It is also unusual for its time as it depicts contemporary women naked, openly pursuing activities in the presence of men, albeit employees. The painting's palette comprises color washes of light green, with highlights of dark green, red, brown, and gold. The painting bears several similarities to *The Beauty Contest*, particularly at its left, where, under a canopy, the artist again arranged a trio of African American musicians. However, in *Natatorium Undine*, the musicians' facial features, poses, gestures, and simple, elegant clothes are less caricatured than in *Beauty Contest*. As the pool is exclusively for women, the musicians' backs are to the activities, and they are prevented from seeing what is taking place in the swimming pool by a hanging curtain.

The sixteenth-century Swiss alchemist and philosopher Paracelsus gave the name Undine to female spirits, such as water sprites or mermaids, usually found near forest ponds or waterfalls. Natatorium is a Latin term for an indoor swimming pool. Stettheimer liked this title so much she included it twice, once at the lower left edge of the painting and again on a column at right, where she also included her first name and the year she completed the work. Always the observer, Stettheimer placed herself in the painting at far left, in the same location as *The Beauty Contest*. Dressed in a flowered gold halter, matching Capri pants, and red Greek-style strapped shoes, she reclines on a rose-decorated chaise overlooking the pool. She again holds a parasol to shield her

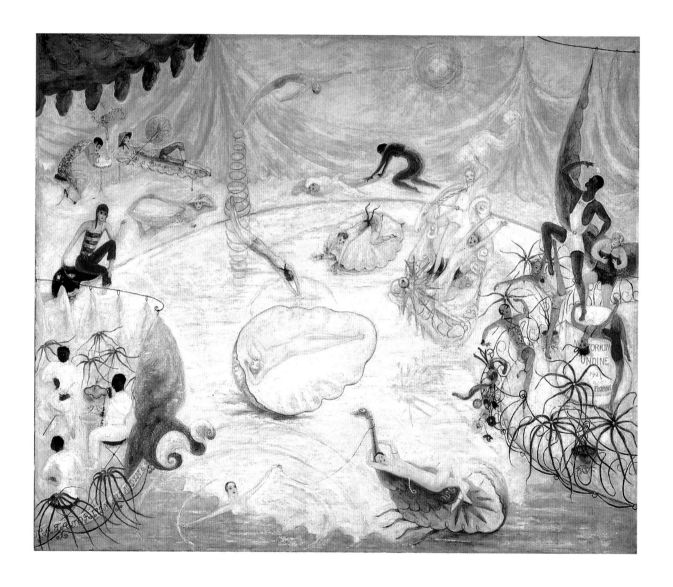

Fig. 69 Florine Stettheimer, *Natatorium Undine*, 1927, oil and encaustic on canvas, 50 ½ × 60 in., The Frances Lehman Loeb Art Center, Vassar College, Poughkeepsie, NY, Gift of Ettie Stettheimer, 1949.5.

skin from the bright sun, demonstrating her vanity. At Stettheimer's left, Fania Marianoff, wearing a brightly colored shift, bends over and sips her drink through a straw. Ettie sits below, at the side of the pool. With furrowed brow, she dips her feet into the water and contemplates entering.

The feminist aspects of the painting are reinforced in that the only men are paid employees whose responsibility is to *serve* the women by offering musical accompaniment, physical exercise, and aesthetic enjoyment. At the right, an extremely handsome, wasp-waisted, muscle-bound, darkly tanned lifeguard poses on a half column, wearing a shirt with the pool's initials, N.U. He is leading a ladies' exercise class. From the preening gyrations of the women who dance around him (including a heavy, bejeweled woman who pushes up her large breasts while gazing admiringly at the man's classical profile), it is obvious that Stettheimer intentionally created an ironic role reversal, where now it is the man's role to act as the erotic interest for the women guests.

In the upper middle of *Natatorium Undine*, another male staff member kneads the calves of a plump white woman swaddled in white towels, as she blissfully rests her head in her hands and smokes. The main action of the painting takes place in the huge oval pool in which nine women enjoy themselves in the water. In the foreground, three women are naked except for their jewelry. One, wearing long dangling earrings, creates concentric circles as she sweeps the water with her left hand. With her right, she pulls the leash of a red dragon float marked with the initials "W.S.," on which another woman reclines wearing only a long string of pearls and an ankle bracelet. The third woman, whose skin is luminous like mother-of-pearl, lies smoking with her arms overhead as she floats in a large, pink half-shell in the center of the composition. Her body is slim, with small breasts and hips, and she, too, wears a string of pearls around her neck.

Above, two women dive into the water from a tall turned spiral, causing one to literally spring up in the air before executing a perfect backward swan dive. Nearby a woman rides a swimming tortoise whose shell is inscribed "Daddy," a common jazz-age term. At the right edge of the pool, a woman on the back of a large ram float races a companion who is straddling a fish float titled "Jazz Baby."[57] The pool's activity is hidden from prying eyes by large hanging celadon curtains that let in only the sun's rays. Stettheimer gave *Natatorium Undine* a hermetic, self-congratulatory, and languid mood. The women, more worldly-wise than Georgette in Stettheimer's early ballet, no longer need Orpheus's music to loosen their social obligations and enjoy themselves. Instead, these are mostly slim-bodied, independent women enjoying themselves, with men only there for their amusement, entertainment, erotic fantasies, and service.

In most of her paintings of women, Stettheimer favored the adolescent, small-breasted, long-legged body style of the time, which she herself resembled. Ironically, the only person to whom Stettheimer granted an hourglass-shaped, curvaceous figure was the premier male dancer of the

Ballets Russes, Vaslav Nijinsky. In her painting *Music* (*Fig. 70*), the artist depicted herself dreaming of the infamous dancer whom she'd watched perform in Paris a decade earlier. One of only two non-portrait works Stettheimer painted that were not based on actual events, *Music* instead represents dreaming as a conduit to memory as well as offering a fascinating image of bisexuality.

To many theorists and artists during the modern era, the significance of dreams and dream imagery lay in Freud's definition of the dream as a gateway to the unconscious. This, he believed, provided access to the past as well as a relatively safe means of diagnosing the present.[58] In the first volume of his *Remembrance of Things Past*, Marcel Proust observed, "A sleeping man keeps arrayed in a circle around him the stream of hours, the ordering of years and worlds."[59] In France, Edmond de Goncourt had published a novel in which he lay half-asleep in his bed and imagined the bed's former inhabitant, the Princesse de Lamballe, and figures from a nineteenth-century Aubusson tapestry coming to life, cavorting and dancing around him.[60]

Music is Stettheimer's only narrative painting in which she is a main, if unconscious, participant. The artist portrays herself asleep on a lace-canopied bed, like the one in her bedroom. his novel *La Prisonnière*, Marcel Proust described a girl sleeping: "she reminded me of a long blossoming stem that had been laid there . . . those drooping lids introduced into her face a perfect continuity, unbroken by any intrusion of eyes."[61] This is a good description of how Stettheimer painted herself asleep on the bed in *Music*.

In 1926, the same year that *Music* was painted, the Stettheimer women moved to the Alwyn Court building. Stettheimer placed the canopied bed along one long wall in her bedroom, and its transparent draperies doubtless were the inspiration for the bed in the artwork. On the wall opposite her canopied bed, she placed a dressing table with a matching cushioned seat that the artist designed to look like white, gilt-edged drapery. (*Fig. 71*) Stettheimer hung her painting *Music*, its entire frame edged with a matching elaborate gold fringe, directly above the table so that the composition could be seen from her lace-veiled bed. Thus, as she lay down to sleep every night, she could watch herself dreaming in the painting.

In *Music*, the sleeping Stettheimer, suspended in dream time, is vulnerable to and unconscious of the watchful eyes of the viewer. This is her most essential self: removed from the vicissitudes of conscious life, she can give free rein to her imagination and inner life. All around her, within the illusionistic, theatrical space, are images from her favorite productions of the Ballets Russes; Adolph Bolm, in costume and body paint as the Moor in *Petrushka*, lies on his back, with arms and feet in the air (like the white dog in *Picnic*, or similar to Bolm's pose in *Sunday Afternoon in the Country*), juggling a coconut.

In the center of the painting, surrounded by an almost pulsing nimbus of pink light, Nijinsky stands with raised arms in his iconic pose from the 1911 Ballets Russes' production of *Le Spectre de*

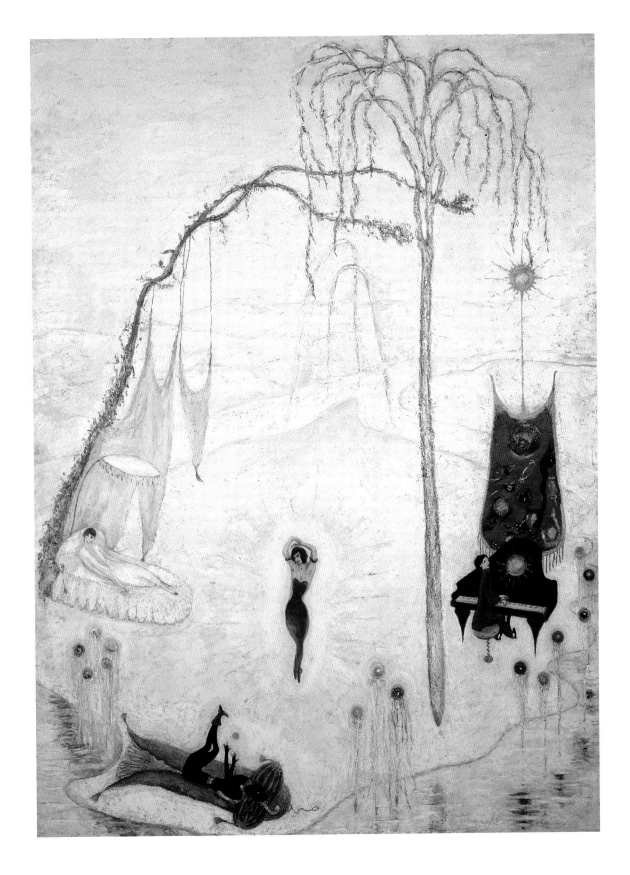

Fig. 70 Florine Stettheimer, *Music*, 1920, 70 × 52 in., Rose Art Museum, Brandeis University, Waltham, MA, Gift of Joseph Solomon, New York.

Fig. 71 Florine Stettheimer's bedroom with the artist's designed, painted, and gilded dressing tables and matching stools and her designed matching frame for *Music*.

la Rose. However, Stettheimer deliberately changed Nijinsky's costume in her painting to create an implication of distinctly erotic bisexuality. Instead of a leaf-covered tunic, the artist placed Nijinsky in a one-piece bodysuit. Its strapless, heart-shaped bodice-like front reveals the cleavage of a woman's breasts, rounded, womanly hips, and a tiny waist. The dancer is positioned on the toes of his ballet shoes (Nijinsky was famous for being one of the only male ballet dancers who was able to dance *en pointe*). His pose, with his arms above his head, and the nimbus of lights radiating around him, give the impression that the dancer has just completed a series of turns.

Stettheimer complicated any purely feminine reading of Nijinsky's figure, however, by also visibly emphasizing the dancer's masculine features, such as his Adam's apple, muscular chest, biceps, hairy underarms, and thick thighs. He is therefore portrayed by Stettheimer less as a generic, androgynous character than as a being who is visibly fluid in his sexuality.[62] While posing, Nijinsky glances flirtatiously from under his arms to the sleeping figure of Stettheimer. Although one is standing and the other reclining, their similarly tilted heads, rounded hips, and crossed ankles create a strong sexual resonance between the two figures. Perhaps, just as she had symbolized her animus

Georgette's temporary freedom from conventional society by having her dance with bohemian artists in the street, in *Music* Stettheimer imagines herself merging with the male Nijinsky in her dreams in order to dance provocatively.

At right, an unidentified pianist[63] sits with his legs pushing the pedals of a highly stylized piano, behind which hangs a colorful flowered shawl or tapestry reminiscent of Bakst's design schemes for the Ballets Russes. Each figure in *Music* is psychologically and physically isolated from the others and lost in his or her own reverie. Like jazz, the figures in Stettheimer's painting are self-referential, non-sequential, disharmonious, improvisational individuals.

Stettheimer's portrayal of Nijinsky with both female and male attributes in a major painting was yet another very provocative act. During the nineteenth century, homosexuals and lesbians were considered to have a mental illness and needed to be cured or punished as criminals. Among the most forward thinkers in Europe and in select parts of America, this view slowly changed thanks to the spread of Freud's theory that all humans were born bisexual, that heterosexuality and its opposite both developed from an original bisexual disposition. To them, being gay or lesbian was due to a certain arresting of sexual development.[64] On January 5, 1919, and again in 1920, the New York Society for the Suppression of Vice encouraged police raids at the Everard Baths, popular with the city's gay men, resulting in numerous arrests and jail time for lewd behavior. In 1923, a New York City law prohibited loitering for sodomy within the city limits.

Nonetheless, among the avant-garde arts crowd, the period from 1910 to 1930 in New York also represented the greatest era of private fluid sexual openness until the present. Gay characters appeared regularly on Broadway stages and in popular literature. In Harlem, gay clubs, commonly known as "pansy clubs," were openly operated and widely visited by residents of all areas and classes.[65] One of the most unusual aspects of the Stettheimer salon was that it served as a comfortable refuge for their many friends to be open about their sexual preferences. For example, several of their closest friends such as Demuth, Hartley, McBride, Van Vechten, and Thomson were gay; Cecil Beaton, Georgia O'Keeffe, and Baron de Meyer were bisexual (the latter was married to a lesbian); and Natalie Barney and Romaine Brooks were lesbians. This open mixture of sexual orientations continued when Stettheimer held salons in her studio in the Beaux-Arts building.

During the 1920s, Stettheimer painted portraits of a number of her gay, bisexual, and straight male friends. Each one displayed her acute discernment and understanding of the sitter, gained through close observation, affection, and experience. Some included motifs and colors commonly known to be codes for gay men.

~~~~~~~

*chapter seven*

# EXPLORING IDENTITY:
# FRIENDS AND FAMILY

## 1922 – 1928

~~~~~~~~

During the 1920s, Stettheimer painted seventeen innovative portraits of friends and family members. In the early decades of the twentieth century, she, like many artists, philosophers, and writers on both sides of the Atlantic, including William James, Marcel Proust, and Gertrude Stein, explored questions of identity—how is a person known apart from just physical appearance, and what does it mean to capture a sitter in an authentic portrait?[1] Sigmund Freud's emphasis on psychological subjective and dream experiences added to this concept of portraiture as a subject for contemporary exploration. Stettheimer's paintings use visual equivalents of the intangible and changeable aspects of her sitters' lives to visually characterize them. They reflect the influences of the contemporary socio-cultural climate as well as Bergson's theories of time and the artists' discussions with Duchamp about the fourth dimension.[2]

Gertrude Stein's "word-portraits" served as a catalyst for many literary and visual modernists. Instead of describing physiognomic facts, Stein created her portraits by arranging words in an insistent style intended to capture the psychological essence of her subjects:

> What does it matter what anybody does . . . The thing that is important is the way that portraits of men and women and children are written, by written I mean made. And by made I mean felt. Portraits of men and women and children are differently felt in every generation and by generation one means any period. One does mean any period by a generation. A generation can be anywhere from two years to a hundred years.[3]

In a 1912 issue of *Camera Work* magazine, Alfred Stieglitz published Stein's word-portraits of Matisse and Picasso.[4] He prefaced the work by noting that they functioned on an evocative rather than narrative level and that they relayed subliminal experience as well as optical facts. During the following years, many of Stettheimer's artist friends created portraits using visual equivalents of Stein's literary explorations. These "object portraits" excluded all figurative, realistic images of the sitters.[5] Instead, their personality and character were implied by objects, numeric equations, and letters, which were collaged or grouped in a manner intended to reference their personality and/or vocation.

By cutting out or drawing pictures of machine parts from advertisements, media images, and mail-order catalogues, Francis Picabia created "mechanical" portraits of his friends. In his portrait of Alfred Stieglitz, for example, alluding to the photographer's German origins and profession, Picabia represented him as an old-fashioned camera pointing toward the word "ideal" written in *Fraktur*, a German typographic style. Another member of Stieglitz's circle, Marius de Zayas, explored psychological insights about a person through geometric forms and abstract numeric equations. An unidentified writer for a periodical called *The Bang* called de Zayas "the exposer of the soul" because his portraits concentrated less on surface appearance than on representations of the subject's inner personality. Stieglitz' artists Marsden Hartley and Charles Demuth both painted abstracted portraits during the first decades of the century, using words, shapes, and objects to stand in for shared memories and the personalities of their sitters.

Stettheimer's mature portraits reveal the same subjectivity and familiarity with her subjects as the other modernists' works, but there are significant differences. In creating their object portraits, her contemporaries moved closer to abstraction and used far more spare forms than Stettheimer would have tolerated. Her portraits are figurative and compositionally cluttered and she consciously sought specific details for her representative imagery. Stettheimer's fully realized portraits used the facts of the sitters' lives and accomplishments to illustrate their character and personality. Carl Van Vechten observed, "She was more interested in the atmosphere of feeling of the character (which she often reproduced with deadly accuracy and a kind of mystic acumen) than she was in actual physical values, although often her physical likenesses were striking."[6]

Just as her group paintings were influenced by and composed as avant-garde theatrical productions, Stettheimer's portraits had far more in common with avant-garde literature than with contemporary painting. Each portrait was conceived as a mini-biography, recording landmark events and the subject's vocations and avocations through the unfolding of his or her experiences.[7] The works echoed Marcel Proust's observation that personality was revealed by unraveling a person and all that has clustered around them: "the whole of that past which I was not aware that I carried about within me."[8] In Stettheimer's hands, assorted objects and references surrounding the central figure become vehicles through which the past, present, and future commingle to offer clues to the sitter's inner life.

Another visual correlation to the portrait series that Stettheimer executed in the 1920s lies with *portraits d'apparat*, loosely translated as ceremonial portraits, a device used by European and American artists in the late eighteenth and early nineteenth centuries to depict royalty and the wealthy, and later by artists including Manet and Van Gogh to paint bourgeois sitters, surrounded

by objects associated with their daily lives. This idea of the ceremonial portrait was also used in the novels of Proust, James Joyce, Joseph Conrad, and Van Vechten. In the latter's work, the protagonists' personality and lifestyle were revealed through the characters' actions and reactions and the contexts in which they were shown. In describing Stettheimer's portraits, Charles Demuth noted that the results were "free from the morbid chase of the real . . . Portraits she calls them . . . Portraits they are; only they are for the few . . . Their sense of arrangement more than their color holds them together, although the color is good and very in our time — very of these states."[9]

In 1919, Stettheimer met Mexican artist and art teacher Adolfo Best-Maugard at Marie Sterner's 556 Fifth Avenue gallery. Before returning to Mexico the following year, Paris-educated Best-Maugard visited her studio, and they shared ideas on art and art-making. Over the years a number of writers have suggested that Best-Maugard influenced Stettheimer's mature style. However, by the time they met, Stettheimer had already painted a number of her most significant works in her mature, idiosyncratic manner, and the differences between the two artists' philosophies and work refute this idea.[10]

Over the following decades, Best-Maugard visited Stettheimer in her studio on several occasions, and they clearly admired each other's work. In 1920, Best-Maugard painted small gouache portraits of both Ettie and Florine. He depicted Ettie in front of a garden statue resembling a Nadelman sculpture. Florine is painted as an artist, wearing a black-rimmed hat and loose-fitting beige painting smock and pantaloons, holding her palette and paintbrush. (*Fig. 72*) She stands beneath a red garlanded curtain on a small red rug bearing her first name.[11]

Stettheimer, in turn, painted *Portrait of Adolph Best-Maugard*, filling the composition with symbols and illustrations taken directly from his system of teaching art. She portrayed the artist as a long, lean, elegant figure and she wittily arranged on his outstretched palm the seven elements that he believed could serve as the foundation for all illustration. He is shown standing on a coiled rope device, like one he recommended in his book for drawing a bow-knot. Stettheimer signed her name and that of her subject on a ribbon in the center of the painting. Directly behind Best-Maugard she placed a cornucopia spilling pineapples, grapes, corn, lilies, assorted flowers, a snake, and a white-plumed bird. The latter represents Quetzalcoatl, the plumed serpent of Mesoamerican folklore.[12]

Best-Maugard was very drawn to the mystical and spiritual aspects of the universe and native Mexican folk tales. In describing his art theories he wrote that as artists, "the farther we develop mentally and spiritually, the more we are able to grasp."[13] According to Parker Tyler, who later interviewed him, Best-Maugard believed in the "articulate mystical aspect of the new art" and "saw everywhere in nature the cosmic design that appears in the spiral universes of vast outer space."[14] A pragmatist, Stettheimer was vehemently against the idea of there being any mystical or spiritual

Fig. 72 Adolfo Best-Maugard, *Florine*, 1920, gouache on paper,
21 ⅞ × 14 ¹³⁄₁₆ in., Brooklyn Museum, Bequest of Richard J. Kempe.

attributes in art. She once became embroiled in an "explosive" argument over dinner with fellow artist Carl Sprinchorn, who said that she maintained that praising and/or labeling an artist's work as "mystical" was too facile. She contended instead that artists who painted supposedly "mystical" work did so because they lacked good technical training as well as a highly creative outlook—a view in direct opposition to that of Best-Maugard.[15]

In early 1922, the Stettheimers' uncle Sylvan died, leaving each of the sisters ten thousand dollars. Ettie immediately bought a car to travel to their summer rental house at Sea Bright, New Jersey. There, during the summer and early fall, Stettheimer painted by the shore. Henry McBride became a regular at the Stettheimers' Sea Bright parties. As art critic for both the *New York Sun* and the *Dial* during the 1920s, McBride was increasingly influential in New York art circles, and the theme of his writing was to find the "American" in American art.

Recalling his years with the Stettheimers, McBride noted that most of Florine's portrait subjects were not aware that they had been chosen for the honor. McBride apparently came closer than anyone else to sitting for the artist, as he described in a draft essay that he never completed:

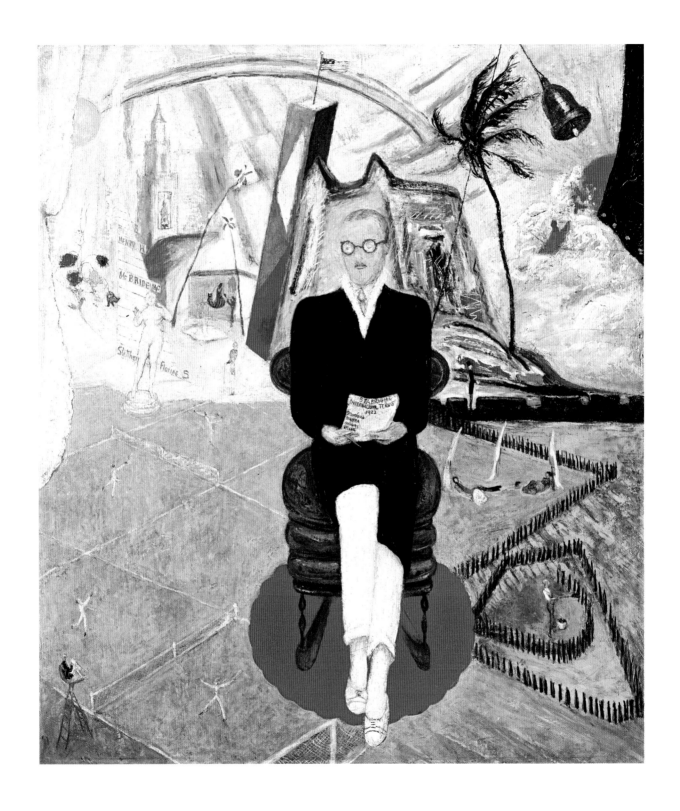

Fig. 73 Florine Stettheimer, *Portrait of Henry McBride*, 1922, oil on canvas, 30 × 26 in., Smith College Museum of Art, Northampton, MA, Gift of Ettie Stettheimer.

My portrait originated during a house-party given by the Stettheimers in a Seabright cottage many years ago and one evening I detected the artist over in one corner of the salon furtively jotting down presumably some of my lineaments but I was not permitted to see what hieroglyphics she had acquired nor how many — but they must have been few.[16]

A year later, when the finished *Portrait of Henry McBride* (*Fig. 73*) was revealed, he expressed surprise at some of the iconographic elements, particularly the heavy emphasis on tennis:

At the time of this house-party the Seabright Tennis tournament was in progress and as I was, in those days, something of a player and mad about the game, I went over each afternoon to what the sensational new Frenchmen (Borotra and Lacoste among them) were doing. When my portrait made its debut the next winter I was as much astonished as anybody else to find myself standing, in the picture against the background of a tennis tournament in full progress. Up above, in the sky and elsewhere, were references to my aesthetic preoccupations, such as the celebrated palm-tree watercolor by Winslow Homer, the statue of "Woman" by Gaston Lachaise, a watercolor by John Marin, and so on; but the heavy emphasis upon tennis in the picture was something that I had to explain away to many critics. I have scarcely yet lived that down.[17]

Stettheimer's portrait of McBride represents his pastimes, arranged so that they surround him like a multiscreen cinematic backdrop. Each quadrant reflects an aspect of McBride's life — sportsman, farmer, defender of nineteenth-century American art, and admirer of new tendencies in modern art. The large central figure of McBride perches daintily on a plump green and red-trimmed chair on a scarlet rug. In his hands, he holds a pencil and a scorecard with the name and date of the renowned 1922 Seabright Invitational Tennis Tournament, an annual competition featuring the best tennis players in the world. As the scorecard shows, that year, French tennis player M. Jean Borotra won the men's singles competition. Giving equal weight to women, Stettheimer also recorded that Molla Mallory beat Helen Willis to win the women's singles tournament. The players' names are all legible on the card in McBride's lap.[18]

McBride is dressed in a formal long black jacket, white pants, and white tennis shoes of a tournament official. His eyes are cast down and to the left, where he watches four tiny tennis players leap and contort their bodies toward the oncoming balls. A miniature version of himself, acting as referee for the competition, is seated high on a laddered perch at the lowest left corner of the painting, watching the progress of the men's matches, each player wearing long white pants. Hilton Kramer, in a later review of the painting, noted the implication that, at least for an art critic, "keeping score" has multiple meanings.

Described in his eighties as "six feet tall, erect, hauteur in the carriage of the head, the face unlined, the blue eyes old man's eyes but with a boyish precocity in the open stare," McBride was fussy about his appearance throughout his life.[19] In a series of letters written to Stettheimer during the summer of 1922, he asked pointed questions as to what he should wear and bring to Sea Bright: "Is it a très dress affair? Do gents wear smokings? You see I come in a suitcase and I have no one to advise me but you — so if I take a wrong step in this affair it will be all your fault."[20] Stettheimer's portrayal shows McBride to be a tightly controlled, somewhat vain man, with a trim mustache, receding, slicked-back gray hair, and a tiny, pursed mouth. The two rounded ends of his chair peek out on either side of his arms, making him look like a prissy, middle-aged angel wearing owlish glasses.[21]

When reviewing his portrait at the Society of Independent Artists exhibition in 1926, McBride offered further clues to the veracity of Stettheimer's portrayal:

> The protagonist in this portrait is none other than the humble scribbler of these notes. My old friend Royal Cortissoz was horrified by the guile of the artist. He said, "When I gaze on the behemoth that you are and then turn to the slender reed she tries to make you out, I consider it the most flagrant piece of flattery in all portraiture." But my friend doesn't know the half of it. The fact is l have two silhouettes at my command. Every spring about this time, with unfailing regularity, I become behemothic, and every summer, with equal regularity, I become willowy. It was at the Seabright tennis tournament some years ago that Miss Stettheimer caught the glimpse of me she chose to immortalize, and l was undoubtedly reedlike then. If all art is selection, should not the artist select the best? I'll say she should.[22]

Restoring his West Chester, Pennsylvania, farm, McBride had written Stettheimer long letters describing his travails, which then showed up in the portrait. After a bout of tonsillitis (note the high white scarf protecting his neck), McBride hired a seventy-eight-year-old man, Sam Bonsall, to put a new picket fence up around the farm's property. When Bonsall finished, McBride undertook to paint the fence himself, an enormous task, as he wrote to Stettheimer: "Ever try painting a five hundred rail fence?" Stettheimer included the fence along the lower right side of the portrait. Initially fencing in a group of beachgoers on two sides, the railing soon turns into a maze that traps McBride, wearing overalls and holding a paintbrush.

Stettheimer devoted the background of the upper half of the painting to symbolic representations of the critic's favorite artists: Winslow Homer, John Marin, Demuth, Lachaise, and herself. In the upper right corner, a top-hatted McBride stands along the edge of a stone wall looking out

over a bright orange sunset and a stormy sea. The ocean view is made up of elements from various Homer paintings: the manned, perilously angled rowboat and a bell clanging a warning may refer to the Maine artist's *The Fog Warning*, though the use of red, ambiguous form could also refer to the red scarf in his 1884 painting *The Life Line*. Adjacent to this is a tall, wind-bent palm tree, reminiscent of Homer's numerous watercolors of the Bahamas.[23]

Directly surrounding McBride's central head and upper body, several brightly colored, geometrically angled structures, including a tall, cylindrical building with an American flag, resemble buildings and the loose painting and blue colors in Marin's watercolors and paintings. Below, a faint image of a lean, hatless McBride with a walking stick stops by a fountain, where a man offers a rose to a woman leaning toward him from a wrought-iron terrace. This references a scene from one of the watercolors Homer made during his visits to the Cuban city of Santiago de Cuba in the 1870s. Behind this scene, an elderly woman in a lace collar peers out from the lace-curtained window of a large, angular building that calls to mind the numerous buildings with turrets and peaked roofs painted by Demuth,[24] whom McBride considered one of America's leading artists.

Nearby, Stettheimer painted a laddered pyramid on which she wrote letters from both the sitter's and her own names. The names are broken up and repeated in a rhythm that recalls Stein's word-portraits. As early as 1918, McBride had seen a sculpture titled *Woman* by Gaston Lachaise and declared it to be a masterpiece; Stettheimer included it in the left background of the painting, standing high on her toes, with her arms raised as though in surprise. To the far left of the painting, one of Stettheimer's floral "eyegay" still lifes is placed as an anagram for the artist. It sits beside her characteristic bright sun and bowed white curtain, which reinforces the theatricality of the overall scene.

McBride remembered the first time he actually realized that his portrait resembled a performance, as sitters and their guests bandied about interpretations of the symbolic aspects of the paintings. He observed:

> The pictures were shown only when finished, but when finished they were apt to be shown triumphantly in the studio to a few invited guests. The portraits in particular usually had parties given for their "debuts," the sitters being permitted to invite their own guests for this unveiling and steeling themselves in advance not only against the badinage of the portrait but also of the "assistance;" the sum total of this badinage always being considerable. The sitters, I should hastily add, never actually sat for their portraits . . . imaginative portrayal and sometimes exceedingly whimsical.[25]

Specificity within her paintings was critical to Stettheimer's aesthetic, even if she combined a number of events into a single composition or played with actual proportions and distances. In her

mature portraits, Stettheimer alluded not only to locations of events of particular importance to the sitters, but also her reactions to them. Viewers who were not acquainted with the subjects or events would therefore not be able to identify all of these details. However, Stettheimer painted them with bright colors, precision, and a witty sense of humor, and as a result, even those who do not know the sitters can glean a great deal about their personality by reading the composition closely.

When painting *Portrait of Carl Van Vechten* in 1922, Stettheimer placed the sitter within a room of his apartment. (*Fig. 74*) Following Proust's view that personal spaces were an index of subjective memories,[26] Stettheimer seeded Van Vechten's surroundings with myriad references to his life. Interestingly, it also contains specific references to his alter ego, the protagonist of his autobiographical novel *Peter Whiffle: His Life and Works*, completed the year before she painted his portrait.[27] Stettheimer likely made this painting to commemorate the book's publication. Van Vechten inscribed a copy of the book: "For the sisters Stettheimer, this quest of disillusion."[28] To truly understand the portrait's references, many of which would have been obvious to their mutual friends, one must view the painting together with reading the novel.

In the book, Peter Whiffle, like the author, is born in the Midwest in the 1870s. He soon runs off to New York and Paris, where he seeks the purpose of life. In the opening scenes of the novel, Van Vechten (who puts himself in the novel as the narrator) and Whiffle meet while the former is having his portrait painted by a Martha Baker, whose capturing of his flaws causes him to note, "Posterity might have learned more from such portraits than from volumes of psychoanalytic biography." Echoing Proust's and Joyce's notion of real time operating simultaneously on multiple levels, Peter Whiffle declares that great art is not linear, just as:

> One might write a whole book of two hundred thousand words about the events of an hour. And what a book! . . . My intention is not to define or describe, but to enumerate. Life is made up of a collection of objects, and the mere citation of them is sufficient to give the reader a sense of form and color, atmosphere and *style*. And form, style, manner in literature are everything; subject is nothing . . . All great art is a matter of cataloguing life, summing it up in objects.[29]

Many clues to the iconography in Stettheimer's portrait of Van Vechten can be found in the "impressions and objects" found in Van Vechten's loosely autobiographical novel. Whiffle's Paris apartment has tables piled high with pamphlets, notebooks, and books, and his attitude toward life, nature, and art is to always present "two or more faces." As the novel progresses, Whiffle experiments with assorted drugs (as Van Vechten had done) and avidly reads *The Book of the Dead* and various sorcerers. When the narrator next encounters him, Whiffle is involved

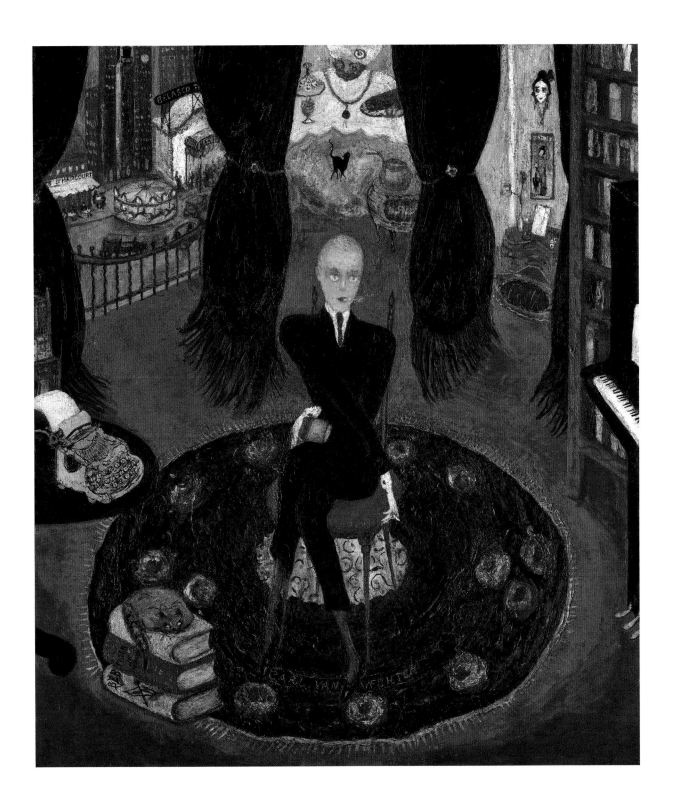

Fig. 74 Florine Stettheimer, *Portrait of Carl Van Vechten*, 1922, oil on canvas, 30 ½ × 26 in., Yale University Art Gallery, New Haven, Yale Collection of American Literature, Beinecke Rare Book and Manuscript Library, Yale University, New Haven, CT.

in satanic rituals, accompanied by a black cat named Lou Matagot, from the Provençal word for "the Cat of Dreams and Sorcerers." In a room filled with amulets and talismans, stuffed serpents, and divining rods, and "everything . . . that [famed theatrical producer] David Belasco would provide for a similar scene on the stage," Whiffle attempts to resurrect the spirit of the fiend Mersilde by combining various potions in a brass chafing dish.[30] The dish explodes, killing the cat and sending both men to the hospital. When he visits Whiffle for the last time, Van Vechten finds him terminally ill, having "curled himself into a sort of knot," smoking Fatima cigarettes, and declaring that the purpose of life is simply to live as fully as possible, like a cat, "the only animal with true centeredness."

After Van Vechten's novel was published, Stettheimer wrote him a poem in which she noted her amusement with the many portraits concealed in it:

〜〜〜〜〜〜〜

Carl

Carlo

Carl Van Vechten

There is Fania

There is Peter

There is Mabel

There is Edna

There are cats

Past cats

Present cats

Future cats

There is music —

However

There are

Carl

Carlo

Carl Van Vechten[31]

〜〜〜〜〜〜〜

Stettheimer painted an elegantly (and unrealistically) thin Van Vechten sitting with his arms and legs curled, like Whiffle's last incarnation, so that his upper and lower body turn in opposite directions. He holds a copy of his book and stares into space. The smoke exhaled from a cigarette curls above Van Vechten's head, where the cat, Lou Matagot, preens. Above the black cat a second, more robust figure of Van Vechten enters the composition wearing a turban and carrying a Victorian leaded lamp and a platter of food. Set off by heavily fringed curtains as though he were a dream figure or spirit, this character has multiple references: the drug-induced rituals conducted by the real Van Vechten and in the book by Whiffle; Van Vechten's reputation among friends for preparing a fine cordon bleu; and his constant worries about his weight.[32] The painting is ablaze in reds and yellows offset by stark black forms. Van Vechten later noted that Stettheimer's use of the black is the "keynote" that draws all her portraits together into a unified series.[33]

Further blurring the boundaries between reality and artifice, at one point in the book, Van Vechten suggests that he and he visit the studio of the artist Florine Stettheimer, whose work he is certain Whiffle will like. Instead, the protagonist decides to buy an Aubusson carpet with garlands of huge roses of pale blush color. In her painting, Stettheimer refers to this homage by placing the central figure of Van Vechten on the rose-dotted carpet, onto which she incises his name with the back of her paintbrush. The portrait also contains numerous references to Van Vechten's work as a dance and music critic and novelist. A piano and extensive book collection stand at right, and at left a manual typewriter sits on the floor with a sheet of white paper inserted, ready for the author's next words. In the typewriter's keys, Stettheimer inserted her own name and the date of the painting.

At lower left, one of Van Vechten's omnipresent cats stares out at the viewer while sitting atop a stack of books. Two of the bindings reveal titles of other works by Van Vechten, *The Blind Bow Boy* and *A Tiger in the House*, a collection of tales about cats. As a thank-you for a birthday present of a flower bouquet from Van Vechten, Stettheimer sent her friend a gouache painting of a bouquet of cat's eyes and tails. Below the bouquet, she wrote:

This is my
Birthday bouquet
From you
Carl Van Vechten
You big man with cat's eyes
You collect cat's tails
From men and women
And bunch them together
And give them to other men & women
I am one of them and thank you[34]

Stettheimer also included references to another "tiger" in his household: his second wife, the Russian-born actress Fania Marianoff. Although Van Vechten was gay, and friends noted that their relationship was marked by frequent, often explosive arguments, his marriage to Marianoff lasted for decades. In her portrait of Van Vechten, Stettheimer's references to Marianoff include a small shrine and a throw rug bearing her name; a dressing table with a Japanese ukiyo-e woodblock print hanging above; and a Noh mask that bears a striking resemblance to the actress. In a 1932 letter to

Van Vechten headed "Dear Snakecharmer," Stettheimer mentioned her mother's ironic remark on visiting the Van Vechten apartment: "Separate rooms, said she."

For her portrait, Stettheimer painted Van Vechten wearing a red tie—a code at the time for gay men—and long purple socks, another color associated with homosexuality. In the 1946 catalogue for Stettheimer's retrospective exhibition, McBride obliquely referred to this identification with sexual orientation, stating of the artist's portrait: "She knew very well that Mr. Van Vechten frequented cafés both in Paris and in New York, and said so in the picture—but apparently, she did not hold it against him."[35]

At the upper left side of Stettheimer's *Portrait of Van Vechten* there is a terrace looking out over New York City, with cars, tall buildings, the Belasco Theatre (complete with a marquis featuring Marianoff's name), and the Café d'Harnoncourt, which Van Vechten enjoyed patronizing.[36]

In December 1922, Stettheimer held a tea in her studio to celebrate the unveiling of *Portrait of Carl Van Vechten* and *Asbury Park South*'s admission to the *Salon d'Automne* in Paris. She invited Robert Locher, Marcel Duchamp, Alfred Stieglitz, and the Van Vechtens. Carl Van Vechten brought a book reviewer whom Stettheimer described as "a harmless young man." In her diary she noted, "They all seemed to like my portrait of Carl—they called it all sorts of distinguished names." Among the critics who responded favorably to the portrait was Penelope Redd, who, in a letter of May 5, 1922, may have been acknowledging Stettheimer's depiction of Van Vechten's sexuality when she wrote of his "device of concealment behind his vocabulary" and of Stettheimer as the "omniscient observer":[37]

Do you wonder that the fact that you exist and comment in paint is incredible to me? . . . Your simultaneous comment in paint is much more skillful and timelier than comment in words. I am thinking of "Chrome Yellow" and of "Peter Whiffle." Mr. Van Vechten's device of concealment behind his vocabulary is amateur in contrast to your agile mask of diffidence in painting. Your physical being is even presented in your compositions and yet you achieve detachment toward all the others who are engaged in cataloguing each other. You contrive the omniscient observer and without the mechanics. It is great and fine art.[38]

When *Portrait of Carl Van Vechten* was exhibited at the Society of Independent Artists in 1923, the reviews were again enthusiastic. In the *New York Tribune*, Burton Rascoe called it "the funniest work in the show . . . a thing of many colors, including gilt and silver, and being, all in all, a dirty crack at Carl, but he says he thinks it is wonderful." In an otherwise incredibly racist and inappropriate review, Alexander Brook called the work "a remarkable piece of painting. The color is in defiance of that hackneyed phrase, "good taste." . . . If France has its Marie Laurencin, we have our Florine Stettheimer and let us hope that we will be as proud of her as they are of Mlle. Laurencin."[39]

Henry McBride noted that Stettheimer depicted Van Vechten:

at his very best — in fact, at the moment of creating "Peter Whiffle." His eyes dilate, his legs intertwine, his fingers clutch the air — he composes! The innocent public that always imagines writing to be mere play will be aghast at these revelations of the agonies of an artist, but Mr. Van Vechten's fellow scribblers will gaze at him in the moment of his apotheosis with peculiar sympathy.[40]

Van Vechten's next novel, *The Blind Bow Boy*, was printed the following year. In another of their mutual homages, the novel contained the first and only, albeit symbolic, sale of a Stettheimer painting. A character named Ronald, Duke of Middlebottom, purchases and hangs a Stettheimer painting of a bowl of zinnias in his West Twelfth Street home in Manhattan. Stettheimer suggested that the author advertise the novel by placing her portrait of him in the window of Brentano's bookstore. The painting was included in the exhibition at the Art Gallery of the Women's World Fair, held in Chicago in April 1925. Although Stettheimer refused to sell any of her paintings, in a rare instance, she gave Van Vechten his portrait.

Although several artists and critics believed Stettheimer's portraits would be the works for which she would be most appreciated, their readings of them varied considerably. In what was evidently a personal issue, Marsden Hartley seemed unable to get beyond what he called the "feminine qualities" of Stettheimer's work, and completely misread them.[41] Ignoring their humor and irony, he termed them "fragrant portraits . . . [which] exhale pungency's [*sic*] and sweetness on the air around them . . . They are portraits of the qualities and essences that emanate from them (the sitters), from their minds or from their delicately adjusted or maladjusted spirits." Hartley added that the works caused:

certain delectable, social and esthetic enjoyment. It is as if these beings had come to bloom freely and clearly in spite of alien temperature and alien insistence, perhaps chiefly under glass, if you will, subjected to special heats, special rays of light, special vapors, but there they are replete in their own beauty, their own hypersensitized charm. There is, thank heaven, no trace of stolidity in them, they perform their singular effects by means of an almost clairvoyant veracity.[42]

Van Vechten, in an unpublished essay, wrote the most incisive description of Stettheimer's portraits:

They represent to a certain extent a group of her friends, and admirers, her relatives. Each then awakens a special problem or technique . . . Miss Stettheimer does not ask her models to pose for her. Rather, in her own mind she creates a synthetic portrait, built up of details from the life of the person she is painting. Then the portrait gradually emerges in the secrecy of her studio.[43]

At Edward Steichen's urging, Frank Crowninshield, the editor of *Vanity Fair*, wrote a series of letters over the next six years urging Stettheimer to consider sending photographs of her portraits to the magazine as they would make "an amusing feature."[44] Unfortunately, Crowninshield rarely spelled Stettheimer's first name correctly when addressing her, an act of negligence that did not endear him to the artist, who was fierce about controlling her image, from her depiction in her paintings to "branding" herself as a professional artist through her clothing. As a result, the "amusing feature" never materialized.

Stettheimer met Georgia O'Keeffe for the first time at her December 1922 unveiling party for the Van Vechten portrait.[45] Stettheimer had probably met Stieglitz a year earlier, when, having seen her painting *Heat* at Marie Sterner's *First Retrospective Exhibition of American Art* at the Fine Arts Society building, he remarked how much he liked it. Since seeing her work, Stieglitz had tried in vain to convince Stettheimer to be the seventh artist, with O'Keeffe, Marin, Demuth, Hartley, Arthur Dove, and Paul Strand, to join what would become his well-known Intimate Gallery.

A year earlier, Stieglitz had gained notoriety by organizing an exhibition at the Anderson Gallery and Auction House that included a photographic "Composite Portrait" of segments of O'Keeffe's naked body. She later observed that for Stieglitz, the "idea of a portrait was not just one picture; it was a composite of pictures capturing an idea and personality that was too large to fit in a single photograph." On the evening of the Van Vechten portrait unveiling, Stieglitz brought O'Keeffe to Stettheimer's to introduce her to the artist. In her typical caustic and ironic manner, Stettheimer remarked to her, "Miss O'Keeffe, it is good to meet you whole, as so far I only knew [you] in sections."

After the party, Stettheimer wrote to Ettie, who was in Atlantic City, that "Stieglitz and O'Keeffe did not come by daylight as they said . . . She has grown broader and mature looking since her last photos. She looks strong and capable and calm. He spouted all sorts of indiscretions and is as alive as ever."[46] Stettheimer later composed an ironic poem that encapsulated the symbiotic relationship, both personal and professional, between Stieglitz and O'Keeffe:

He photographs
She is naked
he proclaims
She has no clothes
other than his words.
Goldenbrown and autumnred
they drop fast
and cyclone about her

She turns them
into painted air
rainbowhued
that whirls and swirls
and sucks him in[47]

Fig. 75 Florine Stettheimer, Postcard of color swatches, Yale Collection of American Literature, Beinecke Rare Book and Manuscript Library, Yale University, New Haven, CT.

During 1923, Stettheimer was particularly prolific and painted a large number of portraits of friends, her sisters, and herself. The summer air at Sea Bright again inspired her to work, this time on several paintings simultaneously. Soon after their arrival at their beach home, both Florine and Ettie began regular correspondence with a young relative by marriage, Louis Bernheimer, affectionately known as Lulu. Bernheimer, whom Ettie referred to later as "a tragic boy," was an amusing, extremely good-looking gay man. In early summer, he wrote to Ettie, describing how he intended to rent a room on Nantucket, where he would "swim naked every day until I approach the cutaneous condition of a coffee bean, and become, if possible, younger than ever. I have invented a religion, called protoplasmism: one endeavors, by intense effort of silence, to regain the naive simplicity of the amoeba."[48]

This description must have intrigued Stettheimer, because in early August she wrote to Bernheimer, sending him a postcard containing seven paint samples ranging in color from yellow to very dark brown. (*Fig. 75*) She urged him to compare the swatches of color to his tanned skin and to "match the shade—make a cross against it and return to Fl. St. Seabright."[49] Bernheimer marked the two shades that were the closest to his current skin color, and wrote to the artist in some excitement at the possibility that she might be painting his portrait:

> Dear Florine—you scared me to death. I thought the police were after me. What are you up to, anyway, with all these little color things? The nearest my color, after a good bit of worrying, are the two I've marked. The one on the right is closer but it isn't exact.

Somewhere between the two. But why do you want to know? Are you doing the portrait you spoke of? That would be very exciting . . . Have you written any more DADA poetry — if so, please send me copies. And give my love to your sisters and your mother.[50]

The resulting painting shows a deeply tanned Bernheimer casually leaning against a doorjamb, his hands in the pockets of white pinstriped summer pants. (*Fig. 76*) His almost fluorescent orange jacket, with its large red boutonnière, contrasts sharply with the deep blue of the hotel's carpet. In the upper left corner, Stettheimer reproduced one of her flower paintings, complete with her monogram and gilded frame. Stettheimer also designed and had a frame made for this portrait. On the outside of the traditional white-painted wood frame, she added a surround of interlacing white-painted wooden loops that resemble lace and are inextricably part of the portrait.

In an August 1923 diary entry, Stettheimer noted that she had "started the painting of Ettie's portrait — in my bathroom/boudoir/studio," and the next day, "started to paint my portrait." Both completed works, *Portrait of My Sister, Ettie Stettheimer* and *Portrait of Myself*, are the same size, and the women's bodies are aligned in opposing directions so that when placed together, they bracket each other as embodiments of night and day.[51] Stettheimer's treatment of these two works differed considerably from that of her contemporaneous portraits of Van Vechten and McBride. Rather than being situated in identifiable environments, the sisters float in amorphous space. Although André Breton did not officially found the Surrealist movement until the next year, the term "surrealism" had been used in European literary circles since 1917. As evident in her earlier painting *Music*, Stettheimer was undoubtedly aware of Surrealism's incorporation of dreams and unconscious imagery when she painted these.

In *Portrait of My Sister*, Ettie lies against a red velvet cushion before a purple-black evening sky, its opaque surface broken only by the full moon and glittering stars. (*Fig. 77*) Stettheimer gave visual definition to Ettie's theatrical personality by the dark night setting, making it a direct contrast to the pure white background she painted in her self-portrait. Languishing on a dramatically fringed scarlet shawl and wearing a low-cut gown held up by a single jeweled strap, Ettie stretches her bare arms and shoulders as though she has recently awakened. Florine repeated this sexually inviting pose of placing an arm over her head in several of Ettie's portraits, including *Picnic*, *The Bathers*, and *Heat.*

Florine painted her sister's face, with its characteristically conspicuous eyebrows, wearing an expression of perplexity and uncertainty. She lies inactive, gazing into space. McBride later ambiguously described the portrait as looking "wide-eyed, for the mystery of life . . . as happy a blend of her worldliness and spirituality as any psychiatrist could ask for."[52] The same year, Alfred A. Knopf published Ettie's second book, a long novel titled *Love Days*,[53] which she'd written under the

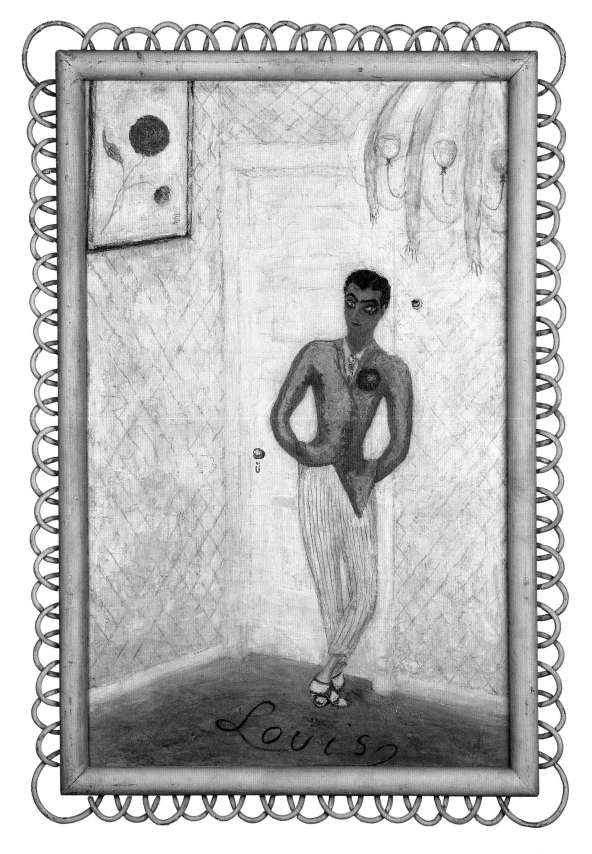

Fig. 76 Florine Stettheimer, *Portrait of Louis Bernheimer*, 1923, oil on canvas, 28 × 18 in., The Robert Hull Fleming Museum of Art, University of Vermont, Burlington, Gift of the Estate of Ettie Stettheimer.

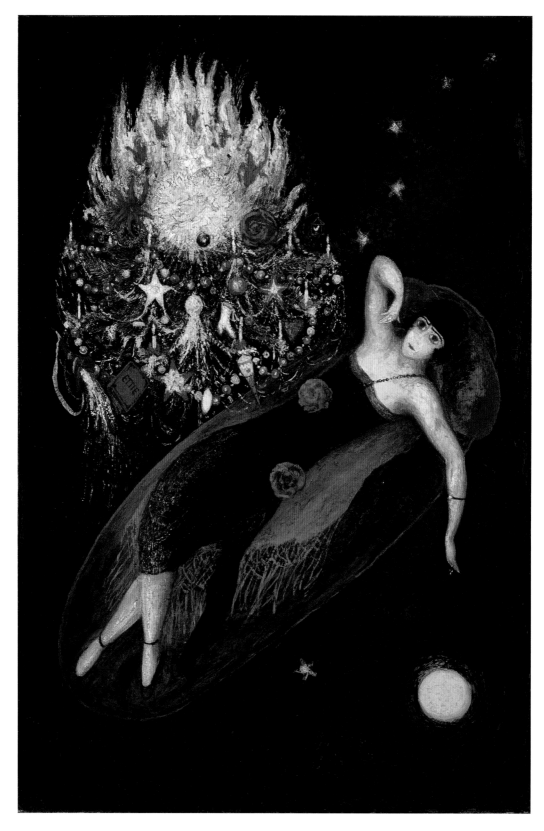

Fig. 77 Florine Stettheimer, *Portrait of My Sister, Ettie Stettheimer*, 1923, oil on canvas laid on board, 40 ¼ × 26 ¼ in., Art Properties, Avery Architectural & Fine Arts Library, Columbia University in the City of New York, Gift of the Estate of Ettie Stettheimer.

pseudonym Henrie Waste, made up of some of the letters of her name, Henrietta. *Love Days*, a thinly disguised autobiography with satiric portraits of Nadelman and Duchamp, was harshly criticized by both the critic Bernice Kenyon and the Stettheimers' friend Leo Stein. Following its negative reception, Ettie retreated from the public eye and never wrote another original work for publication.

According to Parker Tyler, Van Vechten once mentioned that he "recognized malice as an ingredient of Florine's portraits."[54] In her portrait of Ettie, Stettheimer evidently incorporated a slyly humorous element at her sister's expense. To the right of Ettie's bent arm, also floating in outer space, is a brightly decorated Christmas tree with a ribbon bearing Florine's name and the year 1923. The tree is strung with colorful lights, tiny lit candles, and elaborate ornaments such as stars, high-button boots, caged birds, hearts, glass balls, roses, a horn of plenty pouring out gold dust, and a red leather-bound book with Ettie's name prominent on the cover. The top of the tree is on fire, with large gold flames and bright red, flame-like lilies rising into the midnight sky. At the white-hot center of the conflagration, a small nude putto, discreetly covered by a winding blue ribbon, reclines in counterpoise to Ettie.

In her diary entry for October 2, 1923, Florine noted that she had not yet completed the portrait and caustically remarked that "Ettie has a Xmas tree burning bush combination — I have decided the Xmas tree is an outcome of the burning bush of Moses."[55] Florine often stated she enjoyed the ritual quality of Catholic ceremonies, and every year the Stettheimer women put up a Christmas tree. She also included a huge Christmas tree as the center of another painting, titled *Christmas*. Ettie, however, did not enjoy the fact that her family celebrated the holiday. In March 1939, she wrote Fania Marinoff, apparently apologizing for a remark she had made as she did not realize "Christmas is an important & great or holy day for you I make no excuses for not having guessed it, for you have always stressed your Jewish feeling very vociferously & I myself have a very *unpleasant* conscience about celebrating Xmas at all, which I only do — after reducing the celebration to its smallest dimension — because our family, brought up in Germany, got the Xmas habit."[56] It is therefore highly doubtful that Ettie would have chosen to have a Christmas tree, burning bush of Moses or not, as the main element of her portrait as Stettheimer painted it.

In *Portrait of Myself*, Stettheimer symbolically transformed herself into a visionary artist drawn to the light. In the painting's top right corner, a small, highly stylized bright red dragonfly pauses under the brightly shining sun, whose extended white rays appear to sweep the artist upward toward the same destination. (*Fig. 78*) Similarly, her position, with one leg bent under the other, curved torso, and rounded head accentuated by a black beret, mirrors the small, winged insect. The billowing red cape Stettheimer wears as she floats in the air resembles wings. Both the dragonfly and Stettheimer's face and body are painted red, as though burned by the sun.

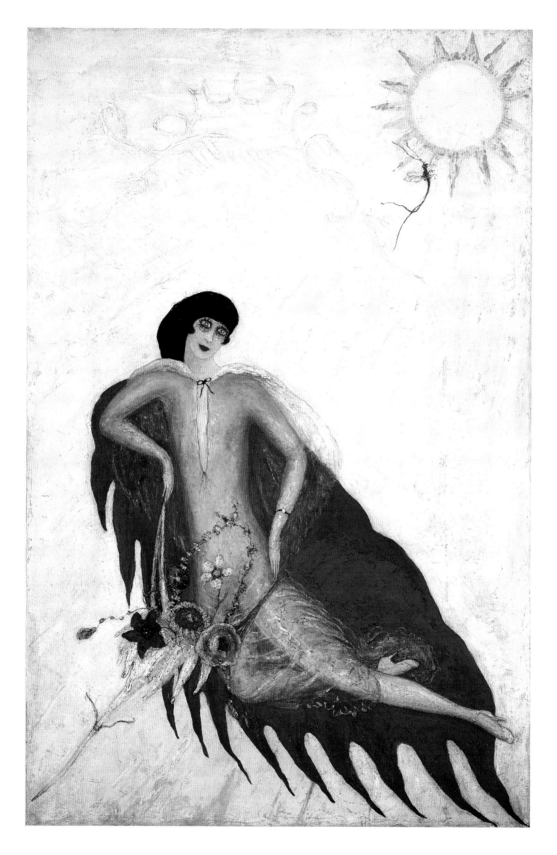

Fig. 78 Florine Stettheimer, *Portrait of Myself*, 1923, oil on canvas laid on board, 40 ⅜ × 26 ⅜ in., Art Properties, Avery Architectural & Fine Arts Library, Columbia University in the City of New York, Gift of the Estate of Ettie Stettheimer.

In another of her undated poems, the artist made an interesting contrast between men, who are earthbound, whom she calls the "great mud makers," and women such as herself who are "the sunbursts" floating in the sky:

~~~~~~~~~~~

You are the steady rain

The looked-fors

The must-bes

The understandables

The undistinguishables

The inevitables

The earthmoisteners

The great mud makers

We are the sunbursts

We turn rain

Into diamond fringes

Black clouds

Into pink tulle

And sparrows

Into birds of Paradise[57]

~~~~~~~~~~~

Echoing the dragonfly's delicate, transparent wings, in her self-portrait Stettheimer wears an ephemeral gown of white cellophane, with a second, smaller cellophane cape attached at her neck by a small black bow and glistening on top of the larger red cape.[58] In this work, Stettheimer distances herself even further from traditional notions of female sexuality. Unlike in her earlier *Nude Self-Portrait*, she is now almost entirely sexless, with the bouquet of flowers covering her genitals. Even though the décolleté of the dress extends halfway down her midriff, her body lacks apparent breasts; her torso more closely resembles that of a slim young man than of a fifty-two-year-old woman. Marcel Duchamp is said to have stated that Stettheimer "had no female body under her clothes [so that her] clothes hung on her."[59] Her own vanity about her beautiful legs, though, caused the artist to include rounded thighs visible behind folds in the transparent cellophane, with elegant calves and ankles, as usual, terminating in fashionable high heels.

One idea that was celebrated by the avant-garde between the world wars was the French poet Charles Baudelaire's "cult of the multiplied sensation."[60] This concept was that the central principle

of modern life was the cultivation of one's own individuality, experienced through the senses. It was often sought by artists using alcohol and drugs to develop "heightened powers of vision and perception."[61] A number of modernist writers, artists, and musicians attempted to "enter a state that is simultaneously totally full and totally empty, at once transparent and opaque, able to draw the world in to the self but at the price of divesting all things of their substantiality, creating images of a 'weightless, floating self.'"[62]

In the painting, Stettheimer incorporated one of Surrealism's principles: that women were special seers.[63] In early Surrealist journals, women were often depicted as children, their eyes wide open with a hypnotic gaze,[64] indicating their openness to emotions and the stream of autonomic, unconscious stimuli. In *Portrait of Myself*, Stettheimer similarly exaggerated her eyes' huge pupils and heavily mascaraed, thick-lashed, red-rimmed prominence. By combining this expression with a black beret, she identified herself as having the heightened vision of an artist.[65]

Marcel Duchamp characterized artists as being like "mediumistic" beings, not in possession of "consciousness on the aesthetic plane." He further described the artist as a person who speaks from "beyond time and space."[66] Should anyone be unable to see that the wide-eyed, all-seeing, risk-taking, floating figure in *Portrait of Myself* is the artist, Stettheimer wrote her name in subtle white script across the top two-thirds of the composition. Set against the white rays radiating from the sun, the writing is almost illegible except to the discerning eye, but it is many times larger than Stettheimer signed her name in any other painting. The curved letters "Florine" form a written white canopy over her self-portrait below, while the abbreviated "St" drops down so that the "t" almost touches one end of the flutterby's tail, reinforcing the latter as her anima.

As is often the case with Stettheimer's paintings, clues to the iconography can be found in art history. The mayfly/butterfly and dragonfly have long been symbols of metamorphic transformation and concepts of the feminine. The French entertainer Loïe Fuller, who personified Art Nouveau ideals, performed as a butterfly with iridescent wings. In her memoir, she stated that the dance was conceived as a transformation of the psychological sleep-dream state triggered by the hypnotist.[67] Images conflating humans and insects were also common in Surrealist media, positing the idea that objects and phenomena could be themselves and something else at the same time.[68] On February 9, 1923, an "Insect Frolic" costume ball was held at Webster Hall in Greenwich Village. The poster for the fête was illustrated in black and white with a large drawing of a butterfly with two tiny nude women, one hanging from the insect's tail and the other floating in the air.

Stettheimer's interest in flying insects, evident as early as the turn of the century in her gilded family screen, was noted by Van Vechten, who sent the artist an article on the praying mantis and drew an enigmatic drawing of an insect on the accompanying letter. Stettheimer considered the

mayfly, or dragonfly, her anima, or alter ego. According to the artist Pavel Tchelitchew, she saw herself as an *éphémère*, a short-lived, slender insect with a delicate, transparent body and wings and two or three long filaments on its tail.[69] She came up with her own name for the mayfly: flutterby, possibly referring to its short life, which she also alluded to in several of her poems:

> An Ephemère:
> I broke the glistening spider web
> That held a lovely ephemère
> I freed its delicate legs and wings
> Of all the sticky, untidy strings
> It stayed with me a whole summer's day
> Then it calmly simply flew away —[70]

And:

> I saw a flutterby die...
> It was on Easter Sunday morning
> in my white and gold bed-room
> overlooking the Tuileries gardens . . .
> It must have hidden away
> in a bunch of lilies
> out of which it limply fluttered
> to the high sunny balcony window
> and then swooned . . .
> I tried to revive it
> I sent Jeanne for the honey jar
> I sent Jeanne for the sugar bowl
> but the flutterby crawled
> over my sky-blue satin couvre-lit
> spread its yellow wings
> and did an unbeautiful act
> . . . It died . . .[71]

Stettheimer's early life—its constant moves, her experience of the war, and her love of flowers—left her very aware that everything in life is transient and in constant flux. The prominence of the flutterby in *The Portrait of Myself*, flying like Icarus so close to the sun, emphasizes the temporality of life, as does the thin black watch with a white dial on the artist's left arm. *Ars longa, vita brevis*: time being fleeting, Stettheimer saw that her role as an artist was to document what she saw and experienced through her paintings and poetry.

A fundamental characteristic of the modern, as opposed to the Victorian, novel, at least according to Proust, was the discovery of what he called "a different self." The aim was no longer to tell a story or expound a moral, but to achieve a breakthrough to a different, deeper, more human self. This exploration of individual sensibility by Stettheimer and many contemporary artists and writers was a powerful early twentieth-century message.[72] By titling her portrait *Portrait of Myself*, rather than using the usual terminology: "self-portrait," Stettheimer emphasizes that the work is not just painted by her but also represented her view of her authentic self.

In 1899, when Stettheimer was in her late twenties, Kate Chopin's *The Awakening* provoked significant controversy because of its sympathetic portrayal of a woman trying to break the constricting bonds of a bad marriage. The novella was widely denounced at the time and banned from bookstores and libraries. As Edna, the protagonist, tells a friend, "I would give up the unessential; I would give my money, I would give my life for my children; but I wouldn't give [up] *myself*. I can't make it more clear."[73] Although Stettheimer never recorded reading the work, she was undoubtedly aware of it due to its notoriety and feminist theme and her proclivity for seeking out feminist literature. The novel may therefore have contributed to Stettheimer's unusual titling of her self-portrait.

Portrait of Myself also echoes Stettheimer's early ballet *Orphée* in the dual roles Stettheimer gave Georgette as society lady and member of an avant-garde artists' troupe—divergent social strata which Stettheimer was attempting to balance in her own life. The black beret and facial alignment of her persona in *Portrait of Myself* is remarkably similar to a drawing of the Apache woman that Stettheimer made for her ballet, again intimating a rebellious, nonconformist side to her personality. (*Fig. 79*) Now with eyes wide open, Stettheimer is no longer a follower of others' painting style, but an innovator.

By 1923, when she painted *Portrait of Myself*, Stettheimer was receiving a great deal of positive recognition for her paintings. At the same time, however, she was still struggling to find the time and emotional space to work. Her immediate family's lack of support and belief in her work, coupled with the constraints of her life and social obligations, meant that she was constantly torn. It was only when painting that she felt the most comfortable and at home. Her awareness of the split between her familial and social obligations and her ambition to have a major career were implied in one of her most poignant poems:

~~~~~~

Occasionally
A human being
Saw my light
Rushed in
Got singed
Got scared
Rushed out
Called fire
Or it happened
That he tried
To subdue it
Or it happened
He tried to extinguish it
Never did a friend
Enjoy it
The way it was
So I learned to

Turn it low
Turn it out
When I meet a stranger —
Out of courtesy
I turn on a soft
Pink light
Which is found modest
Even charming
It is a protection
Against wear
And tears
And when
I am rid of
The Always-to-be-Stranger
I turn on my light
And become myself[74]

~~~~~~

In October 1923, Carrie and Ettie, who were always closer to each other than to their artistic sister, rented a small apartment in the Dorset Hotel just to work on their own projects. Ettie planned her next book, which never materialized, and Carrie continued to work on her elaborate dollhouse whenever she had time free from household and social duties. That year Stettheimer also paid tribute to her elder sister's achievements in a painting, *Portrait of My Sister, Carrie W. Stettheimer* (*Fig. 80*), in which the dollhouse takes up the left half of the composition and serves as a metaphor for Carrie's identity. The raised building, bearing the date and a plaque with her name, firmly grounds Carrie as the domestic hostess and caretaker. In contrast to the strong, bright colors that Stettheimer used to paint Ettie's and her portraits, pale pastel shades dominate. Stettheimer also emphasized the details of the setting more than the figure of her sister, who blends into the background.

Stettheimer used narrative to create the passing of time. In the foreground, a pink, yellow, and blue curtain has been pulled aside to reveal Carrie standing on a rose-covered carpet bearing her monogram in gold along its oval border. Carrie wears a gown with an ermine train and a dark lace shawl, a pearl choker matched by hanging earrings, and a white cloche hat from which two slender antennae extend, identifying her as an insect. Her face, with its round, heavy features and blue eyes, is turned toward the viewer. In one hand she holds a cigarette, in the other a miniature upholstered chair intended for the dollhouse.

At middle right, Stettheimer recreated an image of her family seen in *Family Portrait I*. Carrie, hatless, wears a diaphanous blue gown, and Ettie slouches in a characteristically bright red dress in front of a lace-covered table. Rosetta sits at the center of the table on the other side, and Florine, in a straw sun hat, stands next to her, arranging a bouquet.[75] Adjacent to the miniature family group, a series of rose arbors recalls the gardens of André Brook, and a large farmhouse is visible, in front of which a woman sits milking a cow and a man pushes a wheelbarrow. This differentiation between rural and urban, background and foreground, recalls a similar device Stettheimer used in her 1917 painting *Picnic in Bedford Hills*, allowing us to read the painting both chronologically and metaphorically.[76] During all the years as the Stettheimer women moved between their urban apartment and their summer rental estates like André Brook, Carrie continually worked on her dollhouse, which remained unfinished at the time of the portrait. Nonetheless, Florine included a small plaque on the façade of the dollhouse, conferring on Carrie the title of "Decorator, Designer & Collector."[77]

One of Stettheimer's most complex portraits is of the novelist Joseph Hergesheimer. (*Fig. 81*) In 1922, Hergesheimer was so popular that a *Literary Digest* poll at the time rated him the best contemporary author, surpassing even Eugene O'Neill. Brought up in the strict Presbyterian home of his maternal grandfather, he entered the Pennsylvania Academy of Fine Arts to study painting at sixteen. The effect of Hergesheimer's art training is evident in his fiction, where detailed descriptions

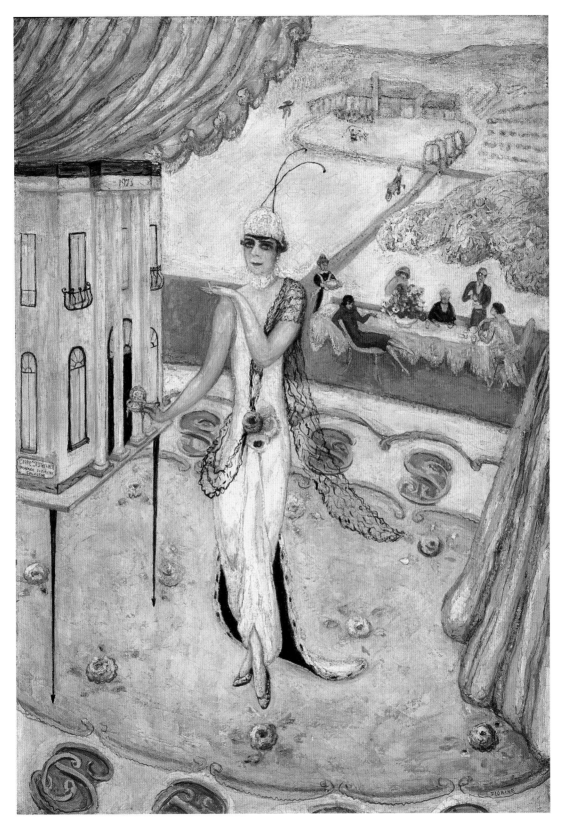

Fig. 80 Florine Stettheimer, *Portrait of My Sister, Carrie W. Stettheimer,* 1923, oil on canvas laid on board, 37 ⅞ × 26 in.,
Art Properties, Avery Architectural & Fine Arts Library, Columbia University in the City of New York, Gift of the Estate of
Ettie Stettheimer.

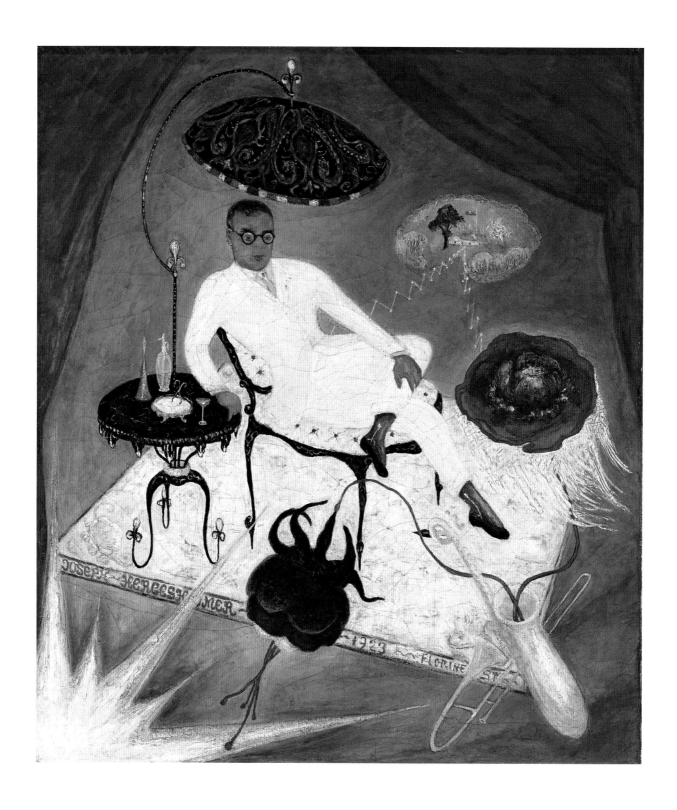

Fig. 81 Florine Stettheimer, *Portrait of Joseph Hergesheimer*, 1923, oil on canvas, 30 × 28 in., Yale Collection of American Literature, Beinecke Rare Book and Manuscript Library, Yale University, New Haven, CT.

of interiors and arrangements of furniture and gardens prevail over his treatment of the plot or characters. On occasion, he would use two or three paragraphs to describe a single table.

Hergesheimer's greatest pleasure was researching his own novels. As an author, he claimed to use the aggregation of details "to represent larger human traits — the decline of honor, the struggle for personal integrity."[78] Throughout the decades, Hergesheimer, whom one biographer described as "an American aesthete," grew hostile toward the increasing democratization of American life. This led him not only to recreate and romanticize previous eras in his novels, but also to travel to such places as Mexico and Cuba to escape what he felt was the increasing lack of high culture in the United States.

Hergesheimer's experiences in Cuba resulted in an autobiographical novel, *San Cristóbal de la Habana.* Published in 1920, the novel gained notoriety chiefly by introducing Americans to the daiquiri cocktail. The island was also the setting for Hergesheimer's most popular novel, *Cytherea,* in which Havana was the sophisticated setting for those wishing to escape the stultifying conventions of middle-class America. The popularity of these two novels earned Hergesheimer financial security, allowing him to indulge indiscriminately in Bugatti cars and Hepplewhite furniture. Van Vechten, who visited the novelist in his hometown of West Chester, Pennsylvania, recalled that the home, Dower House, was furnished with "excellent examples of early American furniture and early American glass and silver, a perfect little jewel in its way of an eighteenth-century American interior." He further observed,

> Joe's curiosity, confined in the beginning to early Americana . . . took a new slant . . . invading the baroque precincts of Victoriana, of bright shawls, of Manchu gentlewomen, and of journeys to Tampico and to Cythera. It is this phase that Florine Stettheimer has depicted in her colorful portrait of Joe . . . The motto for his picture might be his own phrase: "There are certain cities, strange to the first view, nearer to the heart than home.[79]

Stettheimer caught the complex, often contradictory aspects of the sitter's character. In constructing the work, Stettheimer juxtaposed the torrid splendor of the foreground with the placid, rural atmosphere of Hergesheimer's home in West Chester, visible in a punched-through oval against the even blue of the background. She depicted Hergesheimer in sartorial splendor and surrounded by overly designed surroundings. Seen through her ubiquitous parted curtains, a robust but accurately square-jawed Hergesheimer sits in a yellow tufted chair. Stettheimer invented the style of the chair and matching table by combining delicate and fanciful elements from various nineteenth-century revivals of traditional American furniture. An enormous Tiffany lamp that in reality would have been far too heavy for its curved neck balances above Hergesheimer's head.

The daiquiri mixings on the table and large brass instruments are references alluding to his novels, including the Latin music played in Havana.

On November 23, 1923, Stettheimer gave a tea party to unveil Hergesheimer's portrait. The sitter traveled from Virginia to attend the event, which was written up in the *New York Tribune*.[80] Hergesheimer's reaction was enthusiastic. He remarked to a friend, "What do you think of it, Burton: it's the horrible truth about me at last!" and his wife told the artist that the likeness was "uncanny." Upon returning home to West Chester, Hergesheimer wrote to Stettheimer that he was "incalculably in your debt. . . . Thank you again for a compliment, a portrait, that most certainly does neither of us a particle of injustice."[81] Nonetheless, rumors that he did not sufficiently appreciate the work reached Stettheimer's ears, and on January 2, an apologetic Hergesheimer wrote to reassure her:

> You know very well I liked your picture of me immensely and I would have commissioned it like a shot. But the whole conditions of your work, of the painting of an imaginary portrait, were so unfamiliar to me that I never actually realized that, where they were concerned, they were under way. Then at your studio when the portrait was finished, I found myself in what I conceived to be an embarrassing situation — to be utterly frank, I didn't know whether I could pay you for your portrait of me or not; and so, instead of being direct and simple and reasonable, I merely floundered. That is as candidly as I am able to explain the awkwardness of a position my inattentive clumsiness brought about.[82]

A month later, Hergesheimer again wrote to Stettheimer, this time stating more directly, "I would like to have my portrait for $500.00 dollars [$7,500 adjusted for inflation today] and as soon as I'm back, we will conclude this transaction."[83] The offer of payment, particularly as it was at least a hundred thousand dollars less than she priced her works, offended the artist. An agreement between the two was never reached.

From 1922 to 1925, Stettheimer exhibited regularly at exhibitions of the Independents as well as in monthly exhibitions organized in New York City's largest department store, Wanamaker's. The two-story store, which was located on Ninth Street, included in its interior a model home known as "Belmaison," in which there was a retail commercial art gallery.[84] By the early 1920s the art gallery was directed by Stettheimer's friend, the artist Louis Bouché. Initially a painter, interior designer and gallerist, later in life Bouché followed in his father's footsteps as a decorative painter, painting murals in private homes, government buildings, train club cars, and at Radio City Music Hall. He met the Stettheimer sisters in 1918, and thereafter became a regular visitor to their salons.

Bouché and Stettheimer shared a taste for the feminine, translucent qualities of lace, most of which came from the Nottingham area of England. During the 1920s, Victorian lace was very

much in vogue with some people, while others considered it the height of bad taste. In the 1930s, Stettheimer draped her bedroom in her studio in lace and designed several of her paintings' frames to resemble the material. Bouché used Nottingham lace in many of his paintings, later explaining that the lace curtains that he painted were an attempt to "glorify bad Victorian taste."[85]

In 1923 Stettheimer painted a *Portrait of Louis Bouché*, exaggerating his height and leanness by elongating his body in its brown suit, topped by a black brimmed hat. (*Fig. 82*) Not only did she frame Bouché with lace curtains decorated with monumental roses, but she wrapped part of a curtain around his body as he perches on his walking stick. Caught in the act of exhaling smoke from his cupid's bow lips, in Stettheimer's portrayal, the heavy-lidded sitter is the epitome of languor and sophisticated disinterest.

In December 1924, Stettheimer entered her portrait of Bouché in the spring exhibition of the Society of Independent Artists in New York. McBride, reviewing the exhibition, observed that:

> Miss Stettheimer's portrait of Mr. Bouché is one of a series of portraits that already enjoys much fame. The technic is both free and new and seems to be evolved from the theme itself . . . Mr. Bouché, as all New York knows, attaches a Freudian significance to the use of Nottingham lace as decoration and in many of his studies of the low and upper-low life uses it. In Miss Stettheimer's portrait, the bread he cast upon the waters returns to him, and he is surrounded by the despised Nottingham lace, most cleverly arranged and painted.[86]

In the painting's turquoise background, Stettheimer first used a palette knife to lay down thick dabs of white paint to create the lace curtains and then incised the paint with the back of her brush to create the intricate whorls and designs. As in all of her portraits of fellow artists, Stettheimer made direct references to Bouché's work. In the center, for example, a cascading garland of roses weaves down around the neck and body of an arabesque-handled urn. It then falls under her sitter's legs and terminates in the mouth of small fish bearing a ribbon. All three elements in Stettheimer's portrait — the vessel whose shape mirrors that of the fish, the long circling garland of roses, and the small fish itself — are taken from a 1921–23 painting by Bouché, *Fish and Roses to My Darling*. Stettheimer apparently gave the portrait to the sitter, then borrowed it back, then returned it, then borrowed it again, as though testing how much Bouché liked the work. Only when he called and declared he really wanted it did she permanently give the work to him. It likely helped that Bouché had made a rare portrait of Stettheimer (and her sisters) of which she approved.

Bouché was the one person other than the artist herself to manage to capture all three sisters in a single image.[87] In 1918, he drew Florine, Carrie, and Ettie together in charcoal on paper. The work is fascinating for the way it illustrates their different personalities as well as their relationship

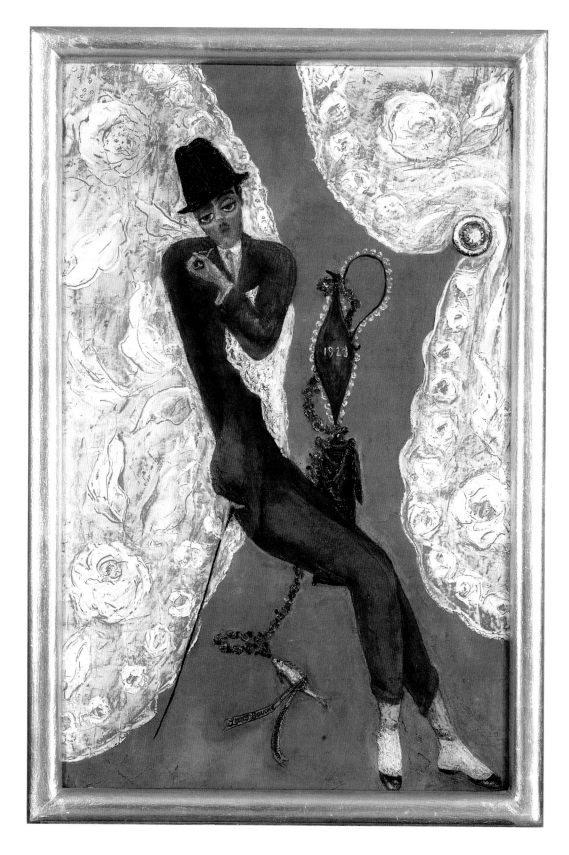

Fig. 82 Florine Stettheimer, *Portrait of Louis Bouché*, 1923, oil on canvas, 28 × 18 in., The Heckscher Museum of Art, Huntington, New York, Gift of the Baker/Pisano Collection.

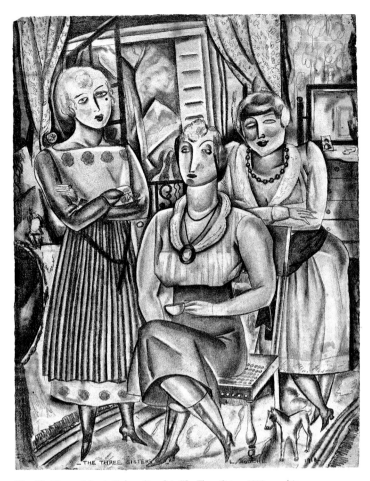

to each other. (*Fig. 83*) Carrie sits stiffly in the middle, with perfect posture. She wears a plain dark skirt and a traditional lace-collared blouse, a large cameo around her neck, and a stern expression. Behind her at right, a smiling Ettie, identified by the dark short bob she wore throughout her life, leans closely against the back of Carrie's chair. Ettie's dress is wrapped around her waist by a dark sash, and the low-cut collar of her blouse reveals her décolleté, a sign of her flirtatious personality. Her eyes are blank, lacking pupils, as though she were looking inward.

On the left, standing confidently with her arms crossed, Florine is physically and psychologically distanced from her sisters — even in this drawing by another artist. In contrast to their traditional clothing, she wears a modern dress with a wide placard bodice and tiny pleated skirt. Huge round dots march across the neckline and hemline. Florine's head is cocked slightly, her hair fashionably short and lighter than Ettie's. She looks directly out at the viewer.

Bouché included Stettheimer's paintings in many exhibitions he organized at Wanamaker's Gallery from 1922 to 1924. He reproduced her *Portrait of Louis Bernheimer* in blue and red tones

on the cover of a brochure for an exhibition that also included works by other prominent male modernist artists.[88] In 1923, Stettheimer included her early painting *Spring* and one of her flower paintings in Bouché's March Wanamaker exhibition, whose theme was that modernism had created a renaissance in the decorative arts.[89] In May, Stettheimer sent *Liberty/New York* to an exhibition that Bouché organized on images of the city.

Many of Stettheimer's friends, including Carl Van Vechten, Cecil Beaton, Alfred Stieglitz, Edward Steichen, and Baron de Meyer, were prominent photographers. Baron Adolph de Meyer, as he was known after around 1900, was a particularly colorful character and is considered by many to be America's first fashion photographer. Although he used various names during his life, he was born Demeyer Watson in Paris in 1868. His father was a German Jew, and although some sources claim he was given the title of Baron by Frederick Augustus III of Saxony, others claim there was no evidence of this title's origin.

In 1899 de Meyer married Olga, the beautiful amateur women's fencing champion of Europe, who claimed, again with no evidence, to be the goddaughter of King Edward VII of England.[90] De Meyer's fame as a photographer grew when in 1903 and 1907 Stieglitz published his photographs in his quarterly magazine, *Camera Work*. In 1912, de Meyer also gained visibility when he photographed Nijinsky in Paris. At the outbreak of World War I, apparently based on the advice of an astrologer, de Meyer and his wife took new first names, Gayne for him and Mahrah for her, and moved to New York City. Theirs, like the Van Vechtens, was a marriage of convenience: de Meyer was gay and his wife bisexual. De Meyer is said to have told Olga: "Marriage based too much on love and unrestrained passion has rarely a chance to be lasting, whilst perfect understanding and companionship, on the contrary, generally make the most durable union."[91] De Meyer was hired by Condé Nast as a photographer for *Vogue* from 1913–21, and then for *Vanity Fair*. Beaton dubbed him "the Debussy of photography." He and his wife quickly became members of the Stettheimers' social circle and appeared in several of Florine's early group paintings after 1917.

For his fashion photography, de Meyer developed a high-key, soft-focus style featuring dazzling effects, halo-like backlighting, and poses of ultra-casual sophistication. Exclusiveness became his hallmark, and sitters received only one print of their portraits. He was particularly drawn to the texture and sheen of satin, the cobweb nature of lace, and the design of Art Deco wrought iron. As one reviewer stated, "It is not an exaggeration to say that [de Meyer] is unrivaled in his instinct for the appropriate detail significantly placed."[92]

In 1923, de Meyer left Condé Nast for *Harper's Bazaar*, where he was made responsible for designing entire issues of the magazine. To commemorate his success, Stettheimer painted his portrait, including in the background an embroidered hanging plaque inscribed "B de M/in Pleasant

Remembrance/FS/1923." (*Fig. 84*) De Meyer leans lightly against a tall black pedestal on which flowers are arranged beneath a glass dome. The hermetically sealed atmosphere of this still life detail pervades the painting. The photographer is dressed in a black velvet smoking jacket with a brocade design at the collar and cuffs, a pink silk vest, long gray pants, and elegant black and white spats. The stiffness of his stance replicates that of his sitters who had to remain in place until the shutter of his box camera closed. In recognition of de Meyer's supposed royal connections, Stettheimer included an ermine and red velvet robe lying across the arm of a heavily flounced white chair and she alluded to his love of fine fabrics with the black lace mantilla, heavy blue drapery, and cloth embroidered with exotic birds.

During the early 1920s, Marcel Duchamp temporarily reentered the Stettheimers' lives. Leaving Buenos Aires on June 22, 1919, he set sail for Europe, and in December he returned to New York. He resumed his regular interaction with the sisters. The relationship between Florine and Duchamp was far more important that has been noted or explored to date. The two artists enjoyed each other's company, discussed art at length, and respected each other's work. They also shared several traits: both were private people, having been raised in a nineteenth-century European environment, were intelligent, cultured, highly judgmental but not particularly outspoken, and took their work seriously. Despite the limitations due to her gender, Stettheimer was, like Duchamp, a modern-day *flâneur*.

In Baudelaire's words, the *flâneur* was a compulsive observer "always on the outside, distracted and fragmented by the experience of modern life";[93] someone who used elegance and aloofness as a way of distancing themselves from others. Both Stettheimer and Duchamp strolled through life, maintaining their psychological distance, mingling with the crowd but never quite joining it. The two artists understood the notion of separating oneself from one's subject matter in order to view it objectively, and yet still being interested and/or emotionally tied to it in order to create meaningful work. Duchamp later noted, "I've had anything but a public life . . . I was never interested in looking at myself in an esthetic mirror. My intention was always to get away from myself, though I knew perfectly well that I was using myself. Call it a game between 'I' and 'me.'"[94]

From the beginning of their friendship in 1915 through the next decade, Duchamp and Stettheimer mutually supported each other. In 1920, Duchamp launched, with artist Man Ray and patron of the arts Katherine Dreier, the Société Anonyme, a series of exhibitions and lectures to introduce the American public to European and American avant-garde artists. Stettheimer was among the founding members, but did not actively participate since the generally abstract explorations of the group were not appropriate for her work.

Stettheimer wrote her poems for her own amusement, yet as one indication of the closeness between herself and Duchamp, she sent him an unidentified poem in 1922. Duchamp admired her

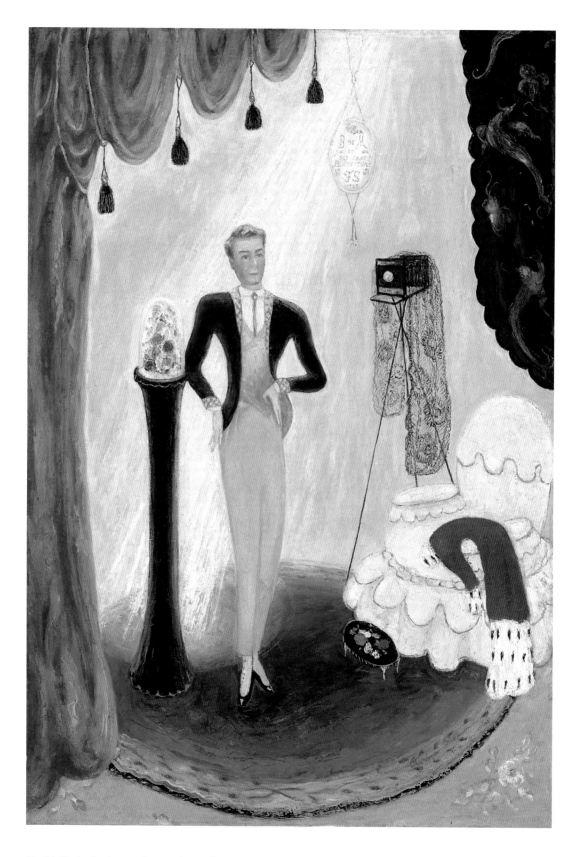

Fig. 84 Florine Stettheimer, *Portrait of Baron de Meyer*, 1923, oil on canvas, 38 ⅛ × 26 in., The Baltimore Museum of Art, Gift of Ettie Stettheimer.

Fig. 85 Marcel Duchamp, *Portrait of Florine Stettheimer*, 1925, pencil on paper, 20 ½ × 13 ¾ in., Private collection, Courtesy of Timothy Baum, New York.

caustic wit; however, as usual, judging by a letter he wrote Ettie in July, Stettheimer declined his request to publish the poem as an example of Dada work:

> Thanks to Florine for the poem. But won't she sign it if I publish it in Paris In a DADA Magazine? R.S.V.P. (She can sign it Florine if she doesn't want the family to be compromised).[95]

Duchamp also drew a beautifully rendered portrait of Stettheimer, one of the very few portraits of herself by another artist which she admired and kept. (*Fig. 85*) Using thin lines and shading, he captured the artist's face in a three-quarter turn, depicting her as an intelligent-looking woman of indeterminate age. The work emphasizes her facial features and her dark, watchful eyes, which gaze directly out at the artist as though watching him. The fact that she trusted Duchamp to create a portrait of her indicates the depth of their friendship. Duchamp portrayed Stettheimer exactly as she would have wished to be seen: not dominant but elusive, ever watchful, the ultimate observer. She liked the unsigned charcoal drawing so much that she inscribed it "Portrait of me by Marcel Duchamp" in pencil across the lower half of the page.[96]

Stettheimer in turn painted five portraits of Duchamp, two of which are single portraits of the artist. In one beautiful, undated portrait, his head floats in an ambiguous space surrounded by a radiating nimbus. (*Fig. 86*) With Stettheimer's ironic humor and predilection for emulating motifs from Old Master paintings, she based this portrait of Duchamp on the *Veil of Veronica*, an important Catholic religious relic painted by many artists beginning in the fourteenth century. She was familiar with the motif from her visits to numerous cathedrals in Spain, Austria, and Italy, such as St. Peter's Basilica in Rome. The image of Jesus's face floating on a piece of cloth was thought to have originated when Saint Veronica used her veil to wipe the blood and sweat from Jesus's face as he carried the Cross on his way to Calvary. When she did, his face miraculously imprinted itself on the material.

The lines radiating from Duchamp's head also humorously suggest the almost exalted status with which he was held in the eyes of many contemporary artists, collectors, and amorous women at the time. The intense energy of the aureole may in turn symbolize the Frenchman's intellectual powers. The almost completely gray palette Stettheimer uses — the pinkish tinting of his lips Stettheimer's reference to Duchamp's alter ego, Rrose Sélavy — seems to refer to the "gray matter" of the brain. In Stettheimer's portrayal, Duchamp has no need of a body or limbs, as all his creativity derives from his superior mind. Although the work is undated, the close-cropped hair and facial features — slightly cleft chin, long thin nose, prominent brow bone, and tight, unwrinkled skin — indicate that it was painted between 1920 and 1922, when Duchamp was back in New York.

Both Stettheimer and Duchamp adopted aspects of the opposite gender in creating alternate personas. A crucial aspect of Stettheimer's life was her social persona, which provided an invisible shield for her more authentic, private self. Wearing pantaloons, Capri pants, or a black velvet pantsuit was a cultural and political male-referenced strategy that enabled her to undermine the dominant social categories of gender that marginalized women. Similarly, Rrose Sélavy provided Duchamp a feminine double that was integral to many of his works. It is revealing that Duchamp signed himself *Rrose Sélavy* in more letters to the Stettheimers than to any other correspondents.[97]

During the first few decades of the twentieth century, Duchamp developed several distinct personae: the art dealer-businessman, the inventor-engineer, and Sélavy. Rrose's face first appeared in a 1920–22 photograph taken by Man Ray (*Fig. 87*), and her signature first appeared on a 1920 work titled *Fresh Widow*. The latter consisted of a model of a French window with the panes covered in black leather (which Duchamp insisted be shined like shoes daily) instead of transparent glass so they are opaque. Duchamp also added Rrose's signature to Francis Picabia's 1921 collage *L'Oeil Cacodylate*. As an inventor-engineer, Duchamp created many imaginary machines and used and juxtaposed existing objects for his so-called "readymades." Duchamp also purchased art for private collectors and served as the Romanian sculptor Constantin Brancusi's representative in New York.

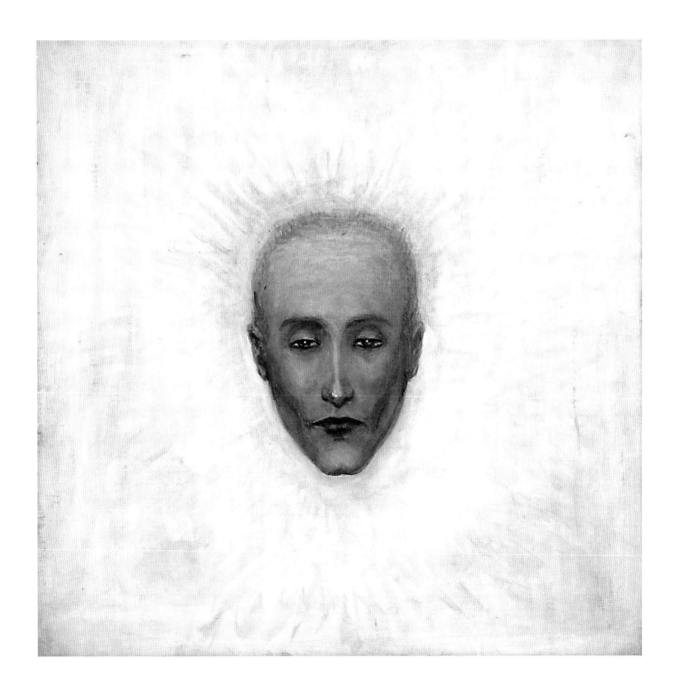

Fig. 86 Florine Stettheimer, *Portrait of Marcel Duchamp*, c. 1923–26, oil on canvas, 25 ¼ × 25 ¼ in., Michele and Donald D'Amour Museum of Fine Arts, Springfield, MA, Gift of the Estate of Ettie Stettheimer.

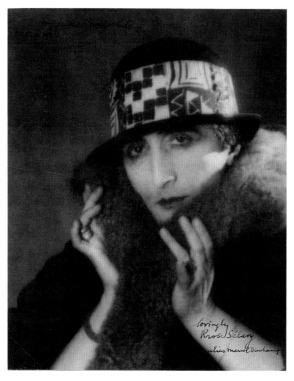

Fig. 87 Man Ray, *Marcel Duchamp as Rrose Sélavy*, 1920–22, silver gelatin print, 8 ½ × 6 ¹³⁄₁₆ in., © Man Ray Trust / Artists Rights Society (ARS), New York / ADAGP, Paris, The Philadelphia Museum of Art, The Samuel S. White 3rd and Vera White Collection.

In 1923, soon after Duchamp returned to Paris, Stettheimer incorporated all three of his personae in a major portrait of the artist. (*Fig. 88*) Writing about Stettheimer's portrait, Henry McBride acknowledged Duchamp's enigmatic private persona, noting, "There is nothing accidental in this, for Marcel in real life is pure fantasy." He saw that Stettheimer interpreted Duchamp's public personae as a conscious fabrication:

> If you were to study his paintings, and particularly his art constructions, and were then to try to conjure up his physical appearance, you could not fail to guess him, for he is his own best creation, and exactly what you thought. In the portrait he is something of a Pierrot perched aloft upon a Jack-in-the-Box contraption which he is surreptitiously manipulating to gain greater height for his apotheosis . . . The most complicated character in the whole contemporary range of modem art has been reduced to one transparent equation.[98]

Stettheimer reinforced the enigmatic nature of Duchamp's personality through her palette. Abandoning the bright, saturated, and high-contrast colors of her other portraits, the artist executed Duchamp's portrait in pale color washes against a light celadon-tinted background. At left, Duchamp the businessman, inventor, and artist is wearing a conventional jacket, pants, and high-topped boots

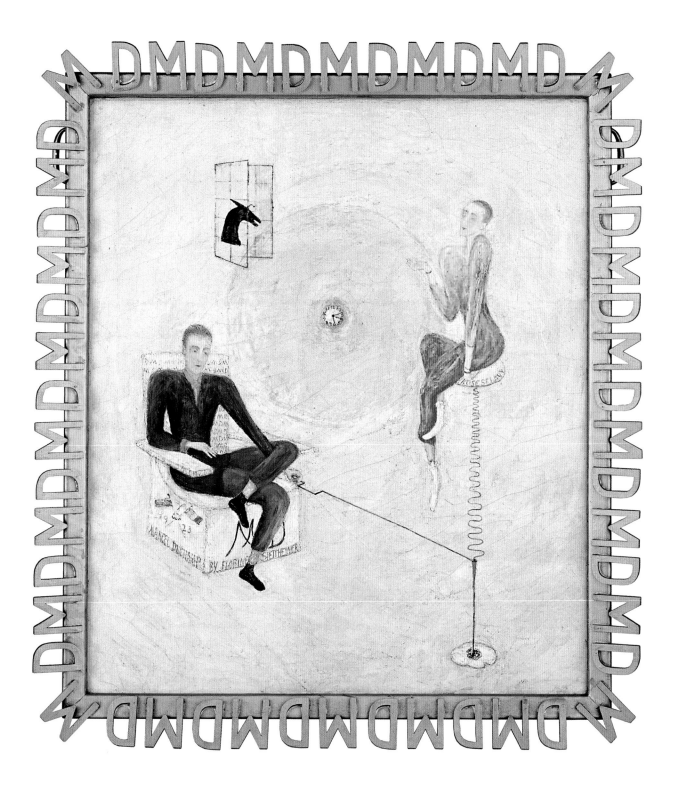

Fig. 88 Florine Stettheimer, *Portrait of Marcel Duchamp*, 1923, oil on canvas, 30 × 26 in., Private collection.

in neutral tones of brown and gray. Seated in an armchair decorated with the French and American flags, his intertwined initials, and the phrase "Marcel Duchamp by Florine Stettheimer," he strikes a desultory pose. He holds a lit cigarette in one hand while the other, curiously tucked through a folded leg, turns the metal handle of an apparatus at right. The long crank attaches to a thin, cylindrical pipe fastened to a scalloped base. From the top of the cone-shaped tube, a spiral of wire, reminiscent of the shadowed corkscrew in Duchamp's painting *Tu m'*, supports a small round platform bearing the name of Rrose Sélavy. The feminized figure perches on top of the platform.

As Virgil Thomson later noted, Stettheimer positioned Rrose's shoulders and back so that they resemble a large pink heart.[99] She also painted Rrose in variations of her eponymous color as she sits holding one hand out, palm up. Although her facial features remain recognizable as Duchamp's, Stettheimer altered her chin and bone structure to give her a more feminine, flirtatious expression than the preoccupied, almost sullen scowl of the male Duchamp at the left. Rrose's legs are twisted in a manner mimicking those of Duchamp at the left, as well as the spiral of the stool. However, hers are a more feminine, serpentine, variation on Duchamp's seated posture, with its traditionally masculine pose of ankle over knee.

In describing Rrose's origins, Duchamp later stated,

> In effect, I wanted to change my identity, and the first idea that came to me was to take a Jewish name. . . I didn't find a Jewish name that I especially liked, or that tempted me, and suddenly I had an idea: why not change sex? It was much simpler. So the name Rrose Sélavy came from that.[100]

It is tempting, given the close resemblance of Rrose to Stettheimer, to speculate that Duchamp used Florine as a model in his original creation of Rrose:[101] Stettheimer often wore a black, rounded top, brimmed hat similar to the one Rrose wears in Man Ray's photograph, as can be seen in the portraits of her by Sprinchorn and Best-Maugard. (*See Figs. 51 and 71, respectively.*) Both Rrose and Florine have long noses and slightly pointed chins. Stettheimer shared with Duchamp's female anima a preference for dark eye makeup and red lipstick.[102] In both examples, the female sitter looks out at the viewer with a dark, unsmiling, enigmatic gaze.

Although there is no written evidence that Duchamp used Stettheimer as his model, it is an intriguing and viable possibility. There are hints that Stettheimer herself fancied this idea, based on the similarities in her renderings of the figure of Rrose in her *Portrait of Duchamp* and of herself in her *Portrait of Myself*, made the same year. Both figures have an androgynous air and exist within indeterminate space. Stettheimer also painted herself and Rrose using only rose-tinted red paint. Both women are portrayed with the same slim, boneless bodies, wrapped in iridescent rose-red

tones and positioned with one foot tucked behind the other leg's calf. This use of light translucent rose to depict an entire body also appeared in Stettheimer's rendition of Nijinsky in *Music*, executed three years earlier to imply sexual ambiguity. Rrose also has orange hair, just as Stettheimer does in *Portrait of Myself* and her early self-portraits.

This gender doubling between them continued in their wordplay. Duchamp called Stettheimer a "bachelor," conflating its French definition of *célibataire* with her "New Woman" attributes and professionalism as an artist. He thus conferred on her a "bachelor of the arts . . . a 'tribute' in a serious play on the sex implied in the doctoral degree in art."[103] Meanwhile, she referred to him as "my confrère," or accomplice.[104]

Stettheimer's *Portrait of Duchamp* has more empty space than any of her other works, and its brushwork, although thickly applied, is barely discernible as she smoothed its surface. This reflects her acknowledgment of Duchamp's denunciation of "retinal" art and his desire to "get away from the physical aspect of painting," putting painting "once again in the service of the mind."[105] The spare motifs that Stettheimer did include in the portrait directly refer to a number of Duchamp's artworks, theories, and interests. Stettheimer alluded to the painting *Tu m'*, several readymades, and some of his graphic works, demonstrating her intimate understanding of his most advanced and conceptual work.

On his arrival back in New York, Duchamp began experimenting with optics and film, and with Man Ray's assistance, he constructed a motor-driven machine called *Rotative plaque verre*. The barely visible circle growing out from the center of the portrait alludes to Duchamp's *Rotary Demisphere (Precision Optics)* and his optical experiments with rotating discs. Years later, Duchamp interpreted the small three-handed clock at the very center of Stettheimer's portrait as referring to discussions he had had with Stettheimer on time as the fourth dimension as an exploration of "space-magnitude in all directions at one time." One of several definitions of the fourth dimension, it was undoubtedly the reason he termed her use of numerous time periods on a single canvas "*multiplication virtuelle*."[106]

As Duchamp was an avid chess player, Stettheimer may have also intended the clock as an allusion to the clocks used by players in timed games. The horse's head at upper left represents both the knight chess piece and the Laughing Ass emblem used on the Société Anonyme's membership cards. (*Fig. 89*) The gridded window surrounding this emblem recalls Duchamp's *Fresh Widow*.[107] By portraying Duchamp in an ambiguous space with various displaced art objects floating around him, Stettheimer referred to the French artist's concern not with the intrinsic beauty of things, but with challenging the conventions by which works of art were traditionally viewed and valued.[108]

Stettheimer designed the frame for Duchamp's portrait as a running frieze of the artist's initials, each individually applied like a line of type for newspaper text. Duchamp's cover design for the 1921 publication of his magazine, *New York Dada*, featured the first photograph by Man Ray of

Duchamp as Rrose Sélavy. It was inserted in a roundel surrounded by a background of typed words that covered the page. (*Fig. 90*) Stettheimer repeated this motif in her portrait by painting the French artist's initials around the back of his chair. She also designed a unique wood frame consisting of individual three dimensional letters "M" and "D" on all four sides.

In mid-February 1923, Duchamp returned to Europe, where Henry McBride visited him and described Stettheimer's double portrait of him in "glowing terms." In January of the next year, Duchamp wrote Ettie, praising the recent publication of her novel *Love Days*, which included a character, Pierre Delaire, whom she had based on him. Using an amusing translation of the name to sign the letter, "Stone of Air," he wrote her again, expressing, as he had a year earlier from Paris to the artist, his surprise at her asking so much money for her paintings: "I believe that Florine must now be making portraits professionally? Am I right? Or is she asking too much? Whatever, she will get where she wants to. If there's a photo of mine (my portrait) I would love it if she might send it."[109]

Stettheimer composed one more portrait of Duchamp, a poem about his ephemeral and transient nature which she titled "Duche," using the affectionate, pun-layered[110] term by which she and many of his other friends referred to the French artist:

~~~~~~~~

Duche

A silver-tin thin spiral

Revolving from cool twilight

To as far as pink dawn

A steely negation of lightning

That strikes

A solid lamb-wool mountain

Reared into the hot night

And ended the spinning spiral's

Love flight —[111]

~~~~~~~~

Fig. 90 *Belle Haleine with Marcel Duchamp as Rrose Selavy,* from *New York Dada* magazine, 1921 issue. Cover designed by Marcel Duchamp, Image photographed by Man Ray. Spencer Collection, The New York Public Library. The New York Public Library Digital Collections. 1921–04. © Man Ray Trust ARS-ADAGP

The poem might have been written as a companion to her double portrait of Duchamp, as he is depicted cranking up the "silver-tin thin spiral . . . To as far as pink dawn" of Rrose. The term "Love flight" may have been a response to the news, in 1927, that Duchamp had married. Carrie, who met the couple in Paris two days after their wedding, wrote to her sisters, describing the bride as "a very fat girl . . . very, very — fat." Although Duchamp, sounding much like the Stettheimers themselves, had earlier declared himself against romantic love and marriage, at age forty he wed the virginal, twenty-four-year-old automobile heiress Lydie Sarazin-Levassor in Paris. Francis Picabia acted as the witness, and the ceremony was filmed by Man Ray. Soon thereafter, however, Duchamp set up his new wife in a separate apartment and proceeded to visit her only on occasion, leaving her lonely and mystified. The marriage ended in divorce a year later, with Duchamp later recalling, "We were married the way one is usually married, but it didn't really take, because I saw that marriage was as boring as anything. I was really much more of a bachelor than I thought. So, after six months, my wife very kindly agreed to a divorce."[112] Ettie and Alfred Stieglitz humorously ruminated on the implications of Duchamp's marriage, the latter writing, "I oughtn't to be surprised for last winter I remarked to him now that he had become 'salesman of art' what next? [A]t any rate its [*sic*] a woman he married."[113]

Meanwhile, as she noted in her diary, Stettheimer saw Duchamp in her dreams, "getting bald and his forehead and headtop [were] made of opaque milk glass which perspired — and which

he constantly mopped — I asked him about his wife — what she was like — he said she looked about eight or nine years old." Stettheimer wrote to McBride, describing her peculiar fantasy of Duchamp's wedding fashions: "He had a church wedding — six bridesmaids in white muslin, pink sashes, pink picture hats. Two little Kate Greenaway girls two little Eton-jacketed boys — the Bride in Silver-cloth. I think she should have worn a wedding gown of near-glass with a neat wire trimming — spiral design. However, so few do the appropriate thing."[114] Duchamp did not return to New York or the Stettheimers' lives until after Florine's death; later in life he told her biographer that he "loved" Stettheimer's portrait.

By 1924, in her mid-fifties, Stettheimer was painting more than ever before and exhibiting regularly to high praise from friends, curators, and critics. In April, she gave a tea party to unveil the completed portrait of Ettie. She invited an eclectic group of guests, including Carl Van Vechten, Edward Steichen, and poet Carl Sandburg, as well as progressive educator Helen Parkhurst, actress Fania Marinoff, the famed character actress Helen Westley, and the poet Elinor Wylie, for whom Van Vechten organized a torchlight parade through Manhattan to celebrate the publication of her first novel.[115]

On November 11, Rosetta, then in her eighties, called her lawyer to prepare her will. She appointed her brother William and two of her children, Carrie and Walter, who lived in California, to be her executors. She left everything to her three youngest daughters, stating, "I feel justified in this decision and act knowing that my son Walter and daughter Stella are well provided for otherwise." At the same time, Stettheimer began a portrait of her mother. This portrait, which Henry McBride later called her best and most serious, completes the cycle of family portraits Stettheimer had begun two years earlier. As McBride observed:

> [Rosetta's] is an idealized portrait done with great tenderness and love and yet touched with irrepressible wit. I call it witty the way the straggling carnations break the severe blacks of the piano. I call it witty the way the palm-leaves venture into the composition and the way in which the laces frame in the mother's dream-picture of her children in the background. The mother's faintly bewildered but uncomplaining expression as she thinks of these children is witty, too. It is a true apotheosis; and it is a picture, I believe, that will take permanent rank in the not too great an array of distinguished American portraits.[116]

By the time Rosetta's portrait was painted, she was very frail. Most of the artist's friends remembered her as delightful but socially inconspicuous, and her daughters tended to act as buffers between her and others. Once, at a Sea Bright house party, McBride happened to find Rosetta sitting alone. She took the opportunity to ask him, "Do you really think Florine is a good painter?" This was

a question reiterated by other family members throughout Stettheimer's life. Despite the regular praise from critics in major newspapers and periodicals, her own family tended to view painting as more of a hobby than a vocation, which must have been disheartening to the artist. On this occasion, before McBride could answer, Stettheimer appeared and interrupted the conversation. Clearly embarrassed, she scolded Rosetta for having committed a faux pas by putting McBride on the spot.[117]

Stettheimer's *Portrait of My Mother* is a meditation on traditional feminine sensibility, fertility, and life's transience. It has none of the staid pomposity, rigid authority, or solemnity of traditional parental portraiture. (*Fig. 91*) Set off by a voluminous green taffeta curtain on one side and a roundel of white and black lace on the other, the composition traces the passage of a woman's life from the pale spring memories of early motherhood in the background to the bold, jeweled winter colors of older age in the foreground. The middle ground of the painting is empty; Stettheimer's mother has already passed through this stage and is continuing toward the last phase of her life.

Directly above Rosetta's head, offering her thoughts and memories, is a small tableau with four of the Stettheimer children playing and performing, visible through an opening created by red-lined glass doors. As a wealthy woman, Rosetta left most of her maternal duties to the children's nurse, Maggie, except, as Florine recalled in the following poem, reading to the children when they were ill, which the artist recalled with a "thrill." Otherwise as a mother, Rosetta personifies a cherished world of childhood memories of decorative fantasies, wide-ranging culture, and elegance:

And things I loved —
Mother in a low-cut dress
Her neck like alabaster
A laced-up bodice of Veronese green
A shirt all puffs of deeper shades
With flounces of point lace
Shawls of Blonde and Chantilly
Fishues of Honeton and Point d'Esprit
A silk jewel box painted with morning
 glories
Filled with ropes of Roman pearls
Mother playing the Beautiful Blue Danube
We children dancing to her tunes

Embroidered dresses of white Marseilles
Adored sashes of pale watered silk
Ribbons with gay Roman stripes
A carpet strewn with flower bouquets
Sèvres vases and gilt console tables
Mother reading to us Grimm's fairy tales
When sick in bed with childhood ills —
All loved and unforgettable thrills.[118]

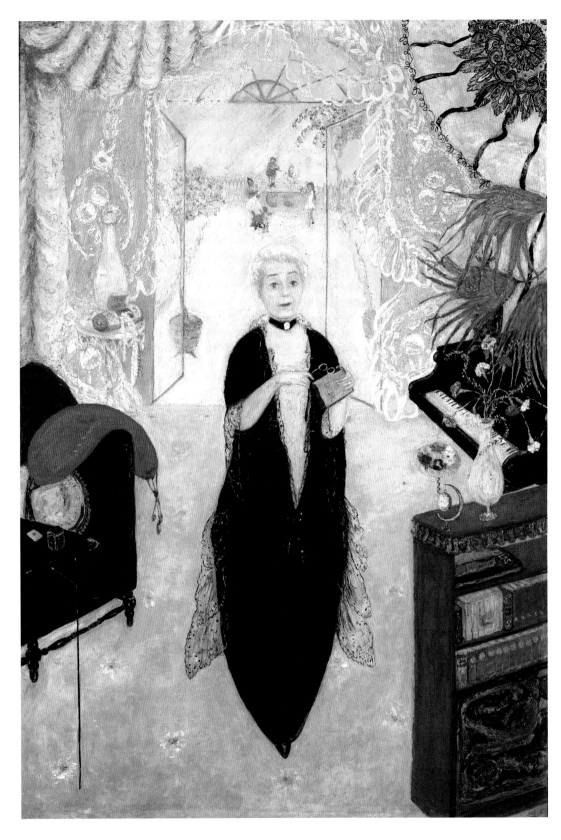

Fig. 91 Florine Stettheimer, *Portrait of My Mother,* 1925, oil on canvas, 38 ⅜ × 26 ⅝ in., The Museum of Modern Art, Barbara S. Adler Bequest.

Rosetta's fertility is reinforced both by her placement directly below the images of her five children and the deep "V" cut in the front of her black gown that descends, like an arrow, terminating directly over her vaginal area. Other elements in the composition reinforcing the image's fecund sensibility include the fat, rounded pillows, oversized chair, wide piano, and overblown plans and curtains. In her typically ironic fashion, Stettheimer refers to romance by having her mother carry a copy of Ettie's book *Love Days*; and to sex itself in the red and gilt lacquer bookcase at the right, which holds a number of leather-bound books. The books titles, which can be read, again reveal Florine's ironic sense of humor (obviously more than her mother's literary tastes): they are all classic erotic literature, including Boccaccio's *Decameron*, Henry Fielding's *Tom Jones*, and Samuel Richardson's *Pamela*.[119]

Among the guests who visited the Stettheimers' summer house in 1926 and 1927 was Father Hoff, a handsome priest from a nearby parish. He reciprocated by inviting Carrie, Ettie, and Florine to visit his chapel, with its five altars, garden of calla lilies, and wine cellar. As Stettheimer noted in her diary, "There's a cellar with ten bottles and now only nine for we have one—precious gift, a bottle of Toquay—pre-prohibition!" The next summer the four women returned to West End, and Father Hoff again came to tea. In her diary, Stettheimer recorded their meetings in her diary with her usual cynicism, noting that Ettie had given the priest a Byzantine Madonna icon "for the pure fun of the thing. Most people are only half alive—and talk about the next life—possibly believe in another life—are saving up their vitality for it—that may also account for the stinginess in the world."

On her birthday, August 19, 1927, Stettheimer picked her annual bouquet and put on a gown she had created with her seamstress, which was made of oyster-white crêpe de chine with oversized shrimp-pink roses. Father Hoff gave her a plant called lady's slipper, which he planted in her garden. Ettie gave her a small set of garden tools, and Carrie a pair of ribbons she described in her diary as "gold stripes." That night, dressed in a "radium silk pink night gown strewn with deep pink roses," Stettheimer took "a sudden fancy to make a Padre Carlos portrait." She called up Hoff and "[told] him I was coming and wanted to see him in priestly garments—he donned his habit. I went to San Alfonso . . . and came away with a photograph of the Padre and some fresh data."

In her *Portrait of Father Hoff*, Stettheimer included Ettie's Byzantine icon in the background and treated the entire painting as if it were a religious retable. A large figure of the priest wearing his habit stands in front of what appears to be a wooden shrine, with the words "San Alfonso" and the number "755" inscribed in the tympana above. A second, tiny image of Father Hoff as a gardener with a straw hat is seen at the right of the composition. At far left, five tiny figures cavort in the surf. Hoff loved the sea and was an avid swimmer. Ironically, he died by drowning a year after the portrait was completed.

Of all the sisters, Ettie was the closest to Stieglitz and O'Keeffe, but in 1927 and 1928 Florine also began to correspond with the pair on a fairly regular basis. Stieglitz's letters from Lake George,

where he spent the summer, were largely complaints about his loneliness without O'Keeffe, an account of his burning of old negatives that he did not wish to survive him, and descriptions of various aches and pains. In 1928, when the two were preparing to leave New York for Lake George, Stieglitz had a minor accident that so exasperated O'Keeffe that she wrote to Florine describing it. Apparently, after taking a bath, Stieglitz was pulling up his underpants, slipped on the wet bathroom floor, and injured one of his fingers. As they were eager to leave, O'Keeffe suggested they use a wood popsicle stick and some tape to bind it and leave for their summer home. But, as she noted in a frustrated tone, Stieglitz "insisted" on going to an emergency room, where they sat for hours waiting to see a doctor. Finally, when they did see one, he bound Stieglitz's finger with a flat wood stick (just like a popsicle stick) and tape. O'Keeffe ended her letter to Stettheimer with an exclamatory remark to the effect of how ridiculous "men" are.[120]

At the end of 1925, Stieglitz opened the Intimate Gallery in room 303 at Anderson Galleries. "The Room," as it was known to insiders, was intended as the annual showcase for "Seven American Artists: John Marin, Georgia O'Keeffe, Arthur G. Dove, Marsden Hartley, Paul Strand, Charles Demuth and Number Seven (six + X)," whom Stieglitz defined as an authentic American artist in identity and national spirit. Stieglitz's virtually continual entreaties to Stettheimer to exhibit her work in the Room indicate that he hoped to include Stettheimer as "X." However, she continued to decline his and every other gallerist's request to sell her work.[121] Her refusal caused O'Keeffe to write, "I wish you would become ordinary like the rest of us and show your paintings this year!"[122]

A few years later, in spring 1928, Stettheimer painted her *Portrait of Alfred Stieglitz*. (*Fig. 92*) Hartley admired the work when he visited the Stettheimers at their summer house, as Stettheimer archly observed in her diary: "[Hartley] seemed to find my portrait of Stieglitz very amusing — and Father Hoff's very charming: 'Two feminine men,' said he." In the portrait, she indicates Stieglitz's double roles as artist-photographer and gallerist-promoter by including two images of him. Except for a bright yellow glove and date, fragments of green and brown suits, shoes, and glove, and a sepia leaf, the painting's palette is black, gray, and white, reflecting Stieglitz's vocation.

The predominant central image depicts the sixty-four-year-old photographer as a handsome, vigorous man striding purposefully through the room in a theatrical black cape. As in her own *Portrait of Myself*, Stettheimer emphasized Stieglitz's eyes in this image, highlighting the pupils and the bottom edge of his round glasses with dabs of pure white paint. Stieglitz looks intently at some point just outside the painting's border. While one hand grips the collar of his cape, the other curves in front of his body as though guiding him toward a place beyond the canvas.

The second figure of Stieglitz stands with his hands folded on his chest, leaning against the curtained window at the left side of the interior of the Intimate Gallery. Through the left window, a

small view of the Saratoga racetrack, which Stieglitz loved to attend, is visible beyond New York City skyscrapers. Light reflects off his glasses, making his eyes impossible to see as he stands surrounded by images and symbols of the artists he champions. At right, an ermine-cuffed hand opens the door, signaling the pseudo-royal entrance of Baron de Meyer. Charles Demuth, whose gloved hand holds his walking cane, enters the composition on the left. A tiny, round Arthur Dove sits leafing through a book. Adjacent to him are three large standing boards: at left, Marsden Hartley's name is written in elaborate, serpentine script. On the central board is a loose version of Elie Nadelman's 1907–9 drawing *The Bird*, in which he portrayed the flying creature with the fewest lines possible. At right, propped up by the base of a table holding a black press used to mount photographs, a board spells out photographer Paul Strand's name.

Stettheimer included four references to Georgia O'Keeffe in Stieglitz' portrait. O'Keeffe's name is inscribed vertically and backward on the upper right wall. Stettheimer also painted a faint profile of O'Keeffe adjacent to and facing away to the central portrait of Stieglitz. The artist created an almost invisible reference to an O'Keeffe drawing via a dark, swirling form made of thick black paint within Stieglitz's cape. The unfurling spiral form emulates O'Keeffe's 1915–16 charcoal drawing *No. 8* from her "Special" series, which first brought her work to Stieglitz's attention. The form subtly circles around his right hand and can be seen only in a strong raking light. A fourth reference to O'Keeffe hangs with pride of place in the back center of the composition. During the 1920s, O'Keeffe painted a number of works during various seasons she and her husband spent at Lake George. Referring to these, in Stieglitz' portrait Stettheimer conflated two types of O'Keeffe paintings from this period: a verdant landscape that is juxtaposed with an overlarge sepia leaf.

Stieglitz was in Lake George when Stettheimer wrote him that she had painted his portrait. In September, after returning from Wisconsin, where she had been visiting an aunt, O'Keeffe learned the news and immediately wrote to the artist in her favored green ink:

> The idea of seeing it is one of the very few things that gives me any feeling of pleasure when I think of returning to the city. I am very curious about it — He is so many contradictory things that I can't help wondering what you chose to put down — You undoubtedly don't see him as I do — no reason why you should. But I like it that you have painted him — no matter what you have painted. He has had a bad summer . . . his finger worried him all summer . . . now he is in bed with an uncertain heart . . . I have a nurse for him and am trying to get him straightened out . . . but I don't know anything about ailing hearts — I only wish it had happened some other time of year as this is my best time for painting — but that is the way it goes . . . Again I must say I am most curious about Stieglitz' portrait.[123]

Fig. 92 Florine Stettheimer, *Portrait of Alfred Stieglitz*, 1928, oil on canvas, 38 × 26 ¼ in., Alfred Stieglitz Collection, co-owned by Fisk University, Nashville, TN, and Crystal Bridges Museum of American Art, Inc., Bentonville, AR.

Stettheimer wrote back in her characteristically caustic manner, "I don't think I have painted your special Stieglitz—I imagine I tried to do his special Stieglitz—but probably only achieved my special Stieglitz.[124] I hope the real Stieglitz is pleasing you and himself in the matter of his health . . . Let's make a date for the unveiling."

After the customary unveiling of the painting to a group of friends including Stieglitz and O'Keeffe, word got to Stieglitz that the artist did not feel he had expressed enough admiration for it. In November, Stieglitz wrote Stettheimer to reassure her:

> My dear Florine . . . the Portrait has been ever standing before me I seem to see it every-where—I have been wanting to tell you again and again how very fine I really think it is—In every way—And when you said it was to be for me—"mine"—I seemed to say nothing—But I felt you'd understand. But perhaps you didn't—I was quite as surprised as when you had written to Lake George that you had painted The Portrait—You see I still have the feeling that The Portrait does not exist—I also have the feeling because of that it can't possibly be mine. It's all too much like a fairy story! . . . the painting is beau-tiful—I thank you in many many ways . . . your old Stieglitz.[125]

Apparently, that did the trick, and Stettheimer gave Stieglitz the work—along with Van Vechten and Bouché's portraits, one of only three works of art that Stettheimer is known to have given away during her lifetime.[126]

~~~~~~~~

*chapter eight*

# NEW YORK, NEW YORK

## 1927 – 1933

# On her birthday in August 1927, Stettheimer recorded in her diary that

she was reading Olive Schreiner's 1926 feminist anti-war novel, *From Man to Man*. The book was acclaimed for its bold renunciation of racism against Blacks, Jews, and Native Americans. Its plot centered on two white South African sisters, one of whom was married but struggled against her confining domesticity while the other was a kept woman in London's East End. The novel posited that there was little difference between prostitution and marriage in a world where women are valued mainly for their bodies. This idea would have resonated with Stettheimer's own view of marriage as stifling women's freedom and creativity.

In 1927 and 1928, Stettheimer continued her ritual of picking flowers from her garden, arranging birthday bouquets, and painting a still life. She also painted an Odilon Redon-like bouquet for Ettie in which the small grouping of flowers is flanked by two parted curtains, giving the painting a theatrical air. Traditionally associated with the conclusion of a successful performance, the bouquet may have been Stettheimer's tribute to her sister's publication of her novel *Love Days* that same year.

Rosetta's increasing illness made life very hard for Florine and her sisters. In July 1928, Florine recorded in her diary:

> This winter has worn me out very much. I look haggard — and feel prostrated — I have had to watch time slip by while I sat in enforced idleness [during] which I could have painted, because of the equal division of time to be home with mother . . . I am suffering from nervous breathing in fact all summer I have been bothered. I wish I could live somewhere in beauty for a while — I have tried not to suffer.

Ettie cut many pages out of her sister's 1928 diary, suggesting that Stettheimer continued to vent her frustrations and anger on its pages. To have some contact with the outside world, Stettheimer corresponded regularly with Carl Van Vechten and Charles Demuth, who included in his letter a mention of Gertrude Stein. Stettheimer replied that Stein did "not interest me very much — I only know her through her writings."

In June 1929, the four Stettheimers again traveled to a summer house in Tarrytown. Florine brought her easel and watercolors. However, Rosetta soon became depressed, causing Stettheimer

to note in her diary, "The longest day seemed long — but this one seems longer, and the future ones are stretched out like flat noodles." This was not helped when her work was not chosen for that year's Museum of Modern Art exhibition *Nineteen Living Americans*. Henry McBride was so upset that O'Keeffe was included — the only woman artist in the show — but Stettheimer was not, that he complained of it in his review of the exhibition.[1]

For her fifty-eighth birthday, Stettheimer picked and painted a bouquet that she titled *My Birthday Eyegay*, describing the painting in her diary as portraying "a heart aflame from which flowers blaze." (*Fig. 93*) Once again, her sisters gave her what she described in her diary as a "foolish book on Art" and she returned it. When the women returned to Alwyn Court in the fall of 1929, they continued to entertain and hold salons for mixed groups including composers Virgil Thomson and Aaron Copland, playwrights Eugene O'Neill and Philip Moeller, the writer and satirist H. L. Mencken, and their usual artist and writer friends, including the Van Vechtens, Marie Sterner, McBride, Stieglitz, and O'Keeffe.

The stock market crash in October did not significantly affect the Stettheimers' lives. Their finances remained in the hands of their lawyer, Alfred Cook, who persuaded the women not to sell their stocks. They therefore rode out the Depression without much hardship and ended up earning a great deal of interest on their investments.[2] Despite the impact the Depression had on millions of Americans, it is not mentioned in either Ettie's or Florine's diaries, reflecting their privileged position. Nor were its results mentioned in correspondence with their friends despite the thousands of unemployed and destitute New Yorkers throughout the city. The only exceptions to this: in a 1930 letter to Stettheimer, Stieglitz obliquely noted, "As for myself I'm at peace — & that despite Wall Street & several jolts I received," and in 1931, McBride wrote to his friend Robert McAdam, "People are scared to death here over the financial situation and they say the whole world is going to smash. I've just got a new suit at Brooks. I thought if the world did smash I'd better be prepared with adequate garments."[3]

During the late 1920s and through the early 1930s, Stettheimer showed her work in a number of exhibitions at the Museum of Modern Art and other important venues. In 1929, the Arts Council of the City of New York showed her painting *Heat* in its exhibition *One Hundred Important Paintings by Living Artists*. In 1932, Stettheimer exhibited a work in the *Exhibition of the American Society of Painters, Sculptors and Gravers*.

One of the few industries that thrived during the Depression was motion pictures, which provided audiences with an escape from their harsh realities. By 1920, there were more than twenty thousand movie houses operating in the United States, and capital investment in films reached $2 billion. In New York, palatial movie houses were built around Broadway and Times Square, each trying to outdo the other in luxurious interior design and seat capacity. Along with everyone else

Fig. 93 Florine Stettheimer, *My Birthday Eyegay*, 1929, oil on canvas, 37 ¼ × 25 ½ in., The Addison Gallery of American Art, Phillips Academy, Andover, MA, Bequest of William Kelly Simpson.

who could afford it, the Stettheimers and their friends frequented the cinema, and the discussions at their parties often included mention of actors, actresses, and the latest films. At one such party, McBride recalled, Philip Moeller made such a fuss over the new James Cagney movie *The Public Enemy* that Van Vechten and Max Ewing got up and left the party to go see it. Attending films became one of Stettheimer's favorite pastimes throughout the 1930s. She noted in her journal that she had seen *Robin Hood* and that she had seen Marlene Dietrich in *The Pearls of the Crown*. As usual, Stettheimer was not chary with her criticism. With Stella and Rosetta, she went out to see *Abie's Irish Rose*, writing afterwards in her diary, "I am back with Proust and look at last evening's

boredom with amazed horror." She particularly loved Disney cartoons and Charlie Chaplin's films, calling the latter "a great artist" when she saw him in *The Great Dictator*; however, she found the movie version of *Wuthering Heights* with Laurence Olivier "too tame."

Sometime in 1929, Stettheimer began the first of her series of four monumental *Cathedrals* paintings, each one featuring what Stettheimer saw as the new bastions of New York, the most modern of twentieth-century cities: *The Cathedrals of Broadway* celebrated the movie theaters around Times Square; *The Cathedrals of Fifth Avenue* reflected high commerce and luxury along the famed avenue; *The Cathedrals of Wall Street* heralded the district that established New York as the world center of finance; and *The Cathedrals of Art* presented New York's revered museums and art world. Although the paintings were completed several years apart, their subjects are so comprehensive that it is hard to imagine that Stettheimer had not already envisioned all four of the paintings as a series. Each is a world unto itself, presented like the final scene in a grand opera.

In *The Cathedrals of Broadway*, the first in the series, Stettheimer paid tribute to the movie theater as a shining secular shrine. Two years before she began this painting, *The Jazz Singer* starring Al Jolson, the first feature-length film to have synchronized sound, ended the reign of the silent era. After its appearance, most films, termed "talkies," featured sound and were so popular that over seven million people began attending movie screenings in a single day.[4] In *The Cathedrals of Broadway* Stettheimer used her composition and details to simulate, in two dimensions, the multimedia experience of visiting a film in a Broadway theater, with various concurrent events, sounds, and motion — a multi-ring circus of form and color. (*Fig. 94*)

A large red banner with gold letters at left proclaims the title and date of the painting and the artist's name. The background is a lighting extravaganza, filled with the names of Broadway's most fantastic movie palaces. With her love for detail, Stettheimer reproduced almost exactly their unique façades and signage. For example, at upper right, we see the Capitol Theatre, whose dome was based on the U.S. Capitol in Washington, D.C. In the upper left, Stettheimer reproduced the Rialto Theatre's unique spiral lighting element, which terminated in the name written in fiery lights in the night sky. Tucked to the left side above a huge crowd is a facsimile of the entrance of the Mark Strand Theatre.

*The Cathedrals of Broadway*'s composition is arranged around a theatrical proscenium arch with a shallow, tilted foreground. Reflecting her evolving interest in time and space from her earlier use of *multiplication virtuelle*, Stettheimer arranged the viewer's experience of the painting to emulate attending an actual performance of a movie in 1929. To accomplish this, she based many of the painting's details on the actual interior of Broadway's famous Roxy Movie Theatre. Often cited as the most impressive movie palace ever built, it opened only two years before Stettheimer's painting

**Fig. 94** Florine Stettheimer, *The Cathedrals of Broadway*, 1929, oil on canvas, 60 ⅛ × 50 ⅛ in., The Metropolitan Museum of Art, New York, Gift of Ettie Stettheimer.

was completed and was called "The Cathedral of Motion Pictures" by its creator, Samuel "Roxy" Rothafel.[5]

In the middle foreground, a partially snow-covered, yellow-suited police officer urges arriving moviegoers to enter the Roxy at left, where Stettheimer, her sister Stella, and their nephew Walter Wanger can be seen coming through the door. They pass by the cordoned-off "world's largest oval rug,"[6] inscribed with the word "silence." This reprimand is echoed by a gilded statue whose finger is pressed against her lips. She is backed by a plaster, gilded, vertical leaf, ringed on either side by fully liveried ushers. (The Roxy's employees went through rigorous training and daily inspections by a retired Marine officer to ensure they provided the highest level of courtesy and efficiency.) Patrons move to the lower right box office, and ticket in hand, enter the door to a world of multi-tiered entertainment.

Although the audience would have seen the activities one after the other, Stettheimer placed the evening's sequence of entertainments onstage concurrently. On the right, a woman organist plays the Kimball theater pipe organ that provided music between the various acts, while a clown gets a seal to catch a ball on its nose. In the middle of the stage, a male ballet dancer holds his graceful partner in the air. Surrounding them on two sides in a "U" shape, a famous line of women precision dancers called the "Roxyettes"[7] forms a chain emanating from a small classical monument. A small male ice skater pirouettes at the lower left, and above him, with a huge, bright yellow shape resembling a sun's rays, the Roxy's 110-member symphony orchestra (the world's largest permanent orchestra at the time) rises on a platform from the basement. All of these performances would have taken place at the theater before the film was shown.

Stettheimer filled the motion-picture screen with a black-and-white scene from a popular short displaying, in the critic Paul Rosenfeld's words, "the vulgarly handsome mask of Jimmy Walker opening the baseball season; the derby atilt on his head; the face of him hard as a wisecrack; the baseball offensive in his twisted hand." This was an annual event enjoyed by New York's mayor and audiences who watched shorts prior to feature films. Stettheimer never mentioned a particular interest in either the mayor or baseball; but in the painting, as she enters at the lower left, she pauses and looks up at the grisaille screen.

As in most of her works, there are myriad humorous details throughout, whether it is the young child peering through the glass at the ticket office while the ticket taker is flirting with an usher, or the tuxedoed man who waves down from a viewing box at left with no visible egress. The wide decorative arch surrounding the stage has opposing niches in styles of two distinct periods, which, per the artist's feminist inclinations, each contain a female statue. On the left is a gilded early Gothic-style altarpiece containing a niche, inside of which is the figure of a nun reclining

on a bier or coffin. This image is taken from the 1923 Lilian Gish film *The White Sister*, whose title Stettheimer inscribed directly below. On the right, a large rounded niche, repeating the arch and red curtain of the theater itself, holds a chandelier over a marble nude Venus or Aphrodite, a garland hiding her genitals. Directly beneath, Stettheimer included a painting of a horned bull by the artist Rosa Bonheur, a renowned symbol of the "New Woman" and the first woman artist recognized by the nineteenth-century French Academy.

Stettheimer clearly intended to imbue the *Cathedrals* canvases with the monumentality of architecture as well as connotations of belief and ritual. To accomplish this, she based each composition on Old Master paintings she admired. In designing the frame with which to convey the drama and excitement of Broadway, Stettheimer turned to precedents in fourteenth-century Italian painting, in this case Giotto's Arena (or Scrovegni) Chapel in Padua, considered to be the most cinematic of Italian pre-Renaissance artworks.[8] Stettheimer echoed the Arena Chapel's double-barrel vaulting with the Roxy's stage arch,[9] which also frames the arrangement of *The Cathedrals of Broadway* and becomes a vortex, drawing the viewer's eye past the dazzling mini-stories taking place on either side.

The *Cathedrals* paintings portray an image of popular culture in New York City similar to those in works by other artists, including Reginald Marsh, but with obvious differences. The same year that Stettheimer painted *Cathedrals*, John Marin, one of the artists in Stieglitz's circle, painted a watercolor, *Broadway Nights*. Marin's work recreates the theater district's dazzling array of light and entertainment by juxtaposing and overlapping Cubist-style angular, geometric forms and bright colors. Marsh's later painting *Twenty-Cent Movie* captures lower-class street life surrounding the brightly lit, poster-laden entrance to a movie theater. In comparison to both, *The Cathedrals of Broadway* is not merely a compilation of flattened abstract forms or a frozen moment in time. Instead, it is a humorous *experiential document* of the preoccupations of the uniquely modern city. It draws viewers into a visual and sensory cacophony of encounters and incidents that recreate the experience of being there.

In one review of *The Cathedrals of Broadway*, a critic noted, "Those temples of pleasure, the Paramount and Roxy, can no longer complain that art has ignored them. Miss Stettheimer has summed them up in a way to entice all Europe to these shores." When it was exhibited at the Whitney Museum of American Art in 1932, Paul Rosenfeld noted that the painting provoked a hubbub among viewers and other artists in the exhibition:

> The sensation of the show . . . this season was surely Florine Stettheimer's witty and satiric apotheosis of popular American art, splendor, and ceremony entitled *Cathedrals of Broadway*. It is a piercing, amusing and elegant piece of work, and very brilliantly pigmented. Originality of idiom distinguishes it from the derivative and compromising pieces necessarily evident in any omnibus show.[10]

The conservative critic Edward Alden Jewell, writing for the *New York Times*, was less impressed. He described "shuddering at the too painfully vulgar tinsel of Florine Stettheimer's *The Cathedrals of Broadway*, with passages raised in relief, recalling Mr. Sargent's rococo prophets in the Boston Public Library."[11] Another reviewer compared the work favorably to the French artist Marie Laurencin. Arnold Genthe disagreed, however, writing to the artist:

> I was delighted to see the article about your work in *Creative Art*. It is well and entertainingly written, but I believe that your *Broadway Cathedrals* deserves a little more space in a critical review than just a mention *en passant*. To my mind, it is not only the most significant of your paintings, but it is a unique and exceedingly brilliant and original presentation of a phase of modern New York which has never before received such an illumination and radiant interpretation. And Laurencin who paints with raspberry syrup and whipped cream and coal does not deserve the honor of having her name in an article about Florine. Them be my sentiments![12]

In 1930, Stettheimer's work continued to receive recognition from her peers. Albert Gallatin, founder of the Gallery of Living Art in New York, asked to see her work, as did the director of the Gallery of Living Art in America. The American Society of Painters, Sculptors and Gravers made her a member. All the same, it was also a period of reflection and some bouts of depression for the artist, either because of the strain of Rosetta's worsening health or her own impending fifty-ninth birthday. Her only diary notation on her birthday was, "I had breakfast, I got up, I had lunch, I am about to have dinner and then I expect to go to bed." A month later she wrote, "I finished a history of my life that takes about five minutes to read."[13]

The Stettheimers spent the summer of 1931 at a house rented at 35 Beach Street in Larchmont, New York, mainly because it had an elevator for Rosetta. Although the area had a picturesque little beach, Florine felt confined and uncomfortable, and in one of her snobbish, entitled phases, she complained at having to share a beach cabin with complete strangers: "People are so common in our country." She attempted to "raise the social standing of the neighborhood" by feeding a local squirrel Mallard's "marrons en manqué de peanuts." Later, when she noticed a newspaper editorial about the "effete" squirrels in Central Park, Stettheimer was pleased to think that Larchmont would soon also be able to brag about having a "debauchée" squirrel due to her efforts. She spent one weekend as a guest at the Briarcliff Country Club, which she described as "an expensive convalescent home." As always, Stettheimer was thrilled when the summer ended, when her family finally returned to New York and she could return to her studio.

In 1930–31, Stettheimer began a painting she titled *Love Flight of a Pink Candy Heart* (*Fig. 95*), a visual reminiscence of past friendships and romances.[14] An inscription on the stretcher of the

**Fig. 95** Florine Stettheimer, *Love Flight of a Pink Candy Heart*, 1930, oil on canvas, 60 × 40 in., Detroit Institute of Arts, Gift of Miss Ettie Stettheimer.

painting states: "My Romance Past NY / House Party Eden, New York / In memory of a sugar coated heart / My house . . . on Paradise / (my Party) . . . Arcadia / Beautiful young men / I have known / Paradise, NY / House Party Eden N.York / April 1930,"[15] suggesting that the scene took place at one of the summer houses the family rented for the summer. The artist laid out the main components of the painting in a loose preliminary sketch. In the final oil painting, she replaced a nondescript woman looking out over a balcony with a self-portrait. In *Love Flight*, as she had with Nijinsky in *Music* and Rrose Sélavy in *Portrait of Marcel Duchamp*, Stettheimer painted herself using only a rose-based paint, indicating that she (and the work itself) represents an alternate "state" — a memory or dream rather than an actual event.

Stettheimer painted herself standing with her eyes tightly closed, resting her head in her hands as though sleeping, with her elbows on a red pillow on the railing of an elaborate filigreed balcony. Dressed in ruffled capri pants, the artist playfully laces one of her legs through the intricate wrought iron of the balcony, while her other foot falls out of the red shoe behind her, furthering the impression that she is dreaming. This idea is reinforced by the undifferentiated ground of the painting and its lack of horizon line, which causes figures to float in an almost surreal manner across the space. The steep angle of the ground creates the impression that we, the viewers, are in a theater's highest balcony seats, looking down on the scene below.

In the middle foreground, a small red-haired girl, possibly the artist as a child, releases a red, white, and blue arrow that flies through the air and is about to pierce the floating, lace-trimmed pink heart of the work's title. Stettheimer wrote various poems mentioning pink hearts, equating them with memory and childhood:

A pink candy heart
In fluted tin
A spun glass rainbow
On a lace paper sky
A toy peacock
That spreads its tail
A first beau's picture
With glossy curls
Were early cherished treasures[16]

Another of her poems, which also reflects what is probably a childhood memory, is more in keeping with the sense of irony so visible in most of Stettheimer's paintings and writings:

> I found pink hearts
> soft to the touch
> stuffed with fragrance
> nestling among her underthings
> I gently stole one
> jammed it
> full of pins
> and hung it up
>      my Saint Sebastian.[17]

As *Love Days* indicates, at age sixty, Stettheimer's memories of past romances brought a sense of nostalgia and lasting amusement. In her dream, she recalls youthful flirtations and close friends. The scene immediately below her displays a grouping of young men and a single woman who are all physically beautiful. In the lower left of the painting, the slim, aristocratic figure of Arnold Genthe enters, with his prominent nose, strong jaw, and windswept hair.[18] He wears a tuxedo with tails and carries a mysterious dome on a silver salver. (*Fig. 96*) A very dapper-looking Charles Demuth lies under the balcony, reading a book. Stettheimer painted him looking very healthy, with the cane he used in his later years abandoned in the foreground of the painting. Demuth's back rests against an opulent white tablecloth laden with a flower bouquet, wine goblets, fine plates, and coffee cups. Stettheimer used so much paint to decorate the lacy cloth, dishes, and flowers that they have actual dimensionality.

At the top of the lace-edged cloth is an elegant woman with fashionably bobbed hair who holds her hand out toward a white dove. Lying at her feet are two handsome young men baking in the bright sun, but neither pays any attention to her or to Stettheimer. One man, with dark wavy hair with a center part, thick straight eyebrows, and smoking a pipe, is James Loeb, the man with whom she had a romance in Europe for several years during her twenties and thirties and who eventually broke her heart. (*See Fig. 16.*) After Loeb's death, his niece described him as "the most vivid, brilliant personality. As handsome as a Greek god,"[19] and that is how Stettheimer painted him: naked, his tanned body stretched out, lying on his stomach. Directly above Loeb a large goose flies away, a reminder that Stettheimer once referred to Germans as "geese," perhaps a metaphor for her

romance with Loeb in Germany and his subsequent desertion. Lying next to him is an unidentified but notably attractive man whose ankles and wrists seem bound, so that his muscle-bound body is stretched out in its tiny patriotic bathing suit for intimate viewing. As Stettheimer ironically noted:

> I adore men sunkissed and golden
> Like gold gods
> Like Pharaoh amber-anointed
> Thus I mused aloud
> Lying on a lace-cushioned-couch
> On my verandah overlooking Lake
> Placid —
> My August-guest
> Heard me and smiled
> And rose lazily from the turkey-red
> Cushions
> He became a golden speck
> Paddling into the blazing sun
> Hours later he came back
> Looking self-conscious and
> parboiled[20]

The woman reclining near the picnic blanket appears to be a reference to a character in Carl Van Vechten's 1923 novel *The Blind Bow Boy*. Among the book's protagonists were the socialite Campaspe Lorillard and her husband Eros (or Cupid). The cover of the novel, displaying Cupid holding his

quiver and bow with his eyes bandaged, has the same ironic tinge as Stettheimer's painting. Van Vechten loosely based his idea on an Elizabethan play of 1584 by John Lyly titled *Alexander and Campaspe*, in which Campaspe was a concubine so beautiful that the artist Apelles fell in love while painting her portrait. The latter play is best known for the poem which begins:

Cupid and my Campaspe play'd
At cards for kisses – Cupid payd…[21]

Van Vechten, being gay, created his own set of characters for the novel, including the infamous Duke of Middlebottom, who dresses like a sailor, carries an umbrella, and proclaims, "A thing of beauty is a boy forever."[22] Stettheimer's awareness of her friend's sexual proclivities is evident in the following poem she wrote to Van Vechten on the book's publication:

Carlo
Colorful scents
Scented rhythms
Rhythmic flavors
Flavorful discords
Discordant youth
Youthless gaiety
Gay degeneration

You created
For greeneyed
Campaspe to her delight
to my amazement

My thanks[23]

A young, godlike, sexually ambiguous figure in a white robe and blue stole, with pure white lines of light radiating from their head, appears to float through the air toward the elegantly seated woman at the top of the picnic cloth. If the woman is Campaspe, then this is Eros, or, perhaps,

it is the artist's "favorite man," the Apollo Belvedere, whose sculpture she kept on her bedroom mantle for most of her life.

Distinct from the scene below, the top half of *Love Days* is filled with the departure of a handsome man with a beautiful profile resembling that of Duchamp, whose poem she ended with the words "Love Flight," which are also part of the title of this painting. He rides away as he so often did from their lives, bareback on a golden-maned horse at the edge of a huge lake. At top right, under a red fringed curtain shaped like the petals of a flower, an indistinct body lies on a float deep in the lake, protected from the sun by an umbrella. Another faint figure appears to be executing a back dive into the lake, recalling the many sites of the Stettheimers' pool parties.

The final "stage" in the composition is in the lower right corner where, to the sounds blaring from six-horned speakers, Stettheimer painted herself again, dancing with a masked harlequin figure. By portraying herself wearing white pantaloons, red heels, a long black lace veil, and her artist's beret, Stettheimer signals that in this area of the painting, she is the free, bohemian artist. Duchamp,[24] again as the masked harlequin, rocks the artist back off her feet as they dance. Her eyes remain blissfully closed, and their image is reflected in the star on the mirrored dance floor. Duchamp is the perfect foil to the foreground of *Love Flight*. When donating the painting to the Detroit Institute of Art, Ettie noted, "It seems to me that Florine is laughing a little at herself."[25]

With the exception of the masked dancer, the men in *Love Flight of a Pink Candy Heart* are completely absorbed in self-beautification or exist in psychological isolation. This corresponds to the reality of Stettheimer's life by 1930. Her youthful flirtations were two decades in the past, and most of her closest male friends were dead, gay, married, or not interested in marriage. The artist often reiterated her aesthetic enjoyment of the male form in her paintings and poetry but remained absolute in her conviction not to allow any emotional or sexual attachments to get in the way of her creative life:

You remind me
of a follower
who adores me
who bores me

If you adored me
would you bore me
I shall wonder
forever[26]

As she gazes down to the heart about to be pierced, the various components of *Love Flight* combine to invest the work with nostalgia and the sense of past love as fleeting, i.e. time's fool. As painted by Stettheimer, the voyage of life and love is filled with isolated vignettes arranged in one's memory.

Although it is not clear why, 1930–31 were the only two years between 1917 and her death in 1944 that Stettheimer did not include her work in any pubic exhibitions. On October 3, 1930, Stieglitz again wrote to ask her to give a solo show at his gallery — a major honor, as by now he was considered one of the most important and influential gallerists in New York:

> The stars willing it is our intention to open An American Place with Marin — November — We are wondering would you like to show some of your paintings during December — and during Xmas week you could add an Xmas tree if you wished to. Or would you prefer April for show? I'm sure your things would look very beautifully in The Place. Of course, you have been hoping for a much larger place but why not try this? I know it would be a beautiful event.

Despite their close friendship, she again turned down Stieglitz's request for a solo exhibition or to join his gallery:

> "Your colossal generosity makes all my would be answers sound selfish — be they acceptances or refusals of your beautiful offer of a show. By now I am just paralyzed into inaction — there is not an effort I care to make — excepting to paint. Thank you I am grateful and so pleased that you care to show my paintings. The summer I have just spent has made me more than ever indifferent to a public. I met old acquaintances who remembered I had gone to Art School and had I "kept up my painting?" I had no room nor lights nor paints in Larchmont — and I am happy to be back [in my studio in New York] where I belong."

Stieglitz persisted, reiterating that he believed Stettheimer belonged among the seven American artists he wanted to promote in his gallery:

> I received your letter & I understand. But I want you to know that I wasn't unselfish in asking you. First of all, I care as little about a public as you do, but I feel that the impersonal idea I have been following for years includes your work. And that without it my little "building" will ever remain not quite complete. Then too I personally would have enjoyed the privilege of living with your paintings for 4 whole weeks to enjoy them in my own way really *seeing* them. And *that* privilege I wish to share with a few others who I know wanted

the opportunity to see your paintings in an atmosphere like that of 291 — But as I said I understand how you feel & I respect that feeling as I respect your work.[27]

The small size of Stieglitz's new gallery may have had something to do with Stettheimer's refusal to have a solo exhibition there.

Just a year later, she negotiated with Stephen Bourgeois of the Bourgeois Gallery to have "a show of [my] own" in the dealer's new gallery, which was large enough to accommodate her recent works. Nothing appears to have come of these discussions, but Stettheimer continued to explore the possibility of a solo exhibition over the next decade. Stettheimer was not averse to exhibiting her work in commercial galleries. However, when she did exhibit them for sale, she asked exorbitant prices as she simply did not want to sell them. Her friend Max Ewing reported in a letter to his parents in 1929 that Stettheimer was asking $250,000 for each of her paintings (the astonishing equivalent of $3.8 million dollars in 2019). As a result, they never sold.

The winter of 1930 was particularly frigid, and Stettheimer saw many traffic accidents occur below her studio window. In mid-December, she fell on the icy sidewalk in front of her studio. Fastidious as usual, she particularly disliked the fact that she had to be helped to her feet, and have her body touched up by people she didn't know: "'Tis ignoble to be ill — having to take recourse in outside help . . . doctors — x ray photographers — intensifies the horror . . . being helped up after a fall on glass pavement on the street — seven men from nowhere crowding about me — I smiled them away . . . they disappeared . . . a body that gets damaged should be able to turn on a healing apparatus. It's strangers that the body, at least my body, resents." (Ettie expunged the remainder of this passage.) An added sadness in 1931 was the death of Stettheimer's eldest sister, Stella. Because of their mother's age and fragile health, news of her daughter's death was withheld from her. Carrie wrote discreet cards to family and friends, telling them of Stella's passing, stating that the three remaining sisters were "composed as we have to be under the circumstances."

While Carrie also traveled to Europe during the summer of 1931, Florine, Ettie, and Rosetta rented the Lyndhurst estate, also known as the Jay Gould estate, a Gothic Revival country house within its own 67-acre park.[28] Located along the Hudson River in Tarrytown, New York, it earlier belonged to railroad magnate Jay Gould.[29] As Florine noted in her diary: "Truly on the Hudson this time . . . Mrs. Gould just died here."

Several of their summer neighbors were artists, causing Stettheimer to complain, "There are four of us addicted to art within a few acres . . . there may be hundreds in Tarrytown — oh horrors." They invited a number of their friends to join them, and with the whirl of social activities and the need to assist in caring for her mother, the artist seldom got a chance to work. Toward the end of

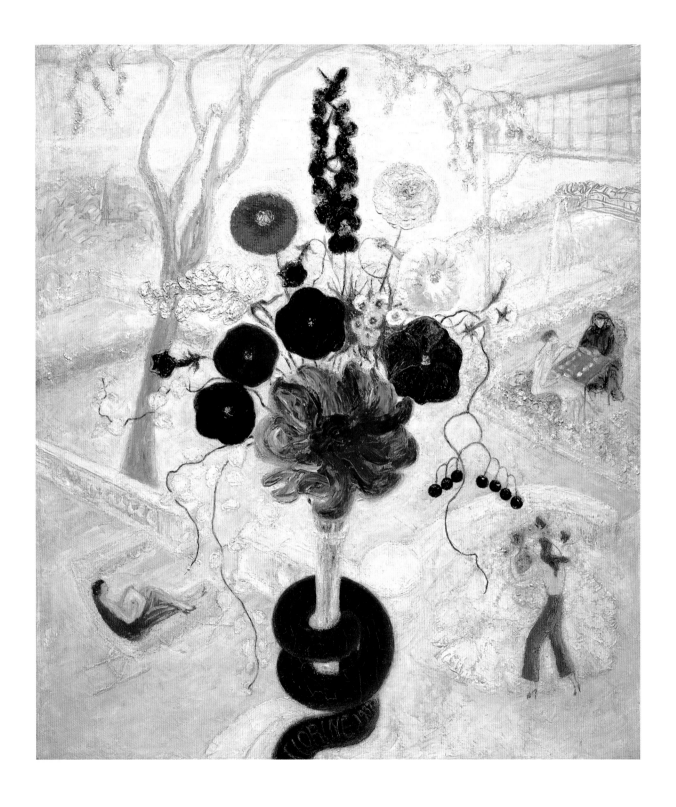

**Fig. 97** Florine Stettheimer, *Birthday Bouquet (Flowers with Snake)*, 1932, oil on canvas, 30 × 26 ⅛ in., Nelson-Atkins Museum of Art, Kansas City, MO, Gift of Mrs. R. Kirk Askew in memory of R. Kirk Askew, Jr.

the summer, Stettheimer was able to finally set up her canvas and equipment, noting in her diary, "At last it looks as if I were going to paint."

On August 19, 1932, her sixty-first birthday, Stettheimer dressed in what she described as a "greekish" white moiré gown with fringes and gold sandals and gathered her annual birthday bouquet of fresh flowers from the garden. She noted in her diary: "My Birthday — NOON — I have made my bouquet." That evening, she began work on a painting titled *Birthday Bouquet (Flowers with Snake)*. (*Fig. 97*) She designed the painting around a familiar device: the grouping of her mother and sisters around a bouquet of flowers, as she had a decade earlier in the painting *Russian Bank*. A glass vase holding a huge assortment of pansies, daisies, dahlias, portulaca, and other blossoms dominates the composition. A blood-red snake, on which the artist incised her first name and the date, is coiled around the base of the vase, reminiscent of the snake that curls up the trunk at the side of Stettheimer's Apollo Belvedere.

Tiny images of Stettheimer's mother and sisters are situated within three quadrants of the beautifully landscaped gardens. At middle right, Rosetta, in black, sits playing cards with Carrie. At lower left, behind a terraced wall, Ettie sits, reading. As usual, isolated from the others, Florine arranges another vase with flowers on an elaborately skirted table on the raised balustrade in the composition's lower right corner. Ettie and Carrie are portrayed wearing light summer dresses; Florine painted herself in long red pants and a white blouse. Three years later, Alfred Barr, director of the Museum of Modern Art, organized an exhibition to demonstrate to his trustees the quality and scope of the collection he was seeking for his new museum. A fan of Stettheimer's work, he requested a painting to include in the exhibition, and she sent *Birthday Bouquet.* When the exhibition opened, the painting was singled out and praised by critics and the media, and Barr thanked her for her choice.

Throughout the spring and early summer of 1932, Stettheimer corresponded with McBride from her New York studio and the Gould estate. From the latter she described various activities that were occupying her in addition to her painting. As always, she read voraciously, often books about strong women in history. In her letters she described women who lived through the French Revolution, such as the Baroness de Bode, a highly independent woman who emigrated with her children to Russia, where she made a place for herself in the court of Catherine the Great. In one letter written early in her marriage, de Bode wrote to her younger sister, urging her to join her in France: "But take my word for it, my dear Kitty, that even with the best of husbands, the single life is ever preferable."[30]

Writing to McBride, Stettheimer also speculated on the upcoming presidential election, expressing her preference for Al Smith, the Catholic Democratic candidate, and described lectures she and her sister attended, including one on Russia at Muriel Draper's Salon, given by Esther Murphy Strachey, a wealthy American heiress married to John Strachey, an English Socialist recently

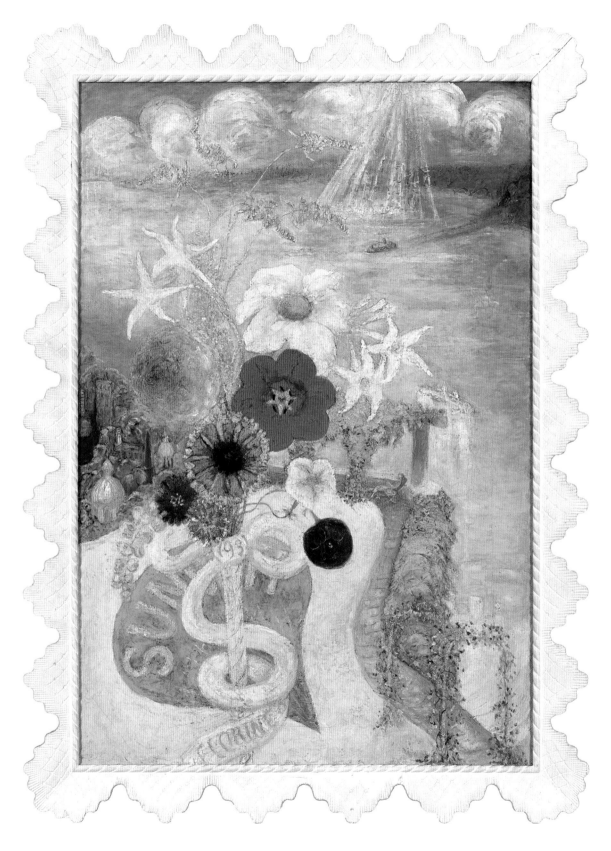

**Fig. 98** Florine Stettheimer, *Sun*, 1931, oil on canvas, 43 ⅝ × 31 ¾ in., Whitney Museum of American Art, New York, Gift of Ettie Stettheimer.

elected to Parliament as a Labor Party member. Florine not only kept up with all the current news on the art world from both sides of the Atlantic, but also read all forms of contemporary literature.

While at the Gould Estate, Stettheimer painted *Sun* from a high perspective, looking down on the terraced garden overlooking the Hudson River. (*Fig. 98*) The work contains many familiar elements, such as a central, oversize bouquet. The flowers stream out of a long cylindrical crystal vase that is encircled by a curled, rounded snake, again bearing the artist's name, "FLORINE S," and the date. The reappearance of the snake in this third painting of her sisters and mother suggests that the artist intended it as a metaphor for discord in even the most Edenic gardens and supposedly close-knit families.

In *Sun*, a veil of light breaks through the clouds and shimmers over the river and clouded sky at the top of the composition. A small ferryboat, visible in the distance, has just left the other bank of the Hudson and is making its way across the river. The figure of a woman, possibly the artist, rests on a chaise in the shade of a vine-covered arbor and gazes out over the Italianate architecture surrounding nearby Tarrytown. Stettheimer designed a special frame for the painting, with a thin twisted inner wood band and a flange of scalloped mounds, their edges lined and crosshatched to resemble fine lace. Like many of her frames, the wood is whitewashed, heightening the sense of light emanating from the painting's center.

Stettheimer designed many of her own highly original frames, often repeating specific features on furniture she designed so that they matched when installed together. As in her earliest Knoedler exhibition, the integration of all of her work continued to be an important part of its presentation. Stettheimer made numerous sketches of design ideas for furniture and matching frames to be fabricated. On one such sketch, she noted, "I should like to have the effect of embroidery—and the frame to incline toward the spectator." Stettheimer's frames and furniture were often painted white, with occasional gilding.

An unpleasant situation arose when Stettheimer accused Billy, one of the frame makers she worked with, of plagiarizing her designs in order to develop a reputation for himself by making frames based on her aesthetic. He denied doing so, claiming that he had always been "charmed by valentines and architecture" and did not realize that she "set such store by" her frames, which he admitted were "an individual painter's effort to accommodate paintings, practically unique." Although he noted that he appreciated her past goodness to him, he claimed he had been working on "similar designs" for a number of years, and that they were his "bread and butter." He felt that her charges against him warranted his sending copies of his reply to several of their mutual friends.[31] Apparently, Stettheimer dropped the issue, but as she had been designing her gold and white furniture and frame designs since the 1920s, it is probable that the framer had been copying her designs.

Between 1931 and 1932, Stettheimer also began the second painting in her *Cathedrals* series, using as its nexus a New York society wedding. *The Cathedrals of Fifth Avenue* clearly reflects her feminist view of marriage as a suffocating undertaking that benefited the man but not the woman. (*Fig. 99*) As in *The Cathedrals of Broadway*, Stettheimer based the format on the structure of an Italian pre-Renaissance work, in this case Giotto's *Ognissanti Madonna* (1306), which she had seen in the Uffizi Gallery. She adapted the painting's pointed vault throne and delicate gable (ornamented with crockets and open-arched wings) in its entirety, but collapsed the realistic space created by Giotto's painted buttresses, replacing it with a hanging red awning. Giotto's *Madonna* represented, for its time, a new mingling of the mystical and spiritual with the human. In placing a similar altar in the center of her canvas, Stettheimer ironically conflated two notions of weddings: the religious ritual, implied by the jewel-bedecked arch-bishop at left and the plain-clothed monk at right, their hands raised in blessing; and the commercialism and acquisitiveness commonly associated with the event among New York society women.

New York's Fifth Avenue between Thirty-Fourth and Fifty-Ninth Streets housed some of Manhattan's wealthiest residents, and luxury businesses opened all along the avenue to cater to this clientele. In *The Cathedrals of Fifth Avenue*, Stettheimer followed these boundaries by painting, in the middle left of the composition, one of the stone lions guarding the steps leading up to New York's Public Library at Fifth Avenue and Forty-First Street. To indicate the topmost limit, she included at middle right the figures of Victory and a partial horse from the statue of General William Tecumseh Sherman by Augustus Saint-Gaudens, which stands at Grand Army Plaza at Fifth Avenue and Fifty-Ninth Street.[32]

Wealthy New York families vied for the most prestigious churches and synagogues as sites for their weddings, and none was more prestigious than Saint Patrick's Cathedral at Fifth Avenue and Fifty-First Street. Begun in 1881, the construction of Saint Patrick's was completed with the enlargement of the sanctuary and the installation of the great organ in 1931, the same year that *The Cathedrals of Fifth Avenue* was painted. Therefore, the wedding at the center of Stettheimer's painting is probably sited on the steps of the cathedral. That a society wedding was both a sacrament and an occasion for ostentatious display was not lost on the popular media. Contemporary newspapers and magazines carried long articles detailing the decoration, fashions, and guests at prominent weddings. Illustrations in popular magazines poked fun at the spectacle of the smart set and their apparent need to see and be seen.

In her painting, Stettheimer ironically floated all the various wedding accoutrements of society brides in the sky around the Gothic arch and down its right side. Beginning next to the figure of Victory is the bride's first stop, the House of Tappé, located in 1910 at Fifth Avenue and Fifty-Seventh Street. There, celebrities and wealthy brides could choose a wedding dress by a French

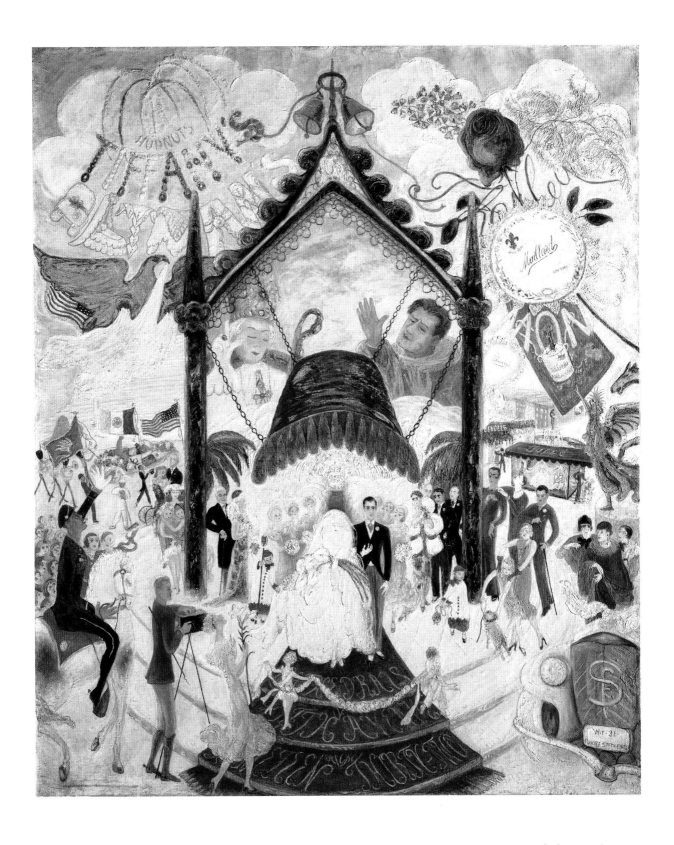

**Fig. 99** Florine Stettheimer, *The Cathedrals of Fifth Avenue*, 1931, 60 × 50 in., The Metropolitan Museum of Art, New York, Gift of Ettie Stettheimer.

designer. Then it was on to Bendel's, on the next block, to buy dresses, such as the first by Chanel offered in the United States, and accessories for their honeymoon. In the sky above the altar's roof line, Stettheimer painted further references to the raptorial movements of nuptial couples. The engagement period is represented at the right by boxes of Maillard chocolates, made at their luxurious store on Thirty-Fifth Street, with a beautiful handmade bone china rose from Thorley's of Staffordshire, England; a wrapped sugar candy from Sherry's on Fifty-Eighth Street; and the gold signage for the famous Delmonico's Restaurant at Fifth Avenue and Forty-Fourth Street, where wedding parties often retired after the ceremonies.

In the sky at left, arches trimmed with colored flowers refer to the many flower-scented products, from perfumes to face creams, of the exclusive Hudnut company, with its headquarters on both New York's Fifth Avenue and Paris's rue de la Paix. Stettheimer spelled out Tiffany's name from images of brightly colored jewels and bands of gold for the wedding and engagement rings. Finally, below, the letters of Altman's department store's name are made up of various furnishings — tables, chairs, curtains, linens, baby cribs — all essential for the well-to-do couple setting up house. Stettheimer was not immune to periodic personal indulgences in these stores:

My attitude is one of love
is all adoration
for all the fringes
all the color
all tinsel creation

I like slippers gold
I like oysters cold
and my garden of mixed flowers
and the sky full of towers

and traffic in the streets
and Maillard's sweets
and Bendel's clothes
and Nat Lewis hose
and Tappé's window arrays
and crystal fixtures
and my pictures
and Walt Disney cartoons
and colored balloons[33]

As in many of her paintings, this poem demonstrates the artist's interest in both high and popular culture — from oysters and Bendel's clothes to Walt Disney cartoons and balloons.

Stettheimer had paid little attention to the female contestants in her painting *Beauty Contest*, and the bride in *The Cathedrals of Fifth Avenue* fares no better. Although the wedding party is the composition's central motif, Stettheimer purposely painted the bride as a non-person. Unlike the many other individualized figures, the bride's face is an undifferentiated fuzzy mass of white paint.

The groom, on the other hand, has a distinct, conventionally handsome face, standing passively like a mannequin in his formal suit.

Many of the other figures in the painting can be identified as friends and acquaintances of the artist. This prompted Linda Nochlin to refer to the *Cathedrals* paintings as "secular icons presided over by contemporary cult figures."[34] A dapper Charles Demuth holding his cane, for example, stands at right. Below him, the blonde, stylish Mrs. Bibi Dudensing (wife of F. Valentine Dudensing, the owner of the Valentine Gallery) struggles with her daughter to control a large gray dog. Behind Demuth, Muriel Draper, dramatically posing in bright red, rests an elbow on the back of writer Max Ewing. In the left foreground, standing along the edge of a red carpet inscribed with the date and title of the painting, Genthe, now with gray hair and in tall riding boots, adjusts his camera to record the wedding party. To his right is a woman in gold, whom Ettie later identified as Mrs. Walter Rosen.[35]

In the lower right corner is an elegant Rolls-Royce bearing the artist's monogram on its grille and her signature and date on its license plate. At its side, the three Stettheimer sisters look out over the wedding as though they had just stumbled upon it. Carrie is shown in front, wearing a red fur cape with green trim. To her right, Ettie wears a red dress with a black bow, her characteristically darkly furrowed brow turned away from the wedding party, recalling the heroine of her novel *Love Days*, who has nightmares of weddings. At far right, Florine peers at the spectacle from over Carrie's shoulder.

The painting displays Stettheimer's rich sense of humor, especially in the depiction of the young children. In the middle left, a bored choirboy holding a scepter uses it to lift and peer underneath the bride's dress. An altar boy at right swings a censer back, about to bash the struggling Dudensing dog with it. Two child attendants in front carry a flower garland before the wedding party, but both are distracted from their duties: the small boy at the right is far more interested in the dog and steps off the wedding carpet to get a closer look; the tiny flower girl positions herself directly in front of Genthe's camera and poses, attempting to draw the photographer's attention away from the bride.

Each of the compositions in Stettheimer's *Cathedrals* series also encloses several worlds within worlds. Smaller, separated ceremonies layer ideas about commerce, art, ritual, religion, and entertainment. In the top left section of *The Cathedrals of Fifth Avenue*, Stettheimer painted a vignette showing Charles Lindbergh's ticker-tape parade, where he sits on the back of an open, flower-laden, chauffeured car. On May 7, 1929, two years before the artist included him in this painting, Lindbergh was given the largest parade in New York history, as four million people lined Fifth Avenue to watch him pass and Mayor Jimmy Walker awarded him New York's Medal of Valor. Lindbergh's historic flight across the Atlantic affirmed that the creativity and innovation of twentieth-century modernism

had shifted from Europe to the United States. Lindbergh also symbolized the transition, in the 1920s, toward a recognition that the modern individual was alone, "in permanent flight, devoid of footing," and that freedom was, above all, a responsibility to oneself.[36] In Stettheimer's painting, the Lindbergh detail acts as ballast to the religious spectacle in the painting's foreground. By balancing the central, generalized wedding group with individualized portraits of the three sisters on one side and Lindbergh on the other, *The Cathedrals of Fifth Avenue* is Stettheimer's witty comment on the value of individualized achievement and idiosyncratic choice over conventional actions.

*The Cathedrals of Fifth Avenue* was exhibited in the 1932 Whitney Museum's *First Biennial Exhibition of Contemporary American Art*, which claimed to show the best contemporary work in the country. The critics reviewing the exhibition raved about the painting. McBride, in the *New York Sun*, declared:

> Miss Stettheimer's *Cathedrals of Fifth Avenue* must be the most modern in method of all these pictures, for it is cinematic, historic, fantastic, realistic, mocking, affectionate, calligraphic, encyclopedic, Proustian, and even portentous. In fact, it has everything and everything in proportion.[37]

In the May issue of *The Nation*, Paul Rosenfeld joined the champions of Stettheimer's work: "The canvases of Miss Stettheimer, indeed, stand well among the exceptional works of art now being produced in the United States." In an article devoted to Stettheimer, he placed her *Cathedrals* series and group portraits under the heading "Americana," calling them "grandiose, documentary caricatures of the land of the free." Citing such works as *Asbury Park South*, *Beauty Contest,* and *Spring Sale at Bendel's*, Rosenfeld observed:

> They are full of marvelously chic and quite diaphanous persona; and if these puppets have the American seriousness mixed with the American childishness, and are all exalted and pompous about ridiculous things, they also have an elegance and selfishness which is not quite of this world. . . . Their spirit and their style are quite as individual as the technique . . . the art . . . is an ornate, a feathery, a spangled one, full of trills and coloratura and floritura . . . Those brilliant canvases of hers do resemble gay decorations in colored paper, and lacquered red and blue glass balls, and gilt-foil stars, and crepe streamers, and angels of cotton wadding, and tinted wax tapers. This is because she has a highly refined decorative sense combined with a certain predilection for the ornamental, the frivolous, the festive; indeed, a sense of the poetry and humor and pathos . . . There are serious people who claim that she is one of the three most important women painters in the country, the other two being Georgia O'Keeffe and Peggy Bacon.

A number of Stettheimer's friends and acquaintances congratulated her on the article. Among them was the influential Hilla Rebay, who in 1939 became the first director of the Guggenheim Museum, who commented:

> I enjoyed so much what Paul Rosenfeld wrote, only I could very well miss O'Keeffe and Bacon and find you not the best only of the women painters (which means very little unfortunately), but the man painters also, all included, I don't know one of them whose work is as fine and original visionary and well done as your works. I said this to McBride the other day. But it is nice they begin to write about you because you deserve it so.[38]

Stettheimer's reply is not known, but she wrote "funny" on the outside of the envelope of Rebay's letter. Another friend, Robert de Bonneville, wrote the sisters from Rome:

> I hear about Florine's great achievement and all circles in Europe said it was the "dernière" thing in America. And my wife . . . was with [Juliana Force, the director] at the Whitney Museum and said Florine had a picture there which she said was the best thing she had seen in America and that she thought Florine was undoubtedly the best painter in America — so we all come into our own sometime.[39]

Despite her successful exhibitions, the requests from top gallerists for solo shows, and the highly positive critical reactions to her paintings, Stettheimer wanted more publicity. She was also somewhat jealous of O'Keeffe's success, although it came directly through her husband's patronage. Stieglitz had exhibited O'Keeffe's work in ten exhibitions at his galleries, and she had had a major exhibition at the Brooklyn Museum. In that same year, 1932, O'Keeffe was given a commission to paint a mural for a powder room at Radio City Music Hall. Stettheimer wrote McBride, complaining at not having large enough walls to paint "such as Radio City is parceling out to the allegorical soul dreamers [O'Keeffe] . . . Shall I never be rescued from oblivion! — Marie Laurencin is to have a whole room at the Chicago Fair."

For years, McBride had warned in his criticism that too often artists and writers "succumb at the first taste of success to the temptation to paint what sells," referring to Stieglitz's nude portraits of O'Keeffe. He replied to Stettheimer:

> As for fame, you get it, as I often have told you, not by deserving it but by outraging public opinion. Georgia got hers by being so completely photographed. I mean publicity, of course, not fame. But it is publicity that gets you into Radio City and such places. As a matter of fact, you are much better *off* out of it.[40]

Fig. 100 Carl Sprinchorn, *Silhouette Cut-Outs of the Stettheimer Sisters*, colored construction paper cut and mounted on cardboard, Yale Collection of American Literature, Beinecke Rare Book and Manuscript Library, Yale University, New Haven, CT.

As the 1930s wore on, relationships evolved among the Stettheimers and their friends. Van Vechten's attention turned from writing almost exclusively to photography. He took detailed photographs of the façade of the Alwyn Court building and asked to take portraits of the three sisters. Florine flatly declined; Ettie and Carrie, however, eagerly accepted. Their reactions to the results, which showed their actual ages, were humorous, but less than enthusiastic: Carrie commented that the photographs "were a revelation: I think, I will get myself to a nunnery," and Ettie claimed that Van Vechten had foretold her next incarnation, when "I shall return to earth as a male & be exactly like this picture — if I live long enough. . . . I must say I am crazy about this quizzical, experienced gentleman & would fall in love with him, if it weren't myself." Carl Sprinchorn also cut silhouette portraits of each of the siblings, using green construction paper and placing each one adjacent to the elegant black silhouette of a tall, dinner-suited man. (*Fig. 100*) Carrie is shown wearing a nineteenth-century gown with a train; Ettie is depicted as a stylish author; and Florine strikes a rakish pose and, as usual, holds her palette and various artist's materials under her arm.

Despite their proximity, the sisters consistently insisted that friends and acquaintances view them as individuals, and deeply disliked any implications that, just because they lived together and had not married, they inevitably shared beliefs and interests. Later in life, recalling that although she and Carrie had never been forcibly put out of Florine's studio, Ettie remarked:

I don't think it ever occurred to us to watch her . . . we were *not* a cooperative group. I never read anything to anyone that was to be published. Carrie never asked anyone's

advice or opinion in connection with the Dollhouse, and Florine spoke only in a general way of what she was painting or about to paint.[41]

In 1932, Alfred Stieglitz opened a forty-year retrospective exhibition of his photography at his An American Place gallery. It included over a hundred works, including his nude portraits of O'Keeffe from a decade earlier, recent portraits of her at forty-five, and photographs of the young Dorothy Norman, with whom he had recently had an affair. Ettie, again showing her prudish nature, was scandalized on hearing this without ever seeing the exhibition. It is not clear whether she was embarrassed by her friend O'Keeffe's nude imagery, or that she believed the nudity was inappropriate, or because some of the images were of Stieglitz's recent lover. Hearing her expound on the impropriety of the exhibition, Paul Rosenfeld took Ettie to task for her reaction and apparently told Stieglitz about it.

On February 15, Stieglitz wrote to Ettie:

It was Georgia's own feelings & no one else's that decided me to withdraw every photograph of anyone that might cause comment. The show is completely proper. You'll see for yourself I hope — of course I understand what you felt and feel — the only regret I have is that you didn't speak to me directly about your feelings instead of discussing the matter with others.

Ettie wrote to Stieglitz in response:

I should feel upset about your having received a report from anyone but myself, did I not realize . . . it is not because my feelings are new, but because you think they may be typical of a class of Georgia's female public . . . The way I differ from the other women admirers, or some of them, is that, knowing Georgia, I hold her in great affection as a person . . . I harbor the same sentiments for yourself . . . My sisters belong out of it. I haven't discussed the matter with them so I don't know whether or what they think of any of it. We differ so often & so much on important & general matters that I'm sure they resent this grouping of ourselves as much as I do. At any rate, they are entirely disassociated from me and from this situation . . . I'm going to follow your invitation to see your Exhibition & behave as tho' nothing were changed between us.

Whatever the reason, Ettie's reactions to the exhibition did not prevent her from providing financial support to Stieglitz's gallery. On March 30, 1932, Norman even wrote a letter to Ettie, addressing her as "My dear Miss Stettheimer" and thanking her for donating money to An American Place gallery.

**Fig. 101** Florine Stettheimer, *Christmas*, c. 1930s, oil on canvas, 60 ¹⁄₁₆ × 40 in., Yale University Art Gallery, New Haven, CT, Gift of the Estate of Ettie Stettheimer.

By this time Stettheimer's interests had broadened considerably to include New York City's architecture and growth. A prime example of this is Stettheimer's *Christmas*, in which she captured her love for New York City's Upper West Side. (*Fig. 101*) The painting demonstrates how accurately she documented the many changes in the city's landscape and architecture. Although for years, art historians identified *Christmas*'s site as Rockefeller Center with its skating rink, the actual site of *Christmas* is Columbus Circle, an increasingly busy intersection of Broadway, Central Park West and Central Park South, a few steps from the Stettheimers' residence at Alwyn Court.[42] As is often the case, the artist collapsed actual distances to create her composition, but every detail is painted with exacting preciseness. The front half of the painting takes place within the southwestern corner of Central Park, looking out onto Columbus Circle, with various avenues radiating out from it into the distance. It is dusk, and the darkly red sun sets over the West Side of Manhattan, throwing a reddish glow and long shadows in the painting's foreground.

In the 1870s, what its developers called a "Grand Circle" was laid out at the open West Side intersection. It was to mark the point from which all distances to and from New York City would officially be measured from that point forward. At the same time, Calvert Vaux and Frederick Law Olmsted were completing their designs for Central Park. The eighty-foot monument of Christopher Columbus, designed by the Italian artist Gaetano Russo, was installed at the center of the Grand Circle to commemorate the four-hundredth anniversary of Columbus's arrival in the Americas in 1892. The West Side subway line was tunneled under the monument from 1900 to 1905, allowing easy travel between downtown and Central Park. The attenuated figure of Columbus on top of the thin column stands at the top center of Stettheimer's painting, *Christmas*. To its right, and directly behind the Christmas tree's gold star, is a view of the elevated subway, its entrance at the beginning of Broadway's broad avenue.

Olmsted's original designs for the park show the same layout of lakes and ponds as today, but contemporary accounts and photographs reveal that in the early decades of the twentieth century what is now a green area between Sixtieth and Sixty-Third Streets on Central Park West was filled with water in winter to provide a popular public area for ice-skating. (*Fig. 102*) It is this skating area that forms the central area of Stettheimer's painting. Many of the details in *Christmas* can still be seen in Central Park today, including the decorative metal-roofed structures the artist included in the lower left and the two bronze statues. There are no clues as to why, of all the sculptures in Central Park, the artist chose to include sculptures of the German naturalist Alexander von Humboldt, seen in the left foreground, and William Shakespeare at the right, other than that they were originally installed at the southern ends of the park.[43] Despite the winter weather, a wreath of fresh flowers is placed at the base of both monuments.

Fig. 102  Unknown photographer: Columbus Circle, New York City, c. 1910, digital print.

The painting's centerpiece is a brightly decorated Christmas tree topped by a gold star that stands in the middle of the frozen lake. The paint forming the strings of lights and balls on the tree is as thickly applied as cake frosting. Various creatures skate and push others around on the ice, forming a fantastic menagerie. Six brown bears link paws in a horizontal line behind a red fox whizzing by to catch a skater in red. Two pink fairies hold torches as they glide on the ice, while at the side two tiny white rabbits greet one another and a fat pink chick balances on long legs. A few human skaters join them: a woman in yellow is pushed in a fancy sled by a red skater, and another skims across the mirrored surface, tucked comfortably into a swan-like boat. All the while, a tiny girl in pink stands and waves from the seat of a green chair next to her red-hatted, fur-coated mother.

In the foreground, a man wearing a Native American headdress and fringed leather costume kneels in his skates to help his companion with hers.[44] The woman, who wears a feathered crown on her head and a thick ermine coat, shyly bows her head and places one leg into the man's lap for assistance. Stettheimer inserted herself as the observer of the action on the far left, her face and hair half-hidden by her thick mink coat and usual black beret. She glances out at the viewer from the corner of her eye and holds a single long-stemmed rose but does not make clear for whom it is intended. In the right foreground Stettheimer, as was often the case, uses a child to add humor to

300

her painting. In this case, a small red snowsuited child stands, weighing a snowball in his mittened hand. He cocks his head and looks up at the sleeping police officer resting against his horse, as though wondering whether to throw it at him.

Stettheimer accurately documented many of the evolving features of Manhattan's architecture during this period. This included images of several iconic buildings surrounding Columbus Circle in *Christmas*. By the turn of the century, banks and corporations had begun to build headquarters there, mixing their new buildings in with those already present. The automotive industry burgeoned after 1914 as assembly lines provided affordable cars that even the working class could buy. The area of Broadway from the West Fifties through the Sixties became known as "Automobile Row" because of the strong presence of salesrooms and huge adjacent advertising.[45] Beginning at the upper left of the painting, under a huge billboard with a blonde woman poking her head through a car tire, is a two-floor automobile showroom. To the right of that, another car salesroom takes up the ground floor of the architecturally traditional seven-story Grand Circle Hotel. Designed by William H. Cauvet in 1874, with a mansard roof, the hotel stood by itself on a small island around which cars maneuvered between intersecting avenues.

Directly behind the small hotel, Stettheimer included the massively stacked General Motors headquarters, two buildings that the company ambitiously combined in the early thirties. She also reproduced huge neon signs advertising competing tire companies — Fisk Tire Company[46] and US Tires, with Fisk's billboard on top of the General Motors building — with their well-known logos that could be seen for miles when lit at night. In front of the GM building, Stettheimer painted an older office building topped by a large sign, a small movie theater, and a huge billboard featuring Old Joe, the camel used to advertise R. J. Reynolds's pre-packaged cigarettes.

To the right of the Camel sign is a tall building that for many years had a huge sign reading "Manufacturers Trust Company" on its roof. Stettheimer faithfully replicated the building's design, but lacking the space to include the full text of the sign, she simply wrote the word "bank" in neon lights. Below, a block-long sign advertises Horton's Ice Cream, with an image of a horned bull in a sunny landscape below, implying the natural source of the dessert. The Horton company, whose headquarters were located about fifteen blocks north on Columbus Avenue, was incorporated in 1860. It advertised itself as the largest ice cream manufacturer in the world, and supplied all the hotels, private clubs, railroad cars, and luxury ships in and around New York City.[47] Directly to the right is a tall vertical yellow sign with a huge hand on its apex, a finger pointing to the left advertising rental parking owned by "Louie" located at #14, and at far right is an unfinished sign advertising holiday toys.

The southwestern corner of Central Park extends through the entire bottom half of *Christmas* as evidenced by the light green color of the grass and faint indication of trees. At the mid-right is a tiny rendition of the *Maine* Monument, which was dedicated in 1913 and still stands today at the entrance to the Park. A gilded bronze sculpture of Columbia Triumphant atop a seashell chariot, it is said to have been cast from the guns of the ill-fated USS *Maine*, which sank in Havana Harbor in February 1898.

In 1933, Stettheimer's device of combining a central floral arrangement with adjoining portraits culminated in *Family Portrait II*, which she called her masterpiece. (*Fig. 103*) A complex, sophisticated work, the painting is organized around three huge hothouse blossoms: a pink rose, a white daylily, and a red poppy. Their stems are encircled by a vine whose trellised arms sweep downward as though ruffled by a slight wind. The blossoms fill the center of the canvas, rising from the lowest edge up the surface plane and creating a strong diagonal form across the composition. The bottom center of the painting is filled with a baroque rug containing a central bright red oval, on which Stettheimer wrote her name and the names of her sisters and mother. The intense colors of the carpet ground the composition and give the bodies a sense of gravity, as though they were held in place around its edge by a centripetal force. This creates an uneasy tension between them, the elaborate design, and the gigantic, floating flowers. Stettheimer designed the painting's frame as a conventional wood rectangle with a recessed channel surrounded by huge, open, intersecting loops, all painted characteristically white.

As in her portraits of the 1920s, Stettheimer placed architectural elements alluding to the personalities and character of the four women above each one's painted image. Blue-eyed Carrie enters the painting from the right, below a detail of the crowned dragon ornament from the neo-Renaissance exterior of their family home, Alwyn Court. The architecture and her figure allude to Carrie's being as quiet and impenetrable as stone. The address of the building, "182 West Fifty-Eighth Street, New York," is clearly inscribed on its granite lintel, reinforcing Carrie's role as the main keeper of the home and organizer of social activities and meals. An elongated red velvet drapery with gold fringe, hanging like a gigantic bell pull, recalls the color scheme of the Alwyn Court dining room. Its attenuated lines parallel Carrie's rail-thin figure, clothed in a white sheath dress with black shawl and abundant jewelry. Delicately strapped, toeless high heels peek from under her gown as she pauses, cigarette dangling from one hand, and glances toward the center of the painting.

Rosetta also resides in the right, more domestic, side of the composition. She is once again enshrined, sweet and white-haired in a gold scalloped throne chair immediately to the right of the central pink rose. She gazes out at the viewer, her facial features little changed since the 1916

portrait despite the reality of her increased age and illness. Wearing a black velvet choker and an elaborate lace mantilla over a billowing pink gown, she sits with her hands poised over yet another game of solitaire. The table is tilted so viewers can read the faces of individual cards. Directly behind her head is the Statue of Liberty, seen from an aerial perspective on its star-shaped island. Like Liberty, the figure of Rosetta is the maternal concordance of security and comfort for her daughters. In a letter to Ettie, Henry McBride noted that "I was thinking of the little portrait of your mother in the group. It does seem to me exact in some strange way—more like her than any photograph could have been."[48]

On the left side of the painting, separated by the three huge flowers from her mother and Carrie, Ettie is seated in a blue-tufted chair, her back turned conspicuously to Florine. Wearing a black lace dress and a thick gold bracelet, she rests one hand, nails varnished with red polish, on the armrest; the other holds a red fan, a foil for her renowned hot temperament and pleasure in flirtation. In her first novel, Ettie noted, "I flirt to arouse feeling irrespective of its nature, and in order to see something in the outside world happen through my instrumentality and thus quicken my sense of power and of life."[49] Stettheimer further signified Ettie's personality by placing her beneath two forms renowned for their sharp edges: the Chrysler Building and a crystal chandelier. Reinforcing the reference to Ettie's autobiographical writing, an open book lies over her lace-covered lap. Under heavily knotted brows, her eyes stare, as usual, as though she were lost in thought, analyzing her personal philosophy or reliving her "love days." She later expressed regret at not having a serious relationship with a man and recalled that 1933, the year *Family Portrait II* was painted, was the year "when probity vanished from most of the world and peace from all of it" due to the election of Adolf Hitler as German chancellor. This mood of thoughtful longing, whether sadness, concern, regret, or nostalgia, gives Ettie's character a look of complete self-absorption.

When it came to recording her own image, Florine dispensed with all of the feminine finery of her sisters' and mother's clothing and jewelry, and, other than a red scarf, she chose to depict herself in the simple black velvet pantsuit that she had specially made to facilitate ease in painting. Despite being sixty-two, Florine depicted herself as early middle-aged, with her lanky, thin body still balancing on her ubiquitous red ankle-strapped high heels. She stands conspicuously separated from the others behind the heavy blue chair in which Ettie sits. Florine rests slightly back on her haunches and holds her ever-present palette and paintbrush, surveying the scene before committing it to canvas. She is emotionally and physically distant from the rest of the composition in her habitual role as observer and subject. The background elements she chose to illustrate her personality are all theatrical in nature: the RCA sign over the Radio City Music Hall building (which by 1930

(Next spread) **Fig. 103** Florine Stettheimer, *Family Portrait II*, 1933, oil on canvas, 46 ¼ × 64 ⅝ in., The Museum of Modern Art, New York, Gift of Miss Ettie Stettheimer.

303

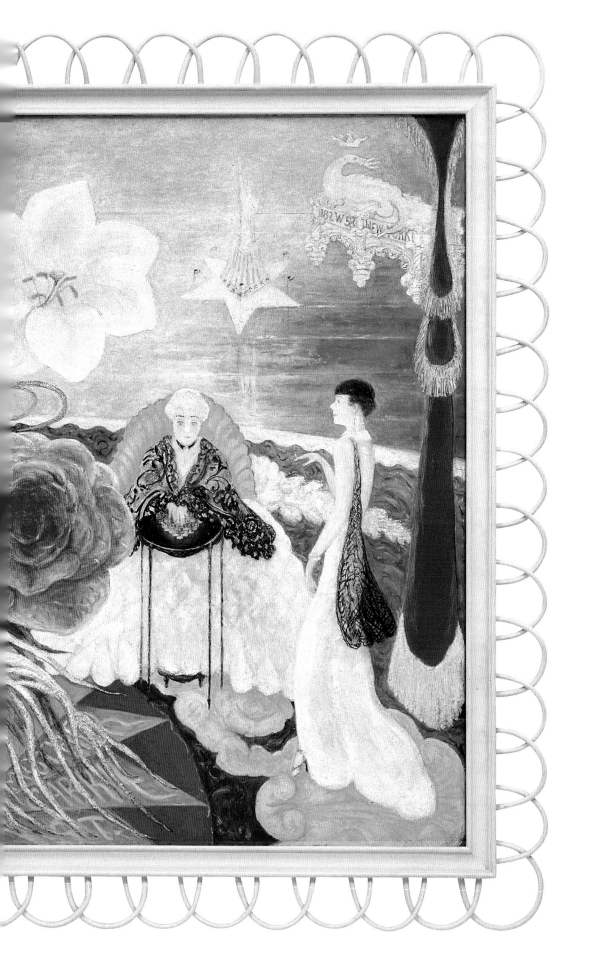

was part of Rockefeller Center), including the tall, elegant tower around which drapes a ribbon announcing "4 Sts. Seen By Florine," referencing the scenery and costumes she was designing for Virgil Thomson and Gertrude Stein's forthcoming opera.

The painting's complex iconography and vivid coloration give it a sultry atmosphere, as though the scene were being enacted during a particularly hot, humid New York City summer. The florid scheme contributes to this greenhouse effect, but it is the flowers and environment, not the women, that blossom and absorb the heat. The composition's upper half is washed in blue and white with a bright red poppy completing the patriotic triad, while the lower part of the painting is saturated with intense shades of red and yellow so that the figures form a black and white chain across the canvas. The lush, bright colors of the painting caused McBride, writing in the *New York Sun* in 1944, to compare the painting to "an Arabian Night's entertainment: very exquisite, very charming . . . very exact to the likenesses." Yet the largely black and white figures are ghostlike accents trapped within the environment. Unlike so many of Stettheimer's paintings where the figures are active as though caught in mid-activity, in *Family Portrait II*, the women appear frozen and immobile. Each is rooted in isolation, their pursuits — playing cards, reading, even painting — momentarily abandoned.

In 1945, Paul Rosenfeld, writing on Stettheimer's work in *Accent*, astutely observed in *Family Portrait II* a greater distance and a more tangible irony. He perceived three underlying currents within the painting, whose forms assembled to "structure, surprise, and divert the eye and mind." He remarked that on the surface, "the shapes nearly all are dainty in proportion . . . Meanwhile the total form rivals the theater, the opera and even the circus."

Rosenfeld also detected a double meaning in the painting, which he interpreted as an awareness of the emptiness of the life of independence:

> At first it appears full of a lyricism of the life of complete self-sufficiency, aestheticism, independence. The four figures seem entirely engrossed in, satisfied by, an existence of amusements and refinements, beautiful decorations, art, literature. . . . Gradually, we receive a sense of elegant waste, a feeling that this life of independence and aestheticism is illusory, a bauble, a bubble, and the two meanings together face us.[50]

In fact, *Family Portrait II* is Stettheimer's homage to the family that Rosetta, now gravely ill, held together for six decades. At the same time, however, the artist included many indications that she was already not only emotionally but physically removing herself from her family. Stettheimer further isolates herself from the other women by a large gold-fringed curtain that drapes from the top left of the painting. It is held up by the same serpentine wood posts that she designed for her bed at Alwyn Court and installed as part of her 1916 Knoedler exhibition. A decade later, she would again use this gold-fringed curtain as a device to detach herself from the art world in her final painting, *The Cathedrals of Art*.

By separating her figure from the central area of the composition, Stettheimer reinforced why she only included three flowers, not four: Rosetta, Carrie, and Ettie had spent their lives intertwined, always traveling, living, and socializing together. Conversely, Florine had constantly battled to find time to paint. She chafed against her mother and sisters' social activities and the restrictions they imposed on her. Florine painted the red poppy for Ettie, white daylily for Rosetta, and pink rose for Carrie, all bound together with green vines. There is no bound flower for Florine — she is free and on her own, an artist and observer of the scene. *Family Portrait II* was presciently painted at a moment just before the family was to undergo significant changes. For the artist, the independence and freedom she had sought for so long was about to arrive.

*chapter nine*

# FOUR SAINTS
# IN THREE ACTS

## 1928 – 1936

In the mid-1930s, Stettheimer's desire to create a *Gesamtkunstwerk* finally came to fruition in the form of an opera, *Four Saints in Three Acts*, with a libretto by Gertrude Stein and score by Virgil Thomson. Through this collaboration, Stettheimer became the first American artist to design the stage sets and costumes for an opera. Moreover, Stettheimer achieved widespread international recognition from more than just the art world, and her aesthetic vision and skill were validated and admired by a group of highly opinionated, talented collaborators as well as by sold-out audiences. First produced in 1934, *Four Saints in Three Acts* is considered the first avant-garde American opera and the prototypical *Gesamtkunstwerk* of the modernist era. One of the most innovative aspects was that all the opera's performers were African Americans.

The collaboration between Thomson and Stein began in the winter of 1925–26, when the young American composer was introduced to Stein by fellow composer George Antheil at a Christmas Eve party at Stein's Paris apartment. Thomson, a gay, Harvard-educated Midwesterner who had long admired the writer, put some of Stein's short writing to music. She was delighted with the result, and they decided to join forces on a larger work. In one of her notebooks, Stein wrote, "Collaborators tell how in union there is strength."[1] Stein wrote a *Portrait of Virgil Thomson*, playing on the idea of having a creative partner as well as the question of where this new venture together might lead:

> Yes ally. As ally. Yes ally yes as ally. A very easy failure takes place. Yes ally. As ally. As ally yes a very easy failure takes place. Very good. Very easy failure takes place. Yes very easy failure takes place.[2]

Stein and Thomson had to decide on a theme for their opera. Stein initially wanted to address American history, but Thomson vetoed the idea, saying that all American military uniforms look alike, implying the idea would be visually boring. Thomson suggested instead that the overarching theme be the life of the artist. Stein agreed, adding that devotion to art was similar to religious commitment, particularly if the theme of the opera represented a kind of contemporary spirituality. For its location, the two chose Ávila, because Stein and her lover Alice B. Toklas had fond memories of visiting the Church of St. Theresa there.

Emulating eighteenth-century Italian operatic traditions, Thomson and Stein divided the role of the main character, St. Theresa, between two singers. Thomson also added a master and mistress of ceremonies, or *compère* and *commère*, to sing the production's stage directions. Despite the title, Stein's libretto contained closer to twenty saints and more than three acts. In March 1927, she wrote to Thomson, "I think it should be late eighteenth-century or early nineteenth-century saints. Four saints in three acts. And others. Make it pastoral. In hills and gardens. All four and then additions. We must invent them."[3] As Thomson later ironically reminisced, "A Jew and a Protestant turn out a Catholic opera about Spain in the 16ᵗh Century."[4] In July, Stein gave him the text, and he returned to his apartment in Paris to write the score.

Stein gave the composer permission to make whatever cuts he deemed necessary to her libretto. Stein suggested Pablo Picasso as stage designer, but Thomson declined, "preferring to remain, except for her, within my age group.[5] I did right then beseech [Christian] Bérard to consider designing an eventual production, though at the time he had not touched the theater. He said yes with joy and began instantly giving off ideas . . . All these maneuvers, I remind myself, had to do with a work not yet in existence."[6]

In November 1928, Thomson returned to New York with his treatment for the opera. On February 15 of the next year, Carl Van Vechten hosted an audition of the new score in his apartment at 150 West Fifty-Fifth Street. Among the select audience were Max Ewing, art patron Mabel Dodge Luhan, writer Muriel Draper, art collectors and philanthropists Alma and Maurice Wertheim, and Ettie.[7] That evening, Thomson sat at the piano and played the whole score, singing all the parts himself. Van Vechten cabled Stein the next day: "EVERYBODY LOVED IT."

Ettie was also very impressed and arranged for Thomson to play the score for her sisters; on February 22, Thomson came to Alwyn Count for a second performance. Carrie prepared her characteristically elaborate meal of mushroom timbales, halibut in aspic, and poussins in orange and jelly in the chandelier-lit dining room. Thomson felt himself in a "kind of camp on elegant New York houses inhabited by artists . . . And in their terms it was a kind of joke about the German royal style." He later noted that Maurice Grosser described the Stettheimers' furnishings as "prickly Baroque."[8]

In addition to Thomson and the Stettheimer sisters, the guests included McBride, Van Vechten, Fania Marinoff, O'Keeffe, Aaron Copland, publisher Joseph Brewer, and Moeller. After dinner, additional guests arrived to hear Thomson perform the opera. During the performance, Moeller, in particular, refused to sit quietly and continued to talk, much to the consternation of Van Vechten. In his letter to Stein describing the evening, McBride complimented Thomson's "imperturbability," adding, "He is absolutely undefeatable . . . When singing some of the opera to me he was constantly

interrupted but never to his distress; he would stop, shout some direction to the servant, and then resume absolutely on pitch and in time. We all pray that the opera will be given."[9]

Florine was so taken with the opera that she invited the composer to visit her studio so that she might hear the work again. Afterward she wrote in her diary, "Virgil Thomson played his whole opera *Four Saints in Three Acts* to me today — it delighted me and his voice is so pretty — He sang the whole — He makes the words by Gertrude Stein come alive and flutter and in sound have a meaning. He wants me to do the visual part of the opera."[10] Thomson, in turn, was astonished by Stettheimer's highly original paintings and frames and the decoration of her white and gold studio, with its monumental cellophane curtains, original white and gilt furniture, and cellophane flowers. He later recalled, "Throughout the house were pictures by Florine, a painter of such high wit and bright colorings as to make Matisse and Dufy seem by comparison somber."[11] (*Fig. 104*)

McBride, who was present the night Thomson visited Stettheimer's studio, recalled the composer's enthusiastic remarks: "Why have I never heard of these things? What a succès they would have in Paris!" When someone suggested that Stettheimer design the sets for *Four Saints*, Thomson declared, "That would be perfect." As McBride observed, "There was never any question after that, but that Florine was to do them."[12] Thomson later remarked of Stettheimer, "She was scandalous in the same way that Gertrude was scandalous. You didn't always know what she was up to." Explaining his choice of Stettheimer to design the costumes and stage settings, Thomson noted, "Florine's paintings are very high camp, and high camp is the only thing you can do with a religious subject. Anything else gets sentimental and unbelievable, whereas high camp touches religion sincerely and its being at the same time low pop. People who have been cured of an eye disease put little toy eyes in front of a statue of a saint. And then the world of tinsel can only be sincere."[13]

When Thomson left New York for Paris on March 29, Stettheimer sent a bottle of champagne to his third-class cabin on the *Île de France*. Even though Ettie had arranged for Thomson to perform the score for her sisters, she became vehemently against Florine's participating, "harping on the risk it would entail,"[14] and declaring that courting publicity in this manner was not proper for women of their social class. Carrie agreed with Ettie that working on the opera presented "too great a risk of public humiliation" not just for Florine, but for the entire family. There was, however, probably another, subtler reason for the sisters' antipathy toward the artist's participating. By now, Florine was the only one of the three who was still active in any professional manner. After the very poor critical reviews and lack of sales of her novel, Ettie was no longer writing for publication; and after a decade of work, Carrie had left her dollhouse unfinished and never touched it again.

Decades later, Ettie rather spitefully inferred that it was Carrie, rather than Florine, who should have, "had circumstances been favorable," been the sister known for her "stage design. . . . Her acute

**Fig. 104** Peter A. Juley & Son, Interior of Florine Stettheimer's Studio, at the Beaux-Arts Building, 307–10 East Forty-Fourth street, New York, February–March 1929, photograph, Florine Stettheimer Papers, Rare Book and Manuscript Library, Columbia University in the City of New York.

sensibility to literature, her originality and wit would have provided freshness and individuality for the immediate visual impact that supplied the clarification or enhancement of dramatic content."[15] This statement negates the two sisters' stated distaste for publicity throughout their lives, and the possibility of negative publicity and public humiliation they used to try to convince Florine not to agree to work on the *Four Saints* opera. Like her fashion sense and bedroom design, Carrie's doll-house aesthetic is a mishmash of generic pseudo-seventeenth through nineteenth centuries. Unlike Florine's dazzlingly original cellophane stage designs for *Four Saints*, there is no evidence of anything Carrie left behind that is particularly "fresh" or ultimately unique. Instead, the statement appears more as another sign of enmity between the sisters. Years later Thomson remembered, "Carrie and Ettie were both sad ladies. Florine was not sad."[16]

For Florine, working on a professional theatrical production was the opportunity she had been waiting for ever since 1912, when she had worked on the unrealized *Orphée* ballet. She was elated, and thanks to her "hard core of confidence in herself,"[17] she knew she was up to the challenge.

The project provided an opening to reach an entirely different sort of audience. After decades of designing and integrating furniture, frames, and paintings into a total work of art, she was ready to transition to the stage.

In April, a month after Thomson departed, the artist made a small drawing of his profile and wrote him a poem describing her anticipation of their project:

The thrush in our elm tree top

has been singing questions

for days

I feel clarified.

This is my clarification

My role is to paint

Your four active saints

and their props

inside and out your portrait

St. Gertrude will protect you all[18]

In a flurry of excitement, Stettheimer noted in her diary, "I may do Virgil Thomson," and she began a portrait of the composer, including many references to the planned opera. Later, Thomson noted that "she painted my portrait, she got in the whole thing."[19] (*Fig. 105*) The painting depicts a dream space, an ambiguous area in which figures, words, and animals float among clouds and blue sky. At lower left, a young Thomson accompanies himself at a piano inscribed with the opera's title repeated as a dual linear series: "3/4/3/4/3/4 . . ." followed by an abbreviation of saints and the word "acts": "STS./ACTS./STS./ACTS./STS."

Always adept at doing in-depth research to ensure accuracy in her paintings, the artist learned that a line of stone lions with metal chains runs along the side of Ávila's famous cathedral. She added a yellow lion on a circular rug to the lower right of Thomson's portrait, one of a pair that would eventually serve as integral parts of Stettheimer's final stage design.[20] A chain wraps around the lion's neck and is tied around a rainbow on which white ribbons hang carrying the names of two of the opera's main characters, Saint Teresa and Saint Ignatius. Stettheimer also conferred saintly status on Thomson's and Stein's names and abbreviated her own last name, "Florine St.," making herself the fifth saint. (She would use this as her signature in a number of subsequent paintings.) No other Stettheimer painting included so many written words. Each is written on the large

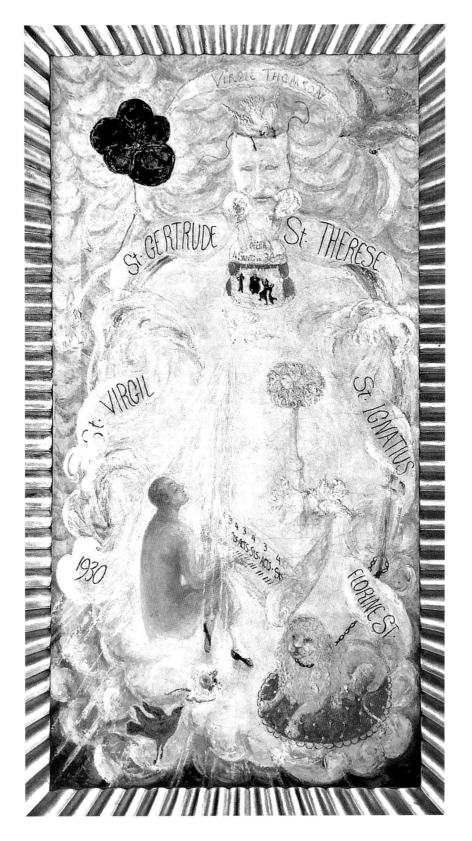

**Fig. 105** Florine Stettheimer, *Portrait of Virgil Thomson*, 1930, oil and ink on canvas, 38 ½ × 20 ⅛ in., The Art Institute of Chicago, Gift of Virgil Thomson.

pinkish, cloud-like floating form on which everything in the painting floats — perhaps emulating the cellophane fabric with which Stettheimer would wrap the back of the stage and parts of the sets.

At the top of the painting, Stettheimer carved Thomson's name with the handle of her brush onto a white banner held on one side by a fat red bird and on the other by a black pansy. This flower, like the red necktie in her portrait of Van Vechten, was a common symbol for homosexuality, as "pansy" was a code word for effeminate and gay men. Later in life, Thomson worried that people "would get it . . . But friends had assured him that the unknowing never would and the knowing knew already," making clear that Stettheimer was including overt controversial markers of homosexuality in her paintings despite federal laws making this sexual preference illegal. [21]

To the right of the flower, a large, theatrical, icy mask of Stein's face, like the Wizard of Oz's disembodied head, peers down at the scene below. Her hands manipulate strings directing the gestures of the four saints on a tiny stage, indicating that she is the background force behind the performance. A white dove in the center illuminates Thomson with a pure white light, and she later gave Thomson complete credit for the production, ignoring Stein's contribution. When an interviewer noted that many people imagined that they saw Stein-esque qualities in Stettheimer's work, Stettheimer immediately contradicted her:

> I've never met [Stein]. In fact, I've hardly read her. I've started a number of times . . . got tired . . . Why we are at the opposite extreme ends of the pole you might say . . . I put in infinite detail, as you can see . . . when things become so abstract that the artist merely suggests his ideas, they are so abstract that the artist might as well retire from the scene altogether, and let the public find the idea for themselves in the first place. [22]

In another interview, Stettheimer said of Stein's libretto, "I really haven't the least notion what she is talking about . . . I am a Proustian, and surely there can be nothing farther from the style of Proust than that of Miss Stein." [23] Stettheimer summed up her rather nasty and unkind attitude toward the expatriate writer in a short poem she wrote for her own amusement. It is unusual for Florine, who was usually progressive in her attitude toward varied sexual preferences:

> Gertie met a Unicorn.
> It was black and waved
> its tail
> Gertie roared a big laugh
> back — very male [24]

In 1932, Thomson was again at the Stettheimers' New York apartment, performing his score for *Four Saints*, including a number of changes he had made to the score. All the guests remained thrilled and hopeful that the opera would be publicly performed. Stettheimer showed him her painting, saying that she had put "everything I know about the opera into your portrait." Thomson observed that Ettie, and possibly Carrie and Rosetta, had continued to pressure Florine to not participate because of possibly adverse publicity: "Ettie had been at her and said you mustn't do this because it might be a failure. None of them wanted a failure. They were afraid of it. They had persuaded her to say she couldn't do it." But it was also very evident to him that Stettheimer was very excited at the prospect, so he told her, "Get some new ideas," and left again for Paris to continue working with Stein.[25]

*Four Saints* was the first theatrical production featuring an entirely African American cast whose roles were not caricatures and stereotypes.[26] Thomson remembered Van Vechten had taken him to a performance of Hal Johnson's choral play *Run, Little Chillun*, which was enacted by Black singers at the Lyric Theater. During the intermission, despite what would today be considered the highly racist nature of the play, Thomson was highly impressed with the beauty of the performers' voices: "I am going to have *Four Saints* sung by [Black singers]. They alone possess the dignity and poise, the lack of self-consciousness that proper interpretation of the opera demands. They have the rich, resonant voices essential to the singing of my music and the clear enunciation required to deliver Gertrude's text."[27]

This was a radical move. At the time, the Metropolitan Opera's board of directors barred Black singers, based on the racist idea that they were incapable of the proper enunciation needed to sing opera.[28] Black performers were confined to stereotyped roles in vaudeville acts: jazz singers, dancers in exotic costumes, minstrels, field workers, maids, and cotton pickers. In most opera and ballet, Black characters representing Moors, Africans, or African Americans were played by white singers in dark makeup, not by people of color.[29] The use of blackface and exaggerated mannerisms by white performers was common in most entertainment geared to white audiences even in 1936, when *Four Saints* was performed. For example, in 1936, the Metropolitan Museum of Art's employee association sent out invitations to museum staff to a "Minstrel Show and Dance." The minstrels were probably whites performing in blackface.

To find performers for the opera, Thomson recruited Eva Jessye, the first Black female choral director in America. The daughter of freed slaves, who initially supported herself by leading Sunday choirs in Harlem's Baptist churches, Jessye already had a distinguished career in teaching, performing, and conducting African American singers.[30] She later said of being hired to perform the score for *Four Saints*:

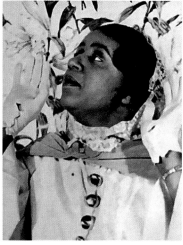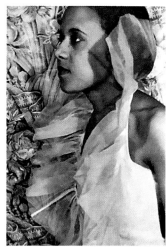

**Fig. 106** Virgil Thomson, *Portraits of Edward Matthews as Saint Ignatius, Beatrice Robinson-Wayne as Saint Teresa, Altonell Hines as Commère,* March 9, 1934, 17.6 × 10.3 in., Yale Collection of American Literature, Beinecke Rare Book and Manuscript Library, Yale University, New Haven, CT.

[It was] quite a departure, because up to that time the only opportunities involved things like "Sewanee River," or "That's Why Darkies Are Born," or "Old Black Joe." They called that "our music," and thought we could sing those things only by the gift of God, and if God hadn't given us that gift we wouldn't have any at all. . . . With this opera we had to step on fresh ground, something foreign to our nature completely . . . what did we know about the minds of Gertrude Stein and Virgil Thomson? We really went abroad on that.[31]

A force of nature, Jessye demanded that her singers be paid for rehearsals as well as performances, which was unprecedented for minority chorus performers. The cast was aware that they were involved in something that was innovative, as Jessye acknowledged: "They thought they were having part in an invention." The singers were hired from varied backgrounds including vaudeville, evangelical church choirs, Black universities, and public schools. It was difficult to find performers who could sing Thomson's unusual modern music and Stein's strange lyrics. The leads included both Beatrice Robinson Wayne and Bruce Howard as the two Saint Teresas, Edward Matthews as Saint Ignatius, and Embry Bonner as Saint Chavez. Abner Dorsey was hired as the *compère* and Altonell Hines as the *commère*.[32] (*Fig. 106*) The rehearsals took place in the basement of St. Philip's Episcopal Church on One Hundred Thirty-Third Street in Harlem, designed by the African American architect Vertner Tandy.

In 1933, Thomson excitedly wrote to Stein on the opera's progress. She initially did not want Black singers to be used, as she was afraid that it would "give the whole thing a sexual tone which she didn't appreciate."[33] Throughout the spring and summer, Thomson and Stein continued to correspond about suitable settings. One of their ideas had been to set part of the opera in a Sunday

school, but this was abandoned.[34] Stettheimer, through her designs, convinced Thomson of an outdoor setting for the second act.[35] As Thomson wrote Stein:

Miss Stettheimer suggested that since any interior is less joyful than an outdoor scene, and since Sunday school rooms and chapels have been done in so many religious plays . . . perhaps the same entertainment might take place on the steps of a church, in this case, the Cathedral of Avila itself, though represented in a far from literal imitation. . . . The colors and materials she suggests are merely an amplification . . . in the construction of religious images out of tin and tinsel and painted plaster and gilding and artificial flowers, having seen the extraordinary elegance which Miss Stettheimer has provided in her own rooms with exactly these colors and materials.[36]

Thomson begged Stettheimer to send him one of her design drawings for him to show Stein: "the simplest kind of sketch would do, as long as the colors were either indicated or written down." In May 1933, he wrote, saying that everyone in Paris was asking about the opera:

There is even question of doing it or a part of it or of asking you and me to do a ballet for the Russians next year. Could you do such a thing? That would mean your coming abroad next spring, probably to Monte Carlo in April. . . . The ballet plans for next year envisage two American works, a fashionable & witty one by Cole Porter and Peter Arno, and a more serious modern one. George Antheil & Alexander Calder are being considered for the second. Also, you and me. Ours would certainly be less *vieux jeu* than anything that pair could do.[37]

Apparently, Stettheimer didn't send any sketches, nor did she respond with an idea for a new ballet. Instead, in June 1933, the sisters gave a fifty-third birthday party for Carl Van Vechten at Alwyn Court. They decided on an entirely pink theme, whether as an acknowledgment of his being gay or simply in tribute to his "fanciful and decorative" nature. Florine arranged a bouquet of pink flowers for the dining table. Carrie's menu included salmon, pink champagne, and strawberry ice cream, all served on a pink tablecloth. Afterwards, Carrie and Ettie left for Atlantic City[38] and Stettheimer began work on the opera.

Instead of making sketches, Stettheimer visualized her designs by making over twenty models of the figures and their costumes using an incredible variety of materials for the costumes and sets. In an interview, she described her preparatory process:

I made a miniature set and I put in everything to the tiniest scrap of lace on my puppets. I started working on it last summer, after Virgil Thomson sang it to me. He gave me no

directions — just let me put in what I please. And as you see, Gertrude Stein has given no directions. I . . . created the ballads I wanted, that I felt would go with the music. When I had finished my puppet stage the stage technician came to me with samples of materials, and I passed on everything. What appeared on the stage finally is simply an enlargement of my miniature stage, a perfect enlargement.[39]

Each of her stage maquettes measures eighteen by twenty-six inches. Stettheimer fabricated every element in advance of Thomson ever seeing them. She made six-inch-high figurines out of wire armatures and round cork heads, with varying shades of skin colors, from light coffee-cream to deep black-brown. (*Fig. 107*) To design costumes for all the opera's characters, the artist visited theatrical supply companies to acquire fabric samples for her miniature performers. The facial features of all the figurines were basically the same, but their costume materials varied from black lace and orange organza to white moiré silk with tiny pearl buttons, red netting, chintz, velvet, metallic ribbon and foil, feathers, taffeta, moiré silk, and satin. Some of the bodies were fully covered, while others had only ruffs of silver foil around their waists. Stettheimer worked out each costume down to the finest detail — the color of the toe shoes, the white of the silk opera gloves, the bright flowers in the Spanish ladies' hair, or the saucy designs of the sailor's scarves.

For the scenery, Stettheimer made palm trees using variegated rooster feathers for the fronds, which she copied from her Alwyn Court bedroom. As she was with the frames for her paintings and her furniture, Stettheimer proved herself to be unusually inventive in terms of finding creative ideas and solutions for her innovative opera designs. In order to ground the bases for her large, feathered palm trees, she used lamp sockets, which were both weighted and already had small holes through which she could hide any wires.[40] She created the overall background setting for each act with shiny transparent cellophane. Drawing from the aesthetics of her studio, Stettheimer crumpled the cellophane along the sides, top edge, and back of the stage, to give the impression of windy haze and clouds. (*Fig. 108*) One critic, Pitts Sanborn, referred to this effect as "Botti-cellophane," and Maurice Grosser described the finished result as a "Shraft's candy-box version of Baroque."[41]

Seven years passed between the first conception of the opera by Thomson and Stein and its opening. During this period, while waiting to hear word about its progress, Stettheimer painted a number of works. Eventually, as years passed and nothing seemed definite, Stettheimer became discouraged and even began to question the viability of enlarging her stage sets to life size. She mentioned her concerns to Van Vechten, to whom she had shown her maquette designs. He responded, "After what I saw yesterday in the way of cellophane and crystal, and pie pans, I think the Opera about Saints will lose a great deal if it loses your invaluable cooperation. Please don't let it!"[42]

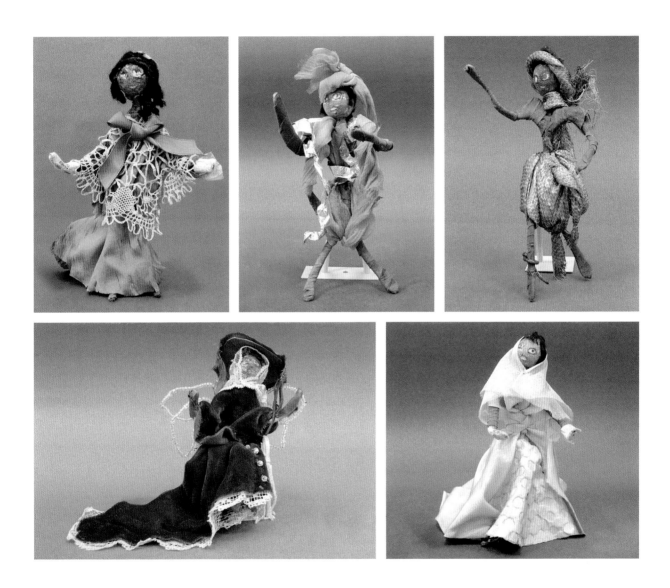

**Fig. 107** Florine Stettheimer, Costumed figurines for individual performers in *Four Saints in Three Acts* opera, c. 1933, wire armature, varied materials, varied from 6 to 7 in. high, Florine Stettheimer Papers, Rare Book and Manuscript Library, Columbia University in the City of New York.

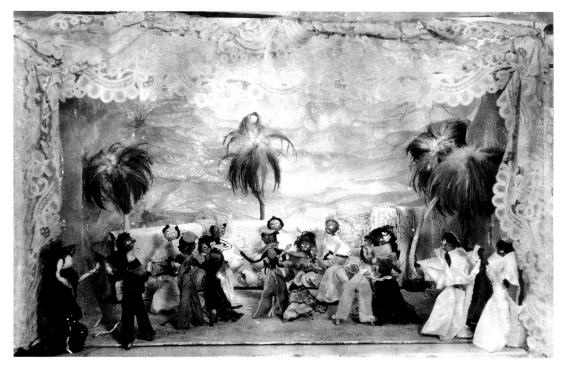

Thomson, meanwhile, concentrated on trying to get the rest of the opera's team together and raise money. Other than Stettheimer and Stein, all the others whom he found to work on the opera were young and inexperienced but would go on to achieve great renown. Through the art dealer Kirk Askew and his wife Constance, Thomson met John Houseman, who would become the opera's director, and the Peruvian-English choreographer Frederick Ashton. Rounding out the group of strong personalities who agreed to take on the challenge simply for the fun of it were Alexander Smallens, musical assistant to Leopold Stokowski at the Philadelphia Orchestra, and the highly talented but cantankerous young lighting expert Abe Feder. As Thomson recalled, "*Four Saints* was a first for everybody. It was Gertrude's first opera. It was my first opera. It was John Houseman's first job in the theater. It was Freddy Ashton's first opera choreography and directing. It was the first modern opera to be produced in a museum. Everything was first about it—and like first things often do, it worked."[43]

Under the innovative vision of director Everett (Chick) Austin, Jr., the Wadsworth Atheneum in Hartford, Connecticut, became one of the most avant-garde art museums in the country. In 1928, he formed a nonprofit society, the wryly named Friends and Enemies of Modern Music, which sponsored performances of musical works by Debussy, Stravinsky, Schoenberg, Antheil, Satie, Poulenc, Bartók, and Ives. Austin planned to open a new museum wing with the first comprehensive exhibition of Picasso's work in the United States. He heard about *Four Saints* through Kirk

Askew and decided to sponsor the opera in conjunction with the opening of the exhibition. In 1934, the Friends and Enemies contributed ten thousand dollars toward the production, their first premiere of an original work. As soon as Thomson knew that the opera would be a reality, he wrote to Stettheimer, urging her to complete the set designs.

Stettheimer made it a lifelong policy to never show anyone any of her work until it was completed. She therefore procrastinated and did not show him her sets until the early 1930s, when she finally allowed him to see the small maquette for Act One, complete with cellophane background and tiny figures in situ. Thomson must have noticed that Stettheimer painted the small performers of the opera's cast with the differing shades of African American skin and rendered them in the full costumes in which they would eventually be seen in the final productions.

Despite having chosen an all-Black cast, Thomson was nonetheless quite racist toward African Americans, something that is particularly evident in an early decision he made concerning the cast. Writing Gertrude Stein regarding the early designs for the *Four Saints*, he noted, "The negroes will, however, be painted white, at least their faces…."[44] In answer to her query as to why, Thomson answered, "My negro singers, after all, are a purely musical desideratum, because of their rhythm, the style and especial their diction. Any further use of the racial qualities must be incidental and not of a nature to distract attention from the subject matter….Hence the idea of painting their faces white."[45]

Thomson also wrote to Stein that in the second act of the opera, the minor saints' robes will be "wired and transparent, revealing the negro bodies underneath…."[46]

Interestingly, to someone like Gertrude Stein who even then was considered innovative in literature and contemporary art, revealing African Americans bodies was simply too shocking and she conservatively replied:

> I do not care for the idea of showing the negro bodies, it is too much what the English in what they call 'modernistic' novels call futuristic and do not accord with the words and music to my mind.[47]

Thomson wrote back on May 30, 1933, promising that "negro bodies, if seen at all, would only be divined vaguely through long dresses," and that their movement would be "sedate and prim" in accordance with the spiritual in art theme of the opera. However, based on Stettheimer's early maquette costume designs, in *Four Saints in Three Acts'* second act, young men appear with bare chests and young women with bare midriffs as they dance. (*Fig. 109*) Stettheimer's costumes enhanced Frederick Ashton's innovative choreography, which synthesized African American music and dance, including jazz and the Charleston, forms of Isadora Duncan's modernism, and classical

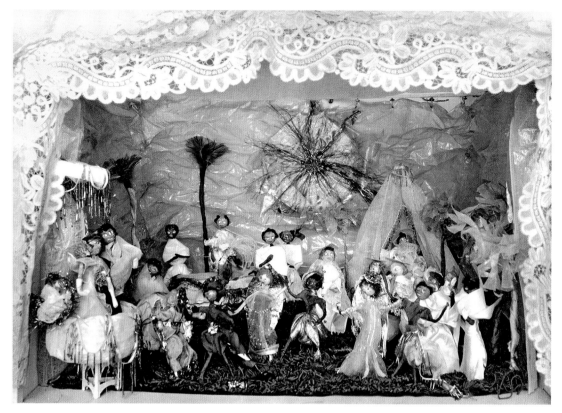

ballet.[48] Their semi-nudity caused at least one audience member to consider them to be "startlingly naked for such a saintly gathering."[49]

As the opera's opening drew closer, frustrations and anxieties developed among the many personalities involved. On February 2, 1934, 1,500 square feet of cellophane arrived, and the material was gathered and arranged for the backdrop by Kate Lawson, the technical director of sets and costumes, according to Stettheimer's directions. It took almost twenty-four hours to install. At the time, stage lighting was largely a trial-and-error affair "of exasperated howling back and forth between the front and the back of the house." In each scene, the cellophane was to be lit differently by lighting designer Abe Feder, who believed Stettheimer "was from outer space."[50] As remembered by Houseman, "*Four Saints* was [Feder's] big chance and he was determined to make the most of it, at no matter what human cost." Feder made it clear from the beginning that he considered Stettheimer's cellophane cyclorama, with its dazzling, light-reflecting qualities, "a creeping bitch," particularly as Stettheimer insisted that she wanted her stage designs in at least the first act lit with "pure, white light."[51] The power struggle between artist and lighting director was vividly recorded in Houseman's autobiography, *Run-through*. It attests to Stettheimer's self-confidence,

even though this was her first public stage production. As Houseman put it, "She wasn't disagreeable . . . she was fighting for her stuff."[52] He described the incident:

> In vain, Feder attempted to explain to Florine, to Virgil, to me, to anyone who would listen, that there was no such thing as white light in the spectrum — that it was obtained by the expert mixing of primary colors projected through various shades of red, blue and yellow gelatin in the two hundred or more projectors with which he had covered the ceiling and sides of Chick's theater. Florine repeated that she wanted clear white light — as in her model. Feder refused to believe her. For three successive nights, he had the escape artists and his crew clambering up and down ladders, changing gelatins, which he then blended with infinite care and skill at diverse intensities. And each morning, when he proudly exhibited his night's work to Florine, she would say quietly that what she wanted was clear, white light. Reluctant and unconvinced, he finally gave it to her at dress rehearsal, and she was grateful.[53]

Thomson remembered the incident a bit more colorfully. In his version, while Feder muttered under his breath that "pure white light" did not exist, Stettheimer's rejoinder was "Tommyrot. We are going to have pure white light on that stage because my décor is highly colored and I don't want it darkened or falsified. . . . " She subsequently took Feder to a store where he could buy "real white bulbs, and we used real white light on that stage, I think for the first time ever." McBride also felt that Stettheimer had "taught the theater professionals a revolutionary lesson in lighting"[54] and had stood by her convictions on all matters of design, large and small.

In the final days before the opening, Stettheimer also discovered several mistakes that had been made in executing her stage and costume designs. The costumes for the male angels' companions, for example, had their trains "wrapped around their bodies instead of hanging," and thus had "no style — couldn't make them understand."[55] In addition, the novices' trains in the second act were mistakenly trimmed. Stettheimer made flowers for the Fourth Act herself out of cellophane that she purchased at a local five-and-dime store. She kept a handwritten list of these errors and inscribed next to each example, "I had to insist" — whether it was that the chorus's seats be draped rather than painted or that the two choirs be arranged in pyramid forms.

For many viewers, it was the most beautiful thing they had ever seen in the theater.[56] The reviewer Gilbert Seldes noted that the opera "has fantasy and vigor. It can be taken as a gigantic piece of mystification and a huge joke; it certainly should not be taken without laughter. It has taste and liveliness, humor and feeling." He described Stettheimer's contribution as having "a great

sense of style . . . made of lace and cellophane and looking like a child's dream of rock candy . . . How a sense of grandeur was begotten out of this material I do not know."[57]

In the final hours, Stettheimer decided that the Fourth Act needed some extra touches. She constructed, at her own expense, a decorative fixture composed of stars and symbols to hang in the air. On the day before the invitation rehearsal, Stettheimer met the entire staff for the first time as they paraded for her in their full costumes. Beatrice Robinson Wayne later remembered Stettheimer looking at her and telling her that she "looked beautiful." Stettheimer subsequently declared to McBride that the cast acted "not like saints but like angels."[58] The only problem arose when one of the women singers objected to a headdress Stettheimer had designed for the second act. The singer tore it off and flung it to the ground when it was first presented to her. "Miss Stettheimer had a long conversation with the artiste, and everything was serene once more and the headdress was to be worn in the Second act."[59] In general the cast loved the rich materials, detailing, and colors of their costumes.

Seeing the costumed cast all together as they rehearsed the entire opera, Stettheimer made a list of things that had been omitted or mishandled. She realized, to her surprise, that she had forgotten to order gloves for all the performers. Noting that "the naked human hand is not beautiful or elegant. You wouldn't come onstage barefoot, why come on bare-handed," she arranged for white cotton gloves studded with rhinestones to be ordered for the entire cast. However, these were not available until after the Hartford performances. Stettheimer sat in the orchestra seats and watched the entire private dress rehearsal. As the cast, technicians, and orchestra each carried out their roles, Stettheimer exclaimed to Feder, "Oh Abe, it's a miracle, it's a miracle."[60]

Just as she had for the opening of her 1916 Knoedler's exhibition, Stettheimer spent the day of the first public performance in such a frenzy of activity that she neglected to write in her journal. When she finally did, ten months later, her only notation was, "I have no record of my doings at the opening of *Four Saints* — it was frightfully cold and my radiator made a noise — !" On the afternoon of the first performance, McBride noticed Thomson and Stettheimer leaving the museum's theater, looking "weary but happily confident."[61] In his hotel room, two hours later, the critic got a call from Stettheimer declaring that she was completely exhausted and could "do no more." She asked McBride to go to the nearest Woolworth's and buy two of the best artificial roses they had, as "the whole fate of the opera was at stake."[62] He did so, and Stettheimer immediately arranged for the *commère* to hold them during part of the performance.

The Hartford premiere was a great civic happening and long before the opening three of the five performances were sold out. By pairing the opera with the Picasso exhibition, Chick Austin had

created one of "the most important events of its kind anywhere in the world";[63] it was "a howling success, for the opera, for the singers, for the entrancing stage-pictures."[64] The weather was a problem, as the temperature hovered near zero degrees and more than two hundred costumes and props for the opera had to be trucked to Connecticut from New York City. To avoid any problems, the choreographer, Freddy Ashton, and the cast arrived a few days early. The latter were greeted by the Negro Chamber of Commerce and "billeted in black households all over town."

For the opening on February 6 and the performances on February 7 and 8, the New Haven railroad added extra parlor cars to its regular afternoon trains so that guests, press, and members of the international art world could attend the opera and see the Picasso exhibition. Mrs. Harrison Williams, the country's perennial "queen of fancy dressers," ordered a dress for the occasion that functioned as a beaded cocktail dress for the train ride and unfurled to include a train for the gallery reception and opera.[65] Buckminster Fuller made a grand entrance, escorting Clare Boothe and Dorothy Hale in the prototype of his Dymaxion car.[66] *Vogue* would later describe the audience as "the top of American intelligentsia (and precocity), highly susceptible to sound, colour, form, and revolution."[67] Among those in the audience were the artists Salvador Dalí and Alexander Calder, as well as Alfred Barr, Jr., architectural historian Henry-Russell Hitchcock, and Edward Warburg, vice director for public affairs at the Metropolitan Museum of Art.

As Stettheimer wrote to her mother and sisters, she was escorted to the premiere by the author Sherwood Anderson and his wife:

> He came and brought & treated his dinner guests — we had a real opening again — crowded house — paid for! And my last Act was considered a great improvement. Harry xx? Kissed my hand and made two speeches — to me about it. Even Jack Houseman was enthusiastic. Virgil said [her change to the last Act] was the making of the Opera!

Around 8:30, a crowd of three hundred entered the Wadsworth Atheneum theater. Following a drumroll by the orchestra led by Smallens, the theater's heavy red curtains parted, revealing a proscenium rimmed with lace. The main cast members had to take twelve curtain calls at the end of the first Act before they could change for the second. During the first entr'acte, McBride rushed backstage in time to see Stettheimer and Ashton embracing:

> Both of them in the kind of heaven that only artists know, at the way things were going; and I could not resist the thought that for Florine this was genuinely a coming-out party . . . I have the idea that she scarcely missed a performance of the work.[68]

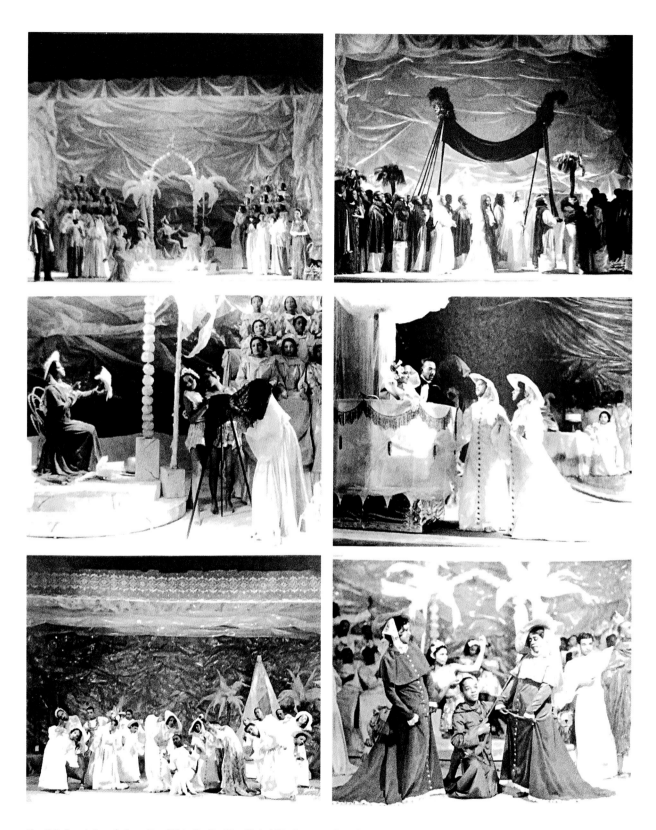

**Fig. 110** Francis Joseph Bruguière, White Studio (New York, NY), Six scenes from *Four Saints in Three Acts* opera, Stettheimer Papers, Yale Collection of American Literature, Beinecke Rare Book and Manuscript Library.

In the lobby after the first Act, Thomson praised the singers, saying they sang "as if they were the saints they said they were." The audience members so busy discussing the opera's avant-garde nature that it was difficult to get them all back into their seats until a shrill whistle was blown. (*Fig. 110*)

Act Two opened, as Stettheimer had suggested, at an outdoor lawn party with, at left, a transparent tented pavilion trimmed in tinsel resembling Florine's canopy bed in Alwyn Court. The back of the stage was draped in huge glistening swags of gathered transparent cellophane that glistened in the white light. As the scene progressed, a "Heavenly Mansion" resembling the U.S. Capitol appeared as a projection on the irregular surface of the darkened cellophane background. The two Saint Teresas wore robes of bright red, Saint Ignatius was in green, and the other saints were in purple and yellow. Behind them, two choirs in blue robes created pyramids on risers on either side. The art reporter for the *New York Sun* noted that "This audience all knew something about pictures and could see at once that the Saint . . . was quite as ecstatic as anything El Greco ever devised . . . the effect produced by the cellophane background and the remarkable lighting were all addressed to the painter's eye."[69]

When the curtain came down for the last time, the chorus shouted "Which is a fact," repeating one of Stein's key lines from the Fourth Act, and stamped their feet and cheered, creating an overall feeling of giddiness and pandemonium. With yells from the audience to take the stage, the opera's collaborators all slowly mounted the stairs. Chick Austin took Stettheimer by the hand and led her up the stairs to join the others in order to be acknowledged by the audience. The artist was wearing a heavy white silk dress with gold pinstripes and gave what McBride described as an "extreme[ly] nonchalant" bow.[70] In her diary, Stettheimer noted of her gloves: "I got excited and I didn't find them until the last moment when I could only carry them with me."

This was ironic given that she had singled gloves out as a key element missing from the cast's costumes, and it indicates how affected she was by seeing her theatrical vision come to life. Typically, although neither attended this important event in their sister's life, after learning that Florine had bowed to the audience without wearing the gloves, Ettie was aghast, and chided her sister, declaring it, "inelegant . . . it was INELEGANT!" Carrie quietly concurred.[71]

Right after the opening, Van Vechten cabled Stein: "OPERA BEAUTIFUL TRIUMPH." The next day he wrote her again, saying, "[The performers] were divine, like El Grecos, more Spanish, more Saints, more opera singers in their dignity and simplicity and extraordinary plastic line than any white singers could ever be."[72] A few weeks later, McBride wrote to Stein, saying, "The fact of the matter is that everybody connected with the presentation caught an inspiration. All of them had to create and all of them did — so that the word 'miracle' is the only one that describes what happened."[73]

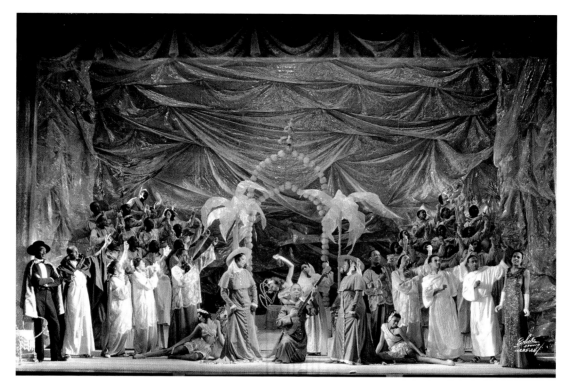

**Fig. 111** Francis Joseph Bruguière, White Studio (New York, NY), Scene from Act One from *Four Saints in Three Acts* opera, Stettheimer Papers, Yale Collection of American Literature, Beinecke Rare Book and Manuscript Library.

Despite the sold-out performance, not everyone praised the opera, even some members of the avant-garde: "The smart thing among the younger artists is to be violently against it, Stieglitz decides also to side with them."[74] But this was mostly criticism that Thomson had the "audacity to give Gertrude Stein in modern dress."[75] Stein's text was particularly denounced by critics who either found it quaintly old-fashioned, a satire of Catholicism, or, as a *Variety* critic wrote, "Drivel, of course, but the most beguiling, fascinating twaddle one can possibly imagine."[76] Although some liked Thomson's score, others felt it too derivative and "at best, happily reminiscent and well-adapted to the form of the performance."[77]

Ashton's choreography, the cast's singing, and Stettheimer's designs and costumes, however, met with almost universal acclaim. The *New York Times* reviewer proclaimed that Stettheimer's settings "attain a gorgeous richness of effect," and the *Herald Tribune* critic Lawrence Gilman found her sets and costumes "slyly witty and captivating."[78] Noted journalist Joseph Alsop also praised Stettheimer's sets, writing, "the setting seemed to give the note for the whole performance . . . [which] managed to be baroquely witty and handsome in one breath."[79] McBride was among those who lauded Stettheimer's contribution, writing, "The Florine Stettheimer settings and costumes are simply sublime. If I could think of a more powerful adjective I would use it, but 'sublime' will have to do for the present."[80] Theater critic Richard Lockridge was more reserved, noting, "The sets are

pretty enough and quaint enough and made chiefly out of cellophane. They are, one might say, quite cute."[81] By contrast, the reviewer for the *Hartford Courant* raved, "The sets by Florine Stettheimer and the costumes were very near the pinnacle of the opera. . . . Altogether a great, sugary confection like the pink frosting-filled Easter eggs that you can look into and see pictures inside." (*Fig. 111*)

Although most critics praised "the novelty and effectiveness"[82] of the African American cast, they also reflected the racist beliefs of the time, writing about the performers using primitivizing, demeaning terms such as "simple" and "childish." None singled out any of the cast members by name as individuals but lumped them all together. Only *New York Times* critic Olin Downes denounced other white critics' statements and lauded the entire opera, writing that "Debussy and the poor old Met were buried last night, buried to shouts of joy and hosannas of acclaim for the new dawn of the lyric drama," and composer George Gershwin described *Four Saints* as "refreshing as a new dessert."[83] The Black critic of *Opportunity*, an African American periodical, ironically noted: "Just how these simple children were able to memorize the highly complicated, intellectual libretto in the first place was never explained."[84]

The audience's response was so positive that there were cries for the run to be extended when it closed. Stettheimer received an outpouring of congratulatory telegrams and letters from various friends. O'Keeffe wrote, "You certainly did your part well," and the sculptor Jo Davidson and his wife Yvonne suggested, "Oh why don't you do more such work? It is so far above anything we have seen . . . never saw anything more perfect." The opera's producers, Harry and Elsa Moses, praised the artist, as did Carl Sprinchorn. Artist Claggett Wilson declared enthusiastically:

Bless your merry dancing fancy and that twinkle in your eye . . . Just to think, even before you die "they" may come to know you for what we few have been shouting aloud for a decade and more, a damned swell, fine artist . . . . I am pleased, happy, delighted and contented with your success. Tho' never for a moment do I lose sight of the fact that you really ride high above mundane recognition.[85]

Stettheimer greatly enjoyed the public approval, which made up for the lukewarm reception her success received within her family. Stettheimer's relatives were generally surprised at the public fuss being made over her and the consequent suspicion that one of their number might be extremely talented and universally acclaimed by critics. Although her brother, Walter, and his wife were so impressed by seeing Florine's name praised in a *Time* magazine review they sent a congratulatory telegram from California, Stettheimer's cousin Edwin Seligman met McBride a short time after the opera's opening and asked the critic, "Is Florrie really so good? 'Sublime,' you know, is a strong word." McBride reassured him, "It is the correct word."

Most tellingly, neither Ettie nor Carrie attended the world premiere. Carrie stayed home to watch Rosetta, and Ettie decided for some reason not to make the two-and-a-half-hour train trip. Given the significance of the event, this absence illustrates the sisters' continuing resentment. Parker Tyler, in his biography, noted: In fact [Florine's] foray into professionalism had injured the devout "amateurism" of both Carrie and Ettie. . . . Florine, as a 'theatre artist,' was not only risking drastic failure with this opera, but also encountering her dubious fate before an immediate and visible public: the audience. . . . was there a modicum of human, all too human jealousy in the bosom of even an adoring sister? If so it may explain why some people believe Ettie failed even to attend the first night of *Four Saints* on Broadway."[86]

*Four Saints in Three Acts* was an immediate success with the public during its five performances in Hartford. After it closed, Harry Moses arranged for the production to move to Broadway's largest theater on Forty-Fourth Street in New York, which held an audience of 1,400, nearly five times the size of the original Hartford stage. It was the first opera to be performed on Broadway. The stage was so large that Stettheimer's cyclorama reached only partway up the wall; Kate Lawson rented a black velour portal and red velvet curtain to mask the uncovered part. Additional lights had to be added to light the cellophane so that it shimmered as it had in the original production.

Right before the premiere, the New York City fire marshal arrived and condemned all the cellophane and the grass mats. Luckily, the theater's janitor recommended water glass, a fireproofing material, which he sprayed over all the cellophane and straw. Unfortunately, the material made the trees droop. Lawson had another set of trees made, which they didn't treat, and the production showed the wilted, treated trees to the inspectors, substituting the untreated ones right before the performances. Luckily, the fire marshals never caught on to the deception, which continued for the run of the show.

On opening night, February 20, eight inches of snow fell, causing most of the city's public transportation to close, but that did not stop the audience and journalists from showing up. Among the luminaries present were Cecil Beaton, Arturo Toscanini, Dorothy Parker, and George Gershwin. Florine took a box at the theater with Thomson, Carrie, and McBride. Ettie sent a cable to Thomson saying that she could not attend because she was "swelling with asthma and conceit at having been one of the earliest admirers of your music."[87] It is difficult to imagine how Ettie expected her sister to interpret the last part of her message. Was it her rationale for not attending, or a sign of her lack of support for Florine?

This time, rather than mounting the stage at the end of the performance, Florine took her bow from her box seats, to thunderous applause. Afterward, she wrote her sisters, "After the opera we went to the Astor bar — about 20 of [*Four Saints*' cast] . . . and the Broadway crowd had a treat." To

celebrate the New York opening, the cast held a reception in March for Thomson, Grosser, Ashton, Houseman, Stettheimer, and Mr. and Mrs. Moses at the Witoka Club in Harlem. Stettheimer reciprocated by inviting Altonell Hines, Beatrice Robinson-Wayne, Bruce Howard, and several other cast members to tea at her Beaux-Arts studio downtown, along with McBride, Thomson, and Kirk and Constance Askew.

Almost 45,000 people attended the Broadway production of *Four Saints in Three Acts* during the four weeks that it ran until closing on March 17. At the end of the premiere, there was "a triumphant roar, through which . . . [one could] vaguely distinguish the sharper tones of cheers and bravos," and there were twenty curtain calls.[88] *Variety* reported that the opera had already more print coverage than any show in the previous ten years. Stettheimer attended almost every performance, and many of her friends saw the production several times, as did the Metropolitan Opera's conductor, Arturo Toscanini, who saw it twice, and Dorothy Parker, who saw it five times. McBride and *Vanity Fair*'s editor, Frank Crowninshield, shared a box with Carrie at another of the New York performances, while Van Vechten sat in the front row of the orchestra and shouted, "Hooray for Florine!" when the curtain descended. According to a reviewer, "The young art enthusiasts howled for more than twenty curtain calls from the cast . . . John Marshall burst his evening waist coat laughing and the fireman on duty in the rear of the auditorium said, 'Jeez, has everybody gone crazy or are they just stewed?'"[89]

On April 2, Harry Moses arranged for the opera to be moved again, this time to the Empire Theatre, where it ran for two additional weeks. For this production, Stettheimer constructed "at her own expense a decorative gadget of stars and symbols that swung in the air above the last scene."[90] While it was at the Empire, Thomson took the opportunity to conduct the opera himself, and as Stettheimer noted in a letter to her sisters, the idea of taking the *Four Saints* opera to Russia came up: "Virgil has to lecture — from tomorrow on he will replace Smallens and conduct — The Opera will run this week — future uncertain. Virgil says it's going to Moscow — he wants me to go too!" A few days before the last performance, on April 11, Florine again gave a tea party at her studio for a number of the opera's stars, including Robinson-Wayne and Hines, along with Thomson, McBride, the Askews, and others. That night she wrote to her sisters in Atlantic City that the African American cast members "made their entrée with an over life-size great Danse. The conversation was such as never occurs in our salon — childbirth — thoroughly gone into by the three women — when the men joined us (sounds antiquated) stories of French — Paris — brothel life."[91] On the night of the very last New York performance, McBride saw all three Stettheimer sisters sitting together in the audience: finally Ettie came to her only viewing of the opera. Whether or not she liked it, or her sister's set designs and costumes, is not recorded anywhere. On May 19, Thomson had a final lobster and squab dinner at Alwyn Court before sailing for Paris on the *Île de France*.

One of the results of the opera's success was that many retailers began adapting elements from Stettheimer's designs. The department store Bergdorf Goodman created a tea gown it called "Saint" in five colors, cellophane dresses with matching handbags quickly appeared in magazine advertisements, and variations of Stettheimer's costumes showed up at the most prestigious department stores along Fifth Avenue. As with everything, Stettheimer took her sudden notoriety with a touch of irony. A New York University graduate student, Sidney Goldberg, contacted her, saying he wanted to do a "thorough and analytical" study of her work for his thesis "in the manner of the famous art historian Julius Meier-Graefe." Although nothing apparently ever came of it, Stettheimer was tickled by his interest, writing to her sisters, "I shall have to keep a secretary like the star members of our cast."[92] When McBride brought his libretto for her signature, she sarcastically noted, "Autographs & interviews — that is fame," and by April she was writing in her diary, "The phrase, 'The most famous sets of *4 Sts*,' has become shopworn."[93]

The widespread publicity for *Four Saints* generated interest in Stettheimer's paintings. Julien Levy and many other major New York gallery owners continued to beg her to exhibit her works in either solo or group exhibitions. She was also contacted by several journalists; as she joked to Dorothy Dayton from the *New York Sun*, "They seem to go away and find they haven't anything to write about."[94]

In November 1934, Moses arranged for the original cast of *Four Saints* to travel to Chicago for a limited run. Stein, who was conspicuously absent at both earlier productions, attended the November 7 opening at Chicago's historic Auditorium Theatre. She first stopped in New York, where she gave a lecture at the residence of a Mrs. John Alexander. In Chicago, she attended a dinner for the opera's principals and invited Stettheimer and her sisters, but none of the three women traveled to Chicago. Nonetheless, a friend who attended the dinner wrote to Stettheimer that when he raved about her contribution to the opera, Stein "joined in enthusiastically & said immediately, oh, I want to send her a wire." The telegram read, "It is perfectly beautiful and fulfilled a dream and made me very happy — Gertrude Stein." Stettheimer's cool, "Steinian" reply followed quickly:

> Dear Gertrude Stein, I am so pleased that our production of the *Four Saints* Opera was not the way you do not like it — many thanks for the telegram. Perhaps you will find time to come to my studio during the week? Why not call me up some day at two o'clock and say when you could come. Greetings to you and Miss Toklas. Florine Stettheimer.

The opera was enthusiastically received in Chicago and many of Stettheimer's friends wrote to congratulate her on her success. One noted that the opera was "like seeing your paintings come to

life — the next thing now is for a movie set — in Technicolor and you to do the scenario as well as the costumes."[95] When Stein and Toklas passed through New York, Stettheimer held a reception in their honor in her studio. According to their friends, the two were merely polite to each other. Thomson remembered, "Not a compliment passed between them."

Stettheimer had little time to rest on her laurels. On April 7, she went to Rockefeller Forum with Virgil Thomson and Maurice Grosser to drop off her *Portrait of Virgil Thomson* for an exhibition by the Salons of America. Demonstrating that she enjoyed having her work singled out, she noted in her diary, "Publicity we hope." The same year, Stettheimer exhibited her 1931 *Birthday Bouquet* in the Museum of Modern Art's exhibition *Modern Works of Art*, which included paintings by European and American masters such as Cézanne, Picasso, Duchamp, Matisse, Hartley, and O'Keeffe.

Francis Dudensing pleaded with Stettheimer to allow him to organize a solo exhibition of her work in his gallery, nicknamed the "temple of modernism" because he organized the first solo exhibitions of Miró, Mondrian, and Kandinsky in the United States as well as organizing the American tour of Picasso's *Guernica* in 1939. He wrote her:

> With the new season and the new gallery, I'm writing to ask you the old question — what about a show? You know how keen we always have been to show them and now we feel we could do them justice — plenty of space to show the big ones we like so much, and plenty of light. The pictures are grand . . . Won't you think it over seriously and let us know? We should want to do a big show — not just a few pictures.

It took her a year to reply, and Stettheimer declined the offer, writing:

> I have not been able to make decisions about anything these last months . . . And so — the very desirable exhibition you have offered me in your beautiful club has been postponed in my life until sometime when I shall be able to cope with it more efficiently — that is if you will still want my paintings at some future time.

Despite exhibiting with the organization since its inception, when the Society of Independent Artists began charging fees, Stettheimer showed solidarity with artist colleagues by resigning her membership. Despite the board's entreaties for her to reconsider, she turned them down with a cryptic answer.

Six months after the opening of *Four Saints* in Hartford, Thomson wrote to Stettheimer about collaborating on a new ballet for the Ballets Russes. He also enlisted Frederick Ashton for the choreography. They agreed that the American theme should be the life of Pocahontas, the daughter

of Powhatan, the early seventeenth-century chief of the Virginia Powhatan confederacy of Native tribes. Both Thomson and Stettheimer felt the story offered numerous scenic and musical opportunities of interest.

The general idea for the libretto, as described by Thomson, was to tell the story of how Captain John Smith was captured and brought before Powhatan in 1607. He was saved from execution through the intervention of thirteen-year-old Pocahontas, who laid her head on his lap. Six years later, Pocahontas was taken prisoner by the English and transported to Jamestown, Virginia. There Governor Sir Thomas Dale baptized her, gave her the Christian name Rebecca, and she fell in love with and married John Rolfe. Pocahontas and Rolfe sailed for England, where she was presented at court as a Native American princess and stirred a more generous English attitude toward her people. The marriage marked the beginning of eight years of peace between the English and the Native Americans. She died at the age of twenty-two of unknown causes while preparing to return to Virginia.

Throughout the remainder of 1934, Thomson and Stettheimer corresponded, exchanging ideas for the music and scenery. In a letter written in July, Thomson suggested:

> Why not have a major-domo presenting a miniature ballet of the John Smith beheading with Indian war dances & peace-pipes & maybe even a wedding & then end with a pavane for King & Queen & entire court . . . This makes a place for a pas seul of Poca, a mimic execution, a pas de deux with Smith & a pas de trois with Smith & Rolfe & then the debs as handmaidens to Poca or the wedding-party, the pages as ushers & a finale apotheoses with the couple being blessed by K&Q while the company does the big finale. . . . James Joyce is very desirous (rather insistent) that I do the music/or a ballet of his Children's Games, the story is good, the subject is charming, everything is right with it, only I can't get interested. Pocahontas amuses me a great deal more.

For some reason, Stettheimer and Thomson decided to portray the English Captain Smith and his men as Scottish, complete with kilts and bagpipes. There was no spoken part of the production, but Stettheimer made up small, sometimes rhyming poems for the main characters to assist in designing the different scenes. In one scene, for example, she wrote that Smith presents Rolfe to Pocahontas as his replacement, saying/singing, "Darling I am much too old / Here's a sailor young & bold / In his Majesty's marine / Won't you be his lovely queen." These rhymes are childish and lack the wit, style, and subtlety of her poetry, and it is doubtful Stettheimer ever planned to do anything with these beyond using them as guides for her stage and costume designs.[96]

Stettheimer threw herself into the project by reading every available source on Smith and Pocahontas. She spent hours at the American Museum of Natural History reading history books,

**Fig. 112** Florine Stettheimer, Costumed figurines for individual performers in the proposed ballet *Pocahontas*, photograph, Florine Stettheimer Papers, Rare Book and Manuscript Library, Columbia University in the City of New York, Courtesy of Georgiana Uhlyarik.

taking notes, and making watercolor sketches of Native American tools, carved totems, rattles, head-dresses, and clothing. Stettheimer also made drawings of the different scenes and eventually created twenty-six figurines of each cast member. She tinted the Native American figure's skin a light reddish brown, added long, thick, black braided hair and for the men, bright orange cellophane costumes from their waist to mid-thigh. (*Fig. 112*) Several of the Native men had full, bright red feather head-dresses. Stettheimer's figure of Pocahontas is covered with a gold foil ribbon headdress, a gold yarn and tinsel skirt and gold beaded bracelets down her arms. (*Fig. 113*) One of the British men wears a red velvet vest while most wear kilts of multicolored gauze and silver foil. To portray the ground on which the Native Americans lived, Stettheimer thought of using pink velvet. For some reason, the ballet was never produced; however, continued working on ideas for it until her death.

In January 1935, Ettie and Florine climbed aboard the *Chief Crystal Gorge* for their first cross-country train voyage. Ettie had problems with asthma, and although Florine felt the trip was rather

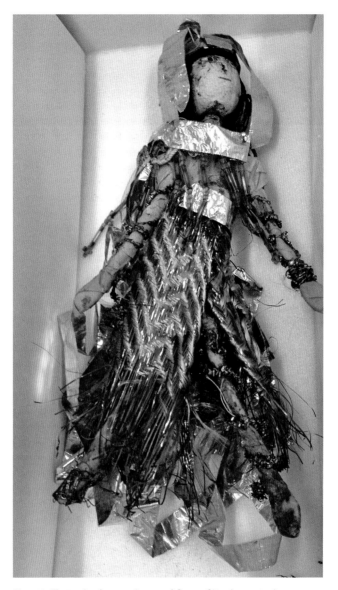

**Fig. 113** Florine Stettheimer, Costumed figure of Pocahontas in the proposed ballet *Pocahontas*, photograph, Stettheimer Papers, Rare Book and Manuscript Library, Columbia University in the City of New York, Courtesy of Georgiana Uhlyarik.

a waste of time, she went along. (Carrie and Rosetta stayed in New York.) In Hollywood, the two sisters saw movies, visited the Archipenkos, and were escorted thorough the RKO movie studios by their friend, now a film producer, Philip Moeller. There they were introduced to several movie stars, including Katharine Hepburn and Charles Boyer, who were starring in Moeller's *Break of Hearts*. They went up a "steep mountain to a house built by [Richard] Neutra . . . it is the most exciting perched habitation I have ever been in — above Los Angeles with millions of lights." While there, they also visited the Arensbergs,[97] and on seeing their art collection again after many years,

Stettheimer commented in her diary: "All the old Duches,[98] Gleizes & other abstractions I used to know with many additions — crowded with 'Art' — Brancusi *Bird in Flight*." They drove by the Beverly Hills homes of Charlie Chaplin and Mary Pickford and visited Grauman's Chinese Theater, which Stettheimer described in her diary: "Oh my it is awful — much worse than Broadway's funniest — it's too horrible to be funny."

From Los Angeles, the sisters traveled to Palm Springs, staying at the El Mirador Hotel, where Florine read Pirandello's short stories and Ettie rested. Writing jointly to Van Vechten, the two women railed against the desert resort. Ettie said that it was like "living in the suburbs of a great bath tub — a communal tub in which everyone but ourselves and the dogs bathe or pretends to — the preliminaries are undressing and lying, greased, all over the garden . . . we feel that if we stay much longer we shall succumb to a permanent hallucination that we are bath attendants to some king." Florine remarked that the only way she knew that she was surrounded by Hollywood celebrities was "when I read it in the papers — They all look alike with and without clothes." She enjoyed analyzing the guests at the hotel, noting caustically in her diary, "Miller's shoe salesman lunched here today — the ultraviolet ray assistant was playing kino in the lounge, the six-foot-four masseur chats with guests in the lounge, the chauffeur who drives us sits in the lounge — it's all the way it should be in a democracy."

While in Palm Springs, Florine received a letter from a Chicago society designer, Shepard Vogelgesang, asking whether she would be willing to have a solo exhibition of her work the following year at the Chicago Arts Club. Apparently, he had already spoken to its director, Miss Boellier, who also was very interested in exhibiting Stettheimer's work. The sisters traveled to San Diego in a chauffeured car and then to Pasadena, where Stettheimer was "not thrilled" by any of the paintings in the Huntington Museum and Library and found a Frank Lloyd Wright house they visited to be "a beast." Actor Olin Howland then escorted them through the Chinese, Japanese, and Mexican sections of Los Angeles, and the sisters shopped and again socialized with friends, including the poet George O'Neill, who invited fifty people to a party for the Stettheimer ladies. Before leaving Los Angeles at the end of March, they spent the afternoon and had dinner with Stein, Toklas, and Man Ray, whom Stettheimer described as "very charming." They traveled up the coast through Santa Barbara and Monterey to San Francisco, where they stayed, for the first time, in the Redwood City home of their brother, Walter.

In mid-April, the two sisters attended an evening lecture by Stein at Stanford University and renewed their acquaintance with Adolph Bolm and his wife. Taking the train home from Oakland on April 15, the Stettheimers stopped in Chicago, where they met with Vogelgesang and Mrs. Charles Goodspeed, the Chicago Arts Club's president. Apparently, nothing came of the

proposed exhibition. Florine and Ettie also met the violinist Nathan Milstein, actress Ruth Gordon, and the writer Thornton Wilder before returning to New York. Sometime toward the end of her California trip, Stettheimer wrote a poem that proved prescient:

This summer is gone
I did not live it —
I killed time
It was like swatting flies
The hours fell dead
Noiselessly —
I did not ever hear them buss
I had no flowers —
Others had a few —
There were big trees
But they belonged to nobody —

Then we drove South-west
Over smooth roads —
That way we got ahead of time —

It is September now —
Children on roller skates
Art gratingly rolling over time —
I shall soon roll on wheels
Back to town
To take up time
And again become over-aware
Of its preciousness —[99]

Soon after their return, Rosetta died and her passing irrevocably altered her daughters' lives. In addition to arranging the burial at the family plot in Salem Fields, Joseph Solomon made plans for selling the Alwyn Court apartment. At the end of August, Stettheimer recorded the imminent changes in her diary: "Expect to go home tomorrow. Home meaning a semi-dismantled apartment — and a search for a new home." On September 30, the day they moved out, Stettheimer noted:

The Collapse of Our Home
Good-bye Home
182 W. 58 St.
The Alwyn Court
Salamanders,
Crowns
Cupids & Fleur de Lis
Farewell

Expecting that the three sisters would continue living together, Ettie and Carrie looked at several apartments with Solomon, finally deciding on a duplex at the Hotel Dorset on Fifty-Fourth Street. They did not, however, reckon on opposition from Florine. After spending the first six decades of her life in the company of her sisters, doing everything but her artwork as a member of a group, Stettheimer had no intention of continuing that lifestyle. She craved independence and the opportunity to concentrate entirely on her work. Instead of joining them, she shocked her sisters by moving permanently into her studio, the Beaux-Arts Building, at 307 East Forty-Fourth Street, ten blocks south of the Dorset.

According to Solomon, Florine's move caused some "unpleasantness" among the three women. "There was no lack of communication, but a good part of the communication . . . [took] place over the telephone."[100] A decade later, Isabelle Lachaise showed great insight into the relationship among the sisters when she wrote to a friend, "Perhaps also, in spite of the devotion of the three there might come such a thing as a release — 'a Room of One's Own,' so to speak. The tie between them, although a devoted one, I have felt might be almost too binding."[101] After this, relations between Florine and her two sisters were never the same. Nonetheless, the three continued to vacation together on occasion, spending part of the following summer in Atlantic City. While there, Ettie grew so depressed over her mother's death and Florine's "desertion" that Stieglitz wrote to her, urging her to get over the feeling that "the world is ugly and not worthwhile."[102]

The enormous critical and public acclaim that Stettheimer received for *Four Saints in Three Acts* enabled the artist to fully realize her twenty-two-year-old goal of producing a *Gesamtkunstwerk*. And she did so, uncompromisingly, on her own terms. For decades, Stettheimer had self-confidently exhibited her idiosyncratic, uniquely innovative paintings in most of the significant contemporary exhibitions of her time. Now she had also received acknowledgment for her work as an innovative and significant artist in multiple media. Having moved into her own space away from her sisters, Stettheimer was finally free to devote herself entirely to making her artwork for the first time in her life.

~~~~~~~~~
~~~~~~~~~

*chapter ten*

# ON HER OWN

## 1936 – 1949

Stettheimer reveled in her privacy and ability to paint and entertain on her own schedule. As the huge duplex apartment was now her home and studio, she further enhanced the space stylistically so that it became a theatrical *Gesamtkunstwerk*, a theatrical stage of extraordinary materials that she designed, in which to live and work that was completely under her control. McBride described the décor in greater detail:

> One of the curiosities of the town; and very closely related, in appearance, to the work that was done in it. The lofty windows (the studio was double-decked) were hung with billowy cellophane curtains, and the chairs and tables were in white and gold, the tables in glass and gold and I have a remembrance of lamps screened with white beads and unreal but handsome gilt flowers in vases. I certainly recall some gilt flowers in a golden bowl on the dining room table, reinforced by draperies of some golden fabric at the windows.[1]

The main room of her studio, where Stettheimer held her own salons, received guests, and worked on her paintings, had a huge stone fireplace. In front of it, she placed the early screens she had created, including the small fireplace cover and the five-paneled screen showing her siblings. Her large paintings to date hung high on the huge room's walls, many in frames of her own design. (*Fig. 114*) To properly light them, she installed a bright chandelier covered with cellophane drapery.

White columns with gilded details on the Corinthian capitals and huge translucent cellophane curtains framed the exit from this room to the small adjoining "patriotic room." Stettheimer gave the latter its name because one corner was designed as a shrine dedicated to George Washington. Having adopted him as a metaphoric replacement for her absent father, she filled the bookshelves with many busts and figures of the founding father and hung her *Liberty/New York* and *West Point* paintings on the walls. Stettheimer designed all the matching furniture for this room and most of the other rooms in her studio, including the corner cabinet, several three-cushioned standing sofas, side tables, and a round central table, all with matching trompe-l'oeil wooden drapery trimmed with tromp l'oeil gilt fringes. (*Fig. 115*)

Directly behind this was the small dining room, also painted entirely white, with gilt-grooved pilasters delineating the walls. One wall was inset with glass shelving and bracketed by her portrait

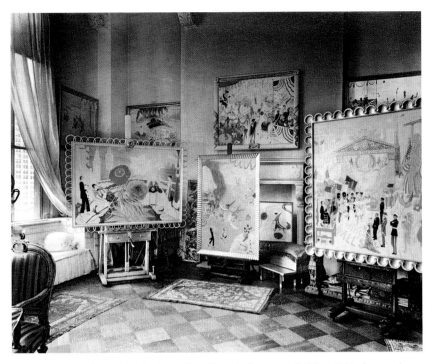

**Fig. 114** Peter A. Juley & Sons, Stettheimer's studio at the Beaux-Arts Building, 1944, photograph, Rare Book and Manuscript Library, Columbia University in the City of New York.

of her mother. On the two facing walls, Stettheimer hung the portraits of her sisters in thin, gilded frames. The entrance to this room was draped with swaths of gleaming gold fabric. Photographs of Stettheimer's studio, taken immediately following her death, are the only remaining images we have of the extraordinary furniture the artist designed. Under Ettie's portrait, for example, Stettheimer placed a Rococo-style side table she had designed in 1917 with raised, gilded imagery of painting palettes on the cabinet doors.

Stettheimer's upstairs bedroom had arched windows covered with Nottingham lace that looked out over the living room. It was accessed via a staircase entered through the dining room with cellophane curtains lining either side. Echoing the abundant lace decorating the room, Stettheimer designed wooden shelves and a standing screen whose edges were shaped into forms resembling sheared lace. (*Fig. 116*) She also designed the frame for *Flowers with Snake*, hanging on an adjacent wall, with large loops of wood, replicating the rounded holes within the decorative lace designs, and created side tables of fat standing putti holding up the tabletops. In a funny anecdote told by Stettheimer's friend Marguerite Zorach, when the artist Max Weber first saw the lace bedroom in Stettheimer's studio he "fell on his knees, clasped his hands, and cried out, "Please God send me a man." As Zorach noted, she "didn't think the Stettheimers ever prayed to have a man in their lives."[2]

In October 1935, Stettheimer faced the unhappy passing of two of her artist friends, Gaston Lachaise and Charles Demuth. She lamented in her diary, "Lachaise's death is sad—Demuth I shall

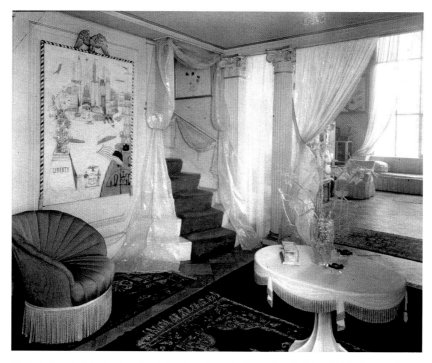

miss. He was somebody to look forward to seeing." At the same time, she valued her independence, and throughout the winter she continued to "stay home a lot. I like it." As she joked to McBride, "Mary, my maid, said that Heaven should look like my new abode—when I get bored with my new Paradise, I shall welcome serpents."[3]

In 1936, Stettheimer admired the exhibition of the young painter and set designer Pavel Tchelitchew at Julien Levy Gallery. The two became friends, and when the George Balanchine ballet *Orfeo ed Euridice* premiered with Tchelitchew's set designs, Stettheimer held a reception in his honor. Among others, she invited the artists Joseph Cornell and Charles Henri Ford, Tchelitchew's lover and the editor of *View* magazine. As the decade progressed, it became a period of professional and emotional upheaval for Stettheimer, who found that she tired easily and lacked energy and interest for anything but her work. This may have been an early sign of the cancer that would take her life eight years later.

I'm tired
My sobs rise
like bubbles
in a syphon[4]

346

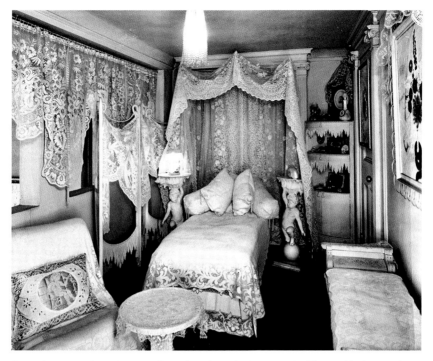

Fig. 116 Peter A. Juley & Sons, Stettheimer's studio at the Beaux-Arts Building, 1944, photograph, Rare Book and Manuscript Library, Columbia University in the City of New York.

In April 1937, she became depressed at tiring so easily and turned down several social invitations, including one to see her friend Leon Kroll's newest paintings, writing, "I am still weeping over having missed seeing your new murals — I had a bad day last Wednesday and my sister Ettie had to stay in and console me." She excused herself from a party at the Van Vechtens', saying: "I wonder if you noticed that I did not arrive at your party yesterday — that may be this year's trouble — I don't arrive anywhere — much to my regret."

In July, wishing to escape the city's heat and break the pattern of renting a house for the summer, the Stettheimer sisters set off together for a train trip to Canada. It was Ettie and Florine's first venture out of the country in twenty-three years. Stettheimer was apathetic, finding Canadian paintings "thin and cadaverous" and everything else "a bore."[5] As they had thirty years earlier, the women complained about the food and often asked the hotel management to change their accommodations. Since none of the three liked Canada, they traveled south to Lake Saranac in the Adirondacks, where they stayed at a former stopping place, the elegant Wawbeek Inn. Florine wanted to return immediately to New York, but Ettie persuaded her to stay. She finally returned to her studio at the end of August, only to find that the ceiling over her lace boudoir had been severely damaged for the fourth time by water overflowing from tanks used by professional photographers in the apartment above.

Sometime during these years, Marguerite Zorach made two quick pencil sketches of Stettheimer without her knowledge or consent. Accustomed to controlling all images of herself, Stettheimer

hated the drawings, as they accurately showed her age. She refused to accept them when they were offered to her, and they exist only because Zorach gave them to the Stettheimers' lawyer after the artist's death.

Toward the end of 1937, Stettheimer received a letter from Conger Goodyear, president of the Museum of Modern Art's board, requesting work for an upcoming exhibition. *Three Centuries of American Painting, Sculpture, Architecture, Graphic Arts, Photography, and Film* was scheduled to open at the Museum of Modern Art and then travel to the Jeu de Paume Museum in Paris the following spring. It was the first survey of American art ever to be exhibited in a major European museum, and Stettheimer initially accepted with eagerness, replying: "You have honored me with an invitation to participate in the Museum's exhibition and that of the French government. I shall be most pleased to send to both." But for some reason, she was not happy with the way paintings had been hung at the Modern recently, so she changed her mind. In October, she wrote to Goodyear, declining to submit "as I find I have no painting suitable for the present Museum walls."

Tom Mabry, the Modern's paintings curator, wrote back in great dismay and pointed out to Stettheimer that Alfred Stieglitz, an adviser to the exhibition, "says there are going to be other very large pictures. We could put yours on one of the short walls, alone, so it would not irregularize the others." She refused to send a painting to the New York exhibition. Recognizing Stettheimer's stubbornness, Mabry further urged her, "At any rate, you'll send to the Paris show, won't you?" To facilitate this, in January 1938, Mabry brought Goodyear to Stettheimer's studio to see her work and reinforce his belief that "an American exhibition in Paris without you would be unthinkable," pleading, "I know how you feel about the Museum. But I shall, personally, be broken-hearted if you are not represented. And I write this only because I want the exhibition to represent our *best* painters. We would lose much if none was in it by you. So — if you can, if you care, think of lending only to your poor friend Tom and not to the Museum, and I shall be ever and ever grateful and proud."[6] Mabry's heartfelt letter did the trick, and Stettheimer sent *Asbury Park South* to Paris, where it was well received by audiences and critics.[7]

During the winter and spring of 1938, Stettheimer's energy returned, and she participated in a flurry of social activities. She attended several exhibitions, including one at Stieglitz's Downtown Gallery, and went antiquing in the village and visited a Salvation Army "glory hole" on Bleecker Street to research the uniforms for *The Cathedrals of Wall Street*. Later Stettheimer included a work in the New York version of an exhibition *Fantasy in Decoration*, which showed an eclectic group, including Whitney Museum director Juliana Force, noted hat designer Hattie Carnegie, acclaimed actresses Lynn Fountain and Helen Hays, painter Pavel Tchelitchew, and playwright and novelist Stark Young, all of whom were cited for doing imaginative, "non-boring" work.[8]

In March Stettheimer received a letter from the Museum of Modern Art requesting a painting for the gala opening exhibition in their new building in midtown Manhattan. The exhibition, titled *Art in Our Time*, was to open the following May in celebration of three things: the museum's tenth anniversary, the opening of its new building, and the New York World's Fair. The curators chose the international artists whose works they hoped would reflect the caliber of the Museum of Modern Art's future permanent collections. Stettheimer decided to send *Portrait of Our Nurse Margaret Burgess* to the exhibition, writing in her diary: "Maggie has gone on a visit to the Museum of Modern Art — I hope she will talk . . ." (Ettie cut the rest.) A week before the opening, the museum's conservators contacted Stettheimer, as she noted: "Hectic morning — Museum M Art — broke my new frame — transport? Also, claimed cracks in painting — that were not in it here when it left! — oh horrors."[9] This did not further endear the museum to Stettheimer, but the issues were resolved, and the artist attended the opening.

The large, celebrated *Art in Our Time* exhibition included paintings by most of the most innovative and significant contemporary Western artists, including Matisse, Cézanne, Ensor, Renoir, Kandinsky, Eakins, Homer, Boccioni, and Picasso. It is a sign of the respect with which the Museum's curators held Stettheimer's work that she, O'Keeffe, and Mary Cassatt were the only women painters included in this remarkable company. Highly judgmental of others' work as usual, the artist returned to view the exhibition with Ettie four days after the opening, commenting again in her diary, "10 cents to get in — only two floors of art open very dull with a few exceptions — and many horrors . . ." (again, Ettie cut off the rest).

On April 30, 1939, a hot Sunday, the New York World's Fair opened at nearby Flushing Meadows in Queens. Organizers hoped that the Fair would bring revenue to New York City and raise the spirits of the American people, and they felt there should be a historical theme. They chose "Colonial America" and timed the opening ceremonies to coincide with the anniversary of Washington's inauguration. The ceremony took place directly under an eighty-five-foot statue of Washington designed by James Earl Fraser.[10] Knowing of her strong affiliation with the Democratic Party and support of Franklin Roosevelt's presidency, Holger Cahill, director of the fair's art exhibition, invited Stettheimer to attend when President Roosevelt laid the World's Fair's cornerstone in June 1938. Despite sitting in the hot sun for the four-hour ceremony, she found the president very charming and amusing.

Because of her reputation and friendship with Cahill, Stettheimer was convinced that he would ask her to design a major work for the fair. With that in mind, once the fair opened, she enthusiastically visited many times, seeking out ideas and models for potential paintings. She began one such work, in which she conflated aspects of the World's Fair with architectural landmarks of

downtown Manhattan and included a painted rendition of the marble bust of Washington that stood prominently in her studio's patriotic room.[11] Carl Van Vechten sent the artist a photograph of Washington that he had recently printed. She immediately responded, "Dear Carlo, how wonderful to receive handsome Washingtons from you — with your help he is the only man I collect."[12]

In the end, Stettheimer was not offered a commission for the fair, and her work was not among the three thousand pieces chosen by the selection committee of artists for the fair's exhibition, *American Art Today*.[13] This is not difficult to understand, as the unstated theme was regionalism, and regional artists' committees chose what they considered "the most typical and representative American works," a definition not applicable to Stettheimer's style or subject matter.[14] A year later, Cahill did ask Stettheimer to execute a painting on the theme of "the World's Fair as I see it." Angry at not being asked to paint the opening ceremonies, she refused, stating, "I am not sure you will feel as sad as I do that I shall not be able to paint [it] . . . owing to my not having seen any of you and the creators in action . . . I should have enjoyed doing you all in the Fair surroundings, alas."[15]

She did, however, use the celebratory and patriotic themes in the next painting in her *Cathedrals* series, *The Cathedrals of Wall Street*. On January 2, 1938, a reporter Elliot V. Bell wrote an article titled "What Is Wall Street?"[16] describing the new international site of finance: "The geographical center of the district lies at the intersection where Broad Street ends and Nassau Street begins. Here on one corner stands the Stock Exchange, on another J. P. Morgan's, and on a third, the outmoded temple of the old United States Sub Treasury, upon which the statue of George Washington stands with lifted hand to mark the site where the first President on April 30, 1789, took the oath of office."

Stettheimer spent most of late 1938 and 1939 painting *The Cathedrals of Wall Street*. (*Fig. 117*) She combined several contemporary events within the composition Thematically, it depicts the celebration of a presidential anniversary, the pageantry sparked by the New York World's Fair of 1938–39, recognitions of President D. Roosevelt's New Deal, and the recovering economy as America began mobilizing for World War II. The left side of the composition represents the 150th anniversary of George Washington's inauguration, on April 30, 1939. The date was celebrated by a public reenactment on the steps of the Sub-Treasury Building, with New York City Mayor Fiorello LaGuardia and representatives of patriotic, military, and naval organizations.

As she worked on *The Cathedrals of Wall Street* throughout the months of January and February 1939, she wrote in her diary:

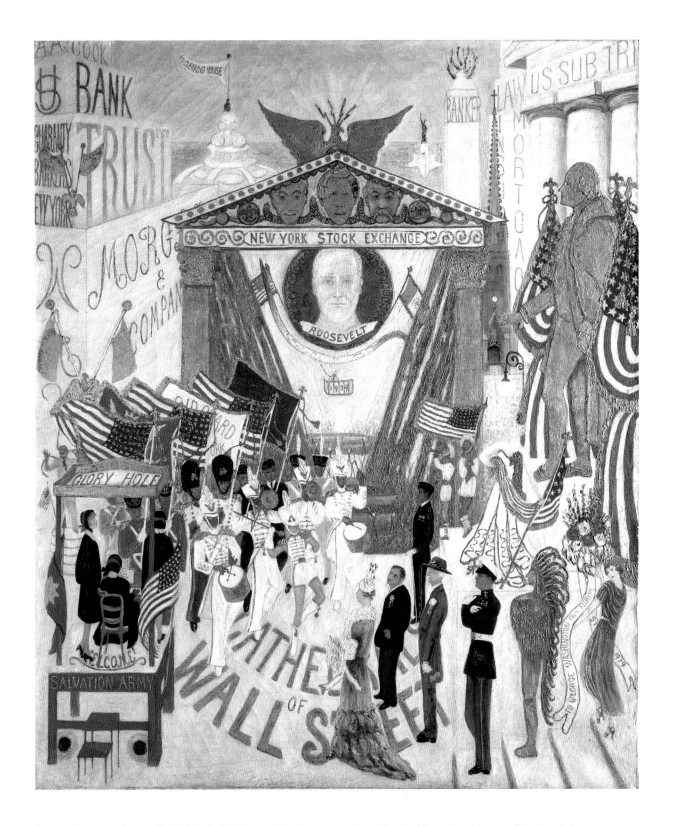

**Fig. 117** Florine Stettheimer, *The Cathedrals of Wall Street*, 1939, oil on canvas, 60 × 50 in., The Metropolitan Museum of Art, New York, Gift of Ettie Stettheimer.

〜〜〜〜〜〜〜〜〜〜〜〜

"Painting —
called on sisters"
"Painted —
called on sisters
"Painting
"Painting
"In all day
 painting"

〜〜〜〜〜〜〜〜〜〜〜〜

On Washington's birthday, she noted in her diary, "I put lots of gold on Washington," referring to the enormous, gilded statue of the president dressed in his inaugural robes which dominates the right side of the painting. Stettheimer based her rendition of Washington on Fraser's statue from the World's Fair. The artist positioned the figure so that he is in the act of entering the scene from the right. Her version faithfully but awkwardly emulates the hand gestures of the original, in which his right hand rests on a Bible during the oath of office. In the painting, the book has been eliminated, so that his hand hangs unconvincingly in the air. On the pillars behind him are written the words "law," "mortgage," and "insurance," terms that were key to Roosevelt's initiatives during his first two terms. As an ardent supporter of the New Deal, she placed a prominent portrait of President Roosevelt in front of the New York Stock Exchange building. Large gold curtains part from gold Corinthian columns to reveal the president's portrait, painted in white with his name set against a gold mcdallion.

In 1931, the French artist Fernand Léger described Wall Street as the symbol of "audacious America, which always acts and never turns to look behind."[17] The juxtaposition of politics, money, and ostentation was a theme also picked up by the media, such as a December 1932 *Vanity Fair* cover in which a group of top-hatted politicians observe a leaning tower of money bags ("America's Monument to the Well-Known Soldier"). Stettheimer filled the tympanum of the Stock Exchange building with three gilded portraits of extremely wealthy men who had a major influence on the American economy: Bernard Baruch, a financier and investor who was a member of Roosevelt's "Brain Trust," the National Recovery Administration; philanthropist and banking titan John D. Rockefeller, Jr.; and J. P. Morgan, the bank titan and a leading lender to Europe following World War I. Above them is the gilded symbol of America, the bald eagle. A tiny figure of the Statue of Liberty is visible near the horizon line at upper right, emphasizing, along with no fewer than nine representations of the American flag, the patriotic tenor of the painting.

A very small "Wall Street" sign under a globe light near the statue of Washington, fronting the alley, leads to Stettheimer's beautiful rendition of the Trinity Church, located at the intersection of Wall Street and Broadway. The church, first chartered and built in 1678, burned down and was rebuilt on the site in 1790.[18] Washington and several of his top officials often worshipped there, as New York, at the time, was the capital of the United States. On either side of the painting, the artist depicted major financial institutions that were also located in the area around Wall Street: the Sub-Treasury Building; an unidentified vertical building carrying the word "Banker" on the right; a stack of rectangular blocks identified as Morgan & Company, Guaranty Bankers New York Trust, and U.S. Bank. At the very top of the stack, Stettheimer placed the name of her family's financial adviser, A. A. Cook, who so successfully guided their investments through the Depression. Two gilded eagles hold gold flags with the inscriptions "Greater New York Fund" on them. Behind is a large white dome flying a flag identifying it as the New York Clearing House.

Throughout the summer of 1939, Stettheimer wrote to her sisters daily while they vacationed in Saratoga, but she refused their requests to join them, saying she did not want to "break up my working mood . . . I painted all day . . . I think I am looking quite healthy — the air in my lace bedroom is much better for me." In the interests of accuracy and research, Stettheimer had her hair shampooed in the same salon as Grace Moore, the operatic soprano and film actress, so that she could see her and get firsthand knowledge of Moore's facial features. Once this was done, Stettheimer added the soprano to the *Cathedrals* painting, on the right at Washington's feet, holding the American flag while singing.

Stettheimer often ventured around the city to conduct research for the painting. The artist visited the Seventh Regiment Armory to copy military uniforms and asked Joseph Solomon to bring her a piece of actual ticker tape so that she could put it in the painting under Roosevelt's portrait. She painted it with red, white, and blue colors, but left the numbers so that the stock's prices were legible. She also requested exact images of the uniforms from the Navy. She asked that Van Vechten introduce her to Eleanor Roosevelt and was very disappointed that he was not able to do so. Nonetheless, Stettheimer included a credible portrait of the first lady in the center foreground, holding a bouquet of flowers. Next to Mrs. Roosevelt she painted Mayor LaGuardia, Michael J. Erikson (superintendent of her building), an American Legion veteran from Post 102, and Captain Clagett Wilson of the United States Marine Corps, whom she depicted pledging allegiance to a flag he is facing. Behind Wilson, Stettheimer placed a tall Native American figure standing in profile with gilt costume and full red, white, and blue headdress. Like the figure of Washington, the image of a Native American man was widely used on posters advertising the World's Fair.

As in the two earlier *Cathedrals*, implied sounds and noise are integral to *Wall Street*. At the far right of *The Cathedrals of Wall Street*, Stettheimer included a self-portrait. Wearing a rare dress, bright red to match her high heels and lipstick, she dances to the music and carries a huge bouquet of red, white, and blue flowers. Hanging from it is an enormous white ribbon on which is inscribed "To George Washington from Florine St 1939." In Elliot Bell's article on the new financial district, he described "itinerant preachers [who] often take their stand outside the Banker's Trust at the corner of Wall and Nassau, exhorting the noon-time crowds of clerks and office boys to forsake Mammon and return to God." In this painting, Stettheimer included an itinerant figure dressed in suit pants and shirt sleeves directly under the Bank Trust building, similarly loudly admonishing passersby at the painting's left edge. The main source of the music and sound in *The Cathedrals of Wall Street*, however, is the Salvation Army staff brass band[19] playing a lively rendition of "God Bless America" on the left side of the painting, in front of the Salvation Army "glory hole." (The term represented a building the Salvation Army maintained for anyone to come in off the street and worship.) Stettheimer fashioned the rooftop of the building in the shape of a gold donation tray.[20]

In the painting, the brass players and drummers play their instruments and march in place while wearing military-style white and navy uniforms with gold trim. A member of the Salvation Army, seated under the covered glory hole, accompanies the band on a small organ, reading the sheet music for "God Bless America," while her two fellow Army corps members look on. The cacophony is amplified by the addition of a young Boy Scout playing his trumpet directly under the right column at the center of the painting, the marching of the band, the singing of Grace Moore, and Stettheimer's dancing feet at far right. Typically, few women would have been on Wall Street, but Stettheimer included seven women in the front half of the composition. Although two of the Salvation Army ladies are only visible from the back, Eleanor Roosevelt occupies the center foreground of the painting, with the artist at far right and a standing Salvation Army officer at left. A smiling, high-kicking uniformed majorette leads the male band, whose faces are partially obscured by instruments or headdresses.

In a July 16, 1938, letter written to her sisters vacationing in Saratoga, Stettheimer described the coming horrors of World War II as seen in film reels:[21] "I . . . went to the Translux—saw Howard Hughes 'Glorification'—and those Nazi camps... . . . being fined (?) & imprisoned—and the audience clapped when the prosecutor made a speech saying they should go back to where they came from—(more elegantly more elaborately)." On September 3, 1939, Stettheimer noted in her diary that war had broken out in Europe. Later, she and Ettie went to Rockefeller Center to see a newsreel on the worsening European situation. Stettheimer left no further written comments about the war,

but almost as soon as she and her sisters became aware of Hitler's rise and the persecution of Jews six years earlier, they acted swiftly to bar from their lives anyone who showed sympathy for his cause.

Marsden Hartley spent 1933 in Garmisch-Partenkirchen, Germany. This was shortly after Hitler had named it the site of the 1936 Winter Olympics. In preparation, the Nazis were pulling out all the stops to ensure the event was a huge celebration of Hitler's regime. During the period that Hartley was in Garmisch, signs reading "Jews are not wanted here" were already posted, and anti-Semitic violence was so widespread that the organizers became concerned that the local population "would indiscriminately attack . . . anyone who even looks Jewish." Hartley's letters to friends in New York show that he was quite taken with Nazi Party athletic events and with the uniforms and pageants of the Hitler Youth. In his letters, he praised Hitler's economic reforms and ability to give the non-Jewish German people a new sense of nationalism: the "good things he has done and they are good—outside of the Jewish question which of course is tragic."[22] When Hartley returned to New York, the Stettheimers barred him from their salons and never spoke to him again.[23]

Despite her deep concerns about the war in Europe, Stettheimer spent the late 1930s and early '40s caught up in a swirl of social activities, often including visits and meals at various World's Fair pavilions that allowed the artist and her friends to eat the cuisine of different nations every night. Stettheimer continued to entertain members of the city's cultural avant-garde, now often hosting them in her studio without her sisters. Her guests now regularly included a large number of prominent, influential, and openly feminist women. Among these were Mabel Dodge Luhan; popular author and social activist Fanny Hurst;[24] founding director of the Whitney Museum Juliana Force; Mina Loy, the modernist poet who is best known for writing a "Feminist Manifesto"; her cousins Laura Dreyfus and Natalie Barney and Barney's lover, the portrait painter Romaine Brooks. As Barney had been in living in Paris for decades, Stettheimer and her sisters took her, Laura, and possibly Brooks in a taxi down to the Battery and East Broadway. There they visited Stettheimer's uncle William Walter's home to look at the Ives' portraits of their mutual Pike/Content ancestors.

Wanting to continue capitalizing on the innovative programs during his tenure as director of the Wadsworth Atheneum, Chick Austin wrote Stettheimer on March 27, 1940, saying he was organizing an exhibition based on all the theatrical performances he had produced at the museum. She agreed to lend her maquettes and dolls from *Four Saints in Three Acts*. On October 13, she recorded "Chick Austin & his assistant xxx Hughes drove in from Hartford to fetch my *4 Saints* Maquette for an exhibition in the museum." It opened in Hartford the following week.

Stettheimer hosted a number of small, elegant parties in her studio for her circle of friends, including Van Vechten and Marianoff, Thomson, and Duchamp. After the success of *Four Saints in*

*Three Acts*, its director, John Houseman, came to dinner to ask her to design the sets and costumes for his next directing venture, a musical titled *Liberty Jones*. However, she decided not to do it. An ardent Democrat, Stettheimer eagerly listened to the 1940 presidential campaign speeches on the radio and was horrified to learn that her friends Henry McBride and Clagett Wilson favored the Republican candidate, Wendell Willkie. In her diary on November 5, 1940, she noted, "Have just registered my vote for Roosevelt," and the next day's entry reads, "I took off my telephone receiver at seven A.M.—'Roosevelt' said the voice instead of 'good morning.'" On January 20, 1941, she wrote, "Thank goodness [the inauguration] came off—heard Oath and speech . . . our most illustrious refugees—Matterlink[sic], Paderewsky, Eve Curie etc." She also attended the premiere of the ballet *Balustrade*, with Tchelitchew's stage designs; and Houseman's *Liberty Jones*, which she lukewarmly termed "a good attempt at a decent play."

Sometime in 1941, Stettheimer first felt ill enough to be taken to the hospital for the first time—likely the first major sign of the cancer that would cause her death three years later. During the remainder of the year, she went to openings or parties at friends' homes when she felt up to it. On May 4, Stettheimer invited her sister Carrie and Thomson to the Museum of Modern Art for a "so-called 'Rehearsal' of *4 Saints*" for an oratorio, or musical performance of the opera performed without the sets, scheduled to be performed at Town Hall. As she recorded in her diary, "Virgil at piano—full cast—all the former singers present from seven years ago." In preparation for the production itself, Stettheimer designed new costumes for the performers, accompanied by her friend Louise Crane, a philanthropist and daughter of one of the founders of the Museum of Modern Art. She dressed the two Saint Teresas in black satin capes instead of their original red and white gowns and made cloaks with cowls in two shades of tan for the chorus. Finding it difficult to obtain the accessories and materials she wanted to finish the costumes, Stettheimer considered abandoning them altogether, but in the end, the singers appeared in her designs.

The *Oratorio Vocal Performance of Four Saints in Three Acts* was held on May 27 at Manhattan's Town Hall with the original conductor, Alexander Smallens, and cast. Stettheimer noted in her diary that she took a box for the performance. It is not known whether either of Stettheimer's sisters attended the event.

On an unusually hot October day, Virgil Thomson visited Stettheimer at her studio and composed a musical portrait of the artist while she sat stringing glass beads onto her cellophane curtains. She was not overly pleased with his characterization of her, believing it was inspired by noises of the drums and trumpets made by military bands playing below her studio on Fifth Avenue. When Thomson played the musical portrait again for her in his apartment the following February, she described it in her diary as "not at all what I thought I was in his eyes and ears—I am very sad

and dreary and suddenly become boisterous and even modernly screechy he said the noisy quality is the color I use — that's that." A few months later, Thomson wrote the artist, "I am orchestrating a dozen or so of my portraits, including yours . . . I think about you all the time. I love you dearly."

Stettheimer noted in her diary her reaction to the bombing of Pearl Harbor on December 7, 1941, and the United States' declaration of war: "more horrors . . . Japan has started a war — with us . . . President Roosevelt has declared war — More horrors — in this world . . . Germany has declared war on us — Listened to speeches of Roosevelt and Chamberlain on radio."

On January 8, 1942, Stettheimer began feeling severe chest pains. On February 25, she went to see a Dr. Lincoln, who "fluoroscoped me etc. found nothing."[25] By March 5, the pain was much worse: "Pain on my chest now — for hours — Dr. L. says it nothing — but he hasn't the pain . . . Had X-ray . . . very complicated — nothing found!" Stettheimer continued to experience severe pain, writing in her diary, "Dr. Lincoln came to see me — arranged for X-rays and flouroscoping by Dr. Pond . . . took ages — hours again — feel normal . . . Next day Dr. Goodrich called in to persuade me to go to [Roosevelt Hospital]. I obeyed everybody and let them do everything." She stayed in the hospital under Dr. Goodrich's care.

Once Stettheimer was back in her studio, Van Vechten brought Daniel Rich of the Art Institute of Chicago to meet her and see her work "at the latter's request," prompting her to note, "He needs many things — especially suspenders."[26] On January 1, 1942, Stettheimer began her last painting, *The Cathedrals of Art*, by staining in large areas of color over pencil outlines. (*Fig. 118*) She took on the topic that she knew best, the world of art museums and the art market, with the Metropolitan Museum of Art as its highest altar. She apparently modeled the structure, featuring a magisterial central staircase with two large columns on either side, where a number of figures stand or line the descending stairs, on Raphael's late Renaissance painting *The School of Athens*.[27] Stettheimer sought to capture a singular moment in the history of New York's art world, portraying the main players influencing the future of contemporary art. As she executed the painting from 1942 to 1944, the city's museum world was caught in a significant series of public and private coalitions and misalliances. *The Cathedrals of Art* shrewdly reveals the delicate balance of power, competition, and interdependence among three major institutions.

The Metropolitan Museum of Art was founded in 1870. Just as today, its founders and major contributors to the collection included extremely wealthy businessmen and financiers, who donated as much to promote business dealings and gain prestige among their contemporaries as they did out of philanthropic spirit. Although one of the stated purposes of the museum was to encourage the development of contemporary artists, both its collections and exhibitions ended up being based on antiquities, Old Master paintings, and other historic objects. As a result, from its inception, artists

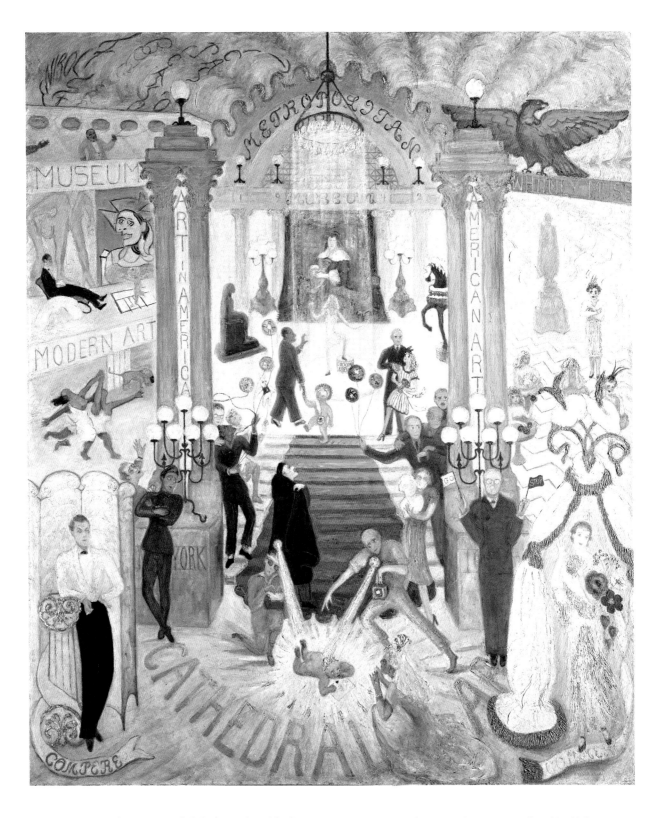

**Fig. 118** Florine Stettheimer. *The Cathedrals of Art*, 1942–1944, oil on canvas, 60 ¼ × 50 ¼ in., The Metropolitan Museum of Art, New York, Gift of Ettie Stettheimer.

and critics widely criticized the museum's neglect of contemporary art. It was this failure that, in the end, directly led to the formation of the Museum of Modern Art and the Whitney Museum of American Art.[28]

In 1940, the Metropolitan Museum's trustees hired the energetic and young Francis Henry Taylor as its new director. He was flamboyant and mercurial, with "captivating charm," "temperamental fury," and an "attitude of casual and caustic superiority."[29] Taylor had a large, rotund body, a small head, and a beak of a nose. Although he advocated a new direction for the museum, promising to make it less a scholarly, passive "treasure house" and more accessible to general audiences, he was not particularly receptive to contemporary art. The curator of European paintings, Harry Wehle, also had no interest in modern art, and in 1933 refused the loan of a Picasso painting. Taylor viewed modern art as reflecting the moral crises of modern life and referred privately to the Museum of Modern Art as "that whorehouse on Fifty-Third Street." That did not stop him, however, from eventually trying to take over the collections of the other two museums.

In the late 1920s, three influential art patrons — Lillie P. Bliss, Mary Quinn Sullivan, and Abigail Greene Aldrich Rockefeller — responded to the Metropolitan Museum's lack of interest in contemporary art by establishing a museum dedicated to the new art. The Museum of Modern Art opened its doors to the public on November 8, 1929, just ten days after the Black Tuesday stock market crash. The public's response was enthusiastic, and over the next ten years, the museum moved three times into progressively larger quarters. In 1939, the museum opened at the site it still occupies on West Fifty-Third Street. The trustees hired as the first director Alfred H. Barr, Jr., a twenty-seven-year-old professor at Wellesley College. Not only did Barr envision a museum dedicated to modern painting and sculpture, but under his leadership, the Modern was the first museum to establish curatorial departments devoted to photography, architecture and design, and film. The museum opened with a loan exhibition of the works of Post-Impressionist artists Van Gogh, Cézanne, Gauguin, and Seurat.[30]

Administrative and personality issues soon troubled the institution. The chairman of the board, Stephen Clark, disagreed with Barr on virtually every front. When museum curators organized an exhibition by the unknown self-taught artist Morris Hirshfield, it was ravaged by critics, and Clark blamed Barr for the bad publicity. When Barr was on a trip to Europe in 1943, the trustees forced his resignation, relegating him to the museum's acquisitions, exhibitions, and architecture committees.[31] No director was hired in his place, and until 1949 administrative duties were handled by the chairman of the museum's coordination committee and Tom Mabry, the director of the curatorial department. Meanwhile, Taylor of the Metropolitan Museum began going over Barr's head at the Modern Museum and negotiating with its next board president, John Hay Whitney, about the possible consolidation of the two institutions.

Others were also establishing institutions for the display of new art, if at a smaller scale. Gertrude Vanderbilt Whitney was an accomplished sculptor as well as a serious art collector. Around 1914, recognizing the difficulty American artists had in selling their work, she established the Whitney Studio Club as a showcase for contemporary American art. By 1929, with the help of her intelligent assistant, Juliana Force, she had acquired a collection of over five hundred works by living artists, which she offered as a gift to the Metropolitan Museum of Art. She also planned to donate money to build a wing in the museum devoted to American art. But its director at the time, Edward Robinson, flatly refused the gift. This, in addition to the Museum of Modern Art's apparent preference for European art, led Whitney to open her own museum devoted to American Art, with Force as its director. The Whitney Museum of American Art opened in November 1931 at 10 West Eighth Street with an exhibition showcasing works from Whitney's collection.

From the museum's inception through her death in 1943, Whitney single-handedly covered the museum's expenses, but late in her life, she decided against endowing the museum to ensure its continuing survival. Therefore, without telling Force, she returned to the idea of donating her collections and creating a Whitney wing at the Metropolitan Museum. At her death, Whitney trustee Frank Crocker, along with Gertrude's oldest daughter, Flora, continued these secret discussions with Francis Taylor. He planned to use Gertrude's estate to build and endow a new wing to house the collection. Although talks eventually broke down, the proposed partnership made Force, at least for a while, the director of little more than a "ghost museum."[32]

Painted during the period when the trustees of both MoMA and the Whitney were in discussions with the Metropolitan Museum about possible mergers, *The Cathedrals of Art* perfectly captures the tensions of this tumultuous moment. Stettheimer's painting is also an ironic comment on the deification of art at a time when the three main New York museums were claiming to show the greatest art in the world, with strongly divergent views of what that art might be. Stettheimer borrowed the device of using two narrators, a *compère* and a *commère*, from *Four Saints in Three Acts*, to intercede between the activity taking place within the composition, i.e. on her compositional stage, and the viewer.

Stettheimer designated her friend Robert Locher, known for his good looks and style, to act as the *compère*. Trained as an architect, he entered the firm of Baron de Meyer just as it was experimenting with flamboyant and original color schemes in the interiors of the homes of the wealthy. In addition to working with advertising firms and magazine editors, Locher developed a reputation for book and magazine illustrations and theatrical design and worked on several works of performing art. His theatrical style, academic training, and ease at moving among the moneyed classes gave him close affinities with Stettheimer.[33] In portraying Locher as the *compère*, the artist drew parallels

with the pose of the stone statue of Apollo, who stands akimbo, his left hand resting on a pillar, looking on from the upper left niche in *The School of Athens*.

On the lower right, Stettheimer included herself as the *commère*, standing under a cellophane-and-gold canopy trimmed with huge white calla lilies. In this final self-portrait, she portrayed herself not as an artist, but as a bride wearing what appears to be a white wedding dress. Like a nun who has metaphorically married Christ, she has, figuratively speaking, married art and dedicated her life to it. Raising one hand toward the audience, Stettheimer wears an expression of amused astonishment at the scene taking place behind her. Bookending Locher, she stands in a pose that loosely resembles that of Minerva, goddess of wisdom and war, who stands in a niche on the right side of Raphael's painting. In place of Minerva's shield, Stettheimer holds her characteristic "eyegay" of flowers. As in their own niches, both the *compère* and the *commère* are symbolically shielded from the action taking place, in Locher's case by a white screen and in Stettheimer's by the gilt-fringed white canopy.

Stettheimer originally titled the painting *Our Dawn of Art*, which she scribbled on the wooden armature used to stretch the canvas. The implications of this title and her arrangement of portraits and devices within the composition reveal her intention to satirize the New York art museums' burgeoning interest in contemporary art. Stettheimer's attitude toward the machinations of the art world was evident throughout her career, but it never was realized as humorously as in her final painting. At some point, in a short poem, she noted:

Art is spelled with a Capital A
And Capital also backs it —
Ignorance also makes it sway
The chief thing is to make it pay
In a quite dizzy way
Hurrah —
Hurrah.[34]

Art critic Hilton Kramer later described *The Cathedrals of Art* as "comic opera . . . the whole scene is one of shameless hustling and posturing. It is a prophetic as well as a delightful painting."[35] In the composition, repeated representations of a naked baby symbolize contemporary art and parody the different museums' responses to it, and how the general disinterest in "baby/young/contemporary" art had a great deal to do with the formation of New York City's Whitney and Museum of Modern Art.

The initial focal point of *The Cathedrals of Art* is the naked putto, or Baby Art, lying in the foreground, at the base of a grand staircase. Stettheimer based the plump, naked child on a third-to-second-century B.C. Hellenistic bronze statue, *Sleeping Eros*, which the Metropolitan Museum acquired in 1943 to widespread publicity. Stettheimer's blond curly-haired baby is depicted making a drawing, but appears more interested in putting the red crayon in his mouth than using it. As a central object of attention, Baby Art is memorialized by the renowned photographer George Platt Lynes.[36] The flash from his box camera clearly illuminates the child, whose every utterance is recorded on a portable typewriter balanced on the bent knee of an art reporter, who is wearing a spotlight directed at the baby's posterior. At lower right, a beautiful woman with a bouquet of flowers atop her long blond hair placates the child. She represents the adoring spectator, who is willing to be seduced by all that is innovative and trendy.

The composition is divided into three parts above the image of the baby. At left is the Museum of Modern Art, titled "Art in America," and at right is the Whitney Museum, titled "American Art." The central portion of the canvas is dominated by the Metropolitan Museum's well-known central staircase. The institution's name is spelled out in flowery script on the dome of the building's central hallway, with its characteristic gilded candelabra. Describing a recent trip to the museum, Stettheimer ironically equated the art museum with a retail store, noting on an odd scrap of paper found among her diaries:

> I couldn't manage to see the Havemeyer Collection . . . but as soon as got to the country [returned to town to visit the Metropolitan M. a hot day — those steps to the entrance and the grand staircase — Macy's, how much more comfortable their means of ascension — would escalators disturb one's art approach?

At the center of *The Cathedrals of Art*, at the top of the stairs, Stettheimer included specific works from the Metropolitan's eclectic collection. She gave pride of place to Frans Hals's *Portrait of a Woman*, painted around 1650 and acquired by the museum in 1891, draped on either side by red velvet curtains. A gilded harp stands directly adjacent to the painting, and on the left stands what appears to be the *Seated Statue of Hatshepsut*, which was acquired by the museum in 1929. Across from the Egyptian statue, a horse fully clad in medieval armor, standing on a pedestal, represents the museum's arms and armor collections.

At the very top of the stairs, Francis Taylor points out the institution's treasured collections to the beribboned Baby Art, but the uninterested child faces backward and is attempting to walk down the stairs. Directly to their right, Stettheimer included a humorous portrait of Wehle, the Metropolitan's curator of European paintings, who was reputed to be an accomplished ladies' man.

He was said to be interested in modern art only if it portrayed pretty young women. Stettheimer mocked this inclination by portraying him with his arms around a nubile young blonde wearing a sash that declares she has won his "first prize."[37]

In the middle of the Met's upper floor, a woman wearing an abbreviated yellow gown stands with a raised arm holding a glass, in the pose of the Statue of Liberty. One of her red shoes is raised high in the air and rests on a plinth bearing the title "The Cocktail Dress," indicating that she is a museum exhibit. Taylor and Wehle had, in fact, recently organized an exhibition on contemporary fashions, as if proving that they did, on occasion, show contemporary art. Stettheimer included this motif as a means of satirizing their refusal to take contemporary art seriously.[38]

In the Mus-e-um
The Directors drink Rum
For Art is dumb
In the Mus-e-um[39]

At left, separated from the area given to the Metropolitan Museum, Stettheimer depicted two floors of the Museum of Modern Art. Reflecting his unsettled status, Alfred Barr, no longer the museum's director, sits among the Modern's collections. Stettheimer portrays him as a passive figure in profile, like that in James McNeill Whistler's 1871 painting of his mother, *Arrangement in Grey and Black No. 1*, also known by its colloquial title, *Whistler's Mother*.[40] Barr is emotionally removed from the antics taking place around him. A prosperous-looking trustee, probably Stephen Clark, stands on the museum's roof, manipulating strings with the names of prominent artists: Picasso (twice), Bouguereau (an interesting choice as he was a nineteenth-century academic, not modern, painter), and her own name, "Florine St.," indicating that the Museum of Modern Art had exhibited her work several times. As the museum still only had a very small collection, Stettheimer highlighted an exhibition, *Picasso: 40 Years of His Art*, which Barr had organized in 1939, by including three works from the exhibition. Stettheimer clearly found amusement in showing that she could replicate Picasso's style so well that each painting can be easily identified. Behind Barr is Picasso's 1930 *Acrobat*,[41] with some changes made by Stettheimer: the original painting is monochrome, not pink and yellow. To that work's right hangs Picasso's 1938 *Portrait of a Woman*. While Barr sits reading, Baby Art plays hopscotch, undisturbed, on a Piet Mondrian painting lying at his feet.

On the floor below, another work from the Picasso exhibition has fully escaped the wall. The figures of Picasso's 1922 *Two Women Running on the Beach* have slipped from their canvas onto the

museum floor, still in their painted poses. Barr so liked this painting that he used it on the cover and as the frontispiece of the exhibition catalogue. To their right, the lion from Henri Rousseau's *Sleeping Gypsy* has escaped and is sniffing the floor. Barr had persuaded Peggy Guggenheim to purchase and donate the Rousseau painting to the museum in 1939, calling it "one of the great masterpieces of modern times."[42]

Stettheimer reserved the right side of the canvas for the Whitney Museum of American Art. Under a huge American eagle, in the foreground of a still-empty gallery space, society women, whose nude bodies are partially hidden by giant calla lilies, sit gossiping at tables. The only art visible in the entire space, looming in the background, is *Chinoise*, a monumental sculpture carved in limestone by Gertrude Vanderbilt Whitney in 1913–14. Within this almost empty room stands Juliana Force, the museum's director, not knowing whether she will have a museum to direct. Force looks out at the viewer with her arms crossed and a grim expression on her face, reflecting her tenuous position.

On either side of the central staircase, Stettheimer inserted members of New York's commercial art world. At the foot of the stairs, Alfred Stieglitz, draped in his dark, mysterious cloak, gazes up at the exhibition halls of Metropolitan Museum, which was the antithesis of what he exhibited in his gallery. On either side of the carpet runner, clusters of art dealers, gallery owners, and other prominent art world figures line the steps. At lower right, Marie Sterner struggles to hold a classical bust by Elie Nadelman, whose work she showed in her gallery. Her prominent placement in front of the other gallerists was likely to acknowledge her giving Stettheimer her first exhibition and to mark her as one of the first women gallerists in New York.[43] Directly behind her, Monroe Wheeler, director of publications at the Modern, holds three colored balloons bearing artists' names, waving them vigorously in front of viewers' eyes as though distracting us from the Metropolitan's collections behind him. He checks his watch with a worried expression and is partially restrained by an unidentified masked man who holds onto his shoulders, unable to "see" any art at all. Behind them, Charles Demuth looks sternly and directly out at the viewer.

On the left side of the staircase, Julien Levy stands at the bottom of a group of art dealers, gazing toward two balloons he is holding. One is inscribed "Dalí," referring to the Spanish artist's painting *The Persistence of Memory*, which generated great publicity when Levy sold it to a donor, who then gave it to the Modern in 1934. A major competitor of Levy's, Kirk Askew, Jr., stands with a hand on Levy's shoulder. He, too, holds a balloon, but instead of bearing a name it contains the picture of a flower, possibly representing Stettheimer's work. Behind Levy stands his wife, Constance, who holds a balloon bearing the image of a red-jacketed white rabbit. Like Stieglitz, both art dealers promoted contemporary art and constantly asked Stettheimer to show with them.

Stettheimer placed the figures of the artist Tchelitchew, critic McBride, and director/curator Chick Austin on either side of the columns in front of the Metropolitan Museum's grand stairs. On the right, McBride stands erect, his elbows pressed tightly against his suited torso. An art traffic cop, he mediates the politics taking place behind him by holding flags inscribed with the words "Go" and "Stop." Like McBride, Austin was not involved in the politics of New York museums, and stands cavalierly with his hands folded, amused by the antics of the scene. Finally, Tchelitchew[44] is half hidden by the huge column at left and anxiously waves as if trying to get anyone involved in the scene to notice him.

*The Cathedrals of Art* endures as a uniquely perceptive portrait of art-world infighting before the three art museums settled into their own separate existences. The painting lays bare the insularity and self-consciousness of the New York avant-garde as salon society slowly dissolved and the art world aligned itself with the major art institutions. Over the next few years, negotiations among the three art museums fizzled, and many of the painting's major players died or disappeared from public view. All the same, Stettheimer continued to work on the painting until six weeks before her death, and it remains unfinished.

In March 1942, Stettheimer visited the Henri Rousseau exhibition at the Museum of Modern Art and was scandalized at how many people were smoking so close to the paintings. She stopped by Tchelitchew's studio to see what she felt was his "chef d'oeuvre," *Hide and Seek*, which the Modern had recently acquired. When his exhibition opened that October, Stettheimer called it "very impressive—even grandiose." She even wrote the artist a short poem:

Dear P  
Your show at the Museum  
is overwhelmingly you  
your mountainous thoughts  
your fountainous talk  

your leafy gestures  
Are you keeping  
your skyey laughter  
and flowery accolades  
for paradise?[45]  

Some critics attacked the painting *Phenomena*, but Stettheimer praised it and was horrified when an "uncouth schoolgirl with the rubber and metal end of her pencil double scratched across part of the painting." She ruefully acknowledged, "I don't know whether there was real damage to the picture—there has been to my enthusiasm for exhibitions which is not very great anyway."

In December 1942, she attended the opening of the *Twentieth-Century Portraits* exhibition at the Museum of Modern Art, where she was pleased to see her two entries, *Ettie* and *Duchamp & Rrose Sélavy*, "very well hung on the wall of my choice." The museum's senior curator, Monroe Wheeler, organized the exhibition in various loose categories—"Eakins and the Eight," "Late Impressionism," "School of Paris" (Picasso, Matisse, and others), "Self-Portrayal," "Professional Portraitists," and "The Poetical Tradition"—which encompassed an eclectic group of artists besides Stettheimer, including Ensor, Rousseau, Redon, de Chirico, Chagall, Duchamp, Dalí, Ernst, Grosz, Delvaux, Tchelitchew, and Hartley. Wheeler was puzzled by what he called her "primitive" manner despite her being "an artist of great culture," but was nevertheless perceptive about her work:

> Perhaps she pretends to be simple or encourages a reputation of slight eccentricity to keep out of the critical limelight and the debating of aesthetics. Her art has been a private commemoration of the enjoyments of a lifetime in the circle of her family and friends. From picture to picture she has continued her account of things, like an album or a diary. To criticize or catalog it properly would require a knowledge and iconography of almost all the artistic side of New York life in the last three decades. . . . Perhaps it is incorrect to call this a poetical art; it is rather like a novel and in a way . . . it makes one think of Marcel Proust.[46]

On January 1, 1943, Ettie gave a party to celebrate her portrait's exhibition, inviting Wheeler along with the Askews, Duchamp, Tchelitchew, George Platt Lynes, O'Keeffe, and others. But by January 8, Stettheimer was in a great deal of pain, and a doctor was called to take X-rays and perform other tests. She complained in her diary, "Pain in my chest now for some time—Dr. says it's nothing, but he hasn't the pain."

On January 8, 1943 a Dr. Lincoln came to see Stettheimer and arranged for a Dr. Pond to take X-rays and fluoroscope her again. The next day another doctor, Dr. Goodrich, persuaded the artist to go to the hospital. During this second hospital visit, in February, she had surgery and was diagnosed as having cancer for which, at the time, there was no cure. Her sisters took a room at the hospital, and Ettie wrote letters reassuring their friends that "she has been wonderful & the Drs. are encouraging & Carrie and I are hoping for the best." Stettheimer was less optimistic. Considerably weakened and very heavily sedated with painkillers, she summoned Joseph Solomon to the hospital and surprised him by saying, "Joe, there is one thing I'd like you to do if and when I pass away. I would like my paintings destroyed." The idea shocked Solomon, but feeling that she was not aware what she was saying, he assured her that he would, later stating:

I find that when a person makes up his or her mind that that person has probably given considerable thought, so I said, OK, I'll follow your wishes; it was a shock and I could not tell Ettie or Carrie what those wishes were because, after leaving the hospital, I decided that her statement was undoubtedly made as a result of the painkillers; and that I would wait until I returned with the actual will to see what her actual decision was. Hopefully, at that time of signing, she would be more aware of what she was saying.[47]

Solomon decided that as he knew that Stettheimer "had often stated she wanted her paintings donated as a collection to a single museum, I believed what she said about wanting her painting destroyed was not necessarily what she really wanted but was directly influenced by the pain medication."[48] Therefore, he never shared the request with her sisters, and she never repeated the statement. She stayed in the hospital until she was allowed to move into an apartment next to her sisters' to recuperate. Eventually, she recovered enough to be able to escape to her studio. As she noted in her diary, "Returned to this studio home after almost three months in Roosevelt Hospital — & over three at the Dorset — next door to my sisters — I thought of doing *Paradise* last December it [*The Cathedrals of Art*] became *Purgatory* which I have done instead." She continued working on the painting, layering in the colors and adding the identifying features to the many characters.

Apparently, even while she was in this weakened state, the artist and Ettie continued to clash. In an undated letter, Isabelle Lachaise observed that following her operation, Florine looked "a little paler, a little frailer, but quite brave," while Ettie was "caustic as always," and Carrie, "the angel of the house, [gave] comfort and ease to any arguments that might arise."[49]

When Stettheimer finally returned to her studio in July, her painting *Natatorium Undine* fell off the wall in what appeared to her and her friends as an ill omen. She resumed her social activities, dining with Tchelitchew, Thomson, and her sisters, and discussed with Tchelitchew the possibility of appointing as her agent the art dealer Askew, who had requested that she allow him to give her a solo exhibition. Stettheimer's unsent reply gives some indication of her state of mind regarding her recent illness:

> That's a beautiful letter K. dear — both you and Pavlik are showing me real friendship. There is no one's integrity I trust/admire more than yours. Pavlik got going when I confided to him that a very stylish/elegant Exh. had been offered me — so far I have not accepted — altho' it would be very chic, however now that I have had a warning that I am not immortal — and I have made no [blank space] and whether my paintings may/are to disappear with me if a pleasing disposition of them cannot be found . . . I have a few unrealistic ideas in their

future which I should like to tell you about. [The last sentence has a large "X" through it.] When you come back I know I can hope for some understanding and possibly sympathy from you.[50]

According to Solomon, when she first returned home, Stettheimer became very frustrated at not having the strength to paint and depressed at the nature of her illness. This passed, and in the fall, Stettheimer and Askew continued discussing the possibility of a solo exhibition at Durlacher Brothers Gallery and of his acting as agent for her work. However, Stettheimer kept returning to the idea of all of her work ending up in a museum as a single collection rather than selling it, and nothing came of her negotiations with the dealer. While her social activities were often curtailed, Stettheimer did attend events when she felt she had a good reason to venture out for the purpose of research for her final work. On New Year's Day 1944, she and her sisters went to An American Place Gallery to congratulate Stieglitz on his eightieth birthday. Although originally she declined an invitation to attend a party at the American British Art Center, Stettheimer went and circulated among the hundreds of people in smoke-filled rooms. She noted that she was very disappointed to find that none of her "'victims' for *Art in America*, I mean *Cathedrals of Art* were there — the reason for my going — to refresh my memory as to their appearances."

Stettheimer's increasing frailty led her to cease lending her paintings to exhibitions. In February, the artist John Taylor Arms asked her to reconsider her decision not to contribute her works to the exhibition *Artists for Victory*, which represented "the best artists in America" and was being sent to England "so that our cousins across the sea may have some greater comprehension of what is being done here." Despite Arms's assurance that "enemy action in transit between New York and London . . . is negligible at the present time," Stettheimer feared that the works would be destroyed during the ocean crossing — a clear sign that she had no intention of having her work destroyed when she died.

Stettheimer's friend Phyllis Ackerman requested a donation of a painting for an exhibition of "distinguished American Paintings" (and an equal number of contemporary Chinese paintings) to be sold to benefit the thousands of Chinese war orphans and the "future of democracy and everything that is opposed to Hitler in this hideously beset world." Stettheimer answered, "My paintings have not been on the market for years — but I am donating [money] with pleasure. The sum, I think the average painting brings nowadays. Please accept my check for your good cause. I have a new painting, *Cath. of Wall Street* — it might amuse you I hope."[51]

On March 16, Stettheimer wrote in her diary, "Dr. Goodrich to see me — same pains . . . Pains persists, burns the skin." On the 27th, she observed, "Came out of hospital a year ago — altho I have pains." In early May, the artist returned to New York Hospital for a final operation. Ettie and

Carrie secured the only double guest room in the twelve-hundred-room facility. From the hospital, they wrote short notes to friends, stating that Florine was "comfortable most of the time, everything that can be done toward that end is being done. She has very good nurses, a good room and a great deal of medical attention." Solomon visited her daily, holding her hand and talking of things "of no great consequence."

Even Parker Tyler stated that Stettheimer's "uppermost wish was to keep her oeuvre perfectly intact as a legacy to the world, with the hope of finding a suitable setting for it as a suite of some museum, which would also display the furnishings of her studio."[52]

Stettheimer told Solomon that she wanted to revise her final will, realizing that it might not prove possible to find one museum to take all her paintings and furnishings as a collection. In her final will, Stettheimer bequeathed everything to her two sisters, with the understanding that "they knew what she wanted done with her artworks."[53] She signed the revised will, and at 11 p.m. on May 11, 1944, shortly after her sisters retired to their room, Stettheimer passed away, with only Joseph Solomon as company.

Solomon handled the funeral arrangements, including, at Stettheimer's request, a non-religious private service in the sisters' apartment at the Dorset. It was officiated by Algernon Black, the leader of the New York Society for Ethical Culture.[54] Georgia O'Keeffe, rather than Ettie, gave the eulogy. In it, she declared that Stettheimer "was like her work. Her work was like her . . . Florine made no concessions of any kind to any person or situation . . . [She] put into visible form in her own way something . . . a way of life that is going and cannot happen again, something that has been alive in our city."[55]

Rather than join her family members in the family plot, Florine directed in her will that she be cremated — apparently preferring to be separate from her family even in death. Ettie did not attend Florine's cremation on May 11, 1944, at the Plaincliff Cemetery in Hartsdale, New York, but had Solomon witness it. Sometime after this, Ettie directed the lawyer to hold the ashes at the Universal Chapel until she decided on their eventual disposition. Just six weeks later, while dining with Ettie at their Hotel Dorset apartment, Carrie experienced a pain in one eye, what the women called an "eye-migraine," and went to lie down in her room. When Ettie looked in on her moments later, Carrie was in a coma. She died within two hours without regaining consciousness. Although both sisters had handled Florine's death with what McBride termed "staunch" and "resolute" courage, Ettie was distraught at Carrie's death, as she and Carrie had grown very close during the years since Florine's "desertion." At Ettie's direction, Carrie was interred in the Walter family plot in Salem Fields, Brooklyn, alongside her aunt Josephine and her mother. In keeping with her lifelong dislike of publicity, Ettie did not want the newspapers to run any obituary for her sisters,

something that struck some of their friends as rather odd. In the end, because of the fame and visibility that Florine's artwork had received during her lifetime, the *New York Times* nevertheless ran a short obituary stressing Stettheimer's participation in *Four Saints in Three Acts* and her portraits of many "well-known people."

Months prior to her passing away, arrangements had been made for Stettheimer to include her *Family Portrait II* in the largest, most significant exhibition in the Museum of Modern Art's short history. Titled *Art in Progress*, it was the museum's fifteenth-anniversary exhibition, and it opened less than two weeks after her death. Organized by Monroe Wheeler, the exhibition filled the entire museum. There were 134 artists included in the paintings, sculpture, and prints section, only six of whom were women. Stettheimer and O'Keeffe were the only twentieth-century women among them.[56]

The news of her death brought an outpouring of sadness and declarations of the singular importance of Stettheimer's art. On May 13, just two days after her passing, Van Vechten wrote to Ettie and Carrie:

> Knowing that Florine is not here anymore will seem very tough indeed but her bright, individual and important art remains. To keep us aware of her always. She was and is, I have always believed, one of the greatest of modern painters and I hope that before many months ago by all of her best work can be brought together and shown.[57]

A month later, Ettie invited Van Vechten to her sister's studio, offering him a choice of anything he wanted. Among the works he chose was a very early painting, apparently over a carte de visite, said to be painted by Stettheimer at eight, of a baby on a cotton handkerchief, as well as the *Portrait of Duchamp* and *Liberty/New York*.[58] Afterward, he wrote to her:

> I am more and more impressed with the importance of the pictures themselves. The best ones are GREAT: no doubt about it, and the lesser ones are expressive of an extremely original personality. To my mind the picture called *Heat* . . . is the masterpiece, but there are many others which approach it.[59]

Duchamp also wrote a letter offering Ettie his assistance:

Dear Carrie, Dear Ettie

I didn't know until this morning about the death of Florine — I want to apologize for my lateness in sending you my profound sympathy in learning the sad news. You know how much admiration I had for her painting and her attitude in general and so can therefore

understand how hard I am hit by this new sadness. I knew that she had been very ill this past year but I knew nothing about her in recent months—Virgil in the last two months did not seem alarmed by the state of her health. Is there something that I can do (to help) in the area of her paintings in terms of her will? You would be very kind to let me know when I can come and see you both—I do not have the ability to get a telex, but you can send me a telex when you prefer for me to come visit you.

With my affection to you both, Marcel Duchamp[60]

Duchamp held a number of meetings with McBride and Askew to discuss mounting a retrospective of Stettheimer's work. Duchamp contacted Wheeler, who had been named director of exhibitions at the Modern, urging him to allow them to organize an exhibition.[61] Wheeler agreed, and the friends set about making plans. Duchamp put together a preliminary list of works to be included, but he soon had to return to France and the others had to keep him informed of their progress through the mail.

Although the men consulted Ettie about the exhibition, according to Solomon, she "showed no great enthusiasm," claiming that her chronic asthma kept her too weak to participate. In July 1944, Wheeler wrote to Ettie, suggesting that she contribute two thousand dollars to commission a "definitive study" of Stettheimer by the Chicago art historian and scholar Edgar Wind for the exhibition catalogue; Ettie declined. Instead, a year later, at the men's continued urging, she finally agreed to pay five thousand dollars toward a chatty essay by McBride that did little to advance the artist's reputation. In addition, Ettie demanded the right to edit the essay, once more controlling her sister's legacy.[62]

The exhibition, which opened on October 1, 1946, was the museum's first full retrospective of a woman artist. Moreover, it was the only major museum exhibition of another artist ever curated by Duchamp. Later, discussing the exhibition, Duchamp wrote of Stettheimer:

Besides my personal admiration for her work, I think her large allegories of New York as well as her family scenes and her portraits deserve to be shown to the public . . . a New York painter, she was among the first artists who, twenty-five years ago, helped build up the "school" of New York.[63]

The evening before the opening, the Museum of Modern Art held a private viewing for the artist's friends and family. New York Governor Nelson Rockefeller and his wife invited Ettie, Joseph Solomon and his wife, and the Van Vechtens to a private dinner at the University Club before the opening. Ettie sent her apologies, claiming to be following a "directive from her doctor": "I feel

that I should be spending it with the paintings themselves." The weather was terrible, just as it had been the evening of the opening of the *Four Saints* opera, but strong attendance made the exhibition a great success. It then traveled to San Francisco's De Young Memorial Museum where, after its closing, Wheeler's assistant wrote to Ettie, saying that the De Young Museum had told him that "the exhibition was an enormous success . . . upon checking the attendance, we find that our records show a total of 31,311."[64] The exhibition subsequently opened at the Arts Club of Chicago, where attendance reached such high numbers that the Club's president, Rue Winterbotham Shaw, sent Wheeler a telegram, saying: "Stettheimer Exhibition so successful in Chicago would like permission to extend another week through Saturday first. Please wire collect if this can be arranged."

When *Art News* magazine gave the Stettheimer exhibition only a single-paragraph review, the artist's friends were furious, and Wheeler's partner, Glenway Wescott, wrote to the editor, chiding him:

> Like it or not, [Stettheimer] had originality which in the pictorial art of our country is rare and important . . . [Her works are] finer in their way than any twentieth-century work except Bonnard's; and in fact her way was not unlike his . . . [Stettheimer's work is] lasting, and it appeals to one's imagination, if one has any, and gratifies the sensuality of the eye, if one's eye is sensual.[65]

High praise for the exhibition, and the offer of help in placing her work in museums, unexpectedly came from lawyer and philanthropist James N. Rosenberg, who wrote Ettie, "The Florine show is thrilling. Marks her, I think, as one of the outstanding creative artists of the last half-century. Her works ought to be in every important museum here and abroad. I'd like to help to that end should that be possible." Ettie answered that Askew was already helping with this.

There was an outpouring of letters expressing sorrow at Stettheimer's death and praise for her paintings. Tom Mabry, a former curator at the Modern, wrote Ettie:

> Beyond my personal loss, I know that the country — our country — has lost one of its very few original painters. Florine's painting was a delight — but more than that it is in a great tradition and has contributed something priceless to our American "culture" — so few will know what the country has lost by her death! And she who was so modest (in the best sense . . .) and so far beyond most of us, will go on living in her paintings.
>
> They will never die . . .

Over the next four or five years, a number of museums — including those at three prominent women's colleges, Vassar, Wellesley, and Smith — held Stettheimer exhibitions, and the Detroit Institute of Art organized an exhibition of fifteen of her paintings. Ettie felt increasingly burdened

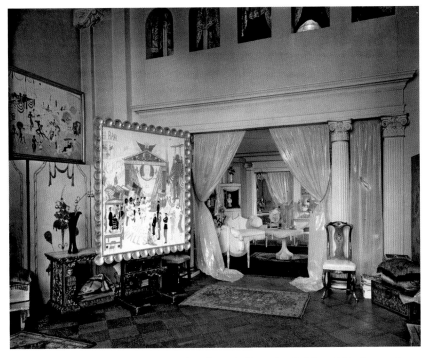

**Fig. 119** Peter A. Juley & Sons, Stettheimer's studio at the Beaux-Arts Building, 1944, photograph, Rare Book and Manuscript Library, Columbia University in the City of New York.

as the executor of her sisters' artworks: "Since my sisters died, six years ago, I have spent a great deal of my time and my flagging energy in preparing their production for presentation and a chance of survival."[66] She began arrangements with Solomon to have Carrie's dollhouse donated to the Museum of the City of New York.

Before anything was removed from Florine's studio, Ettie and Solomon arranged for the same company that Stettheimer had used over the years, Peter A. Juley & Son, to photograph the studio rooms. (*Fig. 119*) However, completely ignoring what she knew were her sister's lifelong wishes, Ettie allowed Askew of Durlacher Gallery in 1948 and 1951, and Knoedler & Co. in 1949, to organize exhibitions, including the sale of a number of Stettheimer's lesser floral paintings. Ettie asked McBride, Askew, and Van Vechten to assist her in setting prices.[67] Over the next year, they priced a few of the paintings at far lower prices than the artist had ever asked for her work—between six hundred dollars for smaller flower paintings and fifteen hundred dollars for the larger, more complex ones.[68]

Distracted by her recurring asthma, Ettie left the disposal of the rest of her sister's work entirely to Solomon.[69] He attempted to get several institutions to take Stettheimer's oeuvre as a single unit, but as she had anticipated, he had no success. Over the next decade, Solomon donated all but three of Stettheimer's mature paintings and her early childhood and academic paintings to important museums across the country. All were accepted into the museums' collections, where they remain.

*Picnic at Bedford Hills*, given to the Pennsylvania Academy of the Fine Arts, was immediately reproduced on the cover of the museum's annual report and described as "one of the most important acquisitions of the year."[70] Solomon gave the four *Cathedrals* paintings to the Metropolitan Museum of Art. *Family Portrait II*, the large early chinoiserie screen *Le Jeu*, the four-sibling screen,[71] and the maquettes for *Orphée* went to the Museum of Modern Art. He gave *Soirée*, *Portrait of Carl Van Vechten*, and *Christmas*, as well as all her diaries, handwritten poems, and correspondence, to the Beinecke Rare Book Library at Yale University.

Around 1970, Solomon donated to Columbia University's Butler Rare Book & Manuscript Library all of the dolls and maquettes for *Four Saints in Three Acts* and *Pocahontas*; Stettheimer family scrapbooks; Florine's childhood artwork and her work from her days at the Art Students League; much of the work she exhibited at Knoedler in 1915, including *Family Portrait I*; and the highly significant *A Model (Nude Self-Portrait)*. Strangely, he also donated three fully mature paintings which, unlike the family portrait and the nude self-portrait, she publicly exhibited: *Portrait of Myself*, *Portrait of My Sister, Ettie Stettheimer*, and *Portrait of My Sister, Carrie W. Stettheimer* of 1923. All of these paintings were given to Columbia's Art Properties department because the artist's aunt Josephine and Ettie graduated from that university.

At the time, Solomon made an agreement with the president of Columbia that the university would create a room to permanently display the paintings. To facilitate this, Solomon also donated $130,000 from Ettie's estate, as provided for in her will (the original amount was $75,000, but Solomon increased the principal by investing it in IBM stock), as maintenance for the works. Unfortunately, the gallery was never built, and for decades, the works remained in the university's basement. In a tragic move, all of the furniture that Stettheimer designed, including those pieces that were intended to be installed with the matching frames for her paintings, was given to Colombia's theater department, where it was used, repainted, and reconfigured for various productions. All of Stettheimer's furniture was therefore eventually destroyed.

Despite entreaties from friends and advisers, Ettie went through Florine's papers and diaries, destroying any references she felt were private and did not relate to her sister's work. While doing this, Ettie discovered the many witty, caustic poems Stettheimer had handwritten over the years on various scraps of paper. Ettie retyped them, edited some, and then had them privately published in a limited edition of 250 in 1949. Intended as a "souvenir for her sister's friends and the friends of her painting," the book was titled *Crystal Flowers* at the suggestion of Van Vechten. The poems stirred a second outpouring of letters eulogizing Stettheimer and commenting on her poems as demonstrating her freshness of approach, her perceptiveness tinged with irony, and her watchful, outsider attitude.

One friend astutely noted:

As I read Florine's playful verses, I could not avoid a feeling that a highly sensitive personality wished to conceal herself behind the simple swing of the rhythm, as she felt compelled to look at the artificialities of our time as a perpetual Carnival, played for her benefit by friend and foe. An enviable outlook, especially in our pessimistic age, which made her life, pictures and poems a unique adventure.[72]

Her cousin Herbert Seligman wrote:

There is so much of your sister in this book. The quick, ironic, penetrating spirit, dazzling often in its immediacy—manifest to me in the few times I saw her and, in the glimpses, I was privileged to have of her paintings.[73]

Tom Mabry wrote to Ettie:

[*Crystal Flowers*] brings Florine back terribly vividly that it fairly makes me cry. And of course the material inside is so essentially Florine: that laconic description and unexpected progression of simile.[74]

A few readers saw the biting wit in Florine's poems, including Donald Gallup at Yale's Beinecke Library:

They are so like her paintings, with the same kind of delicacy and brilliant sophisticated wit, and yet with the freshness of seeing things with new eyes stripped of all the dreary pomp and worldly circumstance. But my how cruel she could be! As in the poems on the collecting habits of the "cocktailedly" who hang whatever the picture merchants sell them on their walls.[75]

Mark Pagano, who worked on the exhibition at the Modern, aptly described the poems as "made of glass—and they have razor edges and needle points—but they have smooth velvety places to touch too. Have they made Florine come alive!"[76] One of the most poignant comments came from Alfred Barr, Jr., who wrote that the poems "make me wish I had known her better."[77]

*chapter eleven*

# EPILOGUE

"It is difficult for a woman to define her feelings in language
which is chiefly made by men to express theirs."

—Thomas Hardy, *Far from the Madding Crowd*

The 1946 Stettheimer retrospective exhibition curated by Duchamp was a great success at all three venues, and all of the museums that were offered gifts of her work welcomed them into their permanent collections. However, within a few years Stettheimer's paintings disappeared into all of the museums' basement storage rooms, where they largely remained unseen for decades. The immediate reason for their disappearance was the radical change in artistic tastes during the years following World War II. Virtually overnight, critics and the cultural avant-garde lost interest in most modernist work, particularly Stettheimer's feminine, theatrical, figurative painting, turning instead toward the male-dominated, ruggedly individualistic styles of Abstract Expressionism.

When Ettie allowed Florine's flower paintings to be offered up for sale by Durlacher galleries in 1951, the critics observed that the exhibition created "a nostalgic atmosphere of the past, a past not so remote in time as remote in its gaiety of life from the disturbed, anxiety-ridden world of today."[1] Another critic added, "Nothing could have been less in sync with the industrial-strength seriousness of postwar American painting than the froufrou, gilt and needling little ironies of Stettheimer's style."[2] By the time Parker Tyler's biography of Stettheimer was published in the early 1960s, her style was also at odds with the ascent of minimalism by artists such as Donald Judd, Sol LeWitt, and Frank Stella. If an artist's work is never on view in museums or galleries and never given the blessing of the art market—which later drove the public recognition of her contemporaries Georgia O'Keeffe and Frida Kahlo—her name disappears from public consciousness.

An exception occurred a decade later when Henry Geldzahler, a curator of American art at the Metropolitan Museum of Art, became interested in Stettheimer as "a protégé of Marcel Duchamp and that sort of New York City avant-garde culture."[3] In the early 1960s, believing Andy

Warhol would enjoy Stettheimer's work, he decided to show him her four paintings stored in the Metropolitan Museum's basement. When the curator visited his apartment, Warhol remembered Geldzahler remarking, "We have paintings by Florine Stettheimer in storage at the Met. If you want to come over there tomorrow, I'll show them to you." Warhol recalled being "thrilled. Anyone who'd know just from glancing around that one room . . . that I loved Florine Stettheimer had to be brilliant."[4] The next day, Geldzahler showed Warhol the four *Cathedrals* paintings. Warhol would go on to tell friends that Stettheimer was his "favorite artist."[5]

It makes sense that Warhol responded warmly to Stettheimer's paintings. They both enjoyed being of their time and making art that found humor in, and expressed, the prevalent moods of life in their contemporary New York. They each therefore used their work to capture many of the significant events taking place around them and celebrated the avant-garde as well as popular culture. Using bright, often primary, colors and images from popular media and advertisements, both artists painted portraits of their friends, famous figures of their time, and political subjects. Each did so by creating a singular, idiosyncratic style.

In 1969, Warhol was invited to organize an exhibition, *Raid the Icebox*, comprised of objects from the Rhode Island School of Design Museum's collection. He visited the museum's storage areas and selected a particularly diverse group of some 404 objects in eleven categories: almost two hundred pairs of shoes, fifty-six parasols, twenty-three jars and vases, and twelve types of wallpaper, covering many centuries and cultures. There were only forty-four signed works; only two were by women. One of them, which Warhol photographed with his Polaroid camera as it lay in its storage bin, was Stettheimer's *Bouquet for Ettie.* (*Fig. 120*) The exhibition, including the painting and Warhol's Polaroid of it, traveled to several small museums but did not receive much public attention.

Henry Geldzahler also showed the *Cathedrals* paintings to other artists, including Jasper Johns, who had seen and liked Stettheimer's work at the 1965 Durlacher Brothers Gallery exhibition in conjunction with the publication of Tyler's biography.[6] The same year, Geldzahler included Stettheimer's work in his exhibition *Three Centuries of American Painting* at the Metropolitan Museum. In the catalogue Geldzahler produced in conjunction with the exhibition, he compared Stettheimer to Warhol, writing that her paintings were "prophetic of concern with Americana that is shared by a number of painters in the nineteen-sixties."[7] But the *Cathedrals* paintings returned to the museum's basement immediately after the exhibition closed.

Stettheimer's work largely remained out of public sight for the next decade and a half. In 1973, Columbia University's art properties department received the remainder of the estate from Joseph Solomon and held a small exhibition of the donated paintings in its Low Library. Solomon wrote the preface to the small catalogue accompanying the exhibition, describing Stettheimer as "the

**Fig. 120** Andy Warhol, *Untitled* (*Bouquet for Ettie* by Florine Stettheimer on storage rack), 1969, Polaroid Polacolor, 3 ³⁄₁₆ × 2 ⅞ in., Rhode Island School of Design Museum, Gift of J. Malcolm and Clarice S. Grear.

sophisticated American primitive . . . hypersensitive and shy," continuing the influence of Tyler's misrepresentations of the artist. The curator, Jane Sabersky, by contrast, perceptively observed in the catalogue that Stettheimer was "a unique figure in American painting" who was "very much her own person and succeeded in fashioning an art that is not only contemporary in idiom but distinctly personal" and "rooted in her direct experience."[8]

It was Linda Nochlin and Ann Sutherland Harris's groundbreaking 1971 feminist exhibition, *Women Artists, 1550–1950*,[9] which brought about Stettheimer's first true revival. The first international exhibition of art by women, it included Stettheimer's work among that of eighty-three artists from twelve countries, and it traveled to Los Angeles, Pittsburgh, and New York. It was based on Nochlin's 1971 essay in *ArtNews*, "Why Have There Been No Great Women Artists?"[10] The artist Barbara Zucker subsequently wrote an influential article on Stettheimer for the same periodical.[11] Nochlin's 1980 essay "Florine Stettheimer: Rococo Subversive" provided a brilliant, in-depth exploration that gave rise to a cult following, particularly among gay men, women artists, and members of the Pattern and Decoration movement, including Robert Kushner, Joyce Kozloff, Thomas Lanigan-Schmidt, and Miriam Schapiro. But as her *Nude Self-Portrait* and *Bathers* were both still unknown

to the public (the former introduced in 1995 and the latter in this publication), Stettheimer's work did not fit within the essentialist, explicit imagery of the first generations of feminist artwork, and it soon disappeared again from public view. Even among later books on women artists, until very recently, Stettheimer's work was typically not included.

A decade and a half later, in 1995, both the publication of the author's book *The Life and Art of Florine Stettheimer* and co-curating the Whitney Museum of American Art's retrospective exhibition *Florine Stettheimer: Manhattan Fantastica*[12] prompted a second revival of interest in the artist. One reviewer, who called the retrospective "dazzling," observed, "[Stettheimer's] achievement was to produce some of the most original and satisfying works of early American modernism."[13] The exhibition gained positive national media attention, appearing on the cover of *ArtForum* magazine, which declared it "one of the best exhibitions of the year."[14] However, virtually every reviewer returned to Tyler's book on Stettheimer and mentioned that the artist had wished to have her paintings "destroyed at her death" and that "her sister Ettie saved them."

Several related events took place that year: the gallery owner Jeffrey Deitch, his associate Jeannie Greenberg, and the author organized a "Florine Stettheimer Salon" in a Gramercy hotel room as part of the Armory Art Fair. Inside, they installed cellophane curtains and the works of a few artists, including Kiki Smith and Richard Green, who claimed their work was inspired by and resonated with Stettheimer's. A series of related lectures took place in that space. In addition, New York's Holly Solomon Gallery also opened an exhibition titled *Love Flight of a Pink Candy Heart: A Compliment to Florine Stettheimer*, curated by Michael Duncan. Along with three early Stettheimer works, this exhibition included the work of twenty contemporary artists who felt an affinity with her painting. As Duncan noted:

> History is revised in complicated ways. Florine Stettheimer — an artist seemingly fallen into obscurity — has had over the years her own acolytes and secret admirers. Although Stettheimer's luscious and startling paintings have only occasionally been exhibited since her 1945 MoMA retrospective, they have had a surprising impact on several generations of iconoclastic artists.[15]

Except for the *Cathedrals* paintings, which have been on permanent view in the Metropolitan Museum's modern art wing since the 1990s, most of Stettheimer's paintings again returned to museum basements.

As recently as 2018, one of Stettheimer's most simplistic works, *Portrait of Father Hoff*, was misguidedly included in an exhibition titled *Outliers and American Vanguard Art* at the National Gallery of Art.[16] The exhibition's theme was the exploration of work by "self-taught artists — variously

termed folk, primitive, visionary, naïve, and outsider," and other artists who "found affinities and inspiration in the work of their untutored, marginalized peers and became staunch advocates, embracing them as fellow artists." The inclusion of Stettheimer's work again ignored her extensive academic art training and reflects a lack of close, careful study of her paintings. Even using the term "faux-naif" immediately prevents Stettheimer's work from being taken seriously. Even during her lifetime, Henry McBride specifically differentiated her work from that of self-taught artists, the latter stating, "although she took all the license of a primitive she was by no means one herself. Her "line" was a draughtsman's line, calligraphic, like so much of the best modern "line," and never to be accused of fumbling…her figures [are] not static, all of which tends to be true of naïfs."[17] Nor, as has been discussed throughout this biography, was Stettheimer ever interested in the work of folk or so-called "primitive" artists, but took her inspiration from Old Master paintings, Post-Modernists such as Matisse and, most importantly, the innovative performative *Gesamtkunstwerk* of the Ballets Russes.

We are now in the midst of a third, and more sustained, Stettheimer revival. In 2015, Stettheimer's first European retrospective opened at Munich's Städtische Galerie. Its catalogue included the first full-page color illustrations of many of her paintings, along with essays by international art historians and artists. It was also the first museum exhibition to include key early paintings such as *Jenny and Genevieve* and *Nude Self-Portrait*. During the last decade, Irene Gammel and Suzanne Zelazo, two professors at Ryerson University in Toronto, have held seminars on Stettheimer and her work. In 2010, they reprinted *Crystal Flowers*, including a large number of poems left out of the original publication, which they annotated, and the libretto of her *Orphée* ballet. In 2017, they organized a symposium, "Florine Stettheimer's Multimodal Modernism," furthering scholarship on Stettheimer in Canada.[18] Gammel and Zelazo edited the essays from the seminar and published them as *Florine Stettheimer: New Directions in Multimodal Modernism* in 2018. That same year, New York's Jewish Museum and the Art Gallery of Ontario jointly organized *Florine Stettheimer: Painting Poetry*, an exhibition displaying forty of her works. As we move into the third decade of the twenty-first century, museums are progressively including Stettheimer in exhibitions exploring the work of women modernists.

Stettheimer's work also received significant new visibility and audiences with the October 2019 reopening of the Museum of Modern Art. Its expanded spaces included an entire new gallery dedicated to "Florine Stettheimer and Friends." This was the first time since the 1946 retrospective that the museum paid the artist any significant attention, causing an outpouring of positive critical and public excitement about Stettheimer's work. MoMA conserved and exhibited Stettheimer's 1911–12 brightly gilded sibling screen. (*Fig. 121*) The costumed bas-reliefs, three-dimensional figures,

**Fig. 121** Author photograph of Gallery 509, *Stettheimer and Company*, Museum of Modern Art, New York, New York, December 2019.

colorful gouache and metallic paintings, and several drawings for her ballet *Orphée des Quat'z-Arts* also made their MoMA debut. The gallery also contained both of MoMA's important Stettheimer paintings, *Family Portrait II* and *Portrait of My Mother*.

Despite this rediscovery of Stettheimer's work, the much larger issue of gender continues to marginalize her work, as it negatively impacts all but a very few women artists today. Sexist descriptions of Stettheimer as shy and an amateur, "lack[ing] the competitive feeling," persist in descriptions not only of her, but of many past women writers, artists, musicians, scientists, etc. and are only fully being revised today due to #MeToo and other contemporary women's movements.[19] Even during her lifetime, the acclaim Stettheimer received for her work was often put in relation to her gender rather than in comparison with her contemporaries as a whole. As Rosenfeld noted:

> At the gatherings one also made the acquaintance of Florine Stettheimer's work. It hung on the walls, stood on the easels . . . and sitting before these pictures probably more than one musing art-lover reached the conclusion that the painter was one of the most talented and individual artists of her sex that have appeared in English-speaking lands.[20]

In the same article when comparing her to another woman artist, he remarked:

[Stettheimer was not] assailed by any selfish utilization of feminine charm such as we associate with some recent French women painters—Marie Laurencin, for example. We meet no affectation here; only truthfulness to a feminine temperament which happens to be uncommon.[21]

Hilla Rebay, who as director of the Guggenheim Museum was one of the first and few female museum directors in the country, noted this decided prejudice by giving Stettheimer the highest praise in explicitly writing to her that she was: "Not the best only of the women painters (which means very little unfortunately), but the man painters also. . . ."[22]

As art historian Linda Nochlin later astutely observed, "For a woman to opt for a career at all, much less a career in art, has required a certain unconventionality. . . . And it is only by adopting, however covertly, the 'masculine' attributes of single-mindedness, concentration, tenaciousness, and absorption in ideas and craftsmanship for their own sake, that women have succeeded."[23] The single-mindedness with which Stettheimer pursued her work was evident throughout her life. She clearly resented almost everything that took time away from looking at or making art. Many writers have described Stettheimer as "virginal" and a "spinster"[24] because she never married and lived with her family until her sixties. However, once one has fully read her diaries and poetry and viewed all of her work in detail, it becomes clear that her feminist gaze included comfort with graphic sexuality. Because she was physically small and slim, some acquaintances, like the photographer Cecil Beaton, remembered Stettheimer as having "a powdery, delicate quality that was delightful."[25] Yet she painted monumental works requiring physical dexterity and strength until six weeks before her death; and whatever her stature and age, she carried out the business required to submit her works to retail and museum exhibitions as a professional artist, without the assistance of gallery staff and managers.

Stettheimer was fully aware of women's secondary place in the world. She believed in the validity of her work and had the confidence in herself and her abilities to succeed without making any allowances. Today, almost a century later, female executives, leaders, and political candidates are still expected to be likable and warm — attributes not expected of their male counterparts — while at the same time professional. Yet it is plainly evident from her diaries, poetry, correspondence, and paintings that Stettheimer was not particularly nice or endearing. She could be outright nasty, even to her friends. She was highly judgmental at the least provocation and made no attempt to be likable. As a wealthy white woman from a family of great privilege, she enjoyed considerable liberty. The Stettheimer sisters were aware that their money and social status provided a unique freedom. Yet unlike her sisters, Florine insisted on working professionally and presenting her work in public.

Stettheimer controlled the theatrical decoration of her salon and the presentation of her paintings to her friends, prior to sending them to exhibitions. She also branded how she would be perceived by the public during and after her life by not allowing herself to be photographed after her forties. In her artwork, she portrayed herself in feminist pantaloons with the accoutrements of an artist. Half a century before Cindy Sherman, Stettheimer inserted her self-portraits in at least

thirty-six of her paintings as both creator and subject, observer and observed; and like Sherman, she revealed femininity to be an effect of representation."[26]

Then as now, artworks by women still represent a small minority of those in museum collections, and art by women sells for a fraction of the amount that male artists' works command on the market. Stettheimer was of the few women artists to be included in major museum exhibitions. However, unlike others such as O'Keeffe, she did this on her own, without the support of a top male gallerist like Stieglitz constantly promoting her artwork and reputation. Nonetheless, Stettheimer exhibited in over forty-six major contemporary museums, salons, and galleries during her lifetime and garnered wide praise from many curators and critics who noted her work was "one of the genuine joys of the exhibition";[27] "an amazingly successful affair";[28] and that "she was one of the few painters "who project an individual point of view on canvas. . . . that also engages us by its human interest";[29] "one of its very few original painters. . . . but more than that [Stettheimer's work] it is in a great tradition and has contributed something priceless to our American 'culture.'"[30] (*Fig. 122*) Juliana Force, director of the Whitney Museum, declared Stettheimer's painting and the artist "the best thing she had seen in America and. . . . [that she was] undoubtedly the best painter in America."[31]

Carl Van Vechten penned one of the most perceptive descriptions of the artist herself soon after her death:

> Florine was a completely self-centered and dedicated person: she did not inspire love, or affection, or even warm friendship, but she did elicit interest, respect, admiration, and enthusiasm for her work in art.[32]

In terms of the long-held idea that Stettheimer was largely "unknown," Henry McBride clarified that "Miss Stettheimer's semi-obscurity was not so much due to the public's indifference as her own,"[33] reinforcing that although most well-known art critics, curators, and museum-going public saw and enjoyed her work, she herself preferred to avoid wide publicity. Stettheimer was "obscure" only in that she particularly disliked the commercialism of the art market, which she ridiculed in her poems:

〜〜〜〜〜〜〜

> Art is spelled with a capital A
> And capital also backs it
> Ignorance also makes it sway
> The chief thing is to make it pay
> In a quite dizzy way
> Hurrah — hurrah —[34]

〜〜〜〜〜〜〜

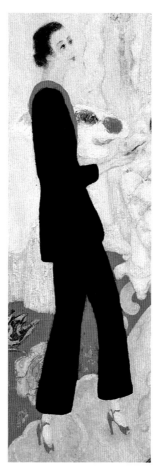

**Fig. 122** Florine Stettheimer, *Family Portrait II*, 1933, oil on canvas, 46 ¼ × 64 ⅝ in., The Museum of Modern Art, New York, Gift of Miss Ettie Stettheimer.

When asked why she didn't sell her work, Stettheimer is said to have exclaimed, "Suppose it were to hang in the bedroom of some man!"[35] Given the countless times over the decades she was asked by gallerists to allow them to sell her work, and knowing her caustic wit, this statement can easily be seen as a mocking answer to a tiresome question.

Creating art was the overarching purpose of Stettheimer's life. She consciously invented a distinctly feminine painting style and turned the male gaze back on itself. Although her earliest mature works centered on her friends and family, during the last decades of her life her subject matter expanded. While her contemporaries chose abstraction and modernist imagery, Stettheimer documented and reflected the experience of wealthy but liberal-minded woman within a distinctly urban New York time and milieu. Van Vechten eulogized her, noting:

> She was both the historian and the critic of her period and she goes a long way toward telling us how some of New York lived in those strange years after the First World War, telling us in brilliant colors and assured designs, telling us in painting that has few rivals in her day or ours.[36]

In 1948, Esther Seaver of the Wadsworth Atheneum noted of Stettheimer's *Cathedrals* series: "By her high keyed palette and her many busy figures and waving flags she conveys the excitement and pace that is New York. Even more the ephemera of fame is suggested by the very stress of surface quality and lack of depth."[37] Betty Burroughs, an art reviewer for the *New York Times*, reinforced that view, writing:

> Florine Stettheimer was in her way a genuine spokesperson of her time. Her pictures . . . become social documents . . . she was impelled to paint the world as she saw it. In fact, as we examine her puckish commentary on the post-World War I follies, we have an uneasy feeling. This may well be where we came in. It is possible to imagine historians of the future turning their backs on the Time Capsule and noting instead the satiric comment (combined with the real footnotes on the life and times that produced them) in Florine Stettheimer's *Cathedral* pictures.[38]

Stettheimer played with art history, taking it apart and starting over by using two dimensions to explore complex concepts like space and time. Her paintings are visual social documents — whether we know the names of the characters, buildings, or events she painted or not. In many ways they most resemble seventeenth-century Dutch genre paintings such as those by David Teniers the Younger and Hendrick Avercamp. Painted at a time before photography, centuries prior to the invention of photography, the Dutch sixteenth- and seventeenth-century paintings are the only visual evidence we have of how individuals (perhaps portraits) of the time and villages lived, what they wore, how they amused themselves, and some of their social issues and moral teachings. Teniers' compositions, in particular, like Stettheimer's, are filled with figures often performing humorous actions. Similarly, Stettheimer was a member of the American "jazz age" of modernism, the first generation to consciously break away from traditional strategies for living and categories of art-making.

Today, as artists increasingly reject being labeled by medium, Stettheimer stands out as one of the first true American artists mastering multiple media. She epitomizes the idea of the *Gesamtkunstwerk* as a painter of innovative style and progressive subject matter; a skillful modernist poet; a highly original designer of integrated, original frames, furniture, and interior design using new, unusual, materials; a librettist; and an internationally acclaimed avant-garde costume and set designer for two ballets and the first American avant-garde opera.

Florine Stettheimer knew that her work was innovative and original and she never compromised it by trying to be anything else. As McBride noted, "Miss Stettheimer knew what she was doing. She had laws of her own and knew them positively . . . She followed her inner impulses with strict

integrity and spared nor time nor labor to realize them."[39] A century later, her paintings, with their bright colors, humor, and feminist inclinations, continue to be and feel highly contemporary. In addition, her subversive, early acknowledgment of identity politics is especially significant and relevant today with its clear assertion that racial equality, condemnation of anti-Semitism, advocacy of gender fluidity and women's independence all have a place in contemporary art as subject matter of monumental paintings.

Stettheimer's friend James Rosenberg, in a letter to William Milliken, then director of the Cleveland Museum of Art, commented:

> I consider Miss Stettheimer's paintings as unique, distinguished and important. I cannot recall another living painter who, without descending to caricature or propaganda, has wit . . . Her color, of course, is superb but her social comments, in those brilliant and beautiful canvases of hers, are like nothing else that I know of, a comment of the life and mores of her generation. . . . It is profound, and in terms of pigment, color, design, drawing has individuality and great direction. . . . Her place in American art is already established and I am confident will become increasingly important as the years go by.[40]

It has taken over seventy-five years since Stettheimer's MoMA retrospective for this, the first biography and full reading of the artist's work, to be published. Now, as "the monolith of modernism is gone,"[41] perhaps it will be easier to recognize and appreciate Stettheimer's innovative and documentary work with its subjectivity, points of social responsibility, and "essential stories. . . . with an extraordinary use of material, scale, ambition, everything, yet anyone may experience, read, grasp, and be part of this art."[42] At the 150th anniversary of Florine Stettheimer's birth, it is time to fully acknowledge her as one of the most innovative and significant artists of the twentieth century, as well as being one of the most relevant to the first decades of the twenty-first.[43]

~~~~~~~~~

Sweet little Miss Mouse
Wanted her own house
So she married Mr. Mole
And only got a hole.

EXHIBITION HISTORY

SOLO EXHIBITIONS

1916 **_Exhibition of Paintings by Miss Florine Stettheimer_**
Marie Sterner, Curator, M. Knoedler & Co. Gallery
New York, New York, October 16–28

1946 **_Florine Stettheimer_**
Marcel Duchamp, Curator, The Museum of Modern Art
New York, New York, October 1–November 17 (cat.)

GROUP EXHIBITIONS
(_During Stettheimer's Lifetime_)

1900 **_25th Anniversary Exhibition of the Arts Students League of New York_**
American Fine Arts Society Building, New York
Listed as a non-resident member

1917 **_First Annual Exhibition of Society of Independent Artists_**
Grand Central Palace, New York
April 10–May 6

1918 **_American Paintings and Sculpture Pertaining to the War_**
M. Knoedler & Co. Gallery, New York
April 19–May 15
Under the Direction of Mrs. Albert Sterner
"The entire proceeds of this Exhibition to be invested in Liberty Bonds"

1918 **_Exhibition of Paintings, Watercolors, Drawings, Etching, Lithographs, Photos and Old Prints of New York City_**
Macbeth Gallery
New York

1918 **_Second Annual Exhibition of the Society of Independent Artists_**
March 12–April 20

1919 **_Third Annual Exhibition of the Society of Independent Artists_**
Waldorf-Astoria
March 28–April 14

1920 ***Fourth Annual Exhibition of The Society of Independent Artists***
Waldorf-Astoria, New York
March 11–April 1

1920 ***Exhibition of Modern Art by Contemporary Artists***
Worcester Art Museum
Worcester, Massachusetts, April 25–May 6

1921 ***Exhibition of Oil Paintings and Drawings Showing the Later Tendencies in Art***
Pennsylvania Academy of the Fine Arts
Philadelphia, April 16–May 15

1921 ***Suggestions for the Decoration of the Fireplace***
Arts Guild Galleries
10 East 15th St., New York, April 11–23

1921 ***First Retrospective Exhibition of American Art***
Fine Arts Society Building
2155 W. 57th St., New York
Under the direction of Mrs. Albert (Marie) Sterner, inaugurating the Junior Art Patrons of America,
May 6–21

1921 ***Fifth Annual Exhibition of The Society of Independent Artists***
Waldorf-Astoria, February 26–March 24

1922 ***Decorative Paintings at the Wanamaker Gallery of Modern Decorative Arts Exhibition***
The Wanamaker Gallery of Decorative Arts, Belmaison Fifth Gallery,
Broadway at 9th St., New York, including February 1922

1922 ***Sixth Annual Exhibition of The Society of Independent Artists***
March 11–April 2

1922 ***Exhibition by Members, First Exhibition of the Modern Artists of America, Inc.***
Joseph Brummer Gallery
43 East 57th St., New York, April 1–30

1922 ***Modern Sculpture, Water Colors and Drawings, at the Colony Club***
Colony Club
New York, April 2–13 (cat.)

1922 ***First Annual Exhibition, No-Jury Society of Artists***
Galleries of Marshall Field
Chicago (cat.)

1922 ***Salon d'Automne, 15eme Exposition***
Jeu de Paume
Paris, November 1–December 20

1923 ***Annual American Exhibition***
The Wanamaker Gallery of Modern Decorative Arts
Belmaison Fifth Gallery, Broadway at 9th St., January 22–February 17

1923 ***Exhibition of Paintings, Watercolors, Drawings, Etchings, Lithographs, Photographs and Old Prints of New York City***
The Wanamaker Gallery of Modern Decorative Arts
Belmaison, Broadway at 9th St., New York

1923 ***Seventh Annual Exhibition of The Society of Independent Artists***
February 24–March 18

1923 ***Second Annual American Exhibition at the Wanamaker Gallery of Modern Decorative Arts***
Wanamaker Gallery
Belmaison, New York, November 8–30

1923 ***Anderson Galleries***
New York, beginning December 5

1924 ***Eighth Annual Exhibition of The Society of Independent Artists***
March 7–30

1924 ***Third Annual Decorative Exhibition in Wanamaker Gallery of Modern Decorative Arts***
Belmaison, New York

1924 ***Twenty-Third International Exhibition of Paintings***
Carnegie Institute
Pittsburgh, April 24–June 15

1924 ***Twenty-Third Annual Exhibition of Modern Decorative Art***
The Art Institute of Chicago
December 23, 1924–January 25, 1925

1925 ***Eighth Annual Exhibition of the Society of Independent Artists***

1925 ***Twenty-Third Annual Exhibition of Modern Decorative Art at the Art Institute of Chicago***
December 23, 1924–January 25, 1925

1925 ***Chicago Women's World's Fair***
Chicago Arts Club
April

1926 ***Ninth Annual Exhibition of the Society of Independent Artists***

n.d. ***"Exhibition at Mrs. Brumback's 12th Street Gallery"***
Mrs. Brumback's 12th Street Gallery
February 18–March 5 [n.d.]

1929 ***One Hundred Important Paintings by Living American Artists***
Arts Council of the City of New York, Architecture and Allied Arts Exposition
at the Grand Central Palace, April 15–27

1932 ***Exhibition of the American Society of Painters, Sculptures, and Gravers***
The Whitney Museum of American Art
10 West 8th St., New York, February 6–28

1932 ***First Municipal Art Exhibition***
Rockefeller Center, New York
Sponsored by Mayor Fiorello LaGuardia

1932/33 ***First Biennial Exhibition of Contemporary American Painting***
The Whitney Museum of American Art
10 West 8th St., New York, November 22, 1932–January 5, 1933

1934/35 ***Fifth Anniversary Exhibition: Modern Works of Art***
The Museum of Modern Art
New York (cat.), November 20, 1934–January 20, 1935

1935 ***American Painting and Sculpture of the 18th, 19th & 20th Centuries***
Wadsworth Atheneum
Hartford, Connecticut, January 29–February 19

1935 ***Exhibition of Women Artists from Five Different Nations***
Marie Sterner Sterner opened her gallery in 1923 and she may have included Stettheimer in other exhibitions but to date I have not been able to find definitive information on her gallery exhibitions.

1938 ***Trois siècles d'art aux États-Unis (Three Centuries of American Art)***
Exhibition at the Musée du Jeu de Paume, Paris
Organized by the Museum of Modern Art

1938 ***Fantasy in Decoration exhibition***
New York
(including Juliana Force, Tchelitchew, Hattie Carnegie, Richardson Wright, Stark Young, Helen Hayes, Lynn Fountain, etc.)

1939 ***Art in Our Time***
The Museum of Modern Art
New York

1940 ***Exhibition***
(highlighting all the past performances at the Wadsworth Atheneum)
Organized by Chick Austin, the exhibition opened around October 20, 1940.

1942/43 ***Twentieth Century Portraits***
The Museum of Modern Art
New York
Organized by Monroe Wheeler (cat.)

1944 ***Art in Progress: Fiftieth Anniversary Exhibition***
The Museum of Modern Art
New York (cat.)

NOTE: A STETTHEIMER EXHIBITION HISTORY THROUGH 2022 (INCLUDING WORKS IN EACH EXHIBITION WHEN POSSIBLE) WILL BE INCLUDED IN THE FORTHCOMING FLORINE STETTHEIMER CATALOGUE RAISONNÉ CURRENTLY BEING COMPILED BY THE AUTHOR.

ENDNOTES

INTRODUCTION

1 Detailed throughout text.

2 The German artist Paula Modersohn-Becker is believed to be the first woman to paint a full-length nude self-portrait. However, the full-nude *Self Portrait as a Standing Nude, 1906* (Staatliche Museen zu Berlin, Preußischer Kulturbesitz, Neue Nationalgalerie) and *Self-Portrait as Standing Nude with Hat, 1906* (private collection, Bremen) both depicted traditional, male-oriented "presentation" poses. To date, no other nude self-portraits painted by women have been identified before 1906 and between Modersohn-Becker's and Stettheimer's c. 1916.

3 Stettheimer's ironic, often biting humor was shared with her contemporary Dada colleagues. See Barbara Bloemink, "Florine Stettheimer: Hiding in Plain Sight," in *Women in Dada*, ed. Naomi Sawelson-Gorse (Cambridge, MA: MIT Press, 1999), p. 478.

4 *Florine Stettheimer*, Museum of Modern Art, October 1–November 17, 1946. The following few women visual artists were given solo exhibitions at the Museum within five years prior to Stettheimer's; however, they were not given "retrospective" exhibitions: an exhibition of selected "Photographs of Children" by Helen Levitt in 1943; a selection of works from a single period by "Josephine Joy: Romantic Painter" in 1942. Selected works by Georgia O'Keeffe were exhibited at the museum two months before the Stettheimer retrospective in 1942.

5 Marcel Duchamp, quoted in Cleve Gray, "Retrospective for Marcel Duchamp," *Art in America* 53, no. 1 (January 1965): 42.

6 Parker Tyler, *Florine Stettheimer* (New York: Farrar, Straus and Company, 1963), pp. 26, 11.

7 Jed Perl, "Jazz Age Pastoral," *The New Republic* (October 2, 1995), p. 39.

8 Too many references exist to name them all. A few include Jens Hoffmann, *Florine Stettheimer: Painting Poetry* (New York: The Jewish Museum; New Haven, CT: Yale University Press, 2017), p. 155, and H. Alexander Rich, "Rediscovering Florine Stettheimer (Again)," *Woman's Art Journal* (Fall/Winter 2011): 26.

9 John Strausbaugh, "Florine Stettheimer: Manhattan Fantastica," *New York Press* (August 16–22, 1995), p. 40.

10 Recent sources include: John Zeaman, "New York's Sophisticated Primitive," *The Record* 8, September 1995; Scott Baldinger, *Forward*, July 14, 1995; R. Barris, "Florine Stettheimer: The Myth of Metamorphosis," Radford University; Melissa M. Liles, "Florine Stettheimer: A Re-Appraisal of the Artist in Context," M.A. Thesis, Virginia Commonwealth University, 1991, p. 20; Cécile Whiting, "Decorating with Stettheimer and the Boys," *American Art* 14, no. 1 (Spring 2000): 24–49.

11 Whiting, Ibid., p. 35.

12 In 1995, this author wrote *The Life and Art of Florine Stettheimer*, published by Yale University Press; however, it has been out of print for several years. Its primary purpose was to determine her genealogy and chronicle her life based on primary sources and interviews with living friends and family members and to identify works as being by the artist and date her extant work.

13 Parker Tyler's biography of Stettheimer, Parker Tyler, *Florine Stettheimer: A Life in Art* (Farrar, Straus and Company, Inc., 1963), was begun in 1956 but not actually published until 1963. In addition, his writing was first submitted to Ettie for approval and editing. Solomon also stated: "Tyler didn't really know her, so he made up a great deal about her using a great deal of poetic license, but he wrote beautifully in a style she would have appreciated." Author's interview with Joseph Solomon, New York City, 1993–4.

14 Carl Van Vechten, "Prelude in the Form of a Cellophane Squirrel Cage," in Tyler, *Florine Stettheimer*, pp. xiii–xiv.

15 Parker Tyler, *Florine Stettheimer,* op. cit., pp. 10–26.

16 Mark Stevens, "Summer Camp," *New York Magazine* (July 31, 1995), p. 48. Jed Perl, "Jazz Age Pastoral," *The New Republic* (October 2, 1995), p. 39.

17 Rich, *Woman's Art Journal*, op. cit., p. 26.

18 Ettie Stettheimer to Glenway Wescott, sometime after November 23, 1946, Stettheimer Papers, Yale Collection of American Literature, Beinecke Rare Book and Manuscript Library, Yale University, New Haven, Connecticut (hereafter YCAL).

19 Ettie Stettheimer, "Preface," *Crystal Flowers*, privately printed, 1949.

20 Henry McBride, *Florine Stettheimer* (New York: The Museum of Modern Art, 1946), p. 13.

21 Ibid., p. 13.

22 Ettie at the end of her life gave a large collection of books on and by women that the sisters had collected to a noted feminist book collector, Mrs. Frederick Overbury, in 1952.

23 Anne D'Harnoncourt and Kynaston McShine, ed., *Marcel Duchamp* (New York: The Museum of Modern Art, 1973), p. 212.

24 For more on O'Keeffe's control of her clothing and image to create a form of branding, see Wanda Corn's brilliant catalogue, *Georgia O'Keeffe: Living Modern* (The Brooklyn Museum, March 3–July 23, 2017).

25 Tyler, *Florine Stettheimer*, p. 35.

26 Henry McBride, *Florine Stettheimer*, p. 18.

27 Tyler, *Florine Stettheimer*, p. 187. Tyler "speculated" that this idea "may have been" the reason that, in September 1914, when she was ill in Switzerland, she wrote to her lawyer saying she wanted to rewrite her earlier will as she felt it was "too fantastic" and revise it to leave "everything to her mother and her sisters, Carrie and Ettie." There is no evidence to back this up nor is there any copy of any early or penultimate will stating Stettheimer ever wanted any of her works destroyed.

28 Hoffman, *Painting Poetry*, op. cit., p. 155.

29 Henry McBride, *Florine Stettheimer*, p. 15.

30 Nancy Miller, quoted in Carolyn G. Heilbrun, *Writing a Woman's Life* (New York: Ballantine Books, 1988), p. 44.

31 Deborah Solomon, "Florine Stettheimer at the Whitney, Finally," *The Wall Street Journal* (July 18, 1995), Section A, p. 12.

32 Tyler, *Florine Stettheimer*, p. 10. Most of Stettheimer's diary entries (like those of her sister Ettie) are not dated beyond the year. Therefore throughout the text, when the artist is quoted, unless there is a footnote citation to specific correspondence, it refers to entries from her diaries.

33 Lesley Higgins, "American Minimalists: Dickinson, Stettheimer, Williams," Florine Stettheimer Multimodal Modern, Inaugural Symposium, November 2017, Ryerson University, Toronto. Higgins expands on this idea in "American Minimalists: Dickinson, Williams, Stettheimer," in *Florine Stettheimer: New Directions in Multimodal Modernism*, ed. Irene Gammel and Suzanne Zalazo (Toronto: Book*hug Press, 2019), p. 120.

34 Tyler, *Florine Stettheimer*, op. cit., p. 88.

35 Ettie Stettheimer, *Crystal Flowers*, op. cit.

CHAPTER ONE

1 Solomon remembers the date as October 14, 1948, thirty-three years after the opening of Stettheimer's one-person exhibition at Knoedler & Co. in 1916. Author interview with Joseph Solomon, New York City, 1994. On September 26, 1948, however, Ettie Stettheimer wrote to Carl Van Vechten, "Yesterday Joe and I drove to Nyack where we had engaged a motor launch and we rode out on a very beautiful silver & blue & green river . . . we strewed the ashes to the wind." Stettheimer Papers, YCAL.

2 Stephen Birmingham, *Our Crowd: The Great Jewish Families of New York* (New York: Harper and Row, 1967), pp. 5–8.

3 Ibid., pp. 5–13.

4 Her paternal great-great-great-grandfather, Jacob Meyer Stettheimer, had a son, Löw Jacob Stettheimer, who was born around 1755 in Württemberg. Löw married Gittel Moses Hollenback and they had eight children, including Moses Stettheimer.

5 This paternal ancestry differs from that in my original 1995 *The Life and Art of Florine Stettheimer*, as Joseph Solomon had mistakenly identified the Stettheimer sisters' grandfather as Joseph, not Sigmund, Stettheimer. The two were brothers. Most Internet genealogical sites (the Latter-Day Saints, etc.) also misidentify or mix up the identities of Joseph S., Joseph J., and Joseph Stettheimer. However, with thanks to Dr. Irene Gammel, Director of the Modern Literature and Culture Research Centre and Professor at Ryerson University in Toronto, Canada, and the census records of New York City, Monroe County, and their marriage and death records, it is clear that Sigmund Stettheimer was Florine's grandfather and Joseph S. Stettheimer was her father.

6 Isaac M. Brickner, Attorney at Law, *History of the Jews of Rochester* (Historical Review Society, 1912).

7 Blake McKelvey, ed., "The Men's Clothing Industry in Rochester's History," *Rochester History* 12, no. 3 (July 1960): 3–4.

8 Ibid.

9 With the demand for uniforms during the Civil War, Sigmund became the third richest man in Rochester and one of the city's major philanthropists, supporting various causes including the major Orthodox synagogue and the local orphan asylum.

10 The New York City census of 1870 lists Josephs S. age thirty, Rosetta age twenty eight, Stella five, Carrie three, their nurse Maggie age twenty-eight, at Henrietta's home along with four of Rosetta's younger sisters and brother and three "domestics."

11 I am indebted to Dr. Irene Gammel for this information.

12 This information can be found in the "Rochester City Directories" of the Rochester Public Library. In the actual census of 1878 it states that "Joseph S. Stettheimer was removed from city," but it is not known what that means. The Geni website provides accurate information regarding Sigmund's birth and familial ties and states after bankruptcy he moved to New York and died in 1888 in Brooklyn.

13 There is no factual information that he went to Australia—that is just conjecture circulated within the family over the years. If he did, Joseph might have traveled under an assumed name as the name Stettheimer is not listed among passengers who entered Australia from Adelaide or Sydney port regions. Thanks to Dr. Kevin Fewster for assisting with this information.

14 Sigmund's Bank, Stettheimer & Tone, closed in 1879, and he and his son Abraham moved to New York.

15 Author interview with Joseph Solomon, New York City, 1994.

16 Although she and her sisters considered themselves non-practicing Jews, strictly speaking according to traditional Jewish law at the time, Florine and her sisters were not Jewish as they descended through the *females* of the generations after their great-great-grandmother Pike, who was Anglican. *Halacha*, a Jewish legal tradition, was in place until 1983, when Reform Judaism finally declared that one could be Jewish based on the religion of either parent or through conversion to Judaism. Many of the wealthy Jewish families who came to America earlier, however assimilated, became non-practicing while remaining Jewish in name and disregarded strict traditions.

17 Another Content daughter, Rosa, married Joseph Seligman's "handsome" son, James, and had eight children, including Florette, who, after marrying Benjamin Guggenheim, became the mother of the art collector Peggy Guggenheim. Birmingham, pp. 68–69.

18 The author wishes to thank Mrs. John D. Gordon for allowing her to view the Ives portraits, the large pastel painting of Israel Walter, and the photograph of the eight Walter children.

19 Even Parker Tyler noted an "absolute lack of evidence that the Stettheimers practiced any sort of traditional religion." Bloemink, p. 13.

20 Author's telephone interview with Jean Steinhardt, Florine's niece, April 1991. Steinhardt said that her father, Walter Stettheimer, once mentioned that there had been another Stettheimer child who was born prematurely and died.

21 Although undoubtedly considered racist today, this use of Black figures as luxury Western furniture fixtures was fairly common during the late 19th century.

22 "Mrs. C. W. Neustadter," in *Evening Sun*, New York, February 2, 1912.

23 When the United States entered World War I, Dr. Walter organized a unit of woman doctors, with the permission of the War Department, for service overseas. After her death, she was an anonymous contributor to more than fifty charities. She also left substantial bequests to her three youngest Stettheimer nieces.

24 The official name change occurred in 1896.

25 Irene Gammel and Suzanne Zelazo, eds., *Crystal Flowers: Poems and a Libretto – Florine Stettheimer* (Toronto: Book*hug Press, 2010), p. 112.

26 There are existing birth certificates for the three youngest girls, but at some later date, either Carrie or Ettie altered the records so that they both appear to have been born in the same year, even though there were at least five years between them in age.

27 Detailed, typed menus of dinners planned by Carrie Stettheimer and served to specific listed guests at various Stettheimer events are in the Stettheimer Papers, YCAL.

28 "Florine Stettheimer," *The New Yorker*, June 1946, p. 27.

29 According to Irene Gammel, in 1875 Maggie was 32 based on her research into the Rochester, New York census when Rosetta was pregnant with Ettie. In this painting Ettie appears to be less than a year old.

30 Gammel and Zelazo, p. 122.

31 In her brilliant new interpretation of this painting for the 2021 College Art Association Annual Convention, Irene Gammel notes the Stettheimer children's floating can be seen as a metaphor for their "nomadic existence."

32 Gammel and Zelazo, *Crystal Flowers*, pp. 124–5.

33 Joseph Solomon also speculated that Rosetta's brother William, who was born in 1862, provided financial support to the Stettheimers after Joseph left. Interview with the author, New York, 1994.

34 Because the poems are not dated it is not clear whether this poem refers to time spent in Rochester or Germany: Maggie apparently accompanied the Stettheimer women to Europe as the children's nurse as the poem refers to her, Mozart and Wagner.

35 Gammel and Zelazo, pp. 123–24.

36 Florine Stettheimer Diary, Stettheimer Papers, YCAL.

37 Dorothy Dayton, "Before Designing Stage Settings She Painted Composer's Portrait," in *New York Sun*, March 24, 1934. Sophie von Prieser was a pioneer in women's education and helped set up and direct a primary school for girls aged 6–15. Thanks to Karin Althaus and Susanne Böller for this information. *Florine Stettheimer* (Munich: Hirmer, 2015), p. 14.

38 Modius Eksteins, *Rites of Spring: The Great War and the Birth of the Modern Age* (New York: Anchor Books, 1990), pp. 74–78.

39 Stettheimer's sketchbooks and all of her early works (pre-1916) were given by Joseph Solomon to Columbia University after her death. They are often undated and unpaginated, and many were roughly edited by Ettie. It is therefore not possible to cite specific references. Florine Stettheimer Collection, Rare Book and Manuscript Library, Columbia University, New York (hereafter RBML).

40 Gammel and Zelazo, *Crystal Flowers*, p. 125.

41 At some point they shortened their last name to "Wanger."

42 Walter married Florence Neustadter, the grandniece of his aunt Caroline Neustadter. Author's interview with Walter's daughter, Jean Steinhardt, 1990.

43 Nancy Woloch, *Women and the American Experience* (New York: Knopf, 1984), pp. 276–77. Barnard College was established in 1889 as an affiliate of Columbia University after the trustees vigorously rejected the admission of women.

44 In 1917, Ettie described this period of her life in her first published novel, *Philosophy: An Autobiographical Fragment.* Her dissertation, written in German, was titled *The Freedom of Judgment as a Basis for the Justification of the Religious Faith, with Special Consideration of the Doctrine of William James.* Her novel *Philosophy* was published by Longrens, Green & Company in 1917. Ettie dedicated the novel to her mother, Rosetta.

45 Gammel and Zelazo, *Crystal Flowers*, pp. 125–26.

46 The first was offered at the Pennsylvania Academy of Fine Arts, which had had a life drawing class with nude female models since the 1860s but fired Professor Thomas Eakins when he revealed a nude male model before his women students. As a result, most women aspiring to be painters were restricted to the less highly regarded fields of portraiture, genre, landscape, or still-life painting.

47 Exhibition catalogue of the *25th Anniversary Exhibition* (Art Students League of New York, May 10–19, 1900), p. 45.

48 Women were not able to compete for the coveted Prix de Rome or numerous other honors by which young male artists made their reputations. Carol Duncan, "Happy Mothers and Other New Ideas in French Art," in *Art Bulletin* 55 (December 1973): 570–83.

49 For discussions on the formation and difference between the German and French opposition between "classical" and "romantic" values and notions of modernism, see Batchelor, pp. 77–85, and Nancy Troy, *Modernism and the Decorative Arts in France* (New Haven: Yale University Press, 1991), pp. 3–5, 8–101.

50 Diary entry, July 24, 1910. In 1913 Stettheimer visited the Japanese exhibition in Paris, savored works by Utamaro and Hokusai (although she found the Hiroshiges disappointing) and identified a print in her own collection as by an eighteenth-century artist named Kunisada Utagawa.

51 Kenyon Cox, *The Classic Point of View* (New York: Charles Scribner's Sons, 1911), pp. 3–5. Cox studied art in Paris, matriculating at the École des Beaux-Arts, where he studied with academician Jean-Léon Gérôme from 1878 until the fall of 1882.

52 Ettie Stettheimer, introduction to *Crystal Flowers*, privately printed, c. 1947–48.

53 Marius Ary-Leblond, "Les Peintres de la Femme Nouvelle," in *La Revue* 39 (November 1, 1901): 275–85, quoted in Deborah Leah Silverman, "Nature, Nobility and Neurology: The Ideological Origins of 'Art Nouveau' in France, 1889–1900" (Ph.D. diss., Princeton University, 1983), p. 129.

54 Actresses such as Lilian Russell, Sarah Bernhardt, and Lillie Langtry helped lower the cultural prohibitions against women's attempting to look younger. As a result, middle- and upper-class women, such as the Stettheimers, began to dye their hair and use makeup to camouflage their age. Lois Banner, *American Beauty* (New York: Knopf, 1983), pp. 222–23.

55 Silverman, pp. 129–33.

56 Elaine Showalter, *Sexual Anarchy: Gender and Culture at the Fin de Siècle* (London: Penguin Books, 1991): 18–21. As Showalter notes, George Gissing, the author of the 1891 novel *The Odd Woman*, defined his title in a letter to a friend as "Les Femmes Superflues"—the women who are *odd* in the sense that they do not make a match; as we say, 'an odd glove.'"

57 Gammel and Zelazo, *Crystal Flowers*, p. 44.

58 Box 10, folder 178, Stettheimer Papers, YCAL. A folder of the First International Feminist Congress of 1896 is in the Stettheimer Scrapbook, and on December 4, 1908, Ettie wrote that she attended a woman suffrage meeting at Carnegie Hall held by the Inter-Urban Woman's Suffrage Council. It is very probable that Florine attended as well. Ettie also attended a Votes for Women "Mass Meeting" at Carnegie Hall on November 17, 1909, called by the National Women's Suffrage Association. According to their archived files, either Ettie or Florine kept a copy of an issue of *American Women's News Bulletin* which noted the organization of a "Who's Who Among Women of the Nation."

CHAPTER TWO

1 Gammel and Zelazo, *Crystal Flowers*, p. 111.

2 According to a later diary entry, although Florine initiated this, Dr. Ricci ended up corresponding with Ettie. Unfortunately, Ettie's editing of the diaries prevents us from knowing either sister's reaction to this state of affairs.

3 Deborah Leah Silverman, *La Grande Dame, Revue de L'élégance et des Arts* 1 (1893): 385–90. For further discussion see Nancy Troy, *Modernism and the Decorative Arts in France* (New Haven: Yale University Press, 1991), pp. 2–102.

4 Silverman, p. 3.

5 Silverman, pp. 22–39, 303–15, 502.

6 Marcel Proust, *Within a Budding Grove* (New York: Vintage, 1970), pp. 83, 178, 237.

7 Silverman, op. cit., pp. 385–90.

8 Stettheimer Collections, Rare Book and Manuscript Library, Columbia University, scrapbook 1. (RBML) In her sketchbook Stettheimer notes when artists arrived in Florence and executed their main commissions and commented on the

colors in their palettes, also the origins of the Rococo in France and the time span of the German Rococo.

9 The cover of the catalogue was designed by Jean-Louis Forain. See Silverman, pp. 495–500.

10 Copies of the catalogue are in the New York Public Library and in the Educational Alliance files of the Yivo Institute for Jewish Research in New York.

11 Stettheimer's interest in folding screens may have been sparked by a lecture titled "Grèce et Japon" given by Edmond Pottier, curator of ancient ceramics on the occasion of an exhibition of Japanese woodblock prints at the Louvre in 1890. The article was also published in *Gazette des Beaux-Arts*, ser. 3, vol. 4, no. 2, August 1890, pp. 105–32.

12 Parker Tyler (op. cit., pp. 165–6) claims that the theme of the screen is "resurrective," as in Etruscan funerary urns, thereby indicating that Stettheimer believed her "fame" would be post-humous. However, when she made the screen, she was in her late 20s–early 30s and the nature of the different panel's details instead represent the differing personalities of the siblings.

13 Walter's daughter, Mrs. Julius Ochs Adler, who formerly owned the screen, claimed that the portrait did not resemble Walter; however, comparison with a photograph indicates that the likeness is quite faithful.

14 Stettheimer painted her eyes in her face with a wide-eyed manner similar to her *Portrait of Myself* a decade later, emphasizing the artistic "vision" of the painter.

15 Although she mentions sending a painting to the exhibition in her diary of this year and Stettheimer is listed in the catalogue as a nonresident League member, her painting is not listed on the checklist, so it either did not arrive, was left out of the catalogue, or was not among those accepted by the judges. Unfortunately, there is no mention of the title or style of the painting submitted.

16 The variety of what they attended ranged from a Metropolitan Opera performance of Isadora Duncan, Ethel Barrymore in *Lady Frederick*, Mrs. Fiske in *Salvation Nell*, Annie Russell in *The Stronger Sex*, and Margaret Anglin in *The Awakening of Helena Richie* to list only a few.

17 Elaine Showalter, *Sexual Anarchy: Gender and Culture at the Fin de Siècle* (New York: Viking, 1990), quoted in Roberta Mock, *Jewish Women on Stage, Film, and Televison* (New York: Palgrave Macmillan, 2007).

18 She also became an "icon of sexual inversion" affiliated with the Parisian lesbian milieu and male homosexual artists like Jean Cocteau and Cecil Beaton. Roberta Mock, "Jewessence: Women and Disease," in Ibidem, *Jewish Women on Stage, Film, and Television* (New York: Palgrave Macmillan, 2007), p. 41.

19 1909 Diary, Stettheimer Papers, YCAL.

20 She visited the studios of artists Herman Hahn, Fritz Behn, Julius Hess and on some visits with a Professor Hirth and his wife and daughter.

21 Ibid.

22 July 18, 1909 Diary, YCAL.

23 September 14, 1910 Diary, YCAL.

24 Although several writers have stated that Symbolism influenced Stettheimer's work, none of her paintings show its influence; and she stated that she was against anything in art having a spiritual or symbolic meaning.

25 All addresses in Germany were provided by Karin Althaus and Susanne Böller, to whom I am grateful for the information.

26 In editing one of her sister's poems, "And Things I Loved," Ettie deleted the word "Grimm's" before "fairy tales," noting that "M[other] did not read German ES."

27 Gammel and Zelazo, *Crystal Flowers*, pp. 93–94. Leopold Stokowski, a celebrated composer, performed Beethoven's 5th so rarely that the artist was probably listening to a performance of the noted NBC Symphony on December 26, 1943, broadcast on NBC radio.

28 Professor Lesley Higgins, York University, "American Minimalists: Dickinson, Stettheimer, Williams," talk given at Florine Stettheimer's Multimodal Modernism Symposium, Ryerson University, Toronto, Canada, November 16, 2017.

29 Gammel and Zelazo, *Crystal Flowers*, p. 130; and Stettheimer Papers, YCAL. Under the word "Meister" Florine wrote "In black swallow tail suit," but she crossed that line out and added the current stanza in blue ink.

30 Shuster-Woldan is best known for a mixture of painting styles between dark, warmish brown colored portraits in Rembrandt-like tones and mythical paintings of naked women and men.

31 Gail Cunningham, *The New Woman and the Victorian Novel* (London: Macmillan, 1978), pp. 1–3. In 1916 the popular American magazine *Vanity Fair* ran a series of articles enumerating the problems with marriage and poking fun at men. In one, a feminist turns down a marriage proposal, saying, "We now know that husband and wife are what marriage makes them—a dull, uninteresting, spiritless couple, usually victims of monotony and routine, slaves to domesticity . . ."

32 Gammel and Zelazo, p. 74.

33 Ibid., p. 75.

34 Ibid., pp. 90–91.

35 Gammel and Zelazo, *Crystal Flowers*, pp. 108–10. James Loeb grew up in New York and studied Egyptology at Harvard University before joining the firm of Kuhn, Loeb & Company. He disliked banking and settled in Germany to recover from a nervous breakdown and consulted Freud. He built a large estate in Murnau, near Munich, which is where Stettheimer met him. He amassed a fine collection of ancient art and rare books. After many years, he married Toni Hamhuchen, his nurse and companion. He died a virtual recluse in 1933. Birmingham, p. 253.

36 Gammel and Zelazo, *Crystal Flowers*, p. 107. This poem was handwritten by Florine in blue ink. Later Ettie annotated it with her own comments: "Can't place 'JS.'—sounds like Sides? Don't like this p[oem]." The poem could also refer to Gerald Sides, an art collector and later acquaintance of the Stettheimers.

37 According to Ettie, the work was first a drawing intended as a book plate and then a painting. She noted, "I admired [it] greatly in those days." It is not clear whether she was referring to her sister's version or to the well-known painting. Marcel Duchamp later reproduced Stettheimer's *Medusa* painting in an issue of *View* magazine (series 5, no. 1).

38 Stettheimer Papers, Letter of August 23, 1948, YCAL.

39 Stettheimer loved the island of Capri, but other places often failed to live up to her expectations. When visiting Versailles, she complained, "For years I have wanted to come to Versailles for a short time to live and sketch in the park. I am here but everything is so different from the way I want it to be . . . the park was full of hoi poloi who were camping out all over everything and a beast of a waiter served us a poor meal."

40 Gammel and Zelazo, *Crystal Flowers*, p. 128.

41 Stettheimer states in her diary that for some reason he was unable to appear at this particular event and the lecture was cancelled. It is not known if it was rescheduled nor whether the sisters ever heard him speak.

42 The qualitative aspect of consciousness is mentioned in section one of Bergson's *Time and Free Will: An Essay on the Immediate Data of Consciousness*, trans. F. L. Pogson (London: George Allen & Unwin, 1910).

43 Henri Bergson, *Duration and Simultaneity: Bergson and the Einsteinian Universe* (*Durée et simultanéité*, 1922).

44 A key figure in the dissemination of the work of Matisse was Leo Stein, who by 1916 was an occasional member of the Stettheimer's New York social evenings.

45 In 1905, the Fauves held their first exhibition at the *Société du Salon d'Automne*, and retrospectives of Georges Seurat and Vincent Van Gogh were staged at that year's *Salon des Indépendants*, with Matisse as chairman of the hanging committee.

46 Ibid., p. 129.

47 Ettie Stettheimer, "Introduction," *Crystal Flowers*, privately printed, 1949.

48 Among Stettheimer's private papers at Columbia University are photographs of Michelangelo's *David*, a medieval knight in armor, and various marble and bronze Greek statues of nude men.

49 1912–13 Diary, YCAL. The painting was never mentioned again or among the works sent to the US and was probably never finished and/or destroyed by the artist.

50 Among Stettheimer's papers at Columbia is a reproduction taken from a contemporary German newspaper of an Englishwoman, Mrs. John Lavern, posing in a costume of Spring from Botticelli's painting.

51 Lionello Venturi, *Sandro Botticelli* (Oxford: Oxford University Press, 1957), pp. 9–12.

52 The initially heavily damaged and unstretched portrait was discovered and identified by the author in a box of works labeled "estate paintings, not by Florine Stettheimer" at Columbia University around 1994. I am grateful to Sally Wiener and Larry Soucy, then of Columbia Art Properties.

53 For comparison of the portraiture, see particularly the head of Pallas in the painting *Pallas and the Centaur*, and the detailed portraits in the background of the *Adoration of the Magi*. The Botticelli painting hangs in the Uffizi Gallery in Florence and so would have been well known by Stettheimer. Stettheimer's use of raised gilded figures can be seen in in *New York/Liberty* painting, *The Cathedrals of Wall Street*, and *The Cathedrals of Broadway*.

54 In the diary of that year she included reproductions of paintings by Daumier (*In the Theater*), Van Gogh (*Die Seiden Erdarbeiter, Still Life, Père Tanguy*), and Goya (*Still Life with Cut Melon*). Stettheimer Collections, RBML.

55 Stettheimer is referring to Manet's painting of Nina de Callais, titled *Lady with Fans*, which was painted in 1873 and is in the collection of the Musée d'Orsay. The side of Mme. Callais' face is pulled upward by the force of her palm.

56 Gammel and Zelazo, *Crystal Flowers*, p. 50.

57 Gammel and Zelazo, *Crystal Flowers*, pp. 126–27. Another version of this poem was handwritten by the artist in brown ink. It differs: "Primitive Saints, Renaissance prophets, Even Gothic Madonnas" are used instead of "cows and sheep".

58 Regnault originally sold the work to an art dealer for $1,000. It was then purchased by Marquise Carcano for $2,000. On May 30, 1912, Carcano put the *Salome* up at auction for $100,000, causing a huge outpouring of concern over loss of a "national treasure." Art dealer Roland Knoedler successfully bid $96,000 for the painting, and there was great controversy in the media about the "American Peril to French Art." T. J. Clark, *The Painting of Modern Life* (Princeton: Princeton University Press, 1984), p. 115.

59 Probably one of Stettheimer's intentionally made-up words, in this case a combination of "moi," the French work for "me," and "bored" in English—all noting that her painting master bored her…

60 Gammel and Zelazo, *Crystal Flowers*, p. 128.

61 Quoted in Robert Craft, "Stravinsky's Russian Letters," *New York Review of Books*, February 21, 1974, p. 17; Edward Marsh, *Rupert Brooke* (Toronto: McClelland, Goodchild & Stewart, 1918), p. 75.

62 Eksteins, op. cit., pp 29–45, and Richard Shead, *Ballets Russes* (Secaucus, NJ: Wellfleet Press, 1989), pp. 31–33.

63 Shead, op. cit., pp. 55–56.

64 Eakins op. cit., pp. 27–29.

65 The only extant photographs of the production were taken by Baron de Meyer, who later became a leading member of the Stettheimers' most intimate circle of friends.

66 The premiere of the ballet at the Théâtre du Châtelet was on May 29, 1912 with music by Claude Debussy, choreography by Vaslav Nijinsky and was inspired by a poem by Stéphane Mallarmé.

67 Diary entry dated June 8, 1912.

68 I disagree with Emily Bilsky that the Schwabing period Pritzel dolls were an influence on either Stettheimer's mature painting style or her ballet/opera doll maquettes. Unlike the latter, which Stettheimer consciously based on the theatrical Ballets Russes and are all formed as if caught mid-dance movement with contemporary, even erotic clothing, Pritzel's dolls are absolutely stiff, rigid, and highly old-fashioned in their dress and hairstyles.

69 Jiri Mucha, *Alphonse Mucha: His Life and Art* (New York: Rizzoli, 1989), pp. 35–42.

70 Stettheimer wrote three drafts of the libretto. The earliest two versions, the first dated c. 1912, are in the Stettheimer collections, YCAL. The first draft included dialogue which, because it is a ballet, was not meant to be spoken but was more of a guide. This is eliminated in the other two. The shorter, final version dated 1916, along with bas-relief, costumed maquettes and drawings, is located at the Museum of Modern Art Library and was published in Bloemink, *Life*, op. cit. pp. 44–45, and again in this volume. All versions will be in the upcoming Catalogue Raisonné.

71 T. J. Clark has pointed out that even in 1872 respectable classes came "in droves" to such Parisian street cafés as Les Ambassadeurs and mingled with the lower classes or at least sat and listened to the same songs and music. Clark, op. cit., p. 212. It is not unlikely that Stettheimer knew that Degas had located a series of pastels at Les Ambassadeurs, where he portrayed singers like Theresa performing to a mixed crowd.

72 Mucha, op. cit., pp. 59–60.

73 T. J. Clark, op. cit., p. 111, quotes Flaubert in his correspondence of 1870: "Everything was false, false army, false politics, false literature, false credit, and even false *courtesans*."

74 Among others, she took notes on Allan Manquand's *Greek Architecture*, Ernest Gardiner's *Greek Athletic Sports and Festivals*, Lanciani's *Destruction of Ancient Rome*, H. H. J. Greenidge's *Roman Public Life*, W. Warde Fowler's *Roman Festivals*, and Walter Lowrie's *Monuments of the Early Church*. Stettheimer Papers, YCAL, Box 8, Folder 142.

75 Finding the pure viscose too still, the Swiss chemist Brandenberger added glycerin to soften the material, and in 1912 he patented it and named it "cellophane" after the words "cellulose" and "diaphane" (transparent). In 1914, it was made available to candy makers in the US and by the 1920s became featured in couture fashion design.

76 A listing of titles on the back of her 1913 diary gives an idea of the eclectic nature of Stettheimer's early reading material: Julia France (whose book, published in 1912, was a novel pleading for women's suffrage), Olive Schreiver (on women and labor), Arnold Bennett, Leo Tolstoy, Julius Meier-Graefe, Arthur Schnitzler, August Strindberg, Edith Wharton, Robert Herrick, H. G. Wells, Otto Ernst, Jack London, Romain Rolland, Henry James, Thomas Hardy, Edmont Kelly (on twentieth-century socialism), George Moore, Winston Churchill, and Bret Harte, among others.

77 Tyler, *Florine Stettheimer*, op. cit., p. 29. Tyler's inference that "it may have been (as will become dramatically clear) her desire to have all her pictures placed with her corpse in a mausoleum" is what has caused this statement to be repeated for over fifty years, making Stettheimer seem like an eccentric. There is nothing to substantiate this stated ["may have been"] completely speculative notion by Tyler, neither in this instance nor at any time later in Stettheimer's life.

CHAPTER THREE

1 *Manet and Post-Impressionism, 1910*, a pamphlet printed to accompany the art exhibition that the critic Roger Fry and Desmond McCarthy, the exhibition's secretary, organized at London's Crafton Galleries that introduced England to the work of Seurat, Van Gogh, Gauguin, and Cézanne.

2 Matthew Lorden, "Why One Artist Became a Modernist," in *The Evening World Magazine*, March 20, 1921. The article was accompanied by a reproduction of Stettheimer's painting *The Picnic at Bedford Hills*. The article was cut out and pasted in the Stettheimer scrapbooks, without volume or page number, Stettheimer archives, RBML.

3 Ibid.

4 Ibid., p. 132.

5 Women born around the 1870s, like Stettheimer, had a life expectancy of 45–48 years. Women were considered "marriageable" until they were around twenty-eight or -nine at most, at which point they were considered too old.

6 Tyler, p. 117.

7 Paula Modersohn-Becker's two little-known works, the fully nude *Self-Portrait as a Standing Nude* and the study *Self-Portrait as Standing Nude with Hat*, both in traditional, male-oriented, "presentation" poses, were exhibited in an exhibition of nude self-portraits by women at the Paula

Modersohn-Becker Museum in Bremen, Germany, in 2013. See note 5 of the introduction.

8 The painting, titled *A Nude*, was among Stettheimer's works donated by the Stettheimer estate to Columbia University, where they resided in the Art Properties department for over two and a half decades. When the author was researching her Ph.D. dissertation on Stettheimer in 1995, she identified the *Nude Self-Portrait* thanks to the identical manner in which Stettheimer had painted her facial features in every subsequent portrait and the few available photographs of the artist.

9 Stettheimer deliberately chose a canvas that was approximately the same size as the three paintings and appropriated some of their motifs. *Nude Self-Portrait* measures 47 x 67 in.; Titian's *Venus of Urbino* is 47 x 65 in., Goya's *Nude Maja* 38 x 74 in., and Manet's *Olympia* 51 x 75 in. According to Roberto C. Ferrari, curator of the Columbia University art collections, under ultraviolet light one can see that Stettheimer "overpainted the attenuated legs, which bear a striking resemblance to those of Ingres's *Grande Odalisque* of 1814," therefore aligning her work with another Old Master nude.

10 Gammel and Zelazo, *Crystal Flowers*, p. 129.

11 Quoted in Gill Saunders, *The Nude: A New Perspective* (London: Herbert Press, 1989), p. 21.

12 John Berger, *Ways of Seeing* (London: Penguin, 1972), pp. 47–54.

13 Mark Twain, *A Tramp Abroad*, http://www.gutenberg.org/files/119/119-h/119-h.htm.

14 A pair of sketches that Stettheimer made for her self-portrait demonstrates that she had originally experimented with placing both of her arms behind her head, as in Goya's nude.

15 Berger, p. 56.

16 Carl Van Vechten, "The World of Florine Stettheimer," typewritten drafts 1–4, Stettheimer Papers, YCAL. The finished article appeared in *Harper's Bazaar* (October 1946), p. 356.

17 Erving Goffman, *The Presentation of Self in Everyday Life* (New York: Anchor, Books, 1959).

18 Interview by the author with Virgil Thomson in New York City, 1989.

19 Gammel and Zelazo, *Crystal Flowers*, pp. 111–12. Gammel and Zelazo note that on the paper on which she wrote the poem, Stettheimer included the line "The civilizers of the world," probably intended as the title; however, Ettie left it out of her privately printed version of the poems (p. 157).

20 Roberto Ferrari, in his essay on the *Nude Self-Portrait* in the Stettheimer Lenbachhaus exhibition catalogue (2015, p. 86), tells that after viewing the Stettheimer exhibition of paintings, drawings, and watercolors held at Columbia University on February 24, 1973, Virgil Thomson wrote the curator, Jane Sabersky, that Stettheimer "*may* be a better fauve than Matisse. Certainly she was a better painter." Columbia Rare Book and Manuscript Library, Stettheimer Papers, Box 1, Folder 6.

21 Review of Knoedler's 1916 exhibition of paintings by Florine Stettheimer in *New York Evening Post*, October 21, 1916. Clipping from Stettheimer scrapbook, Columbia University, Stettheimer Archives.

22 Henry McBride, *Florine Stettheimer* (New York: Museum of Modern Art, 1946), p. 15.

23 Parker Tyler fancifully attributed the illusionism and lack of weightlessness in these floral still lifes to the fact that Stettheimer "is a woman and so secure in ignoring the laws of space." Parker Tyler, "Stettheimer, Leonid, Tanguy," in *View* 7 (December 1946): 186–89.

24 Henry McBride, *Florine Stettheimer* (New York: Museum of Modern Art, 1946), pp. 15, 17.

25 This poem, handwritten by the artist in ink, was not published in Ettie's initial publication of *Crystal Flowers*. It is amusing to speculate that the reference to attributes may refer to the work of her friend Georgia O'Keeffe, whose flower paintings were marketed by Stieglitz and often viewed by contemporary critics as having sexual overtones and as resembling genitals. Gammel and Zelazo, *Crystal Flowers*, p. 60.

26 Their friend, the playwright and theater producer Philip Moeller, lived opposite them. Caroline Walter Neustadter died in 1912. She left two-thirds of her estate to her sister Rosetta and the remainder to various charities, with small bequests to her employees and other sisters. The *New York Times* ran a long obituary on her on February 2, 1912.

27 Ettie Stettheimer Papers, letter dated October 22, 1918, YCAL.

28 This picture is probably one side of Stettheimer's enormous bedroom rather than the living room but has many of the features of the dining room described here.

29 The information on the decoration comes from a letter that Van Vechten wrote to Ettie in 1946, asking her for her recollections for an article he was writing titled "The World of Florine Stettheimer." This information was culled from their correspondence and the article itself. Carl Van Vechten Collection, YCAL and Carl Van Vechten, "The World of Florine Stettheimer," typewritten drafts 1–4, Stettheimer Papers, YCAL. The finished article appeared in *Harper's Bazaar* (October 1946), p. 238.

30 After Stettheimer's death and the success of the Museum of Modern Art retrospective exhibition, Ettie clearly appreciated her sister's flower painting, writing to Van Vechten on July 27, 1946, "I think she painted them as no one has before or since. And they never seem to get reproduced." Stettheimer Papers, YCAL.

31 Carl Van Vechten, "Prelude in the Form of a Cellophane Squirrel Cage," Tyler, *Florine Stettheimer*, op. cit., p. xii.

32 This poem was also not included in Ettie's printing of *Crystal Flowers*, noting on the manuscript, "I don't like this one." It was written in August, while Stettheimer was at Monmouth Beach (probably in the late 1900s or early 1920s). Gammel and Zelazo, *Crystal Flowers*, pp. 38–39.

33 We have no indication who "Jenny" was, as the name is not associated with anyone in Stettheimer's diaries or correspondence or mentioned by any of her acquaintances.

34 Richard J. Powell quoted in interview with Folasade Ologundudu, *Artnet News*, February 18, 2021, https://news.artnet.com/art-world/richard-j-powell-interview-1944754

35 Florine Stettheimer Letter to Henry McBride, August 18, 1932, Stettheimer Papers, YCAL.

36 Although they differ in setting and gender, it is interesting to compare the palette, decorative sensibility, depictions of the mothers, and position of the siblings in *Family Portrait I* and Matisse's 1911 portrait of his own family. Stettheimer never mentions the work, so we don't know for certain whether she ever saw it.

37 Ann-Katrin Harfensteller makes an interesting comparison between the tilted position of Stettheimer's head with her arm bent at the elbow in *Family Portrait I* and Henri Matisse's painting *Le Madras Rouge* of 1907. However, it is not known whether Stettheimer ever saw this particular Matisse painting. See "Rose-Tinted Days: Florine Stettheimer's Family Portraits," in *Florine Stettheimer* (Munich: Lenbachhaus, 2015), p. 77.

38 It is not known what became of most of the sisters' designer clothes. However, when she died, Ettie donated a number of highly eclectic pieces of clothing to the costume department of the Metropolitan Museum of Art. These included two elaborately embroidered black silk House of Paquin overdresses from 1908, a fabulous huge American or European black lace parasol that folds to resemble a long dress with sleeves, another elaborately sewn black and white parasol, an Indian beaded silk dress, a French nineteenth-century lace shawl, a European embroidered linen shirt, a South Asian/Himalayan region nineteenth-century swatch of material and an eastern European heavily embroidered overblouse. Apparently Ettie also gave clothes to Isabel Lachaise when she was low on finances.

39 Cecile Whiting, "Decorating with Stettheimer and the Boys," *American Art* 14, no. 1 (2000): 37–38, contrasts the Stettheimers' "good manners, reflective of Jewish and European upper-class aristocracy" with the younger generation of women who had "the corollary of loose morals . . .short hair and short skirts, their use of cosmetics, alcohol, and cigarettes, their frank conversation, and their more frequent interaction with the opposite sex." As is evident in her photographs, paintings and diaries, the opposite is true: Stettheimer wore visible make-up including eyeliner and red lipstick by 1915, along with stylish bobbed hair. The Stettheimer women served alcohol even during Prohibition and had frank conversations at their salons about sex and nudity.

40 On May 12, 1857, Bonheur received a "permission de travestisement" permit which is displayed on the wall of the Café Rosa Bonheur in Paris, giving her permission to "dress as a man" for "health reasons."

41 Quoted in Carolyn G. Heilbrun, *Writing a Woman's Life* (New York: Ballantine Books, 1988), p. 55.

42 It is believed that André Brook was built by a Dr. Barnhardt around the turn of the twentieth century. It changed hands by 1911 and was owned by Mrs. James McNaught, from whom the Stettheimers probably rented it for the summers. By 1920 it was a private school known as Andrebrook School. The school remained in business until 1942. In the 1950s the property was purchased by the Public Schools of Tarrytown and the building was razed. My thanks to Francis Naumann and his wife Marie Keller for this information, a map and a photograph of the original André Brook c. 1925.

43 From the few black-and-white photographs of Stettheimer, it is impossible to determine the exact color of her hair and whether or not she dyed it as she aged. In all of her self-portraits, she portrayed herself having red hair, varying from the bright orange of this painting to the dark auburn of later images. As Lois Banner has indicated, red hair was for centuries the emblem of deviance and evil and was believed to mark a troublesome, passionate personality. Red hair color came into vogue during the first decades of the twentieth century with everyone from performers to society women. See Banner, pp. 176–77. In the 1940s, Ettie told Van Vechten, "As for the wig: it was an auburn Bobb & I got it for a special dress-up something & for some years wore it on an average of once a year at home chiefly if I thought some party promised to be dull and needed enlivening. Probably that is why you never saw it." Letter of August 9, 1946, Stettheimer Papers, YCAL.

44 For the most comprehensive information on Stettheimer's materials and methods of painting, see Fiona Rutka's presentation of February 2020 at the annual College Art Association Convention. Rutka worked on conserving a number of Stettheimer paintings while conservator of modern and contemporary paintings at the Philadelphia Museum of Art and I thank her for providing me with much new information.

CHAPTER FOUR

1 "French Artists Spur on an American Art," in *New York Tribune*, October 24, 1915.

2 Quoted in Watson, p. 376. Taken from Daniel Robbins, "The Formation and Maturity of Albert Gleizes: A Biographical and Critical Study, 1881 through 1920," Ph.D. dissertation, New York University Institute of Fine Arts, 1975.

3 Stettheimer's later diary entries are not written in bound books and dated as her earlier ones—by now they are often undated pages in lined writing pads or loose scraps of paper stuck within the covers that have all been severely edited by Ettie. Ettie's "diaries" also tend to be typed pages as though intended to be part of an eventual memoir. YCAL.

4 Carrie's dollhouse eventually brought in between $500 and $1,000. A neighborhood carpenter built the forty-foot-long

frame for Carrie's second dollhouse, stylized as an imposing mansion, complete with numerous rooms furnished in various styles popular in the 1920s. At her death it remained unfinished. Ettie emphatically stated that "neither she nor Florine had had anything to do with its creation" and that Carrie never consulted either of them in making the work.

5 *New York Evening Post*, review, October 21, 1916. Between 1912 and 1918, Knoedler held approximately 170 exhibitions, of which an unusual eighteen were devoted to works by women artists.

6 Marie Sterner opened her own art gallery in 1923 but is often neglected in favor of others who came later. For example The Jewish Museum's exhibition of Edith Halpert in 2020 called her "the first significant female gallerist in the United States" although she didn't open her gallery until three years after Sterner. Through her exhibitions at Knoedlers and her gallery, Sterner advanced the careers of many twentieth-century American and women artists. Her papers are in the Smithsonian's Archives of American Art.

7 Gammel and Zelazo, *Crystal Flowers*, p. 106.

8 Stettheimer later revised several of the paintings in the exhibition. In *Morning*, for example, she originally painted Marie Sterner in the act of arranging an abundant bouquet of flowers. She subsequently removed Sterner and replaced her with a gold-scalloped white curtain and two small butterflies, changing the work's focus to the bouquet. In *Flowers #8*, a dark-haired woman wearing a headband was originally seated at the right of a composition that included a white parrot and two vases filled with white blossoms. Stettheimer later eliminated the figure, painting a bowed curtain in its place, extended and darkened the circular pattern of the tablecloth, and emphasized the rounded base of the vase at the right.

9 "Miss Stettheimer's Oils", in *American Art News* 15, no. 2 (October 21, 1916): 3.

10 "At the Art Galleries," in *Saturday Evening Post Magazine* (October 21, 1916): 20.

11 *Evening Mail*, 1916, undated article cut out and pasted in Stettheimer Scrapbook of Exhibition Reviews, in Stettheimer Papers, Avery Library, Columbia University.

12 W. G. Bowdoin, "Miss Florine Stettheimer at Knoedler's," in *Evening World* (October 21, 1916).

13 Dwight C. Sturges, "Clever Painting," in *New York Times* (October 22, 1916).

14 Eddy, "Panel Painting," in *The World*, 1916.

15 Calvin Tompkins, *Duchamp: A Biography* (New York: The Museum of Modern Art, 2014): 170.

16 The writing in her diary is difficult to read, but the composer is probably Johan Svendsen, a Norwegian composer who wrote a symphony titled *Carnival in Paris* around 1871. Diary entry, July 4, 1917, YCAL Series II, Box 7, Folder 126.

17 Tyler, p. 35.

18 Ibid., and Watson, p. 167, describes Stettheimer's lack of sales using words such as "wounded" and "humiliation," and states that after having "failed to sell a single piece" Stettheimer "circumvented these troublesome issues by refusing to exhibit her paintings in commercial galleries."

19 Dana Miller, ed., "Florine Stettheimer, *Sun*, entry," *Whitney Museum of American Art Handbook of the Collection* (New Haven: Yale University Press, 2015), p. 367.

20 McBride, p. 18.

21 Ettie Stettheimer, diary entry, December 5, 1916, YCAL.

22 Duchamp resigned from the board prior to the opening when the society's other directors rejected *Fountain*.

23 Robert Martin, ed., *The Writer's Craft: Hopwood Lectures, 1965–81* (Ann Arbor: University of Michigan Press, 1982), pp. 1–5.

24 A heavy drug and alcohol user, Hopwood kept his homosexuality tightly concealed. Staying with Gertrude Stein in Paris in 1928, he claimed that an unnamed friend was pursuing him and would kill him. He subsequently died while vacationing on the Riviera. Ultimately it was ruled that he had drowned, despite bruises found on his body and the presence in the vicinity of an angry ex-lover who had reportedly threatened him.

25 Ettie Stettheimer to Henri Gans, February 1917, YCAL.

CHAPTER FIVE

1 Gammel and Zelazo, *Crystal Flowers*, p. 79.

2 Jerry Saltz, "What the Hell Was Modernism? The Museum of Modern Art Tries to Open Itself Up," *New York* magazine, September 30–October 13, 2019, pp. 75, 94.

3 "Hello and Goodbye, Francis Picabia, Art-World Jailer: Philip Pearlstein on 'One of the Prime Movers of Modern Art,'" in *ArtNews*, September 1970. https://www.artnews.com/art-news/retrospective/francis-picabia-art-world-jailer-philip-pearlstein-on-one-of-the-prime-movers-of-modern-art-in-1970-7324/

4 To prove his point, McBride added a footnote here from Stettheimer's diary about viewing "new pictures" that retained their color and didn't fade as she felt the American Impressionist works of the same period had. McBride, *Florine Stettheimer*, p. 13.

5 According to several museum conservators, Stettheimer used lead white directly on top of the canvases. On top of this layer of zinc or "china white" paint she added oil colors. Over time, the upper layers of color have sometimes "bled" into the china white paint, causing a loss of detail. According to notes in Stettheimer's diaries, she drew with charcoal or lead pencil

on top of the white ground and then "stained in" the colors of her composition. Then she proceeded to add thick layers of color, often not waiting until they dried properly. On occasion, she painted with pen and ink to add details. Over time, the ink has often flaked and disappeared. My special thanks to independent conservator Fiona Rutka for her detailed analysis from her work on Stettheimer paintings.

6 Charles Henry Caffin, *New York American*, April 10, 1916, p. 7.

7 McBride, *Florine Stettheimer*, p. 35.

8 Marsden Hartley, "The Paintings of Florine Stettheimer," *Creative Art* 9 (July 1931): 18–23.

9 Letter to Marsden Hartley, n.d., Stettheimer Papers, YCAL. Nothing else was written and it is unknown whether the letter was ever sent.

10 Carl Van Vechten, "The World of Florine Stettheimer," op. cit.

11 In May and June 1903, an Islamic art exhibition was held at the Musée des Arts Décoratifs; and in 1907 an exhibition of tiles and miniatures. In October 1910, there was a similar exhibition in Munich. From June to October 1912, the Musée des Arts Décoratifs held another exhibition of miniatures. Stettheimer probably attended at least one of these exhibitions, as she made a few drawings of Persian figures obviously copied from miniature paintings.

12 Robert Goldwater, *Primitivism in Modern Art* (New York: Wittenborn, 1966), p. 203.

13 Trébla, "La Revue a l'Intrigue," in *Le Music-Hall* (May 1, 1912): 17.

14 Thévenaz painted a life-sized oil of Florine around 1916, which was owned by Carl Van Vechten and now belongs to an unidentified private collector. In her diary, Stettheimer noted Thévenaz's premature death from an infection: "All his charm and talent buried with his beautiful person." Tyler, op. cit., p. 90.

15 Gammel and Zelazo, *Crystal Flowers*, pp. 91–92. Several decades later, Stettheimer kept a drawing by Thévenaz of a restless dancer on a hot summer day that he may have given her around this time. Inscribed "l'après-midi d'été ou l'insatisfaite" (or "a summer afternoon, or the unsatisfied,"), it portrays a nude West Indian dancer reclining under a palm tree, Olympia-style, on an elaborate chaise.

16 Ratan Devi was a singer of East Indian songs accompanied by the tambour. Devi was the only dancer at the time to present an authentic "Nautch," a combination of dance, gesture, song, and musical accompaniment, in New York.

17 In the actual photograph of Duchamp taken by Steichen at André Brook on June 22, 1917, the Frenchman stands with one arm against a brick wall as in the painting; however, his head is tilted at a different angle. Reproduced in Anne d'Harnoncourt and Kynaston McShine, *Marcel Duchamp* (Philadelphia: Philadelphia Museum of Art, 1973), p. 220.

18 Tyler, *Florine Stettheimer*, op. cit., p. 106.

19 I am indebted to Francis M. Naumann for bringing these place cards to my attention. Only three of them still exist. Naumann published descriptions of the cards intended for Carl Van Vechten and Fania Marinoff in the exhibition catalogue *Marcel Duchamp* for the Galerie Ronny van de Velde, Antwerp, September 15–December 15, 1991, nos. 38 and 39.

20 Letter of May 3, 1919, from Marcel Duchamp to the Stettheimer sisters, seen by the author in Joseph Solomon's personal collection in 1995.

21 According to Wendy Steiner, the most important conditions contributing to true narrative in painting are that the work present more than one temporal moment, that the subject be specific personages repeated within the composition, and that the setting be at least minimally realistic. These conditions are all met in Stettheimer's work. Wendy Steiner, *Pictures of Romance* (Chicago: University of Chicago Press, 1988), pp. 7–20.

22 Picabia and his wife, Gabrielle Buffet, first visited New York on January 20, 1913. In August 1915, the Picabias returned to New York to escape the war in Europe.

23 Ettie in her diary of July 30, 1917, Stettheimer Papers, Beinecke Library, Yale University. Leo Stein was an insistent and incessant talker. His sister, Gertrude, alluded to his increasing deafness and his intransigence in her essay "Two," in which she tracks the end of their brother-sister alliance: "She was changing. He was changing. They were not changing." It is perhaps the latter characterization that Stettheimer was mocking by splitting him in two in her *Fête* painting.

24 Letter from Ettie Stettheimer to a Mrs. Parker, in the Lake Placid painting file, Registrar's department, Museum of Fine Arts Boston.

25 *New York Sun*, April 28, 1918.

26 Letter from Ettie Stettheimer to Carl Van Vechten, August 2, 1946, Beinecke Library, Yale University. Elizabeth Duncan ran a school in Europe, where she trained young girls in the techniques of dance and movement used by her sister Isadora. When Isadora visited the country, she stole the "Isadorables" for her own troupe.

27 Marcel Duchamp later suggested to Stettheimer's biographer that she liked the American flag because it has the red and white stripes of peppermint candy, but Tyler himself felt she was fond of the flag because it was "like the Stettheimer sisters themselves, tripartite." Tyler, pp. 16–18.

28 This copy was dedicated in 1915. Nochlin, p. 70.

29 Review pasted in Stettheimer scrapbook, Stettheimer Papers, Avery, Columbia University.

30 "Portraits of Men in Service," in *Brooklyn Eagle* (May 5, 1918).

31 Unfortunately, the painting has been missing since the 1950s from the West Point Military Academy, to which it

was donated in 1945, the same year it was used as the cover illustration of the May issue of *Town and Country* magazine. According to the Academy, it was the habit of the school to allow generals to borrow works of art to hang in their offices and homes, and apparently, someone borrowed *A Day at West Point* and neglected to return it when they left the Academy.

32 Ettie, at age forty-nine, spent the year engrossed in flirtations. Throughout March she referred in her diary to the man she nicknamed "Don Juan"—"Elie," Elie Nadelman. According to the Stettheimers' lawyer, Ettie was in love with the sculptor, who was several years her junior. Duchamp later remarked to Parker Tyler that the romance might have been more serious on both sides than either imagined, that it was "somewhat like a movie plot except that nothing ever happened." Throughout the flirtation, Ettie also dated an Englishman named William Piercy, whom she called her "anti-dote."

33 Gammel and Zelazo, *Crystal Flowers*, pp. 133–34.

34 Batchelor, p. 4. See also Kenneth Silver, *Esprit de Corps* (New Haven: Yale University Press, 1991): 164–66. Silver notes there was a "subtle but quite definite shift in the modern artist's relationship to past art . . . We find again the more traditional notion of the past as something to be embraced (rather than negated or neglected) that was beginning to emerge during the war."

35 As described by Hamilton Easter Field in 1919.

36 In 1916, Charles H. Caffin, in a review of Nadelman's sculpture, noted that the sculptor "is for the moment less concerned with anatomical averages and standards than with enhancing the expressiveness," a statement that equally well describes Stettheimer's painted figures.

37 According to later conversations with the Stettheimers' lawyer, Joseph Solomon, and the reminiscences of Marcel Duchamp, the flirtation between the two ended badly when Nadelman married a wealthy heiress, Viola Flannery, in 1920.

38 The artist commemorated the event by inscribing the words "Mother, July 22 1918" on the birthday cake in the foreground, but she also signed and dated the painting "FS/1919" in the lower left.

39 Carl Van Vechten, "The World of Florine Stettheimer," in *Harper's Bazaar* 79 (October 1946): 356.

40 Undated, unpublished manuscript located in Stettheimer Papers, Beinecke Library, YCAL, and in Getty Research. The latter location indicates that this manuscript may have been intended to serve as an essay accompanying the small catalogue for the 1947 *Exhibition of Paintings by Florine Stettheimer* at the Arts Club of Chicago from January 3–28, as the typed pages were included with a copy of the catalogue and correspondence with Joseph Solomon about insurance valuations for works sold in the exhibition by Durlacher Brothers.

41 *Heat* was illustrated in the exhibition catalogue (no. 88).

42 Edward Alden Jewell, "Two Large Exhibitions," in *The New York Times* (April 21, 1929), p. 123.

43 Ettie noted in her diary, "Whatever that expressed I don't know. He has no prospects nor friends down there. I told him to call on me if he got sick or penniless, but I don't believe he would. Poor little floating atom, a strange boy—But a dear." According to Francis Naumann, Duchamp sailed to Argentina on the SS *Crofton Hall* on August 13, 1918, accompanied by Jean Crotti's wife, Yvonne, with whom he had an affair.

44 As Solomon pointed out in an interview with the author in 1994. In a letter of January 3, 1922, from Ettie to Duchamp, for example, she referred to the word games they played as a "pensée-cadeau" or "thought-gift," and one of the four "luggage tags" Duchamp made for Rrose Sélavy included the handwritten inscription: "Ettie qu'êtes," a play on the word "etiquette," possibly implying Ettie's strict reliance on proper behavior.

45 Conversations between Joseph Solomon and the author, summer, 1994. As detailed in later chapters, Duchamp greatly admired Stettheimer's work. She in turn painted more portraits of the French artist than of anyone else.

46 Duchamp letter to Ettie Stettheimer, January 3, 1922, reprinted in Francis Naumann and Hector Obalk, eds., *Affectionately, Marcel: The Selected Correspondence of Marcel Duchamp* (New York: Distributed Art Publishers, 2000), p. 105.

47 Gammel and Zelazo, *Crystal Flowers*, p. 84.

48 Carl Van Vechten, "The World of Florine Stettheimer," in *Harper's Bazaar* 79 (October 1946): 238. The table was set with red damask, a centerpiece of Venetian lace or Italian antique lace altar cloths.

49 An American journalist, essayist, satirist, cultural critic and scholar.

50 Paul Rosenfeld, "Florine Stettheimer," in *Accent* 5 (Winter 1945): 99–102. In Sprinchorn's drawing of the Stettheimers' salon, dated December 1944, from the back row are, beginning from the left: Van Vechten, O'Keeffe Carrie, Demuth Beatrice Keyer, Rabbi, Wise, Florine, Elsa Brill, Beatrice Wagner, Ettie, Isabel Lachaise, a tiny Fania Marinoff, Edna Lilienthal, and in the front from the right are Hilda Hellman, Philip Moeller, Carl Sprinchorn and direction under Van Vechten, Arnold Genthe.

51 Henry McBride, "Artists in the Drawing Room," *Town and Country* (December 1946): 74.

52 Ibid., p. 76.

53 Ibid., pp. 77, 336.

54 Carl Van Vechten, "Pastiches et Pistaches: Charles Demuth and Florine Stettheimer," in *The Reviewer* 2 (February 1922): 269.

55 Tyler, *Florine Stettheimer*, p. 104.

56 This painting has consistently been misdated to c. 1915. However, on the upper left side of a stretcher, "August 25, 1919" is written in pencil and stylistically the painting is far more in keeping with Stettheimer's later painting style. Tyler claimed, as did Emily D. Bilski and Emily Braun at the 2005 exhibition *Jewish Women and Their Salons*, that all three Stettheimer sisters are present in the composition, with Carrie seated next to Madame Gleizes on the red and white settee. In fact it is Florine and not Carrie (who is absent) wearing white pantaloons, looking out at the viewer with the same pose and expression as on *the Nude Self-Portrait* behind her. Bilski and Braun, *Jewish Women and Their Salons: The Power of Conversation* (New York: Jewish Museum, 2005), p. 126.

57 Paul Rosenfeld, "Florine Stettheimer," in *Accent* 5, no. 2 (Winter 1945): 100.

58 Norman Bryson, *Looking at the Overlooked: Four Essays on Still Life Painting* (London: Reaktion Books, 1990).

59 In the late 1910s through the 1920s, Uday Shankar choreographed and performed ballets in the United States. Thanks to Donald Gallup for identifying Shankar in a conversation with the author in February 1991.

60 Michael Levey, *Rococo to Revolution: Major Trends in Eighteenth-Century Painting*, Thames & Hudson, pp. 54–62. The figure at the right side of Watteau's *Fête vénitienne* is a self-portrait. Many modern artists, including Picasso, Gris, Derain, Severini, and Metzinger also painted harlequin figures to represent male figures in their works.

61 Nijinsky played the Harlequin in the Ballets Russes production of *Carnaval*; however, given my reading of the painting, I believe the artist's intended reference for the Harlequin was Duchamp.

62 Examination of this painting under ultraviolet light reveals that Stettheimer reworked and experimented a great deal with the outlines of the figures in the composition, gradually reducing the volume of each and making them less bulky.

63 Ettie wrote to Carl Van Vechten, asking whether he had attended the family party at which, when someone disagreed or asked a question, Stein offered them his deaf ear, saying, "That question is irrelevant." Stettheimer Papers, Beinecke Library, YCAL.

64 To date I cannot find any specific information on a "Luxembourg" exhibition around this date, either taking place in Europe or the United States.

65 From the text of a lecture by Karl Ann Marling on roadside colossi, delivered to the art history department at Yale University on April 25, 1984. Dr. Marling did not refer specifically to the Stettheimer painting, but the description is particularly apt given the recent situation of Stettheimer's life.

66 Although the painting is dated 1918 on the plaque by Stettheimer, after her death, it is dated 1919 in several exhibitions of the artist's work organized by Durlacher during the late 1940s.

67 At 612 feet, until the Metropolitan Life Insurance Building went up, it was the tallest building in the world.

68 In an April 9, 1922, *New York Herald* review of the *Modern Artists of America* show at the Brummer Gallery, Henry McBride completely misinterpreted Stettheimer's painting: "Miss Florine Stettheimer's *Russian Bank* is somewhat of a mystery. The artist figures in the picture herself, entering 'the bank' through a trellised opening in a gay hedge. Whether it is the bank where on the wild thyme blows or merely a bank from which money may be obtained is not clear. Probably the latter, since Miss Stettheimer's Aunt Kate consults a clairvoyant in the foreground as to what the immediate future has in store."

69 McBride, *Florine Stettheimer*, p. 13. At some point after she had the painting professionally photographed, Stettheimer added the figure of her sister Ettie, book in hand, at the base of a tall, attenuated tree at right.

70 As evident in Peter Juley & Sons' photograph.

71 In several exhibitions of paintings after the artist's death that were organized by Durlacher Brothers Gallery, this painting is labeled *At the Dressmaker's*, but there is no indication of why this other title, which has little to do with the composition, was affixed.

72 *Modern Art of America* exhibition, Joseph Brummer Gallery, New York, April 1921.

73 Van Vechten, "Introduction," in Tyler, *Florine Stettheimer*, pp. xii–xiii.

74 Penelope Redd, *Pittsburgh Sunday Post*, May 11, 1924, quoted in McBride, *Florine Stettheimer*, p. 52.

75 Tyler, *Florine Stettheimer*, p. 136.

76 Stettheimer to Van Vechten, September 23, 1925. Stettheimer Papers, YCAL.

77 "Coloured" or "colored" was adopted in the United States by emancipated slaves as a term of racial pride after the end of the American Civil War. It was rapidly replaced from the late 1960s as a self-designation by "Black" and later by "African American."

78 The artist never finished, and a decade later she destroyed both paintings, along with a number of her other early works. The only remaining evidence of them are professionally shot black-and-white slides. The original nitrate slides were in the Peter Juley Photography Archive, Smithsonian Institution, Washington, D.C., c. 1995.

79 There is conflicting information in her diaries and correspondence concerning when the move took place. In June 1926, Alfred Stieglitz wrote to the Stettheimers at the Alwyn Court address, but Florine's diary indicates they moved in June 1927. It is possible they moved into Alwyn Court in 1926 and gave up their residence on West End Avenue, and over the following year moved their remaining belongings to Fifty-Eighth Street.

80 Carl Van Vechten, foreword to Tyler, p. xii.

81 Now in the collection of the Los Angeles County Museum of Art.

82 In the first version, the evening sky above an American flag is illuminated by bursts of red, white, and blue firecrackers. In the second version, the artist painted a flower bouquet on a straw fan that is inscribed with the title, the date, and her first name and two small American flags are crossed at its base, encircled by a string of unlit firecrackers.

83 Gammel and Zelazo, *Crystal Flowers*, pp. 98–99.

CHAPTER SIX

1 David Tatham's article began my thinking of the larger context of Stettheimer's 1920s works. David Tatham, "Florine Stettheimer at Lake Placid, 1919," in *The American Art Journal* 31, nos. 1 and 2.

2 Ettie Stettheimer, preface to *Crystal Flowers*, privately printed.

3 In most descriptions, these works are described as "entertainment" paintings; see Suzanne Böller, "Not 'Advertisement,' No!—But 'Amusement' Mixed with 'Amazement': Florine Stettheimer's Entertainment Pictures," in *Florine Stettheimer* (Munich: Lenbachhaus, 2015), p. 132. In my 1995 book *The Life and Art of Florine Stettheimer*, I also described these paintings as "amusements," as I had not yet fully researched the backgrounds, sites, and contexts within Stettheimer's life vis-à-vis these works.

4 "A Sensation at Saratoga", in *The New York Times* (June 19, 1877), p. 1.

5 Ibid.

6 Peter Hopsicker, "'No Hebrews Allowed': How the 1932 Lake Placid Winter Olympic Games Survived the 'Restricted' Adirondack Culture, 1877–1932," in *Journal of Sports History* 36, no. 2: 208–9.

7 Ibid.: 207–10.

8 Ettie Stettheimer to a Mrs. Parker, August 18, 1950, Lake Placid painting file, Registrar's Department, Museum of Fine Arts, Boston.

9 David Tatham, "Lake Placid": 18.

10 James Gibbons Huneker, "Too Proud to Paint, Independent Idea, When Folk Cannot Draw or Wield Brush, They Develop an Ism or a Cult," in *The World*, March 20, 1920.

11 S. Jay Kaufman, "Round the Town," in *The Globe*, March 20, 1920.

12 Not yet a regular member of the Stettheimers' social circle, McBride did not correctly identify Rosetta as the woman in black standing at the red balcony.

13 There is confusion as to the dating. According to archives at Columbia University, Carl Van Vechten believed the work to have been painted between 1925 and 1930, and not in 1920; however, several exhibition reviews discuss the painting in 1921, indicating 1920 is the correct date.

14 "The Ku Klux Klan in the 1920s," *The American Experience*, PBS, https://www.pbs.org/wgbh/americanexperience/features/flood-klan/

15 W. E. B. Du Bois, *The Souls of Black Folk* (Chicago: A. C. McClurg & Co., 1903), p. 3.

16 Amy Helene Kirschke, "The Evolution of Douglas's Artistic Language," in Idem, *Aaron Douglas: Art, Race & The Harlem Renaissance* (University Press of Mississippi, 1995). http://www.iniva.org/harlem/aaron.html

17 Linda Nochlin, "Florine Stettheimer, Rococo Subversive," p. 72. This idea of "inspectin'" has recently caused quite a bit of criticism among African American scholars, who suggest Van Vechten was drawn to Harlem and African American writing, jazz, and art because of its "exotic," "primitivizing" elements, and who discuss the long history of white influence undermining Black cultural integrity. Emily Bernard, *Carl Van Vechten and the Harlem Renaissance, A Portrait in Black and White* (New Haven: Yale University Press, 2012), quoted in Elizabeth Sussman, "Asbury Park South and Carl Van Vechten," in *Stettheimer* (Lenbachhaus), p. 126.

18 Carl Van Vechten, "Pastiches et Pistaches: Charles Demuth and Florine Stettheimer," in *The Reviewer* 2 (February 1922): 269–70.

19 Bruce Kellner, *Carl Van Vechten and the Irreverent Decades* (Norman: University of Oklahoma Press, 1968).

20 In 1927, Miguel Covarrubias' *Negro Drawings* was published in an edition by Frank Crowninshield. The latter claimed the artist was "the first important artist in America . . . to bestow upon our Negro anything like the reverent attention . . . which Gauguin bestowed upon the natives of the South Seas." The book was published seven years after Stettheimer exhibited *Asbury Park South*. There were also several African American artists who painted scenes of the everyday life of African Americans during the mid- to late 1920s, including Archibald Motley Jr., Winold Reiss, and Aaron Douglas, among others.

21 Joseph Bilby & Harry Ziegler, *Asbury Park, A Brief History* (Charleston: The History Press, 2009), p. 18.

22 Madonna Carter Jackson, *Asbury Park: A West Side Story* (Parker, CO: Outskirts Press, 2011).

23 Victoria Wolcott, *Race, Riots, and Rollercoasters: The Struggle* (Philadelphia: University of Pennsylvania Press, 2014), p. 24; *The Daily Journal*, "Too Many Colored People," July 17, 1885; *New York Times*, "The Colored Controversy," July 20, 1885.

24 *The Daily Journal*, "Intruders," July 29, 1886. Although Bradley was not mentioned by name, he was referenced as "the man very prominently identified with this place."

25 David Goldberg, "Greetings from Jim Crow, New Jersey: Contesting the Meaning and Abandonment of Reconstruction in the Public and Commercial Spaces of Asbury Park, 1880–1889," p. 12.

26 "Answering Mr. Bradley: Colored People at Asbury Park Speak Out at Meeting," in *New York Times*, June 28, 1887.

27 "Story of Girl's Murder, and Continuous Search for Slayer," *Asbury Park Evening Press,* March 15, 1911, p. 12.

28 One of the women appears inexplicitly to be wiping her eyes with a handkerchief. Behind him, strangely, is his chubby alter-ego wearing a turban. Stettheimer included a small figure with the chef's robe and hat and a golden coffee urn in the painting, the latter with the emblem of cordon bleu, directly behind Van Vechten. She also included this figure in her *Portrait of Carl Van Vechten* of 1922.

29 Gammel and Zelazo, *Crystal Flowers*, p. 37.

30 Bushnell Diamond, "Boredom Banished by the Modernists," in *Philadelphia Inquirer*, April 17, 1921.

31 Hamilton Easter Field, "Review of Exhibitions Including Independents," in *The Arts*, April 1921, p. 51. At some point the original frame designed by Stettheimer was lost. The one shown in a photograph by Carl Van Vechten when he and Ettie donated *Asbury Park South* to Fisk University is a plain gilt frame that lacked "flounces."

32 Henry McBride, "Review of the Independents," in *New York Herald*, March 6, 1921.

33 Gaston Lachaise to Stettheimer, March 23, 1921, Stettheimer Papers, YCAL.

34 Marcel Duchamp, *The Selected Correspondence of Marcel Duchamp* (Ghent: Ludion Press, 2000), p. 133.

35 Du Bois's review in *Crisis*, no. 81 (December 1926).

36 Carl Van Vechten, notes for *Nigger Heaven*, YCAL.

37 James Weldon Johnson, "Romance and Tragedy in Harlem—A Review," in *Opportunity* 4 (October 1926): 316, 330.

38 Beinecke Library's Collections contains remarkable chalk drawings by Isabelle Lachaise's African American maid, Mary Bell, that Van Vechten sent to Stettheimer to view and she in turn sent him some poetry by a Black elevator conductor at the hotel where she was staying in Atlantic City at the time. The latter's poems have not been located. In 1927 Van Vechten sent Stettheimer James Weldon Johnson's novel *The Autobiography of an Ex-Colored Man* as a present for her birthday.

39 The paintings were donated to the museum for the benefit of Fisk's African American students. *Asbury Park South* remained in storage at Fisk until 2012, when, needing funds, the university sold *Asbury Park South*. As a result the painting is one of Stettheimer's only major paintings not in a museum collection as she had wished, nor is it any longer accessible for Fisk's

African American students as Van Vechten had desired when he arranged its original gift.

40 There were unfortunate exceptions to this: women in Washington D.C. were initially excepted as the District was not a "State." Due to racist motives, Native American and Asian-American women were excluded from the right to vote, and the existing Jim Crow law made it difficult for many African American women to register or have means and access to vote until 1965, nor did other women of color.

41 Carolyn Hall, *The Twenties in Vogue* (New York: Octopus Books, 1983), pp. 14–16.

42 Eksteins, pp. 257–59, and Hall, pp. 14–16.

43 Carl Van Vechten, "The World of Florine Stettheimer": 353.

44 The sisters bathed outside at various places they rented for the summer. Sometime during a summer spent in the private yard of the Gould estate, an intricate outdoor shower system was arranged for them. Stettheimers' diaries indicate that they indulged more than once in a "fountain bathe among the flower beds and rose arbors."

45 Egon Schiele exhibited a number of his sexually explicit watercolors and images of women at Secessionist shows in Munich beginning in 1911 while Stettheimer lived in Europe. She never mentions him in her diary but does mention visiting Secessionist exhibitions and admires the work of Schiele's mentor, Gustav Klimt, who also made fairly overt sexual drawings. In both the Courbet painting and the majority of Schiele's works prior to Stettheimer's leaving Europe in 1914, the women's genitals are covered with public hair and so not as frank as *The Bathers*. Even in eighteenth-century erotic lithographs, Victorian daguerreotypes, and Persian and Indian miniatures, if women's labia and vulva are shown, the women's legs are generally tightly together and the vulva closed (as in Greek statues or paintings by Ingres, Goya, or Titian) or obscured by public hair; thus making *The Bathers* more remarkable.

46 David Lloyd, "Review of the Society of Independent Artists," in *New York Evening Post*, March 13, 1922.

47 Some writers have claimed Stettheimer's style of painting figures, especially those in *Spring Sale*, was based or influenced by popular illustrations by Tony Sarton or Ann Harriet Fish in *Vanity Fair*. However, Stettheimer's 1911–12 *Orphée* ballet drawings and figures and her paintings from c. 1918 onwards show she was painting in this style years before their illustrations. In fact, they might have seen her work and been influenced by it. Heather Hole, "Florine Stettheimer, the Department Store, and the Spaces of Display, New York 1916–1926," in *Panorama: Journal of the Association of Historians of American Art* 3, no. 2 (Fall 2017), https://doi.org/10.24926/24716839.1604

48 Lloyd, David, "Review of the Society of Independent Artists," in *New York Evening Post*, March 13, 1922.

49 In a review, Paul Rosenfeld vaguely alluded to this relationship between her work and popular culture: "The idea of grandiose documentary caricatures of the land of the free found expression in Miss Stettheimer's art some while before it was popularized by the *American Masters*." Paul Rosenfeld, "The World of Florine Stettheimer," in *The Nation* 34 (May 4, 1932): 524.

50 *New York Herald*, April 17, 1921.

51 Banner, pp. 248–69.

52 Deal Beach, located in Monmouth County, was settled by European immigrants in 1660, making it logical that d'Alvarez would represent that area. It was also one of the country's wealthiest zip codes for a period in the early twentieth century, which is probably why she wears ermine.

53 As Linda Nochlin noted, Miguel Covarrubias also made a few caricatured impressions of Harlem nightlife, which offer stylistic parallels for Stettheimer's depictions of Black figures in this painting. Nochlin, *Art in America*, p. 77.

54 In her essay "Not 'Advertisement,' No! – But 'Amusement' mixed with 'Amazement': Florine Stettheimer's Entertainment Pictures," in *Stettheimer* (Lenbachhaus): 138, Susanne Böeller identified the two male judges in this painting as Arnold Genthe and Robert E. Locher. But by 1920 Genthe was 50, and photographs show he had long, wild, white hair, no mustache, and very thick lips, and thus did not resemble either man in the painting. Photographs from 1930, ten years after this work, show Locher still had dark brown hair and so is not the other judge in the painting. Nadelman, on the other hand, was then forty and had combed-back red hair.

55 In addition to writing poetry, Sandburg had several vocations, including reporter. It is known that Sandburg attended at least one of Stettheimer's studio parties, but whether they ever discussed poetry is not known.

56 In 1924, Alta Sterling, Miss Sioux City, was the first Jewish contestant to enter the Miss America contest. It wasn't until the 1945 when Bess Myerson won Miss New York Miss America as the first Jewish woman ever to do so.

57 Linda Nochlin noted a similarity in graphic stylishness between *Natatorium Undine* and a cartoon by the illustrator Fish in the August 1927 issue of *Vanity Fair*. However, the latter was published a month after Stettheimer began *Natatorium Undine* in July, according to her diary.

58 For an interesting discussion of how dreams and notions of the feminine influenced Surrealism, see Fer, pp. 17–83, 231–47.

59 Marcel Proust, *Swann's Way: Remembrance of Things Past*, Volume One (New York: Henry Holt and Company, 1922).

60 Silverman, pp. 150–55. From Edmond de Goncourt, *La Maison d'un Artiste* (Paris: Charpentier, 1881, nouvelle édition, 1904): 202–04.

61 Marcel Proust, *The Captive: Remembrance of Things Past*, Volume Five (New York: Henry Holt and Company, 1923): 71.

62 There is widespread controversy today among scholars about the nature of Nijinsky's sexual preferences since he had an extensive affair with Diaghilev, as well as a long marriage and two daughters with his wife Romola.

63 From photographs the figure closely resembles Bolm with his high forehead, shock of dark hair and prominent nose. Adolph Bolm must have seen *Music*, as that year he sent the Stettheimers a Christmas card with an ink drawing that was obviously intended as a rejoinder to the painting. In the card he wears a dancer's leotard but retains a defined, masculine body, while his wife Beatrice plays the piano. Bolm's son Olaf is dressed in an Arabic/Moorish costume. I disagree with Cintia Cristia's identification of the figure with Duchamp: "Painting Jazz," in *Florentine Stettheimer: New Directions in Multimodal Modernism*, ed. Irene Gammel and Suzanne Zelazo (Toronto: Book*hug Press, 2019), pp. 192–93.

64 K. Lewes, *The Psychoanalytic Theory of Male Homosexuality* (New York: Simon and Schuster, 1988).

65 As A. J. P. Taylor noted, "At the *fin de siècle* [homosexuality] had been consciously wicked. Now it was neither innocent nor wicked. It was merely, for a brief period, normal." From *Oxford History of England*, quoted in Bevis Hillier, *The World of Art Deco* (New York: Dutton, 1971), p. 38. See also Terence Greenidge, *Degenerate Oxford?* (London: Chapman and Hall, 1930), pp. 89–111.

CHAPTER SEVEN

1 Wendy Steiner, *Exact Resemblance to Exact Resemblance: The Literary Portraits of Gertrude Stein* (New Haven: Yale University Press, 1978), pp. 2–5.

2 When Bergson came to America to lecture at Columbia University in February 1913, the streets were clogged with admirers and would-be attendees. Bergson's book *Creative Evolution* sold in two years in the U.S. half as many copies as it had sold in France in fifteen years. Copies were even sold in popular New York department stores. May, pp. 228–29, 370–71.

3 Gertrude Stein, "Portraits and Repetition," in *Lectures in America* (New York: Random House, 1935), p. 183.

4 Alfred Stieglitz, *Camera Work* (August 1912): 29–30, 225.

5 Jan Thompson, "Picabia and His Influence on American Art," in *Art Journal* 39 (Fall 1979): 14.

6 Tyler, *Florine Stettheimer*, p. 52.

7 Two other paintings that have conceptual similarities to Stettheimer's portraits are Malevich's *An Englishman in Moscow* (1913–14), now in the Stedelijk Museum in Amsterdam, and an unusual portrait by the Mexican artist Frida Kahlo, *Portrait of Miguel N. Lira* (1927).

8 Marcel Proust, *The Past Recaptured* (New York: Vintage Books, 1971), p. 271.

9 Demuth, unpublished manuscript, Stettheimer Papers, YCAL.

10 Best-Maugard believed that the decorative elements of all of what he termed "primitive" art could be reduced to seven primary elements: circle, half-circle, wavy line, s-form, zigzag, straight line, and spiral. He created a step-by-step art-making system that would form the foundation of how art was taught in Mexico for decades afterwards. In addition, Best-Maugard's technique of eliminating shading and ignoring rules of perspective became characteristic of modernist Mexican art. The artist's philosophic concepts and system were published in his highly popular 1926 book, *A Method for Creative Design*.

11 The location of Best-Maugard's painting of Ettie is unknown, but a reproduction exists in the Stettheimer archives at Columbia University, box 3.

12 The whereabouts of this painting are unknown at this time. A small black and white image can be seen in Bloemink, *The Life and Art of Florine Stettheimer*, p. 101.

13 Adolfo Best-Maugard, *A Method for Creative Design* (New York: Alfred A. Knopf, 1927), p. 16.

14 Tyler, *Florine Stettheimer*, op. cit., p. 36.

15 Ibid., p. 37.

16 McBride, *Florine Stettheimer*, p. 45.

17 McBride to Robert McAdam, Archives of American Art, Smithsonian Institution, Washington, D.C.

18 Three years after tennis began as a sport in the U.S. in 1875, residents of Sea Bright ordered the equipment and, on July 24, established the Sea Bright Tennis Club. In 1884, the first invitation tournament was held there and it would become an annual, internationally regarded affair.

19 Cadotte Devree, "Profile, Henry McBride . . . Dean of Art Critics," in *Art in America* (October 1955): 42. Contemporary photographs reveal that Stettheimer convincingly captured McBride's physiognomy.

20 McBride to Florine Stettheimer, June 14, 1922, Stettheimer Papers, Beinecke. For additional letters see also Archives of American Art, McBride correspondence, microfiche roll NMcB 5, fr. 675.

21 In a letter to his friend McAdam of February 15, 1932, McBride described a party at Juliana Force's in which the guests watched a film. McBride lamented, "I was such a fat figure in it that I almost died of shame and what made matters worse is that everybody said it was wonderfully like me. I was shown playing tennis and I don't think I ought to play tennis anymore if I look like that…. I think after this I will be permanently camera-shy." *Archives of American Art*, New York.

22 McBride, *New York Sun*, March 13, 1926.

23 McBride's fondness for Homer was well known. At some point, Stettheimer painted another portrait of McBride over a postcard reproduction of a Homer watercolor depicting a view from Nassau toward Hog Island. On the surface of the card, she painted McBride clutching the trunk of a coconut palm with both arms and looking up toward two small figures who stand in the leafy palm fronds, waving American flags. The work is in the collection of Diane Solomon Kempner.

24 In a 1948 exhibition of paintings by Stettheimer at the Wadsworth Atheneum, organized by the Durlacher Gallery, a label affixed to the painting identified the building as a "church" by Demuth.

25 Henry McBride, draft for essay on Stettheimer, 1945, Stettheimer Papers, YCAL.

26 "That composite, heterogeneous room has kept in my memory a cohesion . . . alive and stamped with the imprint of a living personality. . . . The things in my room . . . were . . . an enlargement of myself." Marcel Proust, *Within a Budding Grove* (New York: Vintage, 1970): 83, 178, 237.

27 The painting was in the collection of Carl Van Vechten and was later donated to Beinecke Rare Book and Manuscript Library, Yale University.

28 Stettheimer wrote the following poem in response to being grouped with her sisters in his dedication to the *Peter Whiffle* book: "Dear Carlo/I am agitated/It's so sudden/so unexpected/bound up with you/for life/chained/cobwebbed/a difference/an indifference/Would you coldly undedicate us/I am agitated/Dear Carlo/Florine" Gammel and Zelazo, *Crystal Flowers*, p. 114.

29 Carl Van Vechten, *Peter Whiffle: His Life and Works* (New York: Knopf, 1921), pp. 49, 177.

30 Ibid., p. 206.

31 Gammel and Zelazo, p. 102. The references are to Peter Whiffle, Edna Kenton—to whom, with his cat Feathers, Van Vechten dedicated *Tiger in the House*—and Mabel Dodge.

32 As Van Vechten noted: "My experience with drugs is that I have experienced very little with very few of them . . . because I had only taken heroin and cocaine or something like that a couple of times. My experience was that when you took this drug you felt as if you knew everything and could write anything. Again it gives you enormous power of feeling that you are all and understand all things." He eventually discontinued drug use, believing that it impaired his writing.

33 Van Vechten, notes for a never-completed essay on Stettheimer, undated, Stettheimer Papers, YCAL.

34 Poem written by Stettheimer directly on a card with the gouache painting of a bouquet with cat's tails sent to Van Vechten—the poem is not reproduced by Ettie in *Crystal Flowers* nor in the more recent publication of the book.

35 McBride, *Florine Stettheimer*, p. 47.

36 Perhaps influenced by Stettheimer's portrait of him, Van Vechten included one of his photographs of the café in the second edition of *Peter Whiffle*, which was published in 1927.

37 In one of Van Vechten's novels, *The Blind Bow Boy*, a male character states, "A thing of beauty is a boy forever."

38 Penelope Redd to Florine Stettheimer, May 5, 1922, Stettheimer Papers, YCAL.

39 Review, March 11, 1923, journal unknown, pasted into Stettheimer's scrapbook in the Stettheimer archives, Avery Library, Columbia University.

40 Review, March 4, 1923, journal unknown, pasted into Stettheimer's scrapbook in the Stettheimer archives, Avery Library, Columbia University.

41 Jonathan Weinberg, *Speaking for Vice* (New Haven: Yale University Press, 1993), pp. 121–28.

42 Marsden Hartley, *Creative Art* 9, July 1931, pp. 21–23.

43 Carl Van Vechten, unpublished notes, Stettheimer Papers, YCAL.

44 Crowninshield to Stettheimer correspondence, Stettheimer Papers, YCAL.

45 O'Keeffe later recalled this incident as being her first meeting with Duchamp as well. "It was probably in the early twenties that I first saw Duchamp. Florine Stettheimer made very large paintings for the time, and when a painting was finished she had an afternoon party for twenty or twenty-five people who were particularly interested to see what she had been painting."

46 December 9, 1929, letter to Ettie at the Shelburne, Atlantic City, Stettheimer Papers, YCAL.

47 Gammel and Zelazo, pp. 102–03.

48 Louis Bernheimer to Ettie Stettheimer, July 1922, Stettheimer Papers, YCAL.

49 Florine Stettheimer to Bernheimer, postcard, August 7, 1922, YCAL.

50 Louis Bernheimer to Florine Stettheimer, August 12, 1922, Avery Library, box 1, folder 8.

51 In 2017, Roberto C. Ferrari, the Curator of Art Properties, and Carole Ann Fabian, Director, of Avery Library, had Eli Wilner & Company restore Stettheimer's original frame (on the portrait of Ettie) and created two period replica frames in the same style (on *The Portrait of Myself* and her portrait of Carrie). This involved recreating Stettheimer's original brushed silver leaf gilt surface.

52 McBride, *Florine Stettheimer*, p. 43.

53 Emily D. Bilski and Emily Braun mistakenly identified Florine Stettheimer, not Ettie, as the author of *Love Days. Jewish Women and Their Salons*, p. 132.

54 Tyler, *Florine Stettheimer*, p. 140.

55 Stettheimer Papers, Box 6, YCAL.

56 Ettie to Fania Marinoff, 1939, Stettheimer Papers, YCAL.

57 Gammel and Zelazo, *Crystal Flowers*, pp. 96–97.

58 In 1923, cellophane was introduced as a dress material at the Parisian Opera Ball, when the Duchesse de Gramont came dressed in a cellophane gown designed by Vionnet and Cheruit, as reported by *Vogue* magazine. Hall, *Vogue in the 20s*, Stettheimer scrapbooks, YCAL.

59 Tyler, *Florine Stettheimer*, p. 86. Duchamp enjoyed sexual relationships with women and therefore viewed women's bodies sexually, whereas Stettheimer would have seen her body more through a woman's eyes, preferring her fashionably slim, chic body.

60 Jerrold Seigel, *Bohemian Paris: Culture, Politics and the Boundaries of Bourgeois Life, 1830–1930* (Baltimore: Johns Hopkins University Press, 1999), pp. 113–14.

61 Quoted in Jerrold Seigel, *The Private Worlds of Marcel Duchamp: Desire Liberation, and the Self in Modern Culture* (Berkeley: University of California Press, 1995), p. 217.

62 Ibid., pp. 245, 243.

63 Notions conflating women with children (the naive *femme-enfant*), flowers, and visible manifestations of emotional states dominated the thinking of Breton and others. For Breton, woman "completes the male vision by absorbing into herself those qualities that man recognizes as important but does not wish to possess himself." Whitney Chadwick, *Women Artists and the Surrealist Movement* (London: Thames and Hudson, 1991), pp. 13–42.

64 Andre Breton's prototype of the *femme-enfant* in his 1927 book *L'Ecriture Antomatique* quoted in "Search for a Muse," in Whitney Chadwick, *Women Artists and the Surrealist Movement* (London: Thames and Hudson, 1985).

65 Tyler claimed Stettheimer painted her pupils under a "caul" and that "the delineation of the eyeball through the flesh below the eye that was a Cubist device . . . indicating another 'dimension.'" Tyler, *Florine Stettheimer*, pp. 40–41. Her wide-open eyes may symbolize her seeing a fourth dimension.

66 Ibid., pp. 221–22.

67 Ibid., p. 632. Linda Nochlin suggested William Blake's *Song of Los* as an influence for *Portrait of Myself*. The image was published in Laurence Binyon's *Drawings and Engravings of William Blake* in 1922, a year before the painting was made. Stettheimer did not mention Blake, and there are few similarities between the two images; however, it is interesting to consider Blake's etching in relation to her portrait of Ettie, as both show a figure reclining with one arm bent behind her head, the whole against a dark, star-studded sky.

68 Sidra Stich, *Anxious Visions: Surrealist Art* (New York: Abbeville Press, 1990), p. 11. See also Mary Ann Caws, Rudolf Kuenzli, and Gwen Raaberg, *Surrealism and Women* (Cambridge: MIT Press, 1991).

69 Tyler, p. 41. This was apparently a popular notion. The 1915 July cover of *Vanity Fair* included an illustration of male and female insects who hold hands and flirt.

70 Gammel and Zelazo, *Crystal Flowers*, p. 66.

71 Ibid., p. 62.

72 Norman F. Cantor, *Twentieth Century Culture: Modernism to Deconstruction* (New York: Peter Lang, 1988), p. 43; see also Silverman, pp. 150–60.

73 Kate Chopin, *The Awakening and Selected Stories* (New York: Penguin, 1976), pp. 51, 68, 124.

74 Gammel and Zelazo, *Crystal Flowers*, pp. 89–90.

75 The main difference between this image and the earlier rendition of the scene is the addition of a man, possibly Walter Stettheimer, at right, and a uniformed maid bearing a tray at left.

76 Wendy Steiner, *Pictures of Romance* (Chicago: University of Chicago Press, 1988), p. 19.

77 Stettheimer executed two watercolor sketches for this work. Both feature a brown-haired young man with blue eyes and a red-haired, blue-eyed woman with two small blue-eyed children. These may refer to one of many visits made by their older sister, Stella, and her family.

78 James J. Martine, *American Novelists*, 1910–1945, vol. 9 of *Dictionary of Literary Biography* (Detroit: Gale Research, 1988), pp. 123–30.

79 Carl Van Vechten, "How I Remember Joseph Hergesheimer," in *Yale University Library Gazette*, pp. 87–93. Undated clipping in Stettheimer. Papers, YCAL.

80 Burton Rascoe, "A Bookman's Day Book," *New York Tribune* (Sunday, November 25, 1923), p. 26.

81 Hergesheimer to Florine Stettheimer, December, 1923, Florine Stettheimer Papers, YCAL.

82 Ibid.

83 Ibid.

84 From 1921 to 1925 Belmaison Gallery exhibited many modernist artists including Georges Braque, Juan Gris, Marie Laurencin, Matisse, Picasso, Demuth, Hartley, Sheeler, Marguerite and William Zorach, and Stuart Davis. *Wanamaker Belmaison Gallery Brochures*, Watson Library, Metropolitan Museum of Art, New York.

85 Bruce Weber, op. cit., https://blog.mcny.org/2016/09/06/ louis-bouche-the-stettheimer-dollhouse-and-mamas-boy/

86 "Society of Independent Artists Review," *New York Sun*, 1923, page torn out and glued in Stettheimer scrapbook, Avery Library, op. cit.

87 Sprinchorn made the papercut silhouettes but these are outlines, not portraits. The only other extant image is the 1914 collaged postcard from Bern.

88 The other artists in this exhibition included Max Weber, Jules Pascin, Eugene Speicher, William Glackens, John Covert, Louis Eilshemius, Charles Duncan, Joseph Stella, Robert Chandler, George Bellows, and Andrew Dasburg. Eight carved paddles from New Guinea and New Britain were also listed for sale in the same show indicating the eclectic nature of the selections.

89 Works by Hunt Deiderick, Robert Chandler, George Biddle, John Storrs, William Zorach, and Charles Prendergast were also exhibited.

90 Sources include Phillipe Julian and Robert Brandau, *De Meyer* (New York: Knopf, 1976), Philip Hoare, *Noel Coward: A Biography* (Chicago: University of Chicago Press, 1998), p. 32.

91 Alexandra Anderson-Spivy, *Of Passions and Tenderness: Portraits of Olga by Baron de Meyer* (Vancouver: Graystone Books, 1992), p. 150.

92 John Savage, "Baron de Meyer: His Influence on American Taste in the Different Branches of Art," in *Vanity Fair* (November 1920): 75.

93 Turcot, Laurent, "Promenades et flâneries à Paris du XVIIe au XXIe siècle: la marche comme construction d'unc identité urbaine" in Rachel Thomas, *Marcher en ville. Faire corps, prendre corps, donner corps aux ambiances urbaines* (Paris: Ed. des Archives Contemporaines, October 2010), pp. 70–78.

94 Pierre Cabanne, *Dialogues with Marcel Duchamp*, trans. Ron Padgett (New York: Viking, 1971), p. 17, quoted in Cleve Gray, "Retrospective for Marcel Duchamp" in *Art in America* 53, no. 1 (January 1965): 104.

95 Rrose Sélavy to Ettie Stettheimer, July 9, 1922, in *Affectionately, Marcel: The Selected Correspondence of Marcel Duchamp*, eds. Francis M. Naumann and Hector Obalk (Brussels: Ludion Publishers, 2000), pp. 118, 122.

96 In 1952, Ettie gave the drawing to Virgil Thomson, who asked Duchamp to sign it. He did, inscribing it "Chère Florine à Virgil/Marcel Duchamp/1952/(done around 1925)." Since Duchamp was not in New York in 1925, the drawing was probably executed in either 1923 or 1926. Joseph Solomon approached Duchamp, asking him to make a copy. Duchamp, who had long since abandoned "retinal" work (i.e. "artwork designed to appeal to the eye"), refused. Solomon then approached Thomson, who at first said he wanted a thousand dollars for the piece but then kept it. The drawing remained in his collection until it was sold at auction to a private art dealer, Timothy Baum, in 1990. Tyler, *Florine Stettheimer,* p. 117, and May 1991 author interview with Joseph Solomon, New York City.

97 Francis Naumann and Hector Obalk, eds., *Affectionately, Marcel: The Selected Correspondence of Marcel Duchamp* (Ghent: Ludion Press, 2000), pp. 101, 122, 133, and letters from Duchamp to the Stettheimer sisters from 1919–25, Stettheimer Papers, YCAL.

98 Henry McBride, "Florine Stettheimer: A Reminiscence," *View* 5, no. 3 (October 1945): 13–14.

99 Author's interview with Virgil Thomson, New York City, October 1983.

100 Cabanne, *Duchamp*, p. 64.

101 The author first suggested that Florine Stettheimer might have been Duchamp's model for Rrose Sélavy in Barbara J. Bloemink, "Florine Stettheimer, Hiding in Plain Sight," in Naomi Sawelson-Gorse, ed., *Women in Dada* (Cambridge: MIT Press, 1998), pp. 478–514.

102 In Man Ray's photo of Duchamp as Rrose Sélavy (1920–21), Duchamp borrowed the hat from his friend Germaine Everling, who also posed for the hands in the photograph but bears no physical resemblance to Rrose.

103 Tyler, *Florine Stettheimer*, p. 11. See also Banner, pp. 190–91, 222–23. In Paris and New York, the term "bachelor girls" was coined to describe unmarried women. It was considered complimentary, reflecting society's acknowledgment that single women, like men, could live irresponsible, pleasure-filled lives. See Virginia Nicholson, *Singled Out: How Two Million British Women Survived Without Men after the First World War* (Oxford: Oxford University Press, 2008), p. 89.

104 Tyler, *Florine Stettheimer*, p. 69.

105 Robert Crunden, *American Salons: Encounters with European Modernism, 1885–1917* (New York: Oxford University Press, 1993), p. 432.

106 "The fourth dimension was defined as essentially "the mirror of a three-dimensional mathematical-style exploration of space-magnitude in all directions at one time." The latter was also the definition that Duchamp used in forming his work the *Large Glass*. Crunden, pp. 430–31.

107 In the title he eliminated the letter "n" so French Window became Fresh Widow, a pun referring to the recent war and the amorous ("fresh") soldiers' widows. The inscription at the base, "Copyright Rose Sélavy 1920," is the first time Duchamp's female alter ego appears. The Laughing Ass emblem also originated in 1920, the year of Stettheimer's portrait.

108 Tyler, as usual, contradicts himself in his biography, stating at one point that Duchamp told him that "they never talked shop or discussed aesthetic values seriously." Tyler then states multiple times how the artist and Duchamp discussed aesthetic issues. Solomon also emphasized the two artists' regular discussions on art. Tyler, *Florine Stettheimer,* pp. 37, 41, 142, 145.

109 Marcel Duchamp, letter to Ettie Stettheimer, January 1, 1924, Stettheimer Papers, RBML, box 1, folder 19. This is a translation; the letter itself was written in French.

110 Thanks to Romy Golan for informing me that *duché* means "duchy" or "aristocracy," and *douche* means shower or bath and was therefore a reference to Duchamp's infamous work

"Fountain." The word also connotes a succession of good and bad news, signified by cold and hot water; also "*donner une douche*" is to give someone a shower, to cool someone off, to tone down their excitement. All these meanings resonate with Duchamp's elegant but cool persona and avant-garde work.

111 Gammel and Zelazo, *Crystal Flowers*, p. 105.

112 Cabanne, *Duchamp*, p. 64.

113 Stieglitz letter to Ettie Stettheimer, June 27, 1927. Ettie Stettheimer Papers, YCAL.

114 Letter from Florine Stettheimer to Henry McBride, July 13, 1927, Florine Stettheimer Papers, YCAL.

115 In March, Stettheimer resigned from the Modern Artists of America and refused its director Yasuo Kuniyoshi's many requests to reconsider. Kuniyoshi sent Stettheimer a handwritten letter: "Perhaps I am not [the] person to make you feel towards the society more friendly, yet I want to write to you because I don't want to lose you from this society for I like your work so much and the society feels the same." She also refused to include a work in the Society's forthcoming portrait exhibition, writing, "I have decided not to show any more portraits for the present as I am keeping them for my own show." The suggested exhibition never materialized. Stettheimer Papers, YCAL.

116 McBride, *Florine Stettheimer*, p. 39. According to Ettie, the portrait takes place at the Stettheimer house in Rochester, NY, where she and Florine were born.

117 Tyler, *Florine Stettheimer*, p. 120.

118 Gammel and Zelazo, *Crystal Flowers*, p. 123. On a typed draft of the poem (Beinecke), Ettie wrote, "[Mother] did not read German," and she crossed out the word "Grimm's" (line 18), which Florine had inserted over the word "us" in pen. This evidence of Ettie's editing of Florine's poems is an example of her attempt to control Florine's posthumous image.

119 Based on the legible names, the works are Decameron (erotic to tragic tales told mostly by women after the Black Death in 1348); Tobias Smollet's 1751 *Peregrine Pickle* (an artist thrown into the Bastille and threatened with castration); Samuel Richardson's *Virtue Rewarded*, and Paul de Kock's 1821 *Georgette, ou la Nièce du Tabellion* (the name Florine used for her persona in *Orphée.*)

120 This letter was among the O'Keeffe papers in YCAL in 1995. However, when the author returned to the files in 2000 and again in 2018, the librarians were no longer able to locate it. It is therefore paraphrased as clearly as can be remembered.

121 Sue Davidson Lowe, *Stieglitz: A Memoir/Biography* (New York: Farrar, Straus & Giroux, 1983), pp. 278–82.

122 Letter from Georgia O'Keeffe to Florine Stettheimer, October 7, 1929, Stettheimer Papers, YCAL.

123 Letter from O'Keeffe to Stettheimer, October 7, 1929, O'Keeffe Papers, YCAL.

124 There is an ironic parallel between this statement and one written in 1870 by the critic Camille Lemonnier describing Regnault's painting *Salomé*, which Stettheimer commented on in her diary of 1912. Lemonnier noted, "I find his figure to be a Salomé, it does not matter to me if she is not the Salome." Quoted in Clark, p. 115.

125 Stieglitz letter to Stettheimer, 1929, Stettheimer Papers, YCAL. After Stettheimer's death, Van Vechten convinced Stieglitz to give this work, along with a work by O'Keeffe, to Fisk University.

126 Other works ended up with certain friends, a few given to them or purchased from Solomon after the artist's death.

CHAPTER EIGHT

1 A number of critics were disappointed in this, the Museum of Modern Art's second exhibition, because of the inclusion of foreign-born artists. In addition to complaining that Stettheimer had been left out, McBride criticized the lack of "advanced artists."

2 Cook invested the women's money in mortgage and participation certificates. Although for a time these were rendered almost worthless, on Cook's advice the Stettheimers held on and eventually doubled their money. When he retired, Cook passed the Stettheimer account on to his young associate, Joseph Solomon. Following the latter's advice, the women invested their savings in preferred equity stocks and ended up with a fortune. Solomon remembered the stir caused by the startling image of three sisters, each wearing highly idiosyncratic garments, coming to his rather staid legal offices for conferences. Interview with author, 1986–87, New York.

3 Stettheimer Papers, YCAL, and McBride, Archives of American Art, Smithsonian Institution.

4 Erika L. Doss, "Images of American Women in the 1930s: Reginald Marsh and Paramount Pictures," in *Woman's Art Journal* 4, no. 2 (Fall 1983).

5 Designed by the Chicago architect Walter W. Ahlschlager, the Roxy was the largest and arguably the most elaborate movie palace ever built. It was the first movie theater to use a rear-projection system and contained a complete hospital with an operating room, a 550-ton ice-cooling plant, and its own radio broadcasting studio. As many as fifty million people visited the theater in its first twelve years of operation.

6 The rug was manufactured by Mohawk Carpets in Amsterdam, New York.

7 Five years later, Radio City Music Hall would open, and eventually the Roxyettes would move venues and become the Rockettes.

8 Critics had also noted that Ashton's choreography for *Four Saints in Three Acts* created "visual moments . . . that replicate . . . pictorial borrowings from various well-known paintings."

Stark Young, "Reading Lesson," in *Theater Arts Monthly*, May 1945.

9 The arch of the painting is also very similar to the one in the Paramount Theatre, which was simpler and lacked the Roxy's elaborate "lacy" top insert. Stettheimer did not include the latter section in her painting.

10 The first review also referred to the American Society of Painters, Sculptors and Gravers exhibition held at the Whitney in 1932, but the clipping title, "Attractions in Other Galleries," is cut out and left undated and uninscribed in the Stettheimer archives at RBML. Paul Rosenfeld, "The World of Florine Stettheimer," in *The Nation* 34 (May 4, 1932): 522–23.

11 Edward Alden Jewell, "Whitney Museum Show of American Society of Painters, Sculptors and Gravers," in *New York Times*, February 14, 1932, p. X10.

12 The letter is cited as "Arnold Genthe 41 E 49th St NY (July 14 or 24, 1931)."

13 Diary entry, September, 1930, YCAL.

14 When the painting was donated to the Detroit Institute of Art, Ettie noted in an accompanying photograph of the work, "Florine contemplating various friends of her youth whom she portrayed with a mingling of symbolism and realistic observation." The fact that all but one of the eight figures she is contemplating are male friends and former romantic interests refutes Rebecca Hart's conjecture that Stettheimer's "subjective gaze . . . is a statement of lesbian desire." Rebecca Hart, "Love Flight of a Pink Candy Heart: Flights of Fancy," *Bulletin of the Detroit Institute of Arts*, Volume 83, Number 1–4. There is no evidence of any lesbian or bisexual inclinations in anything Stettheimer painted, wrote or said, nor in anything written by her friends and acquaintances. On the contrary, many of her poems and paintings feature her heterosexual admiration of male bodies.

15 The inscription on the canvas includes the actual title twice.

16 Gammel and Zelazo, *Crystal Flowers*, p. 122.

17 Ibid., p. 71.

18 Hart, p. 75. Hart identified this figure as Van Vechten, but his hair was flat against his head and his profile lacked the prominent nose and matching chin. The other possibility is that it is Steichen; however, Stettheimer's other two depictions of him show him with dark hair and prominent brows and eyes.

19 Jeffrey Henderson, "The Founder," Loeb Classical Library (https://www.loebclassics.com/page/founder/the-founder). Most photographs show him as an older man without glasses. The facial features in the youngest extant photograph and those of him as an older man are very similar to those in the painting.

20 Gammel and Zelazo, *Crystal Flowers*, p. 92. Another version with the words arranged differently is handwritten in purple

ink by Stettheimer on a loose piece of paper. Stettheimer Papers, YCAL.

21 John Lyly, *A Moste Excellent Comedie of Alexander, Campaspe and Diogenes*, 1584.

22 Edward White, *The Tastemaker: Carl Van Vechten and the Birth of Modern America* (New York: Farrar, Straus and Giroux, 2014), p. 151.

23 Gammel and Zelazo, *Crystal Flowers*, pp. 114–15.

24 Stettheimer referenced Duchamp as a partial figure of Harlequin, as stated in chapter 5. See also Tyler, *Florine Stettheimer*, p. 71.

25 Registration Department, Detroit Institute of Art, File 5 I.I 2.

26 Ibid., p. 95.

27 Stieglitz from Lake George to Stettheimer, October 20, 1930, Stettheimer Papers, YCAL.

28 The house was designed in 1838 by Alexander Jackson Davis and was the home of former New York City mayor William Paulding, Jr., merchant George Merritt, and Gould, whose daughter Anna Gould, Duchess of Talleyrand-Perigord, donated it to the National Trust for Historic Preservation in 1961.

29 On August 10, 1931, Hartley wrote to Stettheimer at the Gould estate asking her to send him information and any books about the poet Gerald Manley Hopkins. She sent him a book on Hopkins's life, noting with surprise that Hartley had not known his work before. He replied, "I would hate to be so informed in that dull sense—as some I have known. I fell in love with Hopkins at once, not only his face—but because he was a sure, fine person." According to their correspondence and to Joseph Solomon, the Stettheimer sisters helped Hartley and several other artists financially, including the sculptor Alexander Archipenko.

30 William S. Childe-Pemberton, *The Baroness de Bode, 1775–1803* (London: Longmans, Green, and Co., 1900), p. 16.

31 "Billy" to Florine Stettheimer, November 12, 1938. Stettheimer Papers, Beinecke.

32 Harriette ("Hettie") Eugenia Anderson posed for the allegorical figure of peace. An African American woman from Georgia, Anderson was described by the artist as "certainly the handsomest model I have ever seen of either sex." Saint-Gaudens may also have fused the subject's facial features with those of his longtime model, muse, and mistress, Davida Johnson.

33 Gammel and Zelazo, *Crystal Flowers*, p. 68.

34 Nochlin, *Art in America*, p. 73.

35 In 1930, there was a Walter T. Rosen who was the chairman of Banker's Trust, a bank that figures prominently in Stettheimer's painting *The Cathedrals of Wall Street*, but there is no evidence this is the Walter Rosen married to the woman in this painting.

36 Eksteins, op. cit., pp. 266–70.

37 Henry McBride, "$20,000 Purchase Fund Leads to Gay & Vivacious Display," in *New York Sun*, November 26, 1932.

38 Hilla Rebay to Florine Stettheimer, May 4, 1932, YCAL.

39 Letter of August 30, 1934, from Robert de Bonneville to the Stettheimer sisters, Stettheimer Papers, YCAL.

40 McBride to Stettheimer, August 20, 1932, Stettheimer Papers.

41 Ettie Stettheimer to Carl Van Vechten, August 2, 1946, Stettheimer Papers.

42 Until 2020, based on the research in this biography, the painting was identified as representing the skating rink at Rockefeller Center. However, photographs from the period, the image of the Christopher Columbus statue, identification of the Grand Circle Hotel, and the architecture of the buildings and banks that existed around Columbus Circle during the mid-1930s establish the latter as the correct location. Rockefeller Center with its skating rink was not permanently opened until 1939, long after the area around Columbus Circle was fully built up, and the Rockefeller Center rink is a sunken rectangle with significant architectural details totally dissimilar to the flat ice of the Stettheimer painting.

43 The Humboldt monument was dedicated at its original location at Fifty-Ninth Street and Fifth Avenue, the far east side of the park, on September 14, 1869. In 1981, it was moved to its current location at Explorer's Gate on Central Park West.

44 In 1934–5 Stettheimer began work on the ballet *Pocahontas* with Thomson and so was concurrently researching Native American designs and clothing for her costumes which may account for the inclusion of the figure in this painting and her *Cathedrals of Wall Street* of 1939.

45 James Barron, "When the Best Shows on Broadway Were the Cars," *The New York Times*, April 22, 2011, Section AU: 1.

46 Fisk Rubber Co. opened in 1889 and by 1917 employed 4,500 workers. Michael French, "Structural Change and Competition in the United States Tire Industry 1920–37," *The Business History Review* 60, no. 1 (Spring 1986): 28054 and Stephen R. Jendrysik, *Chicopee: 1950–1975* (Charleston, SC: Arcadia Publishing, 2012).

47 Sophie Schness, "Weekend History: The Story Behind an Upper West Side Ice Cream Sign: 3 Million Gallons!," *West Side Rag*, August 22, 2015, 7:45am, https://www.westsiderag.com/2015/08/22/weekend-history-the-story-behind-an-upper-west-side-ice-cream-sign-3-million-gallons.

48 McBride, letter to Ettie, July 11, 1944, YCAL.

49 Ettie Stettheimer, p. 460.

50 Rosenfeld, *Accent*, op. cit., p. 101.

CHAPTER NINE

1 Gertrude Stein, "Regular Regularly in Narrative," in *How to Write*, ed. Patricia Meyerowitz (New York: Dover Publications, 1975), p. 244.

2 Gertrude Stein, "Portrait of Virgil Thomson," in *Four Saints in Three Acts* program, cited in Watson, p. 328.

3 Anthony Tommasini, *Virgil Thomson: Composer on the Aisle* (New York: W. W. Norton & Company, 1998), p. 134.

4 Steven Watson, *Strange Bedfellows: The First American Avant-garde* (New York: Abbeville Press, 1991), p. 62.

5 Picasso was fifteen years older than Thomson but a decade younger than Stettheimer.

6 Virgil Thomson, *The Virgil Thomson Reader*, Penguin Publishing Group, New York, 1984, pp. 54–55.

7 Tyler stated that this event at Van Vechten's was attended only by Ettie, who arranged for Thomson to play for her sisters at their apartment. Tyler, *Florine Stettheimer*, p. 47. Steve Watson, in his *Prepare for Saints*, instead stated that both Carrie and Ettie attended the event at Van Vechten's and that Ettie arranged for Thomson to play the whole piece at Alwyn Court for Florine. Watson, *Prepare for Saints* (Berkeley: University of California Press, 2000), p. 66. Florine then asked Thomson to perform the entire score again just for her in her studio, so it is more likely that Ettie first heard the score alone, then Thomson performed it for Carrie and Florine at Alwyn Court, and finally Thomson played it just for Florine in her studio.

8 Watson, *Prepare for Saints*, p. 71, taken from Watson's interview with Thomson on May 7, 1987, in New York. My sincere thanks to Steven Watson for giving my access to these invaluable interviews.

9 Letter from Henry McBride to Gertrude Stein, May 10, 1929, Henry McBride Collection, YCAL.

10 Florine Stettheimer diary entry, March 27, 1929. Stettheimer Papers, Beinecke Library, Yale University.

11 Virgil Thomson, *Virgil Thomson* (New York: A. A. Knopf, 1966), p. 135.

12 Henry McBride, "Florine Stettheimer: A Reminiscence," in *View* 5, no. 3 (October 1945): 14.

13 Thomson quoted in Watson, *Bedfellows*, p. 74.

14 Tyler, *Florine Stettheimer*, p. 50.

15 Ettie Stettheimer, "Introductory Foreword," in *A Fabulous Dollhouse of the Twenties* (New York: Dover, 1976), p. 12.

16 Watson, *Prepare*, p. 167.

17 Tyler, *Florine Stettheimer*, p. 50.

18 Gammel and Zelazo, *Crystal Flowers*, p. 106. The first word in the last line of the poem was published by Ettie as "Et," but in the version written in Florine's hand it appears closer to "St.," which is in keeping with the theme of the opera. She apparently never mailed this to Thomson, keeping it among her other poems on scraps of paper.

19 Steven Watson interview with Virgil Thomson, Transcript Z00M0023, various dates ranging from May 27, 1985, to December 8, 1997, New York.

20 Tyler Parker speculated on the resemblance between the lion and Stein's renowned French poodle, Basket.

21 Anthony Carl Tommasini, *Virgil Thomson: Composer on the Aisle*, quoted in Lisa Barg, "Modernism in Tableaux: Race and Desire in *Four Saints in Three Acts*," in Patricia Allmer and John Sears, eds., *4 Saints in 3 Acts: A Snapshot of The American Avant-Garde in the 1930s* (Manchester: Manchester University Press, 2017), p. 72.

22 Dorothy Dayton, "Before Designing Stage Settings She Painted Composer's Portrait," in *New York Sun*, March 24, 1934.

23 Stettheimer quoted in Marian Murray, "Artist Takes the Stage," in *Hartford Times*, January 6, 1934.

24 Gammel and Zelazo, *Crystal Flowers*, p. 104. There are two handwritten versions of this poem, which are the same except for the reversal of the words "it was" and "it waved." Stettheimer's play on Stein's sexual orientation indicates her amusement at Stein's expense. Henry McBride, "Artists in the Drawing Room," in *Town and Country* (December 1946): 75.

25 I disagree with Watson that Stettheimer's changes to this passage from "It is delightful" to "it delighted me" and from "He sang it all" to "He sang the whole" indicate, as he suggests, that Stettheimer was not excited about working on the opera and was considering turning Thomson down. I believe the changes are minor and still indicate very positive reactions. I also disagree with his opinion that Stettheimer was reluctant to work on the *Four Saints* opera because of her religious views as a Jew. Stettheimer's total lack of, or interest in, any religious beliefs has been documented throughout this text. I also believe that Stettheimer's writing "I may do Virgil Thomson" just prior to beginning his portrait infers that she was simply going to paint the portrait, and not, as Watson states, in lieu of designing the opera. Watson, *Prepare for Saints*, pp. 164, 170.

26 Before *Four Saints* there were few Black performers on Broadway. In 1921, Eubie Blake and Noble Sissle's *Shuffle Along* opened as the first Black revue playing to a white audience, but it still emphasized music and dance specifically related to white audiences' expectations of African American culture.

27 Author's interview with Virgil Thomson, New York City, 1983.

28 Barg, p. 79.

29 At the beginning of the twentieth century, there were few Black opera singers, largely women who performed arias. The best known among them was Sissieretta Jones, who performed at the White House and Carnegie Hall, but it is not known whether Van Vechten or Stettheimer knew of her.

30 A musical prodigy, Jessye studied music in college, taught at the college level, published her poetry in various prominent Black newspapers, and travelled the country with the Eva Jessye Choir, for over five decades. George Gershwin hired her to be the musical director for all of his productions of *Porgy and Bess*.

31 Watson, *Prepare for Saints*, op. cit., p. 245.

32 Hines who was born in Norfolk, Virginia in 1904 and graduated with a B.A. in music from Livingston College in Baltimore in 1930, was able to read music expertly. She and Edward Matthews, who played St. Ignatius and was the most classically trained member of the cast, married soon after the closing of the Opera. Matthews, who graduated from Fisk University and initially studied medicine, went on to play the role of Jake the fisherman in Gershwin's *Porgy and Bess* before Columbia Broadcasting hired him as a concert artist, having Matthews tour throughout Mexico, Cuba, and South America for various companies and commercials. By the 1940s the couple were among the social set living in the Sugar Hill section of Harlem. In 1944 Hines, as a member of the *Sophistichors*, sang in a series of "Salon "Swing" concerts at the Museum of Modern Art.

33 Quoted by John Houseman from an interview with Steven Watson, Transcript Z00M0016, March 27, 1987, New York.

34 Susan Hollbrook and Thomas Dilworth, eds., *The Letters of Gertrude Stein and Virgil Thomson: Composition as Conversation* (New York: Oxford University Press, 2010), p. 37.

35 In an interview with Steven Watson, Thomson noted that Stettheimer "had ideas about the second act. Eventually that developed into a garden party." Watson interview with Thomson, Transcript Z00M0023, various dates ranging from May 27, 1985, to December 8, 1997, New York.

36 Christopher Breward, "Styling Four Saints in Three Acts: Scene, Costume, Fashion, and the Queer Modern Movement," in Allmer and Sears, quoted from Tim Page and Vanessa Weeks Page, eds., *The Selected Letters of Virgil Thomson* (New York: Simon & Schuster, 1988), p. 106.

37 Stettheimer from Virgil Thomson dated May 31, 1933, Beinecke Library. The American subject matter discussed here was undoubtedly the genesis of the *Pocahontas* ballet on which Thomson and Stettheimer intended to collaborate (see chapter 8).

38 Watson states that in winter 1934, "Carrie and Ettie Stettheimer expressed their ambivalence about their sister's Broadway success by leaving town. They vacationed in Atlantic City during the three weeks of the opera's Broadway run, leaving Florine to care for their mother." Watson, *Prepare for Saints*, p. 292. This date is incorrect, as they left for their Atlantic City vacation and the beach and boardwalk in June 1933, not February 1934, according to the Stettheimer diaries. Also, Carrie came to at least two of the New York performances in February and March 1934.

39 See Dayton. A number of writers state that the stage manager "assisted" Stettheimer with the costumes and stage designs, but it is doubtful she allowed anyone else to make any decisions regarding aesthetics of the final production.

40 I am extremely grateful to Georgiana Uhlyarik, Art Gallery of Ontario, for this information in her superb presentation, "Unicorns, Sockets and Sequins: Florine Stettheimer's Fantastical Tactility in her Sets and Costumes," *Florine Stettheimer Panel*, College Art Association Presentation, New York City, 2021

41 Watson, *Prepare*, op. cit., p. 276.

42 Carl Van Vechten to Florine Stettheimer, August 7, 1933, Stettheimer Papers, YCAL.

43 Watson, *Prepare for Saints*, p. 2.

44 Thomson to Gertrude Stein, May 6, 1933, Gertrude Stein Papers, YCAL.

45 Although the letter indicates it is Thomson's idea, some have attributed doing this to either Stettheimer or Stein: Patricia Allmer and John Sears, "Stettheimer also worried that her colour-schemes would clash with the black skins of the performers, who she seriously proposed might be painted white or silver to mitigate this," op. cit., p. 8; Watson said the idea without attribution was "announced to the press," and that Stettheimer made a "joke" about the idea (*Prepare for Saints*, pp. 206–07). In his interview with John Houseman, however (Z00M0016), the latter states that "Henry McBride said there was some point at which I believe she (Stein) was even considering making all of the black cast up in a light make-up." But there is no evidence that *anyone* other than Thomson wanted the performers' faces painted; and it is clear from Stettheimer's maquette dolls that she made for the opera that she intended the performers' skin to be African American variations of skin tones. As Tim Page noted in his article on interviewing the elderly Thomson in the 1980s, he "wanted to change all too many of his long-ago thoughts." Tim Page, "The Book of Virgil," *Opera News* 79, no. 3 (September 2014). https://www.operanews.com/Opera_News_Magazine/2014/9/Features/The_Book_of_Virgil.html

46 Thomson to Stein, May 6, 1933, Gertrude Stein Papers, YCAL.

47 Gertrude Stein to her agent, William Aspenwell Bradley, to Thomson, May 15, 1933, Virgil Thomson Papers, YCAL.

48 Lucy Weir, "Not So Black and White: Frederick Ashton's 'Outsider' Ballet," in Allmer and Sears, pp. 103–18.

49 Watson, *Prepare for Saints*, p. 277.

50 Ibid., p. 257.

51 Ibid., p. 261.

52 Steven Watson interview with John Houseman, Z00M0016, March 27, 1987, New York.

53 John Houseman, *Run-Through* (New York: Curtis Books, 1972).

54 Watson, *Prepare for Saints*, op. cit., p. 261.

55 Watson, *Prepare for Saints*, op. cit., p. 257.

56 Tyler, *Florine Stettheimer*, pp. 65–66.

57 Gilbert Seldes, "Delight in the Theater," *Modern Music* 11, no. 3 (March/April 1934).

58 Watson, *Prepare for Saints*, op. cit., p. 263.

59 McBride, review of *Four Saints*, *New York Sun*, February 10, 1934.

60 Watson, *Prepare for Saints*, op. cit., p. 263.

61 Henry McBride, "Four Saints in Three Acts at Hartford," in *The Flow of Art: Essays and Criticisms* (New Haven: Yale University Press, 1975): 314.

62 Ibid., p. 314.

63 Eugene R. Gaddis, *Magician of the Modern: Chick Austin and the Transformation of the Arts in America* (eBook, n.p., 2000), chapter 11.

64 McBride, *Florine Stettheimer*, p. 33.

65 Watson, *Prepare for Saints*, op. cit., pp. 266–67.

66 Houseman, pp. 115–16.

67 Watson, *Prepare for Saints*, op. cit., p. 265.

68 McBride, *Florine Stettheimer*, p. 34. Julien Levy filmed short clips of several scenes of the Wadsworth Atheneum production in 1934, including the prologue and the aria "The Pigeons in the grass alas." The 16mm silent films are now in the collection of the Museum of Modern Art.

69 Houseman, *Run-Through*, p. 117.

70 McBride, *Florine Stettheimer,* p. 34.

71 According to Joseph Solomon, Ettie never spoke about her sister's participation in *Four Saints.* When Thomson conducted a concert version of the score in New York in 1952, Ettie "felt terrible" that the Saturday matinee was attended by "only a handful of people." Apparently Ettie was far more comfortable attributing recognition for *Four Saints* to Thomson than to her sister.

72 Van Vechten to Stein, February 8, 1934. Van Vechten Collection, YCAL.

73 Watson, *Prepare for Saints*, p. 280.

74 Ibid., p. 286.

75 Paul Bowles to Thomson, quoted in Christopher Sawyer-Laucanno, *An Invisible Spectator* (New York, Weidenfeld & Nicholson, 1989), p. 154.

76 Watson, *Prepare for Saints*, p. 287.

77 Edith Isaacs, "Theater Magic: Broadway in Review," in *Theater Arts Monthly* (April 1934): 246.

78 Stettheimer scrapbooks, taped, cut-out reviews of *Four Saints in Three Acts*, undated from 1934: *New York Times*; Lawrence Gilman, *Herald Tribune*.

79 Nicholas Fox Weber, *Patron Saints: Five Rebels Who Opened America to a New Art: 1928–43* (New York: Alfred A. Knopf, 1922), p. 226.

80 Henry McBride, "Four Saints in Three Acts," in *The New York Sun* (February 10, 1934).

81 Stettheimer scrapbooks, February 24, 1934, "The Stage in Review." Butler Library, Columbia University.

82 Watson, *Prepare for Saints*, p. 288.

83 Ibid., pp. 285–86.

84 "4 Saints in 3 Acts" in *Opportunity* (May 1934), quoted in Watson, *Prepare for Saints*, p. 288.

85 Claggett Wilson to Florine Stettheimer, April 12, 1934. Stettheimer Papers, YCAL.

86 Tyler, *Florine Stettheimer*, p. 62.

87 Cable from Ettie to Thomson, February 1934. Virgil Thomson Papers, YCAL.

88 Watson, *Prepare for Saints*, p. 285.

89 As reported by Lucius Beebee, "This New York," in *Saint Louis Dispatch* (March 4, 1934): e.

90 McBride, *Florine Stettheimer*, p. 37.

91 Stettheimer to Carrie and Ettie, April 11, 1934. Stettheimer Papers, YCAL. It is telling that over the years, largely male writers have interpreted these remarks as evidence of the Stettheimer salon's conservative nature, when in fact they can also be read as the remarks of an independent, unmarried woman, who does not usually have married, heterosexual women who have children attend her salon. At the same time, as a feminist, Stettheimer highlighted the "antiquated" practice of having the "men join" the women after they separate after dinner, something obviously not done usually at Stettheimer salon evenings.

92 Letter to Ettie and Carrie Stettheimer of March 29, 1934. Stettheimer Papers, YCAL.

93 Watson, *Prepare for Saints*, op. cit., p. 292.

94 Dorothy Dayton, "Before Designing Stage Setting She Painted Composer's Portrait," in *New York Sun* (March 24, 1934).

95 Stettheimer Papers, 1935, YCAL. A German friend of the Stettheimers wrote to Ettie, "No one has been so conspicuous by her absence as Miss Florine."

96 Stettheimer's notes indicate that she located an illustration of Captain Smith in a 1918 history of Richmond. She also read *The True Travels: Travel Adventures & Observations of Captain John Smith in Europe, Asia, Africa and America, 1593–1629* by John Randolph, and an article on Smith in *Harper's New Monthly Magazine* (no. 136, November 1860). Stettheimer and

Thomson ultimately took several liberties with the narrative. Their ballet opens with Smith training his men and celebrating his trip to the English royal court. By scene 5, he meets the Native Americans and Pocahontas, who immediately puts in a claim for him, which he refuses. In the next scene, Smith is about to be killed until Pocahontas again claims him. Her father donates Smith to her because she begs him, singing: "Your majesty—I'm a king's daughter Pa governs great forests and water Strangers come to take away our land John Smith came with his little band/Our men were about to beat him to death when I rushed forward and to Pa saith 'Give/him to me and we will unite and lire in a state of bliss/A United State of American bliss." The remainder of the ballet's written versions by Stettheimer will be printed in the forthcoming Stettheimer catalogue raisonné by the author.

97 Stettheimer again found him "very pleasant," but this was the first time she met his wife, Louise, whom she described as "also very admirable and sympathetic."

98 Her abbreviation of Duchamp.

99 Gammel and Zelazo, *Crystal Flowers*, p. 88.

100 Interview with Joseph Solomon, New York, 1991.

101 Letter to R. S. James, September 27, 1945. YCAL.

102 Stieglitz to Ettie Stettheimer, 1936, Stettheimer Papers, Beinecke Library, Yale University.

CHAPTER TEN

1 McBride, *Florine Stettheimer*, p. 24.

2 Steven Watson, *Strange Bedfellows: The First American Avant-garde* (New York: Abbeville Press, 1991), p. 378.

3 Stettheimer to McBride, postcard, October 16, 1935, YCAL. Originally Stettheimer used the word "invite" before "serpents," but she crossed it out and substituted "welcome."

4 Gammel and Zelazo, *Crystal Flowers*, p. 89.

5 July 1937 diary entry, YCAL.

6 Mabry to Stettheimer, January 1938, Stettheimer Papers, op. cit., YCAL.

7 Stettheimer's reluctance is evident in that she did not agree to send the work until after the catalogue was printed, and so her painting is not included in the catalogue.

8 I have not been able to find any record of where this exhibition was held or under what organization's auspices.

9 1938 diary entry, YCAL.

10 The artist and cartoonist Danys Wortman, dressed in costume, played the role of the country's first president.

11 Stettheimer designed her uncompleted painting around two women spectators looking out from a gaily striped balcony at an amalgam of the fair grounds and Manhattan's city streets.

12 Stettheimer was by no means the only one obsessed with images of Washington. The first president's picture was often reproduced, and his life was the subject of articles in popular magazines throughout the period between the World Wars.

13 Conger Goodyear was chairman of the fair's Governing Committee, on which he served with Juliana Force and Holger Cahill. Of the artists on the artists' committee, only William Zorach was a close friend of Stettheimer's.

14 Stettheimer's work did not fit the exhibition's mission. The selectors for New York State were Gifford Beal, Charles Burchfield, Stuart Davis, Philip Evergood, Jonas Lie, Hermon Moore, Henry Schnakenberg, Eugene Speicher, and Max Weber—none of them members of Stettheimer's circle. Exhibition catalogue, *American Art Today* (New York: Apollo Books, 1938–39).

15 Stettheimer letter to Holger Cahill, 1939, Stettheimer Papers, Beinecke Library, YCAL.

16 Elliot V. Bell, "What Is Wall Street," in *The New York Times*, January 2, 1938.

17 Quoted in *Cahiers d'Art* (Paris: Zervos, 1931), p. 197; Eksteins, op. cit., p. 268.

18 The oldest portion of Trinity Church rebuilt in 1790 remains today, making it the oldest public building in continuous use in New York City.

19 Established originally to gather people to spread the gospel, these volunteer Salvation Army corps brass bands were highly influential for many of the leading brass band composers of the twentieth century.

20 Just as did the Salvation Army itself, the term "glory hole" originated in England and is thought to have derived from the cellars in Brighton, where the groups originally met. From 1887, the Salvation Army used the term "glory hole," and Stettheimer placed the words on the collection tray over the Salvation Army structure to represent the donations necessary to support their programs and existence.

21 At this early date, the film reel she likely saw was *Inside Nazi Germany*, which The March of Time released on January 1, 1938. It was the first American film to explicitly attack Hitler and Nazism. Portions of film footage included Adolf Hitler, propaganda minister Paul Joseph Goebbels, and Fritz Kuhn, and president of the German-American Bund; and revealed the persecution of the Jews. This was still a period of isolationism in America, and the film was highly controversial. Howard Hughes never produced a film titled "Glorification" so it is not clear to what she is referring to in the rest of this statement.

22 Donna Cassidy, *Marsden Hartley: Race, Region, and Nation* (Durham: U. of New Hampshire Press, 2015), p. 263.

23 I am grateful to Barbara Haskell of the Whitney Museum of American Art for first suggesting this information to me.

24 Hurst was one of the most widely read female authors of the twentieth century and one of the highest-paid American writers. She actively supported a number of social causes, including feminism, African American equality, and New Deal programs.

25 It is difficult to figure out the exact year of these doctor incidents; the pages in the diaries are loose and only have the month and date, not the year. Also, various events taking place between 1941–44 make it impossible to accurately determine. Tyler dates her first hospitalization to a date in 1941, when she would not have been able to attend the *Four Saints Oratorio*.

26 This is dated February 1942 in her diary. This makes dating her hospital stay very difficult, if she entered in January and stayed for three months, and then recuperated at the Dorset for three months before returning to her studio.

27 Raphael's work was part of a cycle of frescoes referring to the domains of learning: theology, philosophy, law, and the arts. At either side of the composition, grisaille statues of Apollo and Minerva act as counterpoints to Stettheimer's *commère* and *compère*. Raphael intimated the relationships among the figures through their gestures and placement. Raphael included a self-portrait in the center front of his work, glancing directly out at the viewer, just as Stettheimer did as the *commère* at right in her painting.

28 Because of the Depression and the public's perception of museums as mere treasure houses of the past, the Metropolitan's attendance and membership fell throughout the 1930s. City appropriations fell from $501,495 in 1930 to $369,592 in 1939 even as its operating costs continued to rise. In a letter to the *New York Times*, artist William Zorach castigated the Met's policy on American sculpture, and the painter Stuart Davis charged in 1940 that the Metropolitan "suppresses modern and abstract art . . . as effectively as would a totalitarian regime." See Calvin Tomkins, *Merchants and Masterpieces: The Story of the Metropolitan Museum of Art* (New York: Dutton, 1973), pp. 265, 300.

29 Nathaniel Burt, *Palaces for the People: A Social History of the American Art Museum* (New York: Little Brown & Co., 1977), p. 323.

30 Alice Goldfarb Marquis, *Alfred H. Barr, Jr.: Missionary for the Modern* (Chicago: Contemporary Books, 1989), p. 172.

31 In 1946, the trustees relented and made Barr the curator of the collections but with a significant pay cut. Sybil Gordon Kantor, *Alfred H. Barr, Jr. and the Intellectual Origins of the Museum of Modern Art* (Cambridge: MIT Press, 2001).

32 Berman, p. 431.

33 Muriel Draper, "Robert Locher: His Art and Craft," in *Creative Art* 9, no. 1, p. 53. This is the same issue which featured Marsden Hartley's flowery article on Stettheimer. The Stettheimer Papers at RBML contain several letters and hand-drawn Christmas cards rom Robert and Beatrice Locher to the Stettheimers.

34 Gammel and Zelazo, *Crystal Flowers*, p. 72.

35 Hilton Kramer, "Florine Stettheimer's Distinctive Vision of Society," in *New York Times* (March 16, 1980): 33.

36 Nochlin, Art in America, p. 72.

37 In a letter to her sisters of March 29, 1934, Stettheimer noted that Wehle had invited her to dine at his home and meet a man from the museum. Her only written comment was "No!"

38 Tyler mentions that such an exhibition actually took place at the Metropolitan, with a cocktail dress included as one of the primary exhibits.

39 Gammel and Zelazo, *Crystal Flowers*, p. 85.

40 Stettheimer must have known the painting, as it was purchased by the French government in 1891 and placed in the Musée d'Orsay in Paris.

41 The original 1939 catalogue by Barr has a reproduction of *Portrait of a Woman* on page 187, which Stettheimer copied and placed on the left side of *The Cathedrals of Art*.

42 Marquis, p. 181. The work was one of the final acquisitions of collector John Quinn, who had formed the most extensive privately owned collection of modern art.

43 In 1923, the Marie Sterner Gallery opened at 210 East Fifty-Seventh Street, several years before other women gallerists such as Edith Halpert. Like Stieglitz, Sterner was one of the earliest promoters of modern American art, exhibiting work by artists including Nadelman, George Bellows, Alexander Calder, Isamu Noguchi, Charles Burchfield, Arthur B. Davies, and Stettheimer.

44 According to Parker Tyler, Stettheimer was so deeply impressed with Tchelitchew's work that she admonished a critic friend for not demonstrating more respect for it. Tchelitchew had a dream in which Stettheimer appeared wearing a half-silver, half-gold dress, introduced herself, and declared, "I will be your friend to my last days." A few days later, he was taken to her studio. Apparently one of her paintings, *Sun*, so closely resembled his dream that following Stettheimer's death, Ettie and Carrie gave it to him. According to Tyler, "He is the only one she ever 'talked shop' with." This would seem to overlook her conversations with Duchamp. Tyler, pp. 100–01.

45 Gammel and Zelazo, *Crystal Flowers*, p. 105.

46 Monroe Wheeler, *Twentieth-Century Portraits* (New York: Museum of Modern Art, 1942), p. 24.

47 Interview with Joseph Solomon in New York City, May 1994.

48 Unfortunately, in my 1995 biography of Florine Stettheimer (*Life and Art*, op. cit.) I only included partial statements from my 1987–95 interviews with Joseph Solomon regarding the disposition of her paintings. At the time, I believed it was clear that the mention of destroying her paintings was a one-time

statement never repeated by the artist, and the fact that the will she actually signed and what was carried out by her lawyer in her estate's name were her final wishes, i.e. that her paintings all be donated to art museums.

49 Lachaise letter, Stettheimer Papers, YCAL.

50 Undated letter, YCAL. During our meetings in New York City, I also questioned Solomon about the ambiguous wording of this letter. He was adamant that "at no time did any of us close to her believe anything but that she always intended her paintings to end up in museum collections."

51 Stettheimer to Phyllis Ackerman, 1944, Stettheimer Papers, Beinecke Library, YCAL.

52 Tyler, *Florine Stettheimer*, p. 188.

53 The exact wording of Stettheimer's final directive "to my sisters as they know my wishes," was according to Solomon known to her sisters and close friends such as Van Vechten and McBride, to give them all to museums. When Stettheimer died, Solomon had difficulty probating the will. He had to prove that both of her parents were deceased, but her father's whereabouts were unknown, despite the rumors that he had emigrated to Australia where he married (illegally) and had another family. The author saw the final will in 1994 but unfortunately, Solomon has since passed away and none of his heirs kept his files or have any knowledge of the current whereabouts of his Stettheimer files and the sisters' wills. Joseph Solomon, interview with the author, New York City, 1994.

54 Stettheimer's relation, Joseph Seligman, who described himself as a "free thinker," and was what Stephen Birmingham states would today "doubtless be called an atheist," was a founder and president of the Ethical Culture Society where Algernon Black officiated at his funeral as well. Birmingham, *Our Crowd*, op. cit., p. 149.

55 Georgia O'Keeffe "Eulogy, Notes and Typescript," Georgia O'Keeffe Papers, Box 100, Folder 2107, YCAL.

56 The other women were Minna Harkavy, Käthe Kollwitz, Maria Martins.

57 Van Vechten to Ettie Stettheimer, May 13, 1944, YCAL.

58 On the back of the frame of the painting of the baby is a typed label stating: "This painting was made for her mother [illegible] on a handkerchief by Florine Stettheimer at the age of 8." The highly realistic quality of the child's features makes it doubtful that it is the work of an eight-year-old. Instead, it appears to be a painted-over *carte de visite*. I was not able to find a record of these printed on fabric, though it is probable that Stettheimer painted this at a much later age by copying a *carte de visite*, possibly that of her older sister, Stella, who was the only sibling with blonde hair and blue eyes. As the work has not been taken out of its frame since it was acquired from Carl Van Vechten and there is no high-resolution photograph, the exact nature of the work remains unclear.

59 Van Vechten to Carrie and Ettie Stettheimer, May 13, and to Ettie, July 9, 1944, Stettheimer Papers, YCAL.

60 Duchamp to the Stettheimer Sisters, May 18, 1944, Stettheimer Papers, YCAL.

61 Calvin Tomkins, *Duchamp* (New York: Henry Holt & Co., 1996), p. 344.

62 The Museum of Modern Art reprinted the entire catalogue under the title *Three American Romantic Painters*. in 1969. McBride's essay and all the photographs were reproduced in the large hardbound volume along with Barr's 1930 catalogue, an essay on Stettheimer and Charles Burchfield, and Andrew Cardiff Ritchie's catalogue on Franklin C. Watkins.

63 Museum of Modern Art, 1946, exhibition papers, registrar's department.

64 Wheeler to Ettie Stettheimer, Stettheimer Papers, YCAL.

65 Glenway Wescott to Ettie Stettheimer, November 23, 1946, Stettheimer Papers, YCAL.

66 Despite claiming seeking publicity was "unladylike," in a final attempt at receiving some recognition for herself, Ettie had her novels and writings combined and published privately, stating, "I want to be read widely." Ettie Stettheimer, foreword to *Memorial Volume of and by Ettie Stettheimer* (New York: Alfred Knopf, 1951).

67 John Houseman, taped interview with Steven Watson, Z00M0016, in Watson's possession, New York City.

68 An unsigned typed letter from the Durlacher Brothers Gallery of March 10, 1945, to Joseph Solomon mentions a listing of "pictures that are at the Dorset with their insurance valuations." It states that a number 21 has been sold to Constance Askew for $600 (*Flowers with Snake,* now in the Collection of the Nelson Atkins Museum); and number 49, which was "sold to Edward James for six hundred dollars" (*My Birthday Eyegay,* now in the collection of the RISD Museum). $1500 is the equivalent of around $13,500 today—far less than Stettheimer herself priced her work.

69 Following her sisters' deaths, Ettie had Solomon sell a few decorative arts objects they owned at a Sotheby Parke Bernet auction of "Other Bibelots" on Saturday, March 22, 1947.

70 Letter from Joseph Fraser, Jr., to Ettie Stettheimer, Feb 16, 1951, Archives of American Art, roll 70.

71 *Le Jeu*, and the four-sibling screen (both of which the Museum of Modern Art recently conserved), and a small fire screen in the collection of Columbia University are the only extant pieces of furniture designed by Stettheimer.

72 Stephen Bourgeois to Ettie Stettheimer, April 12, 1950, YCAL.

73 Seligman letter to Ettie, dated December 1919, 1949. Stettheimer Papers, YCAL.

74 Mabry to Ettie, November 25, 1949, YCAL.

75 Donald Gallup to Ettie, December 19, 1949, Stettheimer Papers, YCAL.

76 Mark Pagano to Ettie, 1949, YCAL.

77 Alfred Barr, Jr., to Ettie, 1949, Stettheimer Papers, YCAL.

CHAPTER ELEVEN

1 Margaret Bruening, "Florine Stettheimer," in *Art Digest* 25 (March 15, 1951): 17.

2 Robert Hughes, "Camping Under Glass," *Time* magazine (September 18, 1995): 112.

3 https://warholstars.org/henry-geldzahler.html.

4 Andy Warhol and Pat Hackett, *POPism: The Warhol '60s* (New York: Harper & Row, 1980), pp. 15–16.

5 Gary Comenas, "Hard Labor at the Factory: An Interview with Mark Lancaster," in *New York Arts*, http://nyartsmag azine.net/hard-labor-at-the-factory-an-interview-with-mark-lancaster-by-gary-comenas/.

6 Elisabeth Sussman, "Florine Stettheimer: A 1990s Perspective," in *Manhattan Fantastica* (New York: Whitney Museum of American Art, 1995), p. 62.

7 Henry Geldzahler, *American Painting in the Twentieth Century* (New York: Metropolitan Museum of Art, 1965): 126. For the actual exhibition, the museum only printed a pamphlet listing the works in the exhibition; Geldzahler published a catalogue as a companion to the exhibition, with a slightly different title.

8 Jane Sabersky, "Introduction," *Florine Stettheimer: An Exhibition of Paintings, Watercolors, Drawings* (New York: Columbia University, 1973), p. 7.

9 Ann Sutherland Harris and Linda Nochlin, *Women Artists, 1550–1950* (New York: Alfred A. Knopf, 1977).

10 Linda Nochlin, "Why Have There Been No Great Women Artists?" in *ArtNews* 69 (January 1971): 22–39.

11 Barbara Zucker, "An Autobiography of Visual Poems," in *ArtNews* 76, no. 2 (February 1977): 68–73.

12 The exhibition was co-curated with Whitney curator Elizabeth Sussman and included a copy of Linda Nochlin's seminal Florine Stettheimer essay. Another Stettheimer exhibition organized by the author took place the same year: *Friends and Family: Portraiture in the World of Florine Stettheimer*, at the Katonah Museum of Art. Katonah, New York, September 19–November 28, 1995.

13 Roberta Smith, "Extreme Artifice Directly from Life (in New York Between the Wars)," in *New York Times* (July 21, 1995): 62.

14 In a *New York Observer* article entitled "The Best Kept Secret in Art? Florine Stettheimer. Pass It On," Hilton Kramer said the

exhibition "at last does justice to her achievement." Quoted in *The Triumph of Modernism* (Chicago: Ivan R. Dee Publisher, 2006), pp. 237–38.

15 Duncan, "Notes on an Exhibition" essay printed in the pamphlet accompanying "Love Flight of a Pink Candy Heart: A Compliment to Florine Stettheimer," 1995 exhibition at the Holly Solomon Gallery, New York.

16 The exhibition traveled to High Museum of Art, Atlanta, June 24–September 30, 2018 and the Los Angeles County Museum of Art, November 18, 2018–March 18, 2019.

17 McBride, *Florine Stettheimer*, pp. 14–15, and Tyler, *Florine Stettheimer*, p. 146.

18 Irene Gammel and Susan Zelazo, eds., *Florine Stettheimer: New Directions in Multimodal Modernism* (Toronto: Book*hug Press, 2019).

19 Glenway Wescott, "Florine Stettheimer: A Reply," in *ArtNews* 45, no. 11 (January 1947): 56–57.

20 Paul Rosenfeld, "Florine Stettheimer," in *Accent* 5 (Winter 1945): 100.

21 Ibid.: 101.

22 Hilla Rebay to Florine Stettheimer, May 4, 1932, YCAL.

23 Linda Nochlin, "Why Have There Been No Great Women Artists?," in *Art and Sexual Politics*, ed. Thomas B. Hess and Elizabeth Baker (New York: Macmillan, 1971), pp. 1–10.

24 Those who do describe her as a feminist are often contradictory: Nochlin (Ibid., p. 138) was one of the only writers who mentioned her "decided feminism," not yet decoding her work as painted from a woman's gaze. Pamela Wye also mentioned Stettheimer as a feminist but at the same time described her as a "cloistered virgin" and part of "an inseparable quartet" with her mother and sisters. See Wye, "Florine Stettheimer: Eccentric Power, Invisible Tradition," in *M/E/A/N/I/N/I/N/G*, edited by Susan Bee and Mira Schor, # 3 (May 1988): 6.

25 Tyler, *Florine Stettheimer*, p. 86.

26 "October Files #6: Cindy Sherman," *Visual Resources* 24, no. 1 (2008): 88–94.

27 David Lloyd, "Review of the Society of Independent Artists," in *New York Evening Post*, March 13, 1922.

28 Edward Alden Jewell, "Two Large Exhibitions," in *The New York Times* (April 21, 1929), p. 123.

29 Penelope Redd, *Pittsburgh Sunday Post*, May 11, 1924, quoted in McBride, *Florine Stettheimer*, p. 52.

30 YCAL letter to Ettie Stettheimer, 1944.

31 Letter of August 30, 1934, quote by Juliana Force in letter from Robert de Bonneville to the Stettheimer sisters, Stettheimer Papers, YCAL.

32 Carl Van Vechten, "Prelude," in Parker Tyler, *Florine Stettheimer*, p. xiii.

33 McBride, *Florine Stettheimer*, p. 10.

34 Gammel and Zelazo, p. 72.

35 Tyler, *Florine Stettheimer*, p. 24.

36 Carl Van Vechten, "The World of Florine Stettheimer," in *Harper's Bazaar*, p. 356.

37 Seaver, "Gay Twenties," p. 1.

38 Betty Burroughs, "Florine Stettheimer," *New York Times*, April 20, 1947, Stettheimer Scrapbooks, Columbia, op. cit.

39 McBride, *Florine Stettheimer*, p. 13.

40 James Rosenberg to William Milliken, n.d. YCAL.

41 Jerry Saltz, "What the Hell Was Modernism? The Museum of Modern Art tries to open itself up," *Vulture*, October 2, 2019, https://www.vulture.com/2019/10/jerry-saltz-new-moma-modernism.html

42 Ibid.

43 Andrew Russeth, "'Forcing Me in Joy to Paint Them': In Munich, a Rare Look at Florine Stettheimer," in *ArtNews*, October 21, 2014, online (http://www.artnews.com/2014/10/21/forcing-me-in-joy-to-paint-them-in-munich-a-rare-look-at-florine-stettheimer/).

INDEX

Page numbers in **bold** indicate photographs and figures.

SELECTED BIBLIOGRAPHY

ARCHIVES

Columbia University in the City of New York
Art Properties, Collection Files, Avery Architectural & Fine Arts Library, Florine Stettheimer Papers, Rare Book and Manuscript Library

The Museum of Modern Art, New York
Museum Collection Files, Drawings and Prints Study Center and Paintings and Sculpture Study Center

Yale University, New Haven
Florine and Ettie Stettheimer Papers, Yale Collection of American Literature, Beinecke Rare Book and Manuscript Library

BOOKS AND ARTICLES

Allmer, Patricia and John Sears, editors, *4 Saints in 3 Acts: A Snapshot of the American Avant-Garde in the 1930s*, Manchester: Manchester University Press, 2016.

Althaus, Karin, Matthias Mühling, and Susanne Böller, editors, *Florine Stettheimer*, Exh. Cat., Munich: Städtische Galerie im Lenbachhaus und Kunstbau, Munich, Hirmer, 2014.

Bergson, Henri, *Key Writings*, edited by Keith Ansell Pearson and John Mullarky, New York: Continuum, 2002.

Birmingham, Stephen, *Our Crowd: The Great Jewish Families of New York*, New York: Harper and Row, 1967

Bloemink, Barbara J., *The Life and Art of Florine Stettheimer,* New Haven: Yale University Press, 1995.

Bloemink, Barbara J., "Imagine the Fun Florine Stettheimer Would Have With Donald Trump: The Artist as Feminist, Democrat and Chronicler of Her Time," *Art News*, June 7 2017.

Bloemink, Barbara J. and Elisabeth Sussman, *Florine Stettheimer, Manhattan fantastica*. Exh. Cat. Whitney Museum of American Art, 1995.

Bloemink, Barbara J., "Florine Stettheimer, Becoming Herself," in *Singular Women, Writing the Artist*, edited by Kristen Frederickson and Sarah E. Webb, Berkeley: University of California Press, 2003.

Bloemink, Barbara J., "Florine Stettheimer, Hiding in Plain Sight," in *Women in Dada: Essays on Sex, Gender, and Identity*, edited by Naomi Sawelson-Gorse, Cambridge: MIT Press, 1998

Bloemink, Barbara J., *Friends and Family: Portraiture in the World of Florine Stettheimer*. Exh. Cat. Katonah NY: Katonah Museum of Art, 1993.

Bloemink, Barbara J., "Crystal Flowers, Pink Candy Hearts and Tinsel Creation: The Subversive Femininity of Florine Stettheimer," in *Women Artists and the Decorative Arts, 1880–1935: The Gender of Ornament,* edited by Bridget Elliott and Janice Helland, Burlington: Ashgate Publishing Company, 2002.

Brilliant, Richard, *Portraiture*, Cambridge: Harvard University Press, 1991.

Duchamp, Marcel, *Affectionately, Marcel: The Selected Correspondence of Marcel Duchamp,* edited by Francis M. Naumann and Hector Obalk. Ghent: Ludion Press, 2000.

Gammel, Irene and Suzanne Zelazo, editors, *Florine Stettheimer: New Directions in Multimodal Modernism,* Toronto: Book*hug Press, 2019.

Gammel, Irene and Suzanne Zelazo, editors, *Crystal Flowers: Poems and a Libretto – Florine Stettheimer*, Toronto: Book*hug Press, 2010.

Hartley, Marsden, "Florine Stettheimer: A Reminiscence," *View*, no. 5, October 1945: 12–15.

Hartley, Marsden, "The Paintings of Florine Stettheimer," *Creative Art*, No. 1, July 1931: 18–23.

Heartney, Eleanor, "Looking at Art: Florine Stettheimer, Saints, Esthetes and Hustlers," *Art News*, 90, no. 5, May 1991: 95–6.

Jones, Amelia, *Irrational Modernism: A Neurasthenic history of New York Dada*. Cambridge: MIT Press, 2004.

Kellner, Bruce, *Carl Van Vechten and the Irreverent Decades*. Norman: University of Oklahoma Press, 1968.

Lewis, David Levering, *When Harlem Was in Vogue*, New York: Penguin Books, 1997.

Lorden, Matthew, "Why One Artist Became a Modernist," *New York Evening World*, March 20, 1921.

McBride, Henry, "Artists in the Drawing-Room," *Town and Country*, December 1946: 71–7.

McBride, Henry, "Florine Stettheimer: A Reminiscence." *View*, no. 5, October 1945: 13–15.

McBride, Henry, *The Flow of Art: Essays and Criticisms*, New Haven: Yale University Press, 1997.

Motherwell, Robert, editor, *The Dada Painters and Poets: An Anthology*, New York: Wittenborn, Schultz, Inc. 1951.

Naumann, Francis M., *New York Dada 1915–23*, New York: Harry N. Abrams, Inc., 1994.

McBride, Henry, *Florine Stettheimer*, Exh. Cat., The Museum of Modern Art, New York, 1946.

Nochlin, Linda, *Women, Art, and Power and Other Essays*, New York: Harper & Row, 1988. (original article "Florine Stettheimer: Rococo Subversive" in *Art in America* 68, September 1980: 64–83.)

Redd, Penelope, "Daily Life Incidents Art Taken for Stettheimer Decorations: Skill, Pity, Mockery Combined; Three Late Paintings," *Pittsburgh Post,* April 2, 1922.

Rosenfeld, Paul, "The World of Florine Stettheimer," in *The Nation* 34, May 4, 1932: 524.

Sabersky, Jane, "Florine Stettheimer, An Exhibition of Paintings, Watercolors, Drawings," Exh. Cat., New York, Columbia University, 1973.

Saltz, Jerry, "Notes on a Painting: Twilight of the Gods; Florine Stettheimer's Cathedrals of Art, 1942" *Arts Magazine* 66, no. 7, March 1992: 21–2.

Smith, Roberta, "Art Review: Extreme Artifice Directly from the Life (in New York Between the Wars)." *New York Times*, July 21, 1995.

Smith, Roberta, "Art View: The Very Rich Hours of Florine Stettheimer," *New York Times*, October 10, 1993.

Stein, Gertrude. Harry Moses Presents *Four Saints in Three Acts*, with music by Virgil Thomson. New York: Aaronson and Cooper. 1934.

Stettheimer, Florine, *Crystal Flowers*. Foreword by Ettie Stettheimer. Privately printed, limited edition. New York/Pawlet, VT: Banyan Press, 1949.

Tatham, David, "Florine Stettheimer at Lake Placid, 1919: Modernism in the Adirondacks." *American Art Journal* 31, nos. 1–2, 2000: 4–31.

Tomkins, Calvin, *Duchamp: A Biography*, New York: The Museum of Modern Art, 2014.

Thomson, Virgil, *Virgil Thomson*, New York: Da Capo Press, 1976.

Troy, Nancy, *Modernism and the Decorative Arts in France,* New Haven: Yale University Press, 1991

Tyler, Parker, *Florine Stettheimer: A Life in Art,* New York: Farrar, Straus and Company, 1963

Van Vechten, Carl, *Parties. Scenes from Contemporary New York Life*. New York: Alfred A. Knopf. 1930.

Van Vechten, Carl, "Pastiches et Pistaches: Charles Demuth and Florine Stettheimer," *Reviewer,* No. 2, February 1922: 269–70.

Van Vechten, Carl, *Peter Whiffle: His Life and Works*, New York: Alfred A. Knopf, 1922.

Van Vechten, Carl, *The Blind Bow-Boy*, New York: Alfred A. Knopf, 1923.

Van Vechten, Carl, "The World of Florine Stettheimer," Harper's Bazaar, October 1946: 238.

Watson, Steven, *Prepare for Saints: Gertrude Stein, Virgil Thomson, and the Mainstreaming of American Modernism*, Berkeley: University of California Press, 1995.

Watson, Steven, *Strange Bedfellows: The First American Avant-Garde,* New York: Abbeville Press, 1991.

Watson, Steven, "Prepare for Saints: The Making of a Modern Opera." Video Recording, *Connecticut Public Broadcasting Network,* Hartford, 1998.

White, Edward, *The Tastemaker: Carl Van Vechten and the Birth of Modern America*. New York: Farrar, Straus and Giroux, 2014.

Victoria Wolcott, *Race, Riots, and Rollercoasters: The Struggle*, Philadelphia: University of Pennsylvania Press, 2014

Zucker, Barbara, "An Autobiography of Visual Poems: the Freedom and Femininity of Florine Stettheimer's Vision," *Art News* 76, February 1977: 68–73.

Zucker, Barbara, "Florine Stettheimer: A Private Vision," *Women's Studies* 6, 1978.

Barbara Bloemink has written extensively on Florine Stettheimer for several decades. She co-curated the 1995 Whitney Museum Florine Stettheimer Retrospective Exhibition and is currently compiling the artist's catalogue raisonné. Formerly the director and chief curator of five art museums, including the Smithsonian's National Design Museum, the Kemper Museum of Contemporary Art and the Guggenheim-Hermitage Museum, she has organized over seventy-five museum exhibitions, published numerous books, and lectured and taught internationally on art and design. She holds a Ph.D. from Yale University.

〜〜〜

Published by:
Hirmer Verlag GmbH
Bayerstraße 57–59
80335 Munich
Germany
www.hirmerpublishers.com

Author: Barbara Bloemink, New York

Design and visual editing: Alexander Kalman /
What Studio?, New York
Senior editor Hirmer Publishers: Elisabeth Rochau-Shalem,
New York
Project manager Hirmer Publishers: Rainer Arnold, Munich
Assistant Design: Ian Keliher
Pre-press: Reproline mediateam GmbH & Co. KG,
Unterföhring
Printer & binder: Printer Trento s.r.l., Trento

Library of Congress Control Number: 2021914609

Bibliographic information of the Deutsche National-
bibliothek: The Deutsche Nationalbibliothek lists this
publication in the Deutsche Nationalbibliografie;
detailed bibliographic data are available on the Internet
at https://www.dnb.de.

© 2021 Barbara Bloemink; Hirmer Verlag, Munich
ISBN 978-3-7774-3834-4

Printed in Italy

Nat-Pwe

Burma's Supernatural
Sub-Culture

∘

Yves Rodrigue

Paul Strachan
KISCADALE

Translated by
Roser Flotats

Photography by
Yves Rodrigues
and Paul Strachan

Paintings of the
'Thirty-Seven' by
Noel F Singer

Previous: the tragic drama of the buffalo godess Popa Medaw and the Prince is relived at a *nat-pwe*, whilst above right performer-priests rest between the ritual acts. Above left, images of Popa Medaw, the flower eating ogress, with her sons the Taungbyon Brothers in their shrine at Mt. Popa. On the next pages, Popa Medaw performs her dance of the peacock feathers illustrating an event from her tragic life.

Published and designed in 1992 by Paul Strachan - Kiscadale Ltd, Gartmore, FK8 3RJ, Scotland.
Original French text and photos © Yves Rodrigue. Other photos indicated 'P'
© Paul Strachan. Translation © Roser Flotats. Paintings of the 37 Nats © Noel F Singer.
Printed in Hong Kong by Colorcraft. ISBN 1 870838 11 4.

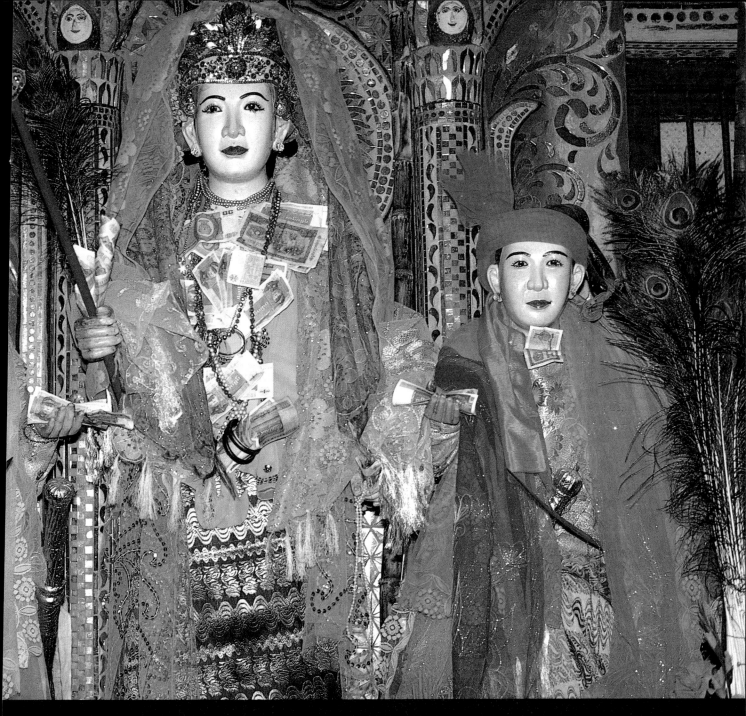

CONTENTS

Introduction

The Burmese are fervent Buddhists and their country is famous for its countless temples and pagodas.

It is said that in the eleventh century King Anawrahta of Pagan was converted to Buddhism which then became the official religion of the entire kingdom.

The teaching of the Buddha was well known before that time in this part of the world. When it was triumphant in India the new religion was introduced among the two so called proto-Burmese peoples: the Mons in the South-East of the country and the Pyus who lived along the Irrawaddy river valley. A legend states that Emperor Asoka in the third century B.C. sent two missionaries, Sona and Uttara, who landed at Thaton, then a port and the capital of the Mons. Another legend designates a Mon monk, Shin Arahan, as responsible for Anawrahta's conversion. The Pyu capital, established by the seventh century AD, was near the modern town of Prome and there we find some evidence of Buddhist activity. Epigraphs have been discovered there with inscriptions in Pali, Mon, Pyu and Old Burmese. The Theravada form of Buddhism had though yet to be firmly established. However, neither was Mahayana which made a short appearance in the north of the country after the Fourth Buddhist Council held by the Kushan king Kaniska. After this council the Mahayana doctrine emerged as dominant over the Theravada. It is possible that the Mahayana with its Tantric offshoots may have lingered in Burma until the 8th century and challenged Theravada amongst the Pyus. Though there is little evidence to prove this.

In fact, both schools of Buddhism had been confronted by more deeply rooted and multifarious ancient beliefs. So much so that even Hinduism had never made serious inroads into Burmese religious life. The early Pagan kings may have been honored as avatars of the Hindu god Vishnu but this was no match for the cults of the planets, the Naga, nats or of the magic squares. Sorcery and alchemy were widespread and the forces of nature were an inexhaustible source of fears that lead to a variety of creeds and rituals.

The Burmese people enjoy life and have that rare capacity to be happy without much money. They care little for great and luxurious houses. They rarely hoard possessions and any money saved is soon spent on building pagodas or monasteries. The women adorn themselves with rubies and flowers. Having yet to enter into a phase of rapid of economic development they have yet to be caught in a spiral of desires. They bear the kicks and spurs of bad fortune with remarkable resilience. Freedom is what the Burmese cherish most. It was never tampered with by their kings who rarely interfered with the affairs of self-governing villages. Tribute was paid to the 'village eaters' who represented the king and usually that was it. The Burmese fear five great evils: fire, floods, snakes, dacoits and governments.

Buddhism has probably done more than anything else to mould the Burmese character into a tolerant, courteous, even-tempered one. There is nothing which embarasses a Burmese more that to be confronted with someone out of temper. Likewise, there is nothing which annoys him more

BUDDHIST MEDITATOR AT THE
SHWEDAGON PAGODA,
RANGOON

than to have to turn down a request. This feeling is called *an-a-de* and is responsible for the Burmese preference for discretion and non-interference in other's business.

A Burman is rarely idle and displays the same enthusiasm whether at work or at play. Whether a monk or layman, meditation is important to him and may make him unavailable early in the morning or in the evening. A telephone call may be fobbed off with the simple excuse 'he is meditating'.

The power of the mind fascinates most Burmese. The Burmese Way to Socialism may have at first appeared to foreign observers as being inspired by Marx's materialist dialectic. However its manifesto loudly proclaims the precedence of mind over matter. Long before Buddhism was known in Burma, man strove to master superhuman powers. These were claimed by certain of the first disciples of Buddha. To convert Mogallana and his two hundred and fifty followers, the Buddha displayed his own magical powers and then never used them again. A believer should not attempt to be more than an ordinary man - an ephemeral and suffering aggregate of matter.

The new and rationalist religion did not put an end to the old dreams of supermen and supernatural creatures. Ancient cults and practices survived in the form of paying homage to the Buddha. The Naga coiled up and over the Buddha to protect him after his Enlightenment. The Gods of the Planets offered obedience to Buddha. The nats were given a king who had converted to the new religion. Alchemists swear that the purpose of an elixir offering Eternal Youth is to enable the faithful to live long enough to do homage to Maitreya, the future Buddha. Thus the votaries of the old gods themselves became Buddhists respectful of the five precepts. There is only one heresy in the old creeds: that of the malevolent sorcerer or *Soun*.

Whether Buddhism absorbed the old cults or the latter embraced Buddhism is academic. They coexist peacefully whilst the more ancient beliefs have progressively faded away. All belong to a rich cultural and psychic heritage.

Though deeply rooted in Burma, and still alive, the cult of spirits and other supernatural beliefs have not generated a very abundant literature. In the year 1829 the king of Burma appointed a committee of scholars to compile old documents and write a 'Chronicle of Burmese Kings'. It was published under the title of *The Glass Palace Chronicle* and part translated into English about one century later. There are in this compilation so many references to the naga, the nats and other supernatural beings that even the most serious historians of that time could not ignore their role in the history of their nation. Indeed, *The Glass Palace Chronicle* gives a somewhat official stamp to the widespread cult of the nats. The cult is far more than just a drift from the universally known cult of nature spirits. It provides a link between the ordinary people and their long and often glorious history. Dr. Htin Aung in the 1960s wrote several books on mythology and folklore contained within the Buddhism of Burma. Precious information has also been published by U Taw Sein Ko, Daw Kin Myo Chit and U Maung Maung Tin and I was privileged to meet the latter two several times. Burmese authors often emphasise the pure Burmese origin and characteristics of the nats. In so doing they sometimes underestimate the Indian influence which increased under British rule when Burma was administered as a province of India and Lower Burma was actively

colonised by Indian immigrants.

One such British colonial administrator, Richard Carnac Temple, was the first foreigner to unveil the importance of the nats. His richly illustrated book *The Thirty-Seven Nats* was published in London in 1906 and has recently been reproduced in a magnificent facsimile edition by Kiscadale. It underlines the historical background to the cult and presents an original Burmese *parabaik or* illuminated manuscript portraying the thirty-seven nats in some iconographical detail.

Melford E. Spiro in his *Burmese Supernaturalism* of 1967 paid more attention to the psychic and psychiatric aspects of the cult. He spent one year in a small village near Mandalay observing popular beliefs. It is an in-depth study of one village in one part of Burma and whilst of anthropological interest the author's extrapolations have led to some misjudgement as there are countless regional variations to the cult and of the legends supporting it.

More recently B. Brac de la Perrière's *Les Rituels de Possession en Birmanie* (1990) is a valuable report of her observations on the mediums or *nat-kadaw* and the three-day *nat pwe*. So far there has been no attempt to tackle the many other facets of this diverse subject. It would require years of research and hundreds of pages to achieve a comprehensive description.

My own curiosity was stimulated mainly by a desire to film as much as I could of the rituals, festivals and other colourful events in the supernatural calender. I depended on many friends who would tell me when and where a ritual would take place and to provide the necessary information to enable the shooting. I thank them with all my heart whether they be scholars, *nat-kadaw* or their followers.

THE SHWE-SET-DAW PAGODA, MANDALAY

The Mythical Universe of the Burmese

The Burmese do not have a cosmography of their own. The Buddhist one, itself inspired by Brahmanic thought, serves the Burmese. The Buddha himself was a moralist and philosopher, more concerned with the mechanics of the mind than those of matter. His followers have borrowed more ancient beliefs and integrated them with their own that denies the existence of both a creator-god and a soul.

Despite this tendency to make things conform to the rules of reason, Mount Meru or Myin-mo, the cosmic mountain and centre of the universe, remains the abode of the gods. Unconcerned with the universe, which to the Hindu continues in a timeless cycle of creation and destruction, the Buddhists even kept the old Vedic name for it - *loka*. Buddhism soon forgot the Hindu history of the world's origins with the stories of Narayana, Manu and Parapati and their associated beliefs in the existence of a creator and the soul. Indeed, none of the twenty-seven past Buddhas bothered to tackle the question of the creation of the universe. To them this was, if not insoluable, irrelevant. Like the turning of the wheel of the law or *dhamma* there is no beginning and no end.

In the Buddhist universe of the Burmese there are three realms of existence: earth, heaven and hell and within these there are thirty one sub-divisions. There are numerous levels of both hell and heaven. The being must escape from a cycle of rebirth caught between these. This universe is topographically circular with Mount Meru at its centre. This is surrounded by seven ranges of mountains and four continents each of a different shape, colour and type of inhabitant. Ours is the southern one and is lozenge shaped. The western continent is in the form of a moon, the eastern a half moon, and the northern square. The inhabitants of each have heads the shape of the continents. The colour of each continent is that reflected upon it by the four sides of Mount Meru: silver, green, gold and ruby. These continents are in fact great islands in the midst of an ocean and themselves are surrounded by archipelagos of five hundred islands. Navigation is possible within each archipelago, fatal outside.

The northerners live for one thousand years. They neither work, get sick or age and make love only once in a century. Women give birth painlessly; the new-born are just left on the spot without risk of death and feed themselves by sucking the fingers of passers-by. They have no need of agriculture, industry or the arts; they never cook, sew, or clean; all they do is just enjoy life without any hope of climbing the ladder of existence. All their requirements are given to them by the *padesa* tree. Here is the Golden Age of Hesiod or even the *Kritayuga* of Hindu mythology.

The eastern and western peoples lives are more like those of the southern continent. They have a limited life expectancy. Their world is rather like the Silver and Bronze Ages of ancient Greece, or the intermediary ages of the Hindus. Indeed, according to Hindu thought the Dharma or Law of Nature once possessed four pillars- loyalty, goodness, devotion and charity. With each age one pillar was lost so that by the third age good and evil were equal and by the fourth or Kaliyuga evil was dominant.

The southern island, where we live, is called Jambudipa, the land of the

jambu tree. Here the people are smaller and darker skinned and the duration of their lives is linked to their morality. Originally a being of the southern island could expect to live as many years as there are rain drops in a three year deluge. However, misconduct has led them to be caught in a cycle of rebirth sometimes regaining their longevity and then falling into decadence. This cycle of working from a poor incarnation to a high one, then falling and starting the process over again will occur sixty times before an apocalyptic end of the world. The only escape is to follow the Buddhist dharma through the earning of merit.

The one advantage of being born in Jambudipa is that here there is the opportunity of escape through Buddhahood. It is is here that the past twenty-seven Buddhas have manifested themselves. In other continents there is no chance of obtaining salvation.

Over the human condition is Zatumaharit, the first paradise. Here amidst the sun and the planets the dewa (gods) govern the seasons and the astrological destiny of men. There are nine planets, our own and two others called Rahu and Kate. Rahu is a monster, invisible to men and jealous of the splendour of the shining planets. When he tries to swallow or hide them he causes temporary eclipses. Zatumaharit inhabitants were referred to simply as nat, a term now used to describe the spirit-gods discussed in the following chapters. There are four guardians of the world whose palaces and gardens would cast anything from the tales of the Arabian Nights into the shade.

Tavatimsa is the second paradise and better known to Buddhists as it was to here that the Lord Buddha ascended to preach the Dharma to his mother, Queen Maya and the many Byammas (Brahmas) and gods who came to hear him from the intermediary levels of form (Rupa) and formlessness (Arupa). Tavatimsa is ruled by Indra who is known as Thagya-min to the Burmese and is in charge of all human affairs. In the Hindu Veda he was the main god after Agni, the god of fire. Agni has been forgotten by Buddhism in favour of Indra whose cult was too strong to eliminate. Instead he is given precedence over the Brahma-Shiva-Vishnu triad. However the Hindus have retaliated by describing the Buddha as the ninth avatar of Vishnu.

Tavatimsa is so magnificent and beautiful that no description can do it justice; its geometrically planned palaces are abundantly filled with precious metals and gems. Thagya-min and his thirty-two princes ride on the elephant Erawan who has thirty-three heads, each with seven tusks on to which are connected seven lakes, seven trees each with seven leaves holding seven beds for the pleasure of the deities. They ride on the elephant to visit the sacred padesa tree when it blossoms with its exotic fruits and exquisite flowers. Here there grows a special ivy which only bears fruit every one thousand years; when eaten this fruit intoxicates for months on end. Thagya-min does not neglect human affairs. When things go wrong in the southern continent his throne grows hot. Then he convenes his thirty-two princes and the four guardians of the paradise below and order is soon re-established. Once a year the king sends emissaries down to report to him on mankind's behaviour. Good deeds are recorded on manuscripts of gold leaf, bad ones on the skin of a dog. At Thin-gyan or new year the Burmese increase any merit they have accumulated by

INHABITANT OF THE EASTERN CONTINENT, MYO HAUNG, ARAKAN

throwing buckets of water over each other in emulation of offering a cooling bath in this hottest of seasons.

The kingdom of Tavatimsa's harmony may be disrupted by invading Asuras. These were the original inhabitants of Tavatimsa and were once expelled through a trick played on them by Thagya-min. He took his host Asura's daughter and then threw them all into the ocean after getting them drunk. They took refuge between the three great rubies that hold Mount Meru up. From time to time they seek retaliation but without success ànd never with any bloodshed.

The four superior paradises are less well known. At each level passion and desire play less and less of a part and love takes on a Platonic form fulfilled with nothing more than a simple smile. Here sexual differences grow less and less so that in the highest heaven the inhabitants are androgynous.

Liberated from the tyranny of sex the consciousness overcomes the sixteen levels of Rupa and will cease to be reborn. This is the point of no return. Beyond Rupa remain only the four levels of Arupa that lead to the ultimate state of Nirvana. This place is said to be so far from the world that a stone falling would only touch the earth four years later.

In the Veda there are seven paradises and seven hells. However, the Buddhists have reduced the number of hells to four, but these are no less unpleasant. The first is to be reborn as an animal. Here to be born as a lion or tiger is not nearly as bad as being born a dog or a vulture who feed on other dead animals. The highest status amongst animals is to be born as an elephant, who of course is a herbivore. Amongst elephants to be born as a white elephant is the ultimate.

Time has different measures for different beings. For men the unit of time is years and they can be reborn for cycles lasting millions of years. For *dewa* existence is calculated in celestial years and for those enjoying the state of *rupa* time is measured in *kalpa*. These in turn are divided into *mahakalpa* - one such of these will last for the duration of four times sixty worlds.

In the hells the damned may be constantly reborn so as to endure the torture and torments for any of these time periods. There is some arguement amongst Buddhist philosophers as to what exactly is being made to suffer: the single consciousness itself or a succession of incarnations as the consciousness transfers from one body to the other.

The most heinous of crimes is disrespect for the Three Gems: the Buddha, the Law and the Order of Monks. In Burma a further two gems are added: parents and teachers. For this crime the sinner must expect at least one thousand years of chastisement which is more than a debauchee or brigand might expect.

Below the animal world are the hells Preitta and Asurake. In these a person will be reborn as a giant only with a mouth so small that he can not feed himself and goes about ever famished. The worst of the hells is Nga-ye. Here in the bowels of the earth are eight divisions: four burning hot and four freezing cold. These domains await the worst of criminals: the murderers of parents or monks, those who sow discord amongst monks, insult the image of a god or speak disrespectfully of the Buddha's teachings. Here there are forty thousand and forty specialist torture

HELL, FROM THE MANDALAY MAHA-MYAT-MUNI PAGODA

chambers where they may be flogged, flayed, branded or impaled for as long as the duration of a *kalpa*.

Eventually mankind's misconduct will set in motion the process of the apocalypse. The first warnings will come one hundred thousand years ahead by the appearace of dishevelled Dewa who will spread about the world instructing people to take refuge in the superior levels of existence which will be unaffected by the chaos. The Dewa themselves will depart from Mount Meru to reach Rupa. The doors of the hells will open and the damned be offered salvation through the opportunity to start accumulating merit. In the cycle of a world there are sixty-four destructions; fifty-four of these by fire to purge concupiscence, seven by water to drench hatreds and one by the wind to sweep ignorance away. The fire will destroy the six paradises also and the deluge will soak through the eight levels of Arupa.

After all this a new world will manifest itself through the joint efforts of the rain and the winds. It will not be much different from the previous one with Mount Meru again at its centre. Initially it will be covered by a cream and have a delicious fragrance that will reach up to the abode of the *byamma* who will have survived the holocaust and will not be able to resist coming down to taste the cream. They will assume human bodies and live happily on the southern island nourishing themselves on this supernatural cream and feeling radiant and light. However, little by little desire for gain will occasion quarrels and their radiance will diminish. The sun will now appear to give them light (as they no longer radiate light) plants grow and they learn to cook rice. No longer feeding on heavenly foods they develop sexual organs and with them passion and sexual desire. A power structure evolves with a king at the top and laws made. Some people prefer celibacy and solitude and will not share meals, sleep or wash with the impious - these are the Brahmins who preach the dangers of evil. The *Vishnu Purana* gave the following prophecy :

DEWA FROM A 19TH C. WALL PAINTING AT THE PAKOKKU SHWE-TAN-TI PAGODA

'Kings will become peevish, irascible and unjust. They will put to death their wives, children and cattle. They will appropriate their subjects' goods and losing their authority will fall as quickly as they came…

Rank will be given according to wealth. Nothing will be respected accept for money. Trials won only by intrigue. Passion the only link between men and women and women will know no satisfaction than that… Thus the era of Kali shall be the era of decline and the human race come to its own ruin.'

The Burmese Supernatural

The Burmese have no god. The Buddha himself is a model of perfection and is only deified by the Mahayana sect. Despite this, they live in a universe populated by mythical and fabulous animals and all kinds of spirits. Among them we find the nats. This ambiguous term has for a long time been applied to Brahma (Byamma-nat) to the devil (Man-nat), to Hindu gods like Ganesa (Mahapeinne-nat), to the old kings of Burma and even to the Buddha himself. It is not certain whether the Burmese themselves possess a rational classification engendered by their own imagination and enriched by external factors. A visit to the nats' pantheon just a few kilometres away from the landing stage at Syriam suggests that there is little system or hierarchy to this belief. Though there is a celebration each year, the place is desolate and badly maintained. Three hundred altars are ranged around a central point where the most important figures are given prominence. If catalogued the list would reveal a surprising mixture of nats, spirits, world guardians, Hindu gods, astrological constellations, and alchemist figures. These are all ranged around the Buddha, his mother and his most important disciples. Though there is a clear relationship between the Buddha and the celestial world, each of its beings is quite different in appearance, associated rituals, legends and mythological background.

The ancient Burmese believed, like other primitive peoples, that the forces of nature were driven by spirits. There was the spirit of the sky Akhatasoe, the spirit of the clouds, Upaka, and the one of the earth, Bumasoe. One of the most important spirits was the spirit Yokhasoe who occupied a tree's trunk and main branches, whilst the earth spirit possessed the roots and the sky spirit controlled the upper branches. Yokhasoe's cult is much alive and his altars are propitiated with offerings of flowers, rice and water. Very few banyan trees today do not have a dwelling for Yokhasoe who is still well respected. No tree or large branch can be cut down without his agreement. He must be asked with an offering and a *dah* or sword which is planted into the ground. If the sword has not fallen over for three consecutive nights, the lumberjack may proceed.

The spirit of the rain is called Moe Kaun Kyaw Swa. When there is a long drought, he is invoked by the tug-of-war (*lun-swe-pwe*). Two teams of about thirty men compete whilst being cheered on by an orchestra. A bunch of eugenia leaves, placed at a mid point between the teams, determines which side is the winner.

The coconut guards the home and plays host to his guest the nat U You Daing. However he was later ousted by Mahagiri, who is one of the most famous nats.

Every spirit maintains (the Burmese use the word 'control') a territory, a dam, a monument or any precious object. This is why any treasure is usually in the hands of the female *ouktazaung*. They are passionate beings, and take advantage of man's greed for gold and lust for women. Sometimes suffering from loneliness, they become jealous of the pleasures of man that are denied to them, they appear in attractive guises to deceive the man they have chosen. If a person succumbs to the charms of an *ouktazaung*, he

will die and share with the *ouktazaung* the guardianship of the treasure. An *ouktazaung* might also lure a victim with promises of treasure rather than tempting him with her charms. If the victim gets caught the *ouktazaung* will kill him and the victim then takes her place. Thus the victim becomes guardian of treasure and an *ouktazaung* becomes an ordinary citizen. The reversal cannot last for more than twenty years, after that the ferocious guardian has to go back to her original post. She is like a *femme fatale, a*nd ready to exploit the loneliness and desperation of whoever owns a treasury. However, the *ouktazaung* serves an honourable cause: she preserves the wealth of a pagoda which in turn will be used to build other pagodas that pay homage to the future Buddha, Maitreya.

The guardian of a town is often called Bo Bo Gyi (the grand father). This anonymous ancestor is usually represented in human form. But his legend remains unknown and sometimes he is not even displayed. He is a transitional figure between the invisible spirits and the historic nats. There are a lot of examples of nats searching for a territory. They are welcomed by a local Bo Bo Gyi and then they may evict him. Bo Bo Gyi is the closest thing to the cult of ancestors in a country where it is not a customary practice. The Burmese refer to Bo Bo Gyi when there is no other guardian in the town or when they do not know his name. There are six popular Bo Bo Gyi in lower Burma: in Rangoon at the Shwedagon, Sule and Botataung pagodas, and also at Syriam, Mawbi and Thingan-gyun (Kyaikasan).

GUARDIAN AT THE SHWE-ZIGON
PAGODA, PAGAN

The Soul of the Butterfly: Ley Bya

There is a popular belief in the existence of a soul in the shape of a butterfly. Whilst his human host is asleep the *ley bya* has some autonomy but at death completely abandons him. If it is a tragic death, and he lacks the necessary accumulation of merit for a Buddhist to enjoy a favourable rebirth, the butterfly might wander aimlessly and become nasty. Mortuary rites ensure that the soul of the departed will not remain to haunt the house. There even exists a special rite called *ameindaw-pyan* to stop officials from working after their deaths. A document relieving them of their responsibilities is laid on the coffin.

BO BO GYI AT MYO HAUNG, ARAKAN

Some lost souls are not so easy to exorcise as they have a *kamma* that dooms them to wander aimlessly till they can be reincarned in a better world. Buddhism calls them *preta* and people call them *tasei* or *thaye* (ghosts). They are known to gorge on corpses in the cemeteries. They may even enter villages at sunset to seize live victims. Often they take the form of great black giants with awesome teeth and ears and big tongues, their appearance reveals their sad condition. The ghost of a woman who has died in childbirth is most feared. The ogres, or *balu*, have greater status than the ordinary ghosts in the popular imagination. In Burmese art their grinning masks are imposing. They can be seen in the entrances of many pagodas and on the top of the bells with their head looming between the garlands of *pan-shwe* (golden flowers). At the main pagoda in Magwe, there are a number of these fearsome masks. Amongst them, there is a smiling face whose origins are unknown. It possibly represents a Burmese version of Hindu demons like Yaksas or Bhutas. As Buddhism denies the existence

of a soul, it therefore ignores the idea of the metamorphosis of a *ley bya*. It accepts, however, the existence of the *preta* or the *balu*, just as it welcomes the *dewa* and the guardian nats of the pagoda's precinct.

The ghosts and ogres are like the bogeymen or werewolves of the West used to scare naughty children. Children are given guardian angels or *kousan* as well. There are six benevolent and six malevolent guardian angels. Every morning the guardian angels are supposed to make a report on their night duty to the *dewa* of *Tavatimsa* or heaven. This makes a good excuse to pull lazy children from their beds.

It is easy to find protection from ghosts. To scare them away, just say *'phyi' 'phyi'* and spit on the floor. For more threatening situations, amulets (*let-pwe*), cabalistic signs (*in*), alchemist's balls (*dat-lon*) are more effective. A tattoo can protect against the natural or supernatural dangers. A large tattoo from the waist to the knees can nowadays only be seen on a few old men. Young people are more scared of facing the agony of receiving a large tattoo than the wrath of the spirits. Nevertheless, they still display small squares or cabalistic signs on their arms and breasts for protection. The tattooers, always present in the festivals, today operate with a less painful battery-powered needle.

As these supernatural beings are so powerful, capable of flying, of slithering like a snake and becoming invisible, many people are tempted to acquire these supernatural powers. Consequently, the occult sciences are alive in Burma and most Burmese have some knowledge of them.

The practitioners are generally called *weikza* and are like a western wizard, half way between the magician and the scholar.

Five of them may be identified :

| | |
|---|---|
| the alchemist | *Pyada Weikza* |
| the small alchemist | *Than Weikza* |
| the quack | *Hsei Weikza* |
| the expert on cabalistic signs | *In Weikza* |
| for religious sects | *Gaing Weikza* |

Alchemy

Alchemy came from India and flourished in Burma between the 5th and the 11th centuries. Though it rivals Buddhism no more, it occupies the popular imagination and sometimes can put a serious strain on the budgets of amateur practitioners. These are more numerous than it might seem. The transmutation of ordinary metals into gold is just the first step in the way to discover 'the stone of the alive metal' or philosopher's stone. And this one is only a step towards becoming a superman and attaining eternal youth. The magic powers belong to the owner of that stone whether he is the inventor or not. Legends abound telling of the fabulous exploits of men holding the magic stone in their mouth, placed in their hair buns or held in their armpits. Not only can they turn lead into silver, and copper into gold, but they can also free themselves of the shackles of time and weight of matter.

The alchemist who wants to go one stage further than discovering the 'stone of live matter' must spread throughout his body the various alloys

made thanks to the magic stone. For this, they must be absorbed during the state of hypnosis and then digested whilst buried for seven days. During this period of time, the *zawgyi* is defenceless against men and devils attracted by the apparently delicious perfume of his buried flesh. This was how the Indian brothers of Thaton, Byat Ta and Byat Wi (pages 29-33) acquired for themselves supernatural powers. The alchemist whose sweat smelling unconscious body they ate up had failed to commit his vulnerable body to the protection of a loyal disciple. Perhaps this was because he had not promised him the magic stone, as was customary, for after all he would not need it any more.

On the day of his resurrection the alchemist leaves the ground happy to become an accomplished magician. He will lead a hedonistic, but lonely, life as described by Dr Htin Aung :

> Fatigue and physical pain are unknown to a *zawgyi* and disease and decay do not occur to his body. A *zawgyi* can live without food and water and never feels really hungry or thirsty, but he enjoys eating fruits. He cannot drink intoxicants or eat meat, because his body cannot bear their smell even. But he is by no means an ascetic and may even indulge in sexual pleasure. However, he cannot love human women, for as they are meat eaters, human beings smell noxious to him. There are trees in thick forests, whose fruits are in the size and shape of young maidens, and a *zawgyi* will put some sort of life in them and make them his lovers.
>
> They do not really become human beings and as they are but fruits, they get crushed and are dead in a few hours. Sometimes quarrelsome *zawgyi* fight over the fruit maidens...
>
> A *zawgyi* leads a lonely life. His fruit maidens are not real beings. He has power over inferior spirits, but remains rigidly aloof from them. In spite of his powers, in many ways he is not received into the society of higher spirits. He does not consort with other *zawgyi*... but he is magnanimous to human beings and many a lone traveller has been given gold and jewels and cured of disease by a *zawgyi*. Although he considers himself superior to human beings he regards kings and princes as more or less his equals and will give away his stone of live metal to deserving kings and princes. The stone is without any use to him as he does not desire human riches. But he is careful as to whom it is given because misplaced wealth would be disastrous not only to the recipient of the stone but also to the society in general...

The illusive happiness of *zawgyi* has worked as an argument for the alchemist's enemies. However, a *zawgyi* will argue that they search for eternal youth not in order to enjoy a life where there is constant suffering but to last till the advent of the next Buddha Maitreya. This is the easiest way to reach Nirvana.

The alchemist bases his experiments on the principle of the four elements of the body, earth, fire, water and air. Behind these destructible elements remains an essence that is not. The alchemist's experiments look to transfer by fire the essence of certain metals into the human body in order to make himself immortal. They use nine metals. Five basic metals lead, pewter, antimony, zinc and copper- that could be transformed to one of the two noble metals, silver or gold. The remaining two, iron and mercury, are neither noble nor basic and so they are the catalysts of the transmutation. There is thus the Mercury School and the Iron School. In Burma iron is a metal known to have one hundred and sixty seven varieties. The alchemist in addition uses another twelve mineral products in his

A YATHE ALCHEMIST AT WORK ON
RANGOON'S YANKIN HILL

A ZAWGYI PUPPET

experiments: sulphur, alum, salt, nitrate, borax, ammoniacs, salts, arsenic, mercury, pure arsenic, lime, soda ash. Unless to each other, alchemists do not reveal their secrets, although a foreign chemist might be taken into their confidence. Though they have never, like the *Ari* monks, been persecuted, they have been openly criticised since the rise of Buddhism in Burma.

The various alchemical schools used to record their discoveries through coded formulas but they had much difficulty decoding each other's formulas. Before Anawrahta, alchemy was the monopoly of the *Ari* monks. Later, it fell into the hands of astrologers, doctors and silversmiths. Though purged by the old kings of Burma and rejected by modern science, the practise of alchemy has refused to die. This is evident in any herbalist's shop where melting pots are always stacked-up for sale. Many yathe, like the ones on Yankin Hill in Rangoon, to this day spend much of their time working bellows at their forges. There are a wide variety of metals available in Burma providing them with ample supplies, though mercury is more expensive than most, even as a by-product of the lacquer industry which is a great consumer of cinnabar, the mercury ore.

The Healers

The healer also believes that four elements compound to form the human body. His duty is to diagnose which is weakening. If a man becomes ill because of a bad karma he cannot be healed. The same illness can be cured by different methods because they are or were chosen according to the horoscope. It was once reported by a writer that healers had prevented their patients from eating certain kinds of food because their names started with a letter connected to their birth date. No *hsei weikza* went so far as to forbid rice (*hsan*) to people born on a Saturday (*sanei*) and chicken curry (*chet-tha-hin*) to these born on a Thursday (*cha-tha-pa-dei*) - they would have lost their customers.

The healer's empiric 'savoir-faire' has perhaps been under-estimated by modern science. The staged performance necessary to maintain the *hsei weikza*'s prestige can overshadow the real virtues of the plants most often used by healers. They can be found in all the markets of Burma and some of have a renowned efficacy.

Plants imported from the Himalayas possess a characteristic reputation. Some healers claim that they travel there on a regular basis to collect. The monk of a monastery near Pegu used to go once a year to the Pegu Yoma forest to collect a plant able to help sciatic and other nerve pains. The potion is given by a syringe applied against the affected zone and tapped by a stone. The end passes through the skin and introduces the soothing liquid. The effect is certain but temporary. This monk used to heal celebrities. He passed away in 1985 and now rests in a mausoleum. The most elementary cure is oriental method massage whilst applying shampoo. Some healers now add to their potions antibiotics or other western medicines and leave their clients to run the risk.

Encouraged by the government, the school of traditional medicine has become ambitious for the future. One of its advocates wrote both to the Pasteur Institute and to the Bethesda hospital willing to undertake the

responsibility in the cure of somebody from Aids. He had not treated anybody with Aids yet, but with his knowledge of the four elements, and a panacea he kept secret, he claimed he could cure the disease.

When a *hsei weikza* cannot cure a patient, he declares that the patient is possessed by a devil or is bewitched. He asks for the assistance of a good weikza or *in weikza* for an exorcism session.

The Sorcerers

The Burmese have two categories of weikzas: the malevolent, the *sons*, being females and the *auklan-hsaya*, the master weikzas that are more powerful than the latter. The *souns* use personal charisma, special formulas and the secret rites of witchery. They can use the most disgusting of substances. The *auklan-hsaya* relies on the power of the spirits and the help of various nats.

To gain this power the master *weikza* makes a mixture of profane and sacred ingredients. For instance, the mixture of earth from a cemetery and from a *sima*, the place where Buddhist ordinations are held. He uses scatological objects as well, and burns them in powerful fire placed under Mahagiri's altar, whose loathing of fire is notorious. He can also subjugate nats; for example, he can make them accustomed to receive raw meat from his hands. Ye Yin Kadaw, the nat whose festival is celebrated at Zee Daw, has a preference for raw meat. She is the patron nat of the witches. So she is a party to their evil spells. This is not the case with Mahagiri, the protector of homes. He cannot fall under the power of *auklan-hsaya*, he simply leaves the place. In his absence, the *weikza* do their works. Witchery is found mainly in central Burma in towns like Yaw, Gangaw, Pakkoku, in Sagaing up to the Naga country in the west, and in the east amongst the Shans.

The difference between a witch and a sorcerer is that the former has an inborn power and the latter has acquired it. The *karma* of a sorcerer is rarely good. But they are less dangerous than witches even if the illnesses they bring about are well known for their incurability. Sorcerers and witches fly at night in the form of a bat, others as birds of ill omen, or simply without a head, their body covered by a shirt. They may also detach their head to pick up the filth they eat. They may act out of spite or for a client. Many confide in them because love has disappointed them. Witches cause harm by adding foreign bodies or *apin* to the food of the victim. For a deserted wife, the witch will introduce menstrual blood, feminine secretions and the blood of the wife herself, her client. Witches can be recognised by the way they scowl so they conceal their strange eye. They are the bad eye of the village (like the *Phi Pop* of Laos) and if the case arises, they become submitted to an ordeal. They are thrown into the river feet and wrists tied up and their head covered by muck. If they float by their supernatural power, they are witches. If they sink, the accusation will be withdrawn and hopefully they are pulled back before it is too late.

The Exorcist

For protection against witches it is necessary to call the *ahtetlan-hsaya* or exorcist. He is generally the member of a near Buddhist *gaing* or sect that

aspires to achieve the supernatural powers of a weikza in order to achieve salvation. The cult of the future buddha, Maitreya, offers a follower the security of eventually achieving Nirvana. However, Maitreya will not appear for twenty-five centuries, so eternal youth must be acquired by alchemical means. The *ahtetlan-hsaya* makes use of all the equipment of the *weikza*: he knows the metals, the healing plants, the cabalistic signs and astrology. He must submit himself to a certain discipline. He may have to swallow *in*, allow himself to be tattooed, avoid passing underneath a ladder or walking under a line with women's clothes hanging on it. He may not stay in a house where there is a mother about to give birth. Furthermore, like the *nat-kadaw*, he will not be allowed to eat in the house of a dead person for forty-five days, nor in the house of a mother delivering a baby, and during a marriage. Naturally, he will eat neither beef nor pork. Of primary importance, he must respect the precepts of Buddhism. The fight of the exorcist against the baleful powers is the battle of a faithful against a heretic. In this case the *son* witch is the heretic.

The exorcist, like the *nat-kadaw*, is a Buddhist. However their relationship with the spirits are opposed. The exorcist faces and challenges the nats and the *nat-kadaw* is their medium and their servant. The exorcist may not be powerful enough to drive the evil spirit away and so he might call for the *nat-kadaw* who has the power to calm it. But the nat remains his adversary, particularly Ye Yin Kadaw, the patron nat of witches. The *ahtetlan-hsaya* can drive away the devil with offerings, but his most powerful weapon is the Buddha. For example if a child is scared of a ghost he will give him a potion to drink whilst reading some sacred texts. In the presence of a patient possessed by a nat, he will make an offering to this nat while he prays to invoke the whole power of the compassionate Lord. By doing this he will be able to guide the patient to pay respect to the Buddha, profess his faith and promise to respect the five precepts. The session of exorcism is a mixture of cuddles, threats, offerings, and violences. The exorcist wishes to dismiss the spirit and the *nat-kadaw* wishes to calm it. The exorcist is a rampart between the nats and the Buddha. The *nat-kadaw*, possessed by the powers that Buddhism condemns, tries to sooth them. Perhaps the popular cult of the nats has prevented the Buddhism of Burma evolving into Tantrism.

Superstitions

To this summary of beliefs it should be added that the Burmese are still a very superstitious people. There are so many doctrines and beliefs that they have been compiled into a classical work, the *Deitton*, which is still popular in rural Burma. In this book it is taught that a man must never pass beneath a woman's washing on the line, nor under a ladder and no meal can be eaten in the house of a mother delivering a baby. That eternal fear of the future and anguish over destiny has given rise to all manner of augurs. Thus a general or a litigant had a very curious way of enquiring into the issue of a war or a trial. They would make the shape of a lion with cooked rice, an ox and an elephant. Depending on what the crows ate first, they would forecast the success, the compromise or the defeat. A litigant who finds a snake or somebody carrying a spade or a broom on his path can

THE TAUNG-GYI BALU,
MANDALAY HILL

be certain his trial will be long. He will have better luck if he comes across a player of cymbals, a female elephant or a dog. The bride will be unlucky if the wind blows off some of the betels leaves which are traditionally offered to her.

When building a house the *Deitton* makes the difference between male beams (of a regular shape), female (broader below), neutral (wider in the centre) or giant (broader at the top). They mean respectively happiness, luck, misery or demise. A house and its occupant's destiny can be read in the knots of the wooden stairs where ten squares will have been traced. A knot in the first square announces the visit of a prince, in the second square it means a huge harvest, in the fourth it indicates a decease, in the eighth, the death of the wife and in the tenth, lots of gold and silver.

It goes without saying that the cry or flight of birds, the laying of the hens, the holes made by mice and dreams have great significance.

For every birth it was a custom to draw a horoscope on palm leaves and to consult it at every crucial moment.

In the king's court, the power of the monks had no equal but that of the astrologers most of whom were Manipur Brahmins. They are still consulted nowadays: the date and time for Burma's independence was set for the middle of the night by astrologers.

The Burmese world of the supernatural contains beliefs more influenced by India than China. The four world guardians are derived from the eight Lokapalas of the Hinduism. They are invoked in all the ceremonies in the following order:

A BALU-MA, OR LADY OGRE

Dhataratha the guardian of the east, controller of devils.
Viroulaka the guardian of the south, controller of monsters - *bou ban*.
Viroupeka guardian of the west, controller of nagas and garudas.
Kouveira the guardian of the north, controller of the ogres - *balu*.

Many Hindu divinities have been Burmanised and favoured with the 'Nat' appellation. Sir R.C. Temple's book on the nats is full of illustrations of these divinities in the disguise of nats. Their disguises are not very convincing, they look alike and lack the attributes by which each nat may be identified without ambiguity. The Burmese nats were further Hinduised when Burma was part of the British Indian Empire. Since Independence, Burma has detached herself from such influences. However, the cult of nats still borrows from India and several divinities such as Sarasvati, Sandi-Durga, Ganesa and Krishna are revered above the world guardians at the opening of various rituals.

The Cult of the Nine Planets

Once a year, or when someone is ill, a Burmese family perform the Ceremony of the Nine Planets. A *hsaya* comes in the afternoon and makes a miniature monastery out of a banana stem. The fragile construction is then placed against the eastern wall of the main room. The *hsaya* decorates it with umbrellas under which the Nine Planets are placed. The planet Rahu is particular to the Burmese cosmography and its mount, a tusked elephant is particularly powerful. Kate, the king of the planets, rides a

THE RITE OF THE NINE PAGODAS

composite animal 'of the five beauties', a mixture of deer, elephant, lion, naga, and fish. Kate originally presided over the ceremony until Buddhism forced it back to a position inferior to the Buddha and the nine arahats.

Then come the the five great gods: Sarasvati, Siva and his consort Chandi, Ganesa and Gawramana, the ninth and future incarnation of Vishnu. The monastery is adorned with prayer flags, flower pots, beeswax candles - always nine in number; begging bowls are placed in front of the Buddha and each arahat, ordinary plates in front of the planets. At dawn these vessels are filled with three kinds of fruits, jam and with rice cooked in an unused earthen pot. The *hsaya* invites the gods of the planets to accept the offerings. He has a specific formula for each, starting with the sun and proceeding clockwise to end up with Kate.

At the end of the night long ritual the planets are dispersed in the same manner. The Buddha and monks are neither invoked nor dispersed. There are some prescribed formulas of worship but a good part of it is at the saya's discretion. It is protection that is sought; personal problems are best solved by turning to one's birthday planet.

The cult is of Hindu origins, but in it no homage is offered to the five gods. The planet of his birthday and all others successively mould the fate of each man's life for a period of one hundred and eight years. Four planets are malevolent (Sunday, Tuesday, Saturday and Rahu) the others are benevolent whilst Kate abstains from interfering with the affairs of man.

The ritual has survived because the Buddha is supreme and worshipped by the planets who face his image. Today the once elegant banana structure is often replaced with a prefabricated wooden or plastic structure.

The Cult of the Runes

Dr. Htin Aung in his book *Folk Elements in Burmese Buddhism* has described how the cult of magic and witchcraft in Burma originally included the 'Cult of the Runes' - a system of magical squares, each containing certain letters and figures and guarded over by a god.

The master who discovered the right square would either be buried, like an alchemist, for seven days or be burnt for three days, like a *zawgyi*. The origins of the cult are obscure and date back to the fifteenth century under the guise of being Buddhist. The master would respect not just the usual five Buddhist precepts but either eight or ten, and go on forty-nine day retreats whilst abstaining from eating meat before casting the runes.

According to Dr. Htin Aung, this cult regained popularity in the fifteenth century. Then the most famous master was the great Mon monk Dhammazedi who was appointed by the king of Ava to tutor his queen, Shin Sawbu, daughter of King Razadirit of Pegu. In 1430 she decided to return to her native Pegu with her tutor. There, twenty-three years later, she became its queen but relinquished the throne after seven years so as to become a recluse. Dhammazedi then disrobed, married her daughter and became king of Pegu. Not only was he a wise and religious king, but was famed for being a *zawgyi* and patron of the Cult of the Runes.

The cult gained another patron in the nineteenth century, Shin Aung or 'Master Victory' was a simple monastery student near Prome when he

became caught up in an extraordinary magical adventure. From the presiding monk he inherited a book of runes that no one dared to touch. He then travelled to India where he met and befriended the Burmese crown prince who also happened to be there at that time. The crown prince returned to Burma to become King Bodawhpaya whilst Master Victory, with little else to do, studied the book of runes.

Learning of these studies the king feared that his friend might use these powers to plot against the throne. So he had him arrested and duly buried alive for the recommended period. After the the master went before the king and complained that he had not trusted him.

'Rather than trying to kill me you should try to rub out the 'O' which I now draw on the floor with a piece of chalk.' The king rubbed and rather than disappear two Os appeared. He rubbed on and they multiplied from four to sixteen and so on till there were so many that the king gave up.

'Friend of my youth', said the master, 'I would have made you king not of your own country but of all the world. Now you shall never see me again.'

Htin Aung concluded in 1959 :

> At the present day devotees of the cult no longer attempt to discover the secret of the potent squares, because they believe there is no need to cast the runes themselves so long as they follow the eight precepts, ...retreat, abstain from eating meat and honour Dhammazedi and 'Grandfather Victory' (Bobo Aung). One of the masters will certainly come and give them the runes so that they will become *zawgyi* and await the coming of the next buddha. In other words, for them the Cult of the Runes has become the 'Cult of the Magus.'

Charms of Invulnerability

Thieves and dacoits are among the main users of various charms of invulnerability. An image of the 'King of Tigers' tattooed on their legs was supposed to make them swift on foot. Magic squares on the back would protect them against gun shots. They could also carry about or hide under their skins balls of mercury, iron, orpiment, amulets and talsimans. There exist mixtures to harden the skin made from black pepper, ginger and honey over which incantations are muttered. In the Shan Hills baths are prepared with a certain plant with the effect of cooling and hardening the flesh.

Such charms have been extensively used by leaders of revolts against British rule. An incantation repeated thirty-seven times over some ashes and partly swallowed gave one day of invulnerability. A similar result was was sought for by drawing cabbalistic letters with mud on specific parts of the body. Failures seldom discourage people to try them again and again.

Charms are also used to do harm to others. The Ponnaka Nat is well known for his triple powers: throwing stones at a house, beating people with a stick, setting fire to a house, always without being seen. To move these powers into action it is necessary to make a wax image of an ogre on horseback. The saddle and bridle should be made of material from dead bodies. The horse tail should be made of the hair of a person who has hanged himself. Then the image is to be taken to a large tree close to the enemy and propitiated with offerings and prayers before being burried Then his creator may ask him to perform one of his three tricks.

The Cult of the Nats

I n the covered walkways that lead to a pagoda there is usually a vendor of small, strangely shaped, wooden statues. Amongst these the visitor might find a woman with the horns of a buffalo, harp players, a prince riding an elephant, a horseman, soldier or an ordinary person straddling a tiger. These are the nats. They are spirits who have adopted human shapes, easily identified by their individual features, their mounts, their clothes and the rituals at their festivals.

The Nats in Daily Life

The Burmese still worship them vigorously. Capable of evil action, nats receive far more attention than the benevolent divinities or ones indifferent to human affairs. They are frequently invoked and often require careful calming. Offerings at every occasion, at any moment, are constantly being made to them. They may be the protector of a property or even a territory. Guardians, or fearsome doorkeepers, they have no compassion for anyone who fails to demonstrate the necessary respect due to them.

Often in the countryside there can be seen, suspended above an altar, puppet-like white horses. This is the mount of Myin Byu Shin, one of the most popular nats. At the east door of the Shwedagon in Rangoon some stall owners do not sell anything other than these wooden equestrian toys.

Few houses do not have a coconut placed at a respectful distance from the altar of the Buddha which is situated on the second pillar to the east inside the house. It is the zone of a nature spirit who was destined later to become the first of the nats. This is Mahagiri, guardian of all houses.

Not many villages are without a guardian nat protecting their entrance. They are sheltered in a good sized cage called a *nat-sin*. At Pagan, they inhabit the niches on a temple's enclosing wall.

Few pagodas and monasteries do not have a room or a building intended to house the resident nats. Their followers never forget to salute them too before performing their devotions to the Buddha.

When a house is built the first pillar is never erected without an offering having first been made to the nats. Likewise the opening of a celebration or a sportive game is always inaugurated with such a propitiation. An enterprise or a career has more chance of success after the performance of such propitiatory rituals. A road is made safe by tieing an offered bunch of flowers to the mirror, or the yoke of an ox cart. A river made safe by tieng a similar bunch of flowers to the prow of a vessel.

Just past the Rangoon Mingaladon airport on the Pegu road to the left at Shwe-gaung-pin, a nat inhabits a golden banyan tree. He is the guardian of the road. Shwe-gaung-pin is a recommended stop for the drivers of new cars and for lorry drivers setting out on a long journey. This halt may be compared with all-risk insurance. Out of reverence, the driver turns his car towards the nat's altar in three distinct manœuvres. Meanwhile, an officiant scatters lustral water with a sprinkler and ties a bunch of flowers onto the car muttering constant incantations. He is given some coins. If

there are any left, the girls selling tamarind, jasmine necklaces and sticky rice cakes are always ready to collect them too.

Nats may be offered special festivals and ceremonies by private people who want to attract good fortune. At such *kadaw-pwe* a green coconut, three bunches of bananas and eugenia leaves are the most fundamental offerings. In addition, flowers and fruits, sticky rice cakes, sugar from the toddy palm, eggs or other provisions are donated. However, meats like pork or beef may not be offered for fear of offending certain Muslim nats or those of Hindu origin. The *kadaw-pwe* is a feature so characteristic of Burmese cultural life and so popular that it is almost a symbol of the national culture.

The origin of the term 'nat' is obscure. It may derive from the Hindu *natha* which means lord, saviour or protector and is an epithet applied to the Buddha in the Pali texts. Perhaps, in reaction against such suggested Hindu influences, the Burmese maintain that the term comes from Central Asia and its similarity with the Pali word is merely a coincidence. The cult of the nats is too ancient to trace its origin. It may have come from India or be an autochtonous animism influenced by Indian religions. Ancient Burmese texts have numerous illustrations of once Hindu divinities now Burmanised. Thus, Vishnu has become Beikthano-nat and Siva, Para-miz-wa-nat. Vice versa, some primitive nats have been Hinduized. This was particularly evident during the colonial period when there was much Indian immigration into Burma.

With this Burmanisation a special iconography for these Indian-origin nats images has evolved. With the exception of the Prome Brothers who are of distinct Hindu origin, as is narrated in their legend, a great number have lost the three pairs of spinning arms characteristic of Hindu divinities.

The Royal Decrees

The great reformer and conqueror Anawrahta (1044-1077), the seventh king of the Pagan dynasty who unified Burma, tried to eliminate the cult of the nats in favour of Theravada Buddhism. His subjects, however, paid homage daily to the nats and to the *naga*, giant snake-like monsters which had been the object of a more ancient and primitive cult rather than that of the nats. In 1048 the king ordered the destruction of all *nat-sin* and all images of the lords were to be manacled into a symbolic state of bondage. The villagers submitted to this command, but adopted the coconut as a symbol of the nats, and as an offering to them. The king was forced to seek a compromise. He chose thirty-six nats and locked them in an annex of the Shwezigon pagoda where copies of them remain to this day. He placed at their head Indra, Burmanised with the name Thagya-min, together with statues of *dewa* who as divinities are superior to the more humble nats. In this way Buddhism integrated, like in other religions, animist beliefs. The cult of the nats may have lost some of its more barbaric aspects, but it was never to disappear.

Even more surprising, members of the great king's family and dynasty were to become nats adding an indigenous element. These figures were rarely saintly or beatific. After the injustices of the the Taungbyon Brothers incident, Anawrahta himself fed the cult of the nats. He punished with

OFFERINGS OF KADAW-PWE

death two of his generals for a minor error because their popularity had become an irritation to him. Anawrahta came close to having been made a nat himself. In Kyaukse, where he had built a system of irrigation which still functions to this day, it is forbidden to eat buffalo during the elephant festival. This is because, Anawrahta died after being gored by a buffalo - that avenged the injustice done to the Taungbyon Brothers. During the Taungbyon festival pork is neither offered nor served as these two nats were Muslims.

The cult was first defined in literature by the *Lawka Byuha*, the *Shwe Bonnidan* and other treaties of protocol. Another king, Bayinnaung tried to purge the cult of the nats in the 16th century in an attempt to purify the religious life of Burma. The sacrifice of white animals was stopped, but not the cult itself.

Mindon, the second last king of Burma, reduced the number of national nat festivals to eight. The cult was revived under his successor King Thibaw. With independence, Burma once again saw a revival of the cult of the nats. Though Prime Minister U Nu, a fervent Buddhist, built a pagoda to the Buddha on the summit of the volcano Mount Popa, he has also erected a temple there to the Mahagiri nat. Perhaps more through opportunism than by conviction, the socialist regime from 1962 - 1988 tolerated the cult of nats.

Nats and Buddhism

Integrated into Buddhism, even if unwelcome, the nats act as a counterbalance for what can be rational and severe. Akin to a Dionysian carnival, a nat festival offers release from the restraints of daily life. Alcohol flows abundantly and the Burmese lose their inhibitions and self-restraint. They dance wildly to the accompaniment of a deafening music. Compared with the peace and serenity of a pagoda, the *nat-pwe* represents Pandemonium. Contrary to notions of Buddhist detachment, the excitements of the flesh and allure of money are well evident. Periods of Buddhist fasting and abstinence are thus broken by ecstatic jubilation and excess.

Though absorbed by Buddhism, the nats have no specific place in its cosmogony. They are not placed in the hierarchy next to their king, Thagyamin or Indra. *Tavatimsa*, the dwelling place of 32 Hindu divinities, the dewa, is not the abode of the nats. Nor do they live in the inferior regions of *Preita* or *Asurake*.

Nats are wandering souls and have had a stormy existence, impious and miserable each has suffered a sudden or unjust death. They have not received the Buddhist unction that assures the serene passage to another existence. They should be pitied for their miserable destiny and feared for their spitefulness.

They are also associated with the Buddhist belief that there is no soul. The concept of the *ley-bya*, or butterfly soul, draws close to ancient Burmese animist beliefs. It is a soul with wings, like the angels flying from the mouth of a dying person in medieval Christian iconography.

In the Burmese supernatural there are no beings as closely associated to mankind, more involved in their businesses, more threatening or more

demanding than the nats. They can manifest themselves into human form. Some Burmese are able to identify, without turning a hair, a contemporary person who is the manifestation of an ancient nat.

The nats are neither spirits nor heroes, nor are they saints or martyrs. But then, they are not ghosts. Various sociological, economical and psychological explanations have been put forward. However the movement is closely bound to the history of the country and to the national pride. As a Burmese author once wrote of the cult :

> When the nation is in danger or if disaster occurs, the country thinks the thirty-seven lords are with them. It is said that when the Tartars invaded the country, the nats fought next to the soldiers and some were injured by Tartar arrows. That the Lord of the White Horse and the Taungbyon brothers shared the sadness, the shame and the glory of the Burmese soldiers who were sounding the retreat in front of the English armies. The golden statues of the thirty-seven Lords cried when Thibaw, the last Burmese king, was made prisoner by the English. When great fires broke out in the 'golden city' of Mandalay in April 1945 after the allies bombing, it is said that the brothers of Taungbyon, unfairly executed by Anawrahta and who symbolise the people's struggle against injustice, worked side by side with the aggrieved people to put out the blaze. A wind of revolt blows every year through the festival.

The nats are very different from the *phi* of Laos and of Cambodia. These are more similar to the spirits of nature, to ogres and genii though some nats of this type belong to Burmese folklore and the mountainous tribes who have not been converted to Buddhism.

The cult of the nats is alive mainly in the middle part of Burma: in the hexagon delineated by Pakkoku, Yemabin, Shwebo, Maymyo, Kyaukse and Meiktila. Elsewhere the cult is also widespread but there the central thirty-seven nats are in competition with local nats whose popularity might be greater. This is the case with Pegu Medaw, the nat with the buffalo horns. Pegu Medaw is one of the most popular nats in Rangoon. So too with Ko Myo Shin and other nats of Shan origin who have come down to inhabit the Burmese plains.

The Arakanese honour the spirits in their own way but they do not know the thirty-seven nats. The course of their history is different from that of Burma's until the annexation of the Arakanese kingdom in the 18th century by the Burmese king, Bodawhpaya.

Possession Cults and Shamanism

The cult of the spirit is an almost universal phenomenon. From antiquity to modern times, few cultures, if any, did not somehow pay homage to the spirits.

In order to survive the cults have had to compromise with the prevailing monotheist religions. The Buddhists are more tolerant in this respect than the Christian church and Islam. Christianity has eradicated from the Greco-Roman heritage both the delirium of Dionysius and the trances of Apollo. There have been flurries of strange cults from 'les possédés de Loudun' in France to the dances of St. John, St. Vitus or St Guy. The churches saw these as psychiatric cases of demoniac possession to be dealt

THE MANUFACTURE OF NAT IMAGES
AT MANDALAY

with by the exorcists. Strange rituals survive in Italy and Spain. Known as tarantism. Stung by a spider or a scorpion the followers cure themselves through an identification with their aggressors. They mime their postures, dancing to the trance. Tarantism appeared at the time of the crusades to the Holy Land. The church has tolerated it as a medicinal practice which may be performed in the precincts of churches dedicated to St Paul. The adepts declare themselves to be the 'spouses of St. Paul'.

Christian missionaries in Africa never compromised with the Spirits Cults, except during the slave trade to America. The slaves, indeed, were baptised before their departure, but according to P. Verger, not discouraged from their pagan creeds. They carried the memory and sometimes the images of their tribal gods. Thus the African cults were transplanted on Christian lands, mainly Brazil where they are called Candomble in Bahia, or voodoo in Haïti. The missionaries had hoped that antagonism amongst these various cults would serve, at the end, the Christian Faith. To escape from being persecuted the slaves and their descendants proclaimed that their Gods were, under African names, the Catholic Saints whom they honoured according to their ancestral traditions. In the *barracon*, the hall where their cult is held, images of Christian Saints are displayed, just as the image of Buddha presides over every *nat-pwe*.

The Islamic religion admits a form of trance, *wadj*, which, it is believed, was experienced several times by the Prophet himself. When fully controlled the *wadj* may lead to a state of annihilation, *fanâ'*, and absorption into Allah comparable to the mystic ecstasy of St Theresa of Avila or to the state of concentrated calm, or *samadhi* of the Buddhists, the outcome of intense meditation.

Amongst the Sufi Brotherhoods, trance is induced by the combined powers of music, poetry, Koranic verses or the mere repetition of Allah's name. One ritual, *samâ*, is a spiritual concert generating a discreet trance soon appeased by dancing. Another ritual, *dhikr*, may lead to extreme excitement. The followers of this ritual induce themselves into trances through corporal practices drifting from the stream of Islamic orthodoxy.

During the profane trance, the Tarab, the possession is not due to any supranatural but to the music and the chants to which the Arabs are hypersensitive. The cult of the *djinn* existed before Islam and is tolerated.

The cult of the Spirits is widely spread in Africa South of the Sahara. The Vodun of West Africa is the cult of the Orisha, the gods of the natural forces: earth, thunder, iron or the snake. In Mali, the Dogon honour their mythical ancestors, the Binou, the Malinke the water genii called Dyide.

These cults have often been affected by wars, slavery, colonisation and technological changes. They served the defensive reactions of the Africans striving to preserve their personality. In South Africa , the Thonga are possessed by their enemies, the Zulu; their cult is a combat against their denomination. The Tsumba cult of the Malagasy Republic, a support of the ancient kings, became a stronghold of anticolonialism and, after independence, a form of contestation of the peasantry against the white collars of the central power. The battle is still going on between the 'Royal Ancestors' and the university graduates.

All these cults, nats included, fall into the category of Possession Cults as opposed to shamanism. Shamanism has its origins amongst the

Toungouse of Siberia from where it reached the Eskimos and other people of North and South America. It may also be observed in Korea, South East Asia and Melanesia.

In the possession cults, the spirits take possession of men, they 'mount' them; the shaman on the contrary, dominates the spirits. He may mount them during his journey: a bird named Koori is the mount of the shaman amongst the Gold tribe of Siberia. In a *nat-pwe* the Spirits are invited and attracted by the music and the smell of the food offered to them. So are the African Gods. The shaman, on the contrary, travels to invisible regions escorted by one or several Spirits. He may go up to the skies, down to hell or, if he is an Eskimo into the depths of the seas. He is endowed with magical powers: he flies, runs speedily, indifferent to extreme heat or cold. The *nat-kadaw* also like travelling but there is no magic in their journeys.

Possession implies substitution: the butterfly-spirit of a nat replacing that of a man or a woman. The shaman coexists with the Spirit, he dialogues with it. There are cases, in shamanism, of frustrated women being possessed by a spirit who would designate them to become shaman themselves and to acquire the power to dominate the spirits.

Nat-kadaw and shamans also differ in their relationship to music. The shaman cannot be separated from his drum. He beats it with the tempo most conducive to his trance. He plays an active role in his own trance, adding his voice to that of his drum. In Siberia the same word *jajar* means shaman or drum. The *nat-kadaw* does not sing. He may adjust his voice for the incantations of a specific ritual, he is not a singer and is not seen holding a musical instrument except those which are the attributes of a Nat.

For the shaman music has the magic power to transform the world. The orchestra of a *nat-pwe* has a tune for every nat, to invite it, to appease it, not to change the world.

Both the shaman and the *nat-kadaw* claim access to the unknown. The former narrates his visions to the assembly whereas the Burmese oracles give only private consultations, often during the intermission between two scenes of the nat-pwe drama.

The shaman is a medicine man. The *nat-kadaw* is not a healer though attending a nat-pwe may cure some psychic troubles.

It may be added that shamanism offers a comprehensive image of the universe. Communism having destroyed it almost completely amongst the Yakouts of Siberia, their scholars have recently reconstituted the map of the universe of shamanism. They think that this religion is the roots of their national culture. The nats are not gods. They are wandering souls. There is no room for them in Tavatimsa, only for their king Thagya-min. The song, the *Nat-maw* of this king clearly refers to the cosmogony that Buddhism has borrowed from Hinduism:

> I am the king of the worlds that are situated in the midst of the Four Islands and are surrounded by the seven ranges of Mountains. The righteous and pure in heart will I protect, and I will punish such as are ungodly and do evil. Therefore have I descended from a height of one hundred and sixty eight Yuzanas to pray that everyone may avoid evil and cleave fast to that which is good.

The Thirty-Seven Nats

The official number of nats was set in the 12th century by King Anawrahta in order to contain a cult that Buddhism had failed to eliminate.

Why, then, thirty-seven? This is no doubt a reference to the number of divinities of Mount Tavatimsa according to original Indian Buddhist cosmography. Their king was Indra, or Thagya-min for the Burmese. The king of Pagan attempted to manœuvre Thagya-min, a god closely associated with the Buddha himself, to a position at the top of the nat hierarchy. Thus the popular Thagya-min would bring Anawrahta's subjects to the bosom of Buddhism. Further confusion would have been created between the nats and the *dewa*. The explanation would be completely plausible if there were not four more nats than there are *dewa*.

To explain this difference some author's refer to the *Mahagita Medanikyan*, an anthology of classic Burmese songs. Amongst these are the *Nat-han* – odes recalling the life of a particular nat with some moral message. The book contains thirty-seven odes. But some nats have two odes assigned to them. It has also been maintained that originally there was a list of thirty-three, the full thirty-seven being made-up with the inclusion of either the four world guardians or four beautiful feamle intruders.

Thus, three things are evident. Firstly, the nats have undergone the influence of Hinduism. Secondly, the Burmese have never mixed their nats with the Hindu gods and they have attempted to hide this loan from Hindu iconography. Finally, the nats have been given permission to stay in a remote corner of the pagodas. At the Shwe-zigon, a pagoda built to receive the Buddha's tooth, King Anawrahta locked the nats up and bound them in chains in an attempt to find a compromise.

Now covered with dust, they are lined-up in a modest building. The hereditary keepers of this *nat-sin* possess the key to the cage that protects them from robbers. The original statues disappeared recently but the one of Thagya-min, larger and more imposing, has escaped the theft. He is preserved in an adjoining chamber and is well locked in.

The final list may be found in a rare book by Sir Richard Carnac Temple printed in a limited edition of two hundred copies in 1906. Temple collected a set of teak nat figurines, a portfolio of coloured drawings produced in the Burmese *parabaik* tradition of folding book, and a series of ink drawings. He included this material in his beautiful and precious book. The Temple list coincides with the *Mahagita Medanikyan* edition of 1891. It has been revived, in a different order, in the *Upper Burma Gazeteer*. The Burmese author, Dr. Htin Aung in 1962 decided to revise it. He wanted to eliminate the twelve nats that were added after the Pagan Period and replace them with others. On analysis of these lists several difficulties are encountered. The least of which is the bizarre mixing of characters over the centuries. One of the most famous, U Min Kyaw, can be identified with four characters from different epochs. Sometimes a new nat has taken the name and the place of a more ancient one.

The expression 'the thirty-seven nats' is familiar to most Burmese but few could quote all their names. They have in common the fact that they

are usually of royal or noble blood. Whilst rarely significant in the history of Burma, they capture the popular imagination with their tragic fates.

They are often the victims of assassination, execution, or strange accidents. They leave widows and mistresses behind distraught with grief. Depraved princes are swept away by drugs and alcohol. Foreign princes languish ill in royal prisons. Valiant soldiers are the victims of a king's ungratefulness. There is a crown prince who hanged himself and another stung to death by a cobra in the monastery he had retired to. Kings may be assassinated by their children. Nobles struck down by leprosy, dysentery or the smell of raw onions. There is a tea merchant who was devoured by a tiger. Amongst all this misery there is one ray of light: a small girl who plays the flute and has not outlived her mother.

Apart from the seven mythical nats that date from Pyu times, the majority of others may be identified with historical characters from between the 12th and 17th centuries. They are recognisable by their costume, by their mount, or by some attribute or gesture that evokes their tragic destiny. Historic or mythical celebrities and great characters, they are all victims of cruelty, injustice and error. They thus harbour resentment against men and must be unflaggingly placated in order to protect oneself from their vengeance.

If the Greek gods were the creation of their poet's imagination, and the Scandinavian gods derived from the feats of the Vikings, then the nats are a peasant product. Villagers are terrified of them but always find them on their side in the time of a crisis. They are part of the nation's heritage. So prominent a role distinguishes them from the spirits of Laos, Thailand or from the ethnic minorities of Burma's mountains. In this way they command far more attention than mere ghosts or other more banal products of superstition.

They are always bound-up with the history of their country. This history may be traced as far back as the ancient Burmese kings of Tagaung and the Pyu kings of Prome. Both traditions meet around the 5th BC in the legends of Old Pagan and are ever present during Pagan's historical phase between 1044 and the Mongol invasion of 1298. Two lines of Shan kings, one at Pinya and the other at Sagaing, dominated the Burmese political scene after the Fall of Pagan till 1364. A Burmese dynasty appeared at Toungoo in 1313. This, though, was to be absorbed in 1540 by the Mon Kingdom of Pegu. The Shan lines were to fuse to give birth to the Burmese Ava Dynasty which fell in 1551 to the Pegu dynasty. The Pegu and Ava dynasties co-existed till 1751, to give place after another short Shan period, to the Burmese Konbaung Dynasty founded by Alaunghpaya. This dynasty was finally defeated by the English in 1885.

Burma thus had many capitals. With Tagaung and Shwebo in the north; Ava, Sagaing, Amarapura and Mandalay in the centre where the nat cult remains most active today; other capitals at Pagan, Prome and Toungoo, which also have an important place in the legend of nats; then in the south Thaton, Pegu, and later Rangoon possessed a different culture, that of the Mon, who were also called 'Talaing'.

The official list of the thirty-seven nats is not accurately chronological. It is, though, easy to re-establish the order. Sir R.C. Temple suggested a classification of the nats with five historical cycles: The Duttabaung Cycle

MAHAGIRI, THE BLACKSMITH OF
TAGAUNG

which was founded by the Prome kings, five centuries before our era. In this scenario the most popular nat of the Burmese legends, Mahagiri, leads another six characters. The Anawrahta Cycle was founded by the Pagan kings in the 12th century, with nine new nats amongst which the popular Brothers of Taungbyon were included. Taungbyon is still the place of one of the most important nat festivals. A Mixed Cycle with eleven new nats added from the reign of Alaungsithu at Pagan up to the Shan dynasty of Pinya (15th century). The Tabinshwehti Cycle was founded in the 16th century under the Pegu dynasty and added four new nats. The Bayinnaung Cycle of the Pegu dynasty which was much shaken in the 17th century by continual violence introduced four new nats.

The Duttabaung Cycle

The first civilisation of Burma, the Pyu, who were initially established near present-day Prome, had their own nats. These had had their history long before the most important nat, Mahagiri, became established near Pagan. Mahagiri means the 'Great Lord of the Mountain'. Prome on the Irrawaddy is situated seven hundred kilometres down from one of the first, by legend, Burmese settlements, Tagaung, which is situated to the north of Mandalay. Mahagiri's marriage to a princess from Prome has created the link between two legends that originally were quite distinct one from each other.

Once upon a time in the ancient kingdom of Tagaung there was a young blacksmith who lived with his two sisters. The youngest, Dway Hla was very beautiful. The blacksmith was known by the name Maung Tin De, the Handsome Man. He was so strong that he could break the tusk of a furious elephant. He used to work with such heavy hammers that he would make the earth tremble. It is a fact that there are many earthquakes in this region, between China's mountains in the north to the great sub-continent of India to the west. There thus may be some basis for this legend.

The Pyu blacksmith's reputation left the Burman king of Tagaung in the shade. So the king decided to get rid of him. Warned of the danger, Maung Tin De ran away and hid in the forest. The king then planned an evil scheme. He married the beautiful Dway Hla and some months later he told her: 'I am not scared of your brother any more because he is now my own brother. Make him come to Tagaung and I will name him governor of my city'. The queen trusted his words. She sent a messenger to look for her brother.

The soldiers captured him just as he was in sight of Tagaung. They tied him up to a saga tree trunk at the side of a big river. The king came to stare at his enemy. He found him dangerous and had bundles of sticks lit about him. The cries of the blacksmith could even be heard as far away as the palace. The queen came outside, her hair all undone, and she flung herself into the flames. The king, who had become much in love with his beautiful queen, went to save her. He seized her hair and pulled as much as he could. He was left with the queen's golden mask in his hands.

The brother and his sister, who was now known as 'Golden Face' or Shwe Myet-hna, turned into nats. They haunted the tree where they met their deaths. Neither man, no beast could get near without dying

mysteriously. The king became angry. He arranged for the tree to be cut down and thrown into the river.

The tree floated down the Irrawaddy like so many others rooted out by the monsoon. At around the same time the king failed to defeat Pagan where Tinligyaung reigned in the fifth century of our era. The nats arranged things so that they appeared to the king in dreams. They reminded him of their plight and begged for asylum.

The king arranged for the trunk to be brought to Mount Popa. Two lengths of four feet each were cut and he had them sculpted into the nats' images and covered with gold. He ordered them to be worshipped in a temple he built for them that July. Eventually Mount Popa was to become the Mount Olympus of Burma. Still today many pilgrims come each July and December. A Pagan king, Kyaupyitha, took advantage of the protection from 'The Lord of the Great Mountain' or Mahagiri Min as the blacksmith was now known. Kyaupyitha made his subjects hang in their houses a coconut in homage to him and in return they received his protection.

The coconut till then had belonged to a nature spirit called U You Daing. Then the milk of the coconut was used to sooth the burns of the fire. Fires are frequent in the wooden houses of Burma. It was then important to have a good ointment made from coconut milk close to hand and the presence of the spirit U You Daing increased its medicinal values. Himself a victim of fire, Mahagiri had good reason to dislike it. The effect of a royal decree was to remove this nature spirit without loss of face. Thus, a coconut lined with a red band and a fan-like palm tree leaf protects all Burmese houses.

The green coconut is renewed every year or more often if it is necessary. It should not be allowed to yellow, nor should it germinate, lose its tail or its milk. Every day it is offered respect to assure the safety and peace of all who live under its roof. Mahagiri Min naturally hates fire. It would therefore be an insult to light candles at his feet. His statue is often under a veil during the day time to spare him the heat of the sun.

The legend which ignores all sense of time and space has given to Mahagiri Min as a wife Shwe Nabe or 'Golden Flanks', the daughter of the naga king. The cult of the naga had reached along the length of the Irrawaddy and was not unlike the cult of the dragon in China. The naga live in the depths of rivers and oceans. They can reduce a man to ashes with only a stare. They are frightened only of the bird-monster *galon* (Garuda) and, for fear of meeting him, rarely fly. A naga's head changes position every month. Burmese try to avoid travelling in that direction as then they might fall into their mouth. The naga was worshipped in Tagaung, at Pagan, as in Prome, up till the arrival of Buddhism. A naga girl in marriage was thus a good match. She became the second queen of the King Duttabaung of Prome. She brought a dowry of a boat covered with the glistening scales of a naga. Nevertheless, there was once a dispute between the king and the nagas. The boat was navigating close to Bassein and the nagas meant to sink it. The whirlpool they created still exists. It is called 'the *naga-yit* whirlpool'. They say it was the place where the nagas drowned the king. Statues of Shwe Nabe always have the coiffure dressed in the shape of a naga. Like Golden Face and a nat called Thon Ban Hla or 'Three Times Beautiful and his daughter also belongs to the Duttabaung Cycle.

MAHAGIRI AT MT. POPA

How Shwe Nabe met and married Mahagiri is a question not to be asked, for there is no answer. Shwe Nabe had the privilege of wearing golden decorations on her robe. This is the reason why she is literally called 'Golden Flanks'. She was born in Midon, a village on the right riverside of Irrawaddy, near Thayet Myo. She had married the petty king of Midon, Chief of the Seven Hill district. Till the British invasion, the kings of Burma maintained an official representative at Midon. Though the title was not hereditary the son or the widow of the last prince usually succeeded. So, Shwe Nabe received the Seven Hill throne. It is not clear exactly why she became a nat. Her death was by no means violent and she never did anything memorable to be credited with. Her one contribution of note was the fact that she gave birth to two children who served the king of Prome.

When Prome was invaded by the Burmese, the king and his suite crossed the river. They wandered for twelve years on the right bank of the river and stayed at Midon for three years. When the king later emigrated to the Pagan kingdom, he added Shwe Nabe to the list of antique Pyu divinities. The lady remains as the guard of Midon. She died of grief when her two children were executed by the king after their father had joined death.

According to the legend, the Shwe Nabe twins had been born from two eggs laid in the river by the Naga woman. They were called Shin Byu Taung or the 'White Lord of the South' and Shin Nyo Myauk, 'Brown Lord of the North'. They were tax collectors for King Duttabaung. Despite this normally despised profession, they became so popular that the king became alarmed. So, according to the ancient chronicles, he naturally had them executed. They were though fine warriors and put up a hard fight right to the end when they finally dropped from exhaustion.

They became nats and are still worshipped in the Prome area. They were called Lords of the Royal Cavern after the place where their effigies are sheltered. They are recognisable because they have six arms like the Hindu divinities that the Pyu knew well. Other nats, like Mahagiri himself, have also been represented with six arms. But they lost them when they became fully Burmese. The fact that the two brothers had kept theirs gives an argument to those who think the Pyu came from India and not from the North.

At dawn, as at midday and dusk, Thon Ban Hla or Three Times Beautiful was a country girl of marvellous beauty. Having heard this, King Duttabaung sent a noble to look for her in order to make of her his Queen of Prome. On the way, the messenger and the lady fell in love with each other. Once near the gates of the city a strategy came to them. 'Great King' said the noble appearing alone before the king, 'her face is very beautiful but her body is so huge that she could not manage to pass through the city gates'. Another version attributes to the ladies of the court the responsibility for this deception. Either way, the king soon forgot the beautiful maiden who lived outside the city walls and earned her living by weaving. She was not fully neglected though, and bore a girl with royal or princely blood. When she died, both she and her loom metamorphosed into a rock that can still be seen.

Her little daughter Shin Nemi was filled with sorrow at her death and

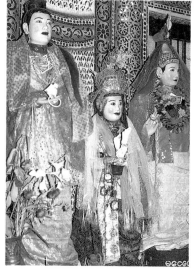

THON BAN HLA (CENTRE)
AT MT. POPA

took solace by playing the flute. She became the patron nat of little children and one of the most endearing nats. Of these there are not so many.

The seven nats of the Duttabaung cycle have a privileged place in the cult of the nats. They are worshipped both individually and collectively. Mahagiri is usually represented in court dress with a fan in his right hand. He may carry a sword and stand on a plinth borne by three ogres whilst riding either a standing or a recumbent elephant. His sister, Golden Face, is shown in court dress and carried by an ogre riding an elephant. She sometimes wears her hair in the style of the nagas. Shwe Nabe or Golden Flanks also wears court costume and can be recognised by her naga hairstyle and the lotus upon which she lies recumbent. Her two children wear ceremonial dress and hold various weapons in their six arms. The stand on a pedestal formed by a lovely lotus. Three Times Beautiful is likewise represented in the court costume and sometimes with a naga hairstyle. She rides Ganesa. Finally, her daughter is corpulent, with dangling arms, and enthroned upon a lotus. Her hair is also fashioned into the shape of a naga.

Anawrahta Cycle

After his accession to the throne in 1044, Anawrahta suspected that the Popa region was a place of plots and rebellion against him. After the defeat of Thaton, he appointed a man 'with daring initiatives' to represent him at Popa. This was Byat Ta whose career had not been without romance.

One morning, a strange object floated on the sea. It was noticed by an old monk who lived on high ground near the city of Thaton. He came down and discovered a raft with two children tied to it. There were no other signs of life on the deserted ocean. The monk thought their ship had been wrecked and that their parents had tied them to the raft to save them from drowning. He examined them and found they were of Indian race. He took them to the monastery, named them Byat Wi and Byat Ta and brought them up as his disciples. The years went by. The boys became adults.

One day the monk found the body of a dead alchemist. He had died at the result of his experiments. He asked his pupils to carry the corpse to the monastery and roast him. Once roasted, the monk told them :

'You see, my pupils, the roasted flesh of an alchemist is only worthy of the great king of Thaton. If he eats it he will become a strong man of power and will protect our country from its enemies. I have to go now to the city to invite the king to dinner. Be good and vigilant during my absence.'

The young people waited till night. In the darkness, the body of the alchemist shone and released such a sweet smell that the two boys could hardly wait to taste the strange meat. They were starving but they did not know anything about the alchemy and the magical qualities of his flesh. Nevertheless, they waited till midnight. Then the eldest said to the youngest :

'Let's just taste a bit each!' They cut a little bit off the roasted body and ate it. The meat tasted so good that they continued eating greedily till

there was nothing left. The youngest moaned :

'Our master will beat us to the bones for having disobeyed.' But the eldest, less perturbed, answered :

'Brother, do not worry about the future. Let's enjoy ourselves'.

Then, feeling happy and full of joy, he lifted the whole monastery, pulled it out of its foundations and turned it upside down.

'Is that the only thing you can do?' Asked the younger sarcastically.

So he lifted a huge rock and deposited it in the middle of the path along which the old monk had walked away. They spent the rest of the night fighting and running about till the break of the day. When the sun rose they saw their master and the king struggling up the slope towards the now destroyed monastery. They lost their courage and raced down the other side of the hill and hid in a ditch. When the monk found the monastery upside down he realised that the worst had happened.

'Alas, my lord', he exclaimed. 'It is a pity that the affairs of the state did not let you leave the city before the morning. I fear my boys have already eaten the alchemist. Unless we capture them quickly they will revolt against us.'

Having reached the top of the mount, the king and the monk searched everywhere without success. Hastily they returned to the city. The king sent his soldiers to look for the two boys, but Byat Wi and Byat Ta had become so strong and quick the soldiers could not catch them.

The two brothers wandered from village to village, pillaging and robbing. Some months after a night of a full moon, Byat Wi, the more excitable of the two, said :

'Brother, let's get into the Golden City and play a good trick on the king and his guards'.

Despite the protests of the younger, the eldest scrambled over the city walls. The other had no choice but to follow him. They went round the city looting and thieving all night. Having had quite a good time, the brothers went back and entered the city again on the following night. Said the elder:

'I am going to kidnap the governor of the city himself; he is the chief of the army'.

He went towards the governor's house and jumped onto the window-sill of a room. However, he found it was not the governor's room. Rather it was Miss Oza's, the governor's only daughter's room. Miss Oza woke with a jump. The two brothers stared at each other dumbstruck .

'My beautiful lady,' sighed Byat Wi, 'I am the eldest of us. We are the outlaws the governor has been trying to capture. You may set off the alarm and I will happily surrender. Then I can contemplate you a little bit longer.'

'Dauntless outlaw', said Miss Oza, 'How can I betray you; you who admires me so much? I am the daughter of the governor, but I am not going to set off the alarm'.

They spent the night conversing tenderly. At dawn, Miss Oza managed to make him leave. The next night, the following, and then at regular intervals the lovers would like this meet secretly .

Eventually, the servants of the house found out about their affair and they told the governor, their master. Realizing the magic powers of the outlaw, the governor consulted a master magician about the ways of

capturing Byat Wi.

'Take the skirt of a woman who had died in labour,' answered the magician, 'and hang it up on the outside above the window through which the outlaw usually enters the room'.

That night the governor hung up the skirt of a woman who had died in labour and waited with the soldiers hidden in the bushes. Yet, the outlaw did not come because his brother had implored him not to do anything. The governor continued his guard. The third night he was rewarded. He saw the outlaw going through the window. Surrounding the house with his soldiers, he burst into his daughter's room. The outlaw saw him coming. Calm and smiling he jumped out of the window. But, sadly for him, he had lost his magical power and fell to the ground all his strength gone. He was defeated. A victim of female clothing. Indeed, to this day all Burmese men still take great pains to avoid walking beneath women's clothes hanging on a washing line.

Dragged before the king, he was sentenced to death. His body, though powerless, remained invulnerable. The executioners' clubs, swords, lances and arrows simply shattered upon impact with his body.

The king, furious, decided to have him crushed by ordering the royal elephants to stomp on him. But, their legs broke and our young outlaw stayed alive. After three days of such torture, Byat Wi became much fed up with life. He said to the king:

'My Lord, as you would like me dead so much, I will oblige; but, send your executioners away and ask my lover to give me betel and a glass of water'.

He was granted what he had asked for. Miss Oza came crying, carrying the betel in one hand and the glass of water in the other. he took his time to chew the betel and drink the glass of water, then he looked at her and died with a smile on his lips. In accordance with the instructions of the magician, the body was cut in pieces. Some was buried together with his guts under the hall of the throne inside the palace. The walls of the city were splashed with his blood. However, there was not enough blood to cover the entire circumference and a space the size of a sitting hen escaped the dousing.

Some days later, Anawrahta's army came close and proceeded to attack the city. Even its commandant, the great Kyansittha could not manage to set his ladder against the wall coated with the blood of the invulnerable Byat Wi. Then, his brother Byat Ta, wandering outside the walls, was spotted by the Burmese laid seige to the walls. Kyansittha convinced him to come into service with him. That night Byat Ta jumped on his own right over the wall. Then, suddenly a fearsome adversary threw himself upon him. He recognized the ghost of his brother :

'Let me in my poor brother, implored Byat Ta, let me take revenge on your killers.' The ghost replied :

'I am afraid my brother, my blood is all over the walls and my guts are buried under the hall of the throne. Here I am sentenced to serve this tyrant for ever and to bar the way of his enemies.'

'How can I help you?' asked the youngest, 'there has to be a way to liberate your soul from the earth for ever.'

The ghost kept silent for a while and then he said :

'Brother, there is a corner on the wall that was not daubed with my blood. I will show you where. If you can jump the wall at this precise spot I will not be obliged to prevent you from so doing. After this, use your brains and let the Burmese have their victory'.

Byat Ta reported this to the Burmese commander. The following night, he led Kyansittha and an elite band of men to the unprotected section of wall and they entered the city. They battled to the hall of the throne and exhumed Byat Wi's guts. Suddenly the ghost disappeared from the walls and the whole Burmese army was able to advance. After the battle, Kyansittha and Byat Ta threw the guts in the sea.

Anawrahta appreciated Byat Ta's services and, according to the chronicles, he liked his frank and simple manners. But he also distrusted a 'man of strength and power'. Without doubt this was the reason why Byat Ta was not named a chief of the army. Of course Kyansittha and the other chiefs were also 'men of strength and power' but Byat Ta's power lay in his mind. The other three chiefs claimed only to possess superhuman powers, not supernatural powers. Byat Ta was therefore appointed to reside at Mount Popa and given the job of each morning bringing fresh flowers for the daily Royal Audience. He could move at a magic speed, never needing a mount, and easily ran the sixty miles.

The offering of flowers as a symbol of submission is a very ancient Burmese custom. There are competitions where in each race, a bunch of flowers is deposited at the destination. The first one to seize it, whether he be a rower, rider or runner, would win. In a boxing or a wrestling match the trainer may throw a bunch of flowers as a sign of resignation, like in Europe where they throw a sponge into the ring. To this day, a child that cannot solve an adversary's trick-question will say :

'I offer you some flowers,' and the other has to give him the solution. Also at court, it was part of the ceremonial and ritual for both ministers and courtesans to offer flowers to Anawrahta at each morning's audience. Byat Ta's daily duty of providing these was two-fold: for not only had he to provide the ministers and courtesans with flowers but it was at the same time a test of his and the Popa Region's allegiance to the monarch.

One morning while picking up the flowers he came across the woman ogre who was an eater of flowers. It was love at first sight. They decided straightaway to get married. But this romantic encounter made Byat Ta late for the morning audience. The king reproached him. A year later, one morning Byat Ta's ogre wife had a baby and he was late again. Once more he was reprimanded. The following year a second child was born and he was again late. This time the king ordered him to be executed. Knowing Byat Ta's invulnerability, Anawrahta gave his own magical lance to the executioners. They waited by the Pagan road and killed him. Anawrahta refused to take advantage of the dead body's magical powers and had him cremated. His ogre wife died of a broken heart. Anawrahta felt compassion and took care of the two young sons. They became heroes later but were executed by order of Anawrahta with his special lance, presented to him by a god. With these two heroes dead, the cult of alchemy and magic suffered a set-back in the kingdom.

Neither Byat Ta nor Byat Wi became nats but the female ogre, the wife of Byat Ta is one of the most popular nats in Burma. She is called Popa Medaw, the Lady of Popa. However Popa Medaw has never been a member

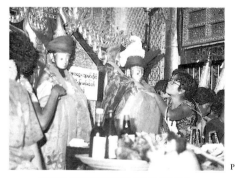

THE TAUNGBYON BROTHERS,
TAUNGBYON

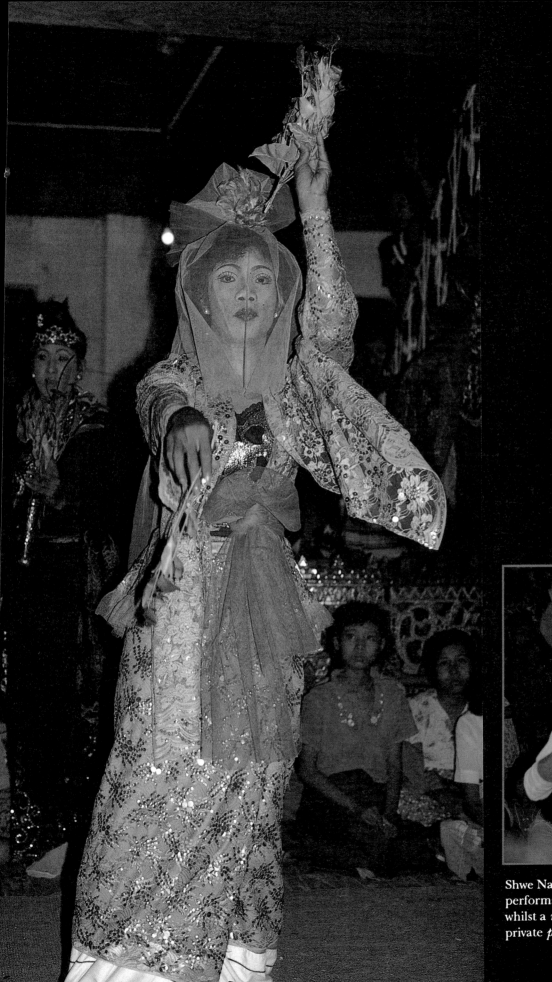

P

Shwe Nabe, the serpent woman performs in the shrine at Mt.Popa whilst a *nat-kadaw* offers homage at a private *pwe* near Mandalay.

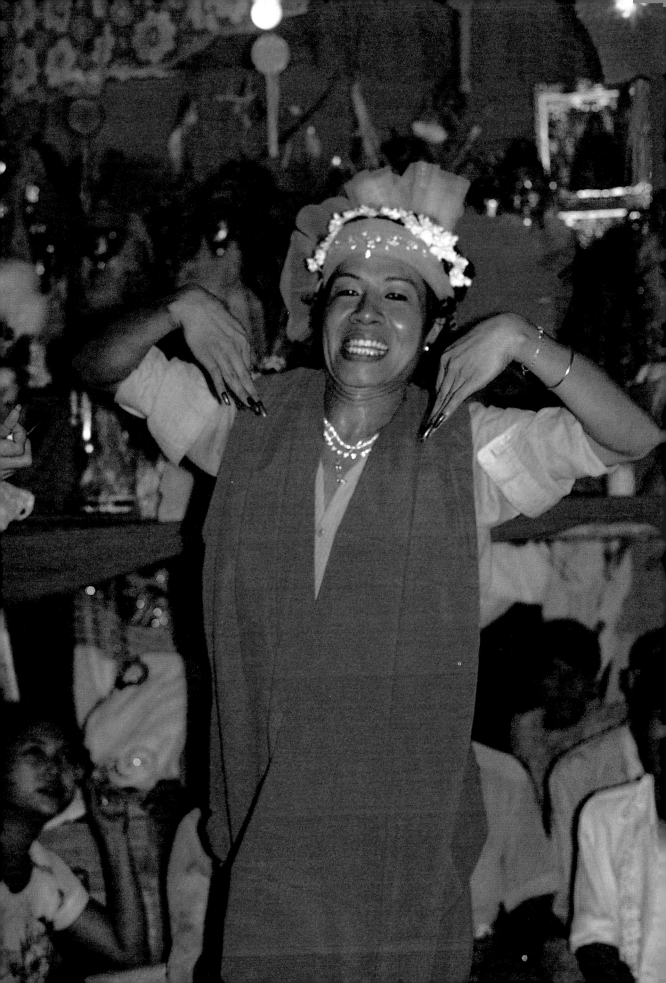

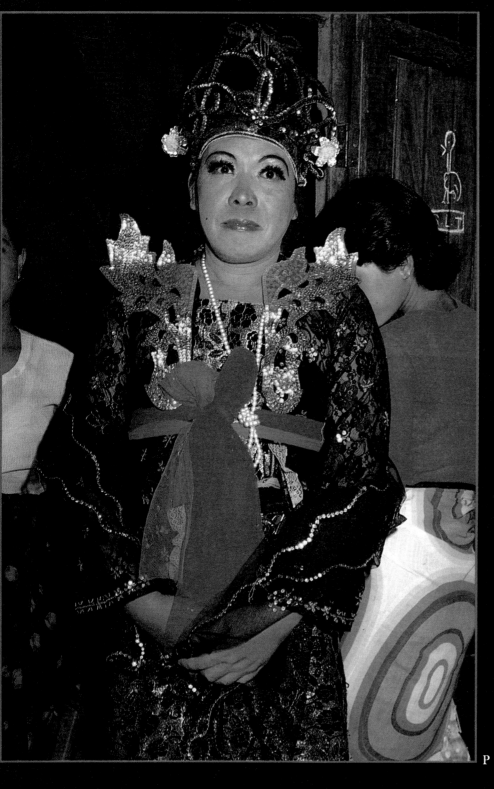

P

On the left a professional *nat-kadaw* performs a ritual dance to one of the
Thirty-Seven in Rangoon. Above and right another professional performs the dance
of Popa Medaw, at a *pwe* held near the Mahamuni Pagoda in Mandalay. On the next
pages: the rush to present offerings to the Brothers
at the Taungbyon *pwe* in August 1986.

Above a *nat-kadaw* performs the dance of a minor nat between the main rituals whilst others worship, dance or pray. A new image is consecrated, fire is eaten and beneath the donors take a break. Opposite U Min Kyaw, the drunken nat, dispenses his favourite Mandalay Rum to eager devotees.

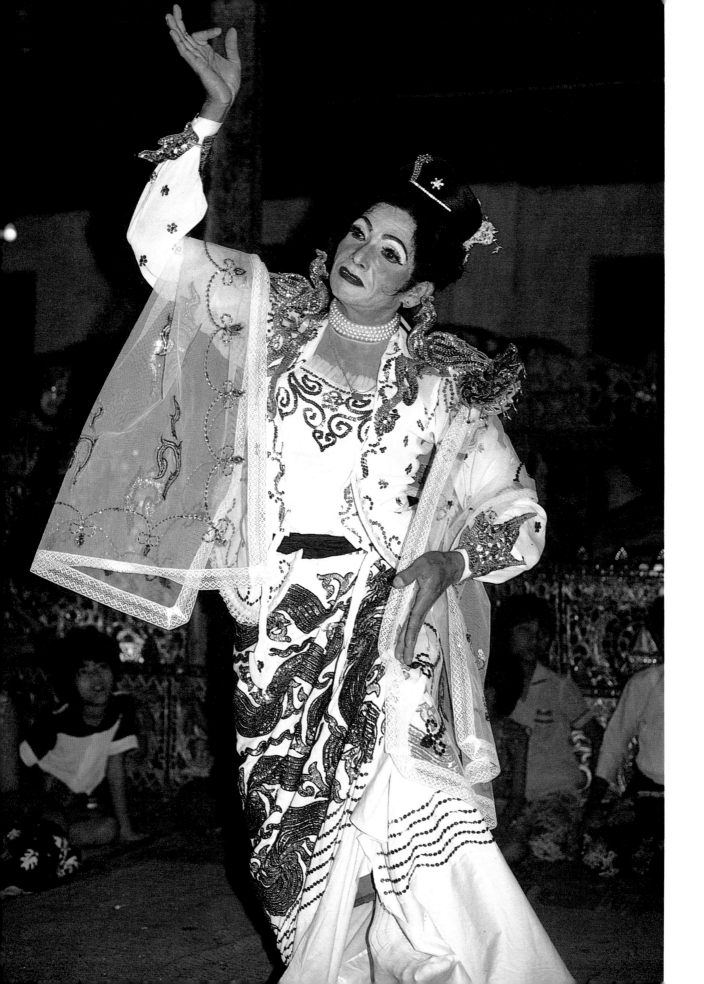

of the pantheon of the thirty-seven nats. Why this is so is obscure. She has however the best position in the famous temple at Popa where the effigies of the thirty-seven nats are housed. She sits enthroned between her two sons, the Brothers of Taungbyon. She is as popular as Mahagiri and stars at all the most important nat festivals.

Now, Anawrahta who had taken the two brothers into the court wanted to do them a favour because he was a little guilty about their father. The custom was to hand out to the various court dignitaries nuggets of gold. As the brothers were not nobles, they received an impure metal. This is why they are known as the 'Impure Gold Brothers' or *Shwe-byin.*

At the age of fifteen they entered the army and soon showed that when it came to bravery they took after their father. Later, they showed they had inherited other features from their father, the turbulent Byat Ta. By then they were counted amongst the four most glorious generals, alongside Kyansittha himself. At that time the king, who was a devout Buddhist, went on a crusade to China. He was determined to find the Buddha's tooth, an invaluable relic, and bring it back with him. The Chinese emperor treated him with scorn, not even deigning to receive him. So the two brothers, who had the supernatural powers of their father, became invisible and entered the palace while the emperor was asleep. With a piece of lime they drew three strokes over his body and some signs on the walls telling him to receive their master, Anawrahta. The trick worked and the two monarchs met each other and became good friends. But then all of a sudden the sacred tooth disappeared. The army returned to Burma, heads hung low. The two brothers reputation began to worry the king and Kyansittha his first general. Kyansittha waited for the right moment to destroy his rivals - as he had done with their father. Both father and sons were doomed through their love for women, whether the flower eating ogress or the local maidens.

Between Mandalay and Taungbyon, there is a hill which is still called after a woman who was wooed by the youngest brother. Mai U was the wife of a forest warden. One day during his absence, she was working at her loom and did not notice the approaches of our young hero. She rebutted his advances. Much later, having become a nat, the youngest appeared to Mai U riding upon a tiger. With the wickedness characteristic of a nat, he made the tiger kidnap her since she had refused to be his mistress when he was alive, shewould now become the wife of a nat. The tiger dragged Mai U off. The nat, invisible to the people from the village, followed behind. The wife, virtuous to the end, died in the struggle.

Mai U's path, south of Taungbyon, is lined by altars recalling her suffering: the place where she lost her blouse or the point where her flower decorations fell to the ground. This last altar is surrounded by trees that each April sprout *tharapi* flowers (*Calophyllum*). Nobody dares pick them until the season where they are brought to the Mai U hill in homage to her fidelity. Her statue and the statue of her husband, are worshipped at the end of August. The Mai U legend still inspires Burmese literature, theatre and cinema. The tiger dance, executed on the third day of a *pwe* recalls the horrible destiny of Mai U who herself became a nat, though not one of the thirty-seven.

Anawrahta undertook to build a pagoda at Taungbyon to be called the 'Pagoda of the Wishes'. Everyone was invited to make a donation and to

ANAWRAHTA'S BUDDHA IMAGE AT
TAUNGBYON

THE TAUNGBYON
BROTHERS PERFORMED BY *NAT-
KADAW* AT THEIR MAIN FESTIVAL AT
TAUNGBYON, 1986

deposit a stone. The two brothers were busy with their various chivalric adventures, so Kyansittha offered to place the stones for them and went there on their behalf. The brothers accepted his offer without for a moment guessing that they were falling into a trap. Once there the general purposely forgot to include the two stones for them.

When the king came to Taungbyon for the opening of the 'Pagoda of the Wishes', he immediately noticed the stones that were missing. He found out who was responsible for this omission and had the two brothers castrated. They died from this. To make good the bad, he arrange for their tutor to be executed, a brahman who possessed magical powers. The brahmin tried to escape. He put a magical thread around a marble statue of an elephant to make it become alive and mounted it. However, the elephant remained of marble and was caught. The brahmin followed his two pupils to the abode of the nats and became known as the Mandalay Bodaw. He is represented in the dress of a minister showing the end of his index finger touching his thumb the moral being 'the brothers' mistake was not bigger than the length finger'. The brahmin had two sisters, that were also executed following the Burmese tradition of a whole family following the fate of one of its members. Neither of them, though, was beautiful. Shin Gwa, was bandy legged. The other, Shin Gon, was hunch-backed. The first is shown in court dress, with open arms and twisted knees. The second is no longer included in the Anawrahta Cycle. She was replaced by another hunchback from the Ava period.

Once nats, the two Brothers of Shwebyin otherwise known as the Brothers of Taungbyon and the other victims gave every possible trouble to their executioner. Anawrahta could not afford remorse; his throne was not hereditary and rival candidates were countless. He had, though, enough political clout to sense the disapproval of the population against so unfair a punishment. He decided to grant a privilege to the Shwebyin brothers. For a nat must be a warden of a particular territory and this was to be Taungbyon, north of Mandalay. There stands the 'Pagoda of Wishes' where the missing stones can still be seen. The nats' temple is opposite one of the pagoda's entrances.

Anawrahta eventually died gored by a buffalo. This had the appearance of the brothers taking revenge. This violent death has, though, not made Anawrahta a nat. He had after all spent his life in opposition to the cult. However if we look at Anawrahta's genealogy many of his forebears became nats.

Forty kings preceded Anawrahta at Pagan. One of them died from picking a cucumber. The furious gardener sent him from this world with a pick-axe. The king's suite said to this farmer: 'The one who kills a king becomes a king himself'. The farmer was too fond of his cucumbers to exchange them for a throne. He would only accept on condition that he would be able to continue with his gardening. He built a statue of a naga, whose cult was then encouraged by the Ari priests. These priests were said to follow the Mahayana form of Buddhism. They wore beards, had long hair, and dressed in an indigo colour; they also practiced the martial arts and drank lots of palm wine. Their monastery was in Thamahti, some kilometres south-east of Pagan. Esoteric, they secretly interpreted to suit themselves the Buddhist texts and possessed magical formulas that would

allow them to escape the effects of their bad *karma*. They intimidated the population, specially taking 'the flower of the virginity' of each maiden on the eve of her wedding. The Bu-hpaya, which is a pagoda with a cucumber shape near to the riverside, evokes this strange epoch.

The 'Cucumber King' was deposed by a legitimate pretender, Kyaungpyu. This one had three sons, Kyi Soe and Sokkate from a first queen, and Anawrahta from a younger one. The two eldest got rid of the king by taking him to a monastery and forcing him to put on the robe. Anawrahta spent his childhood with his parents. Kyi Soe, however, did not reign for long. At the age of twenty-eight, he was killed by an arrow whilst out hunting deer near Monywa. His brother succeeded him and reinstated the cult of the naga. He also took his mother-in-law (the mother of Anawrahta) as a queen. As soon he was grown up, Anawhrata raised an army at Mount Popa and killed his half-brother and his father-in-law in a remarkable battle near Myinkaba, a village a little to the south of Pagan. Of these characters, three of them appear amongst the thirty-seven nats.

Kyaungpyu, father of Anawrahta became Htibyu Saung Nat. He is represented, sometimes as an old man, sometimes as a young man, on a throne wearing a monk's robe and wearing the peaked bonnet of a hermit. The hat (*dauk-cha*), which contains an image of the Buddha, is nowadays exclusive to the *yathe*. These hermits are harmless, often uneducated, hermits and despised by orthodox Buddhists. It would be wrong to describe the *yathe* as descendants of the Ari, who were the Burmese equivalent of the rishi of India. But, in fact, they are a little known off-shoot of Burmese Buddhism; nowadays they no longer live in the forests, but in the precincts of popular Buddhist shrines. They practice alchemy in their search for supernatural power.

The nat, Htibyu Saung Medaw, who was Kyi Soe's and Sokkate's mother, in iconography has the right to a lotus throne and to royal regalia. Her left arm leans on her knee, with the bend of the arm projecting out. This is something the Burmese are very proud of. Kyiso became Bayin Mashin Nat. He wears court dress and is also seated on a lotus throne. To distinguish him from the other nats a bow may be added recalling his death whilst out hunting.

Maung Mintha Shin was a prince from Pagan who killed himself falling from a swing. He appears in a court dress seated on a lotus playing the harp.

When Anawrahta and Kyansittha took Thaton, they took prisoner a Mon prince from the family of King Manuha. He died from leprosy and became a nat. He appears in ceremonial dress, leaning on a stick, his limbs deformed by tubercular leprosy. His name is Nyaung Gyin. He is also called the 'Old Banyan Solitary Father', for his cult is associated with the cult of the Banyan tree. During the hot months the tree is doused with water in a ritual more ancient, it seems, than Buddhism itself. Nyaung Gyin has replaced a nature spirit as the guardian of the sacred tree.

Such are the nine nats of the Anawrahta cycle. The Pagan dynasty gave other kings and princes to the pantheon of the nats. These, though, were after the reign of the great king and merge with the following cycle whose nats belong to another dynasty.

Avatars of the the Queen of the North and the Nats from Ava and Toungoo

The eleven nats from the this cycle get mixed up in a confusion of legends that proves difficult to disentangle. The confusion comes from the fact that the heroine of this cycle, the Queen of the North, has been given three different husbands over a time span of several centuries. According to Burmese court traditions, precedence when it came to the succession was given to the Queen of the South. If the Queen of the North, were to put one of her sons on the throne he would be a 'pretender'. Such ambitions would result in intrigue that often ended badly and the Queens of the North dying from sorrow one after the other.

In 8th century Pagan, two sons of the Queen of the North, Sithu and Kyawswa, hatched a plot to remove the main candidate to the throne, the son of the Queen of the South. The king, annoyed by their constant intriguing, sent the two brothers to Toungoo to fight against the Karens. This they did, gallantly. They went on to found irrigation schemes for the benefit of the people. But then quarrelled about the share out of the water and Sithu killed his younger brother who became a nat. Using his supernatural powers Kyawswa took revenge on his brother who joined him in the abode of the nats. The legend does not say if there they continued their arguments. They were soon forgotten or mixed with other later characters with the same names. Sithu was outshone by the King Alaungsithu, grandson of Anawrahta. This king was murdered by his son Narathu who had arranged for him to be moved, ill as he was, to a temple where he smothered him with his own hands. His elder brother, Min Shin Saw, at that time exiled from Pagan, took up arms against the usurper and perpetrator of parricide. Narathu pretended to concede, gave the throne to his brother, and then promptly poisoned him on the same night of his coronation. That was in 1160. Narathu himself was not assassinated until much later by men in the pay of a minor king from neighbouring Manipur in India. The Manipur king had given his daughter to Alaungsithu as a concubine and she had become his favourite. Narathu then took her as a queen, but did not get on well with her; so he killed her. He too paid for his crime but did not become one of the nats. He became known by the name of Kalakya Min, the 'king killed by foreigners.'

From these tragedies, two nats have emerged: Alaungsithu, alias Min Sithu, who appears preaching, seated on a lotus throne and wearing court dress. The youthful appearance of this nat makes him more like the stormy 8th century Sithu than the old king Alaungsithu. The second nat is a more remote figure: a son of Minshinsaw who fell from a swing and died during his novitiate. He is called Min Tha Maung Shin and appears in the previous cycle as he does in this one.

The Queen of the West, also became a nat. She died of shock when she saw her son Kyawsa appear as a nat and cantering on a brown horse in a cotton field near Ava. Certain legends make her also a queen of Alaungsithu.

Kyawswa is mixed, like his mother, with three other historical characters. The first one is mentioned by the *Mahagita Medanikyan* with the following terms: 'Long ago the King of Pagan (Alaungsithu) had four ministers who were brothers. To the youngest, Kyawswa, he gave in marriage Ma Bome, who sold alcohol at Mount Popa. They were happy for some time, but Kyawswa became an alcoholic and when occasionally sober he used to

spend his time at cock fights and playing with fireworks. At his death he became a nat at Pakhan (near Pakkoku). This nat from Pakhan is, under the name of U Min Kyaw, one of the stars of a *nat-pwe*. A drinker, womaniser, and lover of the carousal, he makes his followers fierce with generous glassfuls of rum and incites them to perform the dance of the fighting cocks. He appears on a brown horse with a sword on his left shoulder. He is often accompanied by a side kick, Bo Nyo, who crouches a lot, is generously tattooed and carries an enormous mallet.

Another Kyawswa was the son of the last Pagan king, at the end of the 13th century, and was made the governor of a Delta town. He had two brothers who likewise ruled Bassein and Prome. When Pagan fell to the Tartars in 1287, the king tried to find shelter with his son at Prome. However, he encircled him with his fleet and forced him to drink poison. Having disposed of his father the Governor of Prome went to Bassein where he effortlessly killed his brother, who was ill. Unluckily he himself was killed when his crossbow backfired just as he was about to kill his one remaining brother, Kyawswa, who was then seated on a throne he had never asked for. But he had to abandon it in 1298 to the Shan lords of Kyaukse who became the founders of the Pinya and Ava dynasties. A great Shan migration, which had already filtered into Assam and Tenasserim, began to spread into the Menam and Irrawaddy river valleys. The Three Shan Brothers, who were princes, made skilful use of the confrontation between their allies the Mongol-Chinese and the Pagan-Burmese. One of them had married his daughter to a brother of Kyawswa's and thereby managed to be elevated to the position of Governor of Kyaukse and of the fortified town of Myin-saing, which is just a few kilometres east of Kyaukse. The Pagan dynasty, never recovered from the Tartar raid and the three Shan princes eventually deposed Kyawswa. The youngest, Thi Hathu Tazishin married his widow whose son was assigned as heir. The new capital was built first at Pinya, then at Ava, the former was said to be inauspicious according to the astrologers. The two cities, situated close to each other, received the rice of Kyaukse through the river Myit-Nge. The Burmese heir reigned for short time. He was deposed by his last younger brother, half-Burmese, half-Shan, Ngazishin Kyawswa. This king was succeeded to the throne of Ava by another Kyawswa, who was by no means the last king to bear this name. Here the story becomes so complicated it is enough to put off the historians.

The followers of the cult of nats simplify matters by seeing in all these different Kyawswa characters and all these various Queens the same misadventures of one single nat. It is for the nat kadaws to disentangle the webs.

Ngazishin Kyawswa, the Lord of the Five Elephants is, though, the first nat to date from after the Pagan dynasty. He reigned from 1343 to 1350 and died from fever. His statue can be easily identified by its mount, an elephant with five heads. The legend recalls how he brought his father a present of five white elephants. In ancient representations he was accorded all the royal regalia and requisites: the costume, umbrellas, vases of offerings, spittoons and betel boxes. He thus appeared as the descendant of all ancient royal dynasties. Perhaps propaganda for the Shan dynasty born only half a century before.

NAT IMAGES FROM THE SHWE-ZIGON, PAGAN

MYIN BYU SHIN, 'LORD OF THE WHITE
HORSE' WITH A KAREN NAT

The second nat of the Ava dynasty is Tarabya who did not reign a year. While he was out hunting in the forest he met an alchemist and an ogress - a confrontation which turned him mad. One of his servants put him out of his misery and killed him. He is called Mintaya Nat, the Lord of Justice. He appears on a lotus throne, holding a fan in his hand and wearing Siamese-style court dress, that it is to say with wing-like shoulder pads.

His successor was Mingaung whose Queen of the North gave birth to another Kyawswa, a great hero of the Burmese history. Minye Kyawswa joined the army at thirteen years old and became commander-in-chief at the age of eighteen. He fought a campaign against the Arakanese, the Shans and even more against the redoubtable Prince of Pegu, Razadirit. Even though having up till then been victorious in the Delta, Kyawswa fell into an ambush set-up by his mortal enemy, Razadirit. Mounted on an elephant, he was injured but continued challenging Razaradit till his last breath was drawn and thus he entered the pantheon of the thirty-seven with some panache. He is often confused with U Min Kyaw. For he shared his taste for alcohol.

There was, near Ava, a lake created by a dam which was used for irrigation. It was called Aungpinle, 'the Sea of Victory' and its guardian was a nature spirit borrowed from Hinduism. Though this deity had been worshipped from the most ancient of times, an Ava king passed on to him his own identity when he died. He was killed in 1426 at one of his disfavoured queens instigation. Whilst inspecting the Aungpinle works riding an elephant, one of his Shan vassals fired a fatal shot at him. The king was given the name of Aungpinle Hsin Byu Shin, the 'Lord of the White Elephant.' He is represented standing or seated on an elephant, which is sometimes three-headed with a mahout and a servant who is an ogre (*balu*) following behind. One of his concubines died of sorrow and joined him in the tempestuous dwelling place of the nats. She did not, though, have the beauty to make the queen jealous. 'The Lady with the Broken Back', Shin Gon, has taken the place of one of the sisters of the Taungbyon brothers' tutor, for each has the same disability. She appears leaning forward with the arms dangling.

Shwe Nawrahta was an Ava prince. He was thrown into the river for plotting against the king. He is portrayed on the classical lotus throne, a polo mallet in his hand. Polo, made popular by the British, originally came from Manipur.

Myin Byu Shin, the 'Lord of the White Horse', is as popular as U Min Kyaw. However, while U Min Kyaw is associated with crooks and wildness, Myin Byu Shin is the protector of the villages where his often riderless, puppet-like horses hang everywhere. He is also associated with the Burmese armies and takes on the dimension of a patriotic nat. He is linked to several legends where the courage of a poor soldier shines out.

One of them tells of Captain Aung Swa of the First Army, which in the 12th century was commanded by the prince brother of the Pagan king. This king fell in love with the wife of the prince and he sent him to the war so he could take her. The mistrusting prince arranged for an official, Nga Aung Pyi, to keep an eye on the situation. When the king was about to make the princess his fourth queen, Nga Aung Pyi mounted his horse and raced to alert the prince. Having reached the riverside opposite the camp, he

waited for the sun to rise before crossing the river. However the prince was angry at the official for being late and had him executed. Later, smitten with remorse, he had him placed in the the pantheon of the thirty-seven nats in place of a more ancient nat.

The prince asked Captain Aung Swa to march on Pagan and to kill his brother, the king, promising him one of his queens as a reward. The mission accomplished, the queen refused to marry a mere captain. Aung Swa was upset about this, and his disappointment further displeased the future king who therefore had him executed. He too was later added to the list of the thirty-seven nats as Aungzwamagyi Nat.

In another legend Min Byu Shin is as Kyawswa's grandson (the one who had been deposed in Pagan by the three Shan brothers). At that time Pagan was no longer a capital but rather the seat of a simple provincial governor. As he was a direct descendant of Anawrahta, and Kyawswa's grandson, though the youngest member of the royal family he still received certain royal prerogatives. He was given the responsibility of suppressing the insurrection of a rebel prince, but instead spent his time entertaining himself. He preferred cock fights to the more manly battles. As a punishment he was buried to the top of his legs and left there to die. He became a nat - Shwe Sit Thin. His mother, hearing about his death, died of grief and became Medaw Shwesaga Nat. She appears in court dress with or without the naga hairstyle, kneeling on a lotus throne, her elbow extended as was the fashion in those days. Shwe Sit Thin sits on a lotus throne in court dress carrying his sword like a candle.

It is only much later that this nat appears mounted on a white horse. It is difficult to say if he is a modified version of Captain Aung Swa, of Nga Aung Pyi or of the young royal prince, or even a mixture of the three - a symbol of magnanimity and servitude for men of arms. Nowadays, he is still known as the 'Son of Shwesaga Nat'. He still has the place of honour everywhere. A festival is dedicated to him in Myet Thu, a village south of Mandalay on the Myit Nge river, near the village Ye Gyi Pauk where his unfortunate mother was born.

Some *natskadaw* make the difference between four separate Myin Byu Shin connected with four different localities: Shwebo, Yet Ma, Zee Daw and Chauktalon (near Toungoo).

Between the Pegu kingdom and the Ava one, the city-states of Prome and Toungoo acted as buffers. Prome, the ancient capital of the Pyu, had an ancient past that could be rivalled only by Toungoo. At the moment of Pagan's decline, the Burmese built a small fort there to protect themselves from the slave hunting Karenni. The village grew without caring too much about finding a suzerain protector. It became important when the Shans occupied central Burma and the people looked for refuge in the south. It became a place of refuge for many noblemen escaping from the Shans, Toungoo was thus the crucible of a revival of Burmese fortunes. Among the twenty-eight chiefs that went there some fifteen perished by assassination, a direct route to becoming a nat.

In 1531, Tabinshwehti succeeded his father after forty-five years on the throne. The Shan invasion was waning and at the same time the Mon Pegu kingdom had declined. Tabinshwehti, conquest by conquest, reunited Burma. He took Pegu without meeting any opposition (the Mon king had

died during an elephant hunt and became a nat popularly worshipped by fishermen under the name of Poyutpi). He took Prome and then Upper Burma pressing his armies into Arakan and knocking at the doors of Ayutthia, the capital of Siam. He owed his power partly to the superior firepower of his Portuguese mercenaries. But, it was the Portuguese who eventually ruined him by plying him with alcohol. He was the victim of a plot of his Mon chamberlain. Drawn into the forest because the Mon pretended that there was a white elephant hiding there, the king decollated at the age of thirty-four. The great conqueror, who had been ruined by alcohol, became Tabinshwehti nat. He is enthroned upon a lotus, in the royal dress of the Siamese fashion, a sword upon his shoulder.

The king had a tutor (with the title 'Warden of the Golden Parasol') whose wife appears in the annals under the name of 'Lady of the North'. Pregnant, she wanted to give birth in his mother's house at Sagaing. The event happened on the road before getting there. She died while giving birth and became a nat - Myaukpet Shinma. She is represented seated in court dress, one hand upon her breast, the other leaning on her knee with the aristocratic jut of her elbow. After Tabinshwehti had transferred his capital to Pegu, her son became Governor of Toungoo with royal prerogatives. Caught one day with dysentery, the governor went on a trip to find a cure for his illness. Unfortunately he had to cross a field of onions where the smell made him feel so ill-at-ease that he died. He became the nat Toungoo Mingaung, in costume of a minister with a fan in his hand.

He had a secretary who died just as strangely. He decided to go and pick some rare flowers in the forest. There he was struck down by malaria, though some say he was bitten by a serpent. He is the nat Thandawgan and carries a fan.

The glory of King Bayinnaung (1551-1581) outshone that of his brother, Tabinshwehti. He took Ava and recaptured Upper Burma once again for the Burmese. He annexed for the first time for Burma the Shan States, and invaded Manipur, Vieng Chang and Chiang Mai. Having won many battles always leading the charge mounted on his elephant, he knew that if he were to capture the seven white elephants of the King of Siam he would possess all the riches of that land. This done, Pegu, enriched by booty, prisoners and the treasures of Ayutthaya possessed an extraordinary splendour. A great builder of pagodas, a reformer of the religion, an intrepid soldier and the father of some ninety-seven children, Bayinnaung was perhaps the most famous of all the Burmese kings and the most fervent defender of the Buddhist faith. There was neither, in his active life nor in his death at sixty-six years old, any misfortune that might have taken him to the abode of the nats. Like that other great reformer, Anawrahta, he had opposed the cult of the nats. Yet, during his reign there had been an unexpected addition to the pantheon: the King of Chiang Mai had been taken prisoner and brought to the capital. Despite special medications he died from dysentery. He is represented seated on his throne, brandishing a sword still in its sheath, an emblem of his frustrated condition as a prisoner of war. He is Yun Bayin Nat.

After Bayinnaung, Burma's unification was once more in jeopardy. When Pegu appointed the provincial governors, the local princes disobeyed their rule. The principality of Ava became independent once again. It had achieved a separation for Upper Burma from the south and in 1635

become a royal capital again. This Ava Period has given the pantheon three nats. These, though, do not seem to have played any apparent role in the history of Burma. They died young and without glory. One was the valiant Minye Aung Din, son of the King of Ava. He was addicted to opium and toddy palm wine and died from it. It is easy to recognize him as he plays the harp whilst seated on a throne. Maung Min Byu Nat, another prince of Ava, died of an opium overdose. He is represented playing a copper instrument. 'The Royal Novice' - Shin Daw Nat - also a son of the King of Ava, perished in a monastery not long after his ordination as a result of a snake bite. A similar destiny to that of the young 'Lord of the Swing.' The Royal Novice is represented in the dress of a monk telling his beads.

This is an almost complete list of the thirty-seven nats. But, Maung Po Tu, the tea trader who was eaten by a tiger on the Pinya road, must be added. He is described sometimes as the only villager who has become a nat. In art the poor merchant is perched on the back of the tiger who devoured him. He is linked with the Shan dynasty because he came from the village of Pinya, their one time capital. He might have lived during the Pagan dynasty as he is occasionally associated with the nats of that period. In ancient engravings he is represented wearing the costume of a prince. This may be the fancy of an artist or perhaps the unlucky merchant did have princely blood.

Between the blacksmith from Tagaung, whose sister became queen, and this unknown trader the thirty-seven nats, with Thagya-min at their head, make an extraordinary gallery of ancestors. The great kings of Burma do not appear with the exception of Tabinshwehti, king of Toungoo. The gallery starts with intrepid soldiers or drinkers, like the brothers of Prome and Taungbyon, who are the ruin of wives, mothers, sisters and servants. The gallery ends with usually decadent and alcoholic princes, opium addicts or victims of weird illnesses. There has been an attempt to eliminate such nats from the pantheon, under the pretext that a nat dating from after the Pagan epoch cannot be accepted as an official nat. But amongst these there are several who are mixed with more ancient nats. The number thirty-seven, originally assigned by Anawrahta, has not lost its magical significance through the centuries. The cycle whereby nats are created continued from the 17th century. Many later nats exist but have never appeared on the *Mahagita* list or at some point have been removed from the list.

The appeal and moving nature of the stories behind each of thirty-seven nats offer constant inspiration to the ordinary people of Burma who will often identify with these victims of the state's injustice. One may perceive in the myths which repeat themselves in various forms certain characteristics: the quarrelling brothers, the inseparable brother and sister, the mother who dies of grief at the tragic death of her son, the faithful tutor or minister, the dangers of young soldiers on the loose. The thirty-seven nats are, with the exception of two prince prisoners, of Burmese stock. The Mons and the Shans have their own set of nats, whilst the Chin, Kachin or Karen are originally animist worshipping nature spirits, borrowing from the Burmese from time to time the small statues of certain nats.

MAUNG PO TU AT MT. POPA

The Outside Nats

The process that elevates history into legend is constant in its creation of new nats. Anthony, a nat from the Delta region reflects the one time Portugese presence there. In the Shan country, English nats may be found: for example a young English soldier killed by the Japanese in 1942 is still honoured in the village were he was hidden; in another, a locally respected colonial District Commissioner is worshipped. The contrast between the thirty-seven declared by Anawrahta and fixed in the official cult and its expansion according to localised folklore is striking.

As has been demonstrated, the list of the official thirty-seven nats itself continues to evolve. There may be an amalgam between a nat from the original list and one or several other figures who appeared later and have similar attributes or background to him. For example, the case of the four musketeers personified in the character called U Min Kyaw is typical. There is also the case of the four versions of the Myin Byu Shin, the avatars of the Queen of the North and those of the Queen of the West. Sometimes an original nat is simply overshadowed by a new one who suddenly appears on the scene. In this way only the nats with grand titles, like King Tabinshwehti, or those with wide popular support, enter the pantheon. It should be noted, though, that the kings controlled the list; no one could be listed without a decree from the palace.

Many nats are omitted from the official pantheon. The nat guardians of channels and dams, the nat-protectors of villages, the nats of the ethnic groups, regional nats whose cult is sometimes more popular (like U Shin Gyi in the Delta) than the cult of a minor nat from the minor pantheon. These are the 'Outside Nats'. Some have acquired importance through the promotional work of a *nat-kadaw*, racketeers or through the migration of population.

It is customary to add Meizaing and Peizaing, the nat-protectors of mothers and fathers, and their cult has expanded well outside the region of its origin. In Burma, the daughter takes up her parents' nat-protector and the son, his wife's nat. The opposite is so amongst the Mons. There are hundreds of outside nats; some of them have become national figures.

The Lord of the Nine Towns - Ko Myo Shin

Ko Myo Shin has his main palace in Maymyo where the third of the eight official festivals are celebrated. The legend has numerous regional variations with many borrowings from other stories and is connected to the Pagan legends through the character of U Min Kyaw.

Ko Myo Shin was the heir to a small kingdom on the banks of the Irrawaddy. Its rulers were known as 'King of the Flowered Hill and Guardian of the Nine Doors'. When the king died, Ko Myo Shin succeeded him and went to fight against the Shans with U Min Kyaw, his brother in law, who was always ready to cross swords. From their expedition they brought back as prisoners the son and daughter of the Sawbwa of Maymio, whom they had decapitated, Kung Saw and Kung Tha. The princess was

entrusted to the care of Ko Myo's sister. But U Min Kyaw took it into his head to marry Ko Myo's sister, for she was beautiful and would give him access, he thought, to the throne. The sister took sanctuary in the home of a merchant who was devoted to her. Ko Myo returned, and discovering her missing, ran off to Maymyo to gather fresh supplies of troops. Years later, U Min Kyaw persuaded the Sawbwa's son and daughter who were now adults to go back to the place of their birth and kill the prince who had murdered their father. To help them he gave them two magic swords. However, once in the presence of the prince, who for years had been their adoptive father, they did not have the courage to decapitate him. Seeing their dilemma, Ko Myo took hold of the swords to chop his own head off with. Before he executed himself, his head rolled onto the ground on its own and he there upon became a nat. Kung Saw and Kung Tha gave the head to U Min Kyaw under a frangipani tree. But he had them executed and they became nats like Ko Myo Shin and they all met up again under the same tree. Ko Myo inquired about his sister the princess, whom he missed. She had married her protector, the rich merchant, denying the vows of celibacy she had exchanged with her brother. So he claimed her butterfly soul and she too became a nat and joined them all in the big frangipani tree.

Unlike the others she had become a nat in her own lifetime which gave her special curative powers. Meanwhile, U Min Kyaw wrongfully took the throne. Out of remorse and to protect himself from his victims' revenges, he gave Ko Myo Shin, who could have been the Guard of the Nine Doors, the guardianship of the Nine Towns in the Kyaukse region. He also became the patron of travellers. Out of respect for him nobody travels in groups of nine. And when this is the case, a wooden doll takes the place of the tenth traveller.

Ko Myo Shin took revenge on U Min Kyaw by chopping down a tree on his head. Once a nat, U Min Kyaw received the guardianship of Pakhan village.

Ko Myo is well known as the nat of the Shans, even though he was Burmese. Like a Shan he wears black and thus his followers have to refrain from wearing clothes of this colour. He can be met at nearly every *nat-pwe* brandishing both of the orphans' swords and practising acrobatic dances.

Kyaukse, an outpost of the Pagan empire, was much fought over with the Shans and Ko Myo Shin and his sister are closely associated with the Shan brother-sister. Ko Myo Shin and his sister were in charge of guarding the irrigation system, built by King Anawrahta. It was an enormous work that can still be seen and made Kyaukse become what is known as the rice bowl of Upper Burma. The one time capital, Ava, was on the periphery of the rice bowl and was supplied with paddy by the Myit-nge River. But Kyaukse in the centre, with its developed irrigation system, was more sought after and it is understandable why it was the site of many battles.

Ko Myo Shin's relationship with the irrigation works is reinforced by the fact that he and the nat protector of the great Sedawgyi dam to the north of Mandalay have the same blood. It was a tradition to make a human sacrifice at the foundation of any public works project. The ghost of the victim would be bound to guard the site for eternity. There were four such sacrifices around the Palace of Mandalay, one for each gate. The astrologer's

task was to orchestrate these sacrifices. At Sedawgyi, they caught a young woman farmer who fitted their description. Before she was thrown into the water, a princess, motivated by a sense of Buddhist compassion, volunteered to go in her place. Each year she is honoured as the Sedaw Thakin Nat.

The origin and the life of the Lord of the Nine Towns should have elevated him to the pantheon of the thirty-seven nats. His career also illustrated contemporary events between Burmese and Shans. However, politics may have influenced these choices. It was his usurping rival, U Min Kyaw, who entered the pantheon.

The Lady Buffalo of Pegu - Pegu Medaw

Although she is not a member of the pantheon, the Lady of Pegu is honoured not only by the Mon but also by all the people of Lower Burma. She is ever present at the *nat-pwe* and her statuette is a best seller for the temple vendors.

There exists an embellished version of her legend. A young prince once lost his way in the forest and was adopted by a female buffalo with whom he lived until some soldiers found him and took him away from his adopted mother. Miserable, the buffalo followed the soldiers to the gates of the palace. The soldiers barred her way as animals were not allowed inside the royal quarters. The Lady Buffalo would not budge. The prince tried, without success, to keep her out. The beast preferred to stay near him and then the soldiers' swords ran through her.

A more historical version identifies the prince with the person who became King of Pegu, Athakouma. Although he was the heir, his uncle coveted the throne. One day he contrived to have the prince lost in the deepest part of the forest. But contrary to expectations he survived there amongst the wild buffaloes. Nobody knows how, bur he even managed to repel an invasion from India. The usurping uncle then appeared on the scene. Remorseful, he wanted to straighten out the situation by offering to the real heir the hand of his daughter. But there was a requirement, the prince had to bring him the head of a wild buffalo, which he did. Interestingly, the sacrifice of a buffalo is a current practise in the Indo Chinese peninsula, particularly at weddings. The buffalo's sacrifice appears to have been a symbolic means to legitimate the position of a usurper.

The Lady Buffalo nat has an important altar at the foot of the great Shwe-hsan-daw pagoda in Pegu.

A ritual for this nat was held in a suburb of Rangoon in January 1987 by a group of donors. It was more than just a normal *nat-pwe*, it was a drama lasting several hours. A large statue of the enthroned nat was placed near the entrance, the other nats were lined up on some east facing shelves. The Lady Buffalo covered by leaves, in imitation of the forest, was flanked by Ko Aung Daing, the buffalo's guardian, but Athakouma's image was missing as well as his mother's, Shwe Bu-thi or 'Golden Marrow'.

After a dance performed by two Karens, the Lady Buffalo appeared for one scene. In a black costume with a black and mauve cloak, she swirled round frantically, her arms linked behind her back, a massive helmet with horns sticking out on her head. There was a pause in which she was offered some *lah-pet* or pickled tea. She tasted it, pinched it, and offered it around.

PEGU MEDAW

The followers, who formed a circle about her, were clearly moved.

Buffaloes love to splash about in water and indeed the ritual had an aquatic element. *Nga-yan* or cat fish play an important part in the drama, for their shape is suggestive of the horns of a buffalo. They are plentiful in the waters where the herds bathe and relax in the hot season. Moreover, this fish can survive for a long time out of the water. Several dozen of them, still alive are placed in basins together with wild asparagus, which both men and buffalos delight in. The Lady Buffalo took a fish in each of her hands and danced. After stroking them and blowing into their mouths she balanced them on the heads of spectators who were petrified with a mixture of respect and fear. This done, the drama began with the Lady Buffalo trotting about on all fours in the form of a transvestite with the eyes of an Andalusian dancer. Then the Prince Athakouma wearing the uniform of a soldier, danced with both his swords - at one moment challenging his adopted mother, then imploring her, either to leave, or to forgive him, or maybe both. The Lady Buffalo wept real tears and searched for consolation amongst the spectators. Suddenly the prince rushed at her and pierced her through with his sword.

A candle was lit on the top of a coconut offered at the *kadaw-pwe* and at this point the Lady Buffalo became a nat. Her son prostrated himself before her and brandished the mask she had held during the dance and then abandoned and offered it to her so that she could dance again. Breakfast time came. On the altar were laid out the customary dishes. There were, though, some other offerings which were more peculiar: rice wine, a coconut slashed on one end and deposited in such way the milk stays preserved inside, grilled peas in honour of a shepherd, and marrows for the prince's mother. The coconut milk was drunk by the *nat-kadaw* who sprayed some of it over his followers.

At one moment the *nat-kadaw* buffalo, gesticulating wildly, soaked his head in the basin where the cat fishes had been. Although this action seemed simply to be like a cool shower to calm him down in his state of nervous excitement, it was in fact another episode in the ritual. On closer inspection it became obvious that he was imitating the frolics of a buffalo in the water. A *nat-kadaw* dressed in ordinary clothes then made offerings and performed devotions before the nat's altar. She set on the *nga-yan* fish that remained in the baskets. She took them in pairs and passed a cord through their gills. The fish were dragged about by the cord at a slow pace, first by the adults and then by the children. Solemnly they turned round the space in an anti- clockwise manner. This was contrary to the direction of circumambulation about a Buddhist monument. An interesting inversion of a standard religious practice.

The logical denouement would have been to put the still live fish back where they had been caught from. In Buddhism returning a fish to water is a typical way of earning merit and it is traditional to release them as part of the new year celebrations. On the contrary, the fishes were executed with a sharp rap of the knife and cooked to be eaten.

Few rituals are as emotional as this one. It provokes tears amongst the Burmese. Perhaps this cult's popularity is because the buffalo is seen as humane and capable of love. The cult's recent success is also due to the idea that this horned spirit brings good luck and wealth.

Guardian Spirit of Lower Burma - U Shin Gyi

U Shin Gyi or 'Lord of the Grey Islands' is one of the most popular of the nats in the vast region between Prome and Tenasserim. His legend has been told by U Maung Maung Pye:

'He is the only nat who was translated alive from this earth to the nat world. He is often represented as a benevolent spirit wearing a yellow robe and holding a harp under his arm. Offerings are made to him before and after a period of abstinence and penance; they consist of cooked rice, coconut jaggery, plantains, preserved tea and betel leaves. In the Irrawaddy Delta almost every house possesses a raised altar on which the occupants make offerings to U Shin Gyi nat. The people who live along the river banks love him and hold him in great reverence. Many accounts of his life exist, but the following is the most widely accepted version.

Two Mon sisters lived in a village near old Pegu. Each of them had a son, and the elder sister's son Maung Aung was attached to his young cousin Maung Shin. When Maung Shin's father died the younger and his mother fell upon evil days. They were forced to depend on the charity of their relatives who were more comfortably off.

Now Maung Shin was eager to become a monk, but they did not know where to turn for the money to enable him to go through the the initiation ceremony. He and his mother went to see his aunt, Maung Aung's mother, but she was not able to help them.

In spite of the aunt's unkindness, Maung Shin and Maung Aung remained close friends and visited the Shwe-maw-daw Pagoda together. Maung Shin was very skilful on the harp and he delighted the pilgrims with his sweet music. His listeners willingly gave him tips in return for the pleasure he had offered them. The two cousins shared the money and it was enough to keep them from starvation. But Maung Aung did not wish to be dependent on his cousin's skill. So he went about looking for some other means of obtaining a living. One day an opportunity presented itself and Maung Aung was quick to take advantage of it.

A boat was leaving for an island in the delta where it would take on a cargo of bamboos and reeds. The captain of the boat was in need of some more men for his crew. The island where they were going was supposed to be haunted by monsters and spirits. The captain was glad to take Maung Aung. The youth at once went home and told his aunt the good news. His cousin insisted on his accompanying him, though Maung Aung tried to dissuade him and his mother begged him not to think of such a perilous journey, as she had dreamed that he had been taken away by some female spirits. Her son, however, would not listen to her. He made a deep obeisance to his weeping mother and as he rose slipped on to the floor, a very bad omen pointing to some evil to come. Maung Shin put his harp under his arm and embarked with his cousin.

The frail craft was soon driven out of its course by storms and whirlpools that threatened to suck it down into the depths. The captain brought the boat safely to anchor near a small island called Meinma Hla Kyun ('Beautiful Lady Island'). ...Maung Shin took up his harp and began to play it. His lovely music floated into the air and attracted a bevy of female spirits who inhabited the island. They came and sat near the boat and encouraged him to keep on playing. When he wanted to stop in order to cook food for the crew the spirits would not let him, but offered to do the cooking for him....

When the crew returned... they found a delicious feast prepared for them. They made laughing remarks about Maung Shin's improvement as a cook but Maung Aung was suspicious. Had his cousin met some female spirits in this place? The next day his worst fears were confirmed when he saw his cousin playing on his harp surrounded by a band of beautiful nymphs. In the evening he asked him if he had been entertaining any visitors.

"They came to listen to my music," he said innocently.

"But they are not mortals, brother. They are evil spirits. Have you told them anything?"

"Yes brother, I have told the youngest of them that I love her and will remain here with her." Said Maung Shin.

When Maung Aung heard this he was so overcome with fear that he sobbed like a child. "Why have you done this?" he cried, but Maung Shin was only surprised at his agitation.

The next day Maung Aung stayed on board hoping to meet the nymphs and ask them to release his cousin from his promise. None came and the captain decided to leave the island as he had obtained a good cargo of bamboos and reeds. He weighed the anchor but the boat would not stir, just as if some hidden hands were holding it back.

Everyone thought that some unlucky member of the crew must be responsible for this, so they cast lots to find out who it was and three times the lot fell on Maung Shin...

The captain had Maung Shin bound hand and foot and thrown overboard. No sooner did he reach the water than the nymphs took hold of him and bore him to the bank where Maung Aung saw him sitting, dressed as a nat and playing serenely on a harp. He had become U Shin Gyi, the guardian spirit and 'Lord of the Grey Islands...'

In the Irrawaddy Delta few nats are more revered than U Shin Gyi, especially among the boatmen travelling through the numerous branches of the great river.

The Nat -Kadaw

The principal performer in the *nat-pwe* is the *nat-kadaw*, which literally means the 'nat's wife'. Though the *nat-kadaw* may also be the husband, son, daughter, brother or sister of a particular nat.

A *nat-kadaw* may be compared with a shaman - he acts both as an oracle and a master of ceremonies. But in some ways he differs from the shaman for he himself neither achieves for himself levels of spiritual exaltation nor performs supernatural acts. At the best he might perform a few magicians' tricks - a favourite is one with duck eggs.

He will obey the commands of the nat by whom he is possessed and whom he honours as consort and servant. But he will not act as an intermediary between the a spirit and its followers. He will usually dance for that nat and often for others too, including the many whom it is not possible to marry.

He is therefore not the priest of a cult from which, with the exception of a few stock formulas used in the acts of homage, prayers are absent. The devotees join in the dance, sprinkle perfume over the *nat-kadaw*, offer money respectfully extending both hands, share out U Min Kyaw's whisky and making other offerings of consumables. The spectators are gathered both to placate the spirit and to enjoy themselves. The *nat-kadaw* act out the ceremony, submitted to the demands of their celestial spouses and occasionally counselling followers on marital and financial matters.

Every village has one or more available *nat-kadaw* often working in the fields or in the home. They are summoned to enact rituals secret to them, that could not be performed by ordinary people, or to act as mediums to find a lost object or cure an ill person. In a state of possession, it will not be the *nat-kadaw* himself who talks but the nat who inhabits him. Even the sound of his voice will change. In return for his services as an oracle he pockets a small fee which naturally goes to the *nat-kadaw* rather than the nat.

Thus he is part shaman, part medium, something of an oracle, and a healer. Sometimes counsellor, he will offer solace to his neighbours in the village. Having said this, the *nat-kadaw* cannot be identified with any single one of these roles. Perhaps it is best to leave him with his Burmese name without attempting its translation.

The Growth of the *Nat-Kadaw*'s Profession

In a movement dominated by women the *nat-kadaw* takes the part of a spouse. Amongst the male *nat-kadaw* a large portion are homosexual, some liberated and some not from the hang-ups of their condition. All the pupils of the famous master U Soun from Rangoon are young ephebes, gay to the extreme. Women *nat-kadaw*s often marry, whilst the men rarely do. Such women are famous for dominating their terrestrial husbands.

The great festivals, like Taungbyon, are attended by every *nat-kadaw* in the land and maybe ten thousand are present. Their profession was originally controlled by the kings of Burma, of whom the last, Thibaw was forced by the British to abdicate in 1885. Between then and 1936 they were

directionless, until the *nat-kadaws* formed their own association, 'the Association of the Dewa' which did not, though, last long as it folded in 1941. Nowadays they could register in the Public Performers Union (*Zat-Tin*), but rarely do.

The recent increase in their number indicates the growth of the cult's popularity. The government does not condemn it openly. After all, it helps to compensate the people for a variety of frustrations. Moreover, in the towns the profession can be quite lucrative and the *nat-kadaw* does not to have to take on other jobs. Sometimes he may even make his fortune.

Money is not always the main motive behind a vocation to become a *nat-kadaw*. Melford E Spiro describes the psychical way in which certain people are loved by a nat and thus have no choice but to marry him. Some women are captivated by a nat in their adolescent age but do not marry him till much later in life to end relentless obsessions. Once they finally marry the nat that had tormented them they at last find peace and serenity.

Sexuality

Conscious or not, sexuality plays a great role in the *nat-kadaw*'s vocation. Though in Burma women have sufficient freedom to keep any frustrations at bay, they make up the majority of *nat-kadaws*. Most are married. Their second marriage to a nat may be a consequence of their dissatisfaction with their first terrestrial marriage or perhaps the by-product of menopausal troubles. The male *nat-kadaws* are nearly always bachelors; sometimes secretly homosexual, more often than not frankly and happily open. Through a joint allegiance to Mahagiri and his sister Hnamadawgyi protection is even offered to bisexual people. Incestuous tendencies are also evident: if it is required a girl will marry a nat even if she is already his daughter. For example, there are the cases of U Min Kyaw and the younger brother of Taungbyon. In some cases a boy dominated by a possessive mother will be forced into becoming a son of Popa Medaw.

Theories of the Freudian complex do not adequately explain the psychological basis for a person becoming a *nat-kadaw*. There are always a variety of motives, including those of a social kind. Mostly from a modest background, the opportunity to wed the spirit of a king or of a prince offers a person some importance. Suddenly possessed by the spirit of a great national hero they are a centre of attention and receive the confidences, homage and offerings of the wealthy and socially prominent.

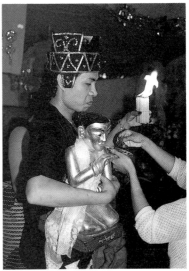

NAT-KADAW
AT THE MINGUN PWE

The Bacchanalian aspect of the cult of the nats has its liberating effects. Buddhist society condemns dancing, the consumption of alcohol and violent acts, yet the cult offers certain releases. To see the lack of self restraint with which the women dance, drinking whisky straight from a bottle brandished by Ko Myo Shin, or fencing each other with the swords of the masters is evidence enough.

Thakin Tet Toe, a well known Burmese journalist with communist leanings, married a nat in 1970 and as a result spent a lot of money on the ceremonies. Though his party had condemned the cult of the nats, he planned to reform it. He wanted to ban alcohol and permissive activities in order to improve its image to that of a solidly rooted institution. His plan was unsuccessful.

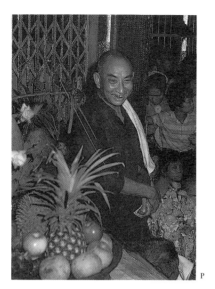

U PYI SONE
MASTER OF MT. POPA

Financial Gain

The *nat-kadaw*s are sometimes motivated by the possibility of financial gain. If in the villages their earnings are poor, they can make a fortune in the towns and famed nat centres.

One such is U Pyi Sone who is a celebrity at Mount Popa. He was a monk who had from an early age shown so much interest in the nats that eventually the government forced him to exchange the saffron robes of the order for the brown outfit of a hermit. Once defrocked he has shamelessly devoted himself to the cult of nats. He has become rich, he owns a car and does many trips to Mogok, the capital of rubies where he is involved in various speculations and investments. He has dedicated half a million *kyats* alone to embellishing the temple of Mahagiri, Lord of Mount Popa. He has decorated it according to his personal fantasies with all his favourite nats, the *nat-sin* at the foot of the *Taung-lei* or 'Little Mountain', the lesser of the two Popa peaks. Here Popa Medaw who had never been included amongst the pantheon's thirty-seven, is enthroned at the very centre of the thirty-seven between her two sons, the Taungbyon Brothers. U Pyi Sone has positioned her in a place of precedence over all other deities including Mahagiri, the Lord of the Great Mountain, to whom this locality had been consecrated.

Popa Medaw, the female ogre and eater of flowers, wears her hair in a rather frightening style. U Pyi Sone encourages his disciples to become, through the *ley-bya-taik* ceremony, the sons of this awesome lady. On one of these occasions, a doctor who had been educated in the west, danced in the classical Burmese manner with Popa Medaw. Little by little she becomes more recognised among the holders of *nat-pwe*. She even made a debut at the Taungbyon's festival some ten years ago, one of the greatest honours for an 'outside nat'. U Pyi Sone presides in his hermit robes over any *nat-pwe* he organises at Popa. He sits before a silver bowl into which bank notes are profusely pushed by anxious devotees.

Ko Nyo Mya, a journalist from Mandalay had the idea of building a *nat-sin* for Mahagiri at the entrance of the famous wooden bridge built by U Bein at Amarapura. The place was ideal but close to the strict and influential Mahagandayon monastery. However, such an enterprise could not be undertaken without the agreement of the monks and not without offering them a generous share of the profits.

Connections with Buddhism

Evidently the monks take care not to allow the cult of the nats to become too powerful. Only the licensed *son* or witches have split from the mainstream national religion and in some respects might be said to be excommunicated. The *nat-kadaw* is, though, no heretic. Outwardly, they respect the Buddhist Five Precepts not to: commit adultery, steal, kill, lie and drink alcohol. They take vows when they marry a nat, and make a personal act of contrition for their sins before the nats. They will personally respect any taboos specific to their own nat or more generally, for example by not eating pork and beef out of respect to those of Muslim and Hindu origin.

Most *nat-kadaw*s who aspire to achieve the power of a proper medium must train for a minimum of five years in order to master the profession

and its complex rites. One year at the great Taungbyon festival U Po Maung turned down the honour of performing as the Palace Minister unless he won for three consecutive times a bet with U Min Kyaw. It worked, and it was murmured that he had *'parami'*, or virtue.

However some *nat-kadaw* may be tormented and anguished by their often confused search for spiritual relief. One such, another medical doctor, had served the Lady of Popa for some years, but is now a strict Buddhist who meditates and reads the scriptures and follows certain more mainstream Buddhist *gaing* in Rangoon.

Syncretistic Tendencies

Such syncretistic tendencies are also apparent with a *nat-kadaw* well known amongst Rangoon's high society. In his youth, U Po Maung escaped miraculously from an illness following an after-life experience. Being of Muslim-Indian origin, his education was Koranic. But, when he was older he had visions of the Madonna. Somehow, he linked these to both the Hindu goddess Sarasvati and to Shwe Nabe of the nat pantheon. He insisted on the Hindu origin of the nats and the primacy of the four Hindu divinities: Sarasvati, Durga Sandi, Ganesha, Krishna. Their images hang on the walls of his house when he holds *nat-pwes*. These festivals last for only one day like in the old tradition respected in Mandalay and usually on a Sunday, the holy day for Christians. In accordance with his duties as Palace Minister at Taungbyon, U Po Maung maintains an orthodox front, but underneath he practices a syncretism not dissimilar to that of the Caodai of Vietnam. Over the same period of U Po Maung's spiritual development Burma had passed through similar tests to Vietnam: colonialism, war and the Japanese occupation, independence followed by an authoritarian regime and economic stagnation.

The Bad Image of the Profession

Though there is some sincerity behind the motives of a *nat-kadaw,* they are not always particularly saintly. Several informants agree that at least seventy-five percent, if not more, (not themselves of course) are dishonest, with perverted morals and greedy ambitions. Harshly criticised by their own peers, they enjoy little esteem amongst the general public. They are only honoured, like the nats, out of fear. Tolerated by the Buddhist Burmese, the transvestite practitioners have not been known to refuse the prestige and rewards their profession brings them.

Some *nat-kadaw* visibly separate themselves from the often decadent homosexual element, claiming them as being marginal in what is in any case a marginal milieu. The important place of dance in the ceremonies encourages the interest of transvestites who are good dancers and love this opportunity to don elaborate costumes and apply extravagant make-up effects to each other. Such practices merely serve to increase the prejudice against an art originally carried out by slaves, vagabonds and even drug addicts.

The racketeering of certain *nat-kadaw,* who launch new nats as if they were pop stars and in doing so exploit an often naive public, leads to

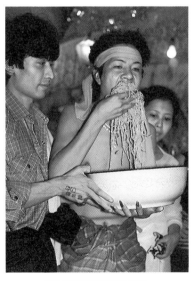

U MIN KYAW FEASTS

numerous criticisms. There was a general protest when one of the most popular Rangoon *nat-kadaw* dared ask for a television set - an expensive item in Burma - as a fee for his services.

Marriage to a Nat

A *nat-kadaw* is consecrated with a ceremony, the *ley-bya-taik*, which employs the butterfly as a symbol of the soul. This ceremony may take place on different occasions: the consecration of a nat's image dedicated by a devotee; the union between a human and a spirit without access to the *nat-kadaw* statute; marriage with a view to becoming a nat. The ritual has a number of versions according to the demands of the nat in question or the practices chosen by the master of the ceremonies.

The *ley-bya-taik* lasts between thirty and sixty minutes and is performed by the *nat-kadaw* either in his home or following a *nat-pwe* during the month of August. The proper ceremony is preceded by the 'differentiation'. This is a practice in which the nat suiting a prospective spouse is identified. Such a nat, desiring to possess a person for his or her *ley-bya hla-de* or beautiful soul, would torment that person with nightmares and sickness till eventually he or she surrenders. The victim is often afflicted by sore nape of the neck. This is why the nat is often described as 'clutching on to a head'. There are no more than a dozen nats that set their hearts on selected humans. Among them there is only one female, Maung We Taung, looking for a husband. The Taungbyon and Prome Brothers and U Min Kyaw are looking for wives. The other nats seem to be content with filial links or brotherhood. The 'differentiation' consists of discovering with which nat the obsessed person has the most affinities and compatibility. This is done by summoning the nats one by one and keeping the most likely contenders, in the opinion of the master, for the end. Their client reacts with the usual signs of possession. A certain informant was destined by an unperceptive *nat-kadaw* to be married to U Min Kyaw. However, another *nat-kadaw* - Daw Thein Khin from Mandalay - soon discovered, by a knowledge of psychology and an examination of his appearance, that the informant actually possessed affinities with Popa Medaw and not U Min Kyaw.

This caricature of a wedding ceremony may be accentuated with the ritual of betrothal. A cup with *yei-zin* or lustral water protects the beloved from the aggressions of a nat wild with love. The petals of the gladioli, the flower of fidelity, are mixed with this water. Later, after a usually rather long delay, comes the actual marriage ceremony. This is generally in the morning. In the case of one woman, who had to be collected from the psychiatric hospital, the ceremony took place earlier at nine o' clock. Her terrestrial husband was an army man serving a seven year sentence in prison. The trauma of this had made her near-insane. She was quickly married to the eldest brother of Taungbyon.

The ceremony borrows from the formal ordination of a Buddhist monk. *Sima*, where ordinations are held, are usually far more isolated; there, not even electricity is allowed to penetrate the sanctuary. Similarly the *ley-bya-taik* ceremony takes place in an enclosure specially marked with coconuts and sealed with white cotton threads. That seven *nat-kadaws* are present as witnesses is also reminiscent of Buddhist ordinations, which arc

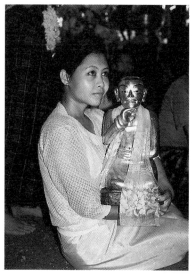

DEVOTEE OFFERS AN IMAGE
TO THE SHRINE

not legitimate without a certain number of monks as witnesses. Like the Buddhist novice, the candidate *nat-kadaw* takes vows, but unlike the Buddhist novice will be obliged to homage the nat every year by making a pilgrimage to its shrine. The rite also borrows from terrestrial weddings, which usually take place without the involvement of any monks. For example, there is the episode where the 'golden chain' being lifted up before the spouses at the conclusion of the ceremony and is then pulled down after the offering of some money.

In old Burma, to be seen in public sharing a meal together, was enough for a young couple to be considered married. And, indeed, the exchange of food nowadays is an essential aspect of the ceremony. Similarly, the master *nat-kadaw* offers rice several times, drinks and offers garlic and other foods to the fiancé. The fiancé, however, does not do the same towards the *nat-kadaw*, who though an incarnation of the nat is not really an equal. Once married, the bride must undertake a seven day retreat in the master's 'palace', in the chamber where he houses his private nat collection. This retreat is akin to the Western honeymoon.

BUTTERFLIES FOR THE LEY-BYA TAIK CEREMONY

The *Ley-bya* or Butterfly Soul

Nothing is more poetic in the cult of nats than the performance of the rite of the butterfly soul. Buddhism denies the existence of a soul in place of the idea of an accumulation of consciousness derived from a perception of the world. It does not accept the idea of a not autonomous soul as given in the nat cultist belief of the butterfly. To Buddhists, reincarnation after death is thus not a transfer of the soul but the transfer of the dead's consciousness to the newborn child's. In the late 19th century Shway Yoe, the pseudonym of JG Scott a Scottish writer on Burma, was the first to introduce the butterfly soul to Western readers.

The butterfly can leave the human body it inhabits. Its wanderings take the form of good or bad dreams. There may be nightmares if it gets lost in places with which his host is unacquainted. There, he might have unpleasant encounters with *balus* which might lead his owner to illnesses and even death. That is why it is a taboo in Burma to wake somebody with a fright. If the butterfly has not returned home then its woken host, without a soul, will be dead. The butterfly concept occasionally leads to extraordinary behaviour. In Upper Burma butterfly hunting is organised when a person from the village, laid low by a sudden illness, would seem to have lost his soul. When a woman dies at childbirth, it is necessary to recover as soon as possible the butterfly soul of the baby. For this, a mirror covered by a piece of cloth, like that used as a net for catching butterflies, is placed next to the corpse. The newborn's butterfly soul, attracted by the mirror, is quickly captured and then the umbilical cord is cut as the soul is pushed into the owner's mouth from the net.

In the *ley-bya-taik* ceremony, the subject's butterfly soul is banished from the chamber by a game of mirrors thus leaving the room vacant for the nat's own butterfly to come in and enter the body. This delicate transplant must be carried out with careful and necessary precautions. The ceremony should be executed in isolation. If successful the subject should be protected by a cotton thread. There has to be total silence and

INTRODUCING THE BUTTERFLY SPIRIT

STITCHING IN THE SOUL

FEEDING THE DONOR

the servants ensure no house work is done or other disturbances made. This way the nat's butterfly will smoothly transplant itself into its new residence. Once there the host will recover in strength and vitality. The old court expression 'san-khan-win' which means 'to take pleasure on entering the bedroom ' does perhaps indicate the essence of this marriage ritual.

The substitution of one soul for another does not belong exclusively to the Burmese cult of the nats. In voodoo the *loa*, the mischievous spirit, takes the place of the soul whilst the possessed is in a trance.

Consecrating a Little Statue

In a White Horse ritual observed in Rangoon, an image of Myin Byu Shin, the Lord of the White Horse, was consecrated at the request of its owner who sat opposite the statue and sponsored the ceremony. If this woman had been a *nat-kadaw* consecrating the nat for professional use, at least fourteen images are required for the *nat-kadaw* to act as such and the consecration would have been held at a *nat pwe*. In this case, the *nat-kadaw*, ordinarily dressed, was performing only this ritual on a statue which would be kept in the sponsor's house.

After the exchange of offerings, the *nat-kadaw* took a comb and acted as if he was dressing the statue's hair and then placed the comb in her hair as an ornament. He knocked on a mirror with a bunch of eugenia leaves, then on the horse's flanks and around the figure. Cotton threads and a needle were dipped into lustral water, the *nat-kadaw* proceeded to prick various parts of the statue.

These three acts are to introduce the butterfly soul of the nat into his image. The hair styling is a vital preparation, for in Burma well cared for and abundant hair is very important. The mirror hunts and traps the nat's butterfly soul which is always present without ever being seen. In the final act the needle and cotton threads are used to stitch the captured soul into the image. The statue, now alive and fully active, is offered food and drink by the officiant and donor. To finish the consecration the *nat-kadaw* holds high the statue with both hands and gently swings it back and forth, something that the nats are said to be fond of.

Scenario for a Ley-Bya-Taik Ritual

The ritual may differ in length or content from the following example which describes the marriage of a man to Popa Medaw at Mandalay in 1978.

The enclosure is prepared and delineated by seven coconuts and tied braids, woven from ten cotton threads to represent the seven nats of the Duttabaung Cycle (lead by Mahagiri), U Po Tu, Ko Myo Shin and his mother Medaw Shwesaga. There are red and white flags and the bride's trousseau.

The main ritual is opened: the applicant crouches down outside the enclosure before, the red flag on the left, and his master, who is before the white flag on the open side of the enclosure. Normally there are seven *nat-kadaw* witnesses. They are chosen by the master and the ceremony is invalid without them. The orchestra is behind the two main actors and the

devotees watch around the sides of the enclosure.

Rice and invocations are offered to the Buddha. If the ceremony takes place during a *nat-pwe* which has already begun these rites are repeated.

The nats are invoked and respect offered to the five gems of Buddhism and to the *dewa*; here the orchestra increases the tempo.

When it has not taken place earlier, the master goes behind the applicant and starts waving a fan calling the nats one by one - this is called the 'differentiation'. He calls ten or so starting with the less compatible in such a way that the possession usually comes towards the end, noticeable by quakes and shakes. If more than one nat reacts to it, the test is repeated. In this case the applicant initially reacted to Thon Ban Hla but then became so fully possessed by Lady Popa that it was not necessary to re-enact the differentiation.

Vows are taken and, once witnessed, he is allowed to dance for some minutes.

The music slows down and the master gives to a disciple rice and sweets to pretend to feed the candidate as many times as offerings are made.

The master comes near with four cord bangles woven from ten threads and three garlands made up from seven different plants. The cords are attached to the wrists and the garlands all round the neck. The applicant lifts one arm and the other to receive them. He will have to keep them for seven days.

A mirror is placed before the candidate whose eye fixes upon it. After it is placed on his chest and the master gives it a light knock with the branches of myrtle. This is repeated on the back and on both sides. Two mirrors are then placed by the master in front of and behind the applicant. He lifts them up, one against the other, to catch the butterfly and ties them with a thread. The butterfly is sleepy, the candidate is reassured by its quietness. It may happen that one of the masters' assistants settles a needle into the chignon of a woman candidate.

Before the seven witnesses, the master takes a roasted chicken and places it on the head of a candidate to whom he asks ten questions; such a questionnaire also occurs at the ordination of a monk. The master then splits the chicken into two; the cleaner the cut is the more favourable the omens are.

The master assisted by a witness three times raises the thread on the open side. If there is to be a marriage a novice *nat-kadaw* enters the enclosure. If instead there is to be a filiation then he acts as if he was going to go in, but then does not.

A veil is offered to the 'married' (sometimes this is a Western-style white veil) sometimes with jasmine garlands. The orchestra starts with the royal march (*sidaw*); occasionally a western tune like 'Here Comes the Bride' is used.

The newly created *nat-kadaw* goes out of the enclosure to perform the dance of a nat. At the point of departure, a golden chain is raised to bar the way and will not be lowered without the presentation of small gifts.

The newly married retreats into the master's private statue chamber for a confinement of seven days. People will bring offerings of food and drink, not to mention much pandering attention.

THE ENCLOSED AREA FOR A
LEY-BYA-TAIK RITUAL

PREPARATION OF THE BRIDE

THE OFFERING OF A ROAST CHICKEN

THE RITUAL ENDS

To keep a nat happy or to avoid its wrath, a *nat-pwe* may be offered. Sometimes, the ceremony is given to obtain a favour or to show thanks for good business.

During the jubilant Taungbyon festival a shopkeeper asked a *nat-kadaw* if business would be good enough to allow her soon to buy a video. The soothsayer put on his pink turban, put three lit cigarettes before the little statue of gilded wood and considered the situation. He asked the shopkeeper for 137 *kyats* and promised to give them back to her if her business failed to prosper as he expected. In a moment of generosity the lady promised to give a *nat-pwe* if the nats looked on her kindly. The *nat-kadaw* then asked for 1,000 kyats as advance against the cost of organising this. Piqued, the lady emptied her bag and offered the oracle a bunch of 'Eugenia'. The *nat-kadaw* took it badly and he asked for a bunch of out of season flowers. As a result of this difficulty, if her enterprise were to fail, then he could justifiably claim that she had not done all that was necessary. In such a situation the lady could hardly dare make her situation worse by asking for her original donation back.

In Rangoon, another lady sold for 300,000 kyats a plot of land measuring about four hundred square meters. Out of gratitude she decided to offer a three day long *nat-pwe*. The cost of this, about 10,000 kyats, was approximately the same as the annual salary of a senior civil servant. A bamboo hut was erected across the street with the agreement of the town council and the monk of the local monastery. In return, the monk would receive a portion of the offerings. Sticky rice, eggs, sweeties, alcohol, cigarettes, perfumes and the usual offerings were stocked by the donors. Such *nat-pwe* may take place in the street, on private property or in the precinct of the pagoda, around the *nat-sin* - the shrine dedicated to the nats.

Money Circulation

In all *nat-pwe* there is a complex web of economic relationships. Paradoxically, this has become even more complicated with the decades of depression that have impoverished Burma since the war. The black market, which in Burma was as significant as the official economy during the eighties, may well have contributed towards the flowering of the *nat-pwe* as a regular event. On such occasions there is a busy circulation of large denomination bank notes. (The devaluation of the 100 *kyats* note in 1986, and the introduction of the 75 *kyat* note imbalanced the black economy as much as the finances of the rebels). Further, the authoritarian character of the regime has led to much anxiety amongst military personnel and the civil servants. The goodwill of the nats have thus become an important ingredient in the advancement of any career. Many former members of the elite, exiled from public affairs since the 1962 coup, found in the cult consolation for their frustrations and keenly devoted themselves to its activities. Nor do they lack the time to attend a three day *nat-pwe* instead of the traditional one day one.

The negotiations between the *nat-kadaw*s and the donors of a *nat-pwe*

is a mixture of haggling and customary rituals. Thus the amount of the down payment varies but it is regulated by magic and numerology. This leads to some unlikely figures as round figures are hated as much as any even number.

Throughout a *nat-pwe* the circulation of money is rarely left to fate. There are points in which the donor is, by ritual, required to make an offering. At such moments the *nat-kadaw* will remind him with an obvious gesture. Afterwards, the proceeds are redistributed by the master to the orchestra, the singers, the attendant *nat-kadaw*, and even to the actual guests, which requires skill and experience. Such money handed out to the devotees brings luck and it is kept especially to be wagered at cock fights.

The money collected in a cup by U Min Kyaw traditionally goes first to the orchestra. Money slipped into the blouses of the *nat-kadaw* women or stuck into the men's turbans remains theirs. Two *kyats* have to be given in exchange for a pair of duck eggs offered by Shin Nemi, the little girl who plays the flute. The notes then must be placed on the crossed sabres of Ko Myo Shin (the Lord of the Nine Towns). The official donors must set the example and display their generosity, spurred on by the ecstatic music and the hot and frenetic atmosphere.

Even if a donor is out of pocket through the excessive sponsorship of such rites he will have acquired merit and can thus count on the protection of a nat. The nat-pwe is also an opportunity for the *nat-kadaws* to increase custom. In the heat of the moment, a devotee may take the vow of offering a future *nat-pwe*. Then, without a moment to spare, the officiant will drag him to his domestic altar and administer the vow with hands placed on the hilt of a sabre pointed at the floor. The engagement is ratified by a deposit left on the altar of a nat and it will stay there till the *nat-pwe* is held. Naturally the *nat-kadaw*, broker of such business arrangements, will be the master of ceremonies when the time comes and will make a handsome profit. Sometimes a *nat-pwe* is financed by a tontine of friends, they draw lots and the lucky one is the sole beneficiary of the *pwe*.

Preparation of the Ritual

The *nat-kadaw* must obtain permission from the town council who usually demand that the *nat-pwe* takes place at a time during the day that does not bother the neighbours. They also ensure that no more than two or three each month are held in the same area.

Then there is a rush to erect the bamboo shelter and to collect the provisions and especially the coconuts, which should be green and undamaged. Massive bunches of bananas are equally essential for a *pwe*. The statues may be provided by the donor or by the *nat-kadaw* and are displayed on a table or shelf in a convenient order. At one end, closest to the donor's house, are Mahagiri and his family of seven in full dress. Behind them are Lady Popa, the four Queen Mothers , or, if there is lack of room or the necessary statues, only the Queen of the West who will represent the three others, the Shan nat Ko Myo Shin (Lord of the Nine Towns), Myin Byu Shin the Lord of the White Horse, the Lady Buffalo of Pegu and the nats of her entourage and finally Shin Nyo the Brown Lord - fourteen nats, all

of the first rank and the minimum that a nat-kadaw must own in order to rank as a professional. Others might be added, especially the parental nats for whom the *pwe* may be intended. Their disposition follows standard pan-Asian protocol: they are ranged according to their importance, facing east or towards the nearest pagoda, in order of intimacy with the donor family. The least important are closest to the entrance and the Lord Buddha is enthroned in the centre on a level higher than the nats lined on shelves below. Even if it is to be a ceremony for the full thirty-seven, all are rarely present and often several of the 'outside nats' might appear.

The Offerings

At a *nat-pwe* the offerings are displayed on tables situated at the foot of each of the statues. There will be bunches of bananas, the quantity depending on the nat's rank, or the symbolic number for that particular figure: the *five* jewels for Buddha, the *seven* members of the Mahagiri family, the *four* Queen Mothers, *nine* hands for Ko Myo Shin, or just two bunches for the more modest lords. Bunches of flowers are tactfully arranged out of consideration for the dislikes or delights of each nat: no frangipani leaves for Mahagiri, who was burnt alive under that tree, but abundant gladioli and sweet-smelling jasmine for the Lady of Popa, a flower eating ogress. The requisites of each nat, like swords or fans, which are required in the performance of its dance are also displayed and ready for use. The dresses and decoration worn by the dancers are kept in the wings. Each morning dishes of food will be laid out on the tables together with cigarettes, perfumes, 'Mandalay Rum' and whisky - gifts from the donor or his guests. It is easy to understand the Burmese liking for the whisky brand 'White Horse' with its obvious association with Myin Byu Shin.

Altogether, a spectacular still life is created with rich colours and the pungent smells that nats find alluring. Also for humans, senses stimulated, this display contributes, together with the heat, alcohol and the deafening din of the orchestra, towards inducing a trance-like state in most beholders.

The Orchestra

Facing the line of altars is placed the cumbersome *hsaing waing* or orchestra. It is composed of twenty-one hanging circular drums called *pat-waing* and eighteen bronze gongs, *kyi-waing* that mix with the drums. There are a further eighteen other gongs called *maung hsaing* with deeper and softer tonal qualities. There are also oboes, cymbals and clappers. And a further eight drums may reinforce the *pat waing*. This was traditionally the orchestra of open air ceremonies. Indoors, at a *nat-pwe*, it is almost deafening and it is no surprise that that the hsaing waign is directed by the drummer or percussionist. The most dominant non-percussion instrument is the high pitched oboe that follows the melody of the drums at an octave higher and often will respond to a motif from the drums to create a delightul alternating dialogue.

The *nat-than* singer will face the orchestra even if not part of their group and is not usually exposed to possession by a nat. Her repertory is taken from the *Mahagita Medanikyan*, a classical anthology containing the *nat-*

THE OFFERINGS

than or 'odes to the nats'. Each ode is dedicated to one of the thirty-seven and tells the story of that nat's life and death. The musicians receive a lump sum payment varying from twenty to sixty *kyats* per day in addition to the many presents and tips they receive out of appreciation for their talent. The *nat-than* of Mahagiri is typical:

> Here I come, radiant with flowering girdle and satin loin cloth of foreign manufacture, with white muslin cloak and ample sleeves. In my right hand I hold a fan and my helmet is made of palm leaf gilded with pure gold. Afore time I was living at Tagaung whose ruler suspected me without cause of harbouring evil designs against him…

A DRUMMER OF THE ORCHESTRA

The *nat-kadaw* makes sure he has all the help needed: dressers, make-up artists, cooks, and will also recruit among his disciples, friends or other known dancers to assist him and take part in the spectacle. He must be a good actor, dancer, and model, often changing costume and make up. The *nat-htein* is a man who is said to be invulnerable to being possessed by a nat and is impartial to alcohol. He is appointed to oversee people's behaviour during the *pwe*. A *nat-htein* is often the guardian of a *nat-sin*, or shrine house, where nats are kept.

The evening before the day convened, the team is in their place and all the arrangements are made. The next morning, at an early hour there will be an offering made to U Shin Gyi, the guardian nat of the Delta, who is usually honoured before sunrise and after sunset. Monks may be invited for breakfast or during the lunch break. They will remain silent, disapproving observers; reflecting that ambivalent relationship between Buddhism and the cult, in the same way that nats are admitted to the extreme periphery of a pagoda enclosure, or when the *shin-pyu* procession that precedes the ordination of a Buddhist novice will stop before the village's *nat-sin* to offer prayers and offerings.

The *nat-pwe* itself will start later in the morning and will continue for six half-days, or three days, in accordance with the statutes. Depending on the region, who the village or district nat is, and their lineages, not to mention the requirements of the donors, there may be any number of variations and additions as determined by the master *nat-kadaw*.

It is not possible to draw up a general scheme for such *nat-pwe* as there are so many variations. There are nevertheless certain dominant features. Usually Mahagiri and his family will appear in the morning and Popa Medaw and her children after lunch. U Min Kyaw and his cock fighting occurs in the middle of the afternoon and the Four Queen Mothers appear towards the end. This happens on each day of a three day *nat-pwe*. Outside nats such as the Lady Buffalo of Pegu (Pegu Medaw) and the nats of the Shan or Karen ethnic minorities, that manifest themselves in many Burmese towns during festivals and mix with the nats of the pantheon of thirty-seven.

On the first day of a three day festivity the nats are summoned. This is done by making them manifest themselves out of the individual *nat-kadaws* who have been possessed by them. The second day is for the feasting. The third is dedicated to saying farewell to the nats who have come. Sometimes lesser nats do not appear till this point dressed more modestly and manifest in the persons of the donors or spectators. The final rite is quite

THE POSSESSION

elaborate and attempts to dismiss any wandering souls and other bad spirits who might compromise the efficacy of the *pwe* for the donor. They will be given some ordinary food in a aritual known as the 'Fall of the Village's Food' whilst the main nats are vigorously fanned.

The *nat-pwe* is directed towards flattering, seducing and placating the fearful spirits. The costumes, particularly that of U Po Maung who was a tailor, are magnificent; perfume atomisers are constantly being sprayed; the music controls the pace and shift of atmosphere; cigarettes and alcohol abound; the buffet is generous. The nats will first imbibe the perfume of the food and then it is eaten up by the assembly.

The Possession

The Burmese terms *nat-myu* and *nat-kyaw* denote the difference between the possession of a professional *nat-kadaw* and a devotee one. The professional *nat-kadaw* has learned to perform whilst possessed in such a way that it does not affect the ritual in which he is the master. With a devotee *nat-kadaw*, though constantly inhabited by the nat he or she is married to, and whose butterfly soul has been replaced by the nat's, possession at a *pwe* reawakens the nat's presence. According to one informant his nat spouse Popa Medaw would manifest herself in this way: 'At the beginning of the dance, before the offering of the fruits that are important to the Lady of Popa, I had gooseflesh, I felt more dynamic, happier and lighter'.

This more discreet manner of possession is less noticeable to the public. One may wonder if such sensations are really felt by the experts or if it is just a charade.

The possession of a devotee is more spectacular but it can also be more dangerous. Between the flight of the butterfly-soul and its relief by the nat, a void is created and this could result in a black-out. At Pegu, during a *nat-pwe* given to the Lady of Pegu, a corpulent woman pushed through the thick of the crowd followed by a man, perhaps her husband. She excitedly moved towards the altar to offer her flowers to the nat. The moment her hands joined she started to shake and began to dance wildly spinning round and round, non-stop; soon she was on the ground writhing like an epileptic. Several witnesses went to help her and free her from that unprepared possession, or at least bring it under control. Women, being more emotional and according to the Burmese, with a more tender butterfly-soul, tend to go into trances quicker than men.

Psychologists have tried to find out if such possession is induced by a psychic disassociation, resulting in a trance and loss of consciousness, hallucination or symbiosis. There is a striking contrast between the *nat-kadaw* dancing harmoniously with the nat he is formally wedded to and a neophyte dancing as if caught in a nightmare. It seems that there is a clear difference between the beliefs of the indigenous Burmese and those of Western science. According to the former, the cause is the power of the supernatural and any mental illness is due to the influence of a malevolent spirit. For the latter, such states are the result of an inner conflict which leads to a maladjusted perception of the world together with related hallucinations.

The audience at a *nat-pwe* is formed mainly of women, usually quite mature in age who have brought along their children to watch. It is not difficult to differentiate between those who come to the ceremony to simply enjoy themselves - clapping their hands, drinking and being merry and observing the antics of those who come in search of a cure for body or mind. Some alcoholics come after promising to give up drink and then swig straight from a bottle proferred by U Min Kyaw. Then it is no longer they who do the drinking, but the nat.

DEVOTEE AT TAUNGBYON
CARRIES OFFERINGS

Ceremonial of a Three Day *Nat-Pwe*:

First day: summoning the nats

Between 4am and 5am offerings are made to U Shin Gyi, the guardian of the Delta. Between 8am and 10 am there are opening homages to the five jewels of Buddha, Dhamma, Sangha, parents and teachers; to the *dewas* of Hindu origin: Sarasvati, Sandi-Durga, Ganesha and Krishna; to the four guardians of the world placed on Mount Meru; to the *Sayadaw* of Samatha such as Bobo Aung, and others; to Thagya-min, king of the nats (with *dewa* status). The orchestra has played five different themes, but as yet there is no dancing.

Then, two *nat-kadaws* face the altar on each side of a stool where the bananas will be placed. Homage is offered: to Mahagiri with a characteristic set of fans; for Hnamadawgyi the *nat-kadaw* holds a bunch of eugenia in each hand, and with them makes three circles, with the leaves pointing up; Shwe Nabe - the leaves now face the ground and the gesture is like the milking of a cow, then the palms join together; Thon Ban Hla - the dance continues, the forearms make vertical and horizontal lines that alternate at chest level; Shin Nemi - both arms make an oblique line pointing down and parallels, the hands on a straight angle, oscillating from right to left; Mandalay Bodaw - the *nat-kadaw* wears a pink or yellow scarf hanging from his neck, an end of the scarf is held with both hands and swung three times in emulation of a Brahmanic dance in which the tutor took part; the Elder Brother of Taungbyon - the scarf is held with the left hand, the right holds a eugenia, a rabbit represented by bananas is offered (the banana's form suggests the shape of a rabbit's ears), the *nat-kadaw* turns the bananas around and every three turns he picks them up with their sword to offer them as the Brothers were fond of rabbits, their boat trip is enacted with swords simulating oars and the boat is a sea vessel recalling the Brothers' expedition to China. This dance is omitted in the *pwe* held for Ye Yin Kadaw, the Queen of Witches, at the Zee Daw Festival as she died from drowning; the Brothers of Taungbyon - the eldest's index finger points up indicating his one mistake when he failed to offer bricks for the Taungbyon Pagoda, his headscarf is tied in the Indian fashion, the Younger's index fingers draw half circles in alternate directions; Min Sithu - the two middle fingers and the thumb touch, the other two point out like two horns. 'Wherever I go even the firm earth must transform itself in water' evokes the magical boat that the King Alaungsithu used in his tours; U Min Kyaw - dances lifting an arm that drunkenly brandishes a bottle. The women arrange their hair with garlands of jasmine.

U MIN KYAW
THE BACCHUS OF BURMA

After about thirty minutes the opening is complete, the two officiants leave and the programme continues. The master of ceremony alternates the obligatory dances with the ones he can order according to his own fancy or in response to the donors' wishes and to introduce moments of tension or comedy where required.

The ethnic Karen and Shan nats appear on the scene with other characters and Myin Byu Shin before the spectacular arrival of Mahagiri *min*. In the dress of a *wungyi* or minister with a tall red and gold conical hat and holding a long handled fan, he enters at the head of a procession that includes members of his family; each performs his own dance.

Shwe Nabe is dressed in pale yellow with a light scarf and holding a betel box. She wears a naga hairstyle. She turns three times upon in a white sheet with flower petals and offerings. She undulates and turns in a state of trance, her hands joined on the top of her head in imitation of a snake. She ends up on the ground twisting herself and rolling like a reptile. At the Myit-thu festival, the Shwe Nabe rolls out from her palace to the river, some hundred metres from there.

Thon Ban Hla is dressed in the same way, but with different colours and without anything in her hand. She simpers about and applies make-up to herself holding in her mouth two roses which she offers to the audience.

Shin Nemi dressed in pink, wears a flowery diadem, with colour on her cheeks, dances and receives offerings in pairs.

Shin Nyo, or Maung Min Shin, and Shin Byu, or Taung Magyi have tucked up their loincloths and wear their bun high up on their heads. They simulate the fight that made them famous.

There may be other settings depending on the time remaining before lunch, for example the dance of Pegu Medaw. Mute, monks may accept the offering of a meal. After lunch the festival would be marked by the dances of individual devotees and interludes before the obligatory appearance of Popa Medaw, the ogress eater of flowers. Dressed richly she wears a scarf that easily transforms into a veil, so that she may suddenly become Lady Kalima. The change of the musical tempo and rythms of the dancing create a Hindu atmosphere.

As many nats as time allows file past before the main spectacle of the afternoon. U Min Kyaw dressed in red and gold breeches, breaks through holding a wooden cockerel in one hand and a cup full of raw rice which he further fills up with offerings in the other. The dancer needs to be skilful, not to spill the money from the cup, normally reserved for the orchestra. His appearance can last for some time and sometimes he may be followed by one of his disciples, the nat Shin Nyo (the Brown Lord) who is bare-chested with a red band wrapped around his forehead. He dances to the sound of the big drum, eating a chicken and distributing pieces among his followers.

There will be comical breaks with performances by more humorous nats like Shin Gon (Lady Hunchback) or Shin Gwa (Lady Bandylegs) before the obligatory dance of the Four Queen Mothers who wear scarves wrapped around black turbans and revolve about the room paddling swords, as if rowing a boat.

Second day: the nats' feast

After the morning offerings, the *nat-pwe* opens as in the first day. Despite

REQUISITES FOR THE RITE OF
PEGU MEDAW

PEGU MEDAW IS PREPARED
FOR HER DANCE

the feasting of the preceding evening more food and other offerings have been prepared. A banquet is set out on tables before the Lords, depending on each's preference when eating.

The family of the Mahagiri min appear first and perform again the ballet of the previous day. The Lord receives sweets, Shwe Nabe prefers milk, puffed rice and mashed bananas. Shin Nemi, the little girl who plays the flute, distributes pairs of duck eggs. Pegu Medaw has the privilege of succulent wild asparagus; though she does not care for the *nga-yan* or catfish her devotees consume it as part of her cult.

Popa Medaw's ritual is the most important feature of the day. She was the ogress who liked to eat flowers. She is flanked by her two sons, the Taungbyon Brothers, and followed by their father Byat Ta, in baggy trousers with a velvet waistcoat. Byat Ta in mime re-enacts their romance. Then Lady Popa starts off a slow and grave dance. She holds two bunches of peacock feathers in her hand and dances before the flowers and fruits presented to her. She then rushes and grasps bunches of these in her teeth and offers them to her sons or sometimes to her devotees. She leaves the hall seated in the arms of her sons.

After this, the table of Nyaung Gyin (Old Man of the Solitary Banyan Tree) is prepared. He is a Muslim and is sometimes referred to as the father of Byat Ta, although Byat Ta is supposed to be a foundling washed up on the shores of Thaton. Saffron rice, noodles and other *halal* foods are offered. His brother Byat Wi and Lady Kalima, their aunt, make an Indian *salaam* and join him for an Indian meal. Veiled Kalima dances turning in circles with a bottle of soda on her head or a dish with a coconut as a relish. The nut will be smashed on the ground as done in India during the Kalí ritual.

At the banquet of U Min Kyaw his own mother arrives. She is dressed in yellow and white and armed with two sabres which she sharpens when she wants to eat. She is offered pancakes and fried fish and picks them up with a sabre. At U Min Kyaw's feast there are always roasted chickens and plenty of alcohol, particularly Mandalay rum and 'White Horse' whisky. The dance of U Min Kyaw might be performed, one in front of the other, by two *nat-kadaw*. One would dance first moving forward and then the other moving backwards according to the Mon fashion. The dance could be followed by the 'capture of the elephant'.

A three day *nat-pwe* never omits the dance of Ko Myo Shin. Many Shans live in the Delta so his performance is well supported and his act spectacular. Dressed completely in black he juggles both swords in a Kung Fu-like performance.

Third day: the nats' departure

The nats do not leave without further offerings of food as on the preceeding days, but with the addition of sticky rice filled with bananas and wrapped in banana leaves, a dish easy to carry away.

During the morning the nats of the preceding days file past and others that had not yet manifested themselves yet come to join them.

The departure of Mahagiri and his family is the correct moment to change the house's protective coconut. The new one will be carried in ceremoniously. The members of the Mahagiri family dance before giving way to the Karen or other minor nats who, more modestly dressed fill the

U MIN KYAW DURING AN
INTERLUDE BETWEEN
MAJOR ROLES

THE RITE OF POPA MEDAW

remainder of the morning.

In the afternoon, Popa Medaw, her sons, the Taungbyon Brothers, U Min Kyaw and his disciple Shin Nyo, reappear. This is an opportunity, many of the professional *nat-kadaw* having now gone home, to give the donors and devotees a chance to manifest their own nat possessions. At the end of this performance the ever popular little girl flutist, Shin Nemi, reappears and distributes pairs of duck eggs amongst the crowd.

The offering of a banquet to the Four Queen Mothers is a tradition at this point. On a round table a plate is placed at each of the four cardinal points. At these four mature and slightly rheumatic women, heads wrapped in black turbans, sit. They consume a marrow soup enlivened with ginger and pepper, sometimes it is enough simply to smell it. Then they leave puffing on enormous cheroots to receive and counsel their devotees as if in a royal audience. Then in a single file they dance, sometimes rather grotesquely. The Queen of the West, who takes precedence over the others, dances 'sharpening the blades' of both her swords against each other. Lit candles are then stuck on to the blades. She also cures those who ask her by passing the blades along the ill person's body. She also swallows fire in the form of several candles, though sometimes this dangerous practice (the wax may reach the vocal cords) is delegated to a disciple. This may be the female inhabitant of the empty spaces, the fearsome Maphekwa. After this the mood relaxes with a more comical arrival.

The statue of vegetarian nats like Popa Medaw and the elder Taungbyon Brother are veiled when a piece of raw beef appears. This is for the Prome Lake Sister. She tears the meat with all her teeth, places it on her head, and spits bits out.

The vehicles of several nats then arrive. A tiger pads in on four legs scaring the children. If there is no meat for him he grabs a bunch of bananas and throws them behind him several times. Sometimes he will ferociously remove the bark of an unripe coconut. The consumption of raw meat will take place in the western corner, as far as possible from the alters so as not to offend the vegetarian nats.

Finale

Tigers become men once again indicating the moment of the assembly's dissolution. They scatter grain and empty a glass of water on the street - an offering called 'let the food of the village fall'. The *nat-htein* or 'nat keeper' with the help of his sword makes sure no nat escapes. Sometimes paper is burnt to chase off any bad intentions.

The master may proceed to perform a parody of the Buddhist ritual *a--hmya wei*, the sharing of merits. Sometimes the donors facing the altar want to make an inscription of good deeds on a palm leaf in imitation of the way royal donations were once recorded or like the annual census of good deeds carried out by Thagya-min during Thingyan, the new year celebrations.

The *nat-kadaw*s pack quickly while the offerings are distributed. The pavilion's ground is swept at least three times a day and the nats are fanned away to prevent the lingering of bad spirits. If the festivities were troubled by bad luck, like drunken violence or a death they let the 'fall of the village's food' chase away any wandering souls that were not the royal Burmese nats but had manifested themselves during the rites.

Minor roles at a *nat-pwe*

In addition to the nats whose rites are described above, like Mahagiri and his family, Popa Medaw, U Min Kyaw, the Four Queen Mothers and Pegu Medaw, other nat-dances can be recognised by the following features:

(1) Maung Maung's cradle: the prince heir of the Ava period whose father left him abandoned floating in a cradle in the river. A cloth filled with the weight of bananas is swung, the executors cry like babies. (2) The enticement of Aung Pin-le's elephant. (3) The enticement of Min Ye Kyaw Swa's elephant: the son of the first king of Ava in battle against the Mons; he was killed by a lance in Taw Gyiwa (near Twante); there is a mime of a fight between two elephants. (4) Dance of Shé Gaing Medaw, mother of U Min Kyaw, with two sabres she moves as if she was sharpening them (a feature of the Pakhan festival). (5) The pursuit of the monkey Shwe Min Wun, companion of Hnamadawgyi. There can be three dancers: the pursuer, the monkey and Hnamadawgyi. (6) Dance of Yun Bayin, the Thai King, sometimes called the king of Chiang Mai, a prisoner of the Burmese: a big coconut is thrown three times into the air to represent the Shan country, Mandalay and Myawaddy. (7) Dance of the Myin Byu Shin: dressed in white, he carousels east, south, west and north, whipping the imaginary mount with a eugenia branch and imitating a gallop. (8) The dance of Ahlone Bodaw, Ngwe Daung's grandfather: a bowl of raw rice in which is planted a lit candle is held by a man squatting, nine dancers turn nine times, passing their hand over the flame. (9) Ma Ngwe Daung: acts as if she had wings by moving her scarf; dances are performed offering sticky rice, fried bananas and sweets to this nat. (10) Dance of the Htibyusaung, father of Anawrahta: dances with a sabre wearing the peaked hat and the brown dress of a hermit. (11) Dance of the Zee Daw Medaw (from near Shwebo): mimes of rice planting, cotton spinning and the cooking of sticky rice - a glass of hot water from cooking the rice is balanced on top of the head; there is as a special festival for her at Zeedaw-Shwebo. (12) Ye Yin Kadaw dances with two sabres on which the offerings are placed, the dance of the fire eaters belongs to this choreography with eight to ten candles bound together. (13) Dance of Shin Gon: the dancer is bent double in a stoop. (14) Dance of the Shin Gwa: the bandy legged nat accompanied by her brother. (15) Dance of the Mandalay Bodaw: tutor to the Taungbyon Brothers and protector from tax collectors, he is seen to be writing like a scribe. (16) Dance of the thieves: Amé Gyan wife of a prince-thief of the Ava dynasty likes beer, palm tree wine, *lahpet* and chicken; her festival held near Kyaukse is in June, thieves and dacoits bring chicken and chicken guts for her. (17) U Po Tu dressed like trader carrying on his shoulder a pack full of tea sacks. (18) Manuha the leper-king dances closing his fingers in imitation of the disease; he is scratched by his devotees to relieve his itching. (19) The weavers Mai U and her companion who died because they resisted the advances of Taungbyon Brothers; they dance on their knees as if they were weaving. (20) The dances of the grandfathers of the village - the Bobo Gyi: the Taungbyon Brothers' grandfather dances with his index finger held out straight, like Mandalay Bodaw, with whom he is often confused; Taung Thamin, eldest brother of the queen, drowned by the king's order as he suspected him of being a traitor; he walks with a stick. (21) The ethnic dances: the Karens dressed in red, turn quickly, their arms folded and hitched to each other; they make, as they dance, a salad of roasted chicken which will be shared by the attendants; the Shan Ko Myo Shin, in black with two swords; the Shan brother and sister; Shan dance of Bye Lei Bin at the Bassein festival; the Mon husband and the wife of Mawbi in the delta with Shan music. (22) There are several tiger dances: the one who drinks water, dedicated to Thon Ban Hla; the one who makes a bunch of bananas jump over his head; these tigers are ridden by six nats - Ye Yin Kadaw, Ko Myo Shin, U Po Tu, the Taungbyon Brothers, Mama Ngè the fiancée of the youngest Taungbyon Brother, the Queen of the West. One may follow another. (23) Brother and Sister of Prome dance: they are ogre eaters of raw meat. (24) Tragi-comical intervals: during the *nat-pwe* clowns may unexpectedly appear - a woman with the skirt turned up, shading her eyes with her hand and complaining because she has not been invited; the bottle keeper, who is supposed to live under a bottle's bottom and turns into a stopper to avoid it overflowing.

A MINOR ROLE

U TIN DE

The Nat Festivals

In the times of monarchy in Burma the official number of nats was limited by royal decree to thirty-seven and likewise the major festivals (also called *pwe*) were restricted to eight. But as with the number of nats, so too the festivals far exceed the set number. Any *nat-kadaw* worthy of his name, if he wishes to maintain his clientele and reputation, must attend the Taungbyon festival where the highest dignitaries of the cult each year assemble. His life will be organised around a cycle of festivals consecrated to the individual nats that incarnate themselves in him.

Usually the *nat-kadaw* organises a farewell ceremony dedicated to the nat who will protect him for the journey. Then the little statues, costumes, provisions, sleeping gear and cots for the nats fill several parcels and are snatched up by benevolent hands and transported to the *nat-kadaw's* personal bamboo shelter that doubles as personal shrine and headquarters for the duration of the *pwe*.

The festivals last five, seven and even fifteen days depending on their importance. They have numerous common features: the ablution of the nats (except Zee Daw for certain reasons not connected to the actual rites); offerings and dances; the inflow of merchants and hawkers; the constant arrival of bullock carts bearing groups of pilgrims; the intensive use of loudspeakers; the liberal use of perfume and alcohol, day and night.

A festival will either start or finish on the night of a full moon. People are visibly affected by the sounds and colourful visual display, particularly at night when the gleam of the full moon is supplemented by electric lights supplied by numerous private generators. On their own the crowds are a performance: tough women with fragrant blossoms pinned to their hair buns; other well formed young country women carry a child in one arm and a coconut offering in the other; children from the villages their hair tied in the traditional top knot; the odd Buddhist novices looking a little shifty; old folk readjusting their *longyis*; merchants of peacock feathers, of sugar cane drink, of sticky rice, doughnuts, flowers, sunshades; tattooers, healers, hairdressers, hawkers; homosexuals covered with make-up; policemen in uniform, or out of uniform; merchants holding a cup beneath their giant green cheroots to collect the ashes; there are the ill who hope to be cured; boys in search of adventure.

The main festivals take place in December, March and during the Buddhist lent or *Waso* that coincides with the monsoon in July and August.

Taungbyon and Irinaku Festival

Of all the festivals, the most important is the one at Taungbyon. Twenty kilometres north of Mandalay, on the Medaya railway line, Taungbyon may also be reached by boat or by road so long as the roads have not been rendered impassable after heavy rains. The celebrations take place before and during the August full moon, in the middle of the month of *Waso*.

Hundreds of *nat-kadaw*, not to mention thousands of pilgrims and the curious who come for the good time, assemble from all parts of the land. All who are married or related to the Taungbyon nats, though not necessarily a professional *nat-kadaw*, must come to pay homage or send a

representative to act for them.

The approach to Taungbyon is punctuated with memorials to the Brothers' stormy lives. Several altars show the stages of the rape of the virtuous Mai U by the Younger Brother riding upon a tiger. The village where the brothers ate their first rabbits is now a place to visit. In Taungbyon itself the place where the boys use to play marbles, the room where they used to meditate and even their bedroom are now attractions. At the Pagoda of Vows, built by Anawrahta as a test of his subjects' loyalty, two bricks are missing by the keystone of one of the porches. The nats' palace is situated opposite the pagoda and is the most important nat shrine in Burma.

Special trains are laid on from Mandalay and the roads are jammed. Though there is a strong police presence, the main responsibility for order is carried by the fifteen hereditary keepers of the shrine and the nine dignitaries 'elected by the nats' and identified by the keepers. The Prince of the Crown, the Four Queens and the Four Ministers of the Palace are at the pinnacle of the *nat-kadaw* hierarchy, which has never been a particularly structured organisation. The office of the Prince of the Crown is an hereditary appointment and was originally made by king Thibaw who enjoyed a considerable income by levying taxes on the hundred buildings that formed the Palace of the Nats complex at Taungbyon. It is around the other eight offices that intrigue amongst the *nat-kadaw* community is more evident.

Amongst the hereditary keepers, three are permanent: in 1986 they were U Hla E, his sister Daw Mya Me and their cousin Daw Mya Khin, reputed descendants of U Pi and Daw So who at the beginning of the century, so it is said, brought up the magical number of seven children. The other twelve keepers are their cousins. One of them was criticized for denouncing some misappropriation to the interior ministry of the government. Some little deals can be overlooked but to report them to a cabinet member born at the village of Lung Taung was a scandal! Lung Taung traditionally provides the ropes to tie the two brothers with and has now been excluded from the festival.

The Taungbyon rites are enacted at three different times in the year. The shrine is opened at the end of a December afternoon. On the following day King Anawrahta's proclamation, originally made after his departure to China in quest for the fabulous tooth relic of the Buddha, is read.

Around February or March the same performance is repeated to celebrate his return. Having failed to win the tooth the expedition returns with a jade Buddha and fame for the two brothers. On the day after this opening of the shrine ablutions are performed. These are minor ceremonies when compared to the important six days and nights of the main event in August.

Then, the first day is devoted to the offerings of devotees in the morning and to the official opening in the afternoon. Some people, having made their offerings, at this point leave the festival to escape the excess of the following days. At the opening of the shrine doors a great crowd rushes forward, many with coconuts held aloft, trying to reach first the altar of the two brothers.

PILGRIMS ARRIVE AT THE
TAUNGBYON RAILWAY STATION

THE MAIN IMAGES OF THE BROTHERS IN
THEIR SHRINE AT TAUNGBYON

TAUNGBYON: ABLUTION
OF THE NATS

The opening starts at sunset in the presence of the fifteen keepers with the nine palace dignitaries lined up behind them. These dignitaries act and dance for the Taungbyon Brothers and the family of Mahagiri *min*. Then, the nation's most famous *nat-kadaw* dance for the other nats till about four o'clock in the morning. Such an honour can be expensive. One informant who obtained it declared that he spent 3,000 *kyats*, five hundred in cash and the remainder on delicacies, seven coconuts, two turbans and many scarves and combs, duck eggs, sweets and biscuits for Shin Nemi, the flutist, to distribute.

Traditionally the second day's ablutions should take place in the waters of the Irrawaddy but nowadays are held in front of the palace. The procession is followed by hereditary soldiers in the uniform of the last dynasty followed by the fifteen keepers and the nine dignitaries of the palace. The two nats, born on palanquins, bow three times before the temple and then go round the hall to where the ablutions are performed. Their secretary, U Than Oo, does not participate in the procession. He stays at his corner, left of the altar, and helps those who have troubles with the tax man.

After another day without any major event the most important offering takes place. Wild rabbits, the favourite of the brothers, were caught at the same village where the Brothers originally hunted. They are carried in by a young man amidst much pomp. He circumambulates the village once and the palace seven times. Then he looks for shelter in front of the palace and swings the two beasts in the direction of the nats. The dignitaries descend the steps, salute the wild rabbits, return and repeat their dance six times more. The rabbits are then taken to the altar.

The crowd swells, tense with excitement; there is ribald singing and bawdy heckling. Alcohol is passed about and drunk as the rabbits are grilled. It is offered to the nats behind the altar in the hall of mirrors where the dancers get dressed.

On the fifth day a tree, the *htein pin,* is cut down and replanted near the river. Anawrahta's death, when he was gored by a buffalo, is now commemorated. The legend says that a nat inhabiting such a tree (or maybe the Taungbyon brothers themselves) turned into a buffalo and took revenge for the victims of this royal injustice. Two ministers from the palace cut for each brother a thick branch and carry it around the village. Suddenly one of the queens of the palace clutches a branch and cuts a bit of it with her sabre. This is the sign for the start of a mad scramble to be the first person to grab the piece of *htein pin*, which is reputed to bring happiness. Some devotees do not want to participate in this vengeful ritual.

TAUNGBYON: PROCESSION
FROM THE RIVER

Throughout the festival loudspeakers relentlessly broadcast instructions to ensure everything is going according to plan. Drivers are in an orderly manner made to line up their cars in the car parks at the outskirts of the village. Hundreds of merchants sell flowers and the necessary fruits for the maintenance of the cult. Before him on the ground a tattooer displays his motifs priced at 10 *kyats* per design . Fortune tellers and astrologers remain at their post day and night. The restaurants are packed. Merry groups of young lads, brave with rum, bandy compliments and blow streamers to passing girls; they may even pinch their bottoms.

Ferns have a particular importance in this festival. Once in contact with

the nats they will protect the vital irrigation channels. The men will make a crown of them for themselves and take it back to their fields.

A week after the Taungbyon festival the Irinaku *pwe*, near Amarapura just south of Mandalay's suburbs, begins. The Lady of Popa, the mother of Taungbyon Brothers, out of maternal love goes to Taungbyon from Popa each year for the festival. In ancient times she travelled on an oxcart; but, more recently, she goes by raft up the river swollen at that time by the monsoon rains. She stops over at Irinaku as it was here that she originally learnt of her son's execution. The festival lasts six or seven days and spreads out from the High Palace to the Middle one and ends at the Lower Palace which was built by an Indian. The palace dignitaries, four queens and four ministers concurrently hold their offices at both Taungbyon and at Irinaku. An exiled foreigner of royal origins , noticable by her hair style, appears, this is Thoe Zaung, taken by King Alaunghpaya as a minor wife. She may have been a Portuguese girl taken from his mercenary troops or it is sometimes said to be a Dutch girl kidnapped from a merchant ship.

The day of ablutions gives way to a procession of boats on the river. Popa Medaw and U Min Kyaw, embark along with the orchestra floating on a barge pulled by oarsmen. There is great jollity on the trip, there and back. The atmosphere is as wild as at Taungbyon. There is only one interesting incident on the final day. Homage is paid to a Banyan surrounded by the floods waters of that time. Everyone pulls up their *longyi* and wades out in the mud to place their offering on one of the altars that cover the tree's trunk and branches.

Then the Taungbyon Brothers return to their territory, as does their mother to hers. Meanwhile the *nat-kadaw* move on to their next stop on the annual nat circuit.

Festival of Mingun

Mingun is a truly delightful village that is just visible from the summit of the Mandalay Hill across the expanse of the great Irrawaddy river. Ferry boats are numerous during the festival and only charge two kyats to take passengers to the other side in a journey of less than an hour. Mingun is famous for its colossal unfinished pagoda. It was the ambition of King Bodawhpaya to turn Mingun into the grandest religious sanctuary in the world. Near Mingun the most erudite *sayadaw* in Burma lives at Momeik where the famous Tipitika pagoda was consecrated in 1985.

Equidistant between these two venerable sites, stands the temple of the Prince and Princess of the Golden Teak. The festival takes place from the fifth to the tenth day of the waxing moon of Tabaung. The legend is related in a little book sold during the festival. The story takes place on the Shweli river between Momeik and another town upstream and in the Shan state also called Momeik. U Hkun Naung was Sawbwa of Hsipaw at the time where Mindon sat on the throne of Burma. His youngest brother fomented a rebellion and managed to oust the sawbwa who was unsuspecting. A number of his six children perished in the confrontation and the usurper did not rest until he had eliminated all the possible pretendants to the principality of Hsipaw.

As a consolation the deposed *sawbwa* accepted from Mindon the gov-

MINGUN: ABLUTION OF THE NATS

MINGUN: THE PROCESSION

MINGUN: THE NAT'S PALANQUIN

MINGUN: THE NAT'S DEPARTURE

ernorship of the Momeik township and went there with his two surviving children - Sai Tung Naung and his sister Sao Naung Htwe. He returned once again to a pleasant and peaceful existence punctuated by sumptuous festivities on the Shweli river during the hot season. One year, suffering from exhaustion the *sawbwa* could not attend the boat race. His young children ran away from their minders and jumped into a long boat and navigated the waters. The governess gave the alert but the people, engrossed in the entertainments, did not hear her. With the approach of a menacing storm everybody looked for shelter as the boat drifted away and the river flooded carrying timbers off. One such teak trunk struck their boat and split it into two pieces, the children grabbed the trunk but drowned by Thit Yaik Kyun, the 'Isle Where the Teak Hit the Log. The loyal governess grabbed another log and went after her children followed by the sawbwa and his mahadevi. When she despaired of finding her children, their mother died from a broken heart. Her husband had at this place the Lwan-hpaya or 'Pagoda of Despair' built.

Nevertheless the fatal tree ended up landing on a sterile shore since known as the Kyun Bin Hla (the Island of the Beautiful Tree). It was then carried off towards the confluence of the Irrawaddy and Sweli rivers. At the village near the Mingun-Thebyu creek the Bo Bo Gyi, the guardian spirit of that locality, announced to the children that they were not human any more but nats and gave them jurisdiction of twelve districts. Obedient to their destiny the new nats established themselves in a tree rooted to the ungrateful and sandy earth of the river banks. Little by little a *nat-sin* developed and a cult formed.

It teaches some strange ideas: no one may approach the teak tree by horse, couples should not come without risking the bite of a snake, an offering of flowers should be tied to the prow of boats for safe passage.

The nats have thus become the keepers of the river and it is said their power spreads from the Shweli as far south as Pagan. In 1937, Daw San Shwe the wife of a boatman saw The Prince of the Golden Teak appear. He asked her to build a bigger *nat-sin* and also a pagoda. The Japanese occupation and the forced absence of her son to work on the Siam-Burma railway made such a donation at such a time not easy. However after the war she fulfilled her obligation and from then till now there has been a festival at Mingun.

The sacred tree is still there and flourishes not around March or April as is normal but in August with its flowers ever turned in respect towards the *nat-sin*. The temple was renewed in 1977 and the pagoda the nats had so wanted was then built.

On the 16th August 1985 the festival arrangements were jeopardized by a cholera epidemic in the Sagaing area. The town council forbade the gathering though the Taungbyon festival, outside the Sagaing Division's jurisdiction went ahead. Despite this, on the following day the party was at its pitch before the indulgent eyes of the local police.

That day was dedicated to the ablution of the nats in the river. Due to the government restrictions the bamboo raft had failed to arrive. The procession therefore went by foot to a creek at about two kilometres away from the temple.

The next day was dedicated to a rather unusual ceremony. The nats

were placed on two swings that were solemnly set in motion. After this short game, the followers rushed to pick up the leaves that ornamented the swings. The swinging ritual was performed outside the temple for the Bo Bo Gyi and then all the *nat-kadaw* themselves took part in the swinging game.

On the fourth day, the public were allowed to swing and the fifth day was dedicated to taking the nats for a stroll in the gardens. On the sixth day a tree, specially cut down for the occasion, arrived. The last day was dedicated to making offerings to the monks who were not averse to showing themselves.

The proximity of the Irrawaddy river gave the festival an unusual solemnity. The legend that gave it birth has some analogy with the Mahagari one. Mahagiri perished with his sister through fire and not water but in both legends they drift on the river on a floating log. During the Burmese monsoon drifting trees are so common a sight that these stories cannot but stimulate the popular imagination.

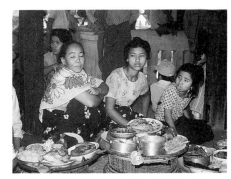

OFFERINGS FOR THE QUEEN OF
WITCHES AT ZEE DAW

Zee Daw Festival

Zee Daw can be reached by crossing the Chindwin at Monywa and taking the Yemabin road for twenty-two kilometres through paddy-country. Then, leaving the main road, after some distance spent jumping dykes in a cloud of dust a deserted wilderness is reached. Were it not for the communal excitement customary at such festivals that transform a dozy hamlet into a fairground then this place would have limited appeal. There reigns a distinct atmosphere caused by the fact that this is the most important gathering of witches imaginable.

Ye Yin Kadaw, the Queen of Witches, was the sister of 'King' Taung U who, other than his name, is a totally unknown character. She became the minor wife of a Shan sawbwa. She had formidable powers and both her wishes and curses were equally effective. The other royal wives were afraid of her and managed to convince the king to send his favourite wife into exile. She took the Monywa road and established herself at Maung Don village near Zee Daw. There she drowned.

Her oldest statue in Burma is at Maung Don and is no more than thirty centimetres high. She is paid homage at the full moon of Tabaung till the eighth day of the waning moon. After the ritual ablutions, she used to be carried on a palanquin to Zee Daw, which is only a few miles away. This arrangement ended around 1978 as a result of some financial disagreement between the two villages.

The Zee Daw people therefore produced their own image of Ye Yin Kadaw and on a far larger scale and adhered its back to a wall to protect it from being stolen by vengeful Maung Donians. As a result there are no processions nor ablutions. Although the Maung Don temple is controlled by five hereditary keepers, the Zee Daw one is under the control of the local people's council and runs at a profit.

The festival starts at Maung Don and then moves on to Zee Daw. It is accompanied by much slaughtering as the nat likes raw meat. After it is offered it is taken back, cooked and offered a second time.

Dressed in black and carrying two swords Ye Yin Kadaw's husband

PROCESSION BY BULLOCK CART
AT AHLONE

performs the ritual dances before the *nat-kadaws* and guests. The human witches can only make their offerings when the guests have finished making theirs and have started packing up to go home. The witches often offer Ye Yin Kadaw pork which she likes so much. However, the *nat-kadaws* refrain from making such an offering out of respect for the Taungbyon Brothers. By so doing the witches hope to achieve some nat-like powers for themselves.

Ye Yin Kadaw, a witch, is expected to eliminate a rival for a job or a promotion for his patron. According to the orthodox *nat-kadaw* a favour is only done when the cause is fair and reasonable. Though the request is made during the festival, the sacrifice of an animal in thanks is made after the festival in accordance with the demands of the trustees.

The Ahlone Festival

Twelve kilometres north of Monywa, on the Shwebo road, the town of Ahlone celebrates its festival from the seventh day of the waning moon of the month of Tabaung until the the new moon.

The heroine of these festivities is Ma Ngwe Daung (Miss Silver Wings) who is also called Ma Pyu Lwa (Miss White and Pure). She was a daughter of the Ahlone Bodaw, who was a minor Indian prince who came down into Burma through Tamu or Kaletmyo. His history would have been forgotten were it not for the love story of Maw Ngwe Daung. The young girl became infatuated with U Min Kyaw, the notorious drunkard, who was hardly an ideal son-in-law for a maharaja, even if a not very important one. It is not difficult to imagine his irritation at the stubbornness of his little daughter who surely deserved a better match. U Min Kyaw's indiscretions proved him right. This womanizer soon lost interest in Ma Pyu Lwa in favour of the embraces of Shin Bome whose father was a manufacturer of a famed toddy or palm wine. The maharaja's family thought their daughter would forget her one-time suitor and so the years went past.

One night she heard from a nearby hill the music of a harp. Ma Ngwe Daung ran until she was out of breath believing that she had heard U Min Kyaw. Once there, in the dark, she threw herself into the harpists arms. Unfortunately it was her brother, Shwe Kyauk Saung who snubbed her. Shameful of this misunderstanding, Ma Ngwe Daung jumped of a cliff. Before giving up her soul she cursed all unfaithful men. All men possessed by her spirit would be perpetually unsatisfied in love and never find happiness even if they had as many mistresses as hairs on their heads. At least as long as they married them. Ma Ngwe Daung was chosen because of this tragic fate to be a nat. Any men she falls for will be abandoned to the agonies of unhappy love. Of all the female nats she is the only one whose victims by the *ley-bya-taik ceremo*ny do not even get to become her brother or son but only her husband.

There was the case of a Burmese professor whose marriage would not work. The unhappy wife took him to be married with Ma Ngwe Daung. He promised to go every year to Ahlone for at least three years. If he was stopped from doing so he would confide his offerings to a *nat-kadaw* who would represent him at the festival. Their marriage recovered and regained its serenity.

Indeed, Ahlone holds much appeal for pilgrims who ask Ma Pyu Lwa to give them the opportunity to have as many mistresses as hairs on their head. The festival appeals also to pilgrims wishing to control or to cure skin illnesses with the lustral water on offer there. Here lepers gather not far from the temple.

The temple itself is situated not far from the railway line. Its architecture is not very noteworthy. The corrugated iron of the roof is as rusty and decrepit as all else seems to be. As at all great *pwe*, merchants have built bamboo stalls about which are parked innumerable oxcarts.

The eve of the festival a torch-lit procession arrives in the dark of the night at the hill where she met her fate. It is not particularly high and it is difficult to imagine the maiden falling to her death from it.

On the ninth day of the waning moon, nine oxcarts in procession carry the nats to the waters of the Chindwin river followed by the hereditary keepers of the temple. In 1985 there were actually only two carts present but the crowd was significant. Eugenia leaves carried aloft in the arms of the devout appeared to form a great green blanket over the passionately swelling mass of followers. Once the water was placed at the temple, the crowd jostled to get in and drink it or rub it over their bodies. Nobody there could explain why the Ma Ngwe Daung legend is associated with the cure of skin diseases. The actual homage to Ma Ngwe Daung does not start till the third or the fourth day of the festival, after the offerings had been given to her grand-father and her grand-mother.

As she was of Hindu origin she cannot be offered meat, neither beef nor pork, and alcohol is banned in remembrance of U Min Kyaw's involvement. Traditional offerings like white flowers, Indian sweets, sweets fried bananas, nine fried fishes with scales and nine rice cakes coloured red and white are, though, common.

The number nine here is held in honour and nine nats appear at the Ahlone festival: Shwe Let Pan (Ahlone Bodaw), Myin Byu Shin (village keeper), Ko Myo Shin (town keeper), La Bo Shindaw (wife of no.1), Shwe Kyauk Saung (the brother), U Si Kadaw (the eldest sister), Ma Ngwe Daung (Ma Pyu Lwa), Shin Saba (the sister), Shin Mya Hnit (the youngest).

At the temple of Ahlone Shwe Let Pan, the elder brother with his wife La Bo Shin Daw sit on the throne but the Ma Ngwe Daung cannot be found. Though one cannot help but be moved by her disappointment in love, the temple is dedicated to the elders who blamed her. The moral of this tale lies in the hands of the listener.

Popa Festival

Mount Popa is a vast volcanic mountain that overwhelms the flat landscape only one hour's drive south-east of Pagan. On the peak are two pagodas situated half a mile apart. The mountain is thickly vegetated and a number of hermits find a living here with the faithful bringing rice to them at the weekends. To the west is situated the *taung-lei* or little mountain, an offshoot of the volcano which is the abode of Mahagiri, the most important of all the nats.

Between the two mountains amidst various monasteries is a large *nat-sin* built under the sponsorship of U Nu, Burma's prime minister in the

THE LITTLE MOUNT POPA WITH
NAT-SIN ABOUT IT

1950s. It contains the statue of Mahagiri and his sisters carved from teak tree trunks. The originals was washed down the Irrawaddy so many centuries ago were of *saga-pin* or frangipani and were four and half feet high, the size of the present ones. Later, at the request of the nats gold heads were added thus conferring the rank of princes of the royal blood. In 1785 Bodawhpaya new ones were moulded and thirty years agonew heads were added. During British rule the heads were transferred to the Pagan museum and then to theBernard Free Library at Rangoon. The procession of these heads to the altar became an important tradition at each year's festival.

In ancient times the annual festival was marked by sacrifices of white buffalos, oxen, and goats in honor of the nat. These sacrifices have now been banned from the festival. The main festival is held from the full moon of December to the sixth day of its waning. There is also a more minor celebration of 'the departure for China' when Anawrahta's proclamation to the army about to go off and conquer China in order to capture the Buddha's tooth is read out.

MAIN FESTIVALS OF THE NATS

| | |
|---|---|
| Ahlone | 7th day of waning moon to new moon of Tabaung (March) for **Ma Ngwe Daung** |
| Amarapura | 7th day of waning moon to new moon of Wagaung (Aug.) for **Popa Medaw** |
| Ava | 10th day of waxing moon to full moon of Tabaung (March) for **Thon Ban Hla** |
| Delta | various places for **U Shin Gyi** |
| Sameikkon | 10th day of waxing moon to full moon of Tabaung (March) for **Shin Nemi** |
| Kyaukse | 1st to 3rd day of waxing moon of Wagaung (Aug.) and 14th day of waning moon to new moon of Tagu (April) for **Shwe Sagadaw** |
| Legyi | 2nd to 5th day of waning moon of Tabaung (March) for **Mahagiri** |
| Maymyo | 1st to 5th days of waning moon of Tabaung (March) for **Ko Myo Shin** |
| Mingun | 5th to 10th days of waxing moon of Tabaung (March) for the **Brother and Sister of the Teak Tree** |
| Myittha | 8th day of waxing moon to full moon of Tawthalin (Sept.) for **Shwe Nabe** |
| Monywa | from full moon of Tabaung (March) to 8th day of the waning moon **Ye Yin Gadaw** |
| Pakkhan | 1st to 16th days of the waxing moon of Tabaung (March) for **U Min Kyaw** |
| Kamebyin | 13th day of waxing moon to full moon of Tawthalin (Sept.) for **Kamebyin Bo Bo Gyi** |
| Popa | from full moon of Nadaw (Dec.) to its sixth day of waning for **Mahagiri**; from 9th to 13th days of waning moon of Wagaung (Aug.) for the **Taungbyon Brothers** (departure for China); night of the 13th to noon of 14th day of waxing moon of Tagu (April) for the **Taungbyon Brothers** (return from China) |
| Prome | Full moon to 5th day of waning moon of of Nadaw (Dec.) for the **Prome Brothers** |
| Sagaing | [not known] for **Htibyusaung Medaw** |
| Shwe-gu-ni | 1st to 15th days of waxing moon of Tabaung (March) for **U Min Kyaw** |
| Taungbyon | 10th day of waxing to full moon of Wagaung (Aug.), 14th day of waxing to full moon of Nadaw (Dec.), 10th and 11th days of the waxing moon of Tabaung (March) for the **Taungbyon Brothers** |
| Zee Daw | 8th day of the waning moon to the new moon and 1st to 7th days of the waxing moon of Tabaung (March) for **Ye Yin Gadaw** |

GLOSSARY OF TERMS

| | |
|---|---|
| a-hmya pwe | ritual of merit sharing by pouring of lustral waters |
| ameindaw-pyan | funeral rite to prevent an official functioning after death |
| apin | ingredients added to ordinary food by melevolent witches |
| ari | unorthodox sect of forest monks at late Pagan |
| arupa | the eleven upper levels of existence of the world of formlessness |
| asura | guardians and judges at *asurake* |
| asurake | purgatory |
| ahtetlan-hsaya | exorcist |
| auklan-hsaya | sorcerer |
| balu | ogre |
| Bobo-gyi | 'grandfather', village protector |
| bou-ban | monsters |
| byammas | Brahmas, gods of the upper heavens |
| dah | sword or knife |
| dat-lon | alchemists bowl |
| dauk-cha | the peaked leather hat of certain hermits |
| Deitton | book of formulas to avoid bad luck |
| dewa | gods |
| dhamma | the Buddhist law or teachings |
| gaing | group or sect |
| galon | garuda, a giant mythical bird |
| ghatas | sacred texts recited during festivals |
| hsaing waing | full classical orchestra |
| htein-pin | tree used in nat festivals |
| in | cabalistic |
| in weikza | wizard who uses cabbalistic signs |
| Jambudipa | the southern continent in Buddhist cosmography where humans live |
| kadaw | to worship or pay respect, also the wife of someone prominent |
| kadaw-pwe | ritual of respect and offerings |
| kala-tain | 'Indian chair', western style chair |
| kaliyuga | the last of the four world eras that terminates in apocalypse |
| kalpa | an aeon of cosmic time |
| kamma | 'karma', the balance of good and bad action that determine man's future |
| Kate | king planet in the cult of the runes |
| kousan | twelve guardian angels of each man |
| kritayuga | the golden age of Hinduism |
| kyat | unit of Burmese currency |
| kyi-waing | eighteen bronze gongs of an orchestra |
| lah-pet | pickled tea leaves offered on social occassions |
| Lawka Byuha | treaty of protocols |
| lawka | the world, originally a Vedic term (*loka*) |
| leh-pwe | amulets |
| ley-bya | butterfly soul |
| ley-bya-taik | rite of possession |
| longyi | sarong |
| lun-swe-pwe | tug of war |
| Myin-mo-taung | Mt. Meru |
| Mahagita Medanigkyan | an anthology of Burmese songs that includes the *nat-than* |
| mei-zaing | mother's protector nat |
| min | king or lord |
| naga | dragon-like mythical animal |
| naga-yit | whirlpool, where Duttabaung of Prome was drowned |

| | |
|---|---|
| nat-kadaw | 'wife' of a nat, a spirit medium or master of rites |
| nat-than | odes of the nats, see *Mahagita Medanigykan* |
| nat-htein | a functionary who acts as guardian of the nats during a *pwe* |
| nat-kyaw | possession of a lay follower |
| nat-myu | possession of a *nat-kadaw* |
| nat-pwe | festival for the propitiation of the nats |
| nat-sin | house or shrine to shelter nat images. |
| neikban | see *nibbana* |
| nga-yan | cat fish, used in the Pegu medaw pwe |
| nga-ye | hell |
| nibbana | the ultimate state of non being; in Sanskrit 'Nirvana' |
| ouk-tazaung | guardian of a treasury |
| padesa | mythical tree in the creation story |
| pan-shwe | gilded flowers that adorn a temple or stupa |
| parabaik | a manuscript |
| parami | a state where suffcient merit has been accumulated to be close to the state of *nibbana* |
| pat-waing | twenty-one circular hanging drums of the orchestra |
| pei-zaing | father's protector nat |
| phi | Thai and Lao for a spirit |
| preita | place of torment between earth and hell |
| pwe | festival, rite or meeting |
| pyin-sa-yu-pa | the mythical composite animal which is the mount of *Kate* |
| pyada weikza | alchemist or *zawgyi* |
| Rahu | planet that shares Wedensday with Mercury and rides a tuskless elephant |
| rishi | hermit |
| rupa | the sixteen immaterial levels on the ladder of existence of the world of form |
| say weikza | quack doctor |
| sayadaw | senior monk, often the abbot |
| sawbwa | a hereditary Shan prince or chieftain |
| shin pyu | ordination ceremony for Buddhist novices |
| Shwe Bon Nidan | a treatise of protocol |
| sidaw | musical term for a royal march |
| sima | Pali for a Buddhist ordination hall, *thein* in Burmese |
| son | female sorcerer or witch |
| tasei | or *thaye*, a ghost |
| Taung-lei | the smaller Mt. Popa, abode of Mahagiri |
| Tawatimsa | the most famous Buddhist heaven (*Tavatimsa*)where Thagya-min resides |
| thabye | a tree (*Eugenia*) used for ritual purposes |
| than weikza | the iron alchemist |
| thaye | a ghost |
| thein | ordination hall or *sima* |
| Theravada | the southern and first school of Buddhism followed in Sri Lanka, Burma Thailand, Laos and Cambodia |
| to-naya | mythical composite animal |
| waso | the Buddhist 'lent', a period of retreat for monks |
| weikza | wizard |
| wun | a royal official |
| wungyi | a government minister |
| yathe | hermit or rishi rejected by the Buddhist orthodoxy, recognisable by pointed leather hat |
| zat-tin | association of performing artists |
| Zatumaharit | the first Buddhist heaven of the four guardian gods (*Catummharajaika* in Pali) |
| zawgyi | magician |
| yei-sin | lustral water mixed with gladioli used in rites of posession |
| yuzana | ancient Indian terms of measurement, equivalent to about ten miles |

GLOSSARY OF CHARACTERS OUTSIDE
THE PANTHEON OF THIRTY-SEVEN

| | |
|---|---|
| Ahlone Bodaw | father of Ma Ngwe Daung |
| Akhatasoe | spirit of the sky |
| Amé Gyan | beer drinking wife of an Ava prince-thief |
| Anawrahta | 1st historic king of Pagan (1044-77) |
| Athakouma | Pegu prince adpoted by Pegu Medaw |
| Bawdithida | Indian king, his image used for invulnerability tattoos |
| Bo Nyo | side-kick of U Min Kyaw |
| Bobo Aung | Grandfather Victory, 18th c. master of the Cult of the Runes |
| Bobo-gyi | Big Grandfather, village protector(s) |
| Byat Ta | father of Taungbyon Brothers with Popa Medaw |
| Byat Wi | brother of Byat Ta |
| Byamma-nat | Brahma, Hindu god |
| Dhammazedi | monk-zawgyi who became king of Pegu |
| Hkun Naung | Sawbwa of Hsipaw, governor of Momeik, father of Golden Teak nats found there |
| Hti Byu Saung | Cucumber King, hermit father of Anawrahta |
| Ko Aung Dain | guardian of Pegu Medaw |
| Ko Myo Shin | Lord of the Nine Towns, an outside nat, associated with U Min Kyaw |
| Mahapienne | Ganesha, Hindu god |
| Mai-U | victim of the Younger Taungbyon's lust, outside nat |
| Mama Ngè | fiancée of Younger Taungbyon |
| Man-nat | the devil, spirit of evil |
| Ma Ngwe Daung | Ma Pyu Lwa, Miss White and Pure, heroine of the Ahlone festival, victim of U Min Kyaw |
| Medaw Shwegasa | mother of Shwe Sippin, |
| Maitreya | the future buddha, no.28 (in Burmese 'Metteyya') |
| Min Ye Kyaw Swa | son of 1st Ava king, killed in elephant battle at Taw Gyiwa |
| Miss Oza | daughter of the governor of Thaton in the Taungbyon story |
| Moe Kaun Kyaw Swa | Good Rain Kyaw Swa, spirit of the rain |
| Myin Byu Shin | Lord of the White Horse, soldier-nat of the Ava period, four legends of origin |
| Pegu Medaw | Eninga Laung, Lady Buffalo of Pegu, outside nat |
| Popa Medaw | Lady of Popa, a flower eating ogress, mother of the Taungbyon brothers |
| Sai Tung Naung | Princess of the Golden Teak, sister drowned in Shweli River, subject of Mingun festival |
| Sao Naung Htwe | Prince of the Golden Teak, brother drowned in Shweli River, subject of Mingun festival |
| Shé Gaing Medaw | mother of U Min Kyaw |
| Shwe Bu-thi | Golden Marrow, mother of Ko Aung Dain |
| Shwe Min-wun | companion of Hin Na-ma Daw-gyi |
| Sokkate | son of the Cucumber King, brother of Anawrahta |
| Taung Thamin | brother of a queen, executed for treason |
| U Shin Gyi | Maung Shin, outside nat popular in delta, particularly amongst boatmen |
| U You Daing | a nature spirit ousted as guardian of homes by Mahagiri |
| Upaka | spirit of the earth |
| Ye Yin Kadaw | queen of witches |
| Yokhasoe | spirit of trees |
| Zee Daw Medaw | popular nat in Shwebo area |

BIBLIOGRAPHY

Bernot, Denise. 'Les Nats de Birmanie, génies, anges et démons.' *Sources Orientales*, Eds. du Seuil, Paris 1971, pp.297-340.

Brac de La Perrière, Bénédicte. 'Le culte de nat, cérémonies dans une banlieue de Rangoun.' *Cahiers de l'Asie de Sud Est*, No. 13 & 14, Paris 1983, pp. 7-47.

Les rituels de possession en Birmanie. Centre National Recherche Scientifique, Paris 1990.

Brohm, John. 'Buddhism and animism in a Burmese village.' *Journal of Asian Studies*, Vol.22, 1963, pp.155-67.

Brown, Grant W F. 'The Taungbyon festival.' *Journal of the Royal Anthropological Institute*, Vol. 45, London 1915, pp. 355-63.

'The dragon of Tagaung.' *Journal of the Royal Asiatic Society*, Vol.47, 1917, pp.741-51.

'The pre-Buddhist religion of Burma.' *Folklore*, Vol.32, 1921, pp.77-100.

'Rain making in Burma.' *Man*, Vol.8, Rangoon 1908, pp.145-146.

'The lady of the weir.' *Journal of the Royal Asiatic Society*, Vol.46., 1916, pp.492-96.

Burlingame, E.W. *Burmese legends.* Harvard Oriental Series, New Haven 1921.

Buchanan, Francis. 'Religion and literature of the Burmans.' *Asiatick Researches*, Vol.6, 163-308, 1779.

Cochrane, H.P. *Among the Burmans.* Fleming H. Revelei, London 1904.

Gorer, Geoffrey. *Burmese personality.* Institute for Inter Cultural Relations, New York 1943.

Hall, D.G.E. 'Burmese religion, beliefs and practices'. *Society for the Study of Religion*, Vol.40, 1942, pp.12-20.

Hattori, Shoichi. 'Burmese cult of the nat.' *Gaikokugu Daigaku Gakuko*, No.14, Osaka 1963, pp.11-38.

Htin Aung. 'Alchemy and alchemists in Burma.' *Folklore*, [no.] Rangoon 1933, [pp.]

Folk elements in Burmese Buddhism. Oxford University Press, Rangoon 1962.

Jordan, Marc. 'L'animisme des chins.' *Bulletin des missions étrangères*, [date, no.] Paris 1953-61, [pp.]

Khin Myo Chit. *A wonderland of Burmese legends.* Tamarind Press, Bangkok 1984.

Langham Carter, R.R. 'Lower Chindwin nats". *Journal of the Burma Research Society*, Vol.23, (1933) and (1934), pp.105-111.

Maung Maung Tin. 'The tradition of the nats.' *Shwey Yadu Thabin*, Rangoon [date] [pp.].

The brother and the sister of the teak tree.' *Samokvan*, No.3, Rangoon 1985 [pp.]

'The four lords of the white horse.' *Samokvan*, No.4, Rangoon 1985, pp.110-113.

'The *natsin* of Amarapura.' *Ahtwe Amyin*, Rangoon 1985, pp20-23.

'Menstruation diseases and the 37 nats.' *Kalya* No. 13, Rangoon 1986, pp.16-19.

Nash, June. 'Living with nats.' In: *Anthropological studies in Theravada Buddhism*, Cultural Report Series, No.13, Yale University Southeast Asia Series, New Haven 1966, pp.117-36.

O'Rilley. 'On the spirit worship of the Talaings.' *Journal of Indian Archipelago and East Asia*, 1850.

Pe Maung Tin and G.H. Luce. *Glass Palace chronicle of the kings of Burma'.* Oxford University Press, Oxford, 1923.

Po Kyar. *Thon-se-hkun-e-se min* [The thirty-seven nats]. Myanma Gonyee Press, Rangoon 1973.

Sangermano, F.V. *A description of the Burmese empire, compiled chiefly from Burmese documents.* Rome 1833, Susil Gupta, London 1966, 5th ed.

Sein Tu, U. *Ideology and personality in Burmese society.* Harvard University Mimeograph [No.] Boston 1955.

J. G. Scott [Shway Yoe]. *The Burman, his life and notions.* Macmillan, London 1882. Reprinted by Kiscadale Publications, Arran 1989.

Gazeteer of Upper Burma and the Shan States. 5 Vols. Government Printing, Rangoon 1900-01.

Spiro, Melford. *Burmese supernaturalism.* Prentice Hall, ISHI, Philadelphia, 1967.

Shwe Zan Aung Maung. 'Hypnotism in Burma.' *Journal of the Burma Research Society,* Vol. 2, 1912, pp.44-56.

Taw Sein Ko. *The spiritual world of the Burmese.* Ninth International Religion Congress, London 1893.

Shorto, H.L.. 'The dewatan sutapan, a Mon prototype of the 37 nats.' *Bulletin of the School of Oriental and African Studies,* Vol. 30., London 1967, pp.127-141.

Temple, R.C. *The thirty-seven nats.* W. Griggs, London 1906. Reprinted by Kiscadale Publications, London 1991.

Vossion L. 'Nat worship among the Burmese.' *Journal of American Folklore,* No.4, 11891, pp.1-8.

FILMOGRAPHY

Rodrigue, Yves. *Esprit es tu la? Le culte birman des nats.* 16mm, 42 minutes, Paris 1989.

De la danse à la transe. CRNS, 16mm, 42 minutes, Paris 1990.

Les esprits en fête. 16mm, 40 minutes, Paris 1992.

The Thirty-Seven Nats

by Noel F Singer

၁။ သိကြားနတ်။

1. THAGYA
Indra or Sakra

၂။ မဟာဂိရိနတ်။

2. MAHAGIRI
'Lord of the Great Mountain' or Maung Tin De,
a Pyu blacksmith of Tagaung who was burnt to death by the king.

၃။ နှမတော်ကြီးနတ်။

3. HNAMADAWGYI
'Great Royal Sister of the Mahagiri', personal name Saw Mair Ya, also known as Taunggyi
Shin 'Lady of the Great Mountain' and Shwe-myet-hna 'Lady Golden Face'. She was burnt
to death with Maung Tin De. Her devotees claim that the title of Mahagiri
belongs to her and not to her brother.

၄။ ရွှေနဖူးတော်နတ်

4. SHWE NABE

'Lady Golden Sides,' so called because her official robe had side panels of gold brocade,
consort of the Mahagiri. She was a Pyu water dragon spirit from
the town of Mindon; died of grief.

ပါ။ သုံးပန်လှနတ်။

5. THON BAN HLA

'Lady Three Times Beautiful', so called because she was beautiful in the morning, afternoon, and at night. Variously stated as being either a Mon ar a Pyu spirit. Some claim that her name was Shin Htway Hla and that she was the youngest sister of the Mahagiri. She was also the chief queen of the King of Okkalapa. Believed to have died of grief.

ျပ ေတာင္ ၄ ႐ွင္ မင္း ေခါင္ နတ္ IL

6. TOUNGOO MINGAUNG

'King Mingaung of Toungoo'. Died from dysentery; the strong smell of onions
is believed to have hastened his death.

၇။ မင်းတရားနတ်။

7. MINTARA
'King Hsinbyushin' Tharabyar of Ava (1400-01). Became confused after an amorous
encounter with the Hindu goddess Sarasvati in the jungle. He was subsequently
assassinated.

8. THANDAWGAN

'Ye Phyar', the Royal Secretary to Taungoo Minhkaung. Variously stated as having died either from malaria while collecting flowers in the palace gardens for the king at night.

9. SHWE NAWRAHTA
The young prince, accused of instigating an assassination attempt, was ceremonially
drowned by King Shwenankyawshin (1501-26) at Ava.

၁၀။ အောင်ဇွာမကြီးနတ်။

10. AUNGZWAMAGYI

'Captain Aungzwa', sometimes known as Myin Byu Shin 'Lord of the White Horse'. Five variations are known. The latter title is also claimed by the Shwe Sit Thin 'no. 19'.

၁၁။ ငါးစီးရှင်နတ်။

11. NGAZISHIN
'Lord of the Five White Elephants' (1342-50).

၁၂။ အောင်ပင်လယ်ဆင်ဖြူရှင်နတ်။

12. AUNGBINLE HSINBYUSHIN
'Lord of the White Elephant from Aungbinle Lake,
the title of King Thihathu (1421-25).

ၥ၃။ တောင်မကြီးနတ်

13. TAUNGMAGYI
'Lord of Due South' also known as Shin Nyo 'Lord Brown', because of the
colour of his robe'. Son of the Mahagiri and Shwe Nabe.

၁၄။ မောင် မင်း ရှင် နတ်။

14. MAUNG MISHIN
'Lord of the North' also known as Shin Phyu 'Lord White, because of the
colour of his robe'. Son of the Mahagiri and Shwe Nabe.

15. SHINDAW
'Lord Novice'. Death caused by a snake.

၁၆။ ညောင် ချင်း နတ်။

16. NYAUNG-GYIN
'Old Man of the Solitary Banyan Tree' was a Mon prince shown here with the distinctive
Mon hairstyle, cousin of the Mon King Manuhaw of Thaton. He died of leprosy sometime
during the eleventh century.

၁၇။ တပင်ရွှေထီးနတ်။

17. TABINSHWEHTI
King of Burma between 1531-50.

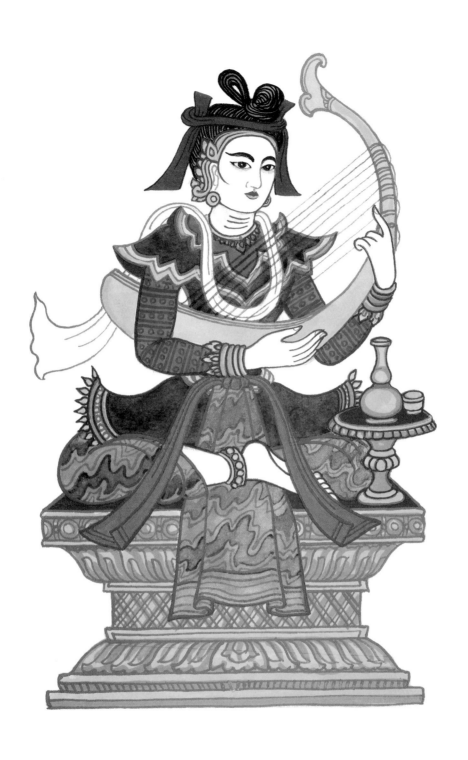

၁၈။ မင်းရဲအောင်တင်နတ်။

18. MINYE AUNGDIN
Brother-in-law of King Thalun, (1629-48) died
from indulging in alcohol and drugs.

၁၉။ ရွှေစစ်သည် နတ်။

19. SHWE SIT THIN

'Prince Shwe Sit Thin, son of Saw Hnit, r.1298-1325'. He also claims the title of Lord of the White Horse. Sent to quell a rebellion, he spent his time cock fighting. He died as a result of being buried up to his waist by his furious father.

၂၀။ မယ်တော်ရွှေစကားနတ်။

20. MEDAW SHWEDAW
'Lady Golden Words, mother of Prince Shwe Sit Thin;
she died of a broken heart.

၂၁။ မောင် ပိုးတူနတ်။

21. MAUNG PO TU
'Maung Po Tu, a Shan Tea merchant of Pinya who was killed by a tiger
during the reign of Minkaung of Ava (1401-21).

22. YUN BAYIN
Maharaja Mekut'i, king of Chiengmai, known to the Burmese as Bya Than, was brought as prisoner to Pegu by Bayinnaung (1551-81) where he died of dysentery.

23. MAUNG MINBYU
'Prince Minbyu; death caused by alcohol and drugs'.

၂၄။ မန္တလေး ဘိုးတော်နတ်။

24. MANDALAY BODAW
'Lord Grandfather of Mandalay'; a Brahmin tutor of the Shwebyin Brothers during the reign of Anawratha. (1044-77). Another version claims that he was the tutor of Prince Minshinzaw, son of Alaungsithu (1112-67).

၂၅။ ရွှေဖျင်း နောင်တော် နတ်။

25. SHWEBYIN NAUNGDAW
'Elder Brother Inferior Gold', who was killed by Anawratha (1044-77).

၂၆။ ရွှေ ဖျင်း ညီ တော် နတ်။

26. SHWEBYIN NYIDAW
'Younger Brother Inferior Gold, who was killed by Anawaratha (1044-77).

၂၇။ မင်းသားမောင်ရှင်နတ်။

27. MINTHA MAUNG SHIN
'Prince Shin, grandson of Alaungsithu (1112-67). While studying in a monastery,
as a novice, he was killed when he fell from a swing.

၂၈။ ထီးဖြူဆောင်းနတ်ူ

28. HTIBYUSAUNG
'Lord of the White Umbrella', Kun Saw the father of Anawratha (1044-77). He was forced
to become a priest by his usurping stepsons Kyi Soe and Sokkate.

၂၉။ ထီးဖြူဆောင်းမယ်တော်နတ်။

29. HTIBYUSAUNG MEDAW
'Lady of the White Umbrella', the mother or Kun Saw.

၃၀။ ပရိမ္မရှင်မင်းခေါင်နတ်။

30. PAREINMA SHIN MINGAUNG
'The Usurper Mingaung of Pareinma', personal name Kyi Soe (986-992 AD).
Killed by an arrow whilst hunting deer.

၃၁။ မင်းစည်သူနတ်။

31. MIN SITHU
'King Alaungsithu' (112-67). Smothered to death by his son Narathu (1167-70).

၃၂။ မင်းကျော်စွာနတ်။

32. MIN KYAWZWA
'Prince Kyawzwa' who was fond of cock fighting, women, opium, and alcohol.

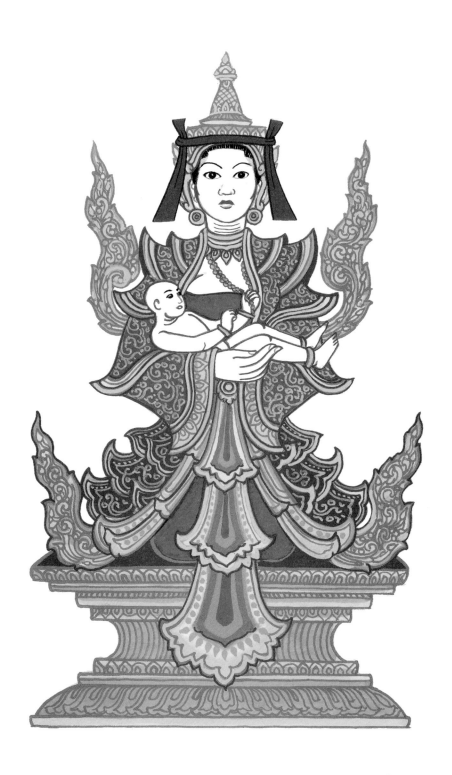

၃၃။ မြောက်ဘက်ရှင်မနတ်ိL

33. MYAUKPET SHINMA
'Lady of the North', died during the reign of Tabinshwehti (1531-50) from complications
arising from giving birth to her child.

၃၄။ အနောက် မိ ဖုရား နတ်�||

34. ANAUK MIBAYA
'Queen of the Western Palace', consort to Minkaung I (1401-21). She died of fright, in a cotton field, when she saw the ghost of her ex-lover Min Kyawzwa riding towards her.

35. SHINGON
'Lady Hunchback', a concubine of Aungbinle Hsinbyushin
or Thibathu (1422-26).

36. SHINGWA
'Lady Bandy -Legs', sister of Mandalay Bodaw, they were killed together with the
Shwebyin Brothers by King Anawratha (1044-77).

၃၇။ ရှင်နေမိမိနတ်။

37. SHIN NEMI
Commonly known as Ma Hnai Galay 'The Little Lady with the Flute', daughter of
Thon Ban Hla nat. The little princess died of grief.

The Mount Popa *taung-lei* or 'little peak',
the abode of the nats and spiritual home of the cult

The shrine to Popa Meda and her sons the Taungbyon Brothers,
who ride tigers, in the main *nat-sin* at Mount Popa